AMERICA'S ROME

AMERICA'S

VOLUME TWO • CATHOLIC AND CONTEMPORARY ROME

William L. Vance

ROME

YALE UNIVERSITY PRESS

NEW HAVEN AND LONDON

Published with the assistance of the
Getty Grant Program

Title page illustration: Hermon Atkins MacNeil, *The
Sun Vow*. Courtesy Art Institute of Chicago.

An earlier version of the essay on baroque Rome
appeared in the *New England Quarterly*.

Designed by Jo Aerne and set in Trump type. Printed
in the United States of America by Halliday
Lithograph, West Hanover, Massachusetts.

The paper in this book meets the guidelines for
permanence and durability of the Committee on
Production Guidelines for Book Longevity of the
Council on Library Resources.

Library of Congress Cataloging-in-Publication Data
Vance, William L.
America's Rome / William L. Vance.
p. cm.
Includes bibliographies and indexes.
Contents: v. 1. Classical Rome — v. 2. Catholic and
contemporary Rome.
ISBN 0-300-03670-1 (v. 1 : alk. paper). ISBN
0-300-04453-4 (v. 2 : alk. paper)
1. Arts, American—Italian influences. 2. Arts,
Modern—19th century—United States. 3. Arts,
Modern—20th century—United States. 4. Artists—
Travel—Italy—Rome. 5. Art and literature—United
States. 6. Rome (Italy) in art. 7. Rome (Italy)—
Intellectual life—19th century. 8. Rome (Italy)—
Intellectual life—20th century. I. Title.
NX503.7.V36 1989 88-20737
700'.973—dc19

The paper in this book meets the guidelines for
permanence and durability of the Committee on
Production Guidelines for Book Longevity of the
Council on Library Resources.

10 9 8 7 6 5 4 3 2 1

This book is gratefully dedicated
to friends in Rome—

Marisa DiVanno
Anna-Maria Bumbaca
Gabriella Bovio Fanning
Catherine Phelan
Marta Szepesvari
Francesco Papa
Claudia Parolini
Robert Della Valle
Rodolfo Conti
Renzo and Dea Gallo
Anna and Pietro Calissano
Vincent Masucci
Nilo Checchi—

and to Charles

Contents

Illustrations

Plates

following page 168

Acknowledgments

Most of the reading for this book was done in the McKim Building of the Boston Public Library, and it is to that noble institution that I am chiefly indebted. In the course of several years I was courteously and efficiently aided by the professional staff in Bates Hall, where I sat near the bust of Henry James, and in the Art Reference Library, where both the Medici Venus and the Venus of Canova kept me company along with William Wetmore Story's *Arcadian Shepherd Boy*, made in Rome. To take a breather in the library's sunny arcaded courtyard was to bring very close the subject of the books I was reading. An equally sympathetic environment was frequently found in the Boston Athenaeum, whose rare volumes are not too jealously guarded by a friendly staff and more Venuses. To the people in both of these libraries I extend my thanks.

I am grateful for the work of scholars who have explored the realm of my interest before me—especially for books by Van Wyck Brooks, Nathalia Wright, and Paul Baker, who mapped out much of the territory. But my indebtedness in volume I is even greater to those art historians, chiefly Wayne Craven and William Gerdts, whose herculean labors to establish the primary facts about nineteenth-century American sculpture and painting have established the historical foundations that make other commentary possible. My reliance on these scholars, and on other authors who have researched primary sources to write monographs on individual artists, has been extensive; specific cases of indebtedness I have tried to acknowledge in the notes and bibliography, an inadequate indication of the general value I have found in their work. Professors Craven and Gerdts also kindly responded to particular inquiries, as did Regina Soria, whose invaluable dictionary of American artists in Italy was not available until very late in my work, but whose long immersion in the life of Elihu Vedder in Rome had been an inspiration to me.

Peter Blume, Paul Cadmus, and Jack Levine beautifully replied to questions about their paintings, and I am very grateful to them. To the painter Alfred Russell and his wife, Joan, I owe a memorable and instructive evening of conversation over wine and cheese in their flat at the Chelsea Hotel.

Several colleagues and friends have read portions of the manuscript in its earlier

stages. For their criticism and encouragement I wish to thank John Malcolm Brinnin, George Landow, Naomi Miller, Roger Stein, and Helen Vendler. To Trevor J. Fairbrother I am especially indebted; he took an active interest in my project from its inception, passing on useful information and advice, showing me Sargents in storage, and giving my long essay on the Campagna a careful reading that greatly helped. Barton Levi St. Armand, of Brown University, wonderfully demonstrated how scholars can become friends without ever meeting; his incisive and sympathetic commentaries upon three of a stranger's drafted chapters displayed a generosity of spirit far beyond mere professional courtesy. At Boston University, a colleague in another department became a friend through the interest that he took in my book; it is impossible to overstate how much Fred Licht's enthusiastic response to the several hundred pages I imposed upon him meant to me—it provided the reassurance that saw me through to the end.

Many other people have my gratitude for contributions of various kinds. Among the countless blessings I have received from the friendship of my colleague Gerald P. Fitzgerald, an increase in my knowledge of Rome and in the ways of loving it is one of the more inestimable. Friends in Rome, to whom the book is dedicated, have sustained my work by changing their city from a place observed to a place of domestic intimacy, a second home. In Rome I am also indebted to Alessandra Pinto Surdi, chief librarian of the Centro di Studi Americani; the personal interest she took in my work made me the beneficiary of her energy, wit, and generosity. Professor Andrea Mariani of the University of Rome, who not only volunteered bibliographical suggestions but went far out of his way to assist me in the acquisition of photographs, is another friend whom I gained through my studies. At the library of the American Academy in Rome I was given generous access to interesting documents. In Boston I received gracious help from Carol Troyen of the Museum of Fine Arts, from Roger Howlett at the Childs Gallery, and from Howard Gotlieb, director of special collections at the Mugar Memorial Library of Boston University.

To the more than eighty individuals and institutions that have supplied me with photographs of artworks in their possession and permission to reproduce them, I extend my sincere thanks. Although the care and time of many people were involved in the process of locating works and assembling the photographs, I must mention in particular Patricia C. Geeson of the Office of Research Support at the National Museum of American Art (Smithsonian Institution). The project was also facilitated by the cheerful help of Barbara Gage Coogan, whose assistance was made possible by a grant from Boston University's Humanities Foundation, to which I wish to express my appreciation. Bobbi Coogan also applied her editorial skills to a wonderfully enthusiastic and attentive reading of the manuscript. Further contributions toward the cost of manuscript preparation were made by Boston University's Graduate School of Arts and Sciences, for which I am grateful to Deans Michael Mendillo and William C. Carroll.

My thanks for help in particular ways go also to Warren Adelson, Rodney Armstrong, James M. Dennis, Gianfranco Grande, Gerald Gross, Jonathan P. Harding, Donald Kelley, Harriet Lane, Lynne Lawner, Thomas W. Leavitt, David Garrard Lowe, John Matthews, Judy Metro, Richard Ormond, Marlene Park, Jan Seidler

Ramirez, Linda Smith Rhoads, Deborah Rosenthal, Judithe Speidel, and Theodore E. Stebbins. I was fortunate to have as my copy editor a most sympathetic and sharp-eyed reader, Cecile Watters.

To Charles W. Pierce, Jr., the first reader of all these pages, I owe a debt beyond words.

Preface

Those have not lived who have not seen Rome.
—Margaret Fuller (1848)

Rome became a city for me only when I chose, as did many before me, to give it a sense and for me Rome can exist only in so far as I have shaped it to my idea. . . . We are not in relationship with anything until we have enwrapped it in a meaning, nor do we know for certainty what that meaning is until we have costingly labored to impress it upon the object.
—Julius Caesar in Thornton Wilder's The Ides of March (1948)

This is a book about Rome.

This is a book about America.

For over two hundred years American writers, painters, and sculptors have been visiting Rome and making artifacts of their own national culture from what they saw and experienced there. This is a book about those artifacts—the representations of that experience in ink, paint, marble, and bronze.

Americans, sharing a fascination for Italy with German, French, and English writers and artists, were extremely conscious of the uses to which Italy had been put by other European nations in their own cultural self-definitions. But as citizens of a new nation, they felt that they had the most to gain and that what they gained would be distinctive. Both the uniqueness of their political identity and the deprivations of their cultural circumstances intensified their experience of Italy. In Italy were to be found a concentration of history and an access to experience, knowledge, and pleasure that could not be had at home. In 1869 Charles Eliot Norton wrote to his friend John Ruskin, "Italy is the country where the American, exile in his own land from the past record of his race, finds most of the most delightful part of the record." Two years later he contrasted the American experience of Italy with that of Germany: "In Italy one feels as if one had had experience, had known what it was to live, had learnt to know *something* if but very little, and could at least enjoy *much*."[1]

Although some Americans preferred to live in Florence or (later) Venice, Rome offered by far the richest repository of historical suggestion and the most provocative stimuli to creative representation. Indeed, in all the ways that Americans were obliged to confront the fact of Europe in the shaping of their own identity (an identity that owed more to Europe than it did to the western frontier), Rome offered the greatest challenge and some of the most precious gifts. England, as the "old home" of the Anglo-Saxon Americans who founded our culture and determined our language, was the place from which America most needed to differentiate itself. In contrast Rome before 1870 was the place most alien to America. Burdened and enriched by more historical strata than any other place; preserver of great art from antiquity and the Renaissance that had been inspired by pagan myths and celebrated the nude; center of a medieval religion from which the original Americans had fled; oppressed by autocratic rule and populated by a sensual and degraded people— Rome, a city with no future, was antithetical to what America was and (in all ways except the aesthetic) to dreams of what it might become. Rome thus originally had for Americans the attraction of the Other, both in the knowledge and beauty that it offered and in the horrors of its spiritual and social condition.

The story of American representations of Rome, however, is one of changes, in the representers as in the Rome represented. Hundreds of writers and artists have written their Roman fictions and commentaries or painted their Roman images and in doing so have represented themselves. But those who wrote of the modern capital of Italy in 1944, when the American Fifth Army passed through its walls, or painted it in 1955, in the days of la dolce vita, had little in common with those Americans who in 1844 or 1855 had visited a supposedly dying little papal city surrounded by a desolate Campagna. Within our narrative of America's possession of Rome through the works of its artists and writers, then, is the story of two great changes: in America's own idea of itself and in Rome as the place against which that idea could be measured.

Much has been written on the subject of Americans in Italy—first and most notably by Henry James, subsequently by Giuseppe Prezzolini, Van Wyck Brooks, Howard S. Marraro, Paul Baker, and Nathalia Wright, and most recently by Michele Rivas and Eric Amfitheatrof. One of the ways in which this book differs from theirs is that the subject of Americans in Italy has a secondary place; its primary focus instead is on Rome and on the actual works by Americans—the writings, paintings, and sculpture—that resulted from their encounter with Rome. These works, of course, always involve a degree of self-representation. This fact is of major significance since it determines the character of the Rome represented, which is always the product of partial perception and selective emphasis. But exploring what individual Americans *made* of their experience is a different thing from describing the historical phenomenon of the American presence in Italy. The lives of Americans in Rome appear here only as they affected representations of Rome. On the other hand, it has sometimes been necessary to consider the ideas of writers and the works of artists who never went to Rome at all, in order to define more sharply the motive of an argument or the relative quality of an achievement in the representations of those who did go.

But neither has a catalog of those representations been my purpose. I have been

most interested in exploring how the representations spoke to each other (not always knowingly), and in how they were devised as messages to America about itself or, in the case of paintings and sculptures, as appropriate, even necessary contributions to American culture. For nothing is further from the truth than the idea that American artists in Europe forgot who they were or where they came from. With rare exceptions, they labored as Americans for America. Some of the most eloquent testimonials from fellow citizens who visited their Roman studios are tributes to the heroism of the artists who lived in self-imposed exile so that they might become capable of giving America the great art it needed and deserved. Their sacrifice was a measure of their patriotism. The necessity of Rome to artists, and its effect upon them, were, of course, points of contention in the writings about Rome (including many by artists themselves). Indeed, Rome in all its aspects was problematical for Americans, as I have already intimated. Italy as a whole was very far from being the Dream of Arcadia or the Enchanted Land that it has been represented as being through a romantic emphasis upon its happier features. And in none of its four contemporary phases—papal, monarchical, fascist, and republican—has Rome offered unalloyed pleasure or an escape from "reality." The question of what could be ignored in order to enjoy what one wished Rome to be is therefore a common element in representations of Rome down to the present day. Starting from the Campagna in 1822 or from the Via Veneto in 1922, we may soon find ourselves far from the actual place, in an aesthetic forest or an aristocratic salon, equally pure products of the imagination.

I have attempted an exposition of my subject sufficiently comprehensive to include the major qualifications necessary to a complex truth. By organizing my descriptions and analyses of hundreds of artifacts around Rome's most prominent sites and sights—those physical things that make Rome Rome, things of which *everyone* had to take notice—I have hoped to discover the dominant perceptions and to bring them into relief by placing them against dissenting and eccentric views, which are often more eloquent because more deeply felt. One of the things I have most wished to avoid is to allow the individual representation to be swallowed up in a generalization about "American" opinion. Such generalizations are sometimes necessary as well as possible, but the truth is that there is no "American" representation of Rome, for not only did Americans change over time, but at any given period there were Americans who saw things very differently from other Americans. This is obviously true in the present century characterized by ethnic pluralism, but from the beginning the Americans who described Rome were far more varied, particularly in economic background, than is commonly thought. The majority of Americans who took up permanent residence in Italy or visited annually were no doubt wealthy, but the writers and painters and sculptors who created our Rome were far more typically poor: the work they did in Rome they did for a living. So "America's Rome" is necessarily a multifaceted and inconsistent Rome collectively created by many diverse individuals. To demonstrate and to preserve their disagreements over matters political, religious, and aesthetic has been one of my major concerns.

I have thought it important, too, to keep them, so far as possible, in the language of the original debates. Nothing is more depressing, or less authentic, than the bland

paraphrase from which the engaged individual voice has been removed. It is, in any case, less the *idea* to which paraphrase reduces any statement than the total character of the statement itself that has interested me. I could no more do without my quotations from writers than I could do without adequate illustration of the paintings and sculptures. This is as true of the scores of forgotten writers as it is of Henry James and Nathaniel Hawthorne. Travel writing or art criticism loses vitality only when it is pared down to a common core of experience or limited to the most frequently restated received opinions. Every individual perceived Rome differently, and the best professional writers possessed distinctive styles of representation adequate to the task of rendering their differences. They also calculated differently what would please their readers back in America, since it was for specific American audiences that they wrote. So every Rome differed and every statement was in some sense fresh. My concern has been much more with the recovery of a vast and varied body of American writing—much more easily lost and less easily recoverable than the paintings and sculptures to which the writing is intimately related—than it has been to simplify hundreds of representations into a single national vision.

Travel books and other kinds of writing engendered by the encounter with Rome besides fiction and poetry—journals, letters, chapters of autobiographies, aesthetic, political, and religious commentary and polemics—are essential records of the experience of Rome in its entirety as it mattered to Americans. Travel writing especially is far more vital than one might anticipate. As Henry James, himself a worker in the field, wrote of William Dean Howells's books on Italy: they "belong to literature, and to the center and core of it—the region where men think and feel, and one may almost say breathe, in good prose, and where the classics stand on guard."[2] Allowing for all calculations of commercial popularity, one still finds in these books immediate personal representations of Rome, representations valuable both in themselves and in the way they provide a context for the usually more artful versions of stories and poems. It is through their representations that we can most recapture what it was like to know Rome in 1850—or even 1950. In digging through old letters and other sources in order to recapture papal Rome, Henry James himself first felt the pathos and the significance of this effort. Thinking of the once-famous painter Jasper Cropsey, and all the forgotten Cropseys of the Hudson River School who also painted Roman scenes with a brilliant palette, James asks "what the Cropseys can have been doing by the bare banks of the Tiber." What makes such questions in "the history of taste" so "thrilling" is that they require us, in living "over people's lives," to "live over their perceptions, live over the growth, the change, the varying intensity of the same—since it was *by* these things they themselves lived." To follow this inquiry is to discover "how such dramas, with all the staked beliefs, invested hopes, throbbing human intensities they involve in ruin, enact themselves."[3]

My narrative, with its stops for descriptions and analyses, makes an irregular circuit of Rome's topography in a sequence determined by the merging of two chronologies. The three great phases of Roman history: classical, Catholic (medieval and baroque), and contemporary (the Rome in which Americans actually lived)—are reflected in my three divisions, the first of which occupies volume I, and the others,

volume II. It happens that the earliest American interest in Rome as a place (rather than as the Antichrist of Puritanism) centered on the earliest period: classical Rome. The Roman Republic filled the imagination of Adams and Jefferson during the same decades that American artists were first seeing the actual ruins of the Empire. And their own imperial possibilities dominated the imaginations of Americans for the following century. Later Americans (including Catholic Americans) became preoccupied with the character and power of the Roman Catholic church and finally interested themselves in the possibility of democratic developments in an Italy with Rome as its capital. Thus by instructive coincidence the chronology of successively emerging American interests in Rome (none of which ever fully fades away) parallels the chronology of Roman history.

A brief guide to the two volumes of *America's Rome*, with an indication of recurrent political, religious, ethical, and aesthetic themes, may be useful. The first three chapters of volume I take the reader from the Forum, center of the ancient Republic, to the Colosseum, greatest emblem of empire, to the Campagna, the melancholy evidence of empire's fall. Political and social questions dominate the representations of the Forum and the Colosseum; they provoke questions about the uses of history for thinking about republics and empires and for imagining new ones. The Campagna also relates to "the course of empire," but interest there shifts to themes from classical mythology and conceptions of symbolic or ideal landscapes (a crucial concern for painters whose obvious alternative was the American wilderness). In the final two chapters of volume I we consider what may survive the fall of empire: the gods and an ideal of beauty. At the Pantheon a consideration of Greco-Roman mythology serves as a prelude to tours of the museums of the Capitoline and the Vatican, where still stand those images of nude gods and heroes that so long served as the problematic ideal toward which American sculpture aspired. Neoclassical works of sculpture and painting produced by American artists as icons for an emergent religion of Beauty are explored at length, in the context of related American writing, as the most conspicuous products of the nineteenth-century encounter with Rome.

Volume II begins with representations of Rome as the center of Roman Catholicism. The Church's three most familiar local icons—as they were regarded by most observers in the nineteenth century—are described: the Santo Bambino, the Mother of God, and the pope. By pursuing representations of the popes down to the present day, we are able to compare the conflicted representations of contemporary American Roman Catholics with those of the antipapal Protestants of the preceding century, whose views had previously been dominant. Religious and aesthetic questions combine in chapter 2, a brief interlude in which we consider the largely negative reaction of nineteenth-century Americans to Rome's predominantly baroque sculpture and architecture. This judgment would be reversed a century later, when neoclassical sculpture was scorned and everyone adored Borromini.

The third chapter of volume II is the counterweight to the fifth chapter of volume I, in which the values, materials, and commitments necessary for aesthetic achievement were considered. Here some of the questions about political and social achievements, previously asked in relation to the ancient Roman Republic, return in the context of Italy's move toward national unification and liberalization. The

representation of Rome consists now of its people and of the walls, both real and symbolic, that divided them. Not long after 1870, when Rome became the capital of United Italy, it ceased to be the magnet for artists it had been, and visual representations (other than by photography) became the incidental products of artists on brief visits, whose primary centers of activity and artistic influence were elsewhere. But Rome as the capital of a nation undergoing rapid transformation held a new fascination. As the American publishing industry prospered and international journalism developed, written representations of Rome greatly increased between 1870 and 1920 and continued down to World War II; and even then they were kept up by a spy and a nun. Therefore it was possible to compose a continuous collective American representation of the volatile social conditions and dramatic events in Rome from the early days of the Risorgimento to the foundation of the Republic of Italy after World War II.

The significance of such an account lies not in its questionable reliability as contemporary Roman history (foreign eyewitnesses could hardly be expected to provide that) but in the commitments, ambivalences, and contradictions about social and political values displayed by the American recorders themselves. For better or worse, America is always the point of comparison with Rome. Usually it is thought of as better—as the model for Italian progress; but often enough, in 1848 as in 1918 and 1948, American disciples of freedom could declare that only in Rome did they find their "true America." These representations of Rome thus serve as a kind of running commentary on the changes that America itself was undergoing. Once more, in representing Rome the Americans represented—and sometimes discovered—themselves. The dual process continues to this day. After the war American artists and writers returned to Rome in unprecedented numbers, and chapter 4, as an epilogue, accounts for something of what Americans have made of Rome in the last forty years. Unquestionably they have been a different people visiting a drastically changed city. But in finding their own ways of taking imaginative possession of Rome, these writers and artists have demonstrated once more Rome's apparently inexhaustible capacity to contribute to America's unending process of critical self-definition. That Rome—America's Rome—is the subject of this book.

AMERICA'S ROME

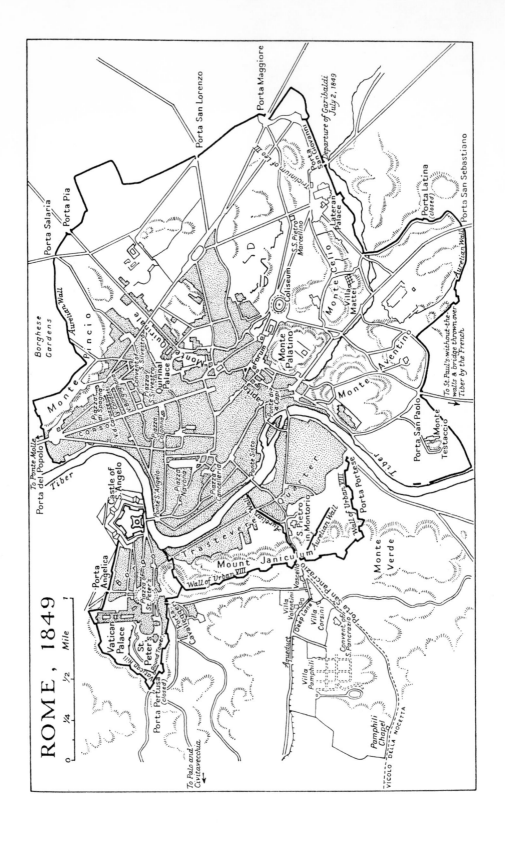

ROME, 1849

0 ¼ ½ Mile

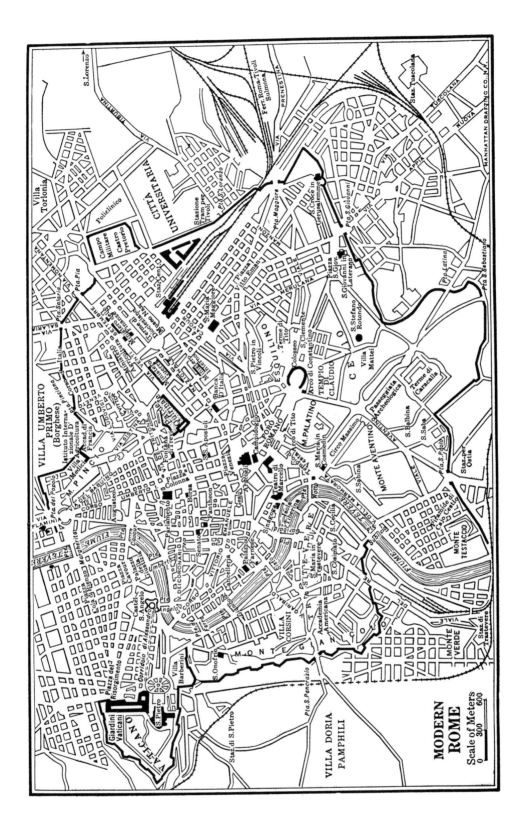

MODERN
ROME

Scale of Meters
0 300 600

Part One

Catholic
Rome

I

The Idols of
Catholic Rome

*I state as my simple deduction from the things I have seen and the things I have
heard that the Holy Personages rank thus in Rome:*

First: *"The Mother of God"—otherwise the Virgin Mary.*
Second: *The Deity.*
Third: *Peter.*
Fourth: *Some twelve or fifteen canonized popes and martyrs.*
Fifth: *Jesus Christ the Saviour (but always as an infant in arms).*
<div align="right">

—*Mark Twain,* **Innocents Abroad**
</div>

When James Jackson Jarves published his *Italian Sights and Papal Princi-
ples Seen through American Spectacles* in 1855, there was no ambiguity about the
meaning of "American" in his title. Viewing the world through the twin modern
lenses of democracy and science, Jarves could easily show that "papal principles,"
as manifest in Rome, were wholly alien to American culture. The Roman religion
was characterized by repressive autocracy and idolatrous superstition, and it fos-
tered ignorance, immorality, and indolence. For the American visitor to Rome,
Catholicism provided a pageant from the past of enormous historical interest, but
politically and intellectually it was repugnant to all progressive values. Jarves's
detailed exposé of "papal principles" was clearly intended to choke off their growth
in the New World, where they threatened the evolution of an enlightened Protes-
tantism into a liberal Christian humanism.

We shall see later that as recently as 1965 an American writer in the tradition of
Jarves could analyze the Second Vatican Council in terms that place the quintes-
sentially "American" values of "Monticello" in absolute opposition to the incor-
rigibly medieval values of "Rome." But the full story of Americans encountering
the icons of Catholic Rome—sacred images, holy relics, and above all the pope
himself—necessarily involves a second contrast, between the American views
defined as antithetical to Rome and those of American Catholics, whose fate it has
been to attempt a union between America and Rome. Naturally charges of bigotry
and intolerance characterize the commentary on both sides. The "Americans" are

as certain of the truth as are the Catholics. "Americans" believe in religious free-
dom as a primary political value, but their tolerance usually does not rest upon
religious indifference. Nor does their own commitment to enlightened forms of
Christianity mean, as they see it, that they possess illiberal minds, like Catholics.

The Baptist clergyman Robert Turnbull, Scottish-born and Scottish-educated
but thoroughly "American," refers frequently in *The Genius of Italy* (1849) to his
own faith as the "true" one with as much confidence as any Catholic, but he also
presents himself throughout his book as the embodiment of the "liberal"—that is,
the free—mind. When Turnbull first descended into Italy from the Alps, he ex-
claimed, upon seeing a statue of Cardinal Borromeo, "How gratifying to a liberal
mind to discover, among the devotees of what may be deemed a false and super-
stitious faith, some pure spirits" such as Borromeo, Fénelon, and Pascal. Possessed
of such self-assurance, it was possible for Turnbull and others to anathematize the
paganism and persecuting bigotry of Catholicism in Rome without fear of falling
into bigotry themselves. For there is one essential difference, according to Turn-
bull, between Protestantism and Catholicism: Protestants could never "justify"
the cruel repressions of which they had also sometimes been guilty, since coercion
is alien to the spiritual freedom fundamental to their faith; but "the Papal faith"
rests upon "false principles" that lead inevitably to rationalized oppression. Big-
otry was the characteristic curse of Italy, as freedom was the blessing of America.
Turnbull naturally assumes that in resting everything on the absolute value of
"freedom" he has the complete assent of his American readers. He in fact presumes
that his readers are even less willing than himself to concede anything to Catholi-
cism. In his introductory chapter he points out that he has seen some of Chris-
tianity's "all-transforming elements" preserved "even amid the corruptions of
Rome." Stars obscured by clouds are still stars, "and shine with benignant radi-
ance, even upon Italian minds." This conceded more to Italian clergymen, after all,
than they would concede to the Reverend Mr. Turnbull, as he learned when he
shared a coach with a friar, a canon, a Jesuit, a Tuscan soldier, and a Lombard
merchant. Only the soldier and the merchant seemed relatively enlightened. When
Turnbull directly queried the Jesuit (presumably the most intelligent of the three
churchmen) about Catholic superstitions, he replied that "the Church has no su-
perstitions, no pretended miracles, no heathen ceremonies." What is more, anyone
who thought otherwise was damned.[1]

The opinion of this confident Jesuit was the one adopted by most American
Catholics, in opposition to the "American" view of Catholicism in Rome. They
assumed both that the church offered the one true faith and that there was no
essential conflict between papal principles and American values. They looked to
the day when all of America would be redeemed by Rome; and a few of them
occasionally imagined a time when Rome itself would become more American.
What is apparently the first book by an American-born Catholic about his visit to
Rome is particularly valuable in that it deals with precisely the same three issues,
from the opposite side, that were to preoccupy American visitors in the nineteenth
century: miraculous icons and relics, the Virgin Mary, and above all the power and
infallibility of the pope. The issues are discussed, moreover, entirely in terms that
should be acceptable to the liberal, rational, tolerant mind. Nowhere in the argu-

ment is any awareness shown of a possible conflict between the values of Monticello and Rome. On the contrary, it is assumed that America's separation from Great Britain—victoriously completed in the same year—has laid the necessary groundwork for its conversion to Rome.

An Account of the Conversion of the Rev. Mr. John Thayer, Lately a Protestant Minister, at Boston, . . . Who Embraced the Roman Catholic Religion at ROME, *on the 25th of May, 1783,* written by himself, begins by admitting that Thayer arrived in Rome "strongly prejudiced both against the nation and the religion of that country, which had been represented to me in the most odious colours." Anyone who has read Cotton Mather on the pope as Antichrist and the Church of Rome as the Whore of Babylon understands what is meant by "odious." Thayer, however, was surprised to discover that Italians were notable for extreme civility and hospitality and that as Catholics they displayed complete tolerance, even after they discovered his clerical profession. Initially his interest in Rome was entirely in the antiquities. But one day at the Pantheon, being "fond of the eloquence of the pulpit," he compulsively extemporized a sermon on how the temple's conversion into a church symbolized the triumph of Christianity over paganism, it being "worthy of God, to make the centre of idolatry, the centre of the true faith." Unfortunately, he did not yet believe the moral of this sermonette to be true, but such "new thoughts" inspired him to study Catholicism further. He assures his reader that the study was undertaken in the same spirit of disinterested inquiry that would have led him to study Mohamet, had he been in Constantinople. Although he knew well enough that Jesuits were "cunning, designing men," they were also "celebrated for their learning," so he did not see why he should not "profit from their lights" while guarding himself "against their subtilty." He presented himself to them as a candid, liberal-minded person: "I may possibly have conceived some false notions of your Religion, as all the knowledge I have of it, is taken from the report of its enemies; if this is the case, I wish to be undeceived, for I would not entertain a prejudice against any person, not even against the Devil."[2]

At the end of three months spent in study and discussion of the articles of faith, Thayer still had many objections. An Augustinian friar then pointed out to him that Catholics distinguish between the crucial articles of faith and the "simple opinions" that they are not required to believe. This discovery was very important to Thayer. Since Catholics of all times and places agree on a few fundamental articles of faith, those articles must be true and universal. Protestants, in contrast, dispute with each other endlessly on every point, and themselves frequently change positions. This confusion of revealed truth and personal opinion results from the fundamental fallacy that individual judgment is to be relied upon in such matters.

Thus far Thayer's "account" has been one of prejudices admirably uprooted and of rational studies industriously pursued to their logical conclusions. At that point a holy man, the Venerable Labre, died in Rome, and miracles began occurring. Thayer assures his reader that Catholic miracles were the *last* thing he would credit. But fair-mindedness required not the coffeehouse levity he first indulged in but rather the objective investigation of the facts of the matter. He personally visited an old nun who had benefited from one of the reputed miracles and found

her in blooming health. Near death as the result of a burst blood vessel, she had been "cured in an instant" by drinking a draught into which one of the Venerable's bones had been dipped. Only after Thayer had painstakingly interviewed all the reliable witnesses—doctors and other nuns—did he come to the conclusion that a miracle was the only rational explanation. After this, the "last difficulty" in recognizing Catholicism as the True Faith lay in its "worship of the Blessed Virgin and of the Saints." This "idolatry" caused him days and nights of agonized struggle. He prayed in rotation to the Father, the Son, and the Virgin, always asking the first two for assurance that it was permissible to proceed to the third, until he became completely comfortable with "devotion to this dear Mother of God."[3]

Now willing to sacrifice "family, state, fortune, reputation" to his new beliefs, Thayer concludes by announcing his intention to return to America to help in its conversion to Catholicism. He suspects that "the surprising Revolution" in American politics was but the preparation for this "much more happy Revolution in the order of Grace." And indeed, history tells us that Thayer became a thorn in the side not only of his former Protestant colleagues but also of his Catholic superiors, who found that the tactless zeal with which this convert pursued his mission was not conducive to good relations with the majority in America. Something of Thayer's aggressive and falsely tolerant tone is evident in two letters to his brother that he appended to his "account," assuring him that only *bad* Catholics are persecutors, he himself having met none who expressed any "animosity toward Protestants." On the contrary, "they pity them, and pray for them, as deluded and deceived." On the other point that particularly troubled his brother, papal infallibility, Thayer is happy to assure him that this is one of those "simple opinions," not an "article of faith." Infallibility belongs to "the whole Church, i.e., to the majority of Bishops joined to the Pope, and not to the Pope alone." Thayer signs off by telling his "beloved brother" that he will be eternally damned if he doesn't agree, since now that everything has been rationally explained to him, he no longer has any excuse for his infidelity.[4] Like the Reverend Mr. Turnbull making affable inquiries of his Jesuit fellow traveler sixty years later, Thayer's brother received a reply that left him hanging over the pit of hell.

In the face of such absolutism and unapologetic confidence, Americans were often frustrated in their wish, when encountering the icons of Rome, to make fair critical discriminations and to allow for variations in cultural traditions and needs. After all, Catholicism in Rome had the fascination of the Other, yet it had undeniable elements of the familiar and the sacred. The Church presented itself as monolithic and impregnable, while the visitor responded differently to different aspects of a perceived complexity. The outrage of Americans at elements of pagan idolatry in Catholicism was tempered by their recognition that the Church was also Christian. Their laughter over its relics was sometimes squelched by their recollection that Catholicism was a religion and therefore deserved respect. Their dismissal of it as intellectually medieval was countered by the entertainment they found in its picturesque customs, and sometimes by doubts about modern forms of belief and unbelief. Their horror over its sumptuous material displays was compromised by the pleasure they themselves found in some forms of its beauty. Representative manifestations of these ambivalences toward Catholicism, not always expressed in

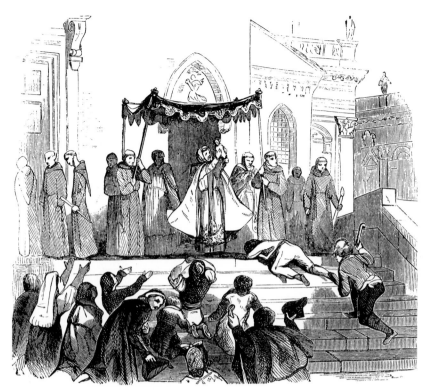

Fig. 1. *The Most Holy Baby.* Illustration for J. J. Jarves, *Italian Sights and Papal Principles*, 1855.

each instance but collectively impressive, may be found in the records of their encounters with the Santissimo Bambino, the Virgin Mother, and, above all, the Holy Father, the pope. These "holy personages" were the leading figures of the Christmas festivities extending from the Nativity to Epiphany, which Americans and other foreign heretics deliberately came to Rome to experience. To characterize American representations of Catholicism in Rome, we may draw primarily upon accounts of that sacred season.

Il Santissimo Bambino of the Ara Coeli

On the opposite side of the Capitoline Hill from the Forum, there are two ways to ascend. One is by the easy gradations of the Renaissance, on the *cordonata* designed by Michelangelo in the sixteenth century. After passing between two ancient Egyptian lions at the bottom, and between antique statues of Castor and Pollux at the top, the climber stands facing the noble equestrian statue of Marcus Aurelius, preserved throughout the Middle Ages because it was thought to represent the first Christian emperor, Constantine. Nothing remains visible of the Temple of Jove Capitolinus that once rose on the southwestern horn of the hill to the right, the most sacred place in ancient Rome. The alternative ascent is by the 122

steep steps that lead to the bleak brick façade of Santa Maria d'Ara Coeli, a church founded in the seventh century on the site of the ancient Temple of Juno. It takes its name from the legend that here the Sybil prophesied to the emperor Augustus that this would be the Altar of God's Son. The beautiful marble columns of its dark, complex interior come from a variety of ancient buildings that had honored pagan gods.

Perhaps nowhere in Rome are the triumph of Christianity over paganism and the mingling of their images more apparent than at the Ara Coeli, as both Gibbon and Henry Adams realized. Here, in fact, many Americans were led to the perception that perhaps, after all, pagan idolatry had not died. Here they encountered many of the most repugnant features of Roman Catholicism: the hocus-pocus of its chanting friars, its incense and holy water, votive candles burning before images of the Virgin, testimonials to miraculous cures, chapels filled with frescoes of martyred saints and tombs of venerated popes and cardinals. On the steps leading to the church squatted beggars of every description; inside was a horde of dirty monks anxious to exploit every visitor as well as the faithful poor. Here the hopelessly "medieval" nature of Catholicism was most apparent, and it was all concentrated in one ridiculous and pathetic figure: the famous Santissimo Bambino of the Ara Coeli. From William Wetmore Story's *Roba di Roma* of 1853, which was banned from Rome itself because of its irreverence toward the Bambino, to Eleanor Clark's expostulations about the doll during the Holy Year of 1950, no object of veneration received more attention and ridicule than this one. The Bambino may stand for one aspect of Catholicism that preoccupies many representations of Rome: its combination of pagan idolatry and medieval superstition.

A feature of nineteenth-century American books on Catholic Europe is their love for long, indignant, and comical lists of things revered by the superstitious to the enrichment of the Church. Americans as diverse as the civil engineer William Gillespie, the clergyman Robert Turnbull of Connecticut, the art historian James Jackson Jarves, and a commonsensical comedian like Mark Twain (whose fun with holy relics began as soon as he arrived in the Azores) are united by the horrified hilarity with which they regard the popularly venerated objects of Catholic faith. In Rome the largest collection of such things was at the Basilica of St. John Lateran. In 1843 Gillespie gleefully translated a list of its precious relics, which in addition to the usual things to be seen everywhere in southern Europe—such as nails from the True Cross and thorns from the Crown—included novelties like "the finger with which St. Thomas touched Christ," "the ashes of S. Lorenzo Martyr, made into a cake with his blood," and, of course, the "unquestioned heads of St. Peter and St. Paul," which are the Basilica's most revered possessions.[5] The Reverend Mr. Turnbull was shown "the mouth of the well of Samaria, two pillars from Pilate's house, the table on which our Lord partook of the last supper, and a pillar of the temple split by the earthquake at the crucifixion!!" In a room above the Santa Scala (which was also from Pontius Pilate's house), he saw a portrait of Jesus by St. Luke, "a feather from the wing of the angel Gabriel," and "a bottle of the Virgin Mother's milk."[6] Everyone laughs over the number of authentic portraits of Jesus or the Virgin painted by St. Luke that they have seen in Italy. "The apostle appears

to have worked diligently in this line," wrote Jarves; the saint will eventually have to be accepted as the founder of modern painting.[7]

One visitor to St. John Lateran, however, consciously refrained from the "irreverent ridicule" of the others. Nathaniel Hawthorne's troubled skepticism fostered an envious respect for the naive faith of Italian Catholics, which he frequently expressed in *The Marble Faun*; most of his fiction, of course, demonstrates his fascination with supernaturally endowed objects and symbols. When he visited St. John Lateran in the company of Story, who was fond of all Roman things simply as human curiosities, Hawthorne found the "table on which the last supper was eaten" the most interesting thing there. He described it carefully in his *Notebooks* and, after observing that it would "accommodate twelve persons, though not if they reclined in the Roman fashion," concluded wistfully, "It would be very delightful to believe in this table."[8]

These comments demonstrate the extremes of American reactions, from scorn to the (very rare) envious ambivalence of Hawthorne. Jarves and Turnbull meet the obligation of enlightened people to expose the intellectually oppressive humbuggery of the Church, and Mark Twain delights on this as on all occasions to expose fraud by the light of American common sense. But sometimes the American ideal of tolerance is recalled. After Gillespie enlivens his pages with a list of ridiculous relics, he states that although philosophically it is possible either to laugh or to weep at these things, "we travel to very little purpose if we do not learn charity to every sincere belief, however absurd it may seem to us; remembering that our own may seem equally so to a more enlightened order of beings."[9] Having said as much, Gillespie goes on to write four mocking pages about the Santissimo Bambino.

During the most popular holiday season the Santissimo Bambino is displayed as the central figure of an elaborate *presepio* in a chapel of the Ara Coeli, where Roman children still deliver sermons to the Babe from a little pulpit. Story's representation of these customs in *Roba di Roma* is informative and affectionate, as are almost all of his discussions of Roman folkways in his invaluable compilation. But even Story finds them a source of humor and an occasion for easy ironies. He says, for instance, that the legend that the wooden doll had been painted by—whom else?—St. Luke does little for the saint's reputation as a painter. Moreover, in the presepio display, the Babe and the Virgin are so overloaded with jewels (the superfluous St. Joseph is left unadorned) that the gift-bearing Wise Men "seem rather supererogatory." More seriously—and no doubt more offensively to the Church— Story speculates that the "modern superstition" of the Bambino derives from the pagan one that worshiped a "bronze she-wolf" on the spot where the "wooden Bambino" now lies.[10]

Story's critical attitude is mild compared with that of the Reverend Mr. Turnbull, who devotes a wrathful page in his usual exclamatory style to this "most popular idol." He can hardly contain himself when, on Epiphany, it is lifted high on the Capitoline steps to the "crash of cannon and martial music," and "the vast multitudes fall prostrate in adoration before it, as if it were filled with all the fullness of the Godhead!"[11] Jarves includes an engraving of this very scene (see fig. 1) in his book, showing the people in operatic gestures and cripples climbing up-

ward toward the Babe. To Jarves, the art critic, it is a "wretchedly-carved wooden doll, loaded with an incalculable amount of precious jewels," which brings to the monks of the Ara Coeli "a revenue which enriches them all."[12]

To many people the enormous wealth of the Babe—and of his proprietors, the monks—seemed even more intolerable than the idolatry. A poem called "Ara Coeli" by the genteel man of letters Thomas Bailey Aldrich introduces the question of the Bambino's wealth as its only point of criticism. "Many a beggar" kneeling before the Bambino at Epiphany, he wrote, would not "envy the Pope" if he received "half the care" given "yonder Image" by its "minions." Throughout the year it enjoys a "silken couch," a "jewelled throne," a "perfumed chamber" (the Sacristy), and "a special carriage all its own." If it could only eat, Aldrich solemnly notes, "it could have the choicest wine and meat." Having exploited the irony of the beggar and the Babe, however, Aldrich concludes sympathetically in a display of sentimental liberal understanding, which seems to have been facilitated by the image of a "princess" who leaves a "glittering bracelet . . . at the Baby's feet":

> Ah, He is loved by high and low,
> Adored alike by simple and wise.[13]

That, however, was not the truth according to Gillespie (who had had the Bambino's toes unexpectedly pressed to his lips by the priest). The New Yorker wishes to do "justice to Roman Catholics of education" by reporting that the tale of the Bambino's kidnapping (from which he escaped, returning to the Ara Coeli on his own feet), was "laughed at most heartily" by "an intelligent Jesuit," who assured him that many "good" Catholics disbelieved the Church's miraculous claims, but would "sin deeply" if they brought the religion into contempt by exposing the "imposture of the priests." Gillespie thus does justice to educated Catholics by reporting their conscious hypocrisy: "The subtlety of this distinction is worthy of a Jesuit," he concludes.[14]

The Santissimo Bambino's wealth chiefly derived from his services as a miracle worker among the sick. Throughout the year he rode about the city in a carriage as fine as any cardinal's, attended by at least two priests and two footmen. According to Turnbull (whose reliability in such matters may certainly be questioned), the Bambino received "more and better fees than all the medical men of Rome." As he passed, everyone "uncovered or fell prostrate on the ground."[15] Story says that "the more superstitious" cried out: " 'Oh, *Santo Bambino*, give us thy blessing! oh, *Santo Bambino*, cure our diseases! lower the water of the Tiber; heal Lisa's leg; send us a good carnival; give us a winning *terno* in the lottery'; or anything else they want." The Bambino's curative powers are not remarkable, Story notes, since the "blood-letting and calomel" prescribed by "the regular physicians" are "intermitted" whenever he calls.[16]

The Bambino's success and popularity were so great that during the brief triumph of the Roman Republic in 1848–49, after Pius IX fled the city, the revolutionaries actually gave the Babe the pope's own carriage. But he appears to have suffered some reverses after Rome became the secular capital of a united Italy in 1871. By 1898 he

had no carriage at all, much less the pope's. Maud Howe describes in *Roma Beata* how in that year her porter's wife had asked her to borrow the carriage of a neighbor, Mrs. Haywood, an American marchesa whose title had been granted by the Vatican, and who lived in the most distinguished Renaissance palace on the approach to St. Peter's. The purpose was to carry the Santissimo Bambino to the home of another neighbor, who had a horribly crippled and suffering child who wanted only to be cured or to die. The Bambino would pay a visit if a private carriage with at least two horses and two servants were sent for him. Mrs. Haywood, however, firmly refused, explaining that the Bambino had already borrowed it so often that she seldom had use of it herself.[17]

After this rebuff the Santissimo Bambino almost disappears from American accounts of Rome, although the Christmas and Epiphany festivities of which he was the protagonist continued. With some surprise, then, one finds him under attack again, in terms hardly less biting than Turnbull's, during the Catholic resurgence of the Holy Year 1950. Another American had found him offensive and perplexing. Eleanor Clark, in *Rome and a Villa*, allowed that one can take a "parasitical profit" from "other people's belief" in some "objects of superstition" because they represent "human continuity"; still others are "offensive only intellectually." But the "miracle-working doll" of the Ara Coeli, "packed like a papoose in a solid swathing of votive jewels," offends "more deeply":

> To see the devotion it inspires can fill one with loathing for every aspect of the religion of Rome. There seems no Catholic dishonesty more guilty than that of intelligent Catholics who separate themselves from this willful infantilism while accepting dogmas that could not have been propagated without it. But what seems dishonest in an Anglo-Saxon mind often does not in an Italian one.[18]

Nothing essentially has changed; the Santissimo Bambino, an idol exceptionally repellent because exceptionally adorned, is inseparable from the intellectual dishonesty of the loathsome "religion of Rome" as a whole. Even the inescapably condescending equivocation of Clark's last sentence is, as we have seen with Turnbull and Gillespie, typical of the enlightened attitude. In the good American style of Benjamin Franklin, Clark avoids the appearance of dogmatism herself by frequent use of "seems," yet manages to judge the Italians "guilty," while allowing that they are, after all, different from us. Stendhal, long before, had thought so, too. Amused but never outraged by the relics of superstition (he mentions even Christ's foreskin, which all Americans overlooked), Stendhal, recalling the strictly Sabbath Day piety of mercantile London, remarked that the Italians were less moral than the English, "but not so stupid."[19]

Santa Maria Maggiore: "The Mother of God"

On Christmas Eve, 1843, the New Yorker William Gillespie passed fifteen hours without interruption making the circuit of all the Roman churches that promised

the most splendid or picturesque ceremonies. Such a typically conscientious visitor began at the Sistine Chapel and ended up the next morning back at St. Peter's in a state of total exhaustion. In between he witnessed the placement of the Santissimo Bambino in his presepio at Santa Maria d'Ara Coeli and heard special musical "performances" at other churches along the route. Most important, he climbed the Esquiline Hill to the brilliantly illuminated Basilica of Santa Maria Maggiore to see the superb procession honoring the Virgin and the Holy Cradle, its own most revered relic.

The Basilica itself, greatest of the more than fifty churches in Rome dedicated to Mary, was admired for its antiquity and the "pagan" beauty of its interior: it looked more like a classical Roman temple than any other. The gold of its ceiling was of special interest to Americans, since it was the first to be sent from the New World, a gift from Ferdinand and Isabella to the Borgia pope Alexander VI, although this reminder of Catholicism's lucrative penetration of the Western Hemisphere was sometimes ungratefully noted. The most problematical sight in the church, however, was the splendid thirteenth-century mosaic in the apse, depicting the Coronation of Mary by her Son. Together with subordinate representations of the Conception, the Nativity, the Purification, and the Translation, it boldly asserted the exalted place of the Virgin in the Catholic faith. The basilica was founded just after the Council of Ephesus in 431 had given to Mary the title of "Mother of God." Moreover, such was the resurgence of Mariolatry in the nineteenth century that the medieval origin of the imagery did not so much establish it as an anachronism as testify to its timeless power, and therefore to the Church's strength and continuity.

The presumption of the Church in perpetuating such idolatry into the modern scientific world naturally incited much outraged commentary. Yet, while mockery of the Santissimo Bambino was easy, since he was obviously just a painted wooden idol that no "American" ever thought of associating seriously with Jesus Christ, the Virgin was difficult to satirize because the adulation for her had affinities both with American respect for Woman, especially for Woman-as-Mother, and with America's own puritanical obsession about woman's sexual purity, if not her virginity. The Italian devotion to a combined image of virginal purity and motherhood was understandable and even admirable, although enlightened people could never join in the actual veneration of Mary herself, who seemed in Rome to usurp the place not only of Christ but of the Deity.

The most sympathetic representations of Mary-worship were written by William Wetmore Story and Nathaniel Hawthorne. In *Roba di Roma* Story observes that the universal Italian "reverence" for the Madonna "paid by persons of all ranks" is most intensely evident in Rome. When he again derives the Catholic practice from pagan tradition, he does not intend any denigration, but rather to show that it responds to a timeless and fundamental human need. The month of May, when festivals in honor of Mary are celebrated, was also sacred to "the Bona Dea among the ancient Romans." Mary is the modern Penates of every home, the *Stella Maris* to every fisherman. The Ave Maria recalls to each person his own mother at the end of the day, and it is on his lips at the end of his life. Gratitude for maternal intercession is recorded on every street, along every wayside. Just as the ancient Romans of every class made votive offerings to their gods, so the humblest wineshop-keeper who

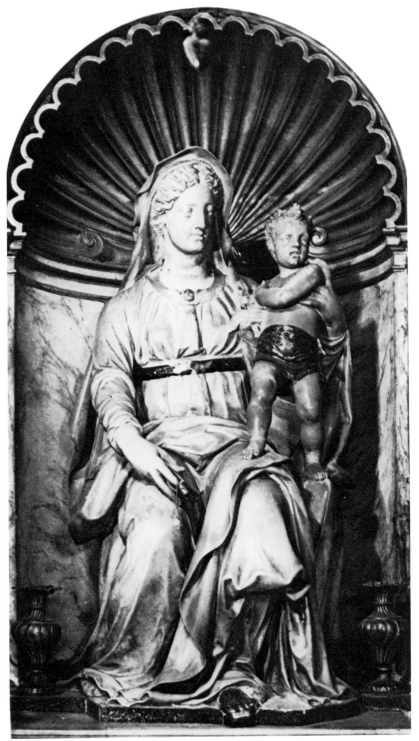

Fig. 2. Jacopo Sansovino. *Madonna del Parto.* 1521. Sant' Agostino, Rome. Photo by Gianfranco Grande.

tacks up a "wretched lithograph" is united in feeling with "the late grand-duke of Tuscany" who built a splendid shrine where he and his children were saved "on the road to Bello Squardo." The fact that "among the Roman people this worship of the Madonna is genuine and unaffected" is enough to make Story accept it—in Italians. As in his entire account of Roman customs, his sympathy is always expressed with the detachment of an eternal foreigner and complacent heretic, who can never himself fully know or feel what he observes, nor wishes to.[1]

The situation is otherwise with Hawthorne, who both in his *Notebooks* and in *The Marble Faun* frequently indicates his appreciation of the psychological value of Catholic worship and his regret that it is unavailable to him. He causes his Hilda, puritan New Englander and white-gowned virgin heroine of *The Marble Faun*, to become herself the tender of a shrine to the Virgin Mary. She—and Hawthorne—see the act from the beginning as irreproachable because it simply honors "the idea of Divine Womanhood." But at the crisis of Hilda's life it becomes more than that; she sees in the "sacred image" "a woman's tenderness responding to her gaze. If she knelt—if she prayed—if her oppressed heart besought the sympathy of Divine Womanhood, afar in bliss, but not remote, because forever humanized by the memory of mortal griefs—was Hilda to be blamed? It was not a Catholic, kneeling at an idolatrous shrine, but a child, lifting its tear-stained face to seek comfort from a Mother!"

This distinction between idolatrous Catholic and suffering child, however, cannot be made when Hawthorne shows the penitent murderer Donatello, his fallen faun, praying to a wayside Madonna whose "mild face" elicited more fervor and more hope than crucifixes had done. Hawthorne admits that "there are many things in the religious customs of these people that seem good." He does not doubt that "the efficacy" Donatello found in "these symbols . . . helped him toward a higher penitence," and even goes so far as to say that his anti-Catholic Kenyon's own prayer for Donatello was "rendered more fervent by the symbols before his eyes."[2]

James Jackson Jarves and the Unitarian clergyman-novelist William Ware forcefully represent those who most feared and resisted the attractions and benefits acknowledged by Story and Hawthorne. But they too differ in their attitude toward Mary, since Ware, although attracted by the music and some aspects of the forms of Catholicism, feels nothing of the art historian's ambivalence toward Catholic icons, an ambivalence arising from the difficulty of dissociating appreciation of beauty from belief. Ware is struck most of all by the incredible degree to which the Virgin has supplanted Christ and God as the object of Roman worship. Romans seem to think that they can talk to her as they cannot to God and that with her a quantitative bargain can be struck: the more proofs of their adoration the more she will intercede for their salvation. Consequently her every image is "bedizened" with fine clothing and tinsel. Ware objects not only to the fact of Mary-worship but to its character. Too much of that "purely human feeling" that Hawthorne admired is "mingled" in the homage of the Romans. As they fondle and kiss her silver toes, while entirely ignoring the Child on her knee, Virgin-worshipers are not an attractive spectacle. It reminded Ware of the bizarre religious feeling in Monk Lewis's gothic novel, *The Monk*.[3]

Jarves, as we have seen, thought the greatest art was necessarily religious but that

religion was evolving (in America especially) toward a rational Religion of Humanity freed from medieval superstitions. In *The Art-Idea* Mary is discussed as the greatest of the saints that constitute Roman Catholic polytheism, which is understood as a natural but inferior continuance of pagan polytheism.[4] But when he considers the tawdry and hideous "heathen idols transformed to modern gods" in his *Italian Sights and Papal Principles*, his own commentary on Mary becomes even more exasperated than Ware's, and inadvertently reveals some biases of his own:

> In 1854, this century of so-called intelligence, the Holy Father . . . has added to the Roman mythology a woman-god, "the most holy Virgin Mary, Mother of God," to whom the faithful are to pray. Despite the experience of Adam, the Roman Church puts its trust in a woman, born of man. Can the imbecility of dogmatism go farther! The woman, of whom Christ said . . . , "Woman, what have I to do with thee?"

The new dogma of the Immaculate Conception of Mary, promulgated that year by Pius IX, perfectly illustrated the "mind-destroying system" of the Roman church.[5] Twenty years later the first American minister to Rome, George Perkins Marsh, spent part of his time composing a strongly anti-Jesuit but scholarly attack upon the Church's cynical exploitation of ignorance and superstition. *Mediaeval and Modern Saints and Miracles*, published in diplomatic anonymity, contains one chapter, "Romish Hagiology under Pope Pius IX," on the increase in fervid Mariolatry and another chapter on Mariolatry in France. A hundred-page appendix documents the Church's encouragement of the movement and lists the thirty-five accumulated titles for Mary. The many-sided Marsh, who also wrote an Icelandic grammar, a book considering the feasibility of introducing camels into the American Desert, and an influential study of man's relation to his environment, is here seriously alarmed that the ingenuous nature of Americans has made "Romish proselytism" successful among them. He earnestly hopes to protect America by exposing the Jesuits from their base in Rome.[6]

It was possible for an American who began with such views to modify them as he became more deeply acquainted with Catholicism. When Charles Eliot Norton, the son of America's "Unitarian Pope" and still in his twenties, first witnessed the superstitious practices of the Eternal City in 1856, he denounced them in a letter to James Russell Lowell, saying that the increasing worship of the Virgin was symptomatic of the need for a revolution; he himself was willing to "roast a Franciscan" or "stab a cardinal" to further the cause.[7] In Norton's *Notes of Travel and Study in Italy* (1859), Italian veneration for the Mother of God is a recurrent complaint. To him, Hawthorne's sympathy for Mary-worship would have seemed completely sentimental, since Norton sees it as nothing more than a medieval mechanism for the enrichment of the church. The pope's power depends upon popular belief in Hell and Purgatory. In their fear of a vengeful Father the people turn to "the Mother of Mercy." Pius IX had recently promised them three hundred days of indulgence for every time they sang one of two new little songs to the Virgin (which Norton reprints), and these are merely the latest additions to a list of thirty-five means of

gaining indulgences through reverences to the Virgin (only five forms relate to the worship of God himself).

But Mary not only is efficacious in providing relief from future pains; she is depended upon for help in this world as well. Norton devotes eight pages to a discussion of the miracle-working statue of the Virgin with Child in Rome's San Agostino (see fig. 2), a Renaissance work by Sansovino that had become the object of special veneration as recently as 1820. So successful was this Virgin in curing illnesses that her chapel was now overloaded with gifts, ex-votos, and candles, and in 1851 the statue had been honored with a coronation, "the final and highest testimony of the Church to its miraculous virtues." To Norton, "that such a state of things should exist at the present time in Rome is a proof of the continuance there of what we are apt to suppose ceased with the Middle Ages—that condition of general belief, and those mental habits, which gave to those ages their common appellation of Dark. The Roman people belong to the Dark Ages." Adding to the scandal is the fact that the popular superstition is supported by supposedly intelligent and sophisticated men, such as Dr. Manning, formerly of the Church of England. In a sermon at San Carlo al Corso, Norton heard him orate on "the honor and worship due to the Virgin as the Mother of God." With "quiet fervor" and "subtle" arguments, Manning eloquently supported "those doctrines of the Church which are most repugnant to reason and most contrary to Christianity."[8]

But in the same year in which Norton was writing these first horrified impressions of the Church's medievalism, he became the intimate friend of John Ruskin, the great English student of Gothic architecture, and Norton's attitude toward Catholicism in its Gothic expression was necessarily affected by his own study of medieval church-building in Europe. Later Norton became one of the leading members of the cultish Dante study group in Boston, and himself translated the *Divine Comedy*. He was also directly and sympathetically involved with Roman Catholics through his efforts to alleviate the housing conditions of the poor. By the time he was writing to his daughter in 1891 while she was traveling in Italy, he could advise her to respect even "the tawdry adornments and trifling *ex votos*" as incongruous "witnesses" to an aspiration toward a universally shared spiritual "ideal." He says nothing of the mentality of the "Dark Ages." In 1901 he wrote to another correspondent that Catholicism was proving useful in the first stages of "civilizing" the "semi-barbarian" Irish immigrants. It was in any case preferable to the native-grown "superstitious delusions" of Christian Science, which were "absurd to the last degree." "Mother Eddy is the most striking and ugliest figure in New England today," and "an illustration of . . . medievalism . . . in its least attractive aspect." The mass of New Englanders, he concluded, were mentally living in the Middle Ages.[9] Italians were no longer more benighted than Anglo-Saxons, and some Americans had shown an equal fondness for a maternal intercessor and a Mother Church.

But for Eleanor Clark a visit to Santa Maria Maggiore ("the perfect ballroom"), as the Virgin-centered Holy Year began on Christmas Eve, 1949, did not encourage excuses for the Church. "HAIL HOLY VIRGIN placards" decorated the "radiators of pilgrim buses," but except for these differences in modes of publicity and transportation, the year might have been 1300, when Dante himself attended the very first Holy Year and the mosaic in the apse had just been completed. The "Mother of God" was the subject of another new dogma, the first of the war-torn twentieth

century: "Havoc moral or physical need not imply a retrogression of intelligence. It was right to wonder if the legitimate anguish of the time could be met by a dogma so arrogantly out of line with modern thought as that of the bodily Assumption of the Virgin."

The adoration of Mary, according to Clark, "has risked turning Protestants against the idea of any motherhood, and in Rome has helped to keep Christ so inconspicuous except as an infant." The Holy Year of 1950, far from an effort to palliate anything for Protestant sensibilities, amounted to an attempt at "a new Counter-Reformation" that would renew the mystery of the Romish faith precisely by promoting its most distinguishing images. Among the new saints canonized that year, the child Maria Goretti, "who happened to have been killed resisting rape," received the most attention. Conveniently, and uniquely for new saints, Maria's mother—*la mamma*—was still alive to be seen in all her "beauty of peasant character, of the old-fashioned or pre-Marxist variety." The Church could thus simultaneously promote motherhood and preach against "sexual laxity." Besides promulgating the new dogma of Mary's bodily assumption into heaven, the pope put out an encyclical condemning (once again) birth control. This cluster of acts illustrates the Church's "physical obsession," as did the dogma of the Immaculate Conception of the previous century: "The preoccupation with Mary's body, traceable to the days of the most ferocious sexual frustration in leaders of the Church, long ago became second nature to Catholicism; and if Christ's mother were free of any 'taint' of sex it was logical that she should not be contaminated by worms either." Whether this analysis is particularly astute or not, it is clearly of the twentieth century. Clark finds "curious" the Anglican furor over the new dogma (which certainly complicated any hopes for re-union), but observes that the "scathing attacks . . . by biologists" were "ludicrous, as though one should take exception to a single thread in a rug."[10]

Thus Roman idolatry of saints, and of the Virgin above all, seemed still to justify repudiation of the Church as a whole. No part of it was separable and therefore pure. On December 18, 1856, Norton witnessed the erection of the column in the Piazza di Spagna, facing the Palace of the Propaganda, in honor of the Virgin of the Immaculate Conception. He noted that the antique column had been discovered to be flawed and had required open bronzework around the lower half to support it. Thus the Roman church is aptly symbolized by the fact that the Virgin on the column's summit stands upon "unsound supports derived from heathen times."[11] Nearly a century later Eleanor Clark witnessed the traditional method of honoring this image of the Virgin that had grown up since. On the Feast of the Immaculate Conception, little children bring "their tons of white flowers" to the column, which Clark maliciously locates "outside the American Express." For a moment Clark seems to understand the sympathetic appeal that Hawthorne and Story had found attractive; but in mid-sentence she shifts away from the children's point of view to remind us of the Holy Mother's political value, to which they innocently contribute:

> She takes care of them all, and of their parents too; she thinks about them, she takes them to herself silently in their sorrows, having herself suffered more than any; she is everybody's most perfect mother, and the Church's most perfect coun-

terforce to the crimes committed in its name, as well as to other hostile powers. . . . No amount of supposings of theology have yet managed to lessen the power and comfort of this great image, and nothing else at the moment seems likely to lessen people's need of it.[12]

In the hundred years that saw the promulgation of the Marian dogmas of the Immaculate Conception and the Assumption, the deification of the Mother of God may be said to have been completed. Her exalted status in fact became a difficulty in the ecumenical spirit of the Second Vatican Council in the 1960s. Accounts of the Council by Protestant observers and not a few Catholics express embarrassment at hearing her evoked as "Co-Redemptrix," the "Mediatrix of All Graces," and so on. It became a source of contention among the bishops whether Mary would be honored with a separate declaration defining her role in the scheme of salvation (something more than the members of the Trinity were to receive) or would be incorporated into the general statement on the nature of the Church, of which she was the first member. Some were anxious to reduce the Mariolatry that Pius IX and Pius XII had so promoted; others feared any implied slight to so popular a person as the Blessed Virgin Mary. The books on the Vatican Council provide an ironic context for this debate, since women are almost totally absent from all accounts of the event (except for an occasional acknowledgment of the efficiency of certain nuns in meeting the domestic needs of the attending bishops). Even an awareness of the existence of females other than the Blessed Virgin is seldom indicated, except implicitly in debates about the advisability of letting deacons get married. In the third year of the council a few women were admitted *as auditors*.

In the end, Mary herself, Perfect Womanhood as defined by celibate popes and priests, emerged triumphant. Although the statement about her was incorporated into that on the Church, Pope Paul VI counteracted any implied demotion by granting her, on his own initiative, an official new title. The Holy Father declared that she was now to be known as "The Mother of the Church." Regrets expressed by the American observers in Rome were but feeble peeps of protest in comparison with what Jarves, Turnbull, Ware, and Norton would have said, could they have imagined that the medieval idolatry they deplored would reach such further heights and intensities in the twentieth century.

The Vatican: The Popes in Their Palace

Yesterday forenoon my wife and I went to St. Peter's to see the Pope pray. . . . I am very glad I have seen the Pope, because now he may be crossed out of my list of sights to be seen.
 —Nathaniel Hawthorne, 1858

The sole and only reason for my trip to Europe was to receive the blessing of the Holy Father.
 —Alfred E. Smith, 1937

Although Mrs. Engel was not a Catholic, she felt that to be in Rome and not see the Pope was to miss something essential. It was like eating an artichoke and ignoring the heart.
 —Patricia Collinge, "Benediction," 1957

Sacred relics and the Mother of God could be seen throughout much of Europe, and in due time in America as well. But until very recently the Holy Father was a uniquely Roman sight. From Pope Pius VII (who, to be sure, had been constrained to crown Napoleon emperor in Paris in 1804 but had reestablished the papal court at Rome in 1815) to the peregrinating Polish pope John Paul II, there have been fourteen popes for Americans to see and comment upon. For most of the nineteenth century, through the first seven popes, the "American" image of the bishop of Rome remained remarkably static: it was that of a benevolent but impotent and somewhat contemptible or even ludicrous old figure, a bizarre medieval anachronism nodding away on his pretentious throne. The tone of outrage or bemusement diminished after the pope lost temporal power over Rome in 1870, but that event only reinforced the image of weakness. "The prisoner of the Vatican," other than as an object of pity, seemed hardly worth describing. There were in fact fewer occasions for doing so, since he no longer strolled on the Pincio, rode about the city in a gilded coach, or even conducted public services in St. Peter's or the Sistine Chapel. Private audiences, however, even for Protestants, remained fashionable, with the result that an autobiographical subgenre, papal-presentation narratives, continued to flourish.

By 1930 a major change in the dominant image of the pope came about for two reasons. First, Pius XI signed the Lateran Pacts of 1929 with Mussolini and emerged from the seclusion of the Vatican with a sense of independent papal power reestablished on a supranational rather than a territorial basis. The former feudal sovereign of an impoverished, malgoverned, and minor state on the Italian peninsula, defended by force of French arms, completed his transformation into a popular figure enjoying worldwide prestige as an advocate of brotherhood and peace. Second, American Catholics began to provide more frequent descriptions of the pope, which in their filial piety and defensive adulation diametrically opposed those exercises in caustic wit and Protestant polemics that embellished most American reports from Rome in the nineteenth century. What is remarkable is that by the time Pope John XXIII opened the Second Vatican Council in 1963, most Protestant observers themselves had been completely disarmed and busied themselves in praise of the pope, though not the papacy.

Americans began viewing the pope at a time when the papacy was at its lowest point of prestige in centuries. The pope seemed clearly to be a religious and political anachronism. True, popes were no longer the depraved sovereigns of the late Middle Ages, the worldly warriors of the Renaissance, or the heretic-hounding fanatics of the Counter-Reformation—the three images that had dominated two centuries of American puritan preaching in which the Bishop of Rome was the Antichrist and the Catholic church was the Whore of Babylon. In the words of James Fenimore Cooper, who was in Rome during the brief reign of Pope Pius VIII (1829–30), "nepotism, cupidity, and most of the abuses incident to excessive temporal influence, are done away with; and as the motive for ambition ceases, better men have been raised to the papal chair. Most of the last popes have been mild, religious men." Cooper allowed that in the Church there was still "more management" than was appropriate to "faith in God," but "all establishments are weak on this point, and the general assemblies, &c. of America are not always purely a convocation of saints."[1]

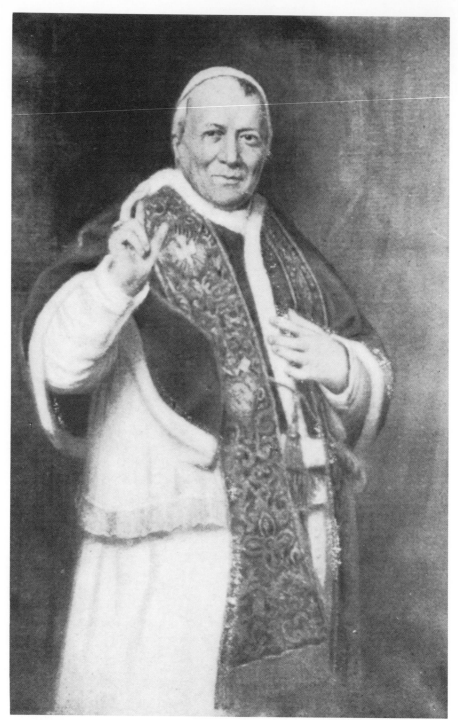

Fig. 3. G. P. A. Healy. *Pope Pius IX.* Oil on canvas. 1866. Formerly
Convent of the Sacred Heart, Albany. Photo reprinted from G. P. A.
Healy, *Reminiscences of a Portrait Painter.*

Yet, for all the apparent piety of modern popes, the religion they headed, as witnessed in Rome, seemed preferable only to outright infidelism, and continuing papal pretensions to temporal power, even though offering no apparent threat to America, were offensive, since they both compromised a Christian leader's spiritual status and resulted in the most illiberal state on the generally benighted Italian peninsula. The pope as a political force opposing the liberation and unification of Italy will be discussed later; here we are concerned with him primarily as a religious figure. We begin with two historical romances of the nineteenth century that sharply defined the inherited and established image of the pope, an image that naturally affected perception of the living popes.

Rome: Christianity's Mistake

The first pope to appear in American fiction is also one of the earliest in history. Felix I is listed officially as the twenty-sixth pope, serving as bishop of Rome from 269 to 274. In the Unitarian William Ware's *Probus: or Rome in the Third Century* (also published as *Aurelian*) (1838), Felix is one of the three most prominent Christian leaders, each of whom represents a different potential development in the new religion. Macer is a puritanical fanatic who fearlessly provokes the authorities by his rabble-rousing attacks on the materialism and immorality of pagan Rome; Probus is a rational, quietly confident "Unitarian" Christian who advocates and practices the simple beliefs and pure ethics of Christ and the Apostles; and Felix is a Roman who has merged the gospel theologically with pagan Hellenism and has adapted forms of worship from heathen rites that require richly decorated vestments and altars. Piso, a Roman aristocrat whose conversion to Christianity has been effected primarily by Probus's example, states plainly in one of his letters that "the Romans are not a people one would select to whom to propose a religion like this of Christianity. They are too rich." On another occasion Piso explains that Felix is more influential than Probus because he seeks converts "not by raising them to the height of Christian principle and virtue, but by lowering these to the level of their grosser conceptions." Felix and his fellow bishops have begun to assume the luxurious trappings of nobility, and he lives in the most magnificent house on the Quirinale. These men, says Piso, by their easy dispositions, self-indulgences, and gracious manner are leading Christianity into "an adulterous and fatal union" with paganism. Such Christians as Probus look upon this annihilation of the true faith with "sorrow and indignation." Probus later declaims at length against the "show and ostentation" that Felix is promoting. Felix has ordered a communion service to be made of gold, he sits in a golden chair, and he wears golden "robes of audience." Some churches now even possess "statues of Christ and of Paul and Peter"; in time Christ, "whom we now revere as a prophet," will be "worshipped as a god," and the disciples will be "adored superstitiously as inferior Deities."[2]

When Fronto, the pagan high priest, has persuaded the emperor to resume persecution of the Christians, Macer welcomes the development as exactly what they need. Probus does not agree that to suffer is the chief glory of a Christian, but in Macer's view, the Church "cries out for a purging" because Felix has set himself up "as a lord, over subjects." "Did Jesus die that Felix might flaunt his peacock's

feathers in the face of Rome?" A Savonarola a millennium in advance, Macer says that if he had the power, he wouldn't wait for Aurelian to do the job, but would attack Felix's polluted temple himself.[3]

This three-way conflict reaches an unexpectedly comic climax at a nocturnal meeting of Christians in the catacombs after Aurelian has issued an edict against Christian worship. With martyrdom hanging over their heads, the factions immediately fall to squabbling about who will speak first—Probus, accused of being "a follower of Paul of Samosata," or Felix, a follower of Plato and Plotinus, "Pagans both!" Macer the fanatic then silences them all, orders Probus to speak, but himself takes the opportunity to praise God that they are all about to die. Probus argues at great length for a moderate course of action. Macer then harangues the crowd on the necessity of uncompromising assertion of their beliefs. Finally, a partisan of Felix proposes that the bishop be sent to Aurelian to plead their case from his position of authority, and by pointing out to the emperor how much their belief coincides with that of "the divine Plato." Another squabble immediately breaks out, with mutual accusations of heresy flying about the underground chambers. From matters of belief, the dispute turns to questions of authority: who are these people who have claimed to be "bishops of Rome," anyway? Amid the cries of "lies and slanders," obviously intended by Ware to be a parody of nineteenth-century controversies among the various Christian denominations, Probus interrupts with a calm plea for mutual tolerance founded upon their common love of Christ, which ought to render doctrinal differences of no importance. In a conciliatory act, he recommends that Felix be their spokesman. Felix, urbanely returning the gesture, urges Probus to go to Aurelian. Piso ends his account of this meeting with the vision of a future, centuries hence, when Christians will be thus humbly united once again in brotherly love.[4] Soon afterward Macer dies horribly but happily on the rack, having defied the edict by preaching on the steps of the Temple of the Sun. By the end of the novel Probus and Felix have both been devoured by wild beasts in the Colosseum. Although Ware focuses on the death of Probus, the ideal Unitarian Christian, he allows Piso to describe as well how the bishop of Rome suffered his martyrdom with fortitude and faith.

That the Roman form of Christianity continued in the corrupt direction established by popes like Felix is the main thesis of Harriet Beecher Stowe's Italian novel, *Agnes of Sorrento.* Stowe, the daughter and wife of Calvinist clergymen, spent the winter of 1859–60 in Sorrento and Florence, with briefer stops in Rome, which lies between them. Her novel is structured upon the geographical symbolism that finds specific virtues in both puritanical "Northern" and pious "Southern" places and their peoples, but finds in Rome nothing but perverted religion and papal hypocrisy. The religion "of force and fear" is exemplified by the imagery of terror in the fresco of the "Last Judgment" with which Michelangelo was soon to "deform" the Sistine Chapel. The hypocrisy is obvious in the Vatican of the Borgia pope Alexander VI "and his adulterous, incestuous, filthy, false-swearing, perjured, murderous crew."[5] Stowe's plot is designed to lead her heroine away from the saintly simplicity of a southern convent to the discovery of the "truth" about the papal Rome she has adored from afar, so that she can adopt the purified and intelligent Christianity of Savonarola, the proto-Luther of Florence whose martyrdom by papal forces supplies the romance with its denouement.

Stowe's tale is larded with pronouncements about religion, art, and history, and about cultural, racial, and sexual distinctions. But she never adopts a polemical tone; all her "truths" are asserted from "the height of our day" and the point of view of "our enlightened Protestantism," with perfect confidence that her readers in the *Atlantic* and in *Cornhill*, where the story first appeared in 1861–62, share all her opinions.[6] Her little discourses are merely self-congratulatory recitations of what everyone knows to be true. This, however, does not preclude self-contradictions, especially on the subjects of class distinctions and the nature of women. For example, the survival of "pure" Christianity over the centuries seems to have been the work of the humble poor, worshiping far from the center of papal corruption. Yet the peasants are shown to be woefully entrapped in superstitions and saint-worship; acceptably refined rebels against Rome are to be found only among aristocrats. Most monks are lazy louts from the lower classes; Agnes finds a satisfactory confessor only in the solitary nobleman among them. Mother Superiors, of course, are always "ladies." Little Agnes herself, who spends most of the book posed like a Guido Reni saint, clasping her hands and rolling her eyes heavenward, had a noble father. True, he disowned her and her mother, but even her mother was no peasant—she came from the steward class. In the end we are gratified to discover that Agnes is actually a Colonna—an ancient Roman family of the most exalted nobility, and famous for its antipapalism.

Agnes's problem is that she innocently believes that her highest possible destiny, as a woman, is to become a nun. From babyhood she has shown "all the signs of an incipient saint." When she rises from prayer, her soul is at peace "as truly as if she had been the veriest Puritan maiden that ever worshiped in a New England meeting-house." Stowe makes much of the fact that the convent of St. Agnes in Sorrento, where our heroine has been educated, rises over the ruins of a temple of Venus, which it has purified. But at one point she implies that the sexual repression of women in convents is not good for them; they ought to become mothers. Yet she also believes that "in those ruder ages" Christian convents offered important "refuges" for women. There they found "enough" to lead full lives in praying, cooking, embroidering, and "divers feminine gossipries and harmless chatterings and cooings." In another mood Stowe expresses unqualified admiration for the great women of the Church, such as St. Agnes and especially St. Catherine of Siena. As their lives proved, "the Church opened a career to woman which all the world denies her." Such a career for Stowe's own little Agnes would certainly be preferable to her subjection through marriage to the "rude authority" of the blacksmith Antonio, an "ox" from the "lower class," who would undoubtedly beat her.[7]

In contrast to this benighted but quaintly pious world of the South, a vigorous puritanism has been developing north of Rome, in Florence. It is true that Luther had not yet "flared aloft the bold, cheery torch which showed the faithful how to disentangle Christianity from Ecclesiasticism," yet "the men of Florence in its best days were men of large, grave, earnest mould. What the Puritans of New England wrought out with severest earnestness in their reasonings and their lives, these early Puritans of Italy embodied in their poetry, sculpture, and painting." Agnes's uncle is a monk-artist follower of Fra Angelico and, like his master, paints in the convent of San Marco where Savonarola is the superior. Stowe quotes the hymns of Savonarola, the "Italian Luther," approvingly and at length, noting that they com-

bined "Moravian quaintness and energy with the Wesleyan purity and tenderness." She also describes a joyous scene in which the little children of Florence, inspired by Savonarola, make a bonfire of "Boccaccio's romances and other defilements." The business of Stowe's tale is to bring Agnes out of her southern Catholic superstitions into the emerging Protestant enlightenment of the North, while preserving her piety and finding her a suitable husband. The agent of this double destiny is a young man of the "Sarelli" family. His brother has been killed and his sister "dishonoured and slain" by the pope's son, Cesare Borgia; also the pope has expropriated his estates and excommunicated him.[8]

On Palm Sunday Agnes arrives in Rome on her pious pilgrimage to " 'the house of our dear Father the Pope,' " of whom she intends to ask forgiveness for her excommunicated lover, in exchange for which she has vowed to become a nun. During the magnificent procession in the Piazza of St. Peter, she sees the pope "raised on high like an enthroned God" receiving "the homage of bended knee from the ambassadors of every Christian nation," while an invisible choir sings of how "Jesus came into Jerusalem meek and lowly, riding on an ass." But Agnes, too "pure" to perceive the satire, longs only to touch the hem of Alexander Borgia's "wondrous and sacred garments." Instead, she is at that moment snatched from the crowd by the pope's lecherous henchmen. "The veil" is thus "rudely torn from her eyes; she had seen with horror the defilement and impurity of what she had ignorantly adored in holy places." Soon rescued, she feels free to marry her prince. It has all turned out as Old Jocunda, the peasant portress of the convent in Sorrento, had predicted when she had encouraged the pilgrimage: "I've seen people cured of too much religion by going to Rome."[9]

Pen Portraits of Popes

In their presentation narratives and in their descriptions of papal processions and ceremonies, American observers of living popes, from Pius VII on, generally continue the criticisms that Ware and Stowe made of historical popes. They see the attitude toward the Holy Father as idolatrous, and they object to the enormous wealth and sumptuous accommodations enjoyed by the Vicar of Christ in hypocritical contrast to the poverty both of the Church's Founder and of the pope's subjects. But three other recurrent motifs in these accounts are more specifically American in character. From Emerson on, there is frequent observation that the individual person of the pope is sadly suppressed by the hierarchical institution he nominally heads; second, the popes are clearly antipathetic to religious liberty, no matter what they say; and last, the popes have a flattering but possibly dangerous interest in America. These concerns affected the way Americans looked at the pope, but were not sufficient in most cases to make them wish to avoid him. On the contrary, they sought out occasions to see him precisely as an antipathetic but picturesque medieval curiosity, most likely soon to disappear.

As with other aspects of Catholicism, when Americans expressed their impressions of popes, the strength and the flexibility of their liberalism were often tested. The few who saw popes in the earliest decades are typically nonjudgmental; they view the pope in a disinterested spirit, confident that their own intellectual and

religious enlightenment rendered them—and America—impervious to a religion
that might still serve a need in a backward country like Italy. This attitude differs
from the tolerance that, at the end of the century and afterward, primarily results
from religious indifference. In between we find the more strenuous judgments of
committed and competitive Unitarians, Baptists, Episcopalians, and others who
defined their own intellectual freedom in part through their negation of papal
superstitions and oppressions. American commentaries on the pope in Rome thus
not only reflected the changing religious climate at home, but were often intended
to be contributions to the national struggle to preserve religious freedom against the
threat of totalitarian Catholicism. What is constant in all the changes of attitude is
the difficulty the liberal mind has in maintaining its ideal of tolerance toward what
it perceives to be an aggressive form of intolerance, a bigoted ideology that exploits
American freedom in order to gain the power to suppress that freedom.

The young George Ticknor, while in Italy preparing to become Harvard's first
professor of modern foreign languages, claimed in 1818 that Pope Pius VII was the
"only sovereign in Europe I ever felt any curiosity to see." In fact, as a rather
aristocratic representative of the great new democracy, Ticknor managed to meet
almost everyone of any importance in Europe (he had letters of introduction to some
of them from two former presidents—Adams and Jefferson). He paid courtly atten-
tion even to deposed kings, and gossiped freely with—and about—Bonapartes and
Borgheses. In this context his meeting with Pope Pius VII is merely one of many
social successes he was able to report to his mother. Ticknor is a worldly gentleman
meeting a sovereign, and few of the major concerns of later Americans arise in his
narrative. It does, however, express a consciousness of national distinction. Their
American identity was what got Ticknor and his traveling companion the "priv-
ilege" of seeing the pope almost alone and out of season. The fact that Americans
originally appeared as strange to the pope as he did to them could not long remain a
basis for special treatment, but Ticknor's pope set the pattern for almost all his
successors by showing unexpected knowledge of, and curiosity about, America. He
flattered his visitors on the superiority of their merchant vessels, and the growth of
their population, which would soon make it possible for them "to dictate to the Old
World." Much pleased to hear this, Ticknor in his turn set the pattern for most later
personal responses to a pope by finding him possessed of "great good-nature and
kindness, and a gayety of temper very remarkable in one so old and infirm." Ticknor
knelt and kissed the pope's hand on both arrival and departure; unlike many
Americans who came after him, he made no fuss about it. The one note of mild
irony that anticipates many later tirades comes when Ticknor says that the pope
"talked a good deal" about America's "universal toleration, and praised it as much
as if it were a doctrine of his own religion."[1] The history of the Inquisition, and of
the Society of Jesus, which this pope had just restored to power, did not encourage
many visitors to take papal endorsements of religious freedom at face value.

More typical of what was to come is the contemptuous description of the same
pope in 1821 by Theodore Dwight, nephew and student of the late Timothy Dwight,
who had been one of the "Connecticut Wits" of Revolutionary War days, a severely
Calvinist theologian, and the president of Yale. His nephew finds even the attrac-
tive "amiableness" of Pius VII an unfortunate trait in someone whose "religious

authority" is a "usurpation." Dwight is representative in his inconsistencies. He despises the popes for having exercised enormous worldly power in the Renaissance and now scorns them for their present lack of power. The great popes of the past consigned disobedient kings to hell, but Pius VII publishes a bull to regulate the tossing of sugarplums during the Roman Carnival. The present pope is too "submissive" to "excite the ordinary curiosity of a Protestant traveller"; the spectacle of a "common mind invested with the supreme power of Rome" arouses "secret disgust."[2]

At the end of the same decade James Fenimore Cooper, an Episcopalian, confessed to a "passion for the poetry of the Roman worship," and he was surprised at the "liberality" of the Church in allowing so many ill-behaved and nonconforming Protestants to attend services. Cooper himself knelt before the Host and wondered why other Protestants refused to kneel even for the benediction of the pope, since "the blessing of no good man is to be despised": "There is too much of the 'D——n my eyes! change my religion? never,' of the sailor, in us Protestants, who seem often to think there is a merit in intolerance and irreverence, provided the liberality and respect are to be paid to Catholics."[3]

Cooper may have been thinking of Samuel F. B. Morse, who accompanied him to many of the Roman religious services and wrote in his own notebook that the Mass in the Sistine Chapel consisted of "monotonous bawling, long and tedious," and that the pope (now Pius VIII), although gorgeously costumed in colors that appealed to an artist's eye, "is very decrepit, limping or tottering along, has a defect in one eye, and his countenance has an expression of pain, especially as the new cardinals approached his toe."[4] Shortly after his return from Europe, the indefatigable Morse contributed in a more serious way to the growing religious controversy at home by publishing (under the name of "Brutus") a series of letters that afterward appeared as a book entitled *A Foreign Conspiracy against the Liberties of the United States* in 1834. This was the year in which the Ursuline convent in Boston was burned, following the anti-Catholic sermons of Harriet Beecher Stowe's father, the Reverend Lyman Beecher. An increased immigration of Catholics was occurring simultaneously with a revival of evangelical Protestant fervor. The Jeffersonian principle of religious tolerance that characterized the first decades of the Republic—whose Declaration of Independence had been signed, after all, by a Catholic from Maryland—was fading.

Both Morse and the artist Rembrandt Peale were in Rome in 1830, when Pope Pius VIII died after only twenty months in the chair of St. Peter. They were therefore able to witness both the funeral of one pope and the coronation of another—Pope Gregory XVI. But because the fifty-one-year-old Peale belonged to the earlier generation, his descriptions of both ceremonies contain only the mildest mockery; his interest was that of an artist and cultivated man objectively witnessing colorful medieval anachronisms. To him such a detail as the stains of kisses on the soles of the dead pope's slippers, put there by mouths "protruding . . . through the bars of the grate," was more important than politics or theology. The new pope's coronation and the ceremony by which he took "possession" of St. John Lateran, to which the Holy Father rode in a brilliant new coach, were spectacles self-justifying in their splendor and human interest. But they could not touch Peale personally, as did the

simultaneous death of a Mr. Hone of New York, whom he saw buried among strangers in the cemetery to which the Church relegated the bodies of heretics.[5]

How alien Catholicism was to most Americans in 1833—the year before the Ursuline convent was burned—is evident from the attitude adopted by N. P. Willis in his reports from Rome that year in the *New York Mirror.* He assumes that his readers have no notion of what a Roman Catholic Mass is like; everything about the religion of Rome is reported as possessing the bizarre charm of the exotic. The pope is the curious central figure of a Mass that Willis witnessed in the Sistine Chapel. After a long wait, the pope finally entered and "tottered around in front of the altar, to kneel," where "his cap was taken off and put on, his flowing robes lifted and spread, and he was treated in all respects as if he were the Deity himself":

> In fact, the whole service was the worship, not of God, but of the Pope. The cardinals came up, one by one, with their heads bowed, and knelt reverently to kiss his hand and the hem of his white satin dress; his throne was higher than the altar, and ten times as gorgeous; the incense was flung toward him, and his motions from one side of the chapel to the other, were attended with more ceremony than all the rest of the service together.

A few days later Willis saw the pope again, arriving in the "state-coach with six long-tailed black horses, and all his cardinals in their red and gold carriages in his train" for the feast day at the Church of San Carlo al Corso. (Thirty-six years later Henry James watched the identical scene from his hotel room on the Corso.) Once again everything about the service conveyed "the irresistible impression that it was the worship of the Pope, not of God." The "servile homage to the Pope" on the part of the cardinals, who appear to be very superior men, "seems unnatural and disgusting." Gregory himself is "a small old man, with a large heavy nose, eyes buried in sluggish wrinkles, and a flushed, apoplectic complexion." "The gorgeous and heavy papal costumes only render him more insignificant" and "it is difficult to look at him without a smile." Enterprising journalist that he was, Willis persuaded Bishop John England, an American, to arrange for an audience with this insignificant and funny person. Closer scrutiny enabled Willis to report conclusively that Pope Gregory was nothing but "an indolent and good old man" who had a "low forehead" and a face "expressive mainly of sloth and kindness."[6]

Willis's image of a lazy and stupid pope should have been reassuring to those Americans who were beginning to fear a powerful papal plot against American liberties. What Willis had not counted on was that Bishop England would read his articles after returning to America and be provoked into reply. In four long letters published in the *Baltimore Gazette* and in the *United States Catholic Miscellany,* Bishop England proved Willis to be a liar, a bigot, and a boor. England had grown up as a combative papist fighting for the rights of Catholics in Ireland against the aristocratic powers of England. He therefore had his own perspective on the importance of religious freedom. His appointment to the newly created diocese of Charleston, South Carolina, in 1820 (when he was thirty-four) may have been a form of banishment brought on by his troublesome democratic prejudices. In the America of the 1820s he found that Presbyterian and Episcopalian clergymen were willing

to allow him the use of their church facilities for Catholic services in his still primitive and far-flung diocese, and he wholeheartedly embraced his tolerant new country. In providing his own diocese with a constitution based upon democratic principles, and in holding a convention of priests and lay delegates, he effected reforms of a sort that still seemed dangerously revolutionary to some bishops attending the Second Vatican Council in the 1960s. The controversies in which Bishop England engaged in America were likely to be with the French and "aristocratic" prelates of his own religion, who disliked his activities and methods. By the time he became, in 1826, the first Roman Catholic priest ever to address the House of Representatives, he had no reason to think that the spectacles through which he viewed the world were not as "American" as anyone else's.

England appealed directly to the national bias in replying to Willis, who had also reported calumniously upon some lectures about Catholic ceremonials that the bishop had delivered in Rome. These were undertaken, says England, partly to prove "that the land that adopted me should not suffer discredit by my negligence. Had some English tourist endeavoured to strike anything belonging to the United States, through my sides, I should feel less than I do. I avow that I did not imagine that any American then in Rome, would have been so thoughtless."

By his own account of the audience with Pope Gregory to which he had accompanied Willis, England shows that the journalist was guilty not merely of frivolity and ignorance but of malice and ingratitude. Willis and his friend had arrived late, after the audience for his group of Americans had already ended, but the pope had graciously agreed to delay more important subsequent appointments (one of them with the Governor of Rome) in order to receive the tardy Americans separately; now Willis dares to accuse the pope of "indolence." (England then summarizes the heavy burdens of the sixty-nine-year-old pope's typical day.) Willis describes the pope as "low-browed"; England has not "measured the forehead of his holiness," but he is certain that it "is at least some dozen lines higher than the writer who described him in the 'Mirror'; this latter, besides the advantage of a sweet countenance, possesses a sufficiently bold front." In any case, the bishop has had a wide experience of men, and has moreover seen His Holiness "several times," so he is in a position to say that the pope is extraordinary for "a clearness of comprehension, an accuracy of judgment, a precision of manner, and a promptness of decision" united with "a peculiar mildness and cheerfulness of manner" and "plain open honesty." (England then details Gregory's pre-papal history as a learned Benedictine monk and an industrious and efficient consulter of the Propaganda.) In the audience with Willis, while the journalist had been dumbly gaping at the pope, the Holy Father had inquired of his companion (also a Protestant) about his home city of Baltimore, expressing "gratification" that the Protestants and the legislature of Maryland "had latterly acted with great kindness toward Catholics, and that there was full liberty not only for the profession, but even for the public performance of the ceremonies of religion." (This was simply following what was already the standard formula for papal remarks to Americans.)

Immediately after the audience, says England, Willis spoke of the pope in terms very different from those he employed in his writing. England can now say only that "if the writer's object was to follow in the usual fashionable mode of undervaluing,

for the depraved taste of any set of readers, the high dignitaries of the Catholic Church, he should at least have had the honesty to decline asking favours from those whom he intended to misrepresent."[7] The bishop of Charleston had made his point. The embarrassed editor of the *New York Mirror* demanded from his popular roving correspondent an apology to his Catholic readers.[8]

Papal processions figure prominently in American writing about Rome down to 1870. The music of trumpets and vocal choirs, the Swiss guards in their multi-colored uniforms, troops of soldiers, clergymen of all kinds in an endless variety of ecclesiastical costumes (especially the flocks of cardinals in scarlet silk robes with enormous trains and ermine-lined hoods), the Roman noblemen personally attend-ing the pope, the *flabella* (huge fans made of ostrich and peacock feathers that slightly preceded him on both sides), and finally the tiara-crowned pope himself bobbing along in his oriental *sedia gestatoria* are all described with an exuberance of detail that shows with what pleasure they were observed. The most exotic ele-ments, however—the flabella and the sedia gestatoria—become almost comically important signs of papal pretension and medievalism. They were brought out again when the pope's processions gradually resumed their grandeur and pomp in the twentieth century, and the political significance of their use or nonuse on any occasion was being interpreted even in the 1960s and 1970s.

Bishop England wrote an entirely independent series of letters to inform and reassure the readers of his *United States Catholic Miscellany* about the elevated character of Catholicism as practiced in Rome, especially with regard to the intel-lectual character of its educational institutions and learned societies, and the sub-limity of its religious ceremonies. In one letter England describes several proces-sions with the moment-by-moment particularity of a participant, especially that for the feast of the Apostles Peter and Paul, in which Peter's successor receives even more homage than usual. England's enthusiasm is conveyed by the precisely obser-vant intensity of his descriptions rather than by exclamatory rhetoric. At the climax, when Gregory XVI is carried into St. Peter's and the choir hails him with the proudly distinctive claim of the bishop of Rome, "Tu es Petrus et super hanc petram aedificabo ecclesiam," Bishop England simply says that the "holy father" was an image of "meek, dignified humility." Thereafter England describes the obeisances in which the cardinals, bishops, and brothers kiss the pope's ring, knee, or foot, according to their rank. Following the vesper service, England, deeply moved, climbs the Pincio to observe the illumination of St. Peter's. There he reflects upon the apostolic succession from a "humble fisherman" and "an obscure tent maker," both martyred in Rome. Only now does he shift into the strained syntax and charged metaphors of homiletics; yet his sense of having a personal connection with the Apostles and their mission into the far corners of the world remains, a connection that has been strengthened through his sojourn in Rome and his witness of the Holy Father in his glorious humility.[9]

Ralph Waldo Emerson was also in Rome in 1833, at a time when he was begin-ning to have doubts even about Unitarian rituals, and was astonished to find himself powerfully affected by Catholic pageantry and symbolism. But what disturbed him—and it was crucial—was an aspect of the very thing that so moved England:

the humble subordination of the individual self to a tradition. Emerson saw the pope as a man submerged in the Church's institutional forms. Since he supposed Gregory XVI to be "learned," "able," and "pure," he wondered as he watched him on Holy Thursday washing the feet of twelve pilgrims (one of them from Kentucky) why the pope did not "leave one moment this formal service of fifty generations and speak out of his own heart," since "one earnest word or act" would "take all hearts by storm."[10] The young Brook Farm resident George William Curtis felt pity for the next pope, Pius IX, on similar grounds of a lost humanity. Watching him bless an absolutely quiet and reverent crowd during one of the great festivals, Curtis thought that it was "a scene for the Arcadia of a poet—or the paradise of a wise Christian." Yet he regards the "noble-looking," "dignified," and "graceful" pope with sadness, since he is "a man sequestered in splendor and removed from the small sympathies in which lies the mass of human happiness. The service seemed a worship of him, but no homage could recompense a man for what a Pope had lost."[11]

Less philosophical Americans giving enthusiastic accounts of papal processions sometimes break them off with sudden sarcasms, in an apparent effort at self-correction. They typically end as William Gillespie ends his, with the remark that "the fishermen of Galilee would stare to see their successors of Rome."[12] Later in the 1840s the Unitarian William Ware for several pages acknowledges the seductive beauty of Catholic ritual, but urges anyone tempted by it to follow his example by going to witness that "revolting solecism," the pope at prayer in his private chapel where he sits on his throne, weighed down by embroidered golden brocades and a bejeweled triple crown, surrounded by kneeling pages holding up needless torches, assisted in every move by decrepit cardinals and Roman princes who constantly rearrange his expensive drapery. The pope at prayer is treated "as if he were an Eastern despot, or helpless baby. . . . But one asks if all this is after the manner of Christ?"[13] Even greater intensity of exasperation with papal rituals is reached by James Jackson Jarves in 1855:

> Imagine the surprise of St. Peter, were he to be present, upon being told that that sleepy-looking old gentleman, so buried in gold and jewels as scarcely to be discernible, and borne under a magnificent canopy on the shoulders of twelve men clothed in the brightest scarlet, performing the pantomime of turning from one side to another his uplifted thumb and two fingers as illustrative of the blessing of the Holy Trinity, was *his* SUCCESSOR![14]

Jarves is describing Pius IX, but in such passages one pope is indistinguishable from another. Nor, after the men of the earlier generations like Ticknor, Cooper, and Peale, is it easy to distinguish between one observer and another. The focus of American spectacles was now sharply anti-Catholic. But this attitude was based, it could still be insisted, upon an equitable and liberal view of the pope. Since the pope in Rome was an absolute monarch, the nature and effects of Catholicism could hardly be said to be misrepresented there. In Rome, if not in America, the Church could be fairly judged. Jarves used a guidebook to religious ceremonies written by an American—Bishop England himself—in order to "keep within the strictest limits of charitable evidence." He quotes verbatim from Roman Catholic authorities;

otherwise what he said would cause "incredulity," and he would be accused of "satirizing what I cannot commend."[15]

The Reverend Mr. Turnbull reaffirms his liberal view by allowing that Catholicism is "infinitely better than paganism" and exhibits "majesty" in spite of its "degeneracy." Moreover, it "yet possesses elements of power, and were it only divested of its *ultra-montanism,* its spirit of bigotry and superstition, its Papal hierarchy, and its armies of monks, it might yet bless the world. It is not so much Catholicism as Popery—not so much the great body of Catholic worshippers as the spirit of Jesuitism, superstition and idolatry, which constitutes the Anti-christ of Rome." Popery, however, condemns itself through the city of Rome—in which is "deposited the very soul of the papacy." It ought to be "the holiest place on earth!" Is it? "Let its swarming beggars, its poverty-stricken populace, its uneducated children, its secret infidelity, its boundless superstition, its covert treason, its gloomy discontent, its deep licentiousness, and, except for the form, its heartless religion, answer the question."

Rome could become great again if it shed its fetishism and fanaticism, admitted "science and free inquiry," and imbibed "the free spirit of an enlarged and devout Protestantism." But this was unlikely to happen. From the "old Pontifex Maximus down," Roman Catholicism is "debased" with pagan "idolatry." At the apex of the Church and the city is the pope, "who carries the sword of a kingdom on earth, and the keys of a kingdom in heaven; the representative of the Son of God . . . and the embodiment therefore of all humility and meekness, of all holiness and peace!" Yet, Turnbull says, "you may see him, on some grand holiday, riding in a magnificent coach, which cost some twelve or fifteen thousand dollars, drawn by six superb black horses, attended by some four or half dozen lacqueys. . . . [He] is dressed in gorgeous robes of silk, with a crown or a tiara of gold."[16] Turnbull's specific complaints about the sword and tiara are especially important, since Catholics themselves would eventually make of the pope primarily a figure of peace and humility.

A Baptist clergyman like Robert Turnbull invested his descriptions with more malicious rhetorical irony than others, but his point was essentially the same as that of the Reverend William Ingraham Kip, an Episcopalian whose *Christmas Holydays in Rome* (1845) was intended precisely to strike "a proper medium" in the judgment of Roman ecclesiastical matters. Kip, who was to become the first missionary bishop to California following the gold rush, is distinctive in that he has a strong liturgical interest; in fact his primary purpose in coming to Rome was to study the Catholic Christmas services. In spite of this, he deliberately avoided the midnight service at Santa Maria Maggiore because he knew that its main purpose was to display the fraudulent "Holy Cradle," and Kip abhorred all such relics. He prepared diligently, however, for the Masses on Christmas Eve in the Sistine Chapel and on Christmas morning in St. Peter's, reading authoritative books and receiving instruction from a Catholic priest. His descriptions of the services, which he followed as well as he could with a missal, are surpassed in detail only by those of Jarves in *Italian Sights and Papal Principles.* Kip was "sighing for Christian Unity," but frequent concern over what St. Peter would have thought of these magnificent but bewildering pagan spectacles effectively discouraged him.

The crux of the matter was not so much the elaborateness of the ritual, but the fact that the pope himself appeared to be the object of worship. His throne was as high as the altar and "more gorgeous," and the pope received far more homage and incense than did the Deity. Kip concludes with a description of the worship service he subsequently attended in the English chapel in an "upper room" outside the Porta del Popolo (Protestant worship not being permitted within the walls). He was pleased to contrast the "pure worship of our own Church" with the "gorgeous and unsatisfactory show" of the Catholics. The Protestant service reminded him, as it did Jarves, of the "primitive purity" of the original Christians of Rome, whereas the Catholic services inevitably recalled the sumptuous superstitious folly of heathens worshiping the Capitoline Jupiter. The pope was the successor not to Peter but to the Pontifex Maximus, whose title he had significantly adopted.[17]

Kip is one of the few who describe both the papal processions and an audience with the pope, since after weeks of waiting he was finally admitted to the presence of Gregory XVI in a company sponsored by the American consul. Typically, Kip was surprised to find that the pope at home in the Vatican was not the repellent idol of the processions but quite an ordinary person. Kip even seems disappointed that the reception was so unceremonious, in comparison with some he had read about. After careful instruction in papal etiquette, the guests were left shivering for an hour in the interminable Hall of Maps, and then taken into the presence of *Il Padre Santo* by a single usher. There were no guards, officers, or "mace-bearers heralding the way." The pope stood at the other end of a long room, leaning against a table, and the Americans (as instructed) stopped three times to bow while approaching him. As heretics, they were not required to kneel or to kiss the pope's hand or slipper in imitation of an imperial custom introduced by Caligula (according to Kip). Pope Gregory wore a simple monkish white flannel robe and a skullcap, but his red morocco slippers displayed the gold cross ("what business has the cross in such a situation?"). Even the pope's snuffbox, which was "in constant use," had a cross on its lid! The pope was not the feeble old man of eighty he had seemed during the Christmas services, but "hale" and "hearty," laughing and talking "in the most sociable manner," although his heavy features—drooping nose, sleepy eyes—gave him an unintellectual expression unworthy of a successor of Hildebrand (Kip does not bring Peter into the comparison). The Holy Father was notable for nothing but "good nature," Kip concludes, sounding just like the frivolous Willis. Yet he admits that the Americans were surprised to hear Gregory inquire whether the rioting in Philadelphia had subsided and ask what they intended to do with Texas? These questions were not as casual as they appear in Kip's account. During the riots in May (1844) between Protestants and Catholics, caused primarily by the use of the King James Version of the Bible in public schools, several churches had been burned and more than forty people killed; and the possible annexation of Texas might affect the long-established dominance of Catholicism in the Spanish Southwest and Mexico. After twenty minutes the pope bowed, rang a little bell, and thoughtfully disappeared into the recess of a window so that his guests could depart without walking backward.

Kip's after-reflections upon the pope make a shift in tone that is typical and

harmonizes more with Emerson than Willis. He pities Gregory as a man condemned to a lonely, confined, and totally ritualized life. Forgetting his opinion of the Renaissance popes expressed elsewhere, Kip goes on to contrast the deserted Vatican halls of the present with the fruitful humanistic revels of Leo X, which filled the rooms with poets, philosophers, painters, and musicians. Now the pope eats alone. True, austerity may be more appropriate than pageantry to the head of the Church, but it is certainly less cheerful. Pope Gregory, moreover, had been chosen by the usual warring factions of the Vatican as an inoffensive compromise, and he is without any talents or personal resources. All he knows how to do is to protect the "most antiquated prejudices" of his church: his most notable actions have been the condemnation of the Christian democratic movement and the banning of railroads from the Papal States. Kip concludes that there is no immediate hope for Christian unity. The Roman church must first exchange its papal diadem for a crown of thorns.[18]

Equally pessimistic concerning the possibility of papal reform is Jarves's more extensive analysis of "papal principles seen through American spectacles," written in the next decade. His pessimism derives from his view of the Church as a self-perpetuating medieval institution that suppresses individuals, including popes. Savonarola—a priest of such personal power that he had attempted an internal reform of the Church in defiance of the pope—is one of the heroes of the book, one-third of which is devoted to very detailed discussion, with illustrations, of the arcane and archaic ways of the Vatican. Ten pages illustrate twenty eccelsiastical costumes, from the pope's down to the lowly chamberlain's, and other illustrations are of such spectacles as "The Pope Borne to His Residence," "Kissing the Pope's Foot," "The Pope's Carriage," and so on. "Machinery and Miracles of Papacy" is the title of the chapter devoted to the means by which the Church uses holiday spectacles, holy relics, and such objects as the Santissimo Bambino and the statue of St. Peter to "cultivate credulity and ignorance" and a "puerile fatalism" in the faithful.[19]

At the center and head of this idolatrous heap is the pope himself, now Pius IX, an obese figure whose doctor has ordered him to play billiards daily to get the exercise that his 108 valets keep him from getting in a normal manner. Jarves describes the daily life of His Holiness as consisting of a system of inhumane torture. "His sanctity dooms him perpetually to solitary meals," which have been tasted first by others for fear of poison (even the Eucharist is tasted before he eats it, in case transubstantiation into the Body of Christ fails to render it innocuous!). The pope lives in "coldly splendid" chambers, but he is "in all the relations of personal freedom and enjoyment, a being little to be envied." He is so "hedged in with sacred etiquette or pusillanimous fear" that a bad pope "can be personally free only by being a hypocrite," and "a good pope is a martyr to a rank which in its daily duties involves a constant contradiction of the simplest principles of Christianity, and is a standing reproach upon common sense." This is the man who presumes still to embody the power enunciated by a bull of his predecessor Gregory IX in the early thirteenth century, by which "every human creature is subjected to the sovereign pontiff." Although today "we may smile" at such a doctrine, the papal ceremonies

of Rome that imply its validity "are yet in full sway, yearly growing in imbecility."[20]

"Pio Nono, bello e buono"

Jarves's intemperate language represents the extreme to which a cultivated and liberal man could go in the mid-1850s, after Pius IX, the long-reigning "Pio Nono," had fallen from the favor he had briefly enjoyed with Americans during his first years as pope.[1] The incorrigibly medieval character of the papacy seemed confirmed by a sequence of acts, epistles, and promulgations beginning with the dogma of the Immaculate Conception (1854), going on to the famous "Syllabus of Errors" (1864), which condemned many contemporary and American ideas, and reaching a climax in the dogma of papal infallibility issued in 1870 by the First Vatican Council. The artist James E. Freeman, who was in Rome so long that he witnessed both Pius's postelection procession from the Quirinal to St. Peter's in 1846 and his funeral procession in 1878, recalled that when Pius IX appeared as the Holy Father for the first time, people in the crowd cried out, "Quanto è bello!"[2] But in the eyes of Americans who viewed him during the next thirty years, his appearance altered drastically and frequently according to their feelings about his political and religious pretensions.

In 1858 Hawthorne stopped short of using Jarves's word "obese," but did observe that the pope walked with a "dignified waddle"; probably he was not "much accustomed to locomotion, and perhaps had known a twinge of the gout." Pius's face seemed "kindly and venerable, but not particularly impressive"; yet his "proximity" made Hawthorne feel "kindly and favorably toward him." Certainly he appeared more trustworthy than his cardinals, to judge by *their* faces.[3] The face of one of these, Cardinal Antonelli (the pope's secretary of state), appears often in American accounts as a foil to Pio Nono's. Howells saw them both in 1864 during a "tedious and empty" religious ceremony in the Sistine Chapel, at which "a grotesque company of old-womanish old men in gaudy gowns" performed. Howells judged Antonelli to have "the very wickedest face in the world" and saw him "cast gleaming, terrible, sidelong looks upon the people, full of hate and guile." The pope, in contrast, looked "gentle and benign enough, but not great in expression." His smile "almost degenerated into a simper," and he was "all priest when, in the midst of the service, he hawked, held his handkerchief up before his face, a little way off, and ruthlessly spat in it!"[4]

If "American" views were becoming more contemptuous, the views of Catholics, of course, remained reverential, although Catholics also were sometimes severely tried—most notably that extraordinary individual Father Isaac Hecker. Hecker had lived through a Transcendentalist phase that included a stay at Brook Farm. Like his friend Orestes Brownson, another eloquent spiritual wanderer and individualist, he never really ceased being an "American" even after conversion to Catholicism. Trained in France as a Redemptorist missionary, he was ordained in 1849 and returned to the United States in 1851. After a few years he and four other Redemptorists wished to open an English-speaking house in America; in 1857 Hecker went to Rome to make their proposal to the pope. Upon arrival he was

promptly expelled from his order because he had come to Rome without asking permission.

Review of his expulsion then took months, as it went first to the Propaganda, then to the Holy Father, and from him to still another Congregation of the Curia, while Hecker's hair literally turned gray in the process. He occupied some of his time by writing an article for *Civiltà Cattolica*, the pope's own journal. In it he supported his "life-thesis" that (in the words of his biographer) "a free man tends to be a good Catholic, and a free nation is the most promising field for apostolic zeal." Hecker also came to the pope's notice for converting the well-known American artist George Loring Brown, a resident of Rome, to Catholicism. Hecker was thereafter received by Pope Pius twice in private audience, and naturally his narratives of these occasions differ from those of all the other Americans. For one thing, the pope has nothing to say to him in praise of religious freedom.

Hecker's greatest anxiety, he later wrote, was to prove that he was "not like Martin Luther"; he was not "a rebel and a radical." On his knees he begged the Holy Father to "lay on the stripes. I will bear them. All I want is justice. I want you to judge my case. I will submit." On hearing this, the pope's eyes filled with tears. Hecker wrote in a letter that Pius then said there was nothing he could do; the affair was still being examined. He went on to say that the American people "are much engrossed in worldly things and in the pursuit of wealth, and these are not favorable to religion." Hecker told him that America was young and still building its house; it was not miserly. The pope allowed that indeed the bishops reported that church-building in America was progressing well. The Holy Father, however, had a second complaint, that "in the United States there exists a too unrestricted freedom; all the refugees and revolutionists gather there and are in full liberty." Hecker's reply to this (a brave one) was that such people then had a chance to see a Catholic church not allied with despotic governments and so might return to it. He went on to claim that "our best-informed statesmen are becoming more and more convinced that Catholicity is necessary to sustain our institutions, and enable our young country to realize her great destiny." It would be "an enterprise worthy of your glorious pontificate," he concludes, "to set on foot the measures necessary for a beginning of the conversion of America." And the pope cried, "Bravo! Bravo!" as Hecker knelt.

About two months later he received notice that he and his fellows had been dispensed from their vows (even if the action was in his case inconsistent with his having already been expelled). It was understood that they would found an entirely new order; if they could enlist a sponsoring bishop in America, the pope would approve it. Then Pius received Hecker a second time, calling him "caro mio" and "figlio mio." When he repeated his charge of materialism against Americans, Hecker pointed to himself and his four brothers, at least, as exceptions, claiming that when his countrymen all became Catholics, they would do "great things for God's Church." "Yes, yes," replied the pope, "it would be a great consolation to me." Hecker knelt for "a large blessing," so that he might "become a great missionary in the United States." And in fact he went home to found the Paulist Fathers and the *Catholic World.* In later years he judged Pius IX to have been "a man of the largest head, of still larger heart, moved more by his impulses than by his judgment; but his impulses were great, noble, and all-embracing."[5] After his own death, some of

Hecker's "American" attitudes toward nature and the modern world, and his belief that the individual experience of the Holy Spirit transcended the need for external signs and ecclesiastical authority, were to be condemned by other popes.[6]

Inevitably Pope Pius IX was painted by G. P. A. Healy (see fig. 3), that specialist in prelates and potentates who was back in Rome in 1866. In his autobiography, Healy, a worldly Boston Irishman and a Catholic, piously asserts (in a chapter called "Crowns and Coronets") that the hours spent in the pope's presence "cast a glow on my later years." He recalls Pio Nono's "gentle reproach to one of my countrymen who, in his American pride, refused to bend before him: 'My son, an old man's blessing never did any harm to any one.'" He also recalls that the pope wittily said of a monk who had left the Church to marry, "He has taken his punishment in his own hands." Although Healy admits that the pope was a "somewhat restless" sitter, this is a more decorous description of the pope's behavior than the one he gave to his fellow artist James E. Freeman. Freeman recalls that Healy told him how the pope, posed three yards away from the easel, several times managed by "'imperceptible little slides of his feet'" to get around to where he could peek at the canvas, whereupon Healy would "hint" that he should resume his previous position. "'Putting his hands together in imitation of a chidden and penitent child, he would patter back to his proper position . . . with a mischievous expression of amusement on his face.'"[7]

Pope Pius was so pleased by Healy's painting that he bestowed a special blessing upon the artist and his family. This may have been received with some misgiving, however, since the pope was popularly known to have the *jettatura*, the Evil Eye. William Wetmore Story, who wrote an erudite monograph on the phenomenon, admits that Pope Pius, being "fat, smiling, most pleasant of aspect, and most kindly of manner," did not fit the usual notion of a jettatore. But in fact people whom he specially blessed tended to die shortly afterward. The men who were to erect the column of the Immaculate Conception in Piazza di Spagna insisted that the pope promise to keep away; and on the day when he took a peek at its progress, a workman fell from the scaffolding and died. Hawthorne, who suspected that his friend Story actually believed in the jettatura, remarks that since Pio Nono's Evil Eye was said to be of "tenfold malignancy," he ought to take the Scriptures literally and start blessing his enemies.[8] Such talk reinforced the perception that even a smiling plump pope could be a sinister medieval creature.

Between 1869 and 1872 the new American consul, David Maitland Armstrong, arranged for "several hundred Americans" to have audiences with Pio Nono, but never went to one himself. His consular business was frequently with Cardinal Antonelli, a "very shrewd-looking" man "with piercing black eyes and a pale face." He appeared "rather sinister" and "looked at one from under his black eyebrows in a sort of catlike and watchful way." The pope could not have differed more. During the year before Pius became "the prisoner of the Vatican," Armstrong saw him frequently "walking on the Pincian Hill" in a hollow square of guards, with "all the people" falling to their knees as he passed by. The pope's appearance and walk would seem to have improved greatly since Hawthorne saw him. According to Armstrong (who was a painter), "Pio Nono was a really beautiful man, . . . graceful and majestic in his carriage, with a very fair, pink and white complexion, black

sparkling eyes and snowy white, abundant, curling hair. He did not look at all old, in spite of his silvery head, which, far from taking away from his brilliant look, seemed to accentuate it." One day on the Pincio, when Armstrong's three-year-old daughter ran by the guards to take the hand of the "benevolent-looking, handsome old man in his beautiful robes," he "kissed her and patted her on the head, remarking [in a variation of the popular rhyme on his own attributes] 'È bella, e buona, e cara,' and gave her his blessing."[9]

But in the same year—1869—Henry James was making his first visit to Rome and saw quite a different person in the pope. James's satisfaction at being able to witness "the most impressive convention in all history" ride by in "a gilded coach" (as he wrote later in *Roderick Hudson*) was more than counterbalanced by his disgust. The "spectacle" of the "Grand Lama in person" was "very handsome, but it was precisely like a leaf out of the Middle-Ages":

> It's a "merciful providence" that the spectators of all this Papistry has [sic] at hand so vast a magazine of antiquity to appeal to for purgation and relief. When you have seen that flaccid old woman waving his ridiculous fingers over the prostrate multitude and have duly felt the picturesqueness of the scene—and then turn away sickened by its absolute *obscenity*—you may climb the steps of the Capitol and contemplate the equestrian statue of Marcus Aurelius. . . . As you revert to that poor sexless old Pope enthroned upon his cushions—and then glance at those imperial legs swinging in their immortal bronze, you cry out that here at least was a *man!*[10]

The growing disgust with the pope—much more evident among visiting writers than among resident artists—reached its height when he was declared to be infallible. The balladeer and folklorist Charles Godfrey Leland recalled the amusement that Americans in Rome in 1870 shared over the idea of "an elderly Italian gentleman, who possibly did not know oxygen from hydrogen, or sin from sugar," declaring himself "to be infallible in his judgment of all earthly things." Leland's popular identity was that of "Hans Breitmann," the hard-drinking, brawling German-American "author" of many volumes of verse. Breitmann, as famous in his day as Lowell's Hosea Biglow and far more widely traveled, naturally visited Rome, where among other things he "vented to de Vacuum, / Vhere de Bope ish keep his bulls." He saw someone arrested for selling "Infallible" matches, since "in Rome dere's nix Infallible, / Dey say, excebt de Bope." At the Santa Scala he realized the meaning of the word "Scala-wag" for the first time, and in another poem he has an interview with Pope Pius on the subject of his infallibility, in which the two babble almost incomprehensibly in a rhymed mixture of Latin, Italian, German, and French.[11] The decree of infallibility, the object of laughter and outrage even when given a more strict and narrow interpretation than Leland's, perhaps did more than anything else to seal for a century the impression of non-Catholic Americans that the Church was a hopeless anachronism, attempting to bring back the day of medieval monarchical superstitions totally irreconcilable with democratic principles and modern scientific truth.

We recall that back in 1783 the Reverend John Thayer had clinched his defense of

Catholicism by stating that infallibility belonged only to the whole Church, not to the pope alone. Now the independent infallibility of the pope was exactly what Pius IX was going to ask—somewhat self-contradictorily—the First Vatician Council to decree. A book by James Hennessey, S. J., called *The First Council of the Vatican: The American Experience* (1963), provides through letters and other records a glimpse of the American bishops in Rome at this time. When they arrived in December of 1869, they were distressed to discover that papal primacy and infallibility were to be the chief concerns of the Council, although these issues had not even been mentioned in the invitation and in America were "scarcely talked of." A majority of the American bishops was opposed to the promulgation of the dogma of papal infallibility, finding it unsound, inexpedient, or both. As the leaders of a minority in a nation where the status of the pope was one of the chief sources of suspicion and obstacles to belief, the bishops thought it inopportune, to say the least, to remove the definition of papal powers from the realm of opinion to that of dogma. According to the bishop of Rochester, Bernard McQuaid, it was a "most unnecessary question," imposed upon them by the Jesuits. If approved, it would be "a great calamity for the Church." The standard Protestant reproach to Catholics that they idolized the pope would be confirmed. They would be self-convicted liars.[12]

Although the American opposition (supplementing that of many French and German bishops) was forcefully stated in the Council, the pope and the Curia were determined to have the dogma approved, and the American representation became deeply divided. The bishops were invited to brief audiences with the pope in small groups. In late January the pope honored them with a visit to the American College, which he had founded. The ways of the Roman Curia now being familiar to the bishops, this visit was cynically interpreted by some as an application of pressure. By May, Bishop McQuaid was in despair. Since a declaration of papal infallibility would be taken as an endorsement of Pius's notorious "Syllabus of Errors" of 1864, which among other things had reconfirmed the temporal power of the papacy and apparently disapproved of both democracy and religious freedom, McQuaid believed that "we can look out for hard times in all countries in which Catholics and protestants are expected to live together. In fact we furnish them with good reasons to drive us out of the country."[13]

In June the bishop of Pittsburgh, Michael Domenec, begged the Council to consider that the dogma would be an obstacle to the growth of Catholicism in America, where without it Catholics would before long be more numerous than they were in Italy, and "with this consolation," that they would be Catholics "not only in name, but in fact, I mean in the practice of their religion." Cardinal De Angelis, the president of the Council, immediately reprimanded him for this slur on Italians. In July the bishop of Los Angeles, Thaddeus Amat, suggested that the final draft of the decree ought not to assert that the primacy of the pope had never been doubted, since this was contrary to fact, and a dogmatic decree ought not to contain such an obvious untruth. This objection was disallowed.[14]

Although the Council had opened with a ban on departure from Rome without permission, many bishops by this time had managed to get themselves excused. Father Isaac Hecker, who had returned to Rome on this occasion as the theologian

for the archbishop of Baltimore, was one of those who left early, unnerved by the controversy, although he had persuaded himself to accept the decree. Charles Eliot Norton had seen him in April just before his departure and described him as "a good specimen of the Romanized American, or vice versa," and "a man of some consequence in Rome, [who] seems to have been talking a good deal of Americanism to the Jesuits."[15] Hecker even had two private interviews with Pope Pius, who remembered him.[16] But his "Americanism" influenced neither the Jesuits nor the pope, who now found it expedient to issue a general permission for bishops to absent themselves from the Council, in effect inviting the opposition to leave. At the final vote, almost half of the original American delegation of nearly fifty bishops was absent, and of those remaining only the bishop of Little Rock voted against the decrees of primacy and infallibility (his was one of two negative votes).

Back in America all the bishops adjusted their public positions as they might to square what they had previously believed and argued with the new dogmas. The most interesting case was that of the Irish-born archbishop of St. Louis, Peter Richard Kenrick. After he had been prevented from delivering his views on the subject fully at the Council, he had published them in Naples, and they had become widely known. Now, after the Council, he was informed that his writings had been condemned by the Congregation of the Index and that the pope was particularly distressed by them. Kenrick then made a personal submission to the pope and to the new decrees. He defended his action as "a most reasonable obedience": without referring to his earlier arguments or retracting them, he simply asserted that it was necessary for him to obey the Church, "an authority established by God." Kenrick was fully aware of the irony of his case. Opinions questioning papal power that he had freely expressed in what he had naively taken to be a true Council had now been condemned by the infallible pope as consisting of "grave errors." He thought it "evident that there can be no liberty in future sessions of the Council."[17] There were no future sessions. Pope Pius IX had succeeded in establishing his primacy and infallibility just in time. On September 22, the Italians seized Rome, and the Vatican Council was permanently suspended.

When Pius preferred to shut himself up in the Vatican rather than accept the new government of Rome and the loss of the Papal States, he added an appearance of personal martyrdom to the transcendent status of the pope that had just been decreed. James E. Freeman makes fun of Pius's voluntary status as a "prisoner" in "the noblest of palaces" with its eleven thousand rooms, its beautiful gardens, its great library, and its "wondrous" art collection, where he freely received gift-bearing potentates and pilgrims from all over the world.[18] Such pitiless mockery was characteristic of Americans in Rome.

The ultimate trivialization of the formerly imposing if ambiguous figure of Pope Pius IX is reflected in an essay called "A Visit to a Certain Old Gentleman" (1875) by that genteel versifier for the *Atlantic Monthly*, Thomas Bailey Aldrich. Lingering after the "season" in Rome, Aldrich and his party are so bored that the only thing they can think of to do is to visit the pope, who quite irrationally has refused to leave the Vatican to go to his summer palace at Castel Gandolfo, even though Rome is getting hot. They will visit the pope precisely because there is no good reason they should do so, and visiting "The Pope of Rome" seems like such an amusingly unreal

thing to do in the modern age. Casually waiting in the audience hall, Aldrich notices that they are practically the only Americans. The reason, someone tells him, is that "his Holiness" now grants audiences to few people from America, since "a lawyer from one of your Western States" recently refused to rise from his seat or to kneel when the pope entered and was therefore removed by the guards. Aldrich is alarmed by this, not having realized that he would have to kneel. Yet as an American gentleman, he hates even more the idea of being ejected in front of foreigners. When the pope enters, Aldrich finds that "there is something in the American knee" that makes bending difficult, but the thought of even momentary notoriety overcomes his reluctance. Aldrich is mainly amused by the groveling devotion of the Catholics present, and by Cardinal Antonelli, "a living dodo" out of Velasquez. But the eighty-three-year-old Pope Pius impresses him as a vigorous survivor, who has led a "blameless private life, in noble contrast to many of his profligate predecessors." Most remarkably, Aldrich sees in Pius's smiling mouth signs of "unusual force of will"—the chief thing his American scrutinizers in the 1850s had *not* seen in him. Pope Pius's triumph at the Council and his refusal to fly from Rome a second time evidently altered his appearance. He was, says Aldrich, "a very beautiful old man," with "a deathly cold hand." In making the rounds of the room, when he arrived at the American party he "was kind enough to say to us what he had probably said to twenty thousand other Americans in the course of several hundred similar occasions"—in other words, nothing worth repeating.[19]

However unfashionable and insignificant the pope had now become in "American" eyes, it was at this time that in the eyes of the American Catholic faithful the good Pio Nono achieved sainthood and martyrdom. In the year before Pius's death in 1878 the reputable historian of American Catholicism John Gilmary Shea published a popular *Life of Pope Pius IX and the Great Events in the History of the Church during His Pontificate.* It was a work of piety for Catholic families in America, intended to make the saintly "character" of the pope as familiar to them as his "countenance," an image of which hung in every Catholic home. Shea's melodramatic rendering of the pope's situation throughout his reign must have caused many tears to be shed for the suffering old man who underwent so many "trials" for the Church. All of Pius's enemies are "criminals," "malcontents," "troublemakers," or—at best—"crafty statesmen." Margaret Fuller's noble Republican friend Mazzini is said to have disrupted the "mild and gentle rule" of the pope in 1848 and is described as "the chief of the enemies of Christ, the very incarnation of anarchy and social dissolution."[20] According to Shea, since 1870 the Antichrist has ruled again in Rome. But all is not lost. Shea concludes his edifying tale by asking Americans to pray for the return of the Papal States to the Holy Father, whose sanctity has recently been proven by several miraculous cures, which Shea records in solemn detail. Needless to say, these prayers were never answered, and Pio Nono has yet to be canonized.

"Prisoners of the Vatican": Pride, Humility, Peace

During the reign of Pius IX's successor, Pope Leo XIII (1878–1903), who was a "prisoner of the Vatican" for an entire quarter-century, "Americans" largely ceased

to make fun of the pope, and he was not a prominent part of the Roman experience for them. Even visiting or resident American Catholics rarely described this widely respected intellectual pontiff. His numerous encyclicals, however, were much commented upon, and some of these did nothing to ease the situation of Catholics in America, who in the 1880s began to contend with fears of "Romanism" (as well as "Rum") even in national political campaigns. An encyclical addressed specifically to American Catholics in 1895, *Longinqua Oceani*, praised America and the growth of American Catholicism, but specifically asserted that the American political system was *not* the "most desirable one." It would be "erroneous" to think that it was "universally lawful or expedient for State and Church to be, as in America, dissevered and divorced."[1]

As to typically American theological tendencies, Pope Leo informed Cardinal Gibbons in an apostolic letter of 1899 that the views of Father Isaac Hecker (whose biography, translated into French, had created scandal) were unacceptable. Hecker, in his eagerness to convert Americans, had made unsuitable accommodations to modern and democratic culture and had emphasized Anglo-Saxon inwardness as a more effective means of conversion than Latin reliance on external signs. In 1903 a new pope, Pius X, the first who would be canonized since the sixteenth century, condemned all aspects of "Modernism" in his *Pascendi Dominici Gregis*. Thus in spite of Pope Leo's great encyclicals on social inequities, the general tendency of the papacy in its Roman isolation continued to be reactionary. But in Rome most Americans were content to leave the still-medieval pope to the Catholics.

The changes in attitude are evident in two accounts of Pope Leo XIII, one in Maud Howe's *Roma Beata* (1904) and the other in an essay that her convert cousin, the novelist Francis Marion Crawford, included in the first edition (1898) of his *Ave Roma Immortalis*. A major point of Maud Howe's story is to contrast her own attitude with that of her mother, Julia Ward Howe. They had been in Rome together in 1878 when Pius IX died. Maud, at that time a celebrated beauty of twenty-four, remembered of his funeral rites only "how handsome" his corpse was, and the peculiarity of one foot being positioned to receive kisses. That winter she was one in a group of about twenty presented to the new pope. But her mother, author of "The Battle Hymn of the Republic," "refused to go: those stubborn Protestant knees would not bow down to Baal or to the Pope." Maud Howe proudly asserts that "our generation takes things differently, not half so picturesquely. We say, 'An old man's blessing is a good thing to have, whether he be a lama from Thibet or a priest of Rome.'" This is not the self-assured civility made possible by strong (but not fanatic) dissenting religious convictions, like those of Ticknor or Cooper, who employed almost the same words to justify their behavior. It is the adeptly equivocating liberalism of indifference, which happily dresses up in Spanish mantillas and diamonds to take part in the show, does not omit to admire the emeralds on the pope's pendant cross or to kiss his "large amethyst" ring, is flattered by his genial assertion that Boston is "a famous city," and interprets as merely "picturesque" the stiff-necked convictions of an earlier generation.[2]

In Julia Ward Howe's own old-age recollections of that occasion, religious convictions seem less quaint. She and her husband had in fact allowed themselves to be presented to Pope Gregory XVI in 1844, she recalls, because "etiquette" was in those

days "not rigorous"; Gregory required only bows. On her second stay in Rome in 1850–51, Mrs. Howe saw Pope Pius IX at the Christmas mass in St. Peter's, but she was more concerned with his government's seizure and destruction of "the entire edition of Deodati's Italian translation of the New Testament" than with any wish to see him more closely. The repression of religious freedom struck at a conviction that was something more than "picturesque." Thus when Mrs. Howe was in Rome again in 1878, she went with her sister, Mrs. Luther Terry, merely to observe the consecration of the new pope, Leo. But when she learned that he "required that all persons presented to him should kneel and kiss his hand," she knew it was something "I could never consent to do." At the consecration in the Sistine Chapel, the pope's "brand new pair of barbaric fans," the "triple crown" on his head, and the "costly silks, furs, and jewels" of the other ecclesiastics made it obvious to what assumptions of power and authority one would be kneeling, and they offended still another "picturesque" conviction, that concerning the humility of true servants of God. The only thing that Mrs. Howe liked was the reading of a passage of the Bible in Greek, which she found herself able to follow.[3]

Twenty years later Maud Howe (who had long thought of herself as the pope's "neighbor" in the Borgo, a quarter of Rome adjacent to the Vatican) went to see the ceremony commemorating his twenty-first year on the throne, a ceremony intended to revive still more fully the papal splendor much diminished since 1870. And indeed everything was back in place and back in use: the brilliantly robed and high-mitred cardinals, the Swiss Guards in red and yellow, the feather fans, the sedia gestatoria, and the pope himself, "feebly" rising to give the benediction, but "as exquisitely *soigné* as a young belle."[4]

Francis Marion Crawford's adulation of Leo XIII is equally removed from his aunt Julia's abhorrence and his cousin Maud's amusement. His essay was originally prepared as one of four lectures to be delivered on an American tour sponsored by Catholic youth groups, and it proved to be the most popular. Afterward Crawford worked on a full-length biography, authorized by the Vatican, in collaboration with Count Eduardo Soderini (who eventually finished it alone).[5] In *Ave Roma Immortalis* the lecture on Leo opens a pious and triumphalist sequence of three concluding chapters, including those on the Vatican and on St. Peter's. The tone and arrangement invite retrospective scrutiny of Crawford's treatment of the history of the Church throughout the book. One notes that the section containing "tales of the Lateran church and palace" and of Santa Maria Maggiore says nothing whatever about holy relics, although elsewhere Crawford complains of the "bad taste" of some "former" Catholic traditions. The discussion of the Inquisition under the heretic-hunting Carafa pope Paul IV quickly turns into an attack on the people—the "southern rabble," who were prevented from burning monasteries by the noble Marcantonio Colonna. Paul IV is also notable for having first confined the Jews to the Ghetto; according to Crawford this was a great benefit to them. When, in his survey of Rome region by region, Crawford arrives at the Campo de' Fiori, he conspicuously fails to mention the statue of Giordano Bruno that had been erected there in 1889 on the spot where the heretical Dominican, a true hero of intellectual freedom who persisted in his doubt that the earth was the center of the universe, had been burned in 1600.[6] His memorial had been intended by the new secular govern-

ment as a reproach to the Vatican and its claims to infallibility, and it was so taken. Maud Howe says that there was much talk of moving the papacy from Rome, that the pope became very ill, and that on the night of the monument's dedication the old man was found "kneeling weeping at his *priedieu*" long after his bedtime.[7]

Crawford's silence on these and other matters in his "history of Rome" and his rationalization of those repressive aspects of Catholic Rome that he cannot avoid mentioning are manifestations of his religious and political conservatism. Crawford claims for Rome "an extreme level of devotion under Pius the Ninth and the French protectorate" that is contradicted by the accounts of most other American observers, including Catholics, unless he means only devotion to the pope. He admits that the Church was damaged by "the coming of the Italians in 1870," but he now sees it as reasserting itself "with undying energy, under Leo the Thirteenth," making of Rome once more "a clerical city," although it is "threatened only too plainly with an impending anarchic revolution."[8]

Crawford's reactionary lecture on Leo[9] employs selective and apologetic methods similar to those he uses in describing the role of the Church in "the history of Rome." He says nothing, for example, of Leo's recent encyclical to the Americans reasserting the ideal of Church-state unity. Leo's stature is also established partly at the expense of his immediate predecessors, whose political crises he did not have to face. According to Crawford the post-Napoleonic popes were "politically insignificant," and the "only stable thing" about even Pius IX was "his goodness; everything else was in perpetual vacillation." Since in 1848 all "Europe had gone mad," it is understandable (Crawford implies) that the good Pope Pius had wavered toward liberalism when he should have stood firm. After his restoration in 1850, he had governed "in kindness if not in wisdom." And even then, the "only restriction on liberty" in Pius's Rome had been "political, never civil." The distinction may be vague, but according to Crawford any excesses of political repression were the fault not of the pope but of his executor Cardinal Antonelli.

Pius's loss of the papal city to Italy in 1870 had been the "death-blow of medievalism," and it had been up to Leo to reestablish Catholicism on a purely spiritual foundation. This meant primarily a refutation of English heresies, since in 1878 the British Empire was at its height in the world, was promoting the "scientific atheism" of Darwin, Huxley, and Spencer, had a monarch belonging to "a German dynasty," and a prime minister "of Israelitish name and extraction." But Leo XIII was the match for these demonic forces. The greatest man of the modern age, Leo could be compared only with Lincoln and Gladstone. He showed the "spiritual" development in the type of which they were the "material" and "intellectual" expressions. According to Crawford, "the greater the man the greater the peacemaker, and Leo the Thirteenth ranks highest among those who have helped the cause of peace in this century." Oddly, instead of substantiating this tremendous claim with specific instances, Crawford goes off into gossipy details about the pope's daily routine, including such curiosities as that he naps facing the light of an open window. Crawford's American audience is assured of the extreme economy Pope Leo exercises in his household—"in the midst of outward magnificence" he is "essentially frugal," and he practices no simony. Contributions to the Church are not squandered. Moreover, contrary to what "too zealous adherents" might imply,

the pope makes no claim to infallibility on political matters. Thus reassured about money and politics, the Americans can appreciate what Leo is doing as the great bulwark in the world against "the mass of social democracy." He is "the leader of a conservative army which will play a large part in any coming struggle between anarchy and order." Crawford, who himself lived like a prince with a vast retinue of servants in Sorrento, says nothing of Leo's great encyclical on social justice, *Rerum novarum* (1891), and one would not conclude from this lecture that it was for the Church's error in burning Bruno that Leo had been weeping.

Leo XIII died in 1903. He was followed by a more reactionary pope who turned out to be a saint, but the now-established respectful or indifferent attitudes of both Catholic and non-Catholic American writers—with one exception—did not really alter for him, or for any other pope until John XXIII, who was a true saint in the eyes of a much larger number. Even a humorist like Booth Tarkington and a social satirist like H. L. Mencken exempted the person of the pope from the laughter the Vatican still occasioned. In 1904 Tarkington, the popular novelist from Indiana, published "A Vatican Sermon" in *Harper's*. A semifictional account of a mass audience held in the Cortile di San Damaso at the Vatican, it begins in the spirit of Mark Twain's *Innocents Abroad*. The Swiss Guards are "gaudier than bumblebees" and show "no signs of overwork"; the sky is "almost as rich, almost as blue, as the summer sky over the United States," the scene in the Cortile "was (to an American) so strangely theatrical that it seemed only plausible that the two guards would presently draw the curtains to disclose an old-fashioned tableau." The honeymooning American couple from Chicago are taken in hand by an aggressively hospitable Italian who becomes an obnoxious nuisance, speaking stage Italo-English: "Come weetha *me!*" He points out the "Pawp's brozzer," who is being treated deferentially while another man—"He Pecci" (nephew of the late Pope Leo)—is now ignored. The unwanted guide is a Liberal: " 'Zees pipple all roun' you, zey haf not brain. No! Bigot! Stupid! But . . . zees Pawp . . . I like 'eem. . . . 'E liberal inside. . . . Ev'rabod' like 'eem, excep' only some cardinals.' "

Finally Pius X enters, and Tarkington becomes sentimental. "For Pius X has the effect of pathos; perhaps it is the transparent and touching quality of the simple goodness that is in his face." He is like the typical "Uncle Billy Jackson" of which every American town has at least one, kind and helpful to every last lame dog or drunkard. Tarkington commiserates with the pope's "imprisonment" not only by his restriction to the Vatican but by "the policy of the powers of his organization," and he will never see his beloved Venice again. A man of the people, he has "grace" and "dignity" without "haughtiness or pomposity or pride of office." His voice "carries to one who hears in it the benediction that exhales from the spirit of Pius X, to all the world, all the time." After the audience ends as usual with weeping, ecstatic cries, and shouts of "Viva il Papa!" the couple leaves "the central figure of all the world" behind them, and "the little bride says, 'Ah, isn't he wonderful! . . . Oh, isn't he a dear!' "[10]

Tarkington's story accurately conveys the sentimental, protective, and implicitly condescending attitude popularly assumed toward popes until the 1950s. They were all considered to be essentially saintly, but ineffectual because controlled by

the wicked Roman Curia with its purely worldly interests. The pope-saint is immune even to Mencken's iconoclasm; his satire hits only the Catholic faithful. In *Heathen Days* Mencken tells how he and his infidel friends crashed a papal audience in 1914, the year Pius X died. After admiring St. Peter's, "especially the immense *pissoir* on the roof—the largest in Europe," they infiltrated a group of smelly, pious pilgrims from Vienna and heard the detailed explanation of "the stage management of a papal audience." Kneeling, they were to kiss the pope's ring, not his hand; "Nicht die Hand! . . . Kusst den Ring!" "The sacred person" would not submit "to the lewd osculations of the vulgar!" Later, they found themselves kneeling in a room that looked like a parlor "in a bourgeois home," trembling lest they be discovered. Pius X appeared, "already an ancient man and beginning to break up. . . . His skin had a startling whiteness, and he stooped from the effects of a large swelling at the back of his neck—not, of course, a goitre, but of the same general dimensions and aspect." For a moment we seem to be back with Willis and Hawthorne and the other nineteenth-century irreverents. But suddenly Mencken changes tone:

> He moved slowly and with effort, and appeared to be almost unaware of his visitors, though he held out his hand for the kissing of the ring, and smiled wanly . . . a man of deep piety and simple tastes . . . caught by the cogs of the Roman escalator. . . . His reign, alas, had not been too peaceful. . . . He looked immensely old. . . . But he walked without help, and in less than two minutes he was gone. This was in May, 1914 . . . and on August 2 World War I began. His Holiness survived that blasting of all his hopes of peace on earth by less than three weeks.

Even Mencken cannot laugh at the man who had refused to bless the Austrian troops. But there is plenty of fun to be found in his followers, as the sketch concludes with the infidels' encounter with their fellow passengers from the *Laconia* back at the hotel. Among them are Catholic pilgrims, including "a ninth-degree Knight of Columbus and his lady" who have come to Rome "for the express purpose of paying their respects to His Holiness." They have just learned that they may have to wait for several hot months dressed in black before they can do so. At first refusing to believe that Mencken and friends had seen the Vicar of Christ, the Catholic pilgrims finally vent their anger by accusing them of "an insult to the Pope [and] a carnal and blasphemous attack upon the Holy Church itself." The infidels are threatened with a beating from the Black Handers, to be supplied by a Jesuit friend.[11]

The first new "American" view of the pope in a long time was, not surprisingly, that expressed in 1911 by Theodore Dreiser, who had already brought a fresh vision to American fiction in *Sister Carrie* eleven years earlier (only to have it suppressed by his own publisher), and who was now, at the age of forty, writing *The Financier*, first novel in the "Trilogy of Desire." Dreiser, like his Sister Carrie, had "outgrown" Catholicism "at an early age." But he is determined to see the pope, although to do so proved very difficult in the season of Lent. Dreiser's description of the papal audience to which he did finally get an invitation concludes his chapters on Rome in *A Traveller at Forty*, so it has a specific and significant context. Dreiser has already

asserted that the "long and messy history of intrigue and chicanery" in the Catholic church makes it impossible for him to "contemplate its central religious pretensions with any peace of mind." St. Peter's Cathedral is a "memorial" to "wars, heartaches, struggles, contentions." But attraction is obvious where revulsion is so great.

Dreiser interpolates an eight-page small-print summary of the Borgia family story—a "charming Renaissance idyl" motivated by "craft, lust, brutality, and greed." This story is told to him by an American woman who has become fascinated by the "artistic insight, political and social wisdom, governing ability, . . . money-getting and money-keeping capacities" of the Borgias. "The raw practicality of this Italian family thrilled her," says Dreiser, and the "horror and cruelties of lust and ambition held no terrors." Dreiser himself obviously finds Papa Alexander VI, Cesare Borgia, and Sister Lucrezia an irresistible family group. The sins and the talents he ascribes to the Borgias are recognizably those of his own ambiguous American hero, the financier Frank Cowperwood, whose character he was even then developing. When in the next chapter Dreiser discusses the great buildings and art collection of the emperor Hadrian, openly envying his "power, subtlety, and genius," we think again of Cowperwood the ruthless manipulator, builder, and collector.

Another important element in Dreiser's attitude is revealed when, just before he meets the pope, he recalls "with a smile" how completely "subjugated" his own father had been "to priestly influence" back in Indiana. "To him the Pope was truly infallible. There could be no wrong in any Catholic priest. . . . The lives of Alexander VI and Boniface VIII would have taught him nothing." And so of course even the life and presence of Pius X leaves Son Theodore in rebellious apostasy. The weary and obviously bored old pope (who had "shrewd eyes" and "a low forehead") patiently made his rounds to get his hand kissed, but "scarcely looked at all" at Dreiser, "realizing no doubt my critical unworthiness." Afterward, Dreiser was glad that he had seen the pope. "I had thought all along that it really did not make any difference . . . and that I did not care." But to have seen weeping pious pilgrims grovel before an indifferent Holy Father, a weary "Pontifex Maximus," reassured him that his father's faith was as intellectually stagnant and pharisaical as he thought. How far it all was from "the Catacomb-worshiping Christians who had no Pope at all, . . . but just the rumored gospels of Christ."[12]

Visits to the pope by lapsed Catholics like Dreiser are as rare as those by American Irish-Catholic laymen going to Rome "for the express purpose of paying their respects to His Holiness" became common. A phenomenon of the increased ease of travel and the growing prosperity of Catholic Americans in the twentieth century, these visits also reflect a new point of view. In 1935 the most famous lay Catholic was certainly Alfred E. Smith, the former governor of New York who in 1928 had been the first Catholic to be nominated for the presidency by a major party. When he met Pius XI it was the first time in his life that he let someone else do the talking: "It pleased me greatly to hear him speak so well and so affectionately of America, and I was indeed embarrassed by the tribute he paid me as 'a loyal son of the Church.' " The multinational group of Catholics assembled at Castel Gandolfo, the pope's summer residence, symbolized the only way to world peace, according to Smith,

because it was "the only real League of Nations that could be made to work." Besides reiterating this now common Catholic assumption that world peace would best be achieved through a Universal Church with the pope at its head, Smith also makes his contribution to the developing image of the Humble Pope by deluding himself into thinking that the pontifical palace at Castel Gandolfo, which Pius XI had just totally rebuilt with the exception of the façade, and to which (by the terms of the Lateran Treaty with Mussolini) he had annexed the enormous Villa Barberini, was "hardly distinguishable" from the "houses of the village," since "they all seemed to huddle together." The pope was just "a humble man of God, living in the middle of a humble peasantry from which he took his origin."[13]

A unique view of the pope from the point of view of a person truly humble is provided by the memories of the pastor of a rural parish in Oregon. In 1942 Father Martin W. Doherty published *The House on Humility Street,* in which he looked back nearly twenty years to his winter in Rome at the North American College. With unaffected simplicity Doherty describes an experience he already knew would be the most intense and rewarding of his entire life. The high point was his participation in the audience granted by Pope Pius XI to students from all the colleges in Rome in honor of the six hundredth anniversary of St. Thomas Aquinas's canonization—"O day of days!"—a day honoring the "greatest of all heroes" and the greatest "of all philosophers." Both at the time (1923) and in retrospect, Doherty was filled with wonder at the sight of himself standing in the Hall of Benediction over the portico of St. Peter's. How was it possible that "Butch the Fifth," the big, fat, sickly son of a Chicago police officer, came to be there? Only a few months earlier he had been a nineteen-year-old crime reporter in the squalid and grotesque world of the immigrant Irish. In the entangled and desperate family and neighborhood relationships of his Chicago, where crime or police work seemed to be the two complementary possibilities of life for young men, the priesthood represented not only to Doherty but to the hoodlum friends who encouraged him in his vocation the one means of transcendence.

By a series of apparent miracles, he had arrived in Rome. Now, waiting for the entrance of the cardinals and the pope, Doherty looked over the crowd of students from all nations, happily babbling together in a hundred languages and beheld a vision of the future "that should bring peace and unity and happiness and beauty to all the people of the world." When he saw the great men of the Church arriving in their brilliant scarlet capes, followed by the proud and gleaming Noble Guard, and finally "a plain figure in white . . . I believe my heart stopped beating. There was the Holy Father, Pope Pius XI." The pope blessed the shouting, sobbing students and delivered a ten-minute address in a "soft and gentle voice" that had "a touch of weariness in it, a touch of sadness. . . . He spoke in a conversational manner with no effort whatsoever at oratorical elegance. . . . Somehow or other . . . he impressed me as being the saddest man in all the universe." When the papal procession had left the hall, Doherty stood "entranced, unable to move from the spot where I had seen the Beauty of the spiritual world manifest itself somehow through the beauty of the things of this world. I had made my way upward . . . to find the Ultimate in Life at last in a plain, white cassock. I had beheld God's vicar." Afterward, standing in a

state of "beatific aberration" before the tomb of a pope in St. Peter's, Doherty had a vision of all the popes of history triumphantly marching behind St. Peter himself: "The immortality of the papacy!"[14]

Doherty beheld the pope on two other occasions, which were contrasts in pride and humility. One was a magnificent installation ceremony for two new American cardinals, held in the north transept of St. Peter's. The pope arrived in his sedia gestatoria while invisible choirs sang "Tu Es Petrus." Doherty dropped to his knees weeping before this "vision," this "glimpse of the universe beyond creation." After this, "the future could promise nothing but drabness." The other occasion, however, captures better the primary emphasis of Doherty's book. On the Feast of the Immaculate Conception, which is also the American national feast day for Catholics, the American students were invited to a papal Mass at the Vatican, and this time "the High Priest, Pius XI" appeared as "a simple priest" like any other; "quietness and simplicity" replaced the "great pomp and splendor" of the other occasions. Appropriately, the students afterward attended a Solemn High Mass held in the chapel of Our Lady of Humility, attached to their own college on Via dell' Umilta. This chapel, built before Jamestown and Plymouth had been founded, was closely associated with "the great pontiff" Pius IX, who had served Mass there as a boy and had visited it shortly after he had founded the North American college in 1859. In fact the image of Pius IX rather than Pius XI dominated Doherty's memories of Rome. A huge life-size portrait of him hung at one end of the refectory where the young men took their daily meals, and Pius IX himself had legendarily dined there "in the days before the Garibaldian invasion."[15]

In the mixture of pride and humility that dominates Doherty's images of the pope, the Church, and himself, there is an implicit longing for that pre-1870 era in which Rome had been a predominantly ecclesiastical city, where seminarians were not called "parasites" by the people in the streets nor were forced to stand aside while black-shirted fascist youths marched by. Yet such is the narrowly and intensely focused priestly preoccupation of Doherty's experience that the Rome of 1923 almost does seem still to be that sacred medieval city. And it goes even further; for not only is modern secular Rome almost absent, but so too is classical Rome entirely peripheral in Doherty's impressions. His Rome is a place where troops of escorted seminarians trudge on weekly visits to various churches and attend baffling Latin lectures and examinations at the famous College of the Propaganda (designed by Borromini but according to Doherty a place neither "beautiful" nor "even architectural").[16] For them a worldly adventure consists of a chaperoned climb up the nearby Spanish Steps; this is no fun for a fat boy. But all the dreariness and discipline of life in Rome can be redeemed by one sight of the pope.

On an entirely different level of sophistication from Smith and Doherty, but no less committed to a wholly favorable presentation of popes, are the essays of the distinguished Catholic journalist Anne O'Hare McCormick, who wrote primarily for the *New York Times*. In her long career she managed to describe three popes from a relatively intimate and informed point of view. From 1921 to 1951, three motifs dominate her dispatches from Rome: the new and constantly growing worldwide prestige of the popes, particularly as the chief spokesmen for peace; the development of mutually respectful relationships between America and the Vati-

can, owing to the great increase in the importance both of America and of Catholicism in America; and—the point at which McCormick's sympathies diverge completely from those of Crawford—the gradual shift in the Church's view of the American ideals of democracy and religious freedom from one of suspicion and fear to one of acceptance and even advocacy. The pope was transformed in American eyes not only because "American spectacles" had ceased to have purely Protestant and humanistic tints, but because the "papal principles" themselves had greatly altered since Jarves's day.

Early in her career, in 1921, McCormick contrasted two events she witnessed in Rome within a single week, the opening of the Italian Parliament, at which Mussolini made his sensational debut, and a session of the Papal Consistory, called by Pope Benedict XV in the last year of his reign. Although recognizing that Mussolini's only "piety" is his "devotion to Italy," McCormick favorably quotes his declaration that "the Latin and imperial tradition of Rome today is represented by Catholicism," and "the only universal idea which exists in Rome is the Vatican." But her main point is to emphasize that the Parliament, like all postwar parliaments the world over, represents turbulent "human nature" at its most volatile and anxious, whereas the Vatican represents "steady and unflustered tranquillity," "undisputed authority," and the ability to wait out any difficulty. At the Papal Consistory, the splendor of the furnishings of the Sala Regia, the brilliant costumes of the participants, and the pomp of the pope's entrance in his golden chair hedged in by "waving fans of white peacock feathers," are not to McCormick, as they were to nineteenth-century Americans, elements of a picturesque anachronism, but of a sublime timelessness. The scene is "a crowded and animated medieval canvas in which one felt strangely and beautifully at home." The contrast with the Parliament, moreover, is not one between democratic and aristocratic systems, since at Montecitorio a strong sense of royal and military privilege was obvious, and at the Vatican "peasants, students, young priests, travelers from the ends of the earth, crowded against Italian princes and Papal counts." As for the pope, McCormick admits that in the face and figure of Benedict XV "there is no majesty, spiritual or secular." She in fact rejoices in the very thing that had so disturbed Emerson: "the man inside the Pope did not matter at all. He was lost in something impersonal, perpetual, obliterating." Good, bad, and indifferent popes are all swallowed up in the papacy, before which representatives of proud nations are seen to kneel. "There is something subjugating in the only unbroken tradition left in the world." McCormick practically equates the triumphant papacy with the Deity: it is "perfectly calm and static" in a whirling world; it has an "authority absolutely assured"; "one has to come to Rome to realize that the Vatican goes everywhere and knows everything."[17]

After Pope Benedict's death, McCormick concluded that this apparently "insignificant" individual had actually done more than his immediate predecessors to increase the prestige of the papacy, so that it was now at its highest point in a century. This was owing to the fact that during and after the war, he had promoted the papacy as an agent of world peace, an arbiter of conflicts. Of course, there were others ready to point out the "political hypocrisy" of the pope's wartime diplomacy,[18] but they had not the advantage of intimate interviews. McCormick recalls

that at her private audience with Pope Benedict, in which he had been more the "friendly host" than the "Sovereign Pontiff," he had spoken anxiously about the fate of the League of Nations, a "great conception" that he had encouraged but the U.S. Senate had rejected. Pope Benedict nevertheless professed himself an admirer of America. He proudly showed McCormick a picture of himself with some members of the Knights of Columbus who had recently made a pilgrimage to Rome and declared that it was the first time "the Holy Father has ever been photographed with a company of laymen—and, of course, they were Americans!"[19] Americans were democratizing the papacy.

In two essays written in late 1935, after the League of Nations had imposed sanctions upon Italy for its invasion of Ethiopia, McCormick attempted to demonstrate that the next pope, Pius XI, was actively and wisely continuing the role of the papacy as an agent of peace, in spite of his displeasure with the action of the League. To counter charges that the pope who claimed to be the Pope of Peace was remaining passive before an Italian war of conquest, McCormick enumerated the steps he had taken and defended his apparent equivocations by saying that as a spiritual authority he was necessarily limited to enunciating "general moral laws" against aggressive wars. Unlike the League, he recognized the cause—"legitimate needs for national expansion"—rather than merely condemning the aggressor. The pope also refused to excommunicate the Italians, as called for by the English, since this would have condemned young soldiers who were guilty only of patriotism. Describing a papal Mass held in the Sistine Chapel in December, McCormick presents Pope Pius XI in his "stiff, bell-like cope, his tall miter," looking "rigid and symbolic as the rock of Peter." He is characterized by a paradoxical combination of vigor and calm, "force in repose," which sets him apart from all the contemporary "shouting rulers." In the chapel what the observer gained was "perspective"; "mounting the Scala Regia out of St. Peter's Square, out of the Rome of sanctions and militant resistance, one passed out of the short into the long view of things." This was owing both to the antiquity of the papacy and to the fact that cardinals and popes are always old; no youth movements such as were distressing Germany and Italy would ever disturb it. The fascist "era," the Roosevelt administration, and "the life of a British Government" are reduced to relatively trivial moments in the eternal lifetime of the papacy, and this "truth" must be remembered "in interpreting papal policies" such as that which has set the pope against the shortsighted attempt of the League "to preserve peace by punishing the aggressor." For years the pope had been calling attention to the false nature of the "peace" that followed the Great War, to the root of all wars in social injustice, and to the nature of true peace. But few had listened. If the pope were to condemn, the condemnation would not fall upon Italians only.[20]

The year 1939 saw the death of Pius XI, the election of his secretary of state as Pius XII, and the outbreak of World War II, by the end of which the relationship between America and the papacy would be greatly changed. McCormick had interviewed Cardinal Pacelli two weeks before Pius XI died, and she was granted an audience with him as Pius XII not long after his ascension to the throne. What she chose to stress about the new pope in March and in May 1939 was his devotion to

the aims he attributed to his predecessor: defense of "liberty of conscience and the inalienable rights of the individual soul," and the struggle "against the 'terrible heresies of the times,'" primarily Nazism and Communism. He had enormous "enthusiasm" for the United States. As papal secretary of state he had flown "across the great American Continent," and thus was the first pope to have a direct knowledge of America. What he most admired was "the largeness of the view, the tolerance, the free atmosphere," which more than any other was "conducive to the free practice and free growth of religion." McCormick makes the pope begin to sound like Father Hecker. Without trying to analyze possible contradictions of policy, however, she does mention that Pacelli had negotiated two concordats between the Church and fascist states that guaranteed these freedoms only to Catholics. More important were the new pope's "peace efforts," described with the implication that they had been coordinated with those of President Roosevelt. "He has dedicated his pontificate to the search for peace."[21]

The sober, even portentous tone of McCormick's reports, in which the pope assumes an international moral and political importance that would have been unimaginable by Americans a century earlier, does not mean that the Holy Father was no longer bothered by requests for audiences from self-important American Protestants. McCormick's friend, the fashionable playwright Clare Booth (who was already a Luce and would become both a Catholic and U.S. ambassador to Italy), also wrote an account of Pius XII at this juncture in world history. Her narrative of a papal audience follows the now standard pattern: everything is amusing except the pope himself, who is beyond criticism. Admitting that she went out of "vanity and curiosity," she also had some fear of "the look in the face of a man of great good will" since it was "so likely to upset me for days." Nevertheless Booth bravely dressed herself according to the advice of the editor of *Vogue* and a Roman noblewoman. Her maid's regret that she had no jewels to wear to see the pope was matched by Booth's shock (she being "a Protestant of Puritan ancestry") that jewels were expected. "I can't help associating emeralds and diamonds and gold with bare alluring backs in nightclubs and fleshpots like the Metropolitan Opera." Protestants will never understand the Catholic church because they "cannot separate, as the Catholics do, the possession of material wealth from the idea of moral and spiritual bankruptcy."

Having made her point in the tradition of Turnbull and Jarves, Booth goes on to recall how she nevertheless went off with the editor of *Vogue* to see the Holy Father, the two of them "looking like something out of Goya." On the way she thought briefly about the Church and the Italian conquest in Africa and saw them as opposed aspects of Roman power. The pope, she was sure, was "the one man in all the world who perhaps had the power that perhaps still resided in the organized Church of Christ, the power that comes of God, to stop this war." Leaving their sables and silver foxes in the anteroom, they joined about forty others, including ladies laden with jewels and nuns "with black mustaches." When Pius XII entered, she knelt, while noting that he was slim, bent, and wearing "little red slippers without heels on his narrow feet." His face was "so intelligent and so beneficent," and he assured her—"in very good English"—that he loved America. He left, and everyone stopped

smiling, got up, and began "to arrange our ties and jewels and crucifixes and veils." Retrieving her silver foxes, Clare Booth went away feeling "for some exceedingly strange reason, so much better in my heart."[22]

McCormick made no such concessions to the amusing, the sentimental, or the personal as she continued her Vatican dispatches. The alliance of pacific purpose between the papacy and the United States became more explicit after Roosevelt sent his personal envoy, Myron Taylor, to the Vatican in 1942; according to McCormick their "spiritual" ends were identical, since "all the freedoms we defend are the extension of the fundamental human right of free will, a right which is at once the basis of natural law and of Christian philosophy." It is now clear to everyone that "the survival of the Church is linked up with the survival of the principle of democracy." After the liberation of Rome in 1944, the pope "seized the opportunity" to support the Dumbarton Oaks conference that was designing a postwar international organization devoted (in his words) to "preserving peace according to principles of justice and equity." This, wrote McCormick, amounted to an "endorsement of the 'American peace plan.'" But far more striking as an indicator of revolution in papal principles was the pope's Christmas message of the same year, in which he declared "democracy the best and safest form of government." Blaming the war on conflicts between dictatorships, the pope now endorsed democracy over all forms of "absolute government, not on political but on moral, spiritual and human grounds." The individual is recognized not as the passive "'object . . . in the social order'" but as "'its subject, its foundation and its end.'"[23]

McCormick's postwar essays are largely devoted to a celebration of the pope's enormous popularity, especially with Americans. On one day in September 1944, he received three thousand soldiers, "mostly boys from the United States, who trooped up the Scala Regia nudging one another and trying to look nonchalant." That the picture is not exaggerated is evident from the testimony of the war correspondent Eric Sevareid, who in his own account admitted that while he was "devoid of any feelings of religious awe toward the Vatican," which he had "always felt" was politically "inclined toward Fascism," the spectacle of the pope emerging on his balcony in "shimmering white robes" to bless the masses of people in St. Peter's Square had been "profoundly stirring." The "medieval splendor and pageantry" demonstrated both the pope's "'showmanship'" and his "political genius." The pope was adding enormously to the prestige of the papacy by taking credit for saving Rome and fully exploiting its liberation. Every day he received and individually blessed hundreds of "tattered and dirty allied troops." The war correspondents, too, were given an audience that broke the traditional relationship of the Vatican to the press. Even an "enormously fat" female journalist in pants was admitted. The behavior of the photojournalists was, of course, abominable; while the pope spoke they rolled about on the floor or climbed on chairs in search of angles, cursing and breaking bulbs. A new era in American attitudes toward the pope, and in papal public relations, had begun. The pope was a celebrity.[24]

Seven years later this "period of 'open house' at the Vatican, during which Pius XII met more Americans than any other Pontiff in history," was over, and McCormick had to advance the difficulty of getting papal audiences as an argument in support of the proposal to appoint Gen. Mark Clark, the liberator of Rome, as the

first American ambassador to the Holy See. In the meantime, Pius XII had gone far toward bringing the American presence into the Catholic church itself, having in 1945 "revolutionized" the College of Cardinals by appointments that greatly reduced the Italian preponderance in the Vatican. Europeans even spoke anxiously of "a tendency toward the 'Americanization' of the Church," since the United States was to receive more new red hats than any other country—giving them fourteen as against Europe's fifty-one. But the pope was building not an "international" organization like the United Nations but a "supranational" and "universal one," universal in both space and time. He was now "the central figure in the Roman pageant," a "tranquil and tranquilizing figure—a Gothic figure whose vestments fall around him in Gothic folds, whose long hands are raised in Gothic gestures, both stiff and graceful." From this timeless figure extends a grace that reaches to the Mississippi Valley through its new cardinal. The "Middle West is recognized in that quiet watch tower where Pius XII looks over the world." The climax of McCormick's vision is reached in her description of Pope Pius's Holy Year of 1950, as she watches a million pilgrims arriving in busloads from Frankfurt, Calcutta, and "Georgetown University." Sublimely at the center of this congregation of the world is "the white figure of the Pope as he holds his mass audiences in the square."[25] This is no prisoner of the Vatican.

Another American woman, Eleanor Clark, was present during that same Holy Year, and we have seen that she regarded it as an incredible anachronism. Nevertheless, with respect to the pope himself, even she finally had something positive to say. Asserting that the Holy Year's most obvious reason for having been called was to advance the power and prestige of the papacy, Clark admitted that even as a purely local Italian phenomenon the Vatican was enjoying unrivaled appeal as a source of pomp and ceremony, now that the fascists were gone and Italy had voted its royal family out of existence. For the first time in three generations, "the cardinal's cloak, the bishop's miter seemed actually supreme again." The "power" that unified everything was the indefatigable Pope Pius XII himself, who was placing his personal imprint upon his Holy Year. The pope displayed "uncommon personal charm . . . , whether or not it were felt as emanating from uncommon holiness; it had warmth and what seemed even a real humility, not incompatible with an autocratic office and a character suited to making the most of it." This pope's distinction, Clark thought (although we have seen the same thing asserted about every pope since Pius IX), lay in his definition of the Church as the spiritual center of global peace. Its universality was more evident than ever in the mixed hordes of pilgrims in the piazza, and in the pope's greetings to them in several languages (a feat that invariably seems miraculous to the single-tongued mumbling masses). Whatever else she found to criticize, Clark allowed that "one grandeur" was a fact beyond all criticism and "for this century the most thrilling possible": representatives of all nations gathered to hear a statement that "contained not a word of anything but affection and respect for the whole human race."[26]

In spite of this central message that transcended all sectarian controversy, Clark in the end judged the Holy Year to have been fundamentally a failure, even from the Catholic point of view. She could not believe that its evident intention to "bring to the old formulae the drive and spirit of a *new* belief" had been achieved.[27] Eight

years later Pope Pius XII's successor, John XXIII, would seem to have agreed, for he made himself the pope of *aggiornamento*, the transformation of the Catholic faith into a living force in the modern world, not a preserver merely of medieval dogmas and forms. This included, of course, continued stress upon the role of the Church as an agent of world peace; Pope John's encyclical of 1963, *Pacem in Terris*, was a most eloquent culmination to this long-developing aspect of the papal mission. But a change in the image of the pope, for Catholics and "Americans" alike, came primarily from John's calling of the Second Vatican Council, his definition of the work it had to do, and the forceful individuality of his personality—so different from that of all the aloof and conspicuously suffering Piuses that had preceded him for two centuries.

Catholic/Roman = Modern/Medieval = John/Paul

The Second Vatican Council, held in a series of four autumnal sessions in 1962–65, provoked the writing of a greater number of books with Rome as their source than had ever been published in so short a time. They were written by both Catholics and Protestants, and by priests, reporters, theologians, and mere writers attracted by an extraordinarily compelling event. For the first time the experience of Rome by people of all persuasions was defined almost exclusively by its Catholic aspect. Nineteenth-century writers like the ministers Turnbull and Kip stated that the ecclesiastical city was their first concern, but in their books they in fact gave more than equal attention to classical Rome. In the books of the 1960s, however, the Rome beyond Vatican City is peripheral and incidental; it consists simply of a few hotels, convents, restaurants, and cafés, and even in these places the talk is always of the Council. Since the debates of the Council constitute the substance of the experiences reported, one might think that their location was of little importance. Indeed, the comment is frequently made that many of the speeches delivered in the nave of St. Peter's would not have been out of place at the Council held in Trent in the sixteenth century. But while reading the books one becomes aware of how intensely the location did matter. For every speech, no matter how abstract in its argument or apparently transcendent in its purpose, was contributing indirectly to the larger debate, which was on how universal the *Roman* Catholic church could become and still retain its identity. Those Italian cardinals of the Roman Curia, who are shown struggling mightily—and, in the eyes of most American reporters, blindly, stupidly, and even immorally—to retain the Latin liturgy, the power of the Holy Office, and the primacy of the bishop of Rome, were concerned above all to preserve the *Romanità* of the Church. The specifically Roman splendor of the setting of these debates (themselves conducted in Latin), and of the papal ceremonies enclosing them, was itself a great symbolic weight on their side.

To represent adequately the differing qualities of the works written about the Vatican Council by Americans alone would require a separate book and in any case goes beyond our present purpose. Even our much more limited concern with their representations of the pope as the central idol of Catholic Rome cannot be fully developed, since nothing complicated the drama of Vatican II more than the fact that Pope John died after the first session, and in Paul VI an entirely different

personality dominated the consciousness of everyone concerned with the Council. And it is beyond question that in these four years, during which the Council in St. Peter's was at the center of the image of Rome, the pope was at the center of the Council. Rarely entering the hall except on ceremonial occasions, he was nevertheless known to be attentively following the debates, even listening and watching by closed-circuit television in the papal apartments that tower beside the church. His hopes, his desires, his powers, and his possible and actual unilateral actions affecting the agenda and the progress of the Council are subjects of constant speculation and discussion in all these books.

Since these accounts began appearing soon after the close of the first session, when John was known to be dying, or just after his death, the necessity fell on all writers to define the relation between John and his successor, and the differences between them. The organization of Michael Novak's *The Open Church: Vatican II, Act II*, published after the conclusion of the second session (which had ended in apparent failure), merely makes explicit a typical (and inevitable) theme when it opens with a "Part I" entitled "John and Paul," in which the hopes aroused by John and the fears stimulated by Paul's first year of equivocal signals are used to focus the meaning and tendencies of the Council as a whole. Our own interest here is to trace the modification or continuance of those motifs introduced by earlier American observers of popes in the characterizations of John XXIII and Paul VI during the years of Vatican II.

Ironically, the first of these motifs, the idolization of the pope, ceased to be of much concern to those who wore American spectacles, partly because Pope John XXIII so effectively undercut it and partly because the Americans proved to be second to no one in adulation of John, not as a pope but as a person. If he was inseparable from his office, he nevertheless dominated it rather than letting it control him, and these books are filled with anecdotes of his deliberate violation of papal protocol and of his ironical attitude toward the pomp of office. John thus met a second concern by answering to the Emersonian wish that the pope might speak from his individual heart rather than from his institutional throne. According to "Xavier Rynne," Catholic author of the four annual volumes of "Letters from Vatican City" that had appeared serially in the *New Yorker*, from the beginning of his reign John "worked strenuously at changing the atmosphere of quasi-adoration that surrounded his predecessor, Pius XII."[1] He simplified titles of address and shortened some ceremonies in which he was necessarily the central participant. Nevertheless, and partly because he convincingly displayed genuine humility as a part of his character, in all the descriptions of the opening ceremonies of the Council, Pope John XXIII is described as the object of an unprecedented adoration that the writers, far from criticizing, also deeply felt.

If most American writers—including Catholics—are made uneasy by the ceremonial trappings of the Vatican that John still consented on special occasions to use, their sarcasms about the props are not made to be commentaries on the pope, as in former days. To Xavier Rynne the opening ceremony was a "dazzling spectacle," a vision of Eternity. But Robert Blair Kaiser, a Catholic reporter for *Time* who at the end of the first session published a full account, described the same ceremony as "just a bit ridiculous," "something that Cecil B. DeMille could have staged." Pope

John was "carried undulantly along on the *sedia gestatoria* by nobles in outrageous red knickers and capes, surrounded by half a hundred young men in blue and orange bloomers, iron breastplates and lace ruffles, and a score of other cartoon characters out of O. Soglow." The flabella, ostrich feather fans flanking the sedia, were "a sobering symbol of the ties binding even a pope with a new vision to the traditions and ancient usages of the past." But John, the pope of aggiornamento, was to be separated from these anachronisms: on entering St. Peter's, he dismounted and walked; he glanced "painfully" at the venerated statue of St. Peter, which wore a jeweled crown and pontifical cloak for the occasion; he had refused to have his throne placed five feet in the air, and he left his tiara untouched upon the altar.[2]

Even Bishop Robert E. Tracy, Council delegate from Baton Rouge, in recalling this opening ceremony, felt obliged to justify to his readers (who were in the first instance his own parishioners) the fact that the beloved pastor-pope was carried into St. Peter's in the sedia gestatoria. This was the only practical way to make him visible to everyone, "like a notable visitor sitting on the back of a convertible." Yet it did "project the image of an oriental prince," thanks especially to the huge flabella. Tracy is certain that not only was John "embarrassed" by these props that distinguished him from his "brother bishops," but that other bishops too thought they should be sent "back to the Cleopatra movie set." Immediately Tracy goes on to counteract the effect of these ceremonies, so loved by nineteenth-century visitors to Rome but now degraded and trivialized through their association with popular motion pictures. He describes his feelings as he watched Pope John through field glasses: "I could look at those kindly features and immediately sense, somehow, that here was a man of God. Pope John's very presence breathed the supernatural. It is my view that if canonizations by acclamation were in order today, as they once were, Pope John would be acclaimed a saint just as readily as was St. Francis of Assisi."[3]

Protestants naturally could not join in the movement to canonize Pope John that began immediately after his death, but they did find their own categories equally as exalting. The Presbyterian theologian Robert McAfee Brown, an invited official observer at the second session, after admitting that the papacy had always been a most alienating aspect of Roman Catholicism for non-Catholics, noted that John had destroyed the "image of austerity and aloofness" and "human pretension rather than divine condescension" that had characterized many of his predecessors. According to Brown, during John's pontificate "non-Catholics did hear the voice of the Good Shepherd" himself. This is surely a comparison beyond even that to St. Francis. Equally adulatory words are in the dedicatory pages of Douglas Horton's published diary covering the first session.[4] Horton, also an invited observer, was a Congregationalist and former dean of the Harvard Theological Seminary and therefore direct heir to the Puritan New England tradition that had feverishly seen in the pope of Rome the Antichrist himself. But his attitude toward Pope John and the "new" Roman Catholic church is so filled with sweet charity, which he takes to be reciprocal, as almost to lack critical common sense, let alone the inflamed fear and hatred of his forebears.

If by now such liberal Protestant clergymen as Horton and Brown were professionally so committed to a dream of Christian re-union that they could only rejoice

in a pope who lovingly addressed them as "separated brethren" instead of anathematizing them, it was hardly remarkable that both Catholic and non-Catholic laymen found in Pope John a wholly sympathetic figure who expressed love and equality instead of judgment from above. Commentators in newspapers, magazines, and television tirelessly asserted that this pope was the man a troubled world had been longing for. There are several descriptions of the torchlight demonstration of love that followed the Council's opening, when half a million people gathered beneath a bright moon in Piazza San Pietro and knelt when Pope John, standing in a high window of the Vatican, movingly addressed them as his children, representatives of the whole world.[5] The character of the scene is entirely different from that of any papal appearance in the nineteenth century, except those in the early days of Pius IX. Descriptions of the large and turbulent audiences held by Pius XII in the 1950s (Patricia Collinge's *New Yorker* story "Benediction" gives a comical account of one)[6] lack the the element of overwhelming love and personal devotion that marked this occasion and others. Pope John was *Time* magazine's "Man of the Year" for 1962, and reporter Kaiser prefaced his subsequent volume on the first session of the Council with a description of the passion of the pope's painful and prolonged death. John is depicted as charging each of his cardinals, one by one, to bring to fulfillment his "vision" of love and goodwill. His "dying wish" was for a "good outcome" for the Council and "for peace among men." He was "offering his life" for these ends. At his death the entire world mourned, as no pope had ever been mourned before.[7]

The Holland-born American artist Frederick Franck also ends the prologue to his own book on the Council with a conception of Pope John as the contemporary Christ. Franck—a nonbeliever—had been drawn to Rome purely by the force of John's personality and vision. To him John is the "prophet" who has "made all things new." His is "a prophecy of coming human unity in the face of all dire threats," and he extends "both hands across all borders in an irresistible gesture of conciliation," thereby restoring to the Church "her primal radiance." In his book Franck sometimes even addresses his words reverently to John himself, who, he believes, has "made the idea of God once more plausible to millions outside the Church and the Churches."[8] Franck returned to Rome from New York when John died in June 1963 and seems practically to have taken up residence in St. Peter's. He describes Pope John's catafalque standing before Bernini's baldachino, and includes ink drawings of cardinals praying during the Requiem Masses. Then he prints five pages of his favorite "sayings" of John. Remaining faithful to the man who had become his idol, Franck continued to attend the sessions of the Council. He became an accepted interloper, familiar to everyone, the sharp-eyed recorder of personalities and of St. Peter's in its form as a council hall. But it is obvious that after John's death Franck's interest in the Council and confidence in its effect diminished; the final three years occupy less than half the book. Paul was not John.

Paul was not John. According to Novak, "When the new Pope, tall but thin, appeared at the balcony of St. Peter's immediately following the announcement of his election, many in the crowd murmured: " 'Pacelli! Pius XII!' Gone was the heavy, rotund, jocund John. Here was the pensive, reflective, careful Paul." Paul VI is so

defined in all these books: in contrast with John, and in comparison with Pius XII, for whom he had labored in the Vatican for much of his career. He is praised to the extent that he manages, in his different style, to promote what the "liberals" took to be John's intention for the Council. He is feared and mocked to the extent that he seems to be reaffirming the papal prerogatives of the Piuses, and the primacy of Rome. In his first radio address he called the Protestants his "brothers," but said that "they will find in Rome their Father's house"—which was perceived, according to Franck, not so much a renewal of John's words of reconciliation as a revival of the old invitation to "return." Franck, attending the new pope's first audience for the press in a hot, crowded hall of the Vatican, says the pontiff looked "dispirited," and when he found the pages of his prepared speech stuck together, he "angrily threw the paper clip" at Pope John's former secretary.[9] Paul was not John.

At Paul's coronation all the "imperial, royal, and feudal props" of the Church's history were brought out once more for a triumphal show, which was staged in the piazza to accommodate the crowds. Franck tried to rationalize it: "It is far too easy to scoff at all this pomp, this cinematographic panoply of past triumphs," whose only real deficiency is that its symbolism is too exclusively Western—and specifically Roman—for a Church that claims to be universal. Roman robes, "medieval habits, Renaissance armor, Napoleonic tunics" are now joined by "television booths on the Colonnade," and certainly this assemblage of images from all the historic epochs of the Church is "an overpowering demonstration of the perennial vitality of a structure that has known how to survive all catastrophes of history." Yet there is no spirituality in this material display; "it is in ludicrous contradiction to the simplicity of the Gospels." Franck makes no attempt to dissociate Paul from these papal forms, as he had John. He only grants that possibly the "stability" implied by "this historical theatricality" is what will make possible "the overdue reforms and renewals."[10]

But for others, even for some Catholics, getting rid of the material and imperial trappings themselves would be among the essential signs of reform. Whether the pope appears at a ceremony walking on his own feet or being carried in his sedia gestatoria—or how far he rides, and how far he walks—becomes a solemnly interpreted sign of his current attitude toward reform and of his degree of liberation from the Roman Curia. On October 28, 1963, during a ceremony commemorating the election of Pope John, Paul VI "had entered on foot and lifted up his arms in greeting to his brother bishops." Five weeks later there was a ceremony commemorating—of all things—the Council of Trent, and Paul was back in his sedia gestatoria, "in full Roman and triumphalist splendor," blessing the bishops "from aloft." There were other signs. At the ceremony marking the end of the second session the next day, everything from the Swiss Guards to the Roman aristocracy was back in full prominence, and Pope Paul's throne in St. Peter's stood on a platform higher than the altar. His cautious speech—coming as it did a few days after a shocking procedural maneuver "from above" had prevented votes from being taken on religious liberty and on the Church's relation to the Jews—made some begin to think not only of Pius XII but even of Pius IX.[11]

On the other hand, the audience for the Protestant observers held by Paul was at least as gracious as John's. Xavier Rynne had seen a sign of John's genuine ecumeni-

cal spirit in the "precedent-shattering move" whereby he met the Protestants in the Vatican's Hall of the Consistory and sat with them in a square, just as he did with his own cardinals in the same room, the only difference being that now he even used an ordinary chair instead of his throne. As one of the Protestant observers the next year, Brown seems to have been even more pleased by Paul, who received the "separated brethren" in his "private library as friends," shaking the hand of each at the door. He conducted the meeting as an opportunity for dialogue rather than for papal conde-scensions, and ended it by joining the Protestants in the Lord's Prayer instead of giving them his blessing in the usual manner of papal audiences. "This," wrote Brown the Presbyterian, "wiped out any negative impact the grand and ornate buildings had produced." On his journey through the corridors and chambers to reach the library, Brown had been discomfited by the Vatican's accumulated wealth: "tapestries, marble floors and walls, and priceless art treasures." To a fellow ob-server he remarked, "This doesn't look very much like a carpenter's house in Nazareth." The reply—"No, quite an improvement"—put him in his place, he admits. (Congregationalist Horton thought the exchange sharp enough to include in his book, too.) Brown supposed that Catholics had to "grit their teeth" and "toler-ate" this "splendor" as "the price that must be paid for a sense of history and tradition." He clearly thinks it a very high price. Such "flamboyance" as the "amaz-ing carved gold ceilings" and the huge thrones he saw in several rooms along the way obviously contradicts the spirit of being " 'least among all,' 'the servant of the servants of God.' " But he mentions the matter, he says, only in order to emphasize how fully "the person of Paul VI overcame whatever negative feelings" the luxurious surroundings provoked.[12]

Both Brown and Horton, in their books on the second session, are generally more willing than the Catholic lay writers (Novak and Kaiser) to give Paul the benefit of the doubt, although even they found their sympathy strained in the second session by his apparent scuttling of the declaration on religious liberty, one of the docu-ments closest to American hearts. Bishop Tracy, not surprisingly, at all times speaks well of the pope's intentions—and even those of the cardinals of the Curia. In a uniquely American metaphor, Tracy sees Paul as a "halfback," who often seems "to take off in one direction and then unexpectedly reverse[s] his field"; not receiv-ing "a key block when he needs it," he then relies "on his own reflexes," keeping "a remarkable balance, with no trace at any time of panic." Thus, when Paul VI opened the third session with an address acknowledging his newly defined collegial relation to the bishops but more forcefully stressing his own primacy as bishop of Rome, Tracy saw the shift as a necessarily conciliatory gesture toward the defeated opposi-tion whose views he did not really share.[13]

By the time the Council ended, the optimism of these liberals proved to be justified—to some extent. After four years, in spite of the ambiguities and contra-dictions of Paul during the last three, their views largely prevailed over those of the conservative bishops, and actions taken by Paul at critical moments had been instrumental to the final outcome. The bishops had persisted in the exercise of what Pope John had called their "holy liberty" to express their honest opinions, even though to do so seemed an outrageous novelty to many of them.[14] What the conservatives, of course, rightly saw in the bishops' free expression of opinion and

its implicit claim to power, which were in themselves a sufficient threat to Roman primacy, was that the principle might be extended beyond the bishops to priests and nuns and monks, to the laity, and even to the "separated brethren." Where would all this leave Rome in the Roman Catholic church?

Without recalling the old anathemas of Trent that remained in force after four centuries, Bishop Tracy still felt it necessary to reassure his flock in Baton Rouge that "there has been no change in our Catholic position" about Protestants. They "possess only a limited possession of the divine deposit of the Christian faith." Yet he has been "impressed by their attitude, their readiness, in spite of former slights and offenses on our part, to forget past mistakes, theirs as well as ours, and to start out afresh in a new climate of Christlike charity and cooperation." Whether the faithful back home could learn from this statement how to avoid new slights against Christians whose "possession" of the "divine deposit" was so "limited" is unclear. Similarly, the declaration on religious liberty, whose passage was delayed until near the end of the last session, would never have passed at all without explicit reassertion that, whatever *tolerance* of other religions the Church's new position might encourage, there was no *approval* implied, no compromise of the doctrine that "there is only one, true Church." Moreover, although the Church is normally better off without the state, "special relationships" between the Church and a state (forbidding the public exercise of non-Catholic religions and requiring Catholic religious education) might continue to be appropriate "in certain historical circumstances" (the bishops from Spain, Ireland, and Colombia had been heard from). Even Bishop Tracy remarks on these inconsistencies frankly, and on the second, unfavorably.[15]

One American book inspired by Vatican Council II is so alert to such qualifications and contradictions in the final declarations that it must be considered apart from all the others. Instead of being a running account of the hopes and anxieties occasioned by Popes John and Paul through the years of the Council, it provides a critical assessment of the whole after its conclusion. More crucially, it claims that its criteria for judgment are the "traditional American democratic values." In effect, "papal principles" are again to be scrutinized through "American spectacles," whose tint and focus, after all, have not been altered by the tremendous growth of Catholicism in America. Paul Blanshard attended the second and fourth sessions of the Council and diligently studied the records of all. Moreover, he brought to his task the knowledge of a lifetime spent analyzing the history and present character of the Roman Catholic church as a political institution in America, Ireland, Spain, Portugal, and elsewhere. His book, published under the auspices of the Unitarian Universalist Association, concedes nothing to the rosy and "starry-eyed" ecumenism of such a one as Douglas Horton, whose books on the Vatican Council belong among those reports that Blanshard finds notable for "amiable manners and sentimental good will." Blanshard's book serves as an eloquent demonstration of the fact that the old dilemma remains: how to practice the liberal ideal of tolerance when faced with an intolerant and intolerably illiberal institution? Blanshard is exasperated by the fact that "American 'brotherhood' in religious matters is often based on both ignorance and silence concerning vital issues." Liberals, he says, "vie with each other in looking the other way when one religion starts to criticize another,"

preferring fog to war clouds. Blanshard is not anxious to revive the "sterile" and "needlessly bitter" disputes of the past, but he does seek clarity and truth on specific issues of importance to American democratic freedoms.[16]

As far as Blanshard is concerned the Roman church remains, after Vatican II, an "obsolete monarchy." The adulation of the pope is still as abhorrent to American traditions as it had been for Willis, Jarves, Turnbull, and Norton. The coronation of Pope Paul was a "barbarically imperialistic" display. He was still addressed, as the triple-crowned tiara was placed upon his head, not only as the Vicar of Christ on Earth but also as the "Father of Princes and Ruler of Kings." The opening of the second session of the Council was characterized by "medieval and servile elegance." The pope did walk "part way" down the aisle in his "brocaded robe," but did nothing else "to symbolize equality or humility." Nor, contrary to popular impression, had Pope John essentially differed in his pretensions from Paul. His personality may have "made the gaudy papal exhibitionism seem human and natural," but he maintained the "prodigious triumphalism of the Papacy," actually increased "the entourage of his papal court," and did not abate in the least the ritual of obeisances that required tottering old cardinals, bishops, and monks to kiss his ring, his knee, or his foot, according to their rank in the rigid hierarchy. Blanshard satirizes the "genial rotundity" of John's popular image that made him "the world's grandfather, wise and kindly," at a troubled moment in history when a grandfather was needed. But in fact John's writings and actions before the last year of his life show him to have been a narrowly educated peasant devoted exclusively to the interests of the traditional Church. That is why he had been elected pope. His one book was on his hero St. Charles Borromeo, who may have been "humane and efficient," but was "an archenemy of Protestantism and an architect of the reactionary dogmas of the Council of Trent that formalized the antifreedom edicts of the era of confessional absolutism." However, claims the Rome-hating Blanshard, the best thing in John's background may have been "his absence from Rome for almost his entire career." That made possible the startling innovations of attitude and procedure expressed in his encyclicals and in his calling of the Council. But the truth is that the Council unwittingly opened doors much wider, and in other directions, than John had foreseen. Fate left it to Paul, whom Blanshard in an allusion to Emerson calls "The Institutional Man," to save what he could of the Church's fundamental structure and the prerogatives of Rome.[17] According to Blanshard, he saved essentially everything.

Blanshard's paramount values are democratic equality and freedom, and therefore his critique has two thrusts. First, he objects to the internal structure of the Roman church because it is not democratic, as Blanshard believes all institutions should be. Second, he is concerned with the pernicious effect of this autocratic medieval institution upon American democracy. He would like American democratic values to start modifying the Catholic church instead. These concerns may be illustrated by Blanshard's discussion of the declaration on religious liberty, a subject that had not even been on the agenda of the Council proposed by John, but that became one of greatest concern to American bishops, observers, and reporters. Blanshard is shocked by the statements of some bishops that "would have been quite acceptable to Torquemada," but is gratified that the "star of the American

delegation," Cardinal Spellman's theological expert John Courtney Murray, was able to feed his "pedestrian bishops with the right words with which to change some ancient doctrines without admitting that they were being changed. He built verbal bridges to the modern world very effectively, and the American bishops crossed over on them joyously, delighted that they could be good American democrats and Catholic scholars at the same time." When, "after two years of debate about a principle considered elementary and basic in Western society," it appeared that "a majority of the most powerful leaders of the Church" would succeed once more in preventing a vote, "Pope Paul performed one of the few courageous acts of his Council career" by overruling the commission and forcing a vote. Blanshard notes that the pope's "unusual decisiveness" was displayed just before he flew to New York to appear at the United Nations and Yankee Stadium. "It was doubly advisable that he appear there as the representative of a Church that stood for religious liberty." But "it was also supremely ironical" that in the end the progressive bishops, in spite of being in the clear majority, had had to "fall back on the autocratic primacy of Pope Paul to secure a vote."[18]

We have witnessed the effort of Catholic writers to present modern popes as men of humility and peace. We have also seen that Blanshard found the attribute of humility, even in Pope John, less than convincing. About popes as peacemakers he is more ambivalent. He has the highest praise for Pope John's *Pacem in Terris*, which he thinks "probably more important for the future of mankind than anything that happened at the Vatican Council," since the encyclical adopted "liberal" attitudes toward world disarmament, thus placing the Church in opposition to the belligerent anticommunism characteristic of American Catholics. Moreover, it clearly attacked racial injustice and supported the international authority of the United Nations. Paul receives similar praise for the speech he made at the United Nations two years later, in which he also shifted the Church's emphasis from "a negative anti-Communism to a positive commitment to world government." But Blanshard's approval is phrased in terms that indicate his fear of the enormous prestige accruing to the papacy as the result of these efforts for peace. Pope Paul's appearance in New York is seen as "a triumph of showmanship for himself and his Church," which also had the advantage of drawing attention away from the rebellious Council "to himself." Paul is "a shrewd political strategist who possesses a genuine ambition to become the world's peace-maker."[19] Blanshard wants peace, but is sorry to see the papacy gain by it.

The unexceptionable papal efforts for peace, the blessed memory of Pope John, and the euphoric and uncritical notion that Vatican II accomplished a great liberation of the Church and a significant move toward Christian unity—all this makes it difficult for a liberal Protestant American to criticize the Church or the papacy without seeming both ungenerous and cynical. But Blanshard takes the risk. The Church, for him, remains medieval. Papal infallibility was upheld by the Council; the "authoritarian" structure centered in Rome was only slightly modified by the doctrine of collegiality; birth control and divorce are still prohibited; Mariology still "flourishes"; the "medieval pomp of the Vatican" was only "slightly reduced"; and "the vast underworld of Catholic superstition represented by such phenomena as relics, saints, indulgences, and purgatory" remains substantially in place. Blanshard

grants that Vatican II achieved some real reforms, but its favorable reception should not lead Americans to overlook all that it failed to change or even address. The "reasonably temperate religious pluralism" that America now enjoys is preferable to a reunited Christianity that would be characterized by "anti-scientific" thought, "sexual fanaticism," and "exploitation" of non-Christians. It is reasonable to expect "reasonable answers" to questions about superstitions and the subjects of "birth control, divorce, mixed marriage, public education, internal Church censorship, papal dictatorship, and the separation of church and state." In separate chapters Blanshard has analyzed Catholic policy on all these areas where it "differs most sharply from prevailing American policy." Vatican II and "the American way of life" have put each other "on trial." The American nation that owes its concepts of church and state largely to Jefferson must "weigh the philosophy of Rome and balance it realistically against the philosophy of Monticello."[20]

In his absolute opposition of the values of Monticello and Rome, Paul Blanshard naturally seemed to many Catholics to be as guilty of bigotry as he accused them of being. Possibly the two thrusts of his criticism muddle the issue by making him seem intolerant of things that do not concern him. His resistance to Catholic impositions on the society as a whole is so energetic that it becomes an attack on the character of Catholicism as a faith and on the internal structure of the Catholic church. His wish to preserve America's democratic liberties and pluralism, when these seem to him threatened by Catholic power, leads him to attack "irrational" and "unscientific" beliefs and "undemocratic" rules to which other individual Americans have voluntarily submitted themselves. The Church's internal censorship of its own priests may be deplorable, but it is a different issue from the Church's attempt to censor publications and films for the society as a whole. The "un-American" habit of mind that makes internal censorship possible may lead some Catholics to attempt the second kind, but the critic who fails to make the distinction becomes guilty of the very thing he is attacking: insistence on universal conformity to his particular truth.

To the extent that American and Roman values are in conflict, American Catholics themselves face a dilemma more painful than the one that the liberal ideal of tolerance imposes on non-Catholics like Blanshard. For many of them have come to agree that the Church, to which they wish to remain loyal, is indeed intolerably undemocratic in form and medieval in thought. The pain is evident in the garrulous, gossipy book by Father Andrew Greeley, *The Making of the Popes 1978.* It is sufficiently comprehensive in its treatment of the three popes in the years after Vatican II to represent the views of many, and thus bring our consideration of nonfictional depictions of the bishop of Rome to a close. Anticipating the death of Paul VI, Greeley—priest, sociologist, and journalist—made frequent sojourns in Rome between 1975 and 1978 to study the political dynamics of a papal election and ended up witnessing two in the same year. His attempts to predict the results of elections by use of computer models proved laughably invalid. Moreover, although his book was intended to show the defects of the undemocratic method by which a pope is elected in a secret conclave of stupid, ignorant, ambitious, dishonest, and conniving old cardinals, responsible to no one, Greeley is in fact overjoyed by the

surprising results of both elections. The value of Greeley's book thus derives entirely from the fact that it is written in a vulgarly egocentric style that graphically conveys the hopes and despairs of a liberal American Catholic priest in Rome in the 1970s.

Greeley's view of Catholic Rome is more depressing than that of any Protestant. He loves secular Rome, but the Rome of Catholicism is filled with grim-faced nuns and unsmiling churchmen who still wear cassocks. Worse, the Vatican is an oppressive and autocratic power that perverts the true character of the Church. Paul VI had formally instituted the reforms of Vatican II, but many of them had been subverted by the Roman Curia, which the pope was too weak to control. At the same time the pope himself—defying the report of his own progressive papal commission on birth control—had issued the disastrously reactionary encyclical *Humanae Vitae*. This had severely compromised the rapprochement between the church and modern science that Pius XII had begun and had alienated the majority of the American laity, who simply ignored its teachings in practice. Finally, the pope's courageous and historic trips away from Rome to Jerusalem, New York, and India, far from diminishing the importance of the Holy See, had identified the bishop of Rome even more clearly as the "super-bishop," dominating all others with his exercise of worldwide power and influence. Modern transportation and the mass media, especially television, had given him an unchallengeable preeminence. As exploited by Paul VI, the results were depressing from the point of view of a liberal who believed in the collegial relation of the bishops to Rome and in the independence of the local church. Greeley rather desperately argued that Paul's strengthening of "the Renaissance ideal of absolute monarchy" in the Roman church revived a historical aberration. He claims that the original and basic conception of the papacy, going back to Leo I (in the fifth century), was democratic. Whether or not this is so, Greeley found that the "disillusionment with the papacy and the institutional church" among Catholics in the late 1960s was "shattering"; nuns, priests, and laymen left the church by the thousands.[21]

In a new and very different pope lay the only opportunity for a renewal of the euphoric spirit of 1965. The funeral of Paul VI in August 1978 was a relatively "simple" one for a pope, made so by Paul's own request and contrary to the charges that he loved monarchical splendor. Greeley admits that it had "elegance and beauty," with its choreography impeccably executed, but he claims that "the artistic genius of Catholicism" thus displayed "is half a millennium old. It has no counterpart in the church today." Besides, on the fringes of the crowd in the square, people were "talking, laughing, eating ice cream, drinking Coke" during the Mass. Thus the funeral of Paul VI left Greeley utterly depressed. But the surprising election of Cardinal Luciani, who became Pope John Paul I, filled him with hope and joy. After years of enduring the always sorrowful and usually pained expression of Pope Paul on world television, Catholics again had a pope who smiled, as Pope John had smiled, and who exuded a similar natural goodness, little "bambino pope" (as he called himself) that he was. He provided a new "model of what the papacy might be" if it "shed its outmoded monarchistic trappings." Pope John Paul I began with a "coronation" at which he refused to be crowned, to sit on a throne, or to ride in the sedia gestatoria. He eliminated the absurdly anachronistic references to temporal

power in his titles, along with the word *pontificate* and the use of the royal *we*. He quoted one of his favorite authors, Mark Twain, in his homilies, and shockingly referred to the "maternal" love of God. Of course, while thus earning the love of the people he earned also the contempt and resentment of both lay intellectuals and the conservative forces in the Church. But Greeley's hope is that the popularity of his thirty-three-day reign in this new style was enough to make any return to the "Renaissance papacy" impossible. According to Greeley, the "enormous power" the pope might exercise as "the most influential" religious leader in the world depends upon his avoiding the "trappings of papal power," and being instead a smiling, humble, holy man in the style of John Paul I.[22]

Greeley's book ends with the election and "installation" (without monarchical pretensions) of the first non-Italian pope since 1522. Greeley is filled with the hope that Rome's hold on the identity and power of the Church has been broken forever. About the papacy itself he remains ambivalent. His attacks on its monarchical character and on the powers and actions of the Roman Curia, and his belief that the Church ought to be allowed to practice its essentially democratic ideals, are as "American" as anything from Paul Blanshard. But nothing would make Greeley happier than a pope of whom he could be proud, a pope who by virtue of his holiness and humanity exercised more power than anyone else in the world. He seems willing to risk the probability that the prestige thus gained would accrue ultimately to the papacy and to Rome.

Toward an American Pope

The American imagination, if not history, was now ready for the logical progression that might resolve the conflict between American and Catholic values: the election of an American pope. In 1979 Walter F. Murphy, a professor of jurisprudence at Princeton, published *The Vicar of Christ,* a novel in which a former Chief Justice of the Supreme Court of the United States of America rather improbably becomes the Supreme Pontiff of the Holy Roman Catholic Church. How much the terms of the relationship between American and Roman values had changed in the years since Vatican II, however, is illustrated by the difference between this novel and Henry Morton Robinson's popular *The Cardinal,* published in the Holy Year of 1950. Both are concerned with ecclesiastical power, with the historical grandeur of the Church, and with the emergence of America as a world power whose secular, scientific, and democratic values and achievements may either weaken the Church or be made to serve its universal mission.

Robinson's book is structured firmly on a Rome-America axis; there are no detours through Ireland. It opens with its Irish-American hero, Stephen Fermoyle, returning to Boston as a newly ordained priest, after four years of study at the North American College in Rome. It ends with Fermoyle returning from Rome as a cardinal experienced in establishing relations between the Vatican and the White House. At the beginning Stephen has just witnessed the coronation of Benedict XV, and the First World War has begun. At the end Stephen has just participated in the election of Pius XII, and the Second World War is beginning. During the intervening twenty-four years Stephen is periodically in Rome. He goes there to serve as the

archbishop of Boston's conclavist in the election of Pius XI in 1922, but remains as an assistant in the Vatican secretariat until the Holy Year of 1925, when he returns to America as the assistant to the new apostolic delegate to the United States. In 1931, now bishop of "Hartfield," he returns to Rome to report on his diocese to the pope. In an act taken from a famous exploit of New York's future Cardinal Spellman, Stephen secretly carries away Pope Pius XI's encyclical against fascism for transmission to the world press. Throughout the novel Stephen is the ideal mediator between Roman Catholic and American values.

Like any good propagandist, Robinson claims in a prefatory note that *"The Cardinal* is neither propaganda for nor against the Church." But his obvious intention is to show that American and Catholic values are not merely compatible but mutually fructifying. He concedes that priests (popes excepted, at least since Leo XIII) are occasionally guilty of anger, lust, pride, and so on; but the Church itself is beyond criticism. America, naturally, is not; it is not yet Catholic. "At what point might the Catholic Church legitimately draw America's attention to the fact that 'business morality' and a laissez-faire theory of economics were forcing men into practices criminally at variance with divine and natural law?" Stephen asks himself. Unfortunately, Calvin Coolidge and Herbert Hoover were not Leo XIII and Pius XI, whose teachings on the "ideal of a Christian state" could have "done much to prevent" the Crash of 1929 and the Great Depression.[1]

Robinson's plot is contrived so that in the course of the book the purity, rationality, and beneficence of the Catholic position on every controversial issue can be established. Episodes concerning such matters as abortion, birth control, and miraculous cures provide occasions for extended statements on Catholic policy, including direct quotations from papal encyclicals. The opposing arguments are almost never given. It is enough simply to show the opponents themselves to be cold-blooded, neurotic, or dishonest Protestants—usually of old New England descent. The question of religious tolerance is treated by means of an Inter-Faith Convocation that Stephen attends as the representative of the apostolic delegate (whose personal attendance might have implied equality and approval). The Protestant clergymen are all caricatured as self-seeking fools. They spout either "vague agreeabilities" or hell-fire curses, while Monsignor Fermoyle represents calm, steadfast reasonableness itself. Inwardly he is "uncompromising," unable to yield "in the name of tolerance" on any point of the "only true" faith, since "man is powerless to alter the truth of God." But for diplomatic reasons he limits his remarks to the assertion that "tolerance" has a "spiritual origin"; it is "an extension of God's great commandment, 'Love thy neighbor,'—an injunction that all of us, irrespective of creed, are bound to obey." When one of these clergymen later publishes a "bigoted" attack on the candidacy of Alfred E. Smith for the presidency because loyalty to the pope is incompatible with loyalty to the Constitution, it is Stephen who secretly provides the arguments for the rebuttal that enables Smith to establish the perfect harmony of his two loyalties while reaffirming "the ideal of free worship in a democratic State."[2]

If America falls short of Catholic ideals in practice, its basic values are nevertheless virtually identical. Catholicism is the great moral bulwark against two of America's chief enemies—fascism and communism. Even the sexual puritanism of

America's Protestant settlers is now best expressed by its Irish Catholics. At the same time the joy that America finds in worldly things is something that Rome thoroughly understands. At the beginning, Stephen's chastity is contrasted with the Italian ship captain's promiscuous sensuality, but the captain tells him that he will "go far in the Church" because he is "not afraid of worldliness." A Roman education has given him understanding of the world without making him worldly—or Italian. As Stephen rises in the Church his ecclesiastical costume becomes ever more splendid, until at the end he attends an aristocratic party in Rome proudly clothed in his newly tailored robes of watered silk and wearing a diamond-studded pectoral cross. The splendor of the Visible Church is celebrated in *The Cardinal* without embarrassment or apology. "No external sign of pomp and pageantry was lacking," writes Robinson of the coronation of Pius XII at the end. His sedia gestatoria "floats above the throng" instead of bobbing, wobbling, or even undulating, as in other descriptions of papal processions; the flabella are "magnificent ostrich-plumed fans" instead of pompous Egyptian anachronisms; and the pope himself, blessing "the multitude with white-gloved hands" as he hears "Tu es Petrus" being chanted by the Sistine choir, is resplendent in a "cloth-of-gold cape . . . caught at the throat by a jeweled clasp." Of course, the hooded monk who stops the procession three times to burn a tuft of hemp and call out "Sic transit gloria mundi" is not lacking either. A man whose tiara will cause princes to bow before him, and whose words would now be clothed in "a semblance of divinity," must be preeminently a man of proven humility.[3] But the glory of the world that will pass is not therefore to be forgone.

The five popes who appear in *The Cardinal* (the last still living when the book was published) are treated with extreme reverence. They invariably embody the highest wisdom and piety. Although they are shown as being deeply troubled by the state of the world, they are never in doubt about what to do or say in response to it. There is never any ambiguity about their actions, and it is not admitted that they were ever even criticized. They deserve only praise. For this reason the pope in Rome—no matter who he is—serves as the major recurrent point of moral and spiritual reference throughout the book, and Robinson delights to create scenes manifesting the reverence and obedience the Holy Father deserves. He solemnly prolongs the episode of Pius XI's election in order to show him newly attired in his "dazzling white cassock," sitting on a "temporary dais" while all the cardinals perform their first *adoratio*, each kissing his ring, his knee, and his foot. Shortly afterward several pages are given to a summary of the typically burdensome papal day and an analysis of the new pope's character, concluding that "no man could have been higher in personal asceticism, deeper in devotion to his Vicarate, lonelier, more isolated as a human being." When Stephen's old mother makes a pilgrimage to Rome in 1925, she is the six-hundred-thousandth person to kiss the papal ring during that Holy Year, but Pius XI finds an "individual touch" in speaking to her. When he gives her a medal of the Virgin and blesses her, "it was the pinnacle of Celia Fermoyle's life; the gold bar of heaven seemed very near as Stephen led her out of the pontifical chamber."[4]

What Robinson progressively suggests is that eventually all America should kneel before this unassailable moral authority, for America and Rome have a

common historical mission. Receiving the archbishop of Boston on February 22, 1922, Pius XI interprets the coincidence of Washington's Birthday with the Feast of St. Peter's Chair, which commemorates the founding of the Church, as a "good omen." Rome, "the pivot of things," has the universal vision that provincial America lacks. In the first half of the book American Catholics legitimately complain that their country is treated as a "stepchild" of the Church. It makes the largest contribution to the Vatican's material support and is completely devoted to the papacy, yet the Vatican secretary of state, a Sicilian, regards both America and democracy with contempt. There are only two American cardinals, and even they do not get to vote for popes, because they cannot get to Rome in time. Pius XI promises to change all this. His title of "Patriarch of the West" takes on a new significance as he creates two more American cardinals and, in his audiences for American bishops, displays detailed knowledge of, and personal interest in, their dioceses. When six hundred "pious New Englanders"—numerous clergymen from the cardinal on down, the governor of Rhode Island, assorted mayors, and many rich businessmen and professionals—arrive together on a Holy Year pilgrimage, the pope grants them the "rarest of honors" by giving them "Holy Communion with his own hands." Afterward he praises them for their "stanch piety" and hails them "as the largest, most loyal, and certainly the most generous band of New World Catholics ever to visit Rome."[5]

The "regeneration" of the New World, to make it the willing servant of Rome, is at the heart of Stephen's own purpose in life. In 1922 his old teacher, who is becoming the apostolic delegate to the United States, tells him that "American energy, instructed and guided by Rome, may well be the decisive factor in the difficult years ahead." Pope Pius XI is shown surveying the heavy burden of the world that he has received along with the triple crown: Europe has fallen into an "abyss" in postwar exhaustion, in the Soviet North "torches of Antichrist were being lighted," and on his own doorstep in Rome "a black-shirted demagogue was bellowing." The Vatican itself is impoverished, and he, the pope, is a prisoner in it. In all the world there is but one "gleam of hope" on the horizon: "America! The western star, ruddy with faith, was rising in the heavens." The first basis for noncontroversial union between Rome and America is, of course, the cause of peace. In the war-threatened world of *The Cardinal*'s opening pages, Pope Benedict XV is presented as the unheard "voice whose only plea is *Pax.*" But in 1938, with war apparently imminent again, Pius XI's voice may be joined with that of Franklin D. Roosevelt, the only secular leader who comes as near to being idolized as the pope. Stephen secretly confers with the president to effect a "closer *rapprochement* between Vatican and White House." The hope is that "through the President's appointment of a personal representative to the Vatican," Rome and America will be able to make "parallel endeavors for peace." The "President and the Supreme Pontiff hold in common" a great purpose: "the avoidance of war, if humanly possible." As the war begins, in spite of their efforts, Pius XI dies and the "diplomatic genius" Eugenio Pacelli becomes pope. As Pius XI's secretary of state, Pacelli had appeared to Stephen as "an El Greco version of Abraham Lincoln," and his "curiosity concerning American affairs" was insatiable. Stephen sails back to America in a ship that conveniently furnishes, for table company, pompous English aristo-

crats, a skeptical French novelist, a Nazi German professor, and a Stalinist Russian general. After they have proposed toasts to their various heroes, the Frenchman asks why Cardinal Fermoyle offers no toast to His Holiness Pius XII. "I didn't want to appear *arriviste*," he replies. Proudly donning his *ferraiolino*, "the great cape worn by Peter's admirals," he goes out onto the deck. Looking through the dark toward the western stars and the New World, the emissary from Rome to America has a vision of humanity's redemption and of universal union in Christian peace—"in God's time," in "some future age."[6] The mission of postwar America, now unsurpassed in secular power and prestige, converges with the spiritual mission of the universal Church.

By the end of *The Cardinal*, Stephen is being mentioned as likely to become the "first American pope."[7] It was left for Walter F. Murphy, however, to imagine this personage, and he imagined him as a very different man from Stephen Fermoyle. *The Vicar of Christ* is as representative of the questioning post–Vatican II period as *The Cardinal* is of the piously conservative decade following World War II. Adulation of Pius XII, and of his longest-reigning successor, Paul VI, is replaced by the severest criticism of both. But fascination with the *idea* of the papacy is greater than ever. Given its uniqueness as an institution in form and in potential influence, and given the enormous publicity the papacy has enjoyed since the end of World War II—thanks to the frequent mass audiences of Pius XII, the popularity of John XXIII and his Vatican Council, the four papal elections, the worldwide travels of Paul VI—speculation about how the papacy *might* be used by a sufficiently bold man is irresistible.

Murphy's novel, however, is no simple imaginative resolution of the historic opposition between American and Catholic values. Nor does it simply reverse Robinson's implicit question—how will Rome reform America?—by asking how America might reform Rome. Murphy's book is more complex and sophisticated than that. For one thing, his American pope is realized as an individual who from the beginning of his reign adopts positions that do not simply reflect the consensus views of liberal Catholics and Protestant critics, as Robinson unequivocally adopted those of the conservative Catholics of his day. Second, Murphy's pope is radically changed by the experience of his office; thus the comforting sense of a single pope's constancy of vision, and of its consistency with the vision of his predecessors, is denied. And last, the nearly four hundred pages covering the papacy of the American pope (about two-thirds of the novel) are narrated by an aged Italian cardinal, who is worldly-wise, ironical, familiar with America, and a personal friend of the new pope (for whose election he is responsible). Yet he himself came of age in the reactionary Church of Pope (now Saint) Pius X, and he has a deep understanding of the practical value of the historic usages of the Church, including those of the Roman Curia. Although his sympathies are with the new pope, he acknowledges the devout faith of the intransigent conservatives, who are not merely to be castigated. Thus the self-righteous anger and simplistic answers of Andrew Greeley, whose book *The Making of the Popes* appeared in the same year, represent in Murphy's novel merely one dimension of a many-sided Catholicism. Ironically, an insider's view of political chicane and conflict in the Curia is more informatively and convincingly presented by Murphy's fiction than by Greeley's reportage.

The reputation of Pius XII is almost completely demolished. Robinson's "diplomatic genius" is now seen as someone who compromised the Church's integrity through alliances with fascist or military regimes in Spain, Italy, Germany, and Latin America, and whose acceptance of democracy was finally forced only by the victory of the Allies in World War II. Even more damning was his silence concerning the Nazi extermination of Jews. This was a virtually unknown issue as late as 1962, when the former Rome bureau chief of *Time*, Robert Neville, published his *The World of the Vatican* to prepare readers for the coming Vatican Council. Neville's chapter on the life of the late Pius XII refers impartially to some of the more controversial aspects of Pacelli's pontificate, most notably his extreme devotion to Mary (of whom he had visions in the Vatican gardens). But his performance in relation to Mussolini and Hitler (though perhaps not Franco) seems unexceptionable and even courageous. During the course of the Vatican Council, Rolf Hochhuth's drama *The Deputy*, which portrays Pius XII as a coward who knowingly remained silent about "the final solution" in order to protect the interests of his Church, was published and performed. Almost all books on the Vatican Council refer to the controversy that followed, which affected the Council's debate on a declaration concerning the Church's relation to the Jews, a declaration particularly desired by the American bishops. In Walter Murphy's *The Vicar of Christ* the new American pope condemns Pius unequivocally. When he is asked by a reporter from *L'Osservatore Romano*, the Vatican's own newspaper, whether progress is being made toward "the canonization of Pope Pius XII, of blessed memory," his reply is that "as long as we are Pope, Pacelli's canonization would be a true miracle. . . . It will take the Church another century, at least, to live down his silence over the fate of the Jews during World War II." Pius, he says, had rewritten Scripture to read " 'Greater prudence has no man than that he save his own skin by letting six million burn.' " Even "if we can understand Pacelli's refusal to risk his own life, we need not canonize him and elevate cowardice or stupidity to the status of virtues."[8]

The issue so disturbed Murphy that in a later novel, *The Roman Enigma* (1981), he went out of his way to include a scene dramatizing the pitiful anguish of the German-loving Pius XII. It shows the pope weepily complaining that the Nazis, now occupiers of Rome, have dared to persecute Jews "within sight of our own window," so that "we can no longer pretend that the evil is not real." While the pope moans in evasive self-pity, Monsignore LaTorre repeatedly assures him that the Vatican's own reports make it certain that the Roman Jews now herded together in an edifice near the Vatican are about to be deported to death camps and that the pope's delay will seal their fate. Pius asks LaTorre exactly what he should do "in this moment of our torture." The reply is blunt: "Speak out, Holiness, speak out. Condemn before the world this brutal act." But Pius says that this would be "self-indulgence" on his part; "patience and prayerful expectation" would be holier and wiser. He claims that his silence is "the product of fear" not for himself but "for the Church." Soviet communism is a worse threat than Nazism. "Because we understand the greater evil, bolshevism, we tolerate the lesser evil, Nazism." He prays that the deaths of the Jews will serve the "worthwhile end" of "stopping communism." When LaTorre, profoundly shocked by this confession of impotence from someone on the throne of Peter, urges him to risk sacrificing himself, just as he constantly preaches

sacrifice to others "as essential to salvation," Pius finally reminds him that it was he, not LaTorre, who was elected pope. And he chooses to confine himself to "prayer" and "quiet, patient, tireless diplomatic negotiation" as the means of meeting the present crisis. LaTorre is left convinced that "he is a true diplomat; he does nothing, he risks nothing, except the lives of others and his own immortal soul."[9] Much of the interest of *The Vicar of Christ* lies in imagining how powerful a modern pope might be if he had LaTorre's faith in the moral power of the papacy and if he did not mistake timidity for prudence, like Pius XII.

Criticism of Paul VI was more to be expected, since it had come severely enough from many Catholics while he still lived. In *The Vicar of Christ* Paul is recalled as "the Pope of Agony," whose failures of will, according to the old churchman-narrator, both made his own life miserable and "left him with thousands, perhaps millions, of lost souls for whom to answer to God." Vacillating and indecisive, he reigned over the turbulent and divided church that came after Vatican II: "Bishops denouncing the Pontiff, priests denouncing their bishops, theologies of liberation and revolution, and supposedly charismatic babbling in tongues." Under Paul there was "a trend toward official indecision, interrupted by foolish pronouncements such as *Humanae Vitae*, condemning birth control." Paul was politically on the Left and theologically on the Right. Thus the virtues of an essentially socialist encyclical *Populorum Progressio* were more than canceled out by the reactionary repressiveness of *Humanae Vitae*, the point of which was immediately understood and rejected by millions of Catholics. The Italian "Manichean" view of sex is to blame for Paul's error. The Irish attitude is "consistently of an unhealthy puritanical sort," whereas the Italians regard sex both in an "earthy" and "candid" manner but also "associate it with sin and spiritual death." Most Catholic clergy, including the pope, "recoil" from sex in horror. The reign of Paul VI has nearly driven the narrator, Cardinal Galeotti, to despair for the Church.[10]

The cardinal's pessimism is countered in this conversation by the critical optimism of the Chief Justice of the Supreme Court of the United States, Patrick Declan Walsh, who says that "the resentment, the restlessness, and the discord" that John XXIII unwittingly helped to create in the Church beneficially destroyed the "dumb acceptance of ideas" that characterized Catholics under Pius XII. The fact that the people immediately rejected Pope Paul's "logically and morally indefensible argument about birth control" testifies to their "intelligent faith." The people are yearning for a religious leader who will "conquer" through an aggressively loving relation to the real world rather than "whining in self-pity" like Paul. "Perhaps from the next Pope," he says; "Papa Paolo can't live forever, although it might seem that long."[11] Obviously other Catholics besides Father Greeley were waiting impatiently for Pope Paul to pass on to his reward—whatever it might be.

Years later Cardinal Galeotti is sitting unhappily in a deadlocked conclave trying to choose the successor to Pope John Paul II (who, having just been elected in 1978, is mercilessly killed off in an airplane crash for Murphy's fictional convenience). Walsh's remarks about papal leadership are among the seeds that now germinate into Galeotti's daring proposal of Walsh for the papacy. Walsh, in the meantime, has retired from the Court and become a Trappist monk, following the death of his alcoholic and childless wife in an automobile accident, a death he guiltily associates

with his adulterous affair with Elena Falconi, his administrative assistant at the Supreme Court. The conclave of cardinals is even more anxious to find a pope than Murphy is to confine himself to probabilities, so Patrick Declan Walsh—Korean War hero (and killer), former Chief Justice (and adulterer), and guilt-ridden Trappist monk—becomes the first American pope, Francesco I.

Initially this development appeals as an attempt to show how an American Pope—a modern man with personal experience of war and an awareness of the ambiguities of justice and politics, a guilt-ridden sinner rather than a lifelong celibate, and a liberally educated intellectual rather than the narrowly clerical product of a Catholic seminary—might exploit the powerful and unique possibilities of the papacy. Some differences simply of style and personal preference are occasions for both amusement and worry. Walsh hires an American journalist as his press secretary, an American Jewish friend as his legal consultant, and (most improbably) Elena Falconi as his administrative assistant. He starts holding regular press conferences, in spite of Galeotti's warnings that he cannot "paint this palazzo white and plant a green lawn around it," and that he will destroy the "mystique" of the papacy by appearing thus as a "mere mortal." A pope's power, Galeotti believes, partly derives from the "awe" that the mystery about him has always inspired, as well as from the "reverence we truly feel for the one who must walk in the path of the Big Fisherman and also that of Christ." But Walsh, "as an American, . . . distrusted awe." The triviality of the reporters' questions, more than Galeotti's objections, soon diminishes Walsh's interest in these conferences. The reporter from *L'Osservatore Romano* wants to know if Walsh will, "like your predecessors of sainted memory," offer any new indulgences to the faithful? The answer is no. His Holiness has plans neither for "indulgences to provide spiritual sustenance nor for burning Protestants at the stake for temporal amusement." The reporter from *Time* asks what clothes the pope wears in private, and what kind of tennis balls he uses.[12] In the meantime the pope has already taken actions that have profoundly altered the relation of the Vicar of Christ to the world.

Late in the book Cardinal Galeotti offers two summary statements, one a list of Papa Francesco's own criticisms of the Church as he found it, the other of the major actions he had taken up to that point to change it while looking toward a long papacy to change much more. In the first Francesco said, "I see many senseless things in the Church—anti-Semitism, sexism, national chauvinism, bureaucratic arrogance, all mixed with medieval notions about man's duty to punish his fellow sinner." That the Church might have defects so damning is not even hinted at by Robinson's *The Cardinal* of less than thirty years before. The "dramatic things, deeply holy things" that Francesco has done in his first few months are cited by Galeotti to comfort the impatient new pope:

"Against the advice of most of us in the Curia, you are going into the world preaching social justice and selling some of the Vatican's treasure to finance that justice. You are trying to bring peace; you've stopped the bombardment of a city by risking your own life; you've gotten down on your knees to secular rulers to give peace and justice to their people. You're traveling to Latin America to encourage bishops to

return to a simple life, so that all men can find the kingdom of God within themselves. These are exciting actions, and they have captured the imagination of the world."

Moreover, Papa Pio, Papa Giovanni, and Papa Paolo did none of these things, says Galeotti. His criticism is directed primarily at Pope Paul, since many of the episodes—the trip to Israel, the speech at the United Nations with a subsequent appearance in a stadium—are obvious adaptations from Paul's spectacular papal innovations. What is different is the character of the performance. Paul's actions were rendered ineffective and merely symbolic by what Galeotti calls his introverted and "parochially Italian" manner, whereas Francesco's behavior is operatically grand, genuinely courageous, and irresistibly challenging. This American pope flies to Tel Aviv not according to a carefully arranged itinerary but while the city is being bombed, gambling that the Arabs will not dare to kill a pope. This pope *literally* kneels before the assembled ambassadors of the United Nations, gives them the papal blessing whether they want it or not, and makes specific proposals that they match his own massive and widely publicized efforts on behalf of the poor, chiefly the beginning of a "crusade" of young people, explicitly modeled on the American Peace Corps. He has anticipated his preaching with sacrificial actions— including the sale of treasures from the Vatican Museums, an act that itself has scandalized many people, both inside and outside the Church. He has given red hats to the radical Latin American bishops who gave away church property to the peasants, and he has removed from power those who were collaborators with the military regimes. He has forced reform in Spain by threatening to place the entire country under a papal interdict; when the Spanish ambassador suggested that the action was "medieval," the pope proudly quoted Innocent III—his thirteenth-century predecessor—as precisely the authority for his action.[13]

Such proof of papal power coming from the daring use of it naturally frightens all political factions of the Church because it enormously raises the pope's own status, to the relative diminishment both of the conciliar power of bishops and of the bureaucratic power of the Roman Curia. The Church's institutional stability is threatened at all levels. Early in his reign the new pope makes gestures of listening and consulting, but in fact he increasingly makes all decisions himself and presents them for approval. The absolutist interpretation of his role is suggested as early as his coronation. The triple crown—symbolizing power over the Church, over nations, and in heaven itself—which Pope John Paul I had refused, is brought back, although now it is made of plain iron. Walsh realizes the ambivalence toward the pope that we have seen in Greeley and in commentators on Vatican II: exercise of autocratic power is welcomed when it effects reforms in other areas of the Church. At the same time the traditionalists are made happy by the sight of the ostrich-feather fans and the sedia gestatoria, and they are willing to accept a shepherd's crook as a replacement for the jeweled crozier. Also, the new pope's preference for the "simplicity" of a "makeshift altar" in front of St. Peter's, instead of the magnificence of the interior, is more than compensated for by "the adulation of a quarter of a million people" that the outdoor ceremony makes possible. And at his insis-

tence—not that of the Curia—the ancient ritual of homage to the pope is revived. The kneeling and ring kissing is a "useful reminder" to the Curial cardinals "where ultimate power rested."[14]

An American pope is thus not a democratizer of the Church. He is instead a ruthless Emersonian individualist who boldly exploits the power of his position to fulfill the Church's divinely ordained ethical and redemptive missions. About these he becomes increasingly idealistic, visionary, and uncompromising. Cardinal Galeotti fearfully observes the transformation of a "good man to a holy man." The Trappist abbot to whom Walsh had turned in guilt and despair after his wife's death has become the director of the pope's great crusade against poverty. But when the abbot is discovered to be a homosexual, the pope banishes him without hesitation or pity. To all of his closest friends he begins to "pontificate" whenever he speaks, and uses the royal *we* as habitually as any pope. His greatest need is now for general audiences—not weekly but daily—in St. Peter's Square, where he receives the adoration of the masses. Eventually he surpasses even Paul VI in "translating the Church into the province of one man." And, ironically, like Paul VI, about whose position on sexual morality he had been so scornful, he finds sexual issues to be the most painfully unresolvable. Constantly postponing statements on birth control, celibacy for priests, and ordination for women, he tells the demonstrating Catholic dissidents that these "are not fundamental problems." He promises only to consider such matters after the "revitalization" of the Church is well established. The anguished dissidents must patiently wait—or burn themselves to death in St. Peter's Square in protest.[15]

What Francesco I is discovering as pope is the transcendent nature of his own divine mission, measured against which all issues must take their relative positions, not those that he himself had given them as a layman. This discovery leads him also into heresy, from the point of view of many in the Curia, for he now comes to question (along with many modern biblical scholars) whether Christ himself had originally realized his own divinity. In his process of self-discovery Francesco begins increasingly to identify himself with the Christ whose Vicar he is. He is profoundly affected by the miraculous cures claimed by certain people caught up in the religious hysteria of the crowds that now assemble to see and touch him. At first deeply disturbed, embarrassed, and skeptical, he comes to regard them with wonder. And they are part of the saintly aura that surrounds him when he begins to preach to the world the most crucial of all his messages—that of peace.

Murphy here takes that long-developing aspect of the papal image to its logical conclusion. Francesco I becomes an absolute pacifist, in imitation of Christ. This pope's message cannot be dismissed as the pious posturing of a feeble and possibly hypocritical bishop of Rome. He is preempting his Marine Corp's old motto, "Follow me," for the service of Christ, whose words they originally were. He begins to write an encyclical forbidding Catholics to take up arms under any circumstances. Moreover, this encyclical will be issued from Jerusalem, to which the Holy See will be transferred. The Roman Curia will be abolished, and the Vatican's treasury will be sold, its grounds and buildings given to the people of Rome. The perversion of Christianity, Francesco I concludes, began in its identity with Rome. The "spiritual values of the Gospels" require the renunciation of the "material values that both

ancient and modern Rome signify." The pope cannot "live like a Roman emperor while asking the people of God to take up the cross." That the Church made a fatal error in locating itself in Rome, the exact "American" opinion argued by the Unitarian William Ware in *Probus* over a century earlier, now issues from the mouth of an American pope. Originally the pope had chosen the name Francesco to signify a union of the pacific values of St. Francis of Assisi with the militancy of St. Francis Xavier. Now Cardinal Galeotti sees that his American pope is really the union of two Johns: St. John the Baptist and St. John of the Apocalypse. And he has become like Savonarola, the hero of Harriet Beecher Stowe and James Jackson Jarves.[16] Certainly in his divorcement from Rome and his embrace of poverty, this pope goes far beyond what the Americans, in all their criticisms of the historical popes, using almost the same words, had ever imagined possible. He is widely thought to have gone mad.

Near the end of the novel, Pope Francesco I returns to America. In appearances at Princeton and the Catholic University he stridently harangues his audiences, calling upon them to repent, to abandon their militarism and materialism. America, he says, must "reorder" its "entire system of values." What he gets is another "miracle"—a blind veteran of Vietnam who, when Papa Francesco touches him, cries out that he can see. The pope helicopters away to his state visit at the White House. There, by suggesting that his government-terrifying pacifist encyclical is imminent, but could be delayed a while if the United States vastly increased its contributions to the hungry of the world, he effectively extorts another hundred million out of the president.[17] Then he returns to Rome to attack the pornography that is disgracing the so-called Holy City; that night several kiosks and delivery trucks are burned. Members of the Curia start meeting secretly to plan a trial of the pope for heresy. When the pope hears of this, he simply removes them all from power and their red hats from their heads.

Papa Francesco I is assassinated while riding in the sedia gestatoria through a worshiping crowd in Piazza San Pietro. The murderer is a black American, a hired gunman who is himself immediately killed. Who hired him is never discovered; there were after all too many powers interested in this pope's demise. The funeral of the first American pope makes an appropriate ending to our story. It is a strangely Roman-American ceremony. There are two honor guards: the Swiss, in their Renaissance regalia and "a platoon of blue and scarlet-uniformed United States Marines." The old cardinals, dressed in their heavy capes, try to march to the music of the Marine Band, which is playing "The Battle Hymn of the Republic." The choir and the vast crowd in the square join in singing the words of Julia Ward Howe, whose New England knees had refused to bend in idolatry before the pope of her day: "Mine eyes have seen the glory of the coming of the Lord. . . . Glory, Glory, Hallelujah, His truth is marching on."

In this apparently incongruous and certainly ironic scene Murphy would seem to suggest that perhaps "His truth" is indeed "one truth," and not simply one of oppositions. The tint and focus of the spectacles through which many American Catholics view the Roman church need not differ substantially from those of other Americans. The bases for intolerance on either side are few. The fundamental Christian values of Rome, however obscured, are the same as those of America.

When they are used to measure the actions and character of either place, however, they produce similar devastating judgments, for in worldly and pragmatic values Rome and America are also at one.

But the American vision of Catholic Rome was never merely a matter of conflict of values that could be resolved by redefinition or reform. The pope existed, and the pope exists, a real person and a real power. Whoever he might be, he remains Catholic Rome's strangest sight and most divisive figure. The conflicting values inherent in his position, some of which have been irrevocably defined and established by Pius IX and his successors, would seem to be just as unresolvable as Murphy (joining a rather long tradition) suggests that true Christian values are irreconcilable with the reality of either Rome or America. Yet for more writers than ever, the old fanatical hatred on the one side and the old uncritical piety on the other—both typically elicited by Pio Nono—have been partially replaced by a historical perspective on the papacy, characterized by a skeptical respect.

2

The Sidelong Glance:
Victorian Americans
and Baroque Rome

In his *Italian Sketch Book* Henry T. Tuckerman excused himself from describing the interior of St. Peter's Cathedral on the grounds that the Boston Athenaeum's recent purchase of Panini's "unrivalled painting" of that church (fig. 4) made such an effort unnecessary.[1] This pleasant assumption, that the curious and worthy who could not go to Rome would surely find their way to the Boston Athenaeum, was not shared by other American writers in the nineteenth century. From James Sloan on his "rambles" in 1816 to William Dean Howells on his Roman holiday of 1908, these travelers wrote many long pages on the chief temple of Catholicism and their reactions to it. Hawthorne and James and some lesser writers of fiction arranged their plots to include a scene at St. Peter's that was almost as obligatory as an episode in the Colosseum.

If the ambiguously baroque St. Peter's—to which we shall return at the end of this chapter—was never omitted from the Victorian vision of Rome, nearly all other Roman baroque monuments of Christian architecture and sculpture were. In the individual and collective representation of Rome by Victorian travelers, one great area remains blank or is badly besmeared: that Rome created from the late sixteenth to the early eighteenth centuries, from Michelangelo's design for the Piazza del Campidoglio down to the Spanish Steps completed in 1726 and the Trevi Fountain begun in 1732—the sculpture and architecture that in fact still dominate the city.

Attempts by Americans in journals, letters, essays, and fiction to ignore or belittle so assertive and omnipresent an art as the baroque are both amusing and instructive. In the records of their experience, baroque Rome is clearly an enlivening irritant that allows them to exercise a talent for invective that complements their rhetorical effusions on classical art. More than others, Hawthorne and James in their less formal writing (journals, letters, sketches) allowed themselves the latitude of genius in spontaneous, unorthodox appreciation of the baroque, but when they shaped their tales for popular consumption—even the great fictions of *The Marble Faun, Roderick Hudson, Daisy Miller,* and *The Portrait of a Lady*—

they fell back on the images of Rome that could be relied upon for conventional responses. With the exception of St. Peter's, the Rome of Hawthorne and James is that of romantic classicism and medievalism. In *The Marble Faun*, Hawthorne willfully misrepresents as medieval what in his journal he knew to be modern; with the habits of a lifetime and for the purposes of his romance, he exercises a gothic imagination upon a baroque city. This tension between the usable, romantic Rome and the actual Rome is commonly omitted from sentimentalizing accounts of the importance of Italy to nineteenth-century American culture. That most of the writers and artists who went to Rome did love it as much as they professed, we need not doubt (although there were exceptions), but the Rome they loved was, even more than has been realized, "no Rome of reality," but an imaginary place, a Rome of the mind.[2] It was—what would seem today to be almost unimaginable—a Rome without the baroque.

"The Lowest Stage of Degeneracy": Borromini and Bernini

From a house in the Piazza di Spagna in the very heart of baroque Rome, Charles Eliot Norton wrote to James Russell Lowell in 1857: "I love Rome more and more, and it becomes more and more a part of myself. There is . . . no city where nature holds her rights so firmly and asserts them so clearly, spite of Berninis and Borrominis, of priests and forestieri." A letter written to Lowell a year earlier reveals that Norton's paradoxical position was the same one he had arrived with: Bernini and Borromini were said to be "the exponents of Roman taste and Roman feeling since Michelangelo died. It is worse now than ever." "As for the priests, the princes and the churches—they are all alike, untouched by the sacred genius of the place."[3]

Norton's assumption that he (although one of the despised forestieri himself) could define the true genius of Rome by eliminating the Romans and all their works of the preceding three hundred years was not at all singular. Whereas the index to a modern guidebook to Rome typically contains more entries under "Bernini" than under any other name, in the nineteenth century, references to his works were few and usually insulting, and Borromini was rarely mentioned at all. As on so many occasions before, the standard of received opinion is also conveniently registered for us on this subject by George Stillman Hillard, who visited Rome in 1847. Having come to pay respects to the font of the legal profession, he was dismayed to find it bedecked in baroque frivolities. The topographical chaos of modern Rome was appalling, and Hillard seems to have spent the next six years rearranging it all in his mind. The result was a carefully organized and highly dogmatic two-volume work, *Six Months in Italy*, which Oliver Wendell Holmes praised for the "sound American thought" that gave it "manly substance." Over the next forty years Hillard's opinions held sway, as his work went through twenty-one editions. Hillard puts everything in Rome in its proper place, frankly warning the prospective visitor that all the engravings are misleading, that the actual Rome is highly disagreeable, and that one must wait for the "Rome of the mind" to assemble itself.[4]

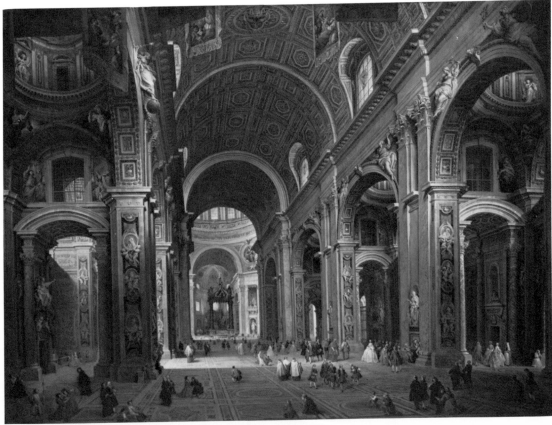

Fig. 4. Giovanni Paolo Panini. *Interior of Saint Peter's, Rome.* Oil on
canvas. 1756. 164.3 × 223.5 cm. Boston Athenaeum.

Hillard found that constructing the ideal Rome required the suppression of an
architect named Borromini:

> In the middle of the seventeenth century architecture had reached its lowest stage
> of degeneracy, under the corrupting influence of Borromini, a man of inventive
> power, but of wayward and fantastic taste—whose fancy ran riot on frivolous de-
> tails and grotesque embellishments—who had an antipathy to right angles and
> straight lines, and delighted in curves, twists, and spirals. . . . It would have been
> well if architecture could have stopped in the middle of the sixteenth century.

What was inevitable in history could nonetheless be blurred in the record: Hillard
does not specify even one of Borromini's works by name. Although, a masterpiece of
Borromini, San Carlo alle Quattro Fontane (fig. 5) is located at the intersection of
two much frequented streets, just steps away from what was for many years the site
of the American consulate, only one out of scores of American descriptions of Rome
mentions the church, and then merely to record the curious fact that it covers an
area no larger than that occupied by one of the piers supporting St. Peter's dome.

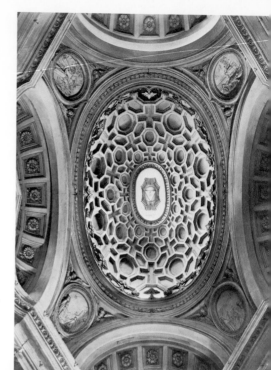

Fig. 5. Francesco Borromini.
Interior of cupola. San Carlo
alle Quattro Fontane, Rome.
1640. Photo: Alinari/Art
Resource, New York.

Fig. 6. Francesco Borromini. Interior of cupola. Capella di Sant' Ivo alla
Sapienza, Rome. 1642–60. Photo: Alinari/Art Resource, New York.

There also seems to be only one American reference to Borromini's other master-piece, Sant' Ivo alla Sapienza (fig. 6). The novelist Francis Marion Crawford, himself born in Italy and a Catholic convert, says it is "as bad a piece of Barocco as is to be found in Rome."[5] The few other references to Borromini scattered in various writings of American authors are uniformly contemptuous. One can assume that his buildings were seldom entered, at least not knowingly or with interest. At mid-century Murray's *Handbook for Travelers* did not even include San Carlo in its long list of churches that were "in any way remarkable." And although for many decades Americans tramped up the great stairs of the Palazzo Barberini to the social gatherings of the William Wetmore Storys, no one ever mentioned that both Borromini and Bernini helped design that familiar place.

Bernini, the master artist of baroque Rome, presented the Victorians with their most puzzling problems. Although many of his major productions were simply ignored, at times a work was not only unavoidable but undeniably gave pleasure. In such cases American writers usually failed to mention Bernini's name, thus avoiding the difficulty of reconciling their experience with their preconceptions. For example, the universally admired Colonnades of the Piazza San Pietro (fig. 14) were often presented as miraculous creations and only sometimes grudgingly attributed to Bernini; James Russell Lowell even wrote that Bramante was their architect. The single notable exception to these evasions is fifty-one-year-old Rembrandt Peale's describing with an artist's delight how he played all the possible games of perspective with the Colonnades and expressing his indebtedness to "the sculptor Bernini" for "the pleasure of this sumptuous array."[6] Another strategy Americans used in writing about a work by Bernini was to admit its existence, describe it, and then in effect deface it with vituperation; and, finally, they sometimes frankly confessed to rare, illegitimate pleasures. These last two devices, by which the baroque manages to enter into the picture of Rome as itself, we shall explore at greater length.

Although the extent of the Victorians' distaste for the baroque in general and Bernini in particular seems excessive today, many factors came together in varying combinations to produce a context in which it would have been difficult for them to react otherwise. Outlining those factors briefly before giving an exposition of the effects from which they can be inferred should, therefore, prove useful. Few of these factors are distinctively American other than in emphasis, but here, as elsewhere, we are concerned with their American formulation.

Throughout the nineteenth century—even outlasting the revival of the Gothic and reemerging in new form with the Renaissance revival at the end of the century—neoclassical standards of taste were persistent and almost absolute. Consequently, Americans resented the effort required to see around or through whatever displaced or enveloped or invaded the classical world of their dreams. Any interference would have been so resented, but the opacity and expansiveness of baroque style made the effort to render it transparent and trivial particularly irksome. Further, a belief in the cyclical nature of cultural change (which often strangely coexisted with the contradictory belief in perpetual social and moral progress) also doomed the baroque, for that view held that a period of decadence necessarily follows a high point like the Renaissance. When Ruskin and his American partner Norton found that the Renaissance itself marked a decline from the Gothic pinnacle

of the Middle Ages, the baroque, perceived as the end point of a downward plunge into worldliness, fell into even greater disfavor. And when the cultural cycle assumed was so enormous that its apex had been reached in antiquity, then all movements following the fall of the Empire had to be denigrated. Thus Theodore Dwight, viewing the Campidoglio from the Forum in 1821, read the entire scene as emblematic: it rose from the "manly taste" of the "early kings," to a "triumph" in the "graceful Corinthian" of the Augustan Age, and then fell into "degradation" with "the doting childishness of the modern Capitol" designed by Michelangelo.[7]

Other considerations affecting the disdain with which Americans approached the baroque arose from their moral and religious values. The belief that social morality and great art are necessarily related—a belief that to some extent underlay both neoclassicism and the Gothic revival—was challenged by an art the patrons of which were wicked popes and worldly princes. Baroque art was recognized and rejected as the dangerously declamatory and self-celebratory instrument of the Counter-Reformation, of a living Catholic church despised for both political and religious reasons. Moreover, an inherited puritan disposition to tolerate art only in its most sober, spiritual, and humorless forms was repelled by the sensuality and fantasy of baroque design, abundantly evident in civic and secular works but invading even churches with its exuberant physicality.

American worship of Nature further encouraged devaluation of an artificially created urban world. The baroque in Rome is a celebration of the manmade environment, the city: of the relation of shadowed or sunlit façades to streets, of ensembles of buildings around obelisks and fountains, of manipulated perspectives from gateways and stairways and terraces across the rise and fall of streets following the topography of hills and river, of large shaped spaces of all kinds, exterior and interior. But to William Dean Howells seeing it in 1863, "modern Rome appeared, first and last, hideous." As we have seen, one of his "vividest recollections of Rome" was of his walk in the Campagna, because it reminded him of Ohio. To Charles Dudley Warner "the best part of Rome" was also "the country," and Francis Parkman said that he would give all Rome's monuments and churches "for one ride on horseback among the Apennines."[8] The Apennines, of course, could be equaled by the Adirondacks; but Americans were aware that nothing to rival modern Rome in architecture and art had been achieved in two centuries by the children of the Puritans who had fled into a wilderness to escape Romish influences. While those ancestors had been knocking together meetinghouses on the shores of America, the Antichrist and his artists had been ornamenting the Whore of Babylon. Until the Capitol dome was finally finished in Washington, the Americans seem to have felt that they had nothing to show for themselves but the Bunker Hill Monument. An easy way to triumph was to oppose an all-sufficient Nature to a denigrated accomplishment in Art.

Finally, through most of the century American visitors to Rome had no word to categorize that accomplishment except *decadent*. Words, as we know, affect both perception and judgment. In 1817 the neoclassical James Sloan is still using *Gothic* in its sense of "barbarous" when he is clearly referring to baroque architecture. Sir Francis Palgrave, author of the first Murray's handbook to Italy, denounced all things *medieval* as "baroque and absurd" as late as 1841. Later in the century, when

the word baroque came to be used with specific reference to seventeenth-century style, it continued to carry the connotations of "flawed" and "illogical." Howells explicitly opposed the "frantically baroque" to the "coldly classic," his own taste in monumental architecture being Gothic.[9] Many years would pass before *baroque* became neutrally descriptive, and still more before it was used as a term of praise.

"Freaks in Marble"

In the Casino of the Villa Borghese were to be seen most of the youthful works of Bernini that are there now. Americans went to the Borghese, but not for the Berninis; rather they sought out celebrated antique mosaics and sculptures, and Canova's statue of Pauline Bonaparte Borghese as Venus. In his report of a visit to the Casino in 1817, James Sloan takes the occasion to pontificate on the history of sculpture. Canova, he asserts, is the only sculptor since Phidias and Praxiteles to have "inherited" their "taste and genius"; Michelangelo, unfortunately, "possessed the defects of an original mind," so he failed to achieve the "ideal" beauty whose "essence" is freedom from "all emotions of the painful or violent kind." But Michelangelo had at least *aimed* at the "religious sublime," whereas Bernini "degraded" art to the particular, the material, and the terrestrial. Following this pronouncement, Sloan left the Casino without describing or even naming any particular work by Bernini.[1]

That it was possible to break free from this official neoclassical way of thinking and seeing is proven by the happier visit of Theodore Dwight in 1821. He dutifully recorded all the "principal objects pointed out by the keeper," including Bernini's *Apollo Pursuing Daphne* (fig. 7), which he surprisingly found to be the only work besides the classical *Spinario* "calculated to fix the attention of unlearned observers" like himself:

> [Its marble is] so full of life, so running over with motion, that it seems as if the fire of Prometheus had just been applied, and we expected to see the statues spring from the pedestals and disappear in an instant. How can anyone define the pleasure communicated by such a specimen of art? I have seen a spectator perform a circuit round the pedestal again and again, then stand gazing on it, and wringing his hands with delight; then almost laugh aloud, and seek another and another point of view, to revive once more the agreeable delusions.

Far more typical was Hillard's view twenty-six years later that such pleasure was suspect. Admitting that the *Apollo* is "wonderfull to look at," he finds a justification for accepting it by improbably discerning the indispensable neoclassical element of repose in the horror-filled face of the metamorphosing Daphne. It "breathes the repose of death," he asserts. Moreover, for "mere technical dexterity and mechanical skill, . . . it is a miracle of manipulation": it produces an "incredulous wonder, as if there must be some trick about it, and . . . [it] could not be what it purports to be." Without calling it beautiful, Hillard stops short of denying the

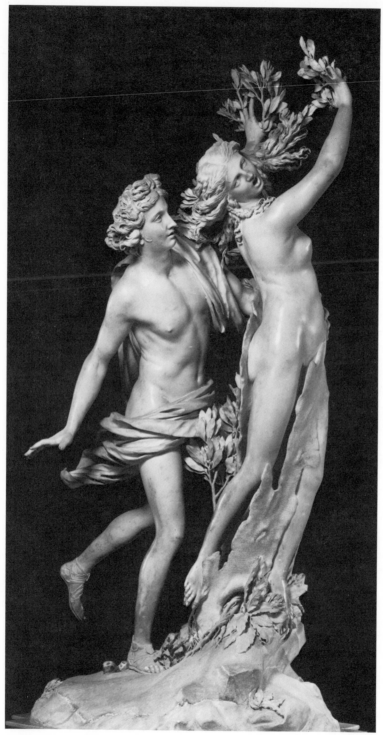

Fig. 7. Gian Lorenzo Bernini. *Apollo Pursuing Daphne*. 1624. Museo
Borghese, Rome. Photo: Alinari/Art Resource, New York.

dubious delight he obviously found in this "trick." Uneasy, since he has already damned Bernini categorically, Hillard finds an explanation for its apparent grace in Bernini's youthful age: since the works housed in the Casino Borghese were created by a boy between the ages of fifteen and eighteen, they reveal his native genius before it was subjected to "the influence of bad taste and corrupt patronage." Then he avers, "When we turn from these works to the clumsy fountain in Piazza Navona, the bronze covering of the chair of St. Peter's, and the vile statue of Sta. Theresa . . . it is difficult to imagine that they all proceeded from the same mind: still less . . . " etc., etc.; he beats a quick retreat.[2]

A decade later Nathaniel Hawthorne followed his friend Hillard in pronouncing the *Aeneas* and the *David* of "great merit" because they "do not tear and rend themselves quite out of the laws and limits of marble, like his later sculptures." But the "Apollo, overtaking Daphne" did not "seem very wonderful" to Hawthorne, "not so good as Hillard's description of it made me expect; and one does not enjoy these freaks in marble." Canova's boldly nude Pauline Borghese also fixed Hawthorne's attention for some time, but he concluded that neither did it "afford pleasure in the contemplation."[3]

Hawthorne, in spite of his lack of pleasure, his debilitating fevers, and his family anxieties, persisted in trudging cheerlessly about the city in search of art. He alone seems to have found and recorded an experience of Bernini's *Rape of Proserpine* (fig. 8), at that time "one of the most striking objects" in the Casino Ludovisi (it is now in the Borghese). Pluto, he says, is "an outrageously masculine and strenuous figure, heavily bearded, and with a prodigious muscular development in mad activity, ravishing away a little, tender Proserpine, whom he holds aloft, while his strong gripe impresses itself into her soft, virgin flesh. It is very disagreeable." Sophia Hawthorne found even her husband's description of the statue too strong, so when she edited his notebooks for publication, she struck out the phrase about "muscular development in mad activity."[4] The Hawthornes no doubt recalled how finely Nathaniel had deprived the Proserpine-Pluto story of all sexual motivation in his *Tanglewood Tales.*

Inhibitions about sexuality, which became even stronger when associated with religion, no doubt explain the absence of comment on Bernini's *St. Theresa in Ecstasy* (fig. 9), now one of his most admired works. Hillard's passing reference to the "vile statue" is almost unique. The silence of others is eloquent, because nineteenth-century journals and travel books characteristically list everything seen. It is unlikely that *St. Theresa* went unobserved; she is centrally located, and comments in popular guidebooks and art histories would certainly have excited curiosity.

Hillard may have taken his word *vile* from the well-known English authority Mrs. Anna Jameson, who states in no uncertain terms that Bernini's is the "grossest" and "most offensive" of all the representations of St. Theresa: "The head . . . is that of a languishing nymph; the angel is a sort of Eros. . . . The vehicle, white marble, its place in a Christian church, enhance all its vileness. The least destructive, the least prudish in matters of art, would here willingly throw the first stone."[5]

The Englishman Augustus Hare, whose *Walks in Rome* was popular during the last three decades of the century, juxtaposes Jameson's opinion with that of Hippolyte Taine (which he leaves untranslated) to contrast English and French taste.

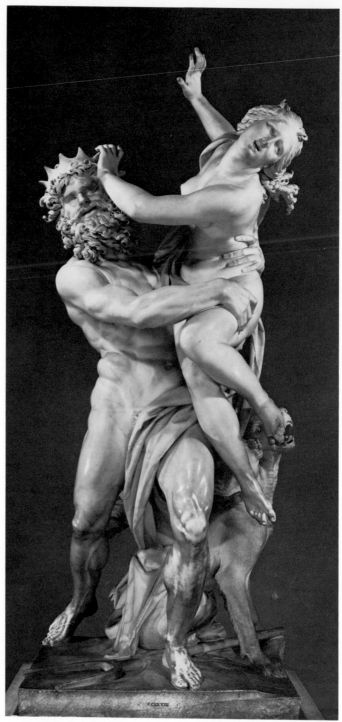

Fig. 8. Gian Lorenzo Bernini. *The Rape of Proserpine.* 1622. Museo Borghese, Rome. Photo from Istituto Centrale per il Catalogo e la Documentazione, Rome.

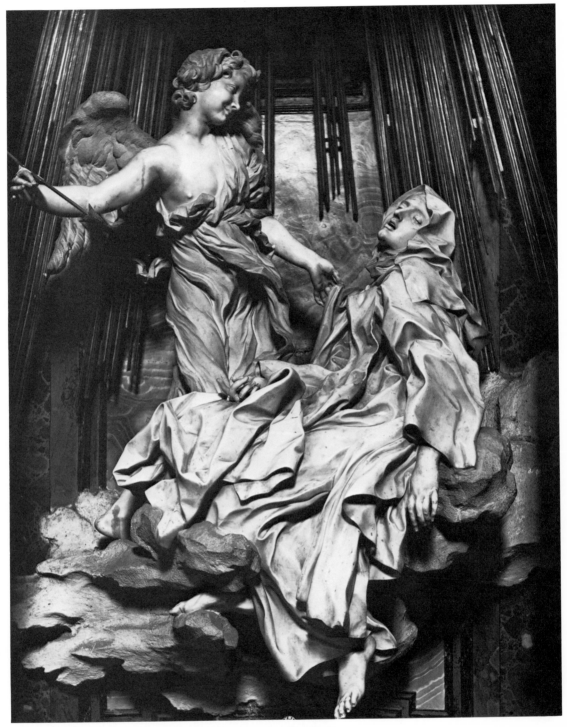

Fig. 9. Gian Lorenzo Bernini. *St. Theresa in Ecstasy*. 1646. Capella Cornaro, Santa Maria della Vittoria, Rome. Photo from Istituto Centrale per il Catalogo e la Documentazione, Rome.

Taine's description of *St. Theresa* is valuable because, even in much abbreviated form, it so clearly illustrates what no American, and perhaps no one from outside the Latin Mediterranean world, could have written at that time:

> She is adorable. In a swoon of ecstatic happiness lies the saint, with pendant hands, naked feet, and half-closed eyes, fallen in transports of blissful love, . . . awaiting her beloved. . . . The moment of agony has come, and she gasps; this is her last sigh, the emotion is too powerful. Meanwhile an angel arrives, a graceful, amiable young page of fourteen, a light tunic open in front below the breast, and as pretty a page as could be despatched to render an over-fond vassal happy . . . ; the golden dart he holds indicates the exquisite, and at the same time terrible shock he is about to inflict on the lovely impassioned form before him. Nobody has ever executed a tenderer and more seductive romance.[6]

Francis Marion Crawford, a Catholic himself, was referring to this description of the *St. Theresa* when he said that "it was reserved for the decadence of our own days to find words that could describe it." The fragment quoted by Hare, however, misrepresents Taine, since the French critic himself goes on to condemn the statue, albeit on completely different grounds from Jameson's. To him the statue distorts profane as well as sacred love; it is, in a word, unhealthy. As no American could yet do, Taine relates the *St. Theresa* to the seventeenth-century devotional literature by which "sensual Italy" transformed the Spanish fevers of St. Ignatius and St. Theresa into "graceful rotundities and glowing carnality." American readers of Taine (he was translated by John Durand in 1868) must have been shocked to find that Taine's new historical perspectivism included even the "pretty saints" of their divine Guido Reni in this summary criticism.[7]

Unseen Beauty and Rare Delights

Americans could avoid baroque works sequestered in churches and palaces, but those that thrust themselves up in public places were not easily ignored. Yet the extent to which the urban landscape went unobserved is striking. The streets of Rome were mostly noted for their filth. Even Stendhal remarked that for years the smell of rotting cabbage kept him from realizing that the Corso was the finest street in the universe.[1] No doubt conditions underfoot did discourage the contemplation of baroque façades. Still, the same conditions at the base of classical monuments did not greatly moderate the raptures of Americans at those sites. By and large they simply did not percieve urban design as an art, and when some work—notably the Spanish Steps at the center of the foreign quarter—evoked their universal praise, they failed to identify it as a product of what they called an Age of Decadence. In fact, some did not even see such creations as Roman. Hillard says that one's first thought about the sun-filled space of the Piazza di Spagna (fig. 10) is simply that "all this is well, but it is not Rome: . . . The majestic shadow of the past is not here. This

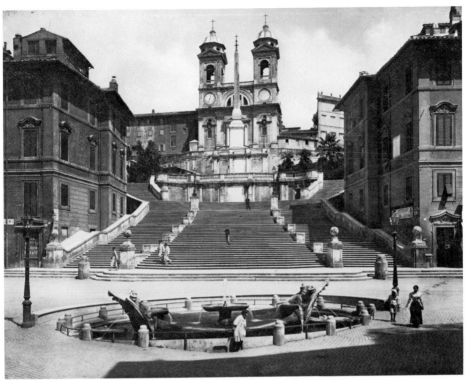

Fig. 10. Piazza di Spagna. Rome. Photo Alinari/Art Resource, New York.

is what I left at home, not what I came to see."[2] One wonders where he found anything comparable in Boston.

The Piazza del Popolo (fig. 11), originally designed to provide an imposing northern entrance into Rome, disappointed Americans, who expected to see the ancient monuments rise up before them as they came through its gate. The artist Rembrandt Peale did perceive a "noble circular space" (actually regularized only in 1814), but Theodore Dwight in 1821, Orville Dewey in 1835, and Caroline Kirkland in 1848 are alone in their decades in grasping the point of the seventeenth-century design: how the twin churches separate the "three diverging streets which meet in the eye." The Reverend Mr. Dewey even remarks that the Piazza is "really an appropriate introduction to Rome—or to what you feel that Rome should be" (rather than the "inexpressibly and insufferably filthy city" that it is).[3] In due course others took a look at the obelisk, the gate, the three churches, the fountains, and the stairs up the Pincio—each separately; only the obelisk pleased, and they did not see the whole. Once again Hippolyte Taine provides a French contrast to the American vision; always comparing Roman spaces with those of Paris, "to which I am accustomed," Taine finds the Piazza del Popolo "both peculiar and beautiful," with "less material grandeur than in the Place de la Concorde," its French derivative, but showing "more invention, and more to interest you." In *Americans in Rome* (published in the same decade as Taine's book), Henry P. Leland's flippant artist-narrator observes the Piazza del Popolo from the Pincio terrace (not the angle for which it

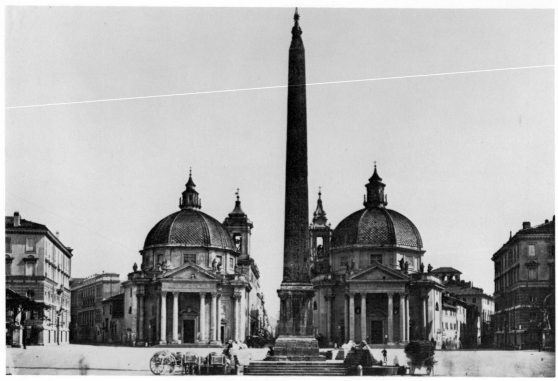

Fig. 11. Piazza del Popolo, Rome, before 1879. Photo: Parker Collection, Fototeca Unione at The American Academy, Rome.

was designed). He remarks that the twin churches framing the Corso "are neither more nor less hideous than nine-tenths of the other three hundred odd churches in Rome; the same heavy, half-cooked look about doors and windows, suggesting the same heavy scroll-work, reminding one of the work of a playful giant of a green grocer who has made a bouquet of sausages and cabbages, egg plants and legs of mutton, and exhibits it to a thick-headed public as a—work of art."[4]

In Piazza Navona (fig. 12), the legendary rivalry between Bernini and Borromini is most directly expressed. The Piazza was the chief marketplace of Rome for centuries, from a time long before its baroque monuments were created until 1870. The crowds of people and wares that filled it obviously distracted attention from its Bernini fountains and its Borromini church. Yet Heinrich Wölfflin, in one of his illuminating discriminations between the classic and baroque styles, twice instances an open-air marketplace as providing the living occasion where animated discrete objects, meaningless and possibly unlovely in themselves, challenge the eye toward unified visual perception. Wölfflin's discussion of this essential characteristic of baroque vision ends with a reference to—precisely—the façade of St. Agnese in Piazza Navona.[5] Bernini's fountain and Borromini's facade might therefore originally have been seen as harmonious with the market activity in the midst of which they arose. My point is not that Hawthorne, whose view of the Piazza we shall consider, ought to have anticipated Wölfflin in recovering the baroque vision,

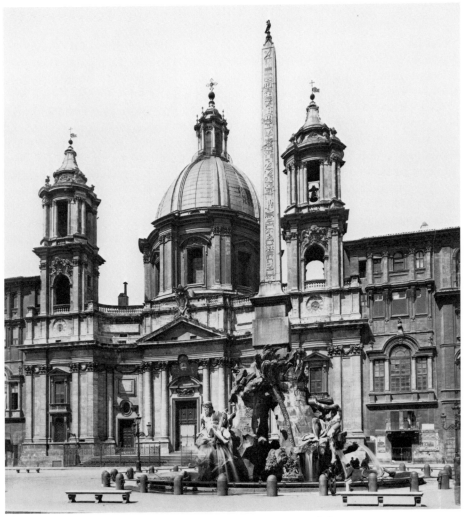

Fig. 12. Piazza Navona, Rome. Gian Lorenzo Bernini, Fountain of the
Rivers, 1651. Francesco Borromini, Façade of Sant' Agnese in Agone,
1653–57. Photo: Alinari/Art Resource, New York.

but to emphasize how what in a different age may have been percieved as contin-
uous, for the Victorian American in Rome fragmented into a discordant series.

Hawthorne's second journal entry on the Piazza Navona is an extended composi-
tion, one of the most effective descriptions of a Roman experience in American
literature. But it breaks into four parts. "It is to me the most interesting Piazza in
Rome," Hawthorne begins, "a large, oblong space surrounded with tall, shabby
houses. . . . The sun falls broadly over the area of the Piazza, and shows the foun-
tains in it." After his general view, Hawthorne focuses upon Bernini's central
Fountain of the Four Rivers. He would have been aware of his friend Hillard's
judgment that this fountain is simply "one of the heaviest sins against good taste"
in the world, a "cold and extravagant allegory," an "absurdity" with "sprawling,

grotesque, and monstrous" statues. "Nothing, however, can be said against the water," which falls in "curves of breaking silver." That the falling water, with the fire of sunlight flashing from it, together with the stone piers and the void of air they enclose, were the four elements of Bernini's composition was not recognized. Surprisingly, Hawthorne echoes Hillard's damnation: the "monstrous devices in marble, I know not of what import," are "one and all of them . . . superfluous and impertinent; the only essential thing being the abundant supply of water." I call Hawthorne's statement surprising because one would expect him to have been attracted by the fountain's allegory; he himself in apparent seriousness suggested to the American sculptor Harriet Hosmer that "Niobe, All Tears" was an excellent idea for a fountain of the Bernini type.[6]

Hawthorne next turns to the aspect of the Piazza of greatest interest to him, the business transacted there, which he describes in detail. The men and women, the variety of goods offered, the colors, textures, sounds, smells, and gestures, are appreciatively evoked, with a conscious avoidance of the sentimental and the picturesque. The "Piazza is dingy in its general aspect, and very dirty," it is true, but "there is more life in it than one sees elswhere in Rome." That Hawthorne loved the baroque vitality of life we can see, but he did not look for it in the plastic arts, where he had learned that repose was the quality preferred. His conclusion, then, is surprising. Hawthorne passes through the concave façade of Borromini's church, without the slightest preconception about it, and finds the interior beautiful:

> [It is] very splendid with rich marble columns, . . . a frescoed dome above; a range of chapels all round . . . , ornamented . . . with . . . bas-reliefs, the figures of which almost step and struggle out of the marble. They did not seem very admirable as works of art, none of them explaining themselves, or attracting me long enough to study out their meaning; but as part of the architecture of the church, they had a good effect.

Hawthorne here responds to one of the chief intentions of baroque design, the integration of architecture and sculpture. His final observation both relates and opposes the exterior and interior worlds: "Out of this busy square, two or three persons had stept into this bright and calm seclusion." Perhaps not accidentally, Hawthorne's next entry concerns a recollection of the Pantheon, the prime exemplar of the distinctively Roman art for shaping noble interior spaces, the art that is a major link between the ancient architects and the baroque.

Hawthorne and his wife stumbled upon unexpected pleasures in other baroque churches whenever they ignored their guidebooks. Hawthorne found even the Jesuit church of St. Ignazio "beautiful" and the normally scorned illusionary frescoes on its ceiling "brilliant." But the Hawthornes' most moving independent discovery came on a day when they had already taken in many of the obligatory sights. Surely on the impulse of the weary, they went into Bernini's little Sant' Andrea al Quirinale (fig. 13) the only work that fully satisfied Bernini himself, but unlisted by Murray. That night Hawthorne wrote, "This little church . . . has a more perfect and gem-like beauty than any I have seen." After a detailed description of its form and materials, he concludes, "I have not seen, nor expect to see, anything else so entirely

Fig. 13. Gian Lorenzo Bernini. Interior of cupola, Sant' Andrea al Quirinale, Rome. 1658–71. Photo: Alinari/Art Resource, New York.

and satisfactorily finished as this little oval church; and I only wish I could pack it into a large box and send it home." Sophia admitted that it is "a perfect jewel of beauty," but (having looked up the architect) she could not resist adding, "In designing this building Bernini certainly redeemed himself, in some measure, from the disgrace of his ranting, stormy statues."7

The "Cross-Fire" of Catholicism

Having watched the Hawthornes find beauty in fully baroque churches, and yet having noted that a masterpiece of baroque religious sculpture was regarded as "vile," we should consider more fully how the general American attitude toward Catholicism in Rome affected reaction to the baroque, before finding our own way back to St. Peter's. For it is certain that the Americans' sense of the religious practices of Catholicism, from the old lady kneeling before a reliquary in a dimly lit side chapel to the splendid processions of Holy Week, was one of the more important influences upon their perception and judgment of baroque ecclesiastical works.

Most of the Americans who created our collective image of nineteenth-century

Rome were not themselves fanatical Puritans; they were Deists, Unitarians, and covert agnostics, with a few Episcopalians and a Catholic convert or two. They had mostly lost the Protestant fervor of belief while retaining its habits of refusal. What some did strongly hold was a belief in the progressive modernity and ethical superiority of America, even if like Cooper or Norton they had no great faith in popular democracy. Any demonstration of the present political power, religious vitality, and material splendor of the Roman Catholic church was thus a threat to American assumptions about history and about the future. As an effective expression of the Counter-Reformation surviving into the present, the churches of Rome were not something they liked to see.

Two brief side trips, to Torcello and to Chartres, may be instructive here. In an essay of 1872 reprinted in *Italian Hours*, Henry James, having evoked the vacancy surrounding the ancient church on the abandoned island of Torcello in the lagoon of Venice, goes on to sketch the "terribly distinct Apostles . . . ranged against their dead gold backgrounds, . . . intensely personal sentinels of a personal Deity. Their stony stare seems to wait for ever vainly for some visible revival of primitive orthodoxy, and one may well wonder whether it finds much beguilement in idly-gazing troops of Western heretics—passionless even in their heresy." Thirty years later Henry Adams composed with calculated effect the conclusion to the tenth chapter of his *Mont-Saint-Michel and Chartres*. Having brought to a climax his richly detailed revivification of thirteenth-century worship at Chartres, using the first person and the present tense, and making himself one of the kneeling imaginary crowd, he focuses for a last time on "the Virgin in her majesty, with her three great prophets on either hand, as calm and confident in their own strength and in God's providence as they were when Saint Louis was born, but looking down from a deserted heaven, into an empty church, on a dead faith."[1]

I think we can say that both Adams and James in these remarkably parallel passages can look respectfully upon Catholic symbols and recognize their power precisely because as nonbelievers neither sees anything to suggest that Catholicism is a vital contemporary force. Moreover, the two forms of expression, Byzantine and Gothic, are highly abstracted and spiritualized in comparison with the rhetorical naturalism of the baroque. They express an assured and transcendent faith rather than a propagandistic intention or a desire for union between flesh and spirit. In baroque Rome, however, Catholicism did not appear to be safely dead, so an empathetic approach to its art was risky. In Rome, the Virgin of Torcello and Chartres did not remotely stare down on empty churches; even in her classical form (such as Sansovino's popular Virgin in Sant' Agostino (fig. 2), she flaunted herself among her servants and the thousands who came from near and far to see her.

In the same letter to Lowell in which he condemned Bernini and Borromini, Norton complained of the worship of "idols and images," saying that "Rome may be battered down and depopulated if in that way we can get rid of these churches and these priests." The Reverend Robert Turnbull wrote that he entered a building he called "the Capella della Humilta" expecting to find "a plain and humble edifice" but was astonished to find it "absolutely glittering with splendor and show."[2] Turnbull clearly failed to see that baroque ecclesiastical art is concerned with the humility of the worshiper, not that of the Church.

There is not, of course, always a sure link between anti-Catholicism and dislike
for the baroque. Francis Marion Crawford as a Catholic convert proved his good
taste by being as contemptuous of Bernini as anyone; and even in Rome neoclassi-
cism had suppressed a baroque altar or two by orders of one pope or another, and
medievalism removed a few ornate facades from medieval churches. But it is clear
that in most cases anti-Catholic prejudices about the worldliness, essential pagan-
ism, sensuality, irrationality, and hypocrisy of the Church comfortably coincided
with, and confirmed, the impressions of the architecture as "gaudy," "wasteful,"
"deceptive," and dangerously alluring in its splendor of marbles, gems, and sen-
suous color. Howells was alarmed by the rebuilding of San Paolo fuori le Mura after
the fire of 1823. Although it was fortunately free of "the antic touch of the baroque"
and therefore superior to St. Peter's, the basilica's reemergence by the end of the
century was itself disturbing, since it proved that the Church could still command
that "unstinted outlay of riches" that over the centuries had "filled Rome with its
multitudes of pious monuments—monuments mainly ugly, but potent with the
imagination even in their ugliness through the piety of their origin. . . . The giving
continues in this latest Christian age as in the earliest, and Rome is increasingly
Rome in a world which its thinkers think no longer believes."[3]

Henry James observed Catholicism's persistence in Rome with greater equa-
nimity. On New Year's Eve, 1872, he braved a musical vesper service in the very
temple of the Counter-Reformation, Il Gesù, "the most baroque church in Rome,"
as Howells calls it, from which the soul "shrinks dismayed." To James, however, it
was a "gorgeous" place that fed "one's sense of the curious." He listened to the
"surprising roulades and flourishes" coming from the choir "perched in a little loft
high up," and observed near him "a handsome, opulent-looking nun. . . . Can a holy
woman of such a complexion listen to a fine operatic barytone in a sumptuous
temple and receive none but ascetic impressions? What a cross-fire of influences
does Catholicism provide!"[4]

It was to this "cross-fire of influences" that all Americans making their artistic
pilgrimages to Rome willingly exposed themselves. Arming themselves more or
less sturdily in puritan or Unitarian attitudes beforehand, they regularly sought out
special services or timed or prolonged their visits to include either the Christmas
season or Holy Week or both with the Carnival in between. They expected a good
show, and they got one. By arguing firmly that Catholicism was nothing *but* a
show—a hollow form, a medieval pageant or Renaissance spectacle—they felt
justified in treating it as one. The numerous accounts of Holy Week in Rome up
until the end of the Papal City in 1870 are appalling. At the various processions and
ceremonies at the Vatican, people trampled each other and screeched curses, hoping
to improve their views in the Sistine Chapel or in the Loggia of St. Peter's where the
pope washed the feet of twelve pilgrims. Women stuck each other with hatpins or
buckled the knees of those in front of them with a kick; veils and other female
garments flew through the air. Grace Greenwood confessed that in the crush of the
crowd she would "laugh occasionally, in a wild, hysterical way." Only Emerson
seems not to have noticed any of this. The English, most numerous, were also the
most offensive, according to American accounts. Cooper is pleased to report that
Americans were well behaved; but what he does not say, and his companion

Samuel F. B. Morse does, is that the two of them actually stepped into the papal procession in order to arrive ahead of all others at the next entertainment.[5]

Fortunately the Mass on Easter Sunday was in St. Peter's itself, large enough to hold everyone in its baroque spaciousness. From N. P. Willis, who elaborately reported the "spectacle . . . all splendor" as a novelty for his *New York Mirror* readers of 1828, to Norton, writing to A. H. Clough that he was going "where miracle plays are got up in the most splendid style," the reviews were all favorable— all, that is, except a disdainful critique from Julia Ward Howe, and another, even more vituperous, from Jarves: "The Holy Week in Rome! What unholy reminiscences . . . ; a purgatorial experience, . . . a vain show." Ironically, no other American account is so well illustrated and so richly detailed as Jarves's, which effectively conveys how attractive and colorful the pageantry (to call it only that) must have been. Jarves saw more clearly than others how the baroque rhetorical machinery of the Church works as a whole: the ceremony, the costumes, and the music were all one with the architecture. The "eyes and ears" are, alas, "avenues" to the "minds and hearts" of men.[6]

St. Peter's: "The World's Cathedral"

All the ambivalences and contradictions, the repressions, evasions, and attractions that Americans experienced in baroque Rome come together in their images of St. Peter's Basilica (fig. 14; see also fig. 4). It is the one baroque creation that everyone mentions, and it alone rivals the Colosseum and the Forum as the city's primary attraction. When Cooper on his first day in Rome commands his *laquais de place* to take him directly to St. Peter's, he defines his relative interests as others do by seeking out first the Forum.[1]

In *The Portrait of a Lady* Henry James indicates the beautiful receptivity of his heroine's soul by noting that Isabel does not take a "superior" attitude toward St. Peter's, just as he intends to reveal a quality that Isabel ought to have noticed when Gilbert Osmond, who says he would be happy to be the pope, expresses his hatred for the basilica because it makes him feel small. Whether St. Peter's makes one feel small or grand, whether it humbles or elevates the individual soul, is in fact the most constantly recurring question; it is a way of asking to what extent the baroque extension and completion of the church overwhelmed its Renaissance beginnings. The preoccupation with measurement is not, as is sometimes suggested, peculiarly American; it is universal and inevitable. William Gillespie, who wished to portray Rome "as seen by a New-Yorker," was a civil engineer, yet his observation that the Pantheon appears larger than it is and St. Peter's smaller does not depend upon a professional or an American eye; it seems almost a paraphrase of Mme. de Staël's identical observation in her rhapsodical *Corinne*. Such concern with the effect of size and proportion is neither trivial nor irrelevant. When Cooper arrives at St. Peter's and immediately embraces one of the columns of the façade, it is not, he tells us, "in a fit of sentimentalism" but to get its human measure, to assure himself that the estimate he had made with his experienced seaman's eye from across the Piazza

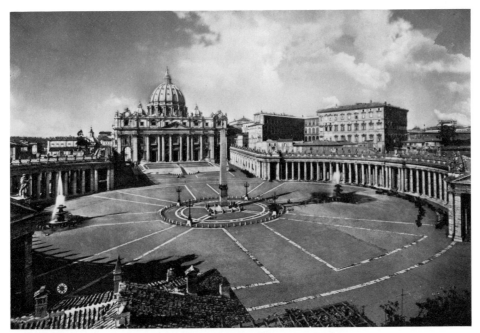

Fig. 14. Piazza San Pietro, Rome. Gian Lorenzo Bernini, piazza and colon-
nades, 1656–67. Michelangelo, dome of St. Peter's Basilica, designed
1558–61. Carlo Maderno, central façade of St. Peter's Basilica, 1607–14.
Photo: Alinari/Art Resource, New York.

had been correct. Inside the church, his sense of its awful vastness is confirmed by
every calculation of proportion and relation he makes: men dwindle into boys; his
own hand in the hand of a marble cherub becomes that of an infant. Certain he is not
deluded, he finds that tears come to his eyes while his own small son clings close to
his side murmuring, *"Qu'est-ce que c'est?—qu'est-ce que c'est?"*[2]

With others the effort of measurement is not so much, as with Cooper, a justifica-
tion for ultimate submission as a means of defense against being overwhelmed.
They see their compatriots and feel themselves shrinking into pygmies, insects,
flies, or spiders, so they reassure themselves that it is all a deception that they can
"comprehend" by carefully observing how everything has been magnified beyond
the human scale. To overcome their awkwardness they make comparisons with the
familiar: the spire of Trinity Church in New York or the Bunker Hill Monument in
Boston.[3]

"The monster Church of St. Peter," says Mark Twain, is in length about the same
as the Capitol in Washington, and the dome about 125 feet higher than the Capitol's
dome. But to him, as to James's jingoistic journalist Henrietta Stackpole (in *Portrait
of a Lady*), St. Peter's looks neither so large nor so beautiful as the American
Capitol. In fact, Twain struggles mightily to see St. Peter's as small, since "there is
nothing to measure by." He knows that the baldacchino is more than half as high as
Niagara Falls, but it only looks like a "magnified bedstead" or a "mosquito bar"—
"nothing more." Finally his efforts in reductiveness fail. Twain admits inadver-
tently that there *is* one scale to measure by: "none but the people, and I had noticed

them. They were insects." Years later, an older Mark Twain would have relished this discovery; but the exuberant young innocent abroad does not. When he ascends the dome and looks out over Rome, he soon spots the Palace of the Inquisition and immediately allies it with the Colosseum in the distance. Persecuted once itself, the "holy Mother Church" in time found its own ways of "persuading" men to honor the Redeemer with thumbscrews and red-hot pincers. "The true religion . . . is wonderfully persuasive." Mark Twain has put the Church in its place, so to speak, and successfully evaded the oppressive rhetoric of its architecture. Emerson, with much less effort, cuts through more simply: "You walk about on its ample marble pavement as you would on a common," he writes, "so free are you of your neighbors." Emerson, who could be glad to the brink of fear on a bare common, did not require a baroque cathedral to experience the sublime. St. Peter's is "not grand," he says, "it is so rich and pleasing."[4]

A far more frequent reaction, however, is a confession of bewilderment. Many Americans return again and again to St. Peter's but their efforts to comprehend it never fully succeed. Willis describes a "lost and unexamining, unparticularizing feeling, . . . a mind swept quite off its feet and confused and overwhelmed with the tide of astonishment—the grand impression of the whole. . . . I left the church, after two hours. . . , despairing." The disorienting aspect of St. Peter's was exploited notably by Hawthorne in his characterization of Hilda in *The Marble Faun* and by James in that of Mary Garland in *Roderick Hudson.* The peril to the Protestant American soul was less ambiguously shown in lesser fiction. The heroine of Sara Loring Greenough's *Lilian* (1863), for instance, is nearly seduced by St. Peter's into "unquestioning reverence" until the hero bluntly reminds her of the Reformation; then she sees "through the shining floor" into the imagined torture chambers below and promptly recovers from her trance.[5]

After a time, however, most resident Anglo-Americans frequented St. Peter's with complete composure, not to be free of their neighbors, but to meet them. It was, in manner of speaking, their grandest salon. In her *Roma Beata* (1904), Maud Howe Elliott, daughter of Julia Ward Howe, writes: "We met Boston society, as we always do when we go to St. Peter's,—an old friend and his bride, and a pair of pleasant Beacon Street neighbors."[6] The report is typical, and we see the scene enacted in all three of Henry James's Roman novels. In *Daisy Miller* Winterbourne's aunt, Mrs. Costello, sets up her campstool and receives visitors not far from the seated statue of St. Peter himself.

The opposite of the humbling effect is not such calm indifference, however, but rather a humanistic reaction that might better have pleased Bramante than Michelangelo. Bayard Taylor, future producer of the most popular American translation of Goethe's *Faust,* articulates a typical position: "It seems as if human art had outdone itself in producing this temple. . . . The awe felt in looking up . . . did not humble me; on the contrary, I felt exalted, ennobled. Beings in the form I wore planned the glorious edifice, and it seemed that in godlike power and perseverance they were indeed but 'a little lower than the angels.'" So much for feeling like a pygmy. Tuckerman, too, thought that the church increased man's "sense of his capacity for excellence," and Hillard said it made it seem "natural" to "act like a hero." Mar-

garet Fuller agreed. At St. Peter's, she wrote, "my feeling was always perfectly regal."[7]

All these various views of the basilica were synthesized by Henry James in an essay reprinted in *Italian Hours.* He urbanely begins with the claim that St. Peter's is the perfect rainy-day alternative to the fashionable park of the Pincio for one's daily "constitutional" and superior to either Piccadilly or Broadway for that profane purpose because it is as inexhaustible to the curiosity as it is spacious for walking. At each return it "expands, it rises sublime again, and leaves your measure itself poor." It is "an exaltation of one's idea of space," in which the scattered human figures "mark happily the scale" ("happily"!). Yet, as you "stroll and stroll and gaze and gaze" you "feel yourself, at the bottom of the abysmal shaft of the dome, dwindle to a crawling dot." But in spite of this diminishment, "ease" may be felt in St. Peter's as it cannot, by the "spiritually nervous," in Westminster Abbey or Notre Dame. St. Peter's speaks to a non-Catholic "less of aspiration than of full and convenient assurance."

> The soul infinitely expands here, if one will, but all on its quite human level. It marvels at the reach of our dream and the immensity of our resources. . . . The image of the great temple . . . seems to . . . make you still believe in the heroic will and the heroic act. It's a relief . . . to feel that there's nothing but a cabfare between your pessimism and one of the greatest of human achievements.[8]

In the same essay James disposes of most of the criticism of the interior decoration. Echoing the views of Stendhal and Mme. de Staël, he finds that the "constituted beauty" is "all general beauty," in which the "specific details" are "practically never importunate." The "supreme beauty is the splendid sustained simplicity of the whole."[9] Such a position was not adequate for Hillard, the Hawthornes, or Howells, nor for Grace Greenwood. All felt obliged to pass judgment on nearly every mosaic, tomb, statue, and vagrant cherub, or—in Howells's case—saw nothing but a general ugliness, "an excess of decadent taste." To Greenwood, Bernini's statues in St. Peter's were "simply detestable," escapees from "some celestial insane asylum," "sculptured abominations" that had to be effaced from memory through contemplation of neighboring works by Thorwaldsen and Canova.[10] Bernini's baldacchino, directly below Michelangelo's revered dome, was hated by almost everyone who mentions it except Rembrandt Peale and Henry James. To James it was "gorgeous," and he loved to watch "the glorious altar-canopy lift its bronze architecture, its colossal embroidered contortions, like a temple within a temple." Hillard, more typically, found it "a pursuing and intrusive presence, . . . rearing its tawdry commonplace into the majestic space, and scrawling upon the air its feeble and affected lines of spiral."[11]

The strategy for dealing with the baroque in St. Peter's was for most Americans the same they used to write about the city as a whole. Its baroque features were neither praised, as by the nonconforming James, nor damned, as by Hillard. By most they were simply ignored, blotted from the perception, the record, and the memory. As the city was loved, so was the church, and therefore what was theoretically not

admirable was overlooked, even when it was a dominant, inescapable fact. Crawford's chapter on St. Peter's in *Ave Roma Immortalis* includes what purports to be a list of its five pope-builders and their architects, but Carlo Maderno and Bernini—the two architects who, with Michelangelo, are the most important among the many who contributed to the church's ultimate design—Crawford simply omitted.[12]

Throughout the nineteenth century St. Peter's offered—if not to Mark Twain or William Dean Howells or Charles Eliot Norton, yet to a variety of Americans from the young tramp Bayard Taylor to the enormously sophisticated Henry James—some of the most moving experiences they had, in spite of what it is, a predominantly baroque church from the "lowest" period of art and a monument of living Catholicism. Many Americans remembered privileged moments in the silence and space of St. Peter's when shafts of diffused sunlight fell obliquely across the nave. The most beautiful confession comes from the guarded and skeptical Hawthorne. On a walk one day in February of 1858, "weighed down with a Roman lassitude," he went alone into St. Peter's. As he strolled around the church, he found that in spite of so many previous disappointments, this time it seemed to grow "in magnitude and beauty." "At times, a single, casual, momentary glimpse of its magnificence gleams upon my soul, as it were, when I happen to glance at arch opening beyond arch, and I am surprised into admiration."[13]

"One Sees What One Brings"

Such a revelatory glance, in a moment of self-forgetfulness free from preconceptions, is rare in any age. And our point cannot be to flaunt our superior capacities for appreciation over the blind Victorians, for they would find us pitiable in our failure to see the greatness of Guido Reni, and in our relative unresponsiveness before classical ruins, which some of them lived long enough to see converted into mere archaeological digs. But in time a new historical perspective and a more liberal aesthetic, answering to a different psychological need, did alter the common perception of the baroque. The style even found a popular place in the eclectic architectural practice of the new age. Three Victorians writing in the early twentieth century reflect an awareness of the coming change in point of view.

The Education of Henry Adams (1907) was written as the companion piece to one of the great appreciations of Gothic architecture, *Mont-Saint-Michel and Chartres*. In the *Education* Adams imagines his idol Gibbon standing in front of a Gothic cathedral, darting "a contemptuous look on the stately monuments of superstition." But Adams is sure that Gibbon can only have "felt in fact the respect which every man of his vast study and active mind always feels before objects worthy of it." Yet Adams finds Gibbon's imagined contempt for the Gothic wonderfully instructive after a hundred years of growing Gothicism, a movement to which Adams himself had just signally contributed. "One sees what one brings," he concludes; "Gibbon brought the French Revolution. Ruskin brought reaction against the Revolution."[1] This dual realization—that aesthetic judgment is neither abso-

lute nor individual, but belongs to one's period, and that the best monuments of any age will command respect when approached by a person of "vast study and active mind"—was opening the way for reconsideration of the baroque as well as the classic and Gothic.

In 1905, Edith Wharton, with her sharp intelligence, clearly articulated the revision that had to take place. In the title essay of her book *Italian Backgrounds* she observes how full is the so-called background of "objects at which the guide-book tourist has been taught to look askance, or rather which he has been coun-selled to pass by without a look." She notes that in Rome it has been the fashion for centuries "to look only on a city which has almost disappeared, and to close the eyes to one which is still actual," because the "great monuments" that dominate the city had been categorized as belonging to a "debased period of art." "It is hard at this late date," she says, "to be patient with any form of artistic absolutism, with any critical criteria not based on that sense of the comparative which is the nineteenth cen-tury's most important contribution to the function of criticism." Instead of "invec-tive and lamentation," what is needed is objective observation and "the artistic and historical sympathy necessary to real understanding." Wharton sees in that *"bra-vura* period," of which Bernini was the genius, "an art in which excessive formality and ostentation are tempered by a free play of line. . . . Delicacy of detail, sobriety of means and the effect of repose were often sacrificed . . . ; but it is more fruitful to observe how skillfully Bernini and his best pupils managed to preserve the balance and rhythm of their bold compositions; and how seldom profusion led to incoher-ence." Concluding with a devastating page-long list of all that would be lost if those who condemned the baroque were taken seriously, Wharton adds that only the most "bigoted archeologist" would fail to see a formal relation between the baroque churches and the revered ruins of the Forum. Rome itself, Wharton claims, is the best defense of the baroque in its brilliant fusion of so many styles.[2]

Capitulation would not come so easily. In *Gardens of This World* (1929) Henry B. Fuller revived the Chevalier of Pensieri-Vani, his hero of 1890, who wanders through another of those charmingly eccentric tributes to Italy that gave Fuller relief from his mordant novelistic studies of cliff dwellers in the skyscrapers of Chicago. In a chapter entitled "Architecture for the New Day," we find the Chev-alier and his companion, the German nobleman von Kaltenau, venturing forth toward Lecce, a remote town in the boot-heel of Italy. They know it is baroque, which they hate, but they have been everywhere else. They have heard that people have started defending the "fantastic and corrupt style" of Bernini and Borromini as exemplified in Rome, but they are unpersuaded. They hope only that Lecce will be "not too filled with freaks." In fact, Lecce turns out to be far less frightful than much they have seen in Germany, and it occurs to them that the "playful elegance" of Italy is quite different from the "sombrely Spanish" baroque of other places.

Then they come upon a young man with a camera and a sketchbook who appears "dissatisfied." He tells them that he is an architect from Hollywood, California. The two aesthetes stare. "They had often heard of that peculiar town and its excesses." It develops that the architect has a commission for "an important mov-ing-picture theatre" and Lecce has given him no satisfactory inspiration. He shows them his sketches of "a singularly odious façade with a preposterous broken gable

over-richly ornamented, and a long row of inverted volutes that served as supports for a balustraded balcony—a fruit-cake in stone." But he feels that his time has been wasted. Hollywood expects more of him. " 'Yes,' " says von Kaltenau. " 'You should have tried in Austria and Swabia. You should have gone to Weissenau, or Ellwangen, or Friedrichshafen, or Ottobeuren. Or you might have stopped at Potsdam and Sanssouci. . . . Or at the Zwinger, in Dresden.' . . . 'I hope,' he said, . . . 'never to see your theatre.' "3

Conspicuously absent from this list of horribly baroque places is Rome. In the dawn of a new day, baroque exuberance finally found a popular American function, but for movie palaces the churches of Bernini and Borromini would have provided models too restrained. Even Fuller's Chevalier has enough of Wharton's "sense of the comparative" to find "elegance" in Italian manifestations of a style he had categorically abhorred. After a century of "invectives and lamentations," some Americans began to see baroque Rome from new angles of vision.

Part Two

Contemporary Rome

3

The Walls of Rome—
The People Within, 1830–1945

When the guerrilla troop in bright array
Took through the gate their melancholy way;
When the Triumvir, fearless, calm and proud,
Resigned his trust to that despairing crowd,
And over breastworks youthful courses made,
The modern Goths their tarnished flag displayed;
When through the breach in Rome's once sacred wall
Filed the battalions of the perjured Gaul,
Oh, why did no celestial sign appear,
Like that which beamed when Constantine was near?
No sainted hero or immortal bard
By heaven armed, that sacrifice retard?
 —Henry T. Tuckerman, "The Siege of Rome" (1849)

"I received your letter amid the round of cannonade and musketry," wrote Margaret Fuller to Ralph Waldo Emerson on June 10, 1849. "It was a terrible battle fought here from the first to the last light of day. I could see all its progress from my balcony. The Italians fought like lions. . . . They make a stand here for honor and their rights, with little ground for hope that they can resist, now they are betrayed by France." To another friend she wrote: "The musket-fire was almost unintermitted; the roll of the cannon, especially from St. Angelo, most majestic. As all passed at Porta San Pancrazio and the Villa Pamfili, I saw the smoke of every discharge, the flash of the bayonets; with a glass could see the men." A few days later she sat in the gardens of the Quirinale, tending the wounded in the absentee pope's own pavilion, and with them she watched the sun set over Monte Mario, where the last light gleamed on the white tents of the enemy encampment. In the "midst of ruin and sorrow," she listened to tales "full of grace and pathos . . . , with noble hope for man, with reverence for woman."[1]

Throughout the Siege of Rome, which had begun in late April and would continue into July, Fuller expended her energies on two fronts. She worked in the

hospitals (she had been made "Regolatrice" of the Fate-Beni Fratelli Hospital on April 30), and she composed eloquent and sometimes frantic dispatches to Horace Greeley's *New York Tribune*. Her descriptions of the heroic actions and immense suffering of the soldiers, and of the barbaric damage inflicted upon the revered city, her testimonials to the courage of her friend Mazzini the Triumvir (who came to see her), and her extensive documentation of the infamous manner in which the French Republic had betrayed the Roman Republic incited Henry T. Tuckerman and other readers to compose impassioned poems of protest. But finally Fuller had to report that in the night of June 21–22 the French army had breached the ancient walls at Porta San Pancrazio and, having brought its cannon forward onto the heights of the Janiculum, was bombarding the city in earnest. By the twenty-eighth, cannonballs were falling in the Piazza Barberini where Fuller lived, and many struck the hotel on the Pincio where Lewis Cass, Jr., the recently arrived and thoroughly bewildered new American chargé d'affaires, had taken up his "temporary abode."

Toward evening on July 2, when the French were preparing to cross the river, Fuller and her friends went down into the Corso and saw the lancers of Garibaldi retreating across the city toward the Lateran Gate. Following the handsome and undaunted troops up into the "solemn grandeur" of the piazza that extends before San Giovanni, they witnessed—as the sun set and a crescent moon rose—the young men in their red shirts and Greek caps assemble before their leader. From the parapet of the Aurelian Wall the great fighter for republican liberty and Italian independence surveyed the road that disappeared into the darkening Campagna, turned to take a last look down over Rome, and then led his gallant legion away into the night toward a destination unknown, since in the swiftly reactionary and again despotic Europe only Venice and distant Hungary still struggled to be free.

On the Fourth of July—"Yes; July 4th!" Fuller exclaimed—the French army took possession of Rome, and the Republic died. James E. Freeman, a resident artist who served as the American vice-consul, recalled long afterward that, "knowing to what an extent Miss Fuller's noble conduct and enthusiastic sympathy had made her obnoxious to the Church party and its Gallic allies," he had hastily "carried to her balcony and planted there with his own hands the 'stripes and stars' of her native land, to secure her, if possible, from molestation."[2] According to Fuller herself, she soon ventured out to visit the battlefield on the Janiculum, and then sickened by what she saw and by the very air of oppression that the French—claiming to be "protectors" of the city—had immediately established in Rome, she planned her departure; she would not abide the return of the pope. Grieving to abandon the wounded soldiers who had come to love her, she yet realized that she and her Italian husband—who had fought the French as a member of the Civic Guard—were in real danger and had to escape. Most other Americans had departed long since.[3]

Margaret Fuller found in the Roman Republic the great cause to which she could actively devote herself. The long-delayed fulfillment of her intense desire to live in Rome had wonderfully coincided with the revolutionary developments of 1847–48 throughout Europe. Thus her experience, she realized at once, was to be far more than the aesthetic and philosophical sojourn she had once imagined; it would be a personal political and ethical engagement. In May of 1847, not long after her first arrival, she wrote to William Henry Channing that "art is not important to me

now. . . . I take an interest in the state of the people. . . . I see the future dawning."
She further distinguished herself from most American visitors when she wrote to
Emerson in June that "to know the common people, and to feel truly in Italy, I ought
to speak and understand the spoken Italian well, and I am now cultivating this
sedulously." A year later she informed Emerson, who was then in London, that she
would not return with him to America because of the great drama then unfolding:
"Methinks I have *my part* therein, either as actor or historian."[4]

"Everything confirms me in my radicalism," she wrote frankly to a Milanese
marchesa, Costanza Arconati Visconti, who had befriended her. She could under-
stand why Madame Arconati, a liberal aristocrat, could not sympathize with Ful-
ler's own Mazzinian republicanism. What she could not understand was how *Amer-
icans* could differ from her. From the beginning they disgusted her. She reported to
the *Tribune* that most of them "take the same slothful and prejudiced views as the
English, and, after many years sojourn, betray entire ignorance of Italian literature
and Italian life." The young sculptor Thomas Crawford was a notable exception in
Rome; he had joined the Civic Guard, as "well becomes the sculptor of Orpheus."
Many Americans, in contrast, spoke of the "corrupt and degenerate state of Italy as
they do about that of our slaves at home." They held the ingrained belief that
"because men are degraded by bad institutions, they are not fit for better," when
they ought instead to have encouraged the Italians "by reciting triumphant testi-
mony" from America's own experience. Yet on second thought Fuller had to admit
that the American example was embarrassing. The most she could claim was that
America had a free press and that talent had a chance to rise there. But were its
politicians or its "social laws" particularly noble? And how could America be
presented as a model republic without displaying its cancer of slavery? Now Fuller
rejoiced in the Abolitionists whom she had found such unendurable fanatics when
she was with them at home. For in Europe the arguments she heard against the
emancipation of Italy were "the same as those against the emancipation of our
blacks; the same arguments in favor of the spoliation of Poland, as for the [Ameri-
can] conquest of Mexico."[5]

Thus not in contemporary America, but in Risorgimento Rome, Fuller dis-
covered her true homeland. In 1847 she appealed to the readers of the *Tribune* to
show their spiritual allegiance to the ideal America by sending practical help to
Italy:

> This cause is OURS, above all others; we ought to show that we feel it to be so. . . .
> In many ways Italy is of kin to us; she is the country of Columbus, of Amerigo, of
> Cabot. It would please me much to see a cannon here bought by the contributions
> of Americans, at whose head should stand the name of Cabot, to be used by the
> Guard for salutes on festive occasions, if they should be so happy as to have no
> more serious need. . . . I should like the gift of America to be called the AMERIGO,
> the COLUMBO, or the WASHINGTON. Please think of this, some of my friends, who
> still care for the eagle, the Fourth of July, and the old cries of hope and honor.

In 1848, in the midst of a letter evoking the "indescribable rapture" with which the
Roman populace celebrated the news of Metternich's fall and tore down the double-

headed eagle from the Palazzo di Venezia, Fuller acknowledged that terrible blood-shed was likely to accompany the necessary revolutions then underway throughout Europe. But Americans might be privileged thus to have a second chance: "to look on and learn in time . . . preventive wisdom. You may learn the real meaning of the words FRATERNITY, EQUALITY: you may, despite the apes of the past who strive to tutor you, learn the needs of a true democracy. You may in time learn to reverence, learn to guard, the true aristocracy of a nation, the only real nobles,—the LABORING CLASSES."[6]

Later in the year, to friends begging her to return to "her country," she could say only that America was not her true home. It was "stupid with the lust of gain, soiled by crime in its willing perpetuation of slavery, shamed by an unjust war." Italy, in contrast, was engaged in a struggle for brotherhood. "This is what makes *my* America." After the pope fled to Gaeta in November of 1848, and the Roman Republic was declared early in the next year, Fuller wrote angrily that Mr. Cass refused to recognize it, since his instructions were to wait to judge whether the Republic would survive. According to Fuller, recognition by the great Republic of the United States would itself contribute to the survival of its sister. Romans ask her, "Is it not true that your country had a war to become free? . . . Then why do they not feel for us?" But the contrast between the ideal of revolutionary America and the present compromised reality was too painful for a reply.[7]

Because of her extreme republicanism and her direct involvement in the events of 1849, Margaret Fuller's delineation of the political and social aspects of Rome defines an active American idealism by which other American representations of these aspects can be measured over the next hundred years. In 1870 the walls of Rome would again be breached to admit the troops of United Italy and to place a king in the pope's palace on the Quirinale. In 1922 Mussolini would ride comfort-ably through the gates on an express train to assume dictatorial command of both the city and the nation. Finally, in 1944 troops from the American Republic itself would break through the walls to be welcomed as bearers of the democratic stan-dards of freedom and equality. And in 1946 Italy would at long last become a united and free Republic with Rome as its capital.

The successive breaching of Rome's ancient walls between 1849 and 1944—whether by the forces of repression or those of liberation—is symbolic of the social and political processes at work within the city and in the developing nation that surrounded it. For nothing is more striking about American depictions of the Roman people than the sense that they are surrounded by walls—not merely the walls that had been built as a defense against barbarian invasions fifteen hundred years before, but many other walls—the walls of inward-looking palaces, convent walls, prison walls, ghetto walls—all designed to create separate worlds, to keep people apart, secure, confined, shut in, shut out.

The literal destruction of these walls was the aim of factions within the Risorgi-mento with which some Americans sympathized. The imagery, however, inevita-bly suggests as well the less tangible political, social, and psychological walls that existed in Roman society. Americans became fully aware of these also and fre-quently employed the natural metaphors of division. Usually they felt themselves

shut out: they looked through a barrier of language, of religion, of cultural assumptions. Inevitably there was a wall between Romans and *stranieri*, even when no one wished it. Many on both sides did wish it, of course, and for their mutual convenience a foreign quarter existed with its hotels, banks, bookshops, and tea parlors where "everyone" spoke English. But another division was more impressive to Americans than it was to the English or French, who had their own more beleaguered versions of the same thing at home: the absolute walls between the classes of Italian society, which were readily visible in the extreme differences between the lives of the rich and the poor. In their encounters with ubiquitous beggars at one extreme, and in their perception of—if not acquaintance with—the exclusive nobility on the other, Americans recalled the "self-evident" truth about men being "born equal." They had to work out a sense of Roman society and define their own attitude toward the people who composed it. For no matter what else they sought in Rome—political and historical meditations in the Forum or Colosseum, aesthetic joys in the Capitoline and Vatican, religious challenges in the churches—they could arrive at none of it without encountering, somehow, the Romans themselves.

In depicting papal Rome, monarchical Rome, and fascist Rome, Americans were far from being consistent representatives of the radical democracy heralded by Fuller. But her assertion that Americans had no interest in the Italian people or their social conditions was not true, even in her day, of those Americans who wrote, or even most of those who painted. She may have been thinking of those tourists (the great majority) about whose views we know nothing, or she may have been generalizing overboldly from the notorious case of Hiram Powers of Florence. Yet the equivalent of her generalization has often been repeated by historians and even extended to later decades when social commentary in fact became abundant. Some historians perhaps have drawn an unwarranted inference from the passivity of resident artists, to whom remaining in Rome meant everything. But a resident foreigner's discretion in an autocratic state does not necessarily imply an indifference to politics; it certainly does not indicate an "entire ignorance" of Italian life or a lack of interest in the Italian people.

The fact is that American writing about Rome, taken collectively, contains a discussion—often rising to vigorous debate—about social values (manners and morals), cultural differences (customs and religion), innate racial variations (temperament and intelligence), opportunities for self-fulfillment (economic and aesthetic), and forms of government (freedom and order). Both America and Italy are being defined in terms of each other, and the discussion is variously descriptive, prescriptive, and prophetic. Any one writer may hastily reduce a complex reality to the simple question of American or Roman superiority in one particular respect, but an entire network of opposing terms can be perceived in the pattern of the discussion as a whole: ancient versus modern Romans, Catholic versus Protestant values, the work ethic versus the sensuous enjoyment of life, aesthetic versus material achievements, papal paternalism versus republican self-government, constitutional monarchy versus fascistic dictatorship, and so on. There are even secondary distinctions, such as Pope Gregory versus Pope Pius as secular sovereigns. One of the more important of these emerges when American writers, within their general opposition of Anglo-Saxon to Roman, show a further concern to distinguish themselves from

the arrogantly judgmental English travelers with whom Italians tended to confuse them. Margaret Fuller expressed her horror when she learned that Frances Trollope had arrived in Florence, threatening to "Trollopize" Italy as she had America.[8]

Indeed, only a constant consciousness of America's differences—not any agreement about political and social values—makes these writings "American." Eclecticism thus becomes another essential American characteristic, not at first of the individual, but of the nation, and this national amorphousness, or lack of definition, in turn produces an uncertainty about identity that is itself a major opposition to the Roman identity, so fully defined. Therefore one of the most interesting aspects of these sociopolitical representations of Rome lies in their disclosure of Americans defining themselves, being surprised into self-doubts as well as self-satisfactions, imagining alternative lives and conditions of life, other modes of government, different combinations of values, other ways of seeing, other reasons for being.

The Pope's Children

When his five years' service as U.S. consul at Genoa ended in 1847, the thirty-two-year-old Charles Edwards Lester, great-grandson of the famous Puritan theologian and preacher Jonathan Edwards, went to Rome for the first time. He was soon summoned to the Quirinale for a private audience with his political hero, Pope Pius IX. In Lester's record of his Italian years, *My Consulship* (1853), this episode provides an intense climax to the second volume. Well known as the author of antislavery writings before his sojourn in Italy, Lester had used his time there to translate works by Machiavelli, Alfieri, and Massimo D'Azeglio (all published in 1845), to research and write a biography of Amerigo Vespucci (1846), to write the introduction to the Italian translation of Bancroft's *History of the United States* (1846), and to publish a collection of essays on the *Artists of America* (1846). Lester's audience with Pope Pius lasted several hours and differed totally from the perfunctory rituals accorded most Protestant visitors. It focused on the ideal of paternal government under a benign sovereign.

Flattered and gratified by the summons, this child of the Puritans knelt and kissed the pope's hand "as I would have kissed the hand of a venerable and beloved father." Someone in the cabinet of Charles Albert, king of Sardinia-Piedmont (which now included Genoa), had notified the pope that Lester was coming to Rome. The pope had his own reasons for wishing to talk with him. This was in March 1848, a time when the most severe political pressures were bearing down upon Pius. Liberal movements that he himself had done much to set in motion by actions taken soon after his coronation in 1846 were now achieving startling results throughout Europe. In January a revolt in Palermo had led to the granting of a constitution for the Kingdom of the Two Sicilies. In February the Bourbons had been overthrown in Paris, and in March the revolt in Vienna made possible the declaration of a Republic in Venice. Before this last event, the pope had already formed a new ministry for the Papal States, which for the first time included laymen, and then had granted a constitution. Cardinal Antonelli, however, was president of the

council, and the constitution preserved the power of the College of Cardinals and the absolute veto of the pope. Pius was being squeezed from both sides, and only eight months later he would flee from Rome.

Lester knelt before a man still venerated by liberals everywhere—including America. And Lester's record of the interview presents a pope whose motives were deeply sincere. The word *liberty* recurs constantly in his conversation, whether the topic is the heroic medieval pope Hildebrand, the greatness of America, or the possibilities of reunion of Protestants with Rome. (Lester's bold suggestion that popes would have to be democratically chosen "as we elect a President" was met with "a kind look" from Pius.) The pope offered to help Lester with his projected biography of Hildebrand by making available materials in the Vatican library. But he was even more eager to help when he learned (if he did not already know) that during Lester's years in Genoa he had written "voluminously but carefully of the events of the last few years," and expected "to print what I have written when I go home." Indeed, Lester's "chief object in coming to Rome" was not to observe ancient ruins (the modern world was already so much "grander") but to discover "the exact truth in regard to yourself and your Pontificate." Pius responded by expressing his great appreciation for "this kind work," it being precisely a historian's "noble" business to record "God's doing on the earth." Lester perceived no non sequitur in this reply, and Pius immediately summoned a monsignore, instructing him to put Lester into contact with a Cardinal ———, who could be relied upon to say whatever Pius himself would have said on the subject. But the interview continued with Pius's own explanation of his pontificate. He had begun with the wish "to administer the Holy See with the same views I had always cherished," that the Gospel and the Church "harmonize perfectly with the largest civil liberty." Priests must cease to be hostile to liberal governments, and the people to be prejudiced against priests. "The power of princes, as such, is gone . . . ; and henceforth they can neither preserve their thrones nor their influence, unless they . . . blend their ambitions and interests with the progress of the human race."

When the interview was finally terminated, Lester knelt again and begged for a blessing. He received probably the longest one ever recorded by any American. It extended not only to Lester, his wife, and his children but to "the country of Washington," that "asylum of exiles and of the oppressed" (where exiles from Pius's own Rome would be arriving within the year). Whereupon Lester "embraced his feet" and "kissed the diamond cross he wore there." He felt that he "was in the presence of a man Heaven seemed to have chosen to lead the human race out of the house of bondage." The pope then took him in his arms and told him not to be "discouraged for the world," for "statesmen no longer control it." After this, Lester fairly floated down "long flights of marble steps" and out into the midnight moonlight that fell upon the "imperishable horses of Phydias" that stand at the top of "this loftiest of the Seven Hills. . . . Below, lay the still city, and its mighty thousands; and they seemed to me like one vast family watched over in their paradise home, by a powerful, loving, and princely father. . . . And then I thought of that distant Continent, away beyond the sea, and how a new Rome was rising over the dim waters."⁹

By the time Lester published his book five years later, he found the sequel

"unutterably sad." "No man, in any age, has left Rome with higher hopes, or more glorious expectations of a reign of splendor," than had Lester in 1848. He believed that the sovereign pontiff of Rome "had undertaken the political and moral redemption of men." Now that "those hopes have turned to ashes," Lester can only defend himself from charges of naïveté by remembering that many of the most politically sophisticated men of Italy and of the world had likewise had confidence in Pius. Lester's history of the pope's pre-1849 pontificate—beginning with a detailed and dramatic account of the conclave that elected him (the cardinal to whom he was referred must have been remarkably candid)—occupies one-third of the volume. An additional fifty pages at the end sympathetically analyze the pope's failure, which is blamed primarily on the incapacity of the Roman people to exercise well the liberties he granted them. But all this is preceded by an angry fifty-page history of the reign of the preceding pope, Gregory XVI, who is barely recognizable as the big-nosed and kindly old monk whom we have heard Emerson and others describing so charitably. Lester's graphic description of the social effects of Gregory's incompetence and irresponsibility does much to explain both why Pio Nono was so ecstatically worshiped by his Roman children during the first year of his reign and also why their political immaturity placed them beyond redemption even by a tender-hearted father with noble intentions. Lester wished his readers to understand that after fifteen centuries of "servile degradation," which reached its nadir under Gregory, democracy was as impossible for Romans as it was "inevitable" for Americans.[10]

The story of the repressive reign of Gregory would be told by other Americans with historical hindsight late in the century, by William R. Thayer in *The Dawn of Italian Independence* (1892) and by William James Stillman in *The Union of Italy* (1898). But these accounts—tendentious in their own right—differ more in tone than in substance from Lester's highly polemical narrative of 1853. Thayer admits that since "Gossip" was "the Clio of Papal Rome," getting at the truth even a half-century later was very difficult; yet "you will search in vain through the opinions" of Gregory's contemporaries "of whatever party . . . for any commendation of Gregory's government."[11] Thayer (the future biographer of Cavour) was tracing the origins of the liberty and unity of Italy, an achievement he saw as one of the greatest events of the nineteenth century, not least because it freed Romans from ecclesiastical rule and ended the temporal power of all popes. In contrast, Lester's indignant account of Gregory is intensified by his personal love for Gregory's successor, who seemed to offer a version of paternal government suitable to Italians. In spite of Pius's sad defection from the reform movement, Lester still saw him as Gregory's antithesis since he was not personally to blame. The Jesuits, the French, and the Austrians all together were too much even for the God-sent Pius when the desire of those repressive powers that Romans should not govern themselves was joined with the unruly behavior of the Romans themselves. Gregory *was* to blame for the conditions Pius inherited; he had willingly consigned responsibility to cruel subordinates and had never troubled himself with the misery of his Roman children in this world.

Lester's pages on Gregory are written in the style of the so-called New Journalism

of the 1960s, as though he had been a direct witness to the private events he vividly describes. He begins dramatically with Gregory's grim and lonely death. Gregory has been abandoned by everyone except his former barber, Gaetano Moroni, who for years has run the papal household and is now allowing the pope to starve to death slowly while he ensures the preservation of the fortune he accumulated by receiving bribes for papal favors. Beyond the walls of the Vatican, all Rome is praying not that the Holy Father will live but that he will die. Lester then uses a flashback to the election of Gregory in 1831 as the typical compromise between warring factions of cardinals. A man of *"mediocre* talent, or exteme age, or feeble or timid character"* is usually chosen; and so it was with Gregory. "His reign began with cruelty"—the denial of "the right or privilege of petition." Although everyone knew some reform was necessary, Gregory "had lounged away some forty years of his life in the cloister" and "knew nothing about government." His only concern was to gratify "his love of ease" and "his personal pleasures." He belonged to "the dusty old ages; which flowed so quietly by, long before the seclusion of the convent was disturbed by the whistle of the steam-car." His ministers deliberately overwhelmed him with petitions so that he would become "crazed with business" and consign all power to them. Soon he refused to read a single petition. The "desolate, sad, wronged, and heart-broken" gathered at his gates, "but the weary old man shut himself up in the deep recesses of his palace, where his tired ear could no longer be disturbed by the cries of the distressed, or the prayers of the poor!" Thus he closed the door on the one means by which his predecessors had relieved the tyranny inherent in their autocratic government.

All civil power now fell into the hands of Cardinal Lambruschini, the secretary of state, who, everyone agreed, "in duplicity and cunning, in cold-blooded cruelty and tyranny, in hatred to all that was new in civilization, and in littleness and bigotry . . . surpassed every minister in Europe." The "blood of many thousands of innocent victims" was on his hands by the time Gregory died. At least twenty thousand were sent into exile, and an equal number executed or imprisoned, claims Lester, who says he took some pains to estimate the number by conversing with "very many persons from and in Rome, of all classes," over a ten-year period. An elaborate system of spies—eventually one-fifth of the population—constituted the "principal agency" of Lambruschini's government. It included all employees in government bureaus (such as postal workers), the army (which consisted mainly of Swiss mercenaries, alien to the local populace), a "large portion of the priesthood," especially the "fearful" Jesuits, and finally the police, which had in its pay countless citizens in all professions. Secret courts of "justice" condemned whomever they pleased. "I have myself seen individuals, who were sent into exile, who never were able to ascertain the crime for which they suffered; and thousands of others were thrown into prisons without knowing even the charges alleged against them." In this atmosphere bribery and perjury thrived, and good men were led to desperate actions while bad men felt secure. Cardinal Lambruschini's "political faith" was "that the only hope of the world lay in retrograding, with all possible speed, to the Middle Ages; . . . and that if the day which everybody else was hoping for should ever come, the ruin would be complete. . . . The Millennium was just dawning on

the world as Luther rose and spoilt it. The Inquisition had done something towards bringing back the good old days, but little could be hoped for till it should be once more established."

Yet if a "tourist who had just come from gazing on the fearful death of Laocoon and his sons" in the Vatican had been informed that "some modern Rienzi had just been strangled in an underground dungeon of St. Angelo," while his "aged mother" had died on her knees "under the merciless walls of that gloomy Bastile," the fact would "sound quite stale." Americans, "whose homes are sacred from the intrusion of spies," do not realize what it means to live under such a system, where "your music teacher, master of languages, your bookseller, who has just bought you some prohibited books, a flower girl," even "a poet-friend, who *for show*, has been imprisoned by the police for his songs of liberty," may all be spies. This is what it was like "in the Roman States while Gregory was alive and Lambruschini was his minister." "Men everywhere felt desperate." Only the long hoped for death of the pope could prevent "a general insurrection." Thus June 9, 1846, was the first happy day the people of Rome had known in fifteen years.[12]

The police-state character of Lester's Gregorian Rome is indirectly discernible in the letters, journals, and travel books written by Americans during Gregory's reign. But the irritated remarks they make about the filth and gloom and lassitude of the city and its common people convey the impression that such was no more than could be expected of a place that belonged irremediably to the past. The submissive character of the Romans seemed natural to their race, religion, and climate. When Pope Pius VIII died and Gregory ascended the throne in 1831, Samuel F. B. Morse was deprived of the Carnival, which was canceled from fear that the popular unrest elsewhere in Italy at that time might infect even Rome. An alarming rumor, that if a revolt occurred the pope-loving Trasteverini were going to murder all foreigners, would not have encouraged sympathy for the revolutionaries, who were already talking of depriving the pope of his temporal power and uniting all Italy. Just after Gregory's coronation, wrote Morse, there were other rumors that he would grant a constitution, that he would flee to another country, or that he would retire back to his convent. He did none of these, but instead filled his prisons. The possibility that Rome might ever enjoy American democratic freedoms under a constitution seems never to have occurred to Morse. His concern was the reverse, that popery would transform America. "Popery and Protestantism," he held, were "convertible terms" with "Absolutism and Republicanism." Popery was "the cunningest political despotism that ever cursed mankind," and America would be "politically attacked under guise of a religious system."[13] Morse's polemic required an absolute opposition between Rome and America, which any amelioration of social conditions of the Roman people, or any sign of weakness on the part of the pope or the "insidious" Jesuits, would have tended to undercut. He could therefore take satisfaction in the evils that confirmed his views.

The rhetorical convenience of perceiving a permanently degraded Rome as the political antithesis to America was naturally exploited by all of the more fervent anti-Catholics. In 1836 the Reverend Orville Dewey stated that the purpose of his European travel book was to show how the Old World gives the reader a "vantage

ground for surveying the institutions, customs, and character of his own country." America is kept always in mind, usually as the positive to a negative, except in the fine arts. Dewey found the Romans notable for their "prevailing gravity and depression." This "deplorable" condition, however, was actually gratifying to anyone who believed in scriptural prophecies:

> The vials of wrath are indeed poured out upon the very seat and throne of the papal hierarchy; the nobles of the land are reduced to poverty, and the poor of the land to beggary; its fields, its plains, once cultivated like a garden, and covered with villas, now lie waste, dispeopled, desolate, under the pestilential breath of the malaria; its villages are falling into ruins: the moment you cross the boundary line, you recognize the places that belong to the patrimony of the church, by their utter misery.[14]

No such fate, of course, awaited Protestant America, for which the prophecies were quite different.

A complex truth was also sacrificed to the exigencies of rhetorical oppositions when the purpose was to criticize Americans instead of Romans. When it occurred to James Fenimore Cooper in 1830 to contrast Rome with New York, beginning with the proposition that they were "physical" and "moral opposites," a truthful depiction of Romans was hardly likely to follow. In order to define New Yorkers as interested only in "Dollar, dollar, dollar, dollar; lots, lots, lots, lots!" it was necessary to depict the Roman shopkeeper as hardly willing to climb a ladder "to earn your *scudo.*" If New Yorkers thought only of the future, all Romans had to be shown "ruminating" upon the past. Romans proudly traced their ancestry back to dwellers on the Palatine, while New Yorkers scarcely knew their own grandmothers or "to what nation they properly belong." Cooper cannot say who is happier, but he is certain that he would rather have been born in Rome than New York or any other money-grubbing "trading town." As for any social change, it might be useful for Rome "partially" to "awake from its dream of centuries," but more probably it will go on just as it is "for ages to come," trafficking in "cameos, mosaics, statuary." Possibly it will simply die of malaria.[15] New York, unfortunately, will thrive.

Cooper's is one of the more extensively developed exploitations of a stereotypical perception of Roman character, supposedly authenticated by a brief period of direct observation, but managed without knowledge of Italian or personal acquaintance with a single Roman. In the early 1840s some writers began describing the Roman people on a more inductive basis, and citing more observable evidence than Cooper's to establish their contrasts with Americans. The closer observation resulted partly from different foci of interest (particularly among women writers), partly from the generic demands of the newspaper sketch or letter (which required vivid detail), and partly from the fact that the Risorgimento's progress in northern Italy made some writers more curious about the potential political capabilities of Italians. Many writers also found here an opportunity to differentiate their views from those of travel writers of other nationalities. However much Americans might defer to English and German opinion in the realm of art, when it came to judging the common people, Americans were experts. They were especially glad to prove themselves free of English prejudice about Italians. Moreover, some of these writers

simply possessed both a humane spirit and a precisely observant eye, neither of which is conducive to polemical writing. It was possible to see differences without resorting to denigration, and to see desolation without inferring despair.

Catherine Maria Sedgwick, fifty years old and famous as a novelist of the domestic joys and sorrows of the American household, is, in her *Letters from Abroad to Kindred at Home* (1841), constantly aware of contrasts and generally of her own country's superiorities in the things that mattered most to her (art not really being one of them). But she is more interested in particular differences than in wholesale judgments. And she is more than willing to follow the lead of a friend who refuses to consider "the 160,000 to 180,000 inhabitants who live within the walls of Rome . . . merely an accessory" to monuments and museums. Sedgwick gladly goes with her to the lively Piazza Navona market, where she is surprised by the variety of foods for sale (including cock's combs and the claws of poultry) and by the cheapness of vegetables. At a friend's home she asks the Italian repairman if the chimneys smoked, and soon afterward she takes note of a "shrivelled, shivering old woman sitting out of doors." When Sedgwick goes to the Vatican, the drive itself occupies three pages, for

> the lower classes of the people are *en scene* in the streets; and the stranger, who has no opportunity of seeing the better condition of Italian life, has here his best opportunities for observation; and I assure you, my dear C., these streets are a curious and affecting spectacle to one accustomed to the bustling, achieving industry of New-York, or to the quiet diligence and innocent leisure of our village life.

From a seat within her carriage, Sedgwick invites the readers of her letters—"dear C." and "little B."—to notice the unglazed ground-floor windows of workshops where there is little work because an "impoverished population" does not require the abundant manufacture of such things as hats and shoes. She points out sullen unemployed men wandering aimlessly about while others play quoits, and she observes that the "clamouring and gesticulating" women on the doorstep are "more cheerful than the men, because they are even more ignorant: they think less, and they have some employment: sewing and knitting are unfailing to women." Swaddled infants, tended by dirty urchins, seem content, for strangely they are never heard to cry. Further along toward Ponte St. Angelo, we come upon soldiers, and then must stop to let the hooded Capuchin friars pass. Finally we are besieged by beggars crying "Muoro della fame!" and "Non m'abbandonate!"—a petition "forever repeated and often true, and thank God, dear B., that you never heard it in your own country." A cardinal's gilded coach dashes on before them as they arrive at the Vatican: "shall we go in, and in that beautiful marble world forget this world of flesh and blood—of sensation and suffering?"[16]

Sedgwick's effectively ordered sequence of Roman genre scenes contains only one or two allusions to America—as a place of abundant manufactures and an absence of beggars. On another occasion, when she heard "a murmuring of tiny voices," she looked into a "dark, damp, cold den" and saw "ragged and dirty" children being taught to pray in *Latin!* She then "thought of the well-lighted, warmed, and spacious school-room in my own country, and the light poured into

the young mind there!" And one night when she was awakened by the bells of a nearby convent, she confusedly thought they were announcing the arrival of an Albany steamer. Suddenly homesick, Sedgwick contrasted "the indications of the bells of the two countries, pretty fairly illustrative of their different conditions":

> The steamer's bell announces the arrival of the politician, busy with the project of making a new governor and dislodging an old one, or framing new laws and abolishing the old; of the philanthropist, who has come to examine prisons, establish a peace society, disseminate Bibles, or help on the extermination of slavery; of an author, about to publish some new theory in religion, or politics, or social life, which is to reform the morals and mend the manners of mankind; of the inventor of a new machine which is to improve the fortunes of the human race and make his own; of a host of merchants to buy and to sell. . . . And what say the midnight bells of Rome? Why, that the poor monks and nuns must out of their beds and troop to prayers! In the severer orders the summons is repeated three and four times during the night—this, dear C., is the productive labour of Rome![17]

This passage acknowledges the existence of evil in America—slavery, prisons, possibly some political shenanigans—but the evil is totally subsumed by the bustling, open atmosphere of intellectual and technological innovation, of self-government and reform, of arrivals and departures. The labor of all Rome, on the other hand, is reduced to dismal monastic prayers, confined within convent walls.

But Sedgwick's sketches are never meant to record more than the impressions of the moment. Willing to contradict herself and anxious to be fair, she is not given to deliberate and absolute summary judgments like those of Cooper and Dewey. She sees that the undeniable sullenness and sadness of Roman men might be "the faint dawn of a better day," since they obviously feel their oppression. She also wonders why, if all the terrible things travelers commonly say about Romans are true, the few whom she herself has "chanced to know"—the vice-consul J. E. Freeman's wife (who as a wife meets our "exacting New-England" standards), Sedgwick's landlord and his family, and her coachman—are all honest, generous, and virtuous. There is "superfluous reviling in this world," she concludes. According to "Mr. G." (George Washington Greene?), in his twelve years in Rome he had known only one robbery, and the few murders resulted from the fact that there is "no public justice" available to right wrongs. While viewing the revered statue of the Virgin in Sant' Agostino (fig. 2), Sedgwick particularly notes the nearby column loaded with "daggers, pistols and knives," testimonials to crimes evaded or forgiven. "The police of Rome is wretched," she asserts. "The laws are ill-administered. Atrocious offenses escape justice, and small ones, if they be against the church, are punished." In conclusion, it seems to her that the papal government treats its people just as Americans treat Indians, with similar degrading results.[18]

William Mitchell Gillespie also sought to perceive likenesses and differences without resorting to terms of virtue and vice. The final words of his *Rome: As Seen by a New-Yorker in 1843–44* are ("in imitation of Alexander to Diogenes"): "If I were not an American, I would be a Roman." According to the reviewer in *The United States Magazine and Democratic Review*, Gillespie's defense of the modern

Roman in his last chapter in fact showed "more amiability than justice."[19] But Gillespie intended an explicit refutation of Anglo-American prejudice. The "fashion" of characterizing modern Romans as "spiritless and cowardly, superstitious and ignorant, effeminate and cruel" can be explained only by the travel writers' fear that their "unvaried praise" of Italian nature and art required some relief, which they provided by pouring "vinegar and gall" upon "the character of the people." The "unprejudiced observer," however, will see that the modern Romans, although "enslaved by a narrow-minded hierarchy" supported by the overwhelming power of Austria, are not "unworthy of their illustrious ancestors." Pope Gregory's government would not be "busily imprisoning and shooting" some of his children if the "struggles for liberty" were not still occurring. Moreover, with spies everywhere, the Romans cannot express openly what they really feel, so the foreigner mistakes their silence for stupidity and sullen resignation.

Gillespie's simple thesis is that whatever faults the Romans have are "mostly due to their *Government*; their good qualities to themselves." The cardinals who run the government "are a century behind the rest of the world in political enlightenment" and are against the development of commerce in Rome. They are concerned only with the propagation of the faith "over the whole world," not with the "temporal good" of their local subjects. Higher education is focused exclusively upon the Church's mission, so anyone who undertakes "liberal investigations" becomes "a dangerous citizen" to be kept under the "surveillance of the police." Elementary education is plentiful, but controlled by a priesthood interested only in perpetuating its prejudices and inculcating "the duty of unreasoning submission to the powers that be." Gillespie's sense of irony perhaps fails him at this point, for he goes on to say that "the people are taught that their own country and government are the best in the world. Of America they have a confused notion." But "cramped and hedged in" as the Roman mind is, it yet shows "unsurpassed acuteness, activity, and power, in the few subjects in which it is allowed fair play," such as theology and archaeology. The common people also are famous for their wit and their "graceful turn of thought" in "every-day language." Romans possess "superior sensitivity" in general, and show "extreme sensibility" to perfumes and to the fine arts. They "idolize a favorite painter, or deify a *prima donna*," instead of "shouting for Hickory poles, or Ash saplings," like Americans during political campaigns. Indeed, the "frenzied applause" at Cerito's "farewell appearance" reminded Gillespie of an American "Mass meeting."

As for *"Superstition"* in Rome, it certainly exists, although less prevalently in the city than in the villages, and more among the lowest class and the nobility than in the more skeptical "middling classes." These nonconformists, however, must of course keep silent, since the Inquisition still exists. But having abandoned physical torture as an instrument of enforcement, it "is not much worse than our own Inquisition of Public Opinion." Finally, the conventional charge of *"Indolence"* is "most unjust." Country people labor incessantly from dawn until dark except during "the sultry hours," and the city dwellers are remarkably "persevering and ingenious in their labors," considering how few and ill-rewarded are the jobs available to them. And in the midst of all the poverty, the essential Roman character is

shown nowhere better than in the city's all-encompassing system of charities, which engages the compassionate labors of the nobility and ecclesiastics as well as the common man. In summary, Romans "of all ranks" are a people in harmony with the "beauty and grace" of their land, their language, and their artistic heritage. Gillespie has learned in Rome "to prize more highly than ever the political and religious privileges of his own free land," yet when he recalls what the Romans have been, "and what they may again be, and, beyond all doubt, eventually will be," then he claims with them a second homeland.[20]

As in Gillespie's reference to the "Inquisition" of American public opinion, some writers discovered not opposing vices and virtues but equivalent defects on both sides. The Reverend William Ingraham Kip, in his chapter on "The Roman People" (1845), made the now-conventional distinction between the government and the people, excused their inactivity on the basis of oppression and climate, argued that the large number of murderers and robbers did not inculpate the "great body of the people," and then noted that the customary ridicule of their superstitious nature came oddly from citizens of a "land which has witnessed Salem witchcraft and Mormonism—without mentioning countless other developments of fierce fanaticisms."[21]

Another book published in 1845, Joel T. Headley's *Letters from Italy* (based on his sojourn of 1842–43), proudly maintained the old oppositions, however. Claiming to give more attention than former travelers did to the social conditions of Italy (a claim nearly everyone now made), Headley seldom missed an opportunity to show the superiority of America. When direct comparisons were possible, America won: American women, for instance, certainly surpass their Italian sisters in appearance, manners, and morals. When the Roman element is unique and magnificent, such as the Easter services at St. Peter's or the "Girandola" fireworks at Castel Sant' Angelo, Headley's method is to describe it in such a way as to show first that he has the capacity to appreciate it and then to introduce some pitiful beggars, true objects of the pope's "maledizione," or a political dissident who mutters subversive remarks into Headley's ear while they watch the Roman candles flare into the sky. He somehow knows that "hundreds" of Romans "return to their homes with dark and bitter thoughts" concerning their "degenerate country" and the "wastefulness" of their "monarch and spiritual father, who in this costly amusement robbed hundreds of mouths of their daily bread." Like Sedgwick and Gillespie, he believes that rebellion lies just beneath the "calm surface." "Men begin to ask questions in Rome as well as in America," so the papacy is doomed. The muttering rebel tells him that there is "as much genius and mind in Italy now as ever," but an "imbecile, yet oppressive government" does not foster them. When the infernal volcano of fire erupts over the Castel, he declares that *"hell is in Rome nowadays,"* and becomes so satirical about "his Holiness" that Headley begins nervously looking about for spies and gendarmes. In spite of his recognition of the smoldering rebellion, Headley ends his book with a summary statement about the "Character of the People" in which he concludes that their "struggling spirit is not strong enough. . . . The poor and suffering have become too poor. They are beggars, that do not care enough for liberty to fight for it. Beside[s], those who should guide the popular will, seem to lack the

steady energy that inspires confidence. The love of pleasure and its pursuit takes from the manliness of the Italian character, so necessary to a republican form of government."[22]

Headley's book was scornfully reviewed by Henry T. Tuckerman, whose two editions of his popular *Italian Sketch Book* (1835 and 1837) had perhaps established him as America's leading Italophile. His "A Word for Italy" in the *United States Magazine and Democratic Review* firmly attacked the Anglo-American puffery that deformed Headley's comparisons, and he pointed out numerous errors of fact. All this was especially unfortunate in a publisher's popular series, which was sure to spread jingoistic ignorance and prejudice far and wide.[23] Tuckerman's own *Sketch Book*, however, was not entirely devoid of the kind of "generalizations" he now complained of, and it is a measure of the growth in sympathy with the Risorgimento (and possibly of a more critical view of American democracy) that he now felt compelled to attack them. After the new pope's liberal actions in the next two years had apparently transformed the prospects for Italy, and for Rome in particular, Tuckerman published in April 1848 a much revised and enormously expanded third edition of the *Sketch Book* in which his own interpretation of modern Rome was almost reversed.

The early editions had heavily stressed the "moral" and "intellectual" value of a visit to Rome, thanks to its ancient monuments and its art. In 1837 Tuckerman did express a hope that the book would awaken "an interest and faith in humanity" as it existed in Italy, but his principal point was that the well-prepared visitor would discover how America was bound to Italy through Antiquity. The frontispiece was an engraving of one of Cole's paintings of the Claudian aqueduct. In 1848 this was replaced with a portrait of Pope Pius IX. The new preface asserted that "the eyes of the civilized world are now turned full of expectation and sympathy toward Italy." The most important additions to the book are a new introduction on "the present social and political state of the country" and a completely rewritten essay on "Modern Italy."

In 1837 Tuckerman had found the condition of Rome almost hopeless and impossible to ignore: "The degeneracy of modern Rome is a subject ever forced upon the thoughtful resident. . . . He cannot rejoice unreservedly in the splendors of human art, when humanity is a wreck around him; he cannot indulge in stirring retrospection over the sculptured figure of an old Roman, while it serves but to render more prominent the moral deformity of his descendent." Tuckerman found the amount of "personal violence and murders" in Rome "almost incredible." Like Sedgwick, he attributed this to the government's exclusive concern for political crimes. A man was hanged only after he had committed his fourth murder. Pope Gregory's costly rebuilding of St. Paul's Basilica, however, was fortunately bankrupting the state and thus destroying his power. Tuckerman expected a revolution. But the 1837 version of his essay on "Modern Italy" does not make it clear why. There the defense of Italians rests upon Tuckerman's appreciation for qualities that others overlook or that others think are faults and he thinks are virtues, but none of them suggests a capacity for successful political revolt. Where others see imposition and mendacity he sees "rare urbanity and friendliness." Where others see laziness, he sees a love for the beauties of life—poetry and music, both greatly appreciated by

the common people. Italians find life worth living in a way that the "ultra-utilitarian spirit of the age" prevents Americans from experiencing. It is true, however, that Italian women are inferior, usually lacking "the intellectual charm, the religious graces, the native modesty, which are the glory of the American female character." Italian women, Tuckerman boldly asserts, have a vivid imagination without moral control. There is, moreover, a "mutual conspiracy" of priests and women—the two classes that *ought* to be "the chief purifying influence"—to stamp out all liberal sentiment. It "embitters and undermines all excellence, individual and political." Consequently the political prospects of Italy are almost hopeless. Italy "is not yet virtuous enough to maintain the forms or evolve the moral glory of genuine national freedom." The "moral constitution" of America is "almost a complete contrast," Tuckerman concludes. In the end his admiration for modern Italians rests not upon a sense that they have the morality, the intelligence, or the courage to overthrow the despots of the Vatican, Vienna, and Naples but upon the fact that they have maintained "an intellectual dominion" and "an empire of the heart" where "the mere external sway of the political sceptre has been most sadly subverted."[24] Such is the comfortably compensatory conclusion of the aesthetic humanist who has no need to fear hunger or imprisonment.

Tuckerman's new introduction to the edition of 1848 encourages an entirely different view. The "general amnesty granted on the accession of Pius IX, and his subsequent liberal policy" awakened "enthusiasm" everywhere. Although the pope has recently caused some doubts about his steadfastness, the "political and social regeneration of Italy has begun." The "spirit of the age has penetrated to the heart," and Tuckerman feels justified in "indulging sanguine though not extravagant hopes." One of the most promising signs is the establishment of Civic Guards to replace foreign soldiers in Tuscany and Rome, since a citizen force "inspires all with self-respect." Second, there is more freedom of the press, which will develop the "greatest social engine of the age—public opinion" (the very thing Cooper and Gillespie saw as America's form of despotism). Heretofore the "great barrier to all political reform" was Rome's "system of intolerance and brute force. Catholicism, as a political institution, is inimical to human progress and freedom, and has presented the chief barrier to the emancipation of modern Italy." Therefore, "among the many contingencies which the imaginative Italians have suggested, no one ever dreamed of a liberal Pope." Only the "agency of Providence" could have provided one. Against the Austrian and Jesuitical oppressions that are still occurring, Tuckerman proposes a "holy war against this gross outrage of human rights." The introduction ends with the hope that the justly popular pope will be able to "escape the machinations of Jesuitism"; if so, "his way is clear."[25]

In the rewritten essay on "Modern Italy," that "land of beauty and anguish," Tuckerman reminds those who still condescend to Italians that the greatest living linguist is Cardinal Mezzofanti (who became for a time one of the obligatory sights of Rome), the greatest living dramatist is Nicolini, Segato made great discoveries in chemistry, and Rossini and Bellini "are the most permanent sources of musical enjoyment in both hemispheres." Forgetting some of his own remarks of 1835 and 1837, Tuckerman castigates the shallowness of those American travel writers who go beyond description to analysis and arrive at the most presumptuous judgments.

Americans are guilty of very selective reporting in promoting the image of their own country as an Eden, while being only negatively selective about modern Italy, he declares, proceeding to make some corrections on both sides of the ledger: He now finds that no generalization about Italian women is valid, since the best of them are never seen on the streets. Considerate manners in Italy are instinctive, rather than being born of "any abstract theory of human rights" such as controls behavior in America. Americans show "precocious age" because their lives are "responsible, monotonous and cold," filled with care and ambition, whereas the Romans, paradoxically, living among the ruins of antiquity, remain youthful and carefree in spirit. Assuming a Toby Belch–like posture, Tuckerman says: "Let not the puritanic mind of the North, therefore, deem its own creed applicable to all the world, or quarrel with a cheerfulness whose fountains gush from the throne of Divine beneficence." For the pleasure Italians take in life is *not* "ignoble contentment" with their lot. When they have added liberty and education to their blessings, where then will be the superiority of America?

> The wonder, the mystery, the glory, the hope of [Italy's] state, lies in the fact so apparent, so grand, that notwithstanding these long epochs of oppression, these baffled national hopes, these priests and beggars, spies and traitors—the invader's sullen footstep and the official's jealous eye—Italy lives—not as a corporate political essence—but in the instinctive and characteristic life of her children.[26]

As Americans in the next two decades showed increasing interest in the "characteristic life" of Rome, the "children" themselves went through three distinct political experiences: the euphoria of benignant paternalism under Pius, then the excitement of a free but besieged republic, and finally the oppression of an autocracy supported by foreign troops. In highly rhetorical representations of these three historical phases, American ambivalences, disagreements, chauvinistic distortions, condescending appreciations, and sober efforts at understanding both Romans and themselves intensified.

Toward a "Rome of the People," 1848–49

Tuckerman's revisions indicate the difficulty faced by those who wanted to praise Italians both because they had an un-American genius for enjoying and enhancing life and because they possessed the sturdy republican virtues of their ancient ancestors and modern Americans. Could Nature's Aesthetes also fight for their rights like Nature's Noblemen? Caroline Kirkland, author of *A New Home—Who'll Follow?* (set on the Michigan frontier), visited Italy in 1848. In *Holidays Abroad: or, Europe from the West*, she said she was glad she had seen Italy in "the Year of Revolutions," for "much as I should rejoice to see the liberties of Italy confirmed," the fact is that "republicanism is good, but it has not yet learned to be beautiful." The Italians she thought "a most amiable people," gentle and well mannered, but at the same time it

pleased her to think that the Trasteverini—those inhabitants of the right bank of the Tiber who claimed direct descent from the ancient Romans—resembled "our men of the South-west—Missouri or Arkansas" in being "a fierce and rude race."[1] Thus Romans were expected to combine two contradictory American ideals.

The advent of an apparently liberal pope in 1846 seemed to have solved the problem: a gracious sovereign would grant his subjects the dignity of free citizens without requiring them to fight for it; a benign Father would find the paternalistic middle ground between tyranny and republican anarchy appropriate to the modern Roman people. The more romantic Americans in Rome immediately sent back the news. In November of 1846, just a few months after Pius had become pope and declared amnesty for most political prisoners, the twenty-two-year-old George William Curtis wrote a "Letter from Rome" to friends at the socialistic Brook Farm Phalanx, which they published in their newspaper the *Harbinger*. To these egalitarian visionaries he described an alternative vision in the relation between pope and people as he perceived it on jubilant festival occasions. It was an image of "the paradise of a wise Christian" where "the mass of people," drawn only by "reverence and respect" for a "chief" who made "no appeal to passion or pride," could be seen "obeying a noble instinct."[2]

Curtis's older Transcendentalist friend, the poet and painter Christopher Pearse Cranch, was also experiencing Rome for the first time in this unusually hopeful atmosphere. After Curtis departed for Germany, Cranch and his wife stayed on. They renewed their Boston friendships with both William Wetmore Story and Margaret Fuller, who arrived in 1847, and with them they tried to enter into the new spirit of the city. In December Fuller wrote to Emerson that she liked to be within the "influence" of the "genuine" love the people displayed for the pope. "It was his heart that gave the impulse, and this people has shown, to the shame of English and other prejudice, how unspoiled they were at the core, how open, nay, how wondrous swift to answer a generous appeal!"[3] The pope's benevolent liberalism was assumed to embrace the popular movement throughout Europe. Both Fuller and Cranch wrote letters describing the jubilation of the Romans when news of the Viennese revolt and of Italian victories in Lombardy was received in March of 1848, and in *Roba di Roma* Story recalled the spectacle as the most brilliant popular demonstration he had ever seen. Cranch's letter gives a sense of direct participation:

The Corso was crowded, everybody wearing tri-colored cockades, feathers and badges and sprigs of box. They collected in large numbers about the grim old Venetian Palace, the residence of the Austrian Ambassador—and ascending the walls with a ladder, tore down the Austrian arms with triumphant shouts, threw the escutcheon into the street and danced upon it. . . . In the evening I thought I would walk into the Corso to see what was going on—when the whole blaze of the *Maccoletti* burst at once upon me. . . . I never saw such jubilant joy and enthusiasm; crowds upon crowds singing national hymns, and shouting, and all holding up their lights. . . . I got into Perkins's carriage, and . . . with our flaming torches in our hands we drove home to the Pincio. On the College of the Jesuits they wrote *Locanda* (to let); and were hardly restrained from doing violence to the premises.[4]

The joy of the Romans in the apparent overthrow of tyranny in Austria was stimulated by the idea that it made possible the fulfillment of the dream of a united and independent Italy with Rome as its capital. Unity and independence, not republicanism, were the two goals the various factions of the Risorgimento were agreed upon. The anti-Jesuit monk Vincenzo Gioberti's *Il Primato morale e civile degli Italiani,* published in Brussels in 1842 (and banned everywhere in Italy except Piedmont), proposed that Italy should regain its ancient importance among the nations by being united under the pope at Rome, the city that gave Italy its moral primacy because there "Heaven has established its seat." Gioberti's "faith in the Pontiff," wrote William J. Stillman five decades later, was "evidence rather of his devotion as a churchman than of his perspicacity as a statesman." The only thing that gave credibility to this idea—preposterous while Gregory XVI still wore the tiara—was, according to Stillman, "the singular and unique accident" of the advent of a "reforming Pope" in 1846. Many joined in the vision of Italy reborn as a constitutional monarchy with a Holy Father as sovereign. Tuckerman wrote a sonnet "To Pius IX" invoking him as a "Benign Reformer" whose "purpose" was to "give a nation birth." The poet assured the pope that "vain is the Jesuit wile, the Austrian steel" against his purified "sceptre." All the world now "hails the Vatican as Freedom's home."[5]

But by the time Gioberti visited Rome in May of 1848 the pope had already lost much of his popularity. Only threatening demonstrations had forced him to expel the hated Jesuits from Rome, and he had refused to sanction the use of troops from the Papal States in the popular war to liberate Lombardy from Austria. On April 29 Margaret Fuller had gone to Monte Cavallo to see the "broken windows and burnt door" of the pope's palace, and in the piazza where she had seen vast crowds kneeling in adoration of the pope just a few months before, she now saw little children at play chanting *"Sedia Papale, Morte ai Cardinali, e morte al Papa!"* Gioberti received the sort of ovation from the populace they had been regularly giving the pope for the preceding two years. "An illumination took place last night, in honor of the 'Illustrious Gioberti,'" wrote Margaret Fuller to Madame Arconati on May 27. "He is received here with great triumph, his carriage followed with shouts of *'Viva Gioberti, morte ai Jesuiti!'* which must be pain to the many Jesuits, who, it is said, still linger here in disguise."[6]

Caroline Kirkland detected that "the people just now are a good deal dissatisfied" with the pope "because of his reluctance to prosecute the war with Austria." She understood his hesitation about confronting "the most potent catholic sovereign" and saw that he was caught between "his people mad for liberty, and Austria bent on despotism." His only "safety" was in "perfect sincerity and candor," not in the "temporizing" policy he had adopted. Kirkland drew her first inferences about him from his appearance in the procession of Corpus Christi, where unfortunately he looked "like anything but a man of sense and spirit," but rather like "the Grand Lama of Thibet." Since he was carried upon a platform in a faked pose of piety, his appearance in this procession was especially irritating (Story and other writers also laugh at it): "His white damask and silver robes were made to enclose a kind of table or reading desk, before which he is supposed to kneel, though in reality he is sitting." Two blocks of wood shaped like red shoes poked out behind the carefully

arranged robes in an attempt to sustain the illusion, but they fooled nobody. "We were very sorry to have seen him thus. . . . 'Pio Nono, Liberatore,' is placarded on every corner of every Italian town, and his name has been on every lip; but it is hard to connect this enthusiasm with the face and form we saw today."[7]

Kirkland's bad impression was corrected by her subsequent private papal audience (before which she had taken a nap "in order to avoid the indecorum of yawning at the Quirinale"). At home in his palace the pope, extraordinarily handsome for a man of fifty-six, was very affable as he constantly bowed and took snuff. The conversation—or Mrs. Kirkland's interest in it—was entirely political. She recorded that Pius "spoke of what he desired to do—of his attachment to liberty," of his distinction from other sovereigns in that he had no interest in extending his territories, but only in defending them, and of his desire for "peace throughout the earth." War "must always be odious to him." This explained his unpopular refusal to join in the fight against Austria. His "incessant" taking of snuff had "not yet injured" his French enunciation, and "we came away . . . quite charmed with the sovereign pontiff, who appears at home like anything but the Grand Lama." His ruddy health belied the rumors that the disgruntled Jesuits were slowly poisoning him. He was indeed "so pleasing and attractive" that "we venture to pity" him in his "very difficult" position.

Certainly Pius continued to be very popular, whatever "the blazing politicians" of Italy may "murmur" about him. "Every poor woman in the street has his image hanging with the cross on her rosary. . . . His name occurs on every corner. 'Viva Pio Nono' graces every old wall and broken arch." Even Gioberti, "the all-powerful Gioberti—who spent two or three weeks in Rome lately, much with the Pope—pronounced him sound in his Italian principles. This quieted the murmurers for a time, but Gioberti went away, and doubt returned." Confessing that it was almost impossible "to come at public opinion" in Rome, since "the property holders" certainly differed from the "loud talkers" of the cafés, Kirkland reported that the possibility of deposing the pope if necessary had already been spoken aloud:

> But Gioberti is decided against a republic, and therefore it is probable even in the last resort, a limited monarchy will be preferred; so our friend the Pope will stand a good chance for maintenance of his temporal sovereignty, if he continues to exhibit the liberal spirit which has made him so popular. There is well known to be a powerful Austrian influence all about him, but the spirit of the age is against its triumph.

Kirkland's optimistic reliance on "the spirit of the age" is typical, but her brief analysis of the political situation in Rome is more astute than most made by travelers on the run during a visit to Rome, and it lacks the fervent bias of the Mazzinian Fuller. When her book was published the next year, it was of course necessary to add a note saying that "subsequent events . . . make any comment on the Pope's character and conduct seem superfluous." She was most of all saddened by the contradiction between the "earnest words" she had heard him speak concerning the impossibility of his approving a war, and his current cries from Gaeta to the Catholic powers "to shed the blood of his subjects." Kirkland now happily dis-

covered among her notes one that read "His countenance does not impress one with an idea of much mental power." She would rather believe him stupid and cowardly than evil.[8]

Others did not wait for the pope's flight to Gaeta and his call upon the forces of Catholic tyranny to start denouncing him, nor did they offer him the excuse of stupidity. Cranch, who during a trip to Naples in April decided not to return to Rome because it was "too disturbed," retreated to Florence, where he wrote an angry poem called "The Bird and the Bell," which received the thoughtful criticisms of the admiring Brownings.[9] It refers to the pope as "The querulous old man who stands between / His children and their hopes, with threats insane," and to Rome as "the last hiding-place of tyranny." The pope is warned that his "juggling false-hoods" will one day be exposed and that he should "Look to the proud tiara on thy brow!":

> Lo, thou art numbered with the things that were,
> Soon to be laid upon the dusty shelves
> Of antiquaries,—once so strong and fair,
> Now classed with spells of magic, midnight elves.[10]

Although most of the American artists resident in Rome remained prudently neutral during these turmoils, not all were immune to the distinctive atmosphere of 1848. Thomas Hicks (aged twenty-five) painted an *Italia*, which Tuckerman describes as "a half-length ideal female figure." (The artist's sanguine vision of the potential nation had apparently not been drained by his being stabbed in the back during Carnival.)[11] A painting by Hicks's friend Martin Johnson Heade, *Roman Newsboys* (fig. 15), is a work of a totally different kind. Instead of allegorizing an abstract and timeless ideal, his beautiful composition captures a particular time and place at a point when and where the "news" was changing daily. The figures of two boys—one in sunlight and one in shadow, both holding out news sheets to an unseen person approaching from the left—are outlined against a typical graffiti-covered Roman palace wall. The corner of a heavily barred window high above the pavement notches out one corner of the painting and looks into a void. Allusions to the pope and to Cardinal Antonelli, including a caricature, are among the scratched salutes and "vivas" on the wall. An old peremptory "Avviso" (Notice), mostly weathered away, disappears off the right side of the painting, while a more recent but also fading poster alludes to Roman freedom, and the freshest of all, still whole and placed high near the center, is a call from "GIOBERTI AI ROMANI." One boy wears a papal dunce cap–tiara bearing the words "Pio IX." The newspaper proffered with such innocent and rather plaintive (but not sentimentalized) expressions is the savagely satirical *Il Don Pirlone, Giornale di Caricature Politiche*, "the *Punch* of Rome" (as Margaret Fuller called it),[12] which began appearing in 1848 and died with the Republic in July 1849. Its malicious representation of a cowering Pio Nono, puppet and parrot of Cardinal Antonelli and "King Bomba" of Naples, is the anti-type of Gioberti's noble ideal, so recently proclaimed to the citizens. Heade's painting thus compresses four phases of the political "news" of Rome in 1848–49 into one painting and conveys the ephemeral essence of "news" itself.

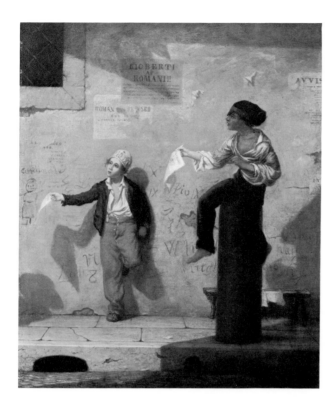

Fig. 15. Martin Johnson Heade. *Roman Newsboys.* 1848. Oil on canvas. 28½ × 24⁵⁄₁₆″. The Toledo Museum of Art, Ohio. Gift of Florence Scott Libbey. (See plate 1.)

When Charles Eliot Norton visited Rome in 1857, he was able to peruse several secretly preserved rare copies of the *Pirlone,* itself now tattered and dim while the man it attacked had his tiara firmly back on his head. Yet Norton found in its pages the freshest *artistic* expression of modern Rome. Crude as some of its drawings were, for a few months it had been a medium for the kinds of intelligent conception and vigorous representation that are impossible—said Norton—under oppressive governments. Its dramatic and witty caricatures were the antithesis to the "utter sterility and impotence of mind . . . , the deadness of the Roman imagination, the absence of all intellectual energy in literature and Art," which "are the necessary result of the political and moral servitude under which the Romans exist." The pages of *Don Pirlone,* he concluded, illustrated "not merely the course of events and the popular feeling of the time, but, on a small scale, they show the working of eternal principles, and explain the degeneracy of modern Italy."[13]

Books on Italy published between 1849 and 1851 were unable to achieve Heade's elegant formal assimilation of the volatile political atmosphere of Rome. In *The Genius of Italy* (1849), Robert Turnbull produced a carefully planned intellectual and moral history of Italy from Dante to Gioberti that is geographically rather than chronologically arranged, since "the genius of a country is always localized." It provides intelligent summary critiques of the great figures as they arise in association with scenes encountered during a tour of the peninsula. But the book is pockmarked with interpolated paragraphs and long appended notes that tried to keep it up-to-date while the political situation in Italy was changing daily. In 1849

Mazzini suddenly returned to Italy and became the virtual dictator of Rome. Turnbull hastily furnished a long biographical note, whose penultimate paragraph asserts that "Mr. Mazzini . . . is now in Rome, . . . revolutionizing the country"; the very next paragraph says, "But, alas! Mazzini is once more an exile from his native land."[14]

Turnbull's thoughtful chapter on Pope Pius IX was obviously written in mid-to-late 1848, after the pope had lost his popularity but while he remained in power. Turnbull usefully contrasts Pius with two of his predecessors: the stong-willed and steadfast Pope Hildebrand (Gregory VII) of the eleventh century, who had asserted a unifying papal dominance over all temporal powers, and Pope Gregory XVI, who is presented as a feeble drunkard whose degenerate reign had created the necessity and opportunity for reform that Pius at first seemed to grasp. Hildebrand, who had made an emperor kneel in the snow, serves to define Turnbull's ambivalence about the spectacle of Pius's capitulations to "the caprice of the giddy populace," which went far beyond what he desired and what was prudent. At this point in his analysis Turnbull appears to have learned of the murder of the pope's minister of state, Count Rossi, and of Pius's flight to Gaeta in November. This news is reported in an awkwardly interpolated page, to which is added a paragraph of rhetorical questions intended to be probing, but conveying only perplexity. Turnbull then returns to his previous narrative plan, which required a sarcastic exposé of Gregory XVI's personal corruption, by which the comparative virtue of Pius was meant to be seen. The final pages—clearly written in early 1849, before either Mazzini or the French had arrived in Rome—expresses "our sincerest pity" for the pope at Gaeta, whose task of reconciling diametrically opposed forces had proven to be an impossible one.

Turnbull predicts that the pope will "be restored somehow to his place," but that henceforth he and his successors will be nothing but a "shadow" and an "echo" in the "new age." Yet the "Roman liberals" who have taken power do not "really understand the nature and genius of a true and orderly freedom." They have "worn their fetters too long" and they "have too little knowledge of the Bible." But they have an "undying instinct, the quenchless love of liberty," and time and the Gospel will lead them to freedom, after perhaps "ages of toil and discipline, . . . of tears and blood, of agony and prayer." Even after so prophetic-sounding a conclusion, when Turnbull turned to write his preface he had to admit that some of his passages "may appear almost obsolete." Indeed, most of the preface itself is rendered obsolete by its own conclusion: "But the ink from our pen is scarcely dry, when we are startled by the news" that the liberty he has just been heralding as the inexorable spirit of the age, even in Italy, has been crushed.[15]

In the outrage and depression that followed the death of the Roman Republic, American poets took up their pens. Tuckerman was obliged to write a new sonnet "To Pius IX in 1849" to print opposite the 1848 version in his collected *Poems* (1851). He now addressed the "Benign Reformer!" of the year before as "Apostate, crouching in a tyrant's lair":

> Thou art the skeleton at Freedom's feast,
> To which thy voice so blandly called the world.
> How soon the man was vanquished by the priest,
> And in the dust the faith of nations hurled![16]

Julia Ward Howe, who had visited Rome in 1843 with her famous humanitarian husband (a champion of Greek liberty) and had written forty edifying quatrains "From Newport to Rome" in 1848, now plainly informed the pope in "Pio Nono" that "Thou should'st have had more faith!" Since he had failed to trust Christ when he was called to walk on water,

> Thine is the doom of souls that cannot bring
> Their highest courage to their highest fate.[17]

But the most vituperous language was employed by the Quaker poet John Greenleaf Whittier, who had never been to Italy but who hailed liberty and cursed its oppressors wherever they appeared. He also wrote a poem "To Pius IX" (1849) calling him, among other things, "the Nero of our times" whose "coward lie / Is backed by lance and sword." He charged the pope to "Go, bind on Rome her cast-off weight":

> Nor heed those blood-stains on the wall,
> Not Tiber's flood can wash away,
> Where, in thy stately Quirinal,
> Thy mangled victims lay!

In a note Whittier disclaimed all anti-Catholic bias, pointing out that he was known for his support of the Irish against English oppression. In a more dramatic poem, "The Dream of Pio Nono," Whittier conjured up a terrifying nightmare in which St. Peter takes Pius from Gaeta to Rome to witness how, at the "gate of San Pancrazio, human blood / Flowed ankle-high," and dead men made a "ghastly barricade of mangled flesh." Charging that these are Roman citizens murdered at the behest of their Holy Father by "the pious soldiers of France," Peter then declares the pope to be the Antichrist, and excommunicates him. The "trembling and muttering" pontiff awakens, while a smiling Cardinal Antonelli observes to King Bomba of Naples that "the Holy Father's supper troubleth him."[18]

The pope's flight from Rome, and his subsequent appeal for armed intervention on his behalf, naturally excited American Catholics as well as libertarians like Whittier and Tuckerman. Irish priests who had been supporting the insurrectionists for popular liberty in Ireland angrily condemned the Romans for their treatment of the pope. Bishop John Hughes of New York was the most vociferous exponent of Catholic anti-Roman outrage.[19] George Washington Greene, who had been American consul in Rome from 1837 to 1845 and took a sympathetic view of Roman Catholicism, penned an essay in June of 1849 called "Contributions for the Pope" in which he asserted that "Bishop Hughes has selected a very unfortunate moment for his appeal to the Catholic citizens of a republic which has founded its greatness upon a people's right to choose their own government."[20] In 1850 this essay appeared as the last in a collection of *Historical Studies* by Greene that were among the results of his finally abandoned effort while in Rome to write a history of Italy (his studies of the ancient topography and walls of Rome were considered in vol. I, chap. 1). These essays discussed Petrarch, Machiavelli, Manzoni, and Verrazzano, subjects that Greene claimed were entirely new in America when they appeared in the *North American Review*. Two essays, one called "The Hopes of Italy," the other

(written in 1848) called "Supplement to the Hopes of Italy," are interesting antecedents to the "Contributions for the Pope," since they maintain a democratic but not anti-Catholic bias, and they show a more informed and subtle understanding of the Italian situation than mere visitors of one winter could attain.

In the first essay Greene based his optimism about the future of Italy entirely upon the improving conditions not in Rome but in northern Italy—improvements in commerce and education, and a growing middle class—the things that fostered freedom by making Italy more like America. But Greene, almost uniquely, even defended the Catholic clergy, saying it had been maligned on the basis of a few conspicuously bad examples. He clearly could not imagine an Italy whose culture was not fundamentally Roman Catholic; in this respect it would never be like America. Thus in the revolutionary year of 1848, thanks to the new pope, Greene's "hopes" for Italy rested mainly upon the elevating and unifying character of Catholicism itself. The pope, "who had so long been regarded as the chief cause of the division of Italy, comes forward as the natural protector of the native Italian, against the oppressions of his foreign invader. . . . Never had Catholicism been painted in more enticing forms." In this spirit Greene wrote admiringly of Gioberti. Nevertheless, when to the astonishment of everyone a Republic was declared in Rome the next year, Greene was clear about where his loyalties as an American lay in any new hopes for Italy. The principle of self-government was absolute.[21]

Whatever existed of the manuscript of Margaret Fuller's history of the Roman Republic was lost in the shipwreck on the return to America that took her life. But her dispatches to the *Tribune*, posthumously collected by her brother in *At Home and Abroad*, and numerous letters to friends written between May of 1847 and July of 1849 collected in the posthumous *Memoirs*, constitute a running record of the events of the time from the point of view of an American passionately committed to the ideals (not the reality) of her own Republic. Her version of the Siege of Rome we have already seen; but another construction from her writings needs to be made. Fuller's political philosophy rested upon a dual belief in the power of individual great men and in the potential nobility of the common people en masse. Consequently from her account of these crucial years we can assemble three narrative portraits that progressively unfold in a series of dramatic episodes: one of Pope Pius IX, one of Mazzini, and one of the Roman people.

Fuller first witnessed Pius during the ceremonies of Holy Week, 1847; the "love and expectation " he evoked in the people gave these rituals an "unusual interest." "He is a man of noble and good aspect, who has set his heart on doing something solid for the benefit of man," she decided. In December she saw him again, officiating at San Carlo al Corso, and then more closely when she met his carriage while riding in the Campagna. He seemed to her one of "the genuine kings of men":

> His is a face to shame the selfish, redeem the sceptic, alarm the wicked, and cheer to new effort the weary and heavy-laden. What form the issues of his life may take is yet uncertain; in my belief, they are such as he does not think of; but they cannot fail to be for good. For my part, I shall always rejoice to have been here in his time. The working of his influence confirms my theories, and it is a positive treasure to me to have seen him.

She had no wish to "be presented" to him, "not wishing to approach so real a presence in the path of mere etiquette."[22]

Fuller noted, however, that his brief speech to the new Council of Rome had clearly implied that "he meant only to improve, not to *reform.*" Although she surmised that the assertion was "made, no doubt, more to reassure czars, emperors, and kings, than from the promptings of the spirit," it suggested that "pontifical government, though from the accident of this one man's accession it has taken the initiative to better times, yet may not, after a while, from its very nature, be able to keep in the vanguard." As early as October, Fuller had begun to doubt—not this pope as a person but the possibility of any pope as a secular ruler. "It is never easy to put new wine into old bottles, and our age is one where all things tend to a great crisis; not merely to revolution, but to radical reform." Rome "must cease to be an ecclesiastical capital; must renounce all this gorgeous mummery, whose poetry, whose picture, charms no one more than myself, but whose meaning is all of the past, and finds no echo in the future." The good pope, unfortunately, encourages the "repulsive" notion that good government is a benefit conferred by the prince and his Church rather than a right of the people. Fuller went to the Quirinale in January to witness the pope install the new municipal officers and was shocked when they "actually kissed his foot." This seemed "disgustingly abject." She sent a translation to the *Tribune* of two pages from a recent papal speech to show how "deplorably weak in thought and absolute in manner" it was. Clearly, "whenever there shall be a collision between the priest and the reformer" within Pius, "the priest shall triumph." On Epiphany she was sickened by the exhibition of the Santo Bambino at Ara Coeli, for she realized that it was through such idolatry as this that the Church maintained its political domination. Poor and miserable people implored help from an "ugly little doll," since they were unable to find relief or comfort elsewhere. During the ceremony "men in white and gold" paraded the bejeweled Babe in its "gilded robes and crown" twice around the church, while "the band played—what?—the Hymn to Pius IX and 'Sons of Rome, awake!' Never was a crueller comment upon the irreconcilableness of these two things. Rome seeks to reconcile reform and priestcraft. . . . Oh awake indeed, Romans!" she concludes; "burn your doll of wood."[23]

Not long afterward Fuller reported that the "liberal" pope had now installed a "retrograde ministry." At the end of April she wrote a letter saying that she would not bother to get an American friend's rosary blessed, as requested, "as none can now attach any value to the blessing of Pius IX." The pope was "quite destitute of moral courage." The night of November 15, after the assassination of the pope's minister of state, Count Rossi, a large crowd gathered on the Quirinale, but the pope refused to appear at the window, and the Swiss Guards fired upon the people. During the night of the twenty-fourth, instead of resigning his temporal power—his "only dignified course," according to Fuller—Pius fled in disguise to Gaeta and cried for aid from the Catholic powers. "Poor Pope!" she exclaimed. "How has his mind been torn to pieces in these later days! It moves to compassion." But she did not seem particularly sorry to say of this man, whom she had so recently considered one of the "genuine kings of men": "No more of him! His day is over." When the pope's excommunicating "Manifesto to the People of Rome" arrived from Gaeta in January

of 1849 (and was paraded through the streets dangling over a chamber pot), Fuller sent her translation of this piece of "silliness" and "bigotry" to the *Tribune*, optimistically remarking that "it is probably the last document of the kind the world will see."[24]

Giuseppe Mazzini was a man who more fully "confirmed" her "theories" about great men, since although defeated he never changed, and she was sure his effect on history would be permanent. Moreover, he stood for a radical republicanism that recognized only "God and the People" as sovereign, whereas Gioberti's ideas of a papal theocracy struck Fuller as those of a "charlatan," in spite of her own passing appreciation for the beauty of paternalism under Pius. She had met Mazzini as an exile in London, where his character contrasted nobly with that of the mean-spirited, reactionary, and egotistical Carlyle (whose own writings encouraged the kind of hero worship toward which Fuller on one side inclined). In November of 1848, on the day before Pius fled, Fuller wrote from Rome: "Mazzini has stood alone in Italy, on a sunny height, far above the stature of other men. He has fought a great fight against folly, compromise, and treason; steadfast in his convictions, and of almost miraculous energy to sustain them, is he. . . . The Roman people murmur his name, and call him here."[25]

Mazzini answered the call, arriving in Rome "by night, on foot, to avoid demonstrations"; but all over the city that he was seeing for the first time, giant placards proclaimed him "Giuseppe Mazzini, cittadino Romano." On March 8 he came to see Fuller and remained for two hours. When he left she feared "that it is in reserve for him, to survive defeat." The entire weight of the Republic's success fell upon him, and he realized that "the foes are too many, too strong, too subtle." He came to see her again during the siege, when—unbearably, to her—blood was being spilt to sustain his ideal, and yet she saw him as "the inspiring soul of his people," whose "soft radiant look" "consecrated" Fuller's own "present life"; she even imagined herself as his "Magdalen." But during the last two weeks of the Republic she did not see him, and as she watched the great trees of the villas being destroyed to make barricades, and as she tended the wounded and the dying, she wrote that if she could have influenced him, "I should have prayed him to capitulate." After the defeat, before he in his turn fled once more into exile, his active role in history essentially over, Fuller sought him out in "the upper chamber of a poor house," bearing "his fearful responsibility," having "let his dearest friends perish":

> In two short months he had grown old; all the vital juices seemed exhausted; his eyes were all blood-shot; his skin orange; his flesh he had none; his hair was mixed with white; his hand was painful to the touch; but he had never flinched, never quailed; had protested in the last hour against surrender; sweet and calm, but full of a more fiery purpose than ever; in him I revered the hero, and owned myself not of that mould.[26]

To the *Tribune* Fuller sent a translation of Mazzini's eloquent first address to the new Assembly. It announced that "after the Rome of the Emperors, after the Rome of the Popes, will come the Rome of the People."[27] That was after all the image of Rome that most appealed to her, and during all the shifting phases of the city's

political life during these two years, it was to the People that she constantly turned for evidence to sustain her most fundamental theories. The actions of a great man—whether Pio Nono or Mazzini—mattered only as they promoted the greatness of the common man. And Fuller's most intricate and loving portrait is of the Roman People, showing them pass through stages of growth to prove what they could become, before they sink back into what tyranny makes them.

In the first stage they are unconscious of the difficulties faced by their good father the pope, whom they simply love like children, expressing themselves "with all the vivacity of their temperaments, to perpetual hurras, vivas, rockets, and torch-light processions." By eliciting joy, trust, and expectation in a dispirited and degraded people, Pope Pius had performed the first step in elevating their character. With "the readiness of genius that characterizes them," they had "entered at once" into the filial relation he offered them. "They, the Roman people, stigmatized by prejudice as so crafty and ferocious, showed themselves children, eager to learn, quick to obey, happy to confide." As for their manner of expressing themselves, she "never saw anything finer" than one jubilant demonstration that went from the Piazza del Popolo to the Quirinale, and on a very different occasion—the funeral procession for a new councilor—the style was equally impressive: "The whole had that grand effect so easily given by this artistic people, who seize instantly the natural poetry of an occasion, and with unanimous tact hasten to represent it." But can artistic children become free men and women? Fuller comments that for centuries the festivals had provided the *only* opportunity for expression of "the thought, the feeling, the genius of the people." Now the "march of reform" is sure to mean that "there will be also speeches made freely on public occasions, without having the life pressed out of them by censorship." As public life thus takes on a new democratic character (obviously more American), Fuller hopes only that in Italy "what is poetical in the old will not be lost."[28]

In the next stage, the Roman People reached the age of discretion. Their initiation resulted from the increasing tension between the "Obscurantist" and liberal factions, subjecting the Romans to contrary appeals. The reactionaries contrived a miracle in which the Madonna del Popolo "cured a paralytic youth" and took the "occasion to criticise severely" the liberal measures of the pope. But neither this nor the inflammatory handbills and rumors of tumult "excited" the Romans "to bad conduct." When they gathered at the Quirinale to receive a papal blessing on New Year's Day, the pope was actually ill, but "Obscurantist" officials hoped to provoke an uprising by rudely announcing that "he is tired of these things: he is afraid of a disturbance." The excited and angry crowd, "with that singular discretion which they show now," instead of inviting repression by behaving violently, went off to consult with the senator of Rome, who intervened for them with the pope. The next day Pius rode through the streets of the city, escorted by Ciceronacchio, "the present Tribune of the People, as far as rule in the heart is concerned." Similarly in their great celebrations of the revolutions in France and Austria, the People, "sweet and noble, who in the intoxication of their joy, were guilty of no rude or unkindly word or act, ... of their own accord," at nine o'clock went quietly home to bed, "singing the hymns for Pio" as they went.[29]

The Roman People next met a trial of their courage and their capacity for self-

sacrifice. Called upon to drive the Austrians from northern Italy, the youth of Rome "rushed to enroll themselves," while both princes and street peddlers contributed their "dollars" or their "pennies," and princesses and servant girls gave up their splendid necklaces or their bits of coral. "These are the people whom the traveller accuses of being unable to rise above selfish considerations," wrote Fuller indignantly; "a nation rich and glorious by nature, capable, like all nations, all men, of being degraded by slavery, capable, as are few nations, few men, of kindling into pure flame at the touch of a ray from the Sun of Truth, of Life." The "illiberal" English—a "porcupine" race—laugh at the idea of the volunteers going off to fight the Austrians; they say, "It is a farce for a Roman to try to walk even; they never walk a mile, and not have their usual *minestra* to eat either." But the English are proven wrong, and Fuller is happy to report that the Americans in Rome are showing a "better, warmer feeling": at their Washington's Birthday celebration, "Mr. Story of Boston" read a poem and "Mr. Hillard" gave a speech, both "fine expressions of sentiment."[30]

But 1848 was for the Roman People merely an apprenticeship in self-respect, patriotism, courage, and self-sacrifice. Their full maturity is proven in 1849 when they are abandoned by their Father and they have to choose between self-government or self-abasement. Natural leaders "who had courage and calmness for this crisis" advise the people to avoid every excess that would justify armed intervention: "The people, with admirable good sense, comprehended and followed up this advice. Never was Rome so truly tranquil, so nearly free from gross ill, as this winter. A few words of brotherly admonition have been more powerful than all the spies, dungeons, and scaffolds of Gregory."

In this new condition the People gain the wisdom of self-knowledge. They had been "enslaved beneath a cumbrous ritual, their minds designedly darkened by those who should have enlightened them, brutified, corrupted, amid monstrous contradictions and abuses; yet the moment they heard a word correspondent to their original nature," they respond, " 'Yes, it is true.' " They need not be priest-ridden liars, beggars, cheats, prostitutes, and relic-kissers. " 'We have long darkly felt these things were so; *now* we know it.' " The "unreality of relation between the people and the hierarchy is obvious instantly upon the flight of Pius." Their mature freedom is confirmed when the general excommunication the pope sent to them from Gaeta is met with "a universal movement of derision." At last the People of Rome "talked as they felt, just as those of us who do not choose to be slaves are accustomed to do in America." At the Roman Carnival of 1849 they showed, moreover, that they had achieved their maturity without loss of that "wild, innocent gayety of which this people alone is capable after childhood." This republican Carnival was "less splendid" than the papal, but not "less gay." There were no dukes and princes with their "coaches and rich dresses," and "fewer foreigners than usual, many having feared to assist at this most peaceful of revolutions." But the "Roman still plays amid his serious affairs, and very serious have they been this past winter. The Roman legions went out singing and dancing to fight in Lombardy, and they fought no less bravely for that."[31]

But three tests remained: the democratic political process, maintenance of order, and self-defense. Passing the first of these was perhaps their most amazing accomplishment:

The people are certainly as ignorant as centuries of the worst government, the neglect of popular education, the enslavement of speech and the press, could make them; yet they have an instinct to recognize measures that are good for them. A few weeks' schooling at some popular meetings, the clubs, the conversations of the National Guards in their quarters or on patrol, were sufficient to concert measures so well, that the people voted in larger proportion than at contested elections in our country, and made a very good choice.

Also, under the new government, Rome was safer than it had ever been. Fuller went "from one end to the other," alone and on foot among the poorest of the people. But her praise for the New Roman depended upon an acceptance of the old stereotypes as true: "The Roman, no longer pent in ignorance and crouching beneath espionage, no longer stabs in the dark. His energies have true vent; his better feelings are aroused; he has thrown aside the stiletto." This is the more miraculous in that agents of the enemy "still lurk within the walls," anxious to incite criminal anarchy.[32]

During the siege came the final test. "But wounds and assaults only fire more and more the courage" of the Romans defending their Republic. "When the bombs began to come, one of the Trasteverini, those noble images of the old Roman race, redeemed her claim to that descent by seizing a bomb and extinguishing the match." Other women immediately emulated her, afterward collecting the balls and carrying them to the Roman cannons. And the proud behavior of the university students and the older men who now lay wounded in the hospital showed that in them a "spirit burns noble as ever animated the most precious deeds we treasure from the heroic age."[33]

This was the climax of the education of the noble Roman People and of Fuller's acquaintance with them. But it was not the end of their story. When she left Rome the next month, never wishing to see the city again now that it had been desolated by war and subjected to military government, the most tragic image she left behind was of the Roman People themselves:

The men of Rome had begun, filled with new hopes, to develop unknown energy,—they walked quick, their eyes sparkled, they delighted in duty, in responsibility; in a year of such life their effeminacy would have been vanquished. Now, dejectedly, unemployed, they lounge along the streets, feeling that all the implements of labor, all the ensigns of hope, have been snatched from them. Their hands fall slack, their eyes rove aimless, the beggars begin to swarm again, and the black ravens who delight in the night of ignorance, the slumber of sloth, as the only sureties of their rule, emerge daily more and more frequent from their hiding-places.[34]

Angered by the revival of cynicism about the Romans after the fall of the Republic, the New York editor Theodore Dwight was moved to write a book that partly compensates for the loss of Margaret Fuller's history. Dwight's preface to *The Roman Republic of 1849; with Accounts of the Inquisition, and the Siege of Rome* (1851) asserts that Americans greatly need to have "the truth laid distinctly before them," since "the true Italian question, especially as regarded and sustained by the

Roman Republicans, is a question essentially our own." He admits that the interest of most Americans has always been not in modern but in ancient Rome. Those who have gone to Italy to enjoy its monuments have "come home confirmed in the common opinion, that the Italians of modern days are a very degenerate race, and neither desire nor deserve a better lot than that which they have to endure." In effect Dwight is referring to his own *Journal of a Tour in Italy*, anonymously published exactly thirty years earlier. Then he had declared that Rome's "system of religion and government" was nicely calculated to produce "mental imbecility" in its "abject" inhabitants: "Men thus become fitted for exactly such a state of things as exist in this country; and could they be transported across the Atlantic, would be as great anomalies, as Americans are in Rome." This absolute difference between Romans and Americans was a strong argument in favor of Protestant principles of education and government.[35]

By 1851 Dwight has not at all changed his opinion about the differing political effects of Catholicism and Protestantism, but he does think better of Romans. For in recent years they have proven that they share American values and can act like Americans. In the fourth chapter of his book he states that the establishment of the Republic and the defense of it against the French army "are facts demanding attention ... especially of Americans" since they "prove that our common opinions of the capacity and character of the Italians are erroneous; for, if they had been so imbecile, unprincipled, cowardly, treacherous, or fickle a people as we have believed them to be, they would never have done what they did." But Americans, for their part, have behaved shamefully toward them, believing the slanders of Catholics and Englishmen, and in doing so have betrayed their own values and done "irreparable injury" to men "whom our ancestors would have loved and honored, for the noble part they have taken in the theatre of the world." We must make amends by realizing that those who in 1849 "established freedom in Rome ... have not been finally destroyed or disheartened, through our neglect, or opposition." American citizens must insist that their government's diplomacy from here on supports Italy's continuing struggle to achieve those rights that America already enjoys. "Certain subjects ... in order to be duly presented to American readers, require to be treated by American writers," says Dwight. This is one of them. It happens to be "the most important" subject "now before the world," and Dwight "has had many opportunities not within the reach of his countrymen generally, to know the facts."[36] He is referring to his intimacy with Italian exiles in America.

The two reasons Americans find it difficult to believe the truth about the Roman Republic are: "First, the evils and atrocities of the papal system are too great to be easily believed; and second, the character, designs, plans and actions of the Italians have been so superior to anything we expected." His book is to provide the evidence that both of these facts, although incredible, are true. He proceeds to construct a melodramatic world with Jesuitical villains and Protestant heroes. It is important, he says, for Americans to realize that most modern Italians are not just antipapal infidels (like the French), they are actually devoted Protestants. His argument that America has a crucial interest in supporting the Risorgimento does not rest simply on an altruistic idea of extending civil liberties around the world. Dwight firmly believes that the success of the Risorgimento means the permanent destruction of

Jesuit imperialism, a real threat to America. But to arouse American sympathy for the Italians apparently required imagining them as Americans, that is, as manly and moral Protestants. So long, says Dwight, as we think of them as "bigotted and fanatical supporters of popery, and so cowardly, fickle, treacherous and bloodthirsty in their dispositions, . . . we cannot easily feel towards them as we do towards each other."[37] The implication is that they are in fact just like ourselves—except for the Jesuits, whom these terms describe to perfection.

Dwight's book in effect combines Margaret Fuller's heroic portrait of the Roman Republic with Lester's portrait of Gregorian Rome, taking both to rhetorical extremes. But he is particularly concerned to show the persistence of the "Gregorian" forces into the period of Pius, quoting in full the horrendously bloodthirsty reactionary oath of the anti-Pius "Sanfedisti" and devoting two long chapters to the Inquisition and the Index. He is rhetorically most effective on the subject of the Inquisition, or Holy Office, whose somber building near St. Peter's he amusingly treats as a "sight" unaccountably omitted from guidebooks and overlooked by tourists. Dwight's most lurid writing is occasioned by his description of the horrors that Republican officials claimed they found when they broke into the Holy Office in April of 1849, for the purpose of converting it into housing for the poor. Once within the walls, what shocking discoveries they made! Files revealing how the spy system made use of foreign representatives (a warning to America about its ill-considered diplomatic recognition), torture instruments of every description in more hidden rooms, and finally remote cells in which the bones of interrogated prisoners lay forgotten (a warning to America that all Catholic convents should be regularly inspected by public officials).[38]

The corrective portrait of the Roman people, besides showing their admirable civic behavior during the period of the Republic and especially during the siege, is enhanced by a scene in which an American sense of equality is stressed. The traditional walls between classes in Rome were broken down at a great banquet "attended by 500 Romans and 300 other Italians" in 1848, when the democratic spirit was just blossoming under the "pretended" liberality of Pius. "There was much less display of luxurious food than of genuine and harmonious intercourse." There was a "feeling of unity" beyond anything that was as yet permitted expression in the press; and there was a general acknowledgment that Rome—although considered "for ages" the chief "source of public misery" in Italy—was to be the "head of the nation." But, most important, "the high and the low there mingled freely and cordially at the same table, and first broke through the separating walls which had prevailed in Rome more than elsewhere, to keep the different classes asunder." The popular leader "Ciceronacchio" (a nickname that everyone spells as he pleases) was "conspicuous for his natural dignity, simple dress and manners."[39]

But the real hero of the book is Garibaldi, whom Dwight befriended in America and whose portrait serves as the frontispiece, just as Mazzini's would surely have served in Margaret Fuller's book, had it survived. Garibaldi gave Dwight his autobiography and private papers, which Dwight translated for American publication (1861). "Italy's Washington" naturally figures as the Great Man in Dwight's detailed and vivid description of the heroic defensive battles just outside the walls on the Janiculum hill. The book's final one hundred pages—nearly half the volume—are

devoted to the Siege of Rome. The engagement is defined as one between, on the one hand, a dishonorable French government and its duplicitous General Oudinot (the instruments of Jesuitical intrigue), and on the other a noble-spirited people fighting for their independence under the indomitable General Garibaldi. Eyewitness accounts from non-Italian sources—particularly a letter from "an American gentleman . . . of education, taste, and much excellence of character"—are drawn upon to show uncontrovertible proof that the Romans "of every class, age, and sex" displayed a self-sacrificing courage that makes them "worthy of freedom."[40]

In conclusion, Dwight asserts that "no one, who apprehends the actual condition of the Italians and the character they have displayed, can avoid wishing that they may be delivered from the oppressive yoke they have so long and so unwillingly endured, and enjoy the freedom which they so richly deserve." Since it was only by "deceit and treachery"—in which the English had a "chief hand"—that they have been reduced once more to their previous "suffering condition," Americans must not believe the propaganda against them being put forward by Catholic priests and others. "The purity, freedom, and honesty of manners prevailing in American Protestant society, and the intelligence, virtue, and truth which flow from our open Bible, forbid the home-production of such men as Jesuits and Inquisitors," but they also make Americans naively vulnerable to Jesuitical misrepresentation, since we cannot easily imagine such hypocrisy and guile. Fortunately, the spread of the Gospel in Italy itself will help destroy the evil at its root. And for this America is to be thanked:

> One of the most powerful lessons which the Italians have received in favor of the Gospel, is that practical one derived from the example of our country. . . . They have had the sagacity and fairness to discover and admit, that our political freedom has sprung from our religious principles and is sustained by them. No other nation, no other band of men, in any distant country, have made this discovery. . . . The Italians have discovered it, and we may thank God, both for them and for ourselves.

Having proved that Italians are—or are becoming—like Americans, Dwight makes a further identification that unites both parties in the ideal that drew so many Americans to Italy in the first place. Everyone acknowledges, he says, that modern Romans look like the "portraits of ancient Romans" that one sees in Rome in the museums and on the Trajan and Antonine columns. "This resemblance of form" naturally suggests "a resemblance in character and habits." And indeed in three traits we see that the Romans of the Republic of 1849 displayed a "perfect resemblance" to their ancestors of the "illustrious" Republic of ancient days, so revered by Americans as their own model: "a great *love* of *liberty*, an acute reasoning *intellect*, and *contempt of death.*"[41] Dwight stops short of logically completing his triangle of virtue by arguing that the ancient Romans were proto-Protestants, nor does he explain how a system so fearfully repressive as that controlled by the Jesuits had allowed the Gospel to spread throughout Italy. But his writing about Italy, like Margaret Fuller's, is not history. It is an impassioned defense of radical American principles, a new myth of the modern Roman Citizen restored to his ancient republican nobility, the pope's picturesque child no more.

Politics of the Picturesque

It was dirty, but it was Rome; and to any one who has long lived in Rome even its very dirt has a charm which the neatness of no other place ever had. . . . Thrift and exceeding cleanliness are sadly at war with the picturesque. . . . Fancy for a moment the difference for the worse, if all the grim, browned rotted walls of Rome, with their peeling mortar, their thousand daubs of varying grays and yellows, their jutting brickwork and patched stonework, from whose intervals the cement has crumbled off, their waving weeds and grasses and flowers, now sparsely fringing their top, now thickly protruding from their sides, or clinging and making a home in the clefts and crevices of decay, were to be smoothed to a complete level, and whitewashed over into an uniform and monotonous tint. What a gain in cleanliness! what a loss in beauty!

—William Wetmore Story, Roba di Roma

But there is reason to suspect that a people are waning to decay and ruin the moment that their life becomes fascinating either in the poet's imagination or the painter's eye.

—Nathaniel Hawthorne, The Marble Faun

After the French army assumed control of Rome, Pope Pius waited for nine months to be sure that his throne was secure before returning to it in April of 1850. American supporters of the Republic refused to concede defeat. As late as February 9, 1855, Theodore Dwight organized in New York a celebration of the sixth anniversary of its founding. Those assembled formally resolved that the pope's government, "restored and sustained by foreign bayonets," was illegitimate.[1] But in Rome itself Americans rapidly became accustomed to a city that now, under Pius, was perfectly continuous with Gregorian Rome, except that the foreign military presence had greatly increased. In May of 1851, Benjamin Silliman, famous professor of natural history at Yale, noted how the ancient walls on the Janiculum had been "scarred and mutilated" by the siege of 1849, and how the venerable trees of the Villa Borghese had been devastated in the defense. These were the only visible signs of the recent struggle for liberty. The present state was signified by the bugles of the French army that awoke him on his first day, as some of the twenty thousand soldiers stationed in Rome paraded across the Piazza del Popolo on their way to exercises on the Pincio. Rome was being "trampled under foot [by] a great nation . . . , itself a republic." But, Silliman considered, if the soldiers hadn't been French they would have been Austrian. In the Europe of 1851, "We cannot even discern the rising dawn of hope for oppressed Italy." On his approach to Rome the day before he had been struck by the congruence between the barren soil and the "extreme degradation" of the people, "ragged, squalid, and dirty." This was the sort of resigned journal note that could have been written by American visitors for half a century past. To judge from their appearance, the Romans were beyond political redemption.[2]

Horace Greeley ("Go West, Young Man!"), who had published Margaret Fuller's letters from Rome in support of the Republic and had participated in New York testimonials on its behalf, also visited the city in 1851. After only three days he found himself competent to dispatch his own letter to the *Tribune* characterizing the "Romans of Today." With the omniscience of a modern journalist in a hurry (he

saw and accounted for all of Italy in less than three weeks), he confessed his disappointment that modern Romans were "a race of fully average capacities, intellectual and physical," and "quite commonly sensual, selfish, indolent, fickle, dishonest, [and] vicious." Further, they were notable for "corruption and degeneracy[,] . . . unfit to be trusted with power over their own political destinies, and indeed incapable of self-government." At this, the bones of Margaret Fuller stirred in their watery grave, and Italian exiles in New York complained, pointing out the brevity of Greeley's visit and the fact that he could not read or speak a word of Italian. Greeley rashly replied that his view was supported by the *Casa Guidi Windows* of the Italophile Elizabeth Barrett Browning, whose qualifications to judge were unassailable.[3]

The next year the celebrated newspaperwoman and poet Grace Greenwood arrived on the scene in search of the thrilling and the picturesque, her specialties. She had the sense to stay in Rome for five months, taking in both the Christmas and the Holy Week seasons. One-third of her *Haps and Mishaps of a Tour in Europe* is devoted to the city. In her fashion, she earnestly tried to understand the modern inhabitants. Her Italian being limited, she relied upon her ability to read eyes:

> O, the *eyes* of this people! great, deep, melancholy, bewildering. You behold them with an ever-unsatisfied interest, you lose yourself in the vain efforts to read a soul life within them, finding yourself groping in void darkness—or you shrink with something of fear from the quick, sudden flashing of their passionate fire. Wherever you go, you meet these orbs of light and night, eyes in which good and evil passions slumber together in dreamy indolence, or contend in a strife of terrible beauty— eyes into which an angel might look, and lose heaven, believing he saw it there— eyes into which . . . [and so on for a full page].[4]

On other occasions Greenwood blinked her vision into sharper focus. After describing the "most magnificent display of fireworks" on Easter Monday, which she had watched from "the windows of Mr. Cass's house" overlooking the Piazza del Popolo, she noted that "only the foreigners were greatly excited by the scene; the people seemed to take it very coolly, as they had the illumination of St. Peter's." From this she concluded that "it is but sullenly that they submit to being amused, instead of being liberated. . . . I rejoice in their sullenness, in their sadness even; and if I could see in them more manly pride and stern determination, I would hope for them against the world." At the Christmas Mass in St. Peter's, she paid more attention to Cardinal Antonelli than to Pope Pius. The true ruler of Rome walked "like a conqueror to majestic music," as quietly as Mephistopheles, but displaying "a right kingly spirit, in the sense of pride, arrogance, and absolutism." As for the "good old-womanly Pope" himself, he was like St. Peter only in that "courage, truth, and honor" had failed both at a critical moment. An even more damning comparison could be made with George Washington, who was recalled on his birthday. Washington had been steadfastly devoted to *"la libertà del popolo,"* and in Rome Greenwood realized as never before "the universality of his greatness." He "has been, and will be, the secret soul of every popular uprising against oppression," since his "grand endeavor" was "sanctified by a complete and preeminent *success.*"

After offering up a pageful of praises for "the rebel triumphant, the soldier olive-crowned," Greenwood shifted the comparison to one with the Italian people. *They*, alas, did not remind her of Washington either. She found them agonized and ashamed, while "their political and religious redemption" required "rage" and "righteous vengeance":

> I see every where among the Italians faces restless, dissatisfied, and mortally sad; but few expressive of the unflinching firmness, joined to fiery valor . . . necessary for such a mighty work. . . . In most modern Italians, the primitive Roman character, manly, and rugged, and stern, is but like an old kingly oak in decay, decorated and inthralled by parasite graces of poetry and romance, and a moss-like indolence and softness.

But pessimism was not Grace Greenwood's product, even when wrapped in picturesque metaphor, and so she forced herself into a belief that hatred for their French and Jesuit masters would soon "get the better of their despairing indolence." Freedom, "the divine genius of enfranchisement, justice and equality," would reveal herself triumphant "in this her ancient realm." In the meantime, the bloodstains from the assassination of Count Rossi in 1848 were still visible on the stairs of the Cancelleria, and Greenwood considered them a tourist sight both more credible and more pertinent than the spot of Caesar's blood on the statue of Pompey, at which visitors had long been gaping in the Spada Palace.[5]

The observations of Silliman, Greeley, and Greenwood show that generalizations about the political prospects of the Roman people returned to what they had been before 1846, just as the government itself reverted to Gregorian means of repression, which Antonelli directed with an ability that made him a worthy successor to Lambruschini. But in spite of the prevailing pessimism about the political capacities of the Roman people, some writers and painters at this time started to observe them more closely and in a more positive light. This new sympathetic interest reflects the democratic revolution in both art and literature that was occurring everywhere, in the elevation of genre painting, in the rise of realism in fiction, and in the emergence of the social sciences. As described by foreigners, the Italian people may be said to have achieved a status as aesthetic objects *before* they were granted political respect, a reversal of the sequence in America, where democratic political assumptions promoted a democratic art. Thus American representation of the Italian people should not be seen as a picturesque rivulet running apart from the mainstream of American culture and eventually drying up in the sands of irrelevancy, but as a tributary from a source where certain aesthetic problems of realism had found a kind of resolution that would affect the way artists and writers came to perceive the aesthetic possibilities of the American people.

Since the Italians and their setting appeared to be inherently picturesque—that is, worthy of being pictured—in a way that Americans and American cities were not, the representation of common life in Italy produced an image that was simultaneously realistic and romantic, containing both the prosaic material truth and the ideal substance of poetry. The result may be called "picturesque realism." This mode conveniently avoided the conventional oppositions between romance and

realism, the historical and the contemporary, poetry and prose, that so troubled American writers and artists and were demolished by Walt Whitman (and later by Winslow Homer) by simple denial of their validity. Yet in picturesque realism, as in Whitman's poetry, the specific human individual and the action depicted are seen as both good and beautiful, independently of their political or material circumstances. To see the common as beautiful, the ordinary as ethically expressive, and the contemporary experience as worthy of permanent record—this is the new aim of some writers and artists in Italy as it was for Whitman. For all the differences—in the character and appearance of the people represented, and in formal and stylistic relation to past conventions of representation—there is shared ground in the assumptions that the proper subject of writers and artists is contemporary reality and that the feudal-aristocratic tradition, which had regarded the common people as brutes and fools worthy only of comedic treatment, must be rejected.

Today, with the standards of a later democratic realism as criteria, what we see in picturesque art and literature is primarily their artificiality and sentimentality, but this should not blind us to the fact that they not only responded to democratic taste but constituted a democratic affirmation by finding the people worthy of serious treatment. And they were found so in Italy before they were in America. In Italy the describer of the picturesque—whether he used words or paint—enjoyed a head start toward the new vision of the common man as both good and beautiful. For in the picturesque tradition there already existed a subject and a treatment that reconciled the facts of the daily, unheroic life—a shepherd with his dog, a young woman filling her pitcher at a fountain—with aesthetic conventions. In the image of a needful human task gracefully performed, the ethical beauty that consists of simplicity and fidelity and fortitude is joined with the natural beauty of the healthy body garbed in enduring practical cloaks and colorful gowns unaffected by the deformities of fashion. Italians living their daily lives were perceived as being picturesque even before they were pictured; few or no transforming adjustments of reality were needed to turn them into art, with its idealizing demands and its need to be "effective."

The nature of picturesque realism can be better understood if we realize that it was a stimulus for the local color movement, a movement ordinarily thought of as an important contributor to the growth of democratic realism. The local color movement was simply the search for a picturesque America comparable in aesthetic interest to Italy, where there was local color even to excess. This connection, however, helps to define the reason Whitman found local color writers objectionable,[6] and to suggest some of the political implications of picturesque realism as a mode of representing the Italian people—or the American. For the traits that make people "picturesque," however "real," are their peculiarities of dress and custom— the same kind of realistic details of local color that would be exploited increasingly by both artists and writers who stressed the regional distinctions of Louisiana, Maine, or the Old Southwest. These differences, rather than a common humanity, easily became the primary purpose of representation. And the appreciation for "quaint" and "colorful" superficialities, rather than typical human qualities and universal conditions, commonly encouraged a condescending and separating attitude in cultivated readers and patrons. The emphasis, moreover, often led to de-

meaning caricature and grotesque distortion, by which the common people reverted
to a low comic status.

The opposite danger was perhaps equally present, namely that of an unwarranted
or misplaced idealization of the common man. When the American Pre-Raphaelite
painter William James Stillman was studying in France in the 1850s, he observed
that Jean-François Millet's ideal of the peasant made his paintings "the elaboration
of a [spiritual] type and not merely the reproduction of a picturesque model." The
necessity of the distinction between peasant type and picturesque model proves the
link between them; both are subjects purporting to represent the people, but neither
is a naturalistic image of the peasant as a brute working in the fields. One is
"merely" a "reproduction," but its subject already conforms to an aesthetic ideal,
just as Millet's conforms to his spiritual ideal. Here too Whitman is useful, for he
recognized in Millet's works a close affinity to his own poetry, while making an
important distinction. According to Stillman, the "peasant" element in Millet's
paintings was merely "incidental to his sympathy with ideal life," but Whitman
thought that Millet, like the poets Burns and Whittier, exalted the rustic as a rustic,
not as a man or woman with a soul that made the rustic equal but not superior to
others. Theirs was not a "modern" view, said Whitman, by which he meant that it
was antiurban and undemocratic.[7]

The same is true of picturesque realism when it suggests that the physical beauty
and moral sturdiness of the common people of Italy derive from their social condi-
tion, which therefore must be left as it is. Aesthetic selectivity—the simple exclu-
sion of the ugly and the wicked—encourages generalizations about a people (Italian
or American) of doubtful validity. And the corrective measures of greater inclusive-
ness of disagreeable fact, or of ironic perspective, were as rarely taken in America as
in Italy. The genre pictures of Whittier's *Snow-Bound* are explicitly witnessed
through the refining lenses of "idyllic" memory. George Caleb Bingham's jolly
boatmen on the Missouri are never shown actually working, and after Bingham had
seen the Italianate models of Dusseldorf, he repainted his rustic's abandoned, angu-
lar dance so that it more gracefully displayed a young man's "line of beauty." The
democratic realism of popular American painting, prose, and poetry persisted in
idealizing the common man and never arrived at a full naturalism. Cynicism has
always been a democratic crime far more serious than sentimentality. Art had a
didactic function, but what it was to teach was not so much the whole truth as a
visually pretty, morally uplifting, sentimental or happy truth, which is to say, the
picturesque truth. This was a truth found first and most easily in Italy. If it encour-
aged the acceptance of a possibly sordid and painful reality as something dirty but
pretty—too pretty to be changed—that was the price to be paid. An egalitarian
society, like a wall "smoothed to a complete level" (in Story's words), is "uniform
and monotonous." The very discovery of interest and value in "the people," which
seemed to encourage political reform and economic progress on their behalf, was
based upon an appreciation of them as they were, a condition that reform and
progress would inevitably destroy.

Ease of accessibility to the picturesque was apparently what caused John Gadsby
Chapman, after he had become a successful illustrator in America, to return to

Rome in 1848 when he was forty, to take up permanent residence. In volume I we looked at two of his paintings, *Harvesters on the Roman Campagna* (fig. I:28) and *Pines of the Villa Barberini* (fig. I:47), which sufficiently represent the picturesque Roman world as he saw it, recognizably not an American world. So it is significant that Henry T. Tuckerman in his *Book of the Artists,* uses the occasion of his commentary on Chapman to generalize about the specific character of American popular art, without drawing distinctions between Chapman's American and Italian works or suggesting that the "souvenir" function of the Italian paintings was anything but adventitious. What matters is not the nationality of the subjects but the fact that both subject and style appeal to the popular taste. Tuckerman seems to regret the loss in Chapman of a grand historical painter—which America did not want—even while he acknowledges that the demands for a popular democratic art to which Chapman responded are legitimate. Further, Tuckerman sees in Chapman a preeminent example of the painter-as-artisan, a conception that identifies the genre painter with the kind of people he paints. He is not an inspired genius-poet, the pet of princes and prelates, but a craftsman who himself belongs to the laboring class.

Tuckerman finds in Chapman a man with an "affinity with all that is picturesque," someone who immediately registers every "effective attitude of monk or vintager" while on his summer excursions, always receptive to whatever might supply "pictures for the artist and lessons for the moralist." A typical Chapman sketch is thus recalled: "It represents an old man, in the garb of a pilgrim, asleep beside the road, his head resting in his daughter's lap, who sits under a tree, and as the sun approaches the horizon, shades his beams with her hand from the father's eyes. The action is simple and effective, and as thus caught by the passing artist, makes as natural a vigil of love as poet or painter could wish." The sketch is clearly Italian, but its essence lies in the fact that it catches "real life" at a moment when that life embodies an elevating sentiment in attractive form. Thus Tuckerman can use it to introduce his assertion that what Tocqueville said about American science, that it seeks only the "immediate," is also true of American art. An "ideal pursuit" has been made to serve "utility" by being assigned a primarily didactic and illustrative function.

Few writers or artists "in this republic"—and certainly not Chapman—have been able to resist the demands that their works be "popular agents," Tuckerman observes. And only reluctantly will he allow that this is as it should be: "it is no ignoble office to take an efficient part, either as a writer or an artist, in the education of the people." Not "ignoble," but certainly lowering for both arts. The painter becomes an illustrator, and the writer a journalist. Although this necessarily renders their works ephemeral, they have the satisfaction of knowing that their "labours have met the exigency of the hour, and have been tributary to the great stream of intellectual life that fertilizes the broad arena of republican industry." Michelangelos and Miltons we cannot have; but we can regard "with complacency the labors of those who have made the arts of design instruments of common good, who have disseminated ideas of the beautiful, and illustrated the popular taste." Chapman in particular, so dexterous in the various means of art production and the author of a popular book on how to draw, naturally shows an "intelligent sympathy with

mechanics," a class he considers "the most original and deserving among the people." This respect had been made explicit in his "graphic illustrations of Whittier's 'Songs of Labor.'" But it is also allied to the respect for the common people manifested over so many years through countless images of Italian peasants, "etched, with grace and truth." These works also are an integral part of American popular art, which is the art of America.[8]

Between 1850 and 1870 many writers and painters participated in the effort to move toward democratic realism from a starting point in the picturesque, if only by the composition of an incidental paragraph or a sympathetic quick sketch depicting popular activities. But three Americans, all of whom coincidentally arrived in Rome in 1856, produced works that most clearly illustrate the trend. Two of them were arriving for the first time: the painter Henry P. Leland, whose odd novel *Americans in Rome* (1863) would be the chief result of his four-year sojourn, and the young Albert Bierstadt, fresh from three years in Dusseldorf, where he had been trained in history- and genre-painting as well as in the landscape art for which he was to become celebrated after his return to America in 1857; his *Roman Fish-Market* was the major product deriving from his winter in Rome. The third was William Wetmore Story, arriving in the city for the third time, now with the determination to settle there as a professional sculptor. Out of the love for Rome that had brought him back, Story produced his *Roba di Roma* (1862), a work that eventually reached an eighth edition in 1887. These three works treat more comprehensively subjects that are treated incidentally by others, and they also express more complex—even self-contradictory—attitudes toward those subjects.

Story directly associates his desire to write a book providing "common out-door pictures of modern Roman life" with his opening meditation upon the dirt of old Roman walls. This dirt and these walls, rightly regarded, are beautiful. Similarly the people of Rome, so long regarded as "unworthy of notice" by "wise and serious travellers" in search of "galleries and antiquities," will be seen to possess a comparable beauty and interest when rightly considered. The people are, besides, the only aspect of Rome that has not been exhausted and conventionalized. For the tourist, Murray now provides all necessary information concerning ancient Rome, and Byron all necessary sentiments. But "the common life of the modern Romans, the games, customs, and habits of the people, the every-day life of *To-day*," has only been "touched upon," usually inaccurately and with prejudice. Story's experience of many years will allow him to provide a truer picture. But in the conclusion to his introductory chapter Story makes three remarks that qualify this aim. The first is that "no one lives long in Rome without loving it," and therefore anyone who disagrees with the "kindly opinions" expressed in his pages must recall that he has seen with the partial eyes of love. Second, he hopes never to be "dull"; yet we realize that amusement is not always reconcilable with the plenitude of truth. Last, he hopes that readers who have seen Italy will be reminded by the book "of happy days spent under the Roman sky," which classes his work with that of a souvenir painter rather than a historian. The lovable, the amusing, the happy truth: picturesque realism.

Another dimension of Story's task remains only implicit in the first edition, but becomes problematical after 1870. To show the "every-day life of To-day" is an aim

perfectly consistent with the growing realism and is a direct anticipation of the theoretical aims of our most conscientious realist, William Dean Howells. In motive, form, and style, *Roba di Roma* in fact anticipates Howells's *Venetian Life* (1866), which in turn was the proving ground for the future novelist's antiromantic view of reality, explicit rejection of conventions of the picturesque style, and affirmation of contemporary common life. Byron had made Venice as difficult to see thus "realistically" as he had Rome, but when Howells finds that after all he cannot be unsentimental about moonlight over the lagoon, or resist converting an old chestnut-roaster into a semi-mythological and emblematic figure, the fault is not simply Byron's. Howells in his first American novels (fictionalized travel writing) continually pinches his scenes and subjects into picturesque profiles. This aestheticism is evident as late as *A Hazard of New Fortunes* (1890), a novel in which New York moves Howells to a darker, more inclusive, and more politically radical vision of reality than he had yet permitted himself. The opening chapters take a detour through New York's Italian slum, where Old World conventions of the picturesque can be fully indulged. Yet Howells is now self-conscious about these conventions, which are among the mental habits that his effete Bostonian hero must overcome in the course of the novel in order to arrive at a more comprehensive vision of reality, one that requires social change at whatever cost to superficial beauty.

Story, in contrast, leaves his problem just beneath the surface: does he want Rome and his Romans to change or not, if change means the sacrifice of all that is beautifully dirty and picturesque? Story is writing about the "every-day life of To-day," and yet what he values about that life are the accretions of time that have given it such a rich character, apparently impervious to change. The realist's "To-day" in Italy is really a part of the romancer's Past, wonderfully surviving into the present. But as early as his revised edition of 1870 Story must express the hope that "with the entrance of liberty, the old picturesque customs and costumes that gave so peculiar a charm to Rome will not be driven out." Yet he knows that "the tendency of modern civilization is to the useful rather than the picturesque," with the result that *Roba di Roma,* meant to be a study of "To-day," will become "purely historical" in a very short time. Seventeen years later a new preface admits that all has changed. But he refuses to revise the text; *he* will not change that picturesque image. Instead, the edition is disfigured with footnotes citing the most striking alterations in the life of the people. With political liberty they have lost their distinction, their beauty, their variety, their individuality, in short, a vital style of life that was itself another kind of freedom. Modernity is uniformity. Liberty and progress, its agents, have whitewashed the walls of Rome.[9]

The means by which Story attempts to achieve a broadly realistic image within the confines of picturesque conventions and values differ from the method of Leland, which anticipates that of Mark Twain rather than Howells. Leland had been reading the sketches of *Roba di Roma* as they appeared in the *Atlantic Monthly* in 1859–60 while he worked at his own book. He was thus aware that his was but one contribution to a growing interest in "Roman popular life"; he mentions also three works by the French novelist and journalist Edmond About, author of *Tolla: A Tale of Modern Rome* (published in translation at Boston in 1856), *The Roman Question* (published in 1859 at both Boston and New York in different translations), and—

most important—*Rome of To-day* (New York, 1861, the year of the book's third edition in French). But this proof of the new subject's popularity only encourages Leland, since every writer has "his own stand-point." Leland certainly does. Although *Americans in Rome* is presented as an "imaginary narration," it is not meant to be fiction. "The characteristics and peculiarities" of Roman life are "portrayed faithfully as I saw them, both as regards form and spirit." The adventures of the Americans of the title serve merely as "the means of developing" an image of modern Rome "nearer to the ease of every-day life" than a published diary could be. The device was useful also because it made possible an emphasis on the "contrast to our own American life," which is what elevates the work above the merely entertaining or informative. Even while Americans with their "war and work" in 1863 "are fighting along stoutly in the advance guard of the world," they need to remember that there has been a past from which they can profit, if only in measuring their progress. Rome best provides that standard, and yet little has been written of "its popular and genial life," although it is "as interesting and instructive to the student of history as any work of art." This is because Roman life "is itself antique." Leland has no doubt that what he is describing is misplaced in the contemporary world: "every peculiarity is founded on some custom centuries old." And all will vanish within a few years, for Rome is certain to become the capital of a progressive modern nation, "no more the prolongation of the Middle Ages." But before it becomes like America, we must study it while "old times still weep and smile as they did in fairy tales and pictures, until the present age of steel came to improve the world. Rome is our direct antithesis. She is all of the past, and full of lessons, even if they be only of warning for the future."[10]

All this sounds quite soberly—even grimly—didactic, and hardly prepares one for the whimsically narrated, wisecracking, punning, irreverent, and often completely frivolous book that follows. Moreover, the title is even more of a misnomer than it seems, since Roman life is depicted not just through the eyes of the leading American character, Mr. Caper, and his compatriots. His two chief companions are artists from France and Germany whose remarks provide for satirical differentiations among national attitudes toward the Romans (the English attitude being a favorite target). Thus Leland frees himself from picturesque sentiment and prettification through comic and sometimes coarse detail, and through multiple perspectives. In contrast, Story, whose genteel and genial humor is by no means repressed, chiefly provides a qualifying context for his basically picturesque scenes by pursuing his broader interest in historical factuality as well, even when those facts become anything but pretty, happy, or edifying. Leland approaches the realism of a Mark Twain, which depends primarily upon the rhetorical deflation of romantic illusions rather than upon descriptive verisimilitude, whereas Story approaches that of Howells, which is achieved through a systematic, inclusive, and neutral exposition of factual details.

A few examples suffice to illustrate these different means of apprehending and rendering "Roman popular life," or "the life of To-day." Story begins with a chapter called "Street Music," and around this theme he develops a series of scenes showing the common people going about their daily business. The first are those who present themselves as professional street musicians, whose lives and appearance might be

said to express the essence of the picturesque. But before the chapter is over we are looking at—and listening to—happy cobblers at their benches, spirited washer-women scrubbing their clothes in the fountains, and wine sellers pushing their carts, accompanied by their little dogs. Everyone is singing lustily. In effect the curtain has gone up on Roman life as an endless opera buffa. But then Story asserts that "since the revolution of 1848 Rome has been stricken with a morose silence." During the first years of Pope Pius's reign, the streets rang day and night with "glad, patriotic songs." Italians, Story claims (sounding like a southerner writing about slaves), sing whenever they are "content," and "there is no clearer proof of their present [pre-1870] discontent than the comparative silence of the streets in these latter days." This observation is irreconcilable with his earlier pictures, which hardly seemed to suggest a "morose" or even "comparative" silence. It also con-flicts with a note of 1887 which says that only when Liberty came in, did Song go out, "for Liberty means taxation and dear living," and "weighs upon the light-heartedness of the people." The two remarks, though apparently contradictory, at least constitute an admission that the picturesque ideal as realized in Italian life is not immune to social contingencies; Romans are not irrepressible songsters, like birds. Another qualification comes from Story's admission that some of the music making is unbearably bad, a possibility that the painting of a musician need never convey. Bands with ill-assorted and cheap instruments growl and groan beneath one's window with painful frequency. Better are the ballad singers, with their incredible repertoire of *respetti* and *ritornelli,* and the players of guitars and man-dolins are usually "charming." And Story's sense of scholarly responsibility does not allow him to leave the ballad singers merely as picturesque images; he conscien-tiously transcribes the dialect verses of several of their songs and gives a translation. They are too precious to be lost to history, as is the Christmas song of the *pifferari,* which is printed complete with music in an appendix.

The pifferari are the most remarkable of all the music makers. These "extremely picturesque" people arrive every Christmas season from the Abruzzi to fill the Roman air with the haunting sounds of their bagpipes. Inevitably one of Chapman's etchings shows a pair of them playing before a shrine of the Virgin (1852; fig. 16). Story remarks that their shaggy "costumes," sunburned brows, and thick and disheveled black hair make them, when they perform upon their strange instru-ments, "a picture every artist desires to paint." "Frayed peacock feathers, or a faded band of red cords and tassels" decorate their conical hats, and their skin sandals are bound by cords laced all the way to the knee. Over all is "a long brown or blue cloak with a short cape, buckled closely round the neck." This outfit, "worn and tattered as it often is," has "a richness and harmony of tint which no new clothes could ever have":

> It is the old story again. The new and clean is not so paintable, not so picturesque, as the tarnished and soiled. The worn blue of the cloak is softened by the dull gray of the threads beneath,—patches of various colors are often let into the jacket or breeches,—the hat is lustreless from age, and rusty as an old wall,—and the first vivid red of the waistcoat is toned by constant use to a purely pictorial hue.

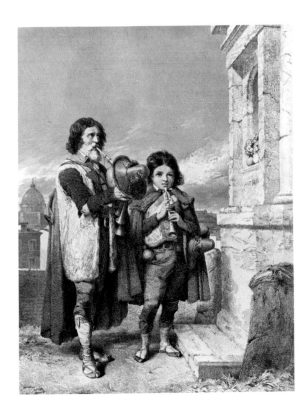

Fig. 16. John Gadsby Chapman. *Pifferari Playing before a Shrine of the Virgin.* 1852. Etching. Print Collection, New York Public Library. Astor, Lenox and Tilden Foundations.

Story was so taken with the pifferari that he invited one pair up to his apartment to get to know them better. The two old friends, who had come to Rome together for thirty-three years and were "quite content" with whatever they earned, delighted Story's children and disgusted his servants. To the servants the pifferari were annual commonplaces; they evidently failed to see the picturesqueness of their dirt. And after 1870 the new government seems to have agreed, for in 1887 Story added a doleful note lamenting the fact that the pifferari had inexplicably been banned from Rome.[11]

Leland's second chapter also concerns the sounds of Rome. But his character, Mr. Caper, does not hear music; he hears noise. His visions of antiquity at the Colosseum are broken into by a cry: "AW-WAW-*WAUN*-IK! *WAW-NIK! WAUN-KI*-W-A-W-n!" This is the baritone "voice of Rome," the bray of a donkey. In the night Caper is awakened by "the long-drawn-out cadences of some countryman singing a *rondinella* as he staggers along the street, fresh from a winehouse." His drunken song has a melancholy fall. During the day Caper's ears are assailed with the cries of people selling everything from broccoli to wild boar. The anchovy seller could not howl louder if he were offering whales. Church bells clang away at all hours, and street singers "screech" out their serenades while a one-legged old gentleman "claws" away at the strings of his guitar. But the "crowning glory of all that is ear-rending and peace-destroying, is carried around by the *pifferari* about Christmas time. It is a hogskin, filled with wind, having pipes at one end, and a jackass at the

other." The pifferari, according to Leland, are mostly "artists' models, who at this season of the year get themselves up *a la pifferari*," wearing "brown rags" and "a shocking bad" hat, "to prey on the romantic susceptibilities and pockets of the strangers in Rome." Unfortunately, opposite Caper's lodgings there was a shrine to the Virgin on the house in which there lived a Scottish artist. MacGuilp naturally loved the "sweet" sound of bagpipes and therefore encouraged the pifferari to play at that shrine. From this circumstance Leland develops a comic tale of revenge, in which Caper conspires to hire all the pifferari in Rome to play together until MacGuilp, deafened and distraught, drives them away forever.[12] Leland's method is "realistic" only because it is antiromantic; but as with Twain, the demolition of an illusion of beauty by the simple propagation of its antithesis does not leave us with a true alternative image; it merely cancels the opposing error.

Leland is not always so concerned with deflating the picturesque perception of Romans. In his random way he introduces humorously appreciative sketches of many of the same activities that Story explores in greater detail. But Story is fond of almost everything he describes, and he describes almost everything. He anatomizes the labor and leisure of an entire year, not omitting the peculiarly Roman ways of getting born, married, and buried. Both Leland and Story delight in the general market at Piazza Navona, for instance, but Story describes *all* of the markets, their different specialties, and their seasonal changes in meats, fruits, and vegetables— evoked in all their colors, textures, and smells. His very comprehensiveness, however, occasionally leads Story into areas resistant to picturesque realism. Even he cannot see beauty in the meat market that spreads in front of the Pantheon and up the adjacent streets. Here the "disagreeable" parts of butchered animals are displayed in the open, since no part is disagreeable to a Roman, and skinned cats are hung up for sale. Under the benches, the accumulated dirt for once remains plain filth.

Roba di Roma's apparent all-inclusiveness, and its amplitude of sober fact and vivid image, give Story's picturesque world a greater verisimilitude than Leland's deflations and exaggerations permit to his comic one. There is, nevertheless, one aspect of common life that Leland reports and Story wholly ignores: its true vulgarity. Their different perceptions and attitudes, which no doubt led them into differing experiences, are apparent in the account each gives of memorable outings among the people.

Those "who like to study Roman manners and humors," says Story, frequently spend an evening at a typical *osteria*; and if they want "a taste of the real spirit of the Romans," they go "incognito" and try to "pass . . . for one of them." For this it is of course "essential" that "you should understand their language well." On one "lucky night" that Story will "never forget," he and his friends dressed up in their "worst coats and most crumpled hats" and slipped into "a shabby old pot-house" near the Piazza Barberini," trying "to attract as little attention as possible." The rest of the company was "composed solely of working men . . . who came in after their hard day's work to take a temperate supper in their shirt-sleeves." Their manners were as good as those "even in what is called the 'best society.'" Of course, they "soon saw that we were not of their class, but their behavior to us was perfect. All the staring was done by us." Story and company were served an "excellent dinner,"

and they exchanged wine freely with the good-humored workingmen, while Zia Nica, "the *padrona* of the establishment," sat in the middle "shrieking out her orders" and exchanging "keen jokes" with newcomers. The meal had been accompanied by the pleasant plucking and strumming of a mandolin and guitar in the next room, and now Story's group "had in" the players. Soon the "old cobwebs in the dusky, soiled, and smoky beams of the ceiling, where the colors of faded frescoes were still to be seen," were shaking to the music. Then old "Zia Nica herself grew excited," and got up and wildly danced a tarantella. Laughing and snapping her fingers, she "shuffled and tramped" until with a "whoop" she fell into her chair, crying "Old Zia Nica's not dead yet."

Next the arrival of a little man who had merely dropped in for a *fiasco* of wine set off a cycle of improvisatory exchanges in rhyme between him and three of the workingmen, accompanied by the mandolin and guitar. The themes were art, love, music, and poetry. "The language used was uncommonly good, and the ideas were of a character you would little have anticipated from such company," Story comments, incidentally reestablishing the difference between "you" and "such company" even while he seems to reduce the difference. "Out of Italy, could anything like this be seen?" he asks. The astonishing performance went on for a half-hour without pause, ceasing only when the police arrived to stop the noise. But Story and his company were unwilling to let this rude interruption spoil their fun. Exercising the prerogatives of their class, they promptly hired two carriages for a drive around the Colosseum and through the Forum, taking the instrumentalists with them. Their evening among the people, so easily transformed into an episode of romantic self-indulgence, then ended with a serenade beneath the window of a "fair lady."[13]

Story's adventure in the "study of Roman manners and humors" thus revealed nothing offensive to genteel sensibilities; on the contrary, the working-class men only rose in his estimation. Leland's discoveries were quite different—not that he cared. Describing the "jolliest dinner" Caper had ever eaten, he lists the complete ten-course bill of fare, "for the sake of future ages which will live on steam bread, electrical beef, and magnetic fish." But his approbation of the feast includes mention of a certain "stout young lady" with the name of "Angeluccia, or large angel," who occupied the attentions of both Caper and his French companion, Rocjean (who had to pretend to be American to put the company "at ease"). Unlike Story's, these Romans did not at once identify the foreigners as "not of their class." Caper and Rocjean, even without dressing poor, were fully welcome at the common table because they were "full of fun, talked and laughed as if they were brother Italians." After plenty of eating and an abundance of wine, "one of the Italians told several stories which were broad enough to have shoved the generality of English and American ladies out of the window. . . . But Angeluccia and the two wives of the stout gentlemen never winked." This frank but uncritical admission of a difference in manners that Story either did not discover or wished to omit is consistent with another occasion on which Leland reports the remarks that a *contadino* made when he lost at the lottery. Leland has to edit them ("C---o!"), for fear that his reader may possess an Italian dictionary: "Suffice it to say, that the exclamations made use of by the Romans, men and women, not only of the lower, but even of the middling class, are of a nature exceedingly natural, and plainly point to Bacchic and Phallic sources.

The *bestemmia* of the Romans is viler than the blasphemy of English or Americans."

Leland's most fully developed violation of the genteel-picturesque image of the Roman people comes when he describes an outing that he and Rocjean made to Monte Testaccio, an artificial hill in Rome created by centuries of dumping, and at that time surrounded by popular wineshops and *osterie*. "In his ardent pursuit of natural art," the episode begins, "Caper believed it his duty to hunt up the picturesque wherever it could be found." He and Rocjean therefore went one October day to Monte Testaccio, where they had a picnic of ham, bread, cheese, sausage, and wine, and then sat smoking and communing with nature:

> Crumbling old walls of Rome that lay before them; wild, uncultivated Campagna; . . . thousand-legged, ruined aqueducts; . . . dome of St. Peter's, . . . Protestant burying ground, with the wind sighing through the trees a lullaby over the graves of Shelley and Keats; distant view of Rome, slumbering artistically, and not manufacturingly, in the sunlight of that morning.

But then they noticed a powder magazine adjoining the Protestant burying ground, guarded by a French sentry. Soon "a couple of Roman women" walked by, saluted the guard, and disappeared behind the magazine. Then two other French soldiers came along, and relieved the guard, who "flew to display to the *dames* his national courtesy." By the end of Caper's second cigar, he had returned, and a second Frenchman went "to pay his addresses." In the two hours that Caper and Rocjean "studied the scenery, guard was relieved four times." " 'Ah!' said Rocjean, 'we are a gallant nation. Let us therefore descend and mingle with what the high-minded John Bulls call "the lower orders." ' "

They did so, and in the first osteria were invited to join the table of their shoemaker, an "artist in leather," who was in the company of three Roman women between the ages of sixteen and twenty, the oldest of whom (the shoemaker's wife) held a *caro bambino* in her arms. The remainder of the day was passed "busily drinking and talking," until finally Caper "noticed that the wine was beginning to have its effects on the large crowd who had assembled at the Osterias and Trattorias around the foot of the Bacchic mountain. Laughing and talking, shouting and singing began to be in the ascendent, and gravity was voted indecent." Rocjean drank to "the good old classic days" and to "the Bacchante." Then, as the sun went down, the crowd began heading back toward the center of Rome. The "*[e]minenti*" set out on foot, and the "slightly-tipsy" females flashed their *spadine* (dirks) as a warning, but the men who had carriages, "foreseeing the inflammable spirit aroused," packed in the women, "and cut them adrift, to float down the Corso." Leland brings his tale of Caper's dutiful search for the picturesque to an ironical end by the sudden interpolation of an exchange between some English tourists who are watching from their balcony:

> "Ah! really, and pray, Mrs. Jobson, don't you think that it's—ah! a beautiful sight; they tell me—! it's the peasants returning from visiting the shrine of the—ah! Madonna—ah?"

"And I think it is *most* charming, Mister Lushington; and I remember me now that Lady Fanny Errol—poor thing!—said it would be a *charming* sight. And the poor creatures seem *much* happier than our own lower orders; they do, to be sure."[14]

A similar ironic perspective is surprisingly present in Bierstadt's painting of the Roman fish market (fig. 17). It incorporates several of the images evoked by Story and Leland, but what sets it apart immediately from most picturesque genre paintings of Rome is the conspicuous inclusion of a pair of tourists at the far right. The immaculate Anglo-Saxon lady and gentleman look upon the same scene that Bierstadt displays to us. They are thus in a sense our surrogates, but we react to their reactions as well. The man, fully dressed in a white jacket, high collar, and black neck-cloth, and firmly grasping *Murray's* red guidebook, holds his chin high and scrutinizes the colorful chaos of the market through his spectacles, much as he might a painting in a museum. With aloof curiosity and complete composure, he strolls onto alien ground. The woman looks behind her in timidity if not fear, and turns back as though considering a retreat from the scene and the smell. Beyond these depicted reactions, Bierstadt has packed his painting with a sufficient variety of human and animal figures to justify almost any other reaction that the viewer might be inclined to have toward common Roman life. Completely stereotypical are the foreground figure of the sleeping man who sprawls with his dog on some straw, and the woman with the embroidered apron near the center, who manages a meditative tilt to her darkly beautiful face (framed by a spotless peasant headdress), even while her industrious fingers keep busy at her distaff and spindle. In the left foreground we see a tender family group: the neatly costumed mother holds her baby on her lap, while her husband, his back to us, works at some task. What might have been squalid in the area where they sit—a heap of dead fish—is a beautifully painted passage of *nature morte,* humorously enlivened by the behavior of the ducks and a cat, and aesthetically augmented by carefully rendered details of pretty clay pots and woven straw baskets. In the middleground to the right some typical buyers and sellers carry on ordinary business.

Almost three dozen figures are visible, however, and such an accumulation includes others less picturesque than these. One man has fallen asleep in an improbable position, clearly a "pose," and he holds a broom which in time may be applied to the dirty pavement. He could thus be emblematic. Faces that would be at home in Daumier appear near the two extremities, one face that of a bawling beggar uncomfortably close to the gentleman (who, however, totally ignores him). In the shadows at the left base of the arch stands a long-bearded rabbi who is the primary indication that the arch demarcated one boundary of the Ghetto. The dense crowd in the street beyond the arch would have been characteristic of this overpopulated quarter of Rome—a walled city within a walled city—to which all Jews were confined (and locked in at night) from 1556 until the end of papal rule in 1870 (although Pius IX had somewhat relaxed the rules during the first years of his reign).

But what has brought the tourist couple to this spot is an interest neither in the popular life of Rome in general nor the character of the Ghetto in particular, but a

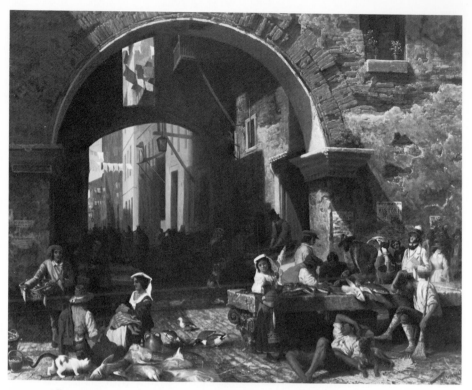

Fig. 17. Albert Bierstadt. *The Arch of Octavia* (*Roman Fish-Market*). 1858. Oil on canvas. 28½ × 37½". The Fine Arts Museums of San Francisco. Gift of Mr. and Mrs. John D. Rockefeller III. (See plate 2.)

purely classical interest in the ancient columns imbedded in the walls of medieval buildings, and in the arch itself. The edition of *Murray* that the gentleman carries makes only the slightest reference to the Ghetto in its introductory matter, citing it as an incredibly filthy region to which the Hebrews had barbarously been confined by the popes. There is no suggestion that the Ghetto be visited. Under "Miscellaneous," however, is listed the Portico of Octavia, named in honor of the sister of Augustus. The style of the remaining columns and the "large brick arch" is said to be "grand and simple, and the proportions and details in every respect worthy of the Augustan age." Such a promise of classical reward would have drawn the tourist, even though accompanied by a warning that the ruins were "situated in the fish-market, the Pescaria, one of the dirtiest quarters of Rome."[15] Although the painting was first known as *Roman Fish-Market*, in 1858 Bierstadt exhibited it for sale at the Boston Athenaeum as *Arch of Octavius, Jews' Quarter, Rome*. The Athenaeum itself bought the painting and dropped the reference to the Jews' Quarter in future listings. The now thoroughly classical name, although itself inaccurate (and not corrected for a century),[16] indicated a more elevated focus of interest than either fish market or Ghetto, a view consistent with the attitude of *Murray* and the gentleman in the painting. It directed the viewer's attention to the architecture—to the beautiful red brickwork relieved by picturesque patches of broken yellow-white plaster and supported by ancient columns with interesting capitals.

Fig. 18. Felix Octavius Carr Darley. *A Street Scene in Rome.* 1867.
Watercolor with graphic underwriting on paper. The Toledo Museum of
Art, Ohio. Gift of Mrs. Warren J. Colburn.

Bierstadt's original title, however, if rightly considered, does not point exclusively to the sordid. The particular complexity of Rome—the simultaneity of its ruined but grand ancient monuments and of its messy but picturesque popular life—is emphasized by the conjunction of the words *Roman* and *fish market.* A *Roman* fish market is one located beneath the remains of a noble arch, one where the fish are sold upon a slab of marble taken from an antique temple, one where an opening within the dark shadows of the arch reveals colorful sunlit laundry hanging above the street, and so becomes a festive patchwork banner on the painter's canvas. It is one where a beggar howls in front of a placard on the wall that announces a performance at the Teatro Metastasio by the great tragedian Adelaide Ristori in *Medea.* This is not a fish market in Philadelphia.

Recognition of such characteristic ironies and incongruities could be more explicitly developed in prose than in paint, and it is to Story's credit that he makes the most of them when, in his chapter on the Ghetto, he arrives at the Portico of Octavia. This chapter is the longest in *Roba di Roma,* and unlike *Murray's*—and precisely because such guidebooks conventionally ignored the Ghetto—Story takes the reader through the heart of it and provides an extensive history of the Jews in Rome. At the Portico, Story begins with a careful description of the remaining ruins, asserting that "nothing can be more melancholy than this spectacle," where the "noble columns" are broken, stained, and walled up, and the "splendor of imperial

Rome has given place to . . . the fish-market." After inviting us to "step under this arch and look up that narrow, dirty, but picturesque street," Story devotes a full page to the "green, crusty lobsters, squirming crawfish all alive, heaps of red mullet, baskets of little shining sardines," and to the "begrimed" façades of the houses, the petticoats dangling over the street, the black beams within the arch, the jutting iron arm with a lantern—in fact, to the scene in its nonhuman aspects just as Bierstadt painted it. But the sight of a Madonna shrine in the Ghetto provides Story with his cue to shift to the subject of the people—the Jewish people, whose problematic modern existence in the capital of Catholicism is juxtaposed to a historical fantasy of their arrival in the capital of the Roman Empire seventeen centuries earlier. "Through these very columns that stink with fish" passed the "glittering train" of Titus after the conquest of Jerusalem, displaying the spoils of the Temple and dragging behind the captive "sons and daughters of Zion" in chains. Yet when the vision fades, the cry that one hears "is no longer '*Io triumphe*,' but 'Ogh clo'—*Roba vecchia*." However miserably, only the conquered have survived.

But upon this double image Story superimposes another not irrelevant to it. By turning to the right, one faces the "uncouth" Church of Sant' Angelo in Pescharia, on the site of the ancient Temple of Juno. In 1347 Cola di Rienzo—"the last of the Romans"—displayed upon the wall of this church an allegorical picture, which he interpreted before leading a procession from here to the Capitol, with his followers carrying "allegorical standards of Peace, Liberty, and Justice." This last attempt to restore the "good estate" to Rome ended with Rienzi's death. When Story awakens from this second historical vision, he sees on the wall of the church only "a marble slab forbidding the playing of any game in the piazza." And "any Jew boy" in the neighborhood will be glad to tell you how it was into this church that for centuries on every Sunday the papal *sbirri*, "like veritable overseers of a slave plantation," drove the "wretched inhabitants" of the Ghetto, forcing them to hear a Dominican preach upon "the text of their perversity." In his long chapter on the Ghetto, Story gives a detailed history of a people's deprivation of Peace, Liberty and Justice, and also a description of the present deplorable condition of their lives. He assures the reader that he has "taken pains" to exaggerate nothing in his account of this "unhappy people." Here is one occasion where the initial attempt to convert Roman dirt into beauty has consciously failed. And this time the footnote provided for the last edition, to record the changes since 1870, was written without regret: the new government had removed all "restrictions and oppressions," and had established equality between Jews and Christians as citizens of Rome.[17]

Bierstadt's painting contains single figures and groups that served separately as subjects for countless picturesque genre paintings inspired by papal Rome. Most of these, being formulaic and fairly dull, suggest nothing about the people beyond an acceptance of the idea that Italians exist to be painted. As far back as 1826 Robert W. Weir could write from Rome, "The men are idle, indolent, and treacherous; and the women, lazy, lovely, and lecherous,"[18] and then set about painting two of them as ideal figures calmly carrying pitchers to "The Fountain of Cicero." Almost half a century later Weir produced from old sketches his own misnamed *Portico of the Palace of Octavia* (1874; Chrysler Museum, Norfolk), which shows a remarkably

neat market with a "Holy Family" group (complete with donkey) as its center of interest. These peasants of art, silent, colorful, clean, and well fed, as painted by so many forgotten American artists—Cephas G. Thompson, John O'B. Inman, Luther Terry, John G. Chapman, C. C. Coleman, George H. Yewell, James E. Freeman, and others of even less renown—are perhaps not worth resurrecting and are probably indistinguishable from their appearance in works by equally forgotten painters from other northern nations, and even by some Italians. What matters is the gradual claim the picturesque poor made upon the attention of artists. They are escapees from the periphery of historical canvases into the center of contemporary scenes (however romantically conceived), or simply actual contadini freed from the function of humanizing a landscape, now standing by themselves as themselves. Genre painting placed a value on the people, even if at first it was only the value of their appearance.

But one other American artist should be considered here, because his work belongs so completely to the popular tradition of illustration in America, and because his drawings and watercolors contain figures more vital than those in most picturesque paintings. Felix Octavius Carr Darley was already famous as the best American illustrator of Irving, Cooper, Longfellow, Dickens, and other popular writers before he went to Europe in 1866 for a year-long tour. The drawings he made along the way were the source for many of the crudely reproduced illustrations in his *Sketches Abroad with Pen and Pencil* (1868), for which he wrote his own juvenile text. The distinction of Darley is that his pictures are almost entirely of people—all kinds of people—rendered in a lively gestural style, but without either sentimentality (a contemplative contadina or two excepted) or caricature (a few jowly priests excepted).[19] On the whole, what is shown is convincingly close to what one might have seen without either picturesque or satirical preconceptions. In *A Street Scene in Rome* (1867; fig. 18), the daily but rather unpoetic act of milking a goat on a city street is simply recorded. Story's description of the same event, in contrast, heightens its character. The herds of goats with tinkling bells are seen following the goatherd in from the Campagna every morning. While one is being milked, the others wait "in picturesque groups," standing or crouching, and the "patriarchal he-goats . . . parade solemnly about."[20] But Darley gives no comparable emphasis—or distortion—to the scene. His goats huddle in natural relationships, and neither the woman at the door nor the occupied children sitting on the stairs of the rather dilapidated dwelling strike a pose. Ironically, this placid scene of contemporary early-morning domesticity in the Old World was the companion piece at the Centennial Exposition in Philadelphia to Darley's historical painting of domestic terror in America, *Puritans Barricading Their Houses against Indians.*[21]

Darley's relatively objective record, however, was as naturalistic as any American—painter or writer—could become when representing the Roman people. They might be rejected as morally degraded or politically hopeless but were always portrayed as at least human beings. The limit can be seen if we consider the presentation of them made by Hippolyte Taine, whose book on Rome and Naples was published in translation in Boston in the same year—1868—that Darley's *Sketches* appeared. Taine presents himself as the "unbiassed" naturalist, "occupied in observing the works and sentiments of man, as we observe the instincts, works,

and habits of ants and bees." He is therefore obliged to describe "the people" for what they are: animals. Taine says that every *object* in Rome is "paintable," and beautifully composed paragraphs display his ability to appreciate "picturesque" architectural ruins and shadowed streetscapes. But they are usually as depopulated as Di Chirico piazzas, and if some of the ragged Roman *canaille* are allowed to wander into them, it is to notice their incongruity. Taine is apologetic about his commentary on the "manners, morals, and character" of the professional and noble classes, since it was necessarily based upon hearsay ("According to the report of strangers, physicians prescribe nothing but enemas, and the lawyers are professors of chicanery"; "The aristocracy is said to be very shallow"; and so on). But his conception of "the people" is unhesitatingly expressed, and such things as dinners in trattorie, games, and songs do not figure into it. Taine simply accumulates anecdotes of unconscionable brutality to demonstrate that the "principal trait" of the people is "their aptitude for violent and dangerous actions." They are "genuine savages," as wily and cruel as American Indians, and thus belong to "a stratum of humanity quite unknown to us." French peasants are simply "stupid," but Italians possess the intelligence of "wild animals, . . . wolves and badgers imprisoned in traps." Here is Taine's one description of a popular quarter of Rome, that of Trastevere:

> horrible streets and filthy lanes; steep ascents bordered with hovels, and slimy corridors crowded with crawling human beings; old women, yellow and leaden visaged, sternly regarding you with their witch eyes; children huddled together in full security like dogs, and shamelessly imitating them on the pavement; ragged vagabonds in red tatters, smoking and leaning against the walls, and a dirty swarming crowd hurrying on to the cook-shops.

Obviously there is nothing here that Taine would wish to preserve, no dirt perceived as beauty. His totally unpicturesque perception of the people thus favors a radical change in their condition, as Story's cannot. Taine believes that emancipation from brutalizing conditions would allow innately "well-balanced faculties" to emerge. If Italians were given "manly" occupations, the "intelligence and energy" which are "their peculiar characteristics" would be humanized. Potentially, "the brain here is ample and . . . man is complete."[22]

To Taine adults are either men or animals; they are never children. Children are children, defecating in the streets like dogs. But Story intends it as one of his highest compliments to the Italian people when he says, repeatedly, that they are like children. He sees their childlike character in the way they sing while at work, in the way they play games, in their religious devotion, and in their behavior at the theater, where they react to the illusion on the stage as though it were reality. Story is not unaware that this implies a simplicity and innocence of character incompatible with moral, emotional, and political maturity as defined by northern Europeans and Americans. He therefore wants to claim both that this definition of maturity is not universally applicable and that Italians can reach political maturity without losing their innocence. These arguments interestingly invert the conventional conception of Adamic Americans defining their innocence against the historic sophistication

and corruption of Europeans. Here American ideas of political and commercial progress are the snakes in the Italian garden. The Italian "habit of song," for instance, contrasts with the "sad silence" in which Anglo-Saxons labor with a "harassed and anxious spirit." Italians are "more easily pleased, contented with less, less morose, and less envious of the ranks above them, than we are." They "have little ambition to make fortunes or rise out of their condition. . . . The nation is old, but the people are children in disposition":

> We who are of the more active and busy nations despise them for not having that irritated discontent which urges us forward to change our condition; and we think our ambition better than their supineness. But there is good in both. We do more—they enjoy more; we make violent efforts to be happy,—invent, create, labor, to arrive at that quiet enjoyment which they own without struggle, and which our anxious strife unfits us to enjoy when the means for it are obtained.

As for the notion that Italians are "quarrelsome and ill-tempered," it is an invalid generalization from the "debased and denaturalized" types with which travelers come in contact. Where uncorrupted by foreigners, the race is "simple, kindhearted, and generous."[23]

The idea that "there is good in both" ways of life, however, is too easy a solution. For what Story—and many other Americans from Cooper on—really desired was that Americans should become more like Italians, and Italians like Americans. They were complementary, but each was incomplete. This is what Story argues after describing the game of *gatta cieca*, a kind of blindman's buff played by adult men in the Piazza del Popolo, in the "august presence" of the great Egyptian obelisk in the shadow of which Moses "may once have walked." The Italians, "who in many respects are children in the good sense, greatly enjoy this game." On moonlit evenings in August it draws a large crowd. Individuals place bets on which of the blindfolded contestants, after being whirled about, will first find his way from the obelisk into the Corso. "Do not, I beg, my most serious friend," says Story, after describing the hilarity of one of these nights, "sneer at this childish game, nor come too sternly to the conclusion that a people which can be thus amused are not fit for liberty":

> So long as the child survives in the man he is living, but when this is gone is no better than a mummy-case. And when a people has lost its susceptibility to fun and its enjoyment of sport, even though it be childish, it has lost what no gravity can ever make up for. The world now overworks its brain and grows severe in its wisdom and feeble on its legs, and a morbid irritability of temper follows as a necessary consequence. . . . The rights of the body need preaching in America more than elsewhere. We need recreation, healthy sport, foolish games, and athletic exercise. Be sure the man will think and act more justly, broadly, and efficiently, whose brain is not overworked at the expense of his body.

Story is glad to hear of the new popularity of boat racing and ice-skating in America. If it increases, perhaps Americans arriving in Italy will cease to be "old broken-down

men of twenty-five" and "pale, fragile girls faded into premature parchment."
"Whatever you think of it," Story concludes, "I find the *gatta cieca* a capital thing,
and believe the Romans all the better fitted for liberty and self-government by the
enjoyment of it. A child-like man is far better than an old-manny boy."[24]

Story does not pursue the obvious question of why the picturesque child-man,
whose carefree play is evidence of his contentment with things as they are, should
wish to gain something called "liberty" as well. Story thinks he should have it, that
it would be good for him, and yet doesn't wish him to "grow up" any more than he
wishes to whitewash Rome's dirty walls. How the sort of wholeness that Story
desires could be achieved is not considered too closely, since picturesque realism—
in America as well as Italy—celebrates stasis, not change. It necessarily tries to
ignore the other side of the conception of Romans as children, the side that says that
children need someone to make their major decisions for them, tell them what is
right and wrong, teach them obedience, frighten them into good behavior, keep
them in order, pray for them, and care for them in need. Yet in Rome this other side
of the conception was even more conspicuous to most Americans than the side of
lighthearted simplicity.

Visible Signs of Oppression: Clergy, Soldiers, Beggars

> *Underneath the ancient portal soon I passed into the city;*
> *Entered San Pietro's Square, now thronged with upward crowding forms,*
> *Past the Cardinal's gilded coaches, and the gorgeous scarlet lackeys,*
> *And the flashing files of soldiers, and black priests in gloomy swarms.*
>
> .
>
> *Like these Roman fountains gushing clear and sweet in open spaces,*
> *Where the poorest beggar stoops to drink, and none can say him nay,*
> *Let the law, the truth, be common, free to man and child and woman,—*
> *Living waters for the souls that now in sickness waste away.*
> *—Christopher Pearse Cranch, "Through the Fields to St. Peter's"*

"The priests, the soldiers, and the beggars, are the most active people here, after
those devoted to the hard necessities of life," wrote the radical preacher Theodore
Parker from Rome in 1859.[1] These three types were certainly the most insistently
conspicuous under the reigns of Gregory and Pius, and also the most alien to
American eyes. They therefore dominate and necessarily distort most characteriza-
tions of the city's inhabitants. All existed in great numbers, and the colorful variety
of their dress and their aggressive manner made them an intense part of the Roman
experience in its most un-American aspect. Together they signified an irrational
and unjust society. The ecclesiastics were the link between the other two groups,
since the foreign soldiers were in Rome to maintain the priestly suppression of
ordinary citizens, while an unprogressive government run by priests reduced its
people to beggary. Moreover, the ecclesiastics themselves were considered to be,
like the beggars, social parasites, and many of them openly begged. William Gilles-
pie, who sought to organize his chapters around cognate subjects, entitled one
"Cardinals, Monks, Beggars, and Robbers." Indirectly, and sometimes explicitly,

most of the writers were collectively defining a wholly repellent urban population and social context; only rarely did they manage, like the artists, to transform ecclesiastics, soldiers, or beggars into the acceptably "picturesque."

Women writers particularly seem to have taken note of the soldiers and to have disliked them. "Do you ask why there are so many soldiers, idle as the idlest, mingling with the crowd?" asked Catherine Maria Sedgwick, nine years before the French troops arrived. "Dogs watching the flock, my dear," she replied, "but ill-trained, ill-fed, and inoperative; the pope's government has not energy enough to maintain a vigorous police." In the days following the French occupation in 1849, Margaret Fuller made invidious comparisons between the Republican National Guard that had been created to replace Sedgwick's idle Swiss dogs and the new "protectors" of the city: "at every step are met groups in the uniform of France, with faces bronzed in the African war, and so stultified by a life without enthusiasm and without thought, that I do not believe Napoleon would recognize them as French soldiers. The effect of their appearance compared with that of the Italian free corps is that of body as compared with spirit." The suitability of soldiers of the French "Republic" for base purposes was owing to the fact that the French were now no more "fitted to have opinions of their own, than the Austrian soldiery."[2]

But by the time Grace Greenwood saw them three years later the French had become a lively and permanent part of the landscape of Rome: "With soldiers and priests Rome actually swarms," she wrote. "Indeed, from the number of barracks, sentinelled points, parades, marchings hither and thither, bugle calls, and noisy drum beatings, one might suppose Rome entirely under foreign rule and military law." Of course, it essentially was; and Greenwood's sympathy remained with the Romans. One day while out riding, she saw "a company of Italian dragoons, fine, gallant men, passing one of the barracks of the French soldiers, when these last, small, brutish-looking fellows, set up a laugh and shouts of derision." Greenwood expected a fight to break out, but, "from contempt or conscious helplessness, the Romans contented themselves with looking their fire," and while Greenwood's blood boiled at the insult, they "rode on with the utmost imaginable *sang froid.*" But by the end of the decade the brief period of respect for modern Romans was over, and Sophia Hawthorne could express her contempt for the French only by allusion to the ancients. She saw the measure of how "low" imperial (not republican) Rome had fallen in the fact that its remains should everywhere be guarded "by these mean-looking, ugly, diminutive barbarians, who crop up at every turn, to shock the vision that is harvesting marvels of art." The French soldiers, "only machines, that carry guns and swords," were incapable of saying anything besides "Je ne sais pas" when you asked them for directions.[3]

Military omnipresence was not something Americans were used to, nor did a soldier necessarily command respect. In her autobiography Julia Ward Howe recalled that when she and her husband were on their wedding journey in Rome in 1843, the philanthropic Dr. Howe had been seized while on his way to the post office when he ignored the warning of a sentry he happened to pass by. Howe "began to beat him over the head," so naturally he was arrested. He was liberated that evening through the intervention of the consul, Mrs. Howe's cousin George Washington Greene. In 1858 William Cullen Bryant noted that the streets resounded with the "tramp of Gallic cavalry," and he was struck by the historic implications of

seeing Norman horses drinking water that came from the Claudian aqueduct, and of knowing that within the walls of the "massive Baths of Diocletian are locked up the thunders [powder kegs] which at a moment's notice may batter down the city. The stranger who strolls near them with a segar is warned away by the French guards." Although visitors were sometimes impressed by the great noise the clanging swords made when the regiments of soldiers knelt to the pope, either within St. Peter's or in the piazza, most Americans found the imposing military presence at religious services particularly offensive. Horace Greeley was reflecting common opinion when he complained of the "multiplicity of spears and bayonets" that guarded the pope while he officiated at Mass. Another famous journalist, Thurlow Weed of Albany, reported that on Easter Sunday, 1852, when a Mr. Jones from New York ignored a French officer's order to take off his hat as the pope was about to give the benediction, the officer knocked it off his head, whereupon Mr. Jones struck him with his cane. The officer retaliated, cutting Mr. Jones's hand. The American was then arrested and marched off to Castel Sant' Angelo, from whence the busy American consul (at this time Mr. Cass) had him freed some hours later.[4]

American antipathy for the papal government in at least one case, however, did not extend to the occupying army that protected it. Indeed, Howard Payson Arnold's *European Mosaic*, dedicated to the author's Harvard classmates of '52 and published in 1864 (the late Civil War date may be significant), finds its only peculiarity (and therefore interest) in the love it expresses for the soldiers of the French army. Arnold observes that the Colosseum is guarded at night by soldiers of Louis Napoleon because of the pope's "great fear" that "secret meetings will be held there of political societies, formed with the object of delivering his oppressed subjects from their present slavery." But the soldiers themselves he finds admirably worthy of their task. Completely reversing the views of Margaret Fuller, Grace Greenwood, and Sophia Hawthorne, Arnold "could not help thinking that the French are the real representatives of the ancient Romans, and that the present inhabitants of the Imperial City are no more the successors of its former denizens than are the bats and owls which infest an abandoned castle the worthy inheritors of its former lords, who held high festival within its walls, or sent forth armies from its gates." Arnold spent much of his time watching the French troops at exercise and concluded that it was "becoming" that these heirs to the discipline and power of the ancient Romans should "watch over their ashes for a time." The Roman soldiers, on the other hand, were "dirty and uncivil, ill-bred and ill-fed, pompous and impudent." So taken was Arnold by the French that among the ten chapters he devoted to Rome, two are occupied with minute descriptions of the soldiers' appearance in their "neat" uniforms, their polite manners and cultivated conversation in the coffeehouses, their daily routine and military traditions, and their accommodations in Rome—down to the quality of their clean blankets and soft pillows. Arnold's other eight chapters on Rome are a dull compendium of all the most conventional observations, but in perceiving the French army to be the most attractive thing in Rome, he found one topic on which he could be completely original—although perhaps, by 1864, also reflecting a new American respect for the military.[5]

As for the "holy priesthood," wrote Grace Greenwood, "as was said of another institution, its 'name is legion.'" Greenwood's catalog is worth quoting almost

entire, since it not only is a lively summary of the variety of types randomly encountered in most American books but also represents the satirical attitude ordinarily assumed:

> You meet, everywhere, dark, sinister-looking Jesuits, in their sombre robes, moving about by twos, at a peculiar, stealthy, prowling gait—walking presentments of the very blackness of spiritual darkness; stupid, vulgar-looking Franciscans, in coarse gowns of brown cloth, rope-girded; barefooted, shaven, begging friars, sometimes leading asses laden with the pious offerings of the faithful—the more asses they; handsome young *abbés*, who contrive . . . to give a dandical touch to their ugly, unmanly costume, and who are seldom too much rapt in heavenly contemplation to cast searching and insinuating glances at the young and comely women they chance to meet.
>
> On the Pincian . . . we often encounter troops of boys and youths, in training for the church, dressed in flowing gowns, and something very like petticoats of black or white flannel, and wearing immense broad-brimmed hats. Nearly all these have faces either cunning, or to the last degree stolid in expression. We there often meet the higher church dignitaries—cardinals, whom we know by their red legs; and monsignori, who are proclaimed by their purple legs. In short, one might suppose it had rained priests for forty days and forty nights on this devoted land.[6]

The ecclesiastical population of Rome was not always subjected to this sort of general moral condemnation, within which the only discriminations are those of costume, or of degrees of treachery, stupidity, and hypocrisy. In 1844 the young Francis Parkman was already planning "a literary undertaking" (his great history of the struggle between the English and French for possession of North America) that "required clear impressions of monastic life, and of Roman Catholic ecclesiasticism in general." He therefore passed a few days in a Passionist convent in Rome for the same reason that two years later he was "domesticated in the lodges of the Sioux Indians" on the Oregon Trail. His remark nearly fifty years later that "I much preferred the company of the savages to that of the monks"[7] is not consistent with the tone of his Roman journals and letters or of his western journal. Even before entering the convent, his antagonistic attitude toward Catholics was changing. Although he earnestly assured his worried parents that he would not emulate the "farce" of a cousin who had converted to Catholicism and was actually taking holy orders, in his journal Parkman confessed that as "a son of Harvard" he found the learning of the Jesuits very impressive. Hesitating in front of "the dreary walls" of the convent because he feared life within would be "an intolerable bore," he nevertheless entered, taking along a copy of Cooper's *The Pioneers* just in case. His Unitarianism, which immediately made the horrified Passionist monks especially solicitous about his soul, was also the anti-Puritan basis for an appreciation of their manner and vocation: "There is nothing gloomy or morose in the religion of these Italians here; no camp-meeting long faces. They talk and laugh gaily in the intervals allowed them for conversation; but when the occasion calls it forth, they speak of religion with an earnestness, as well as a cheerfulness, that shows that it has a hold on their hearts."[8]

Others also sometimes try to make discriminations: between priests and monks,

between monks and friars, and between nuns and monks. Caroline Kirkland observes that "all our romance" fails to redeem the monks, most of whom are "sad, dirty looking fellows," in whose faces one seeks in vain for signs of intelligence. The priests, however, are "better looking men," but their "genius" has also been "extinguished" by their "false position," and they have the "sad" look of men dissatisfied "with their lot in life." Nuns, in contrast, are notably "more cheerful" not only than priests but than "most women." The "recluse life" seems to make them happy: "Perhaps it may be that women are more naturally satisfied with a round of petty duties; ambition is not the vice of their sex. The care of the poor and the suffering, and the education of youth, fill up their lives, and leave them no leisure for repining."[9]

For his part, William Gillespie wished to distinguish between friars and monks, since monks were unjustly "much abused" through association with the stupid mendicants. "Nothing has been made in vain—not even Monks," he wrote; the Benedictines had made their monasteries "asylums of learning in the dark ages," which now entitles them "to the gratitude of posterity." Moreover, they have an income from landed property, which makes them "comparatively independent and respectable." The Franciscan Friars, on the other hand, are mostly poor and ignorant, "and an aristocratic Jesuit priest, of whom I made some inquiries . . . , with a most contemptuous shrug disclaimed all knowledge of them." But these friars— and other mendicant orders—were an unavoidable nuisance and irritant encountered on every street, and the impression they made served as the basis for generalizations about the parasitical character of the Roman clergy as a whole. Gillespie found that in a population of 150,000 in 1844, the priests, monks, and nuns numbered 6,000, "most (though not all) of whom are worthless drones and burdens on the labor of the industrious population." He was certain that the people "unite in abhorring them," even though they "conduct themselves with extreme . . . propriety. . . . Though much is said of their immorality, nothing is proven."[10]

Other Americans, however, often allude to the sexually scandalous behavior of the Roman clergy, from cardinals down to friars and cloistered nuns. Theodore Dwight says that only the inviolable pure-mindedness of his American readers prevents him from giving them the obscene facts, and C. G. Leland plainly states that "cardinals and the wealthier priests kept mistresses, almost openly, since these women were pointed out to every one as they flaunted about proudly in their carriages." But sometimes the vow of celibacy itself, rather than its violation, was criticized. After visiting the macabre underground chambers filled with artfully arranged skeletons at the Capuchin convent—a famous tourist sight, memorably exploited by Hawthorne in *The Marble Faun*—the aged Professor Silliman concluded that Capuchins were not bad, they were just "morbid," "vacant," and "listless"; the worst thing to be said about them was that they lived "in direct opposition to the fundamental principle of human society"—by which he meant marriage and procreation. To the radical Theodore Parker, the "best thing" he heard about the clergy of Rome was that "they don't keep their unnatural vows!"[11]

The Capuchin and Franciscan orders, both "founded in beggary and supported by charity," were the most visible ecclesiastics in the daily street life of the city and therefore found their place in Story's *Roba di Roma*, where they are discussed with

critical sympathy in the chapter on "Beggars in Rome." "The priests do not beg; but their ambassadors, the lay brothers, clad in their long brown serge, a cord around their waist, and a basket on their arm, may be seen shuffling along at any hour and in every street, in dirty, sandalled feet, to levy contributions from shops and houses." Story pities their poverty and appreciates their good nature, but regrets their too obvious "hydrophobia": "They walk by day and sleep by night in the same old snuffy robe. . . . Dirt and piety seem to them synonymous." Story believes that the Roman people regard these mendicants as the "least offensive" of conventual orders and are right in doing so, since—unlike some who preach poverty and live luxuriously—they are obviously sincere in their profession of faith and are constant mortifiers of the flesh, fasting regularly and shivering in the tiny cells from which they emerge at the midnight bell to begin long hours of prayer. True, sometimes their drinking leads to riots in the refectory, for which one can hardly blame them. Story, living in his splendid suite in the Palazzo Barberini, looks down into a Franciscan vegetable garden and at midnight hears the bell of the adjacent Capuchin convent while he sits alone, comfortably reading by a fire.

But the contrast that stirs sympathy also arouses anger. The brothers seem fundamentally degraded creatures, their vocation fit only for the desperate. Story's usual urbanity of tone breaks at the thought of the waste of lives in useless labor and pointless self-denial. He does not, of course, "believe in their doctrine," which is against nature. The proof lies in the fact that even in monkish gardens, "without the least asceticism, oranges glow and roses bloom during the whole winter." But Story speaks not only as artist, but as American: the "thousands of *frati* who are in the Roman States would do quite as good service to God and man, if they were an army of laborers on the Campagna." These monks actually hire others to keep their gardens and to weave the cloth for their robes. Why are such labors less pious than begging? They are, to be sure, less profitable.[12]

In *The Marble Faun* Hawthorne expresses similar indignation through his artist Kenyon when the guilt-ridden Donatello tells him that he is thinking of devoting himself "to God's service" by becoming a monk. "They serve neither God nor man, and themselves least of all, though their motives be utterly selfish," Kenyon declares. "A monk—I judge from their sensual physiognomies, which meet me at every turn—is inevitably a beast! Their souls, if they have any to begin with, perish out of them before their sluggish swinish existence is half done." Kenyon here almost reaches the level of hyperbolic rejection practiced by Mark Twain, who complains of "priestcraft" and beggary throughout *Innocents Abroad*. Even after conceding that some Dominican friars had labored selflessly while "nursing the sick and burying the dead" during the cholera epidemic in Naples, Twain begins his next paragraph with an anecdote about "one of these fat barefooted rascals." Elsewhere he remarks of friars, "These worthies suffer in the flesh and do penance all their lives, I suppose, but they look like consummate famine-breeders."[13]

Mark Twain's epithet suggests more than that friars are fat; he implies that they are the cause of hunger in others. That Catholic policy was itself the chief reason for poverty—and its attendant evils of idleness, beggary, and crime—was a common assertion. In 1903 the historian William Roscoe Thayer, looking back on thirty

years of Italian progress, recalled that "the States of the Church swarmed with beggars, to whom Pius IX showed special indulgence; how, indeed, could a Church which encouraged the Mendicant Orders, sodden in idleness and carnality, effectively reprove untonsured mendicants?"[14] Two books written at the high tide of Pope Pius's Rome—Jarves's *Italian Sights and Papal Principles Seen through American Spectacles* and Story's *Roba di Roma*—include Thayer's point within larger analyses of the *reasons* Rome was, as Jarves said, "the capital of beggardom." For other writers beggars mostly furnished opportunities for rhetorical exercises in outrage or in grotesque and picturesque description.

To Jarves monks and nuns are merely sanctioned beggars wearing costumes, exemplifying the Church's culpability for all the evils of Rome. That the lower classes are mostly thieves and liars, the men effeminate and the women both untidy in appearance and loose in morals, that he, Jarves, is everywhere pursued by pimps—all this results from Church policy. (Of course, in America there are some lax persons as well, but there the drunks and prostitutes constitute a small number of aberrant "professionals," whereas in Italy the immorality is general, and temperance "unknown.") The Church encourages indolence—"the parent of vices"—in three ways, besides setting the example with its own clergy. All three ways are in contrast to American principles of work, education, and charity. First, Rome "appropriates more than a quarter of the year to festivals, on which all labor is forbidden and amusements encouraged." In this it has continued the practice of the Empire, which "trained its citizens into a mongrel race of beggars and robbers, resolved to live without labor." This "hereditary vice" has made all modern Italians, from the pope down to the cripple on the corner (peasants excepted) shameless in their laziness. Second, through its educational system the Church places "fetters on knowledge," repressing all movements of the mind that might result in commercial development. Finally, its ostentatious system of charity, created to alleviate the suffering of which it is the cause, contrasts with the secret charity of Protestants, which is far superior because it does not encourage reliance upon it. In Rome charity removes the spur to work that is the source of progress.[15]

The first cause that Story gives for the abundance of beggars, however, is that there is little work for them to do. Since the government "neither fosters commerce nor stimulates industry," it makes little sense to blame charitable institutions or an excess of holidays for immorally discouraging people from nonexistent labor. Story agrees that as a result of the Church's mentally stunting educational policy, "trade stagnates, industry decays, and the people, ceasing to work and think, have grown indolent and supine." But "free and constitutional England can boast of no superiority in this respect"; outlawing public begging there has not prevented it, nor has industrial development eliminated poverty. Story, however, goes on to declare the most unfortunate thing about Roman poverty to be that it is not seen as an evil; it is "preached as a formula of religion and as a glory of the saints," and is taken as a holy vow by monks and nuns. Beggary is therefore not even shameful, let alone "demanding to be suppressed." Moreover, the cycle of poverty is actually beneficial to the government: "The people, kept at a standstill, become idle and poor; idleness and poverty engender vice and crime; crime fills the prisons; and the prisons afford a body of cheap slaves." Even as Story was writing, the column of the Immaculate

Virgin was being erected by galley slaves! And he cannot look with pleasure upon the "magnificent viaduct" over the "beautiful Val di L'Arriccia," which some people thought placed Pius IX in a class with Pope Sixtus V and the Flavian emperors as builders of public works. It too was built by "poor criminal slaves" rented out to the contractor for next to nothing.[16]

Given the government's responsibility for poverty, Story must in justice praise its charitable works. He describes the operation (not very efficient, but well-intentioned) of the many free hospitals and orphanages, and the various vast expenditures for relief. The poor are better cared for than in Paris, and actual death from starvation, "such as occurs so frequently in London, is absolutely unknown" in Rome. Many of the beggars are in effect "pensioners of the convents." "I have often counted at the gates of the Convent of Capuchins . . . from eight to one hundred of these poor wretches, some stretched at length on the pavement, some gathered in groups under the shadow of the garden wall . . . , discussing politics, Austria, France, Italy, Louis Napoleon, and Garibaldi, while waiting for their daily meal." When the midday bell rings, "the gates are opened and the crowd pours in," and a "burly Capuchin" leads them in a pater noster while he ladles out the cabbage stew. The begging friars thus relieve the begging poor. The fact that this left the fundamental situation unchanged was, of course, the comfort of conservatives. The effectiveness of the system was recognized by Horatio Greenough during the revolutionary turbulence of 1848, when he wrote happily to John Gadsby Chapman that he expected quiet to prevail in Italy since the Catholic religion, "whatever mischief it had done," nevertheless recognized that *"all men* stand above the brutes.—Hence the condition of the lowest class here is superior to that of England & Ireland and the poor *never starving* have not learned the cursed alphabet of *communism."*[17]

The presence of beggars in Italy, of course, did not provoke sociological reflections in most American writers. Beggars were simply a fact that unhappily distinguished Rome from American cities and towns and made it less pleasant to visit. Many writers were conveniently persuaded that the beggars themselves were mostly happy frauds. The Reverend William Kip blamed the government for causing the "evil" by not encouraging trade, but was sure that "this delicious climate probably indisposes" Romans "to active exertion" anyway. They truly believe *"dolce far niente,"* and "they make life one long *siesta.* It glides away in a graceful listlessness—a dreamy, sleepy indolence" until death approaches, and then they are nursed "in their last agonies" by some brotherhood. But however pleasant for Romans, "this state of things . . . cannot be pleasant to a stranger, for it brings constantly before him, misery, real or feigned, in every form, until there is danger lest his heart may at last become hardened against every exhibition."[18] Beggary is bad, therefore, because of the bad effect it has on the visitor's sensibility and soul.

Nathaniel Hawthorne was one of those who confessed that constant refusal of beggars made him "stony-hearted" during his winters in Rome. But he was only following the unqualified advice of English and German guidebooks and residents. Down into the twentieth century, Baedeker was still morally unambivalent about this "favourite livelihood in the streets of Rome. Travellers should decline to give anything, with the word 'niente,' or a gesture of disapproval. Charity should in any case be restricted to the aged and infirm, and on no account be given to children.

Donations, also, should be limited to the smallest amount." Story, from long experience, nevertheless advised that it is always better to give. Otherwise afterward you will be nagged with fears that you failed to give where the need was real. Story knew all about frauds and "professional beggars" and told amusing and appalling tales about them, but he also knew that there were many miserably poor people, whose lives he also graphically described. He would not treat the "individual case" according to a possibly self-serving "general principle."[19]

One American, but only one—the one who called himself "Aguecheek" (Charles Bullard Fairbanks)—went further, finding not only that alms giving was good for you but that poverty itself was a moral good that occasioned proofs of a common humanity. He was "not inclined," he declared, "to complain either of the beggars or of the merciful government, which refuses to look upon them as offenders against its laws." It is to Rome's *credit* that "she is so far behind the age, as not to class poverty among the social evils." Beggars prevent people from feeling "absolved of the duty of private charity" simply because "a vast system of benevolence" exists. They provide "for the exercise of kindly feelings in alms-giving," and this in turn illustrates "one of the most attractive characteristics of the Roman church"—"the kind spirit of equality" that is evident in her cathedrals, cloisters, and universities, "where social distinctions cannot enter."[20]

Our soldier-loving Howard Payson Arnold, however, had no reluctance to make social distinctions or to develop general ideas about the "predatory class" of Italians. In his final chapter of advice to travelers he issued special warnings against beggars. They are pertinacious pests, with a remarkable ability to adapt their appeal—either threatening or flattering—to their notion of a particular tourist's character. But their rhetorical skill should not be rewarded. Moreover, couriers, porters, and the like are all impudent extortionists as well. They are happy if you strike them, since this excuses their use of a knife. "All the Italians," Arnold concludes in one final grand warning, "are vindictive and implacable by nature, and with them a blow can be expiated only with a stab. This is especially true of the lower classes, who are extremely passionate, and lose all control of themselves on the slightest provocation."[21] One can see why he appreciated the French army.

Grace Greenwood was another who found beggars "a prominent and most repulsive feature of Italy":

> They appear in every imaginable variety and degree of wretchedness, disease, and deformity. They beset you every where, and at all times—in walks, drives, churches, on the steps of palaces, in shops, *cafés,* among the ruins—at early morning, at noon, at midnight. It is not safe for you to pause to admire a handsome peasant woman, or child, however well dressed, for begging seems the earliest instinct, the universal, ruling passion of the people.

For someone who liked to gaze into people's eyes, this propensity was obviously very annoying. One "hideous, horrible creature" of seventy who disrupted Greenwood's meditations on the Campagna with her "chattering and howling" had to be "exorcised . . . with a few *bajocchi.*" Although Greenwood claims to be "most touched" by the idea of being crippled or sightless *"in Italy!"* her pity is qualified by

1. Martin Johnson Heade. *Roman Newsboys*. 1848. Oil on canvas. 28½
× 24⁵⁄₁₆″. The Toledo Museum of Art, Ohio. Gift of Florence Scott
Libbey.

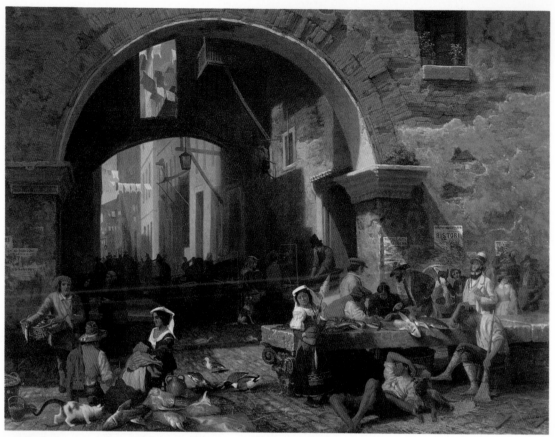

2. Albert Bierstadt. *The Arch of Octavia (Roman Fish-Market)*. 1858.
Oil on canvas. 28½ × 37½". The Fine Arts Museums of San Francisco.
Gift of Mr. and Mrs. John D. Rockefeller III.

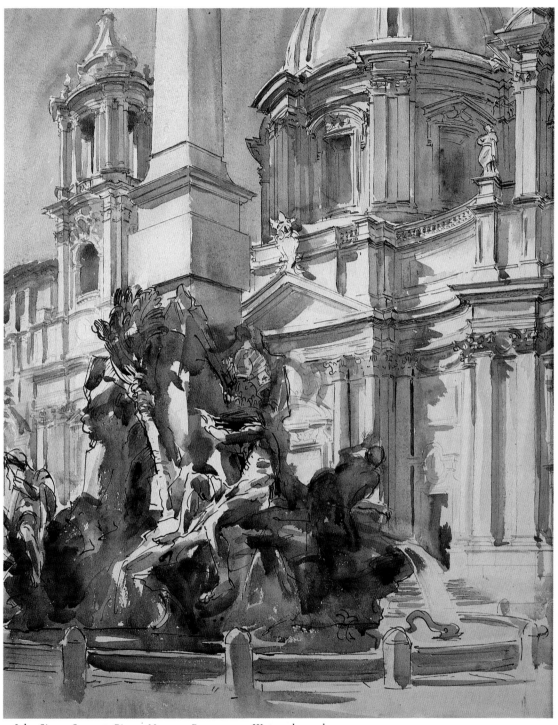

3. John Singer Sargent. *Piazza Navona, Rome.* 1907. Watercolor and
sepia ink. 20 × 16½″. Courtesy Coe Kerr Gallery, New York City.

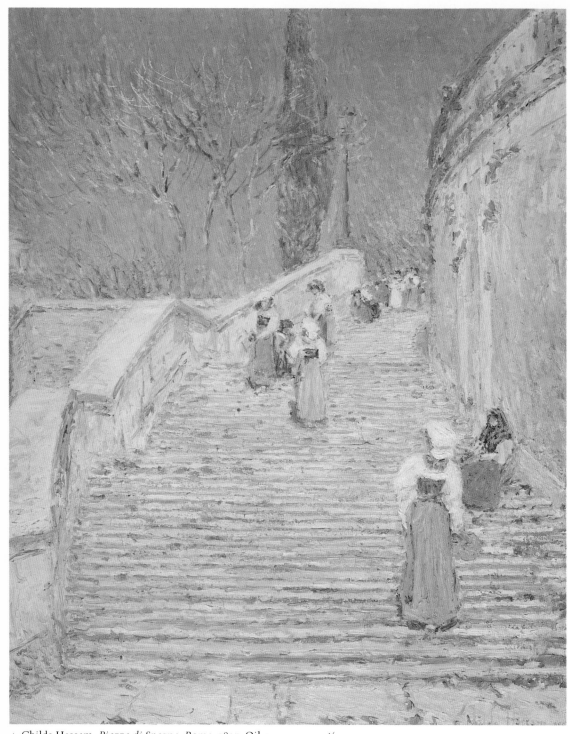

4. Childe Hassam. *Piazza di Spagna, Rome.* 1897. Oil on canvas. 29¼
× 23″. The Newark Museum.

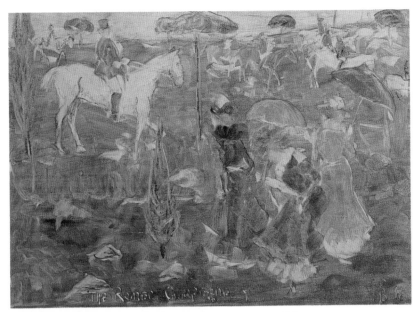

5. Maurice B. Prendergast. *The Roman Campagna.* 1902. Oil monotype
on cream woven paper. 9⅛ × 12⅜". Des Moines Art Center. Truby
Kelly Kirsch Memorial Fund.

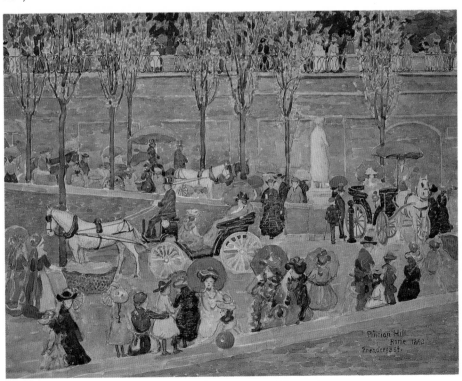

6. Maurice B. Prendergast. *Pincian Hill, Afternoon.* 1898. Watercolor.
21 × 27". The Phillips Collection, Washington, D.C.

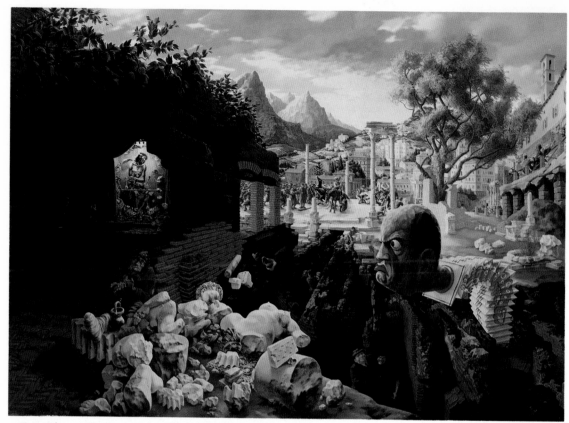

7. Peter Blume. *The Eternal City*. 1934–37 (dated 1937). Oil on
composition board. 34 × 47⅞". Museum of Modern Art, New York
City. Mrs. Simon Guggenheim Fund.

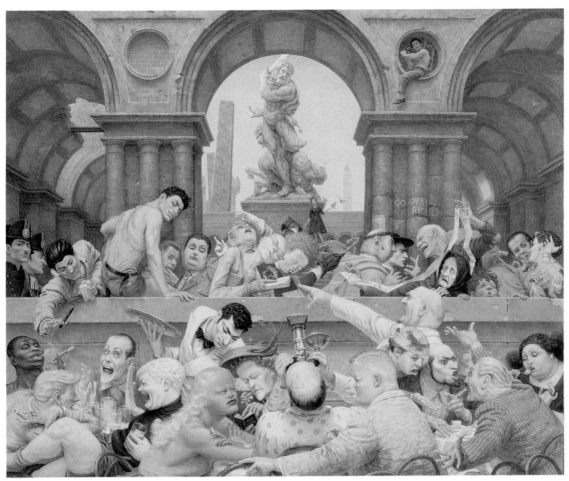

8. Paul Cadmus. *Bar Italia.* 1953–55. Tempera on wood. 37½ × 45½".
National Museum of American Art, Smithsonian Institution. Gift of
S. C. Johnson and Son, Inc.

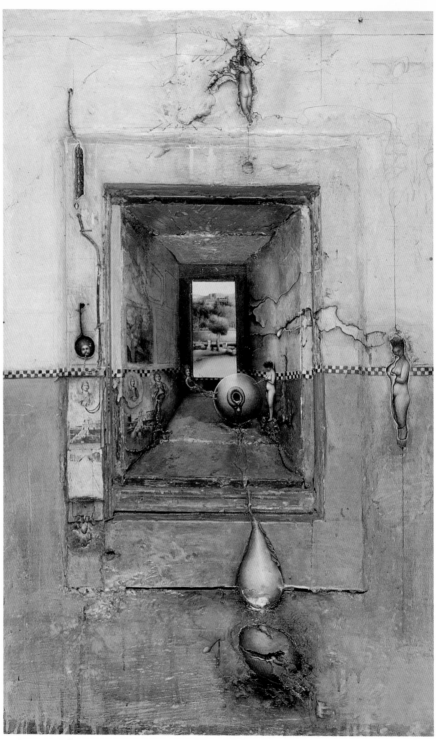

9. Gregory Gillespie. *Exterior Wall with Landscape.* 1967. Mixed media. 38¼ × 23¼ × 3″. Hirshhorn Museum and Sculpture Garden, Smithsonian Institution. Gift of Joseph H. Hirshhorn Foundation, 1972.

her suspicions. All the beggars seem to have somewhere to go when it rains, but "in the sunny interludes they come out upon you from unsuspected places, thick and fast, hungry and clamorous, the lame and the lazy, boundless in impudence and inexhaustible in impositions." Greenwood once went out of her way to help a feverish man who was "apparently dying of hunger and disease" on the Spanish Steps. The next day she found him again in the same spot and in the same condition. Once more she helped him. Two hours later she came upon him still in his "dying agonies," but lying several blocks away, and she "observed for an instant a keen eye peering up through straggling black locks." That was the end of her charity.[22]

Since the Spanish Steps were at the heart of the quarter in which most artists had their studios and most foreigners their hotels or apartments, the Steps served both as one of the beggars' preferred locations (second only to the doors of the more important churches) and also as what Story calls the "models' exchange." Artists' models of all descriptions—Magdalens and Eternal Fathers, Bandits and Boy Jesuses, weeping Virgins and sleeping Endymions—here displayed their likenesses to the great subjects of art. They were generally regarded simply as beggars able and willing to provide a service, fortunate in their appearance as others may have been fortunate in their maladies. Story's discussion of beggars begins with a description of these models, Greenwood's continues with one, and Thomas Buchanan Read's poem "The Scalinnatti" (*sic*), after describing "the glorious flight of stone," devotes one stanza to "sad, misshapen things," who

> crawl and lay
> Their tattered misery in the stranger's way,
> Filling the air with simulated sighs,
> Weeping for bread with unsuffused eyes.

And the next concerns those who

> Bring down their mountain graces to the mart,
> And wait for bread on the demands of Art.[23]

Professional beggars and professional models such as these were both unknown in America and therefore worth writing home about. But the association of beggars and art perhaps encouraged a "picturesque" perception of beggars, which made them occasions not so much for either revulsion or commiseration as for conversion into another reality: the verbal world of the professional writer's "sketch," a world as innocuous as that of sentimental genre painting, and more amusing. In attempting to describe "those ever legitimate objects of charity, the blind, diseased, deformed, maimed, and crippled," Greenwood allowed her popular stylistic flourishes to triumph over her compassionate regard: "Men, legless and armless, mere *torsi*, roll down upon you from declivities; men with paralyzed spines wriggle across your path like reptiles; and, in short, there is no end to these deformed forms of humanity, these dismembered members of society."[24]

"Sketches" of beggars by Catherine Maria Sedgwick and James Russell Lowell show the process even more strikingly. Sedgwick apologizes for not having Cruik-

shanks's power of illustration, but she tries to make do with her weaker medium and lesser talent:

> Then there is the poor moiety of a man whose trunk (torso!), trussed on to a circular bit of wood slightly concave, comes daily down our street of St. Vitale at a jocund pace; and the two old crones at *Santa Maria Maggiore* who hobble towards you with a sort of pas de deux. . . . And there is the handsome youth by the French Academy, who has been dying with the "sagne [*sic*] di bocca" (spitting of blood) for the last fifteen years without any apparent diminution of the vital current! And the little troop of mountain-peasants, whose hunting-ground is somewhere about the American consul's, with their bewitching smiles, sweet voices, and most winning ways; a genuine lover of happy young faces ought to pay them for a sight of theirs. Even beggary is picturesque here.[25]

To Lowell beggary seems "a sudden madness that may seize any one at the sight of a foreigner." Perfectly respectable-looking people suddenly become trembling dilapidated figures holding out hats. But "you soon learn to distinguish the established beggars," and your feelings undergo a series of changes:

> At first, one is shocked and pained at the exhibition of deformities in the street. But by and by he comes to look upon them with little more emotion than is excited by seeing the tools of any other trade. . . . A withered arm they present to you as a highwayman would his pistol; a goitre is a life-annuity; a St. Vitus dance is as good as an engagement as *prima ballerina* at the Apollo; and to have no legs at all is to stand on the best footing with fortune.[26]

Rome was thus a bizarre world where paraplegia became word-play and lameness a dance. Whatever defense of the emotions lay behind this, it seems also to have corresponded to a kind of truth. Where there was no work to be had, misfortunes became a source of relative wealth. Story and others give a page or two to sober discussion of the "profession" of begging and to the fact that some beggars were both industrious and prosperous, and many of them evidently happy.

Beppo, the "King of the Beggars"—a legless but muscular torso (more familiar than that of the Vatican *Belvedere*, says Story)—is in many records of Rome made to suggest that beggary is a lucrative business. Throughout the 1840s and 1850s Beppo rode on his donkey to the exclusive space on the top platform of the Spanish Steps that he rented from the government. There he passed the day scooting himself about on his wooden-shod hands, like a spider (as Hawthorne says) scurrying to catch the fly that has just appeared in some part of its web. Hawthorne also says that Beppo looked like someone coming up through a trapdoor, and that is how he appears in an engraving by Chapman (fig. 19). Chapman's Beppo, however, is also the pathetically fallen gentleman described by many writers, whereas the drawing made by Darley a few years later delightfully catches him in his most grotesque aspect, as he dismounts from his donkey (fig. 20). As the only citizen individually as famous as the pope, Beppo thus appears, more or less pathetic or grotesque, and with many variations in his story, not only in most journals and travel books of those decades

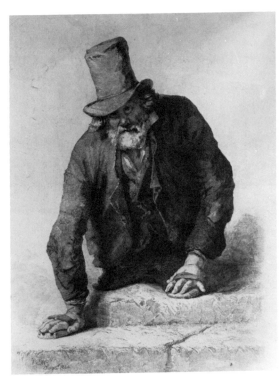

Fig. 19. John Gadsby Chapman. *Beppo, King of the Beggars.* 1861. Engraving. Valentine Museum, Richmond, Virginia.

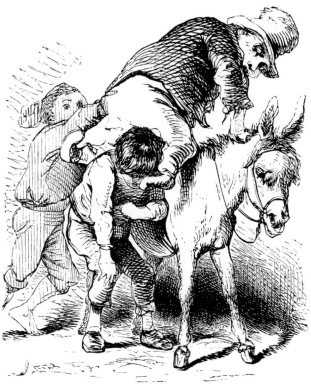

Fig. 20. Felix Octavius Carr Darley. *Beppo.* Drawing. Photo from F. O. C. Darley, *Sketches Abroad with Pen and Pencil.*

but also in fictionalized or versified form in Hans Christian Andersen's *Improvisa-tore*, in Hawthorne's *The Marble Faun*, and in verses by T. B. Read and others. When Cranch returned to Rome in 1858, he was delighted to find Beppo, now gray-haired but "as jolly as ever," still at his post after ten years. "I could as little have missed old Beppo in Rome, and on his old place, as I could have missed the boat fountain at the bottom of the Spanish Stairs," he wrote.[27]

Hillard and Hawthorne (in his notebook) most vividly described the effective begging procedures of this creature, but Story (giving a running account through several revised editions of *Roba di Roma*) left probably the most accurate and complete narrative of his life: Beppo, legendarily the malformed offspring of some impoverished nobility of a country town, becomes so wealthy in Rome that he can furnish his daughters with handsome dowries, provide informal banking services to needy tradesmen and artists, and give large banquets for "roisterers" of his own profession, "porters, and gentlemen celebrated for lifting in other ways." There are the episodes of his banishment after he had insulted an Englishwoman, his return from exile, his transfer to the porch of Sant' Agostino after begging was confined to churches, and finally his death. From his cheerful alacrity in begging, and from his professional pride and prosperity, it was easily inferred that in Rome cripples and the like were a happy and even fortunate breed. "Begging, in Rome, is as much a profession as praying and shopkeeping," says Story. And equally rewarding, for those who had the best qualifications and greatest skill. Pity, therefore, was out of place.[28]

Beppo's severely malformed body made him a legitimate object of charity, but also made him grotesque rather than picturesque in appearance and manner—"an unlovely object," said Hawthorne. Moreover, he was rich, which a beggar by defini-tion ought not to be. But the ambivalence naturally provoked by such a one as Beppo fell away when the approaching beggars were children, especially pretty children (but most children are pretty). One seeks in vain for a woman writer who obeyed the Germanic injunction of Baedeker that children were "on no account" ever to be given anything. "There is one little beggar boy I frequently meet, who is an actual delight to me for his witty persuasion and graceful impudence," wrote Greenwood. He begged for his blind father, who—he always reminded them—"'cannot see the sky, the flowers, and the beautiful ladies. O, yes, yes, you will give me something for him.' And we are sure to give."[29] A blind father here makes giving in good con-science easier, and such additional rationalization for a sentimental reaction to child-beggars was not uncommon. In *Rollo in Rome* (1858), the exemplary Ameri-can boy of Jacob Abbott's series of books for children leads an excursion of infantile tourists in search of the Tarpeian Rock. Some ragged urchins at the gate get the key for the strangers and show them the way, and at the end of the visit Rollo allows some coins to be given to one of the beggars—a pretty little girl who is obviously wasting away with malaria. For this act of "charity" nothing less than a triple justification has been provided: the child is not only poor but sick, and she has performed a service.

Although Beppo was sometimes drawn, boys like Greenwood's were the only sort of beggars that American painters wished to record, which is to say the only kind that tourists wished to carry home as untroubling souvenirs. Children were

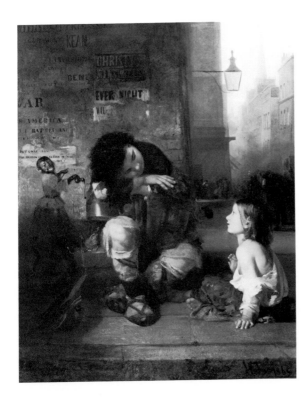

Fig. 21. James E. Freeman. *The Savoyard Boy in London.* 1865. Oil on canvas. 54½ × 43⅞". National Museum of American Art, Smithsonian Institution.

innocent, and even more important, they had a future; one could imagine that they would not always be beggars. Yet in his *Book of the Artists* (1867) Tuckerman found a political statement latent within an apparently innocuous genre painting when he praised as "suggestive" a work called *The Beggars* by that long-time resident of Rome, James E. Freeman. According to Tuckerman only someone who knew southern Europe could realize both how "eloquent" and how close to "nature" it was:

> The pleading, *datemi-qualchecosa* look of the standing boy is more significant than the rags in which he is clothed, and the bare extended arm. The face of the sleeper is calm—a beggar in attire, a happy child in reality. . . . This picture is the epitome of Italy, of her poverty and her clime—her balmy nature and her degraded humanity—her urbane spirit and narrow destiny.[30]

A beggar child is thus essentially a happy child, and his rags a mere costume. But the standing boy's plea signifies a desire for something more than charity and something more than the "narrow destiny" to which Italy confines him. Freeman's *The Savoyard Boy in London* of 1865 (fig. 21) shows a sleeping little Italian organ-grinder (complete with monkey) being solemnly observed by a blonde girl who is (says Tuckerman) Irish. The pathos of two children displaced from their homelands, apparently in search of a destiny less narrow than the one Italy offers, is emphasized by a news bulletin about "AMERICA" that is pasted on the wall behind the laughing monkey. At first glance it seems to announce an option to the poor and displaced. But less legible words make it clear that the news is of the "WAR" and a certain

"BATTLE." The smallest print, at the bottom, however, announces the "Freedom of the Slaves." The painting's explicit definition of time and place thus produces ironic allusions to an America that is possibly as troubled and self-contradictory, as a Land of Promise, as the Italy the child-beggar has left.

But this painting of a child in exile was actually composed in Freeman's Roman studio, where one of his favorite child models, Domenico, found pleasure in entering into the fiction of sorrowful displacement. This might seem to make Freeman merely a calculating manufacturer of sentimental images. But he was in fact no more cynical about his popular art than was Dickens. An entire chapter of Freeman's *Gatherings from an Artist's Portfolio* is devoted to the beloved Domenico, who while dying (in reality, not in play) became the subject of another Freeman painting, which in turn became the subject of a poem by Tuckerman. When one hears of works with titles like *Girl and Dog on the Campagna,* or *The Flower Girl,* which showed its "round-cheeked, curly-headed" subject "grasping a bunch of flowers and leaning against an old wall," one is sure that they were not purchased as images of "degraded humanity." Yet a reading of Freeman's two volumes of *Gatherings* persuades one that neither were they impersonal compositions intended as wholly innocuous souvenirs. Freeman, who married a woman with an Italian father, entered more deeply than most American resident artists into common Italian life, both in Rome and in the hill towns of the Abruzzi and northern Italy that he visited on extensive sketching trips or summer sojourns. Happy in the banality of popular anecdotes, whether visual or verbal, he had a genuine and uncondescending love for the people. Several chapters of both books are given over to affectionate semifictional reconstructions of the lives of his models, which frequently indicate a real concern for their destinies.

In one painting Freeman's identification with Italy's political aspirations became explicit. In 1867 Tuckerman quoted the description, by a recent visitor to Freeman's studio, of a new painting, "life-like" yet "idealized," of a chubby child who is both merry and shy, posed as though wishing to see without being seen. Instead of the expected coy narrative title, however, it carries one that in 1867 made it a pointed political allegory: *Young Italy.*[31] The image as described certainly related ironically to Mazzini's militant and aspiring organization of that name, but in its own way the painting asserted a faith in the Italian future, one that might not be entirely devoid of sentiment. The gentle Freeman could never have painted an equivalent to Henry Kirke Brown's parlor sculpture *Chi Vinci Mangia* (New-York Historical Society), a work so far removed from any context that the question of a child's hunger has become merely an amusing struggle between a boy and a dog.

Whatever became of the actual beggar boys when they grew up, if they survived to manhood (and many no doubt became beggars), they lived on unaltered for a long time in the literature of Italy, in spite of the new government's prohibitions after 1870. With his clever looks and "laughing, saucy eyes," Grace Greenwood's favorite beggar boy would seem to be the same irresistible charmer who shows up forty years later in "A Pretty Roman Beggar" by Frances Hodgson Burnett, creator of Little Lord Fauntleroy. He always runs to greet her in the Piazza della Minerva, crying " '*Soldi, bella Signora!'*—quite sure that he is so pretty and coaxing that he need not pretend to be miserable (which he is not at all), and that the *soldi* will be thrown tinkling

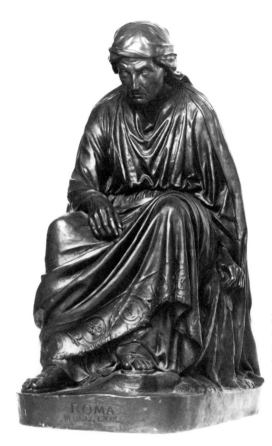

Fig. 22. Anne Whitney.
Roma. Bronze. 27 × 15½ ×
20". Wellesley College
Museum. Gift to College by
the Class of 1886.

onto the pavement." Significantly, Burnett found him "chiefly interesting because
he belongs to a profession which I think does not really exist in America. . . . He was
a professional beggar and a professional beauty." Still, like Greenwood, she "was so
curious to know what thoughts there were behind his beautiful child eyes, or if it
could be that there were no definite thoughts at all." But her sketch ends without
her knowing, for to quiet a conscience that tells her she ought not to be encouraging
his begging, she asks, " 'Do you intend to beg always? . . . When you are older, you
will be strong enough to work for yourself. You will be too strong to beg. Don't you
think so?' " But she could not tell what he thought; he replied only with the smile
that "was a fortune in itself." Burnett can only piously hope "that he will not always
be a beggar, but will find something for his dusky little hands to do when they are
bigger, and that the magnetism and cleverness which made him always the leader
will make a place for him a man need not be ashamed to fill."[32] Sentimental as the
hope was, it had greater plausibility in 1892 than in 1852; for now it seemed just
possible that the destiny of beggar boys might be less narrow—even if it were only
to make them soldiers in the aggressive army of an imperialistic New Italy.

In 1869—the year before the end of papal Rome—Anne Whitney, a sculptor from
Boston, modeled a statuette of an old beggar woman, and called it *Roma* (fig. 22). By
presenting a beggar as an allegorical figure, Whitney immediately dignified the

image and distinguished its function from that of such statues as the *Drunken Old Woman* of the Capitoline and other realistic antique Roman renderings of old age and degradation, to which it is nevertheless formally related. At the end of her two years in Rome, Whitney was able to concentrate in one work her reaction to what she saw on the streets and in the galleries and her feeling for the historic grandeur of Rome. The image of the woman—and of the city—is pathetic enough: slope-shouldered and weary, she is even dropping the one coin that she has. She is a "licensed beggar" (her official medallion is visible), just what the world in some sense had regarded Rome as being for at least a century past. But she wears a gown of incongruous richness, embroidered along its edge with images of the Apollo Belvedere, the Laocoon, the Dying Gaul, and the Hercules. According to Elizabeth Rogers Payne, the folds of the gown originally displayed a satiric mask of "a certain very powerful cardinal" (surely Antonelli), which caused Whitney to send the work off to Florence for safety when the portrait was recognized; and she removed the caricature entirely before the statuette was cast in bronze in 1890.[33]

By the time the work was shown at the World's Columbian Exposition in Chicago in 1893, however, not only Cardinal Antonelli was a thing of the past. Whitney's image of Rome was itself no longer true. Five centuries earlier, as Peter Quennell has observed, both Dante and Petrarch had envisioned Rome as a sorrowful old woman. To Petrarch she was "a gray-haired matron, her garments torn, 'her face overspread with the pallor of misery, . . . yet with an unbroken spirit.'" And in the fifteenth century a manuscript of Fazio degli Uberti's *Dittamondo* showed Rome as a seated old woman enveloped in a black gown, grieving beside the Tiber.[34] But the Renaissance, which grew partly from the desire to restore Rome to her ancient glory (the subject of one of Petrarch's most eloquent cries), destroyed that image of grief. But not forever. By the nineteenth century Rome had sunk once more into poverty and despair and became again the old beggar woman of nations. But the Risorgimento, which explicitly appealed to Dante and Petrarch as earlier liberators of the Italians from ecclesiastical and papal darkness (conceptions echoed in sonnets by Longfellow), once more rendered the image obsolete, the year after Whitney had seen it as truth. Surely it is not accidental that the date "1869" is so conspicuous on the front (not the usual rear location) of the base of Whitney's statue. She must have known—and hoped—that her "ideal" and "timeless" image would soon be a historical memory, and *Roma: 1869* would become the best title for her work.

Palace Walls: "Aristocratic Sympathies"

It was in 1869 that Henry James first came to Rome. As he strolled through the narrow streets of the city, he recalled Edmond About's *Tolla: A Tale of Modern Rome*, which he had been permitted to read in French at the age of fourteen. He kept "wondering which of the palaces had stood for the Palais Feraldi—in which of them the exquisite Tolla had lived, loved, wasted, died; the palaces really having, as it struck me under that violent and irreproducible impression, more to say about

everything Roman than any other class of object." But exactly what the palaces "had to say about everything Roman," beyond their enigmatic impenetrability, was something that few Americans ever came to know. Even James on later visits was frustrated in his desire to meet the Italian nobility instead of the English, or the would-be aristocratic Americans, whom he did not wish to see at all in Rome. This inaccessibility allowed people like Jarves to write freely of the "depravity" of the "higher classes": the men were "effeminate," and the women "unrefined," "neglectful" of their family duties, and unfaithful to their husbands. It also left James free to create a Prince Casamassima and a Prince Amerigo precisely to suit his fictions, without reference to any contemporary reality. Prince Casamassima's very name makes him a palace personified, and at the denouement of *Roderick Hudson* the American narrator can "read" in (or into) the "Italian mask" of the victorious prince's face a "record" of "pride, of temper, of bigotry, of an immense heritage of more or less aggressive traditions," for which the innocent American Roderick and even the half-American Christina are no match.[1]

Prince Amerigo, whom James dares to make a center of consciousness in *The Golden Bowl*, is hardly less externally conceived. What he possesses "of his own" are three properties: the "big black palace" in Rome, a villa in the Sabine hills, and a Castello, "the head and front of the princedom." His eyes are said to resemble "nothing so much as the high windows of a Roman palace, of an historic front by one of the great old designers." And he looks like "some very noble personage" who is "acclaimed by the crowd in the street" as he shows himself at the window to "spectators and subjects" as "a beautiful personal presence, that of a prince in very truth, a ruler, warrior, patron, lighting up brave architecture and diffusing the sense of a function." Amerigo knows himself to be in the eyes of the Americans something to be lavishly "invested with attributes." In a general sense the "attributes" are simply those that America lacked—history and art. Amerigo can be looked up in the British Museum, where volumes are written of "the marriages, the crimes, the follies, the boundless *bêtises*" of his family. Maggie Verver frankly tells him that it was her thought of these "archives, annals, infamies"—especially those of the "wicked Pope"—that attracted her to him. Amerigo realizes that his acquisition through marriage to Maggie of "more money than the palace-builder himself could have dreamed of" simply confirms his own membership in a history-bound "race." But he is not only a book; he is (Maggie tells him) "a rarity, an object of beauty, an object of price." She is certain she will get her money's worth because he "belongs to a class about which everything is known." This is, of course, where she is wrong, because she cannot know what she cannot at first even conceive, what it means to be without the American "moral sense." Prince Amerigo confesses to his friend Mrs. Assingham that he hasn't one:

> "I've of course something that in our poor dear backward old Rome sufficiently passes for it. But it's no more like yours than the tortuous stone staircase—half-ruined in the bargain!—in some castle of our *quattrocento* is like the 'lightning elevator' in one of Mr. Verver's fifteen-storey buildings. Your moral sense works by steam—it sends you up like a rocket. Ours is slow and steep and unlighted."

To this different morality Maggie eventually adapts herself, learning to "lie" beautifully, in the prince's own style, and proud of her ability in the end to "conform" to his "example." Puritan innocence gives way to "princely" character: "his large and beautiful ease, his genius for charm, for intercourse, for expression, for life."[2]

The symbolic mode of *The Golden Bowl* (1904) is, of course, facilitated by such free abstraction and exploitation of racial stereotypes without an inhibiting concern for empirical "reality." Prince Amerigo is pure invention. In *The Portrait of a Lady* (1881) James had still been concerned to represent observed and experienced life, so the inhabitants of the type of Roman palace whose exterior James had so wonderingly regarded in 1869 are, conveniently, Americans. The snob Gilbert Osmond is emulating the exclusivity of the Roman aristocracy, and it is poor little Ned Rosier who, like James himself, must look up from the narrow streets, thinking of his Pansy Osmond as a captive within a dark fortress. James freely draws upon all the romantic clichés he recalled from Edmond About. Osmond's Palazzo Roccanera, "in the neighbourhood of the Farnese," is "a pile which bore a stern old Roman name, which smelt of historic deeds, of crime and craft and violence, which was mentioned in 'Murray.'" According to Isabel Archer Osmond, she and Gilbert "had chosen this habitation for the love of local colour." Rosier can see that it has "quite the grand air," but he is "haunted by the conviction that at picturesque periods young girls had been shut up there to keep them from their true loves, and then, under the threat of being thrown into convents, had been forced into unholy marriages."[3] Gilbert Osmond is keeping up all the Roman traditions.

Hawthorne, in *The Marble Faun*, had not attempted even so indirect an approach to the nobility. In his notebook record of eighteen months in Italy (including two winters in Rome), in the published notes of his wife, and in the memoirs of his daughter and of his son, the only Italians who are more than a name to them are their *vetturino* and a homeopathic doctor. Of the Roman aristocracy Hawthorne can report only what he saw of them in the late afternoon on the Pincio: they were "magnificent, . . . driving abroad with beautiful horses, and footmen in rich liveries, sometimes as many as three behind, and one sitting by the coachman."[4] When the fair Hilda disappears behind the dark walls of the Palazzo Cenci in *The Marble Faun*, she is not seen again until she emerges upon the balcony of another palace in the Corso, freed from her mysterious captivity by shadowy aristocratic-ecclesiastical powers beyond our knowledge or understanding.

Although Americans might imagine that their direct observations of the "people" in the streets allowed them to generalize accurately about the lower classes, they usually realized that about the nobility they knew nothing. Even so celebrated a visitor as James Fenimore Cooper found that the aristocrats were "cautious of opening their doors," and he didn't blame them. The promiscuous character of the hordes of visitors to Rome, and the malicious misrepresentations of Romans habitually printed by the English (promptly repeated by the slavish-minded Americans), hardly encouraged hospitality. What little Cooper did see of the nobility at a ball confirmed his impression that they were more "uniformly elegant and high-toned" than the English aristocracy, and "the females of Rome are among the most winning and beautiful of the Christian world."[5] Cooper is typical in indicating a certain

respect for exclusivity, even if it shut him out, for it belongs to the very essence of the aristocratic nature.

All of the more conscientious travel writers, Cooper included, compensated as well as possible for their ignorance of the nobility by inferring what they could from the significant details of the vast Roman palaces, so unlike anything to be seen in America. George Hillard, William Gillespie, and William Kip were among those who devoted entire chapters to the features of a typical Roman palace, but almost all writers included a few pages on the subject. They express gratitude that the princes of Rome allow visitors into portions of their palaces to see the great collections of art, and they are usually as interested in the palaces as in the pictures. They like to get impressions of the Borghese, the Colonna, and the Doria families from armoirs and portraits, and they often arrive at rather satisfying ideas of a past grandeur and a present dusty decrepitude. Oxymora come into heavy play: according to Hillard, modern Roman aristocrats live their lives in "dreary splendor and desolate magnificence"; and to Hawthorne the palaces are "magnificent hovels." While N. P. Willis was looking at an old portrait of a beautiful young girl of an earlier century—"one of the females of the Doria family"—a dwarfish and deformed old cardinal whose features expressed "imbecility itself" came laughing and shuffling through the gallery, supported by two priests. He was identified by the *custode* as "the Prince Doria, the owner of the palace, and a cardinal of Rome! the sole remaining representative of one of the most powerful and ambitious families of Italy!" The children of Rome, former "mistress of the world," had "dwindled into idiots," Willis concluded.[6]

From 1830 to 1870 the general impression Americans received of the aristocracy hidden behind its high palace walls was of a superb but anachronistic pretension to racial superiority that was in its final days throughout Europe, but in Rome was experiencing a more lingering death, possibly because there its roots were deepest. Only a few Americans penetrated these walls. Those who had a proud sense of family name—of being themselves from a new "nobility"—naturally thought differently about an elite than those who held to a democratic ideal of equality. George Ticknor first arrived on the Roman scene in 1817, when Americans were still a novelty, and he carried impeccable letters of introduction. His correspondence, filled with detailed reports on "Society," reflected Federalist assumptions that an elite class was as natural and desirable in America as it was fixed in Italy. At mid-century the radical democratic activism of Margaret Fuller, who held no such elitist assumptions, brought her into contact with liberal (and therefore untypical) aristocrats. She herself became a marchesa, which she thought a "silly" title for a "radical" like her to bear.[7] And in the final years the conservative and rich Italian-born offspring of American artists—the Storys and the Crawfords—could marry into the noble families with which their parents, by virtue of their long Roman residence and their own social pretensions, had managed to become intimate. Raised in palaces as expatriates, they had very little sympathy with egalitarian ideals. In representations of the Roman nobility throughout the century the specific attitude toward them may range from the scornful to the envious and is often simply ambivalent. But what peers out of all of these accounts, sometimes between the

lines and sometimes in boldface, is an awareness that equality—whatever that means—is an American ideal, the most troublesome of all, both at home and abroad.

Many Americans loved to see an expression of equality, at least before God, symbolized when princes and peasantry knelt together on the pavement of St. Peter's. But some realized that this gesture of universal submission was merely the complement to an equally God-ordained hierarchy of worldly privilege. Barriers between classes were assumed to be "natural," and for some Americans similar ideas of class distinctions and family tradition were attractive, if less absolutely held. The idea of equality, after all, was not taken to have a social application by Americans of the upper classes and "old" families; and when they saw the condition of the lower classes in Italy, a separation seemed even more natural and inevitable there than in America. That did not mean that the most fine-minded of them could not meditate upon the implications of this state of affairs. Henry James, visiting the Castelli Romani, stood before the Chigi Palace in Ariccia, wondering whether its "dusky blankness" could suggest anything beyond "imbecile old age." Surely "a hundred brooding secrets lurk in this inexpressive mask," he told himself. Sloping basement walls and iron-caged windows, with a glimpse through a doorway of a flowered terrace within the courtyard, give "an impression of feudalism . . . to American eyes, for which a hundred windows on a façade mean nothing more exclusive than a hotel." In the piazza one sees a "haggard and tattered peasantry staring at you with hungry-heavy eyes, the brutish-looking monks . . . the soldiers, the mounted constables, the dirt, the dreariness, the misery, and the dark over-grown palace frowning over it all from barred window and guarded gateway." The "votary" of vivid images for their own sake "may well occasionally turn over such values with the wonder of what one takes them as paying for. They pay sometimes for such sorry 'facts of life.' " Unlike America, in Italy there is no class of "happy mediocrity" to serve as a buffer between the prince and the poor, so the prince must "cultivate a firm impervious shell" and think nothing of seeing, when he looks out of his window, "a battered old peasant against a sunny wall sawing off his dinner from a hunch of black bread." Fortunately or otherwise (James is not sure which), on the day that he visited Ariccia the possibility of any "exasperated uprising" seemed very remote. The feudal world lived on.[8]

When Ticknor dined at the Palazzo Massimo in 1837, he had not concerned himself at all with any peasant eating black bread outside. He was only happy that he had gotten inside. He wrote that "I am not aware that there is any other great Roman house where strangers are invited to dinner, or where they can see so much of Roman manners." Thus even Ticknor—who on three visits to Rome spread over forty years came to know five generations of Borgheses as an honored friend of the family—recognized how limited was access to the nobility. He was glad to find that Prince Massimo was a "worthy" Roman prince who "felt the relations and power of his great name and family" (Ticknor respected the claim of descent from Fabius Maximus of ancient days). But he added that this prince was "more enlightened, I am told, than most of his caste." So Ticknor, too, had relied upon rumor for generalization about the nobility, while feeling that his knowledge of the lower

classes of both Italy and America was definite enough to permit confident contrasts between them:

> We have men in the less favored portions of society, who have so much more intellect, will, and knowledge, that compared with similar classes here, those I am among seem of an inferior order of creation. Indeed, taken as a general remark, a man is much more truly a *man* with us than he is elsewhere, and, notwithstanding the faults that freedom brings out in him, it is much more gratifying and satisfying to the mind, the affections, the soul, to live in our state of society, than in any I know of on this side of the Atlantic.[9]

This was a neat solution; in Italy there were different "orders of creation," but in America all were of the same order—the higher one—and all gradations were within that. The "faults that freedom brings out" in "the less favored portions of society" were not too high a price to pay. The less debased condition of the lower classes made it more "gratifying and satisfying" to be an aristocrat in America, but that did not make the European nobility itself less attractive.

Americans grasped what opportunities they found to witness members of the nobility and to measure them by the American world. Even funerals were instructive. The wife of George Loring Brown remarked that "they make a devil of a fuss if a princess or any rich person happens to '*kick the bucket.*'" The funeral for "the Princess of Borghese" (daughter of the earl of Shrewsbury) was "just like our 4th of July" instead of one of "our little quiet burials, in the quiet little village of Shrewsbury-Mass. in America."[10] Mrs. Brown supposed that the woman's husband (who eventually became a patron of Mr. Brown) was a prince because he was "a Pope's grandson." The strong and obvious alliance between the Roman nobility and the Church was one of the aspects that most emphasized its alien quality. Everyone took note of the Noble Guard that accompanied the pope in grand festival processions, but two other events were much more interesting as doors opening into the world of the aristocracy, which sometimes seemed not merely alien but bizarre. One was the ceremony by which the daughter of a noble family took the veil and disappeared forever behind the walls of a convent; the other was the annual Holy Week ritual that saw noble ladies and gentlemen imitating the pope by washing the feet of pilgrims.

Its exotic, wholly un-American character made such an event as a young girl becoming a cloistered nun an intense and strange drama, which a surprising number of Americans made special arrangements to witness. For the most part it was enjoyed simply as an exotic piece of European medievalism, toward which a critical attitude would be impertinent. During his stay in Rome in 1825 Robert W. Weir had sketched the scene in the Church of San Giuseppe as the young daughter of a noble family entered her novitiate in the Ursuline convent. Almost forty years later a painting he made from the sketch excited visitors to Goupil's Gallery in New York. A commentator in the *Evening Post* praised the realism and "high-toned solemnity" of the scene, finding in the figure of the kneeling nun the embodiment of "grace," and in that of the consecrating cardinal the very meaning of "dignity." Crowds

thronged the exhibition room, he reported, taking much "interest in a scene so novel."[11] Tuckerman wrote appreciatively of this painting in his *Book of the Artists*, for in 1834 he himself had responded to the "sad and thrilling poetry" of the ritual and had described it in his *Italian Sketch Book*.[12] And from his terrace in Rome James E. Freeman for many years looked down upon the "ivy-covered walls, as high as those of Rome" that surrounded this same "noted convent" attached to the Church of San Giuseppe. "Could this convent tell you its history, and record the scenes enacted within its walls, it would afford material for many a startling romance in which fiction is blended with painful reality," he wrote. Then, to prove his point, after describing how he had witnessed a "pale and lovely creature" take the veil there, he devoted an entire chapter of his memoirs to a fictionalized narrative of her conventionally sad and romantic story.[13]

One of the most precisely detailed descriptions of this distinctively "Roman scene" was written in 1837 by George Ticknor. His attitude differed significantly from that taken later not only by Margaret Fuller but also by a member of Ticknor's own class, Charles Eliot Norton. Whatever reduction of a human being to a universally humble mortal status may be symbolized by the ritual itself, the occasion was anything but democratic, a fact that emerges clearly from Ticknor's perfectly matter-of-fact account with no hint of criticism. At the invitation of his friend, Princess Massimo, Ticknor witnessed a young countess of the Cenci family being taken into the "fashionable, rich convent of the nobility" at the Tor de' Specchi. The "elite" of all Rome was there, and a military guard lined the church. After a high mass celebrated by a cardinal, the countess, dressed in "pure white, without jewels," and looking "very pretty, gentle, and solemn," was granted permission to enter the convent by the abbess, "an old Princess Pallavicini." She "pronounced her vows of obedience, seclusion, etc.," and "her hair was cut off." The service for the dead was then chanted, "and she was sprinkled with holy water, as the priest sprinkles a corpse." A black pall was thrown over her as she lay prostrate, and the entire burial service was performed. Then "she rose a nun, separated from the world. . . . This part of the ceremony was very painful, and it was impossible for many of us to witness it without tears; for she was a young and gentle thing, who seemed to be fitted for much happiness in this world." Ticknor's pang of regret is simply that shared by others. Afterward, a "tasteful breakfast and collation" was served "in the room of the Superior."[14]

Parallel descriptions by Catherine Maria Sedgwick and Margaret Fuller show that Americans who were not only more democratic but also women looked upon such a ceremony with a more critical eye. Sedgwick confessed that she was mainly moved to "flippancy," whereas Fuller found much to think about very seriously. In 1840 Sedgwick was taken to the Church of Santa Cecilia by an Italian lady, who "expressed as sound opinions on conventual life as if . . . she had been bred in Boston." They waited for "two mortal hours" within the "extra-exclusive" enclosure surrounded by some of the pope's Swiss Guards, for the "cardinal who was to come here to bury the living, was engaged in burying the dead." The mother of "the bride of heaven," whom Sedgwick had regarded as "a mere fashionable inanity," now assumed "a certain dignity" in her appearance as a mother. When the cardinal finally arrived and was elaborately robed, the nun-to-be came in wearing

"that peculiar expression of repressed exultation that you may have seen on a silly young girl" at a wedding. Vulgarly dressed in the vanities she was to renounce, her gown "sustained by an ultra fashionable hump," she trod upon artificial flowers cast by small children with painted "feather wings sewed to their backs." As blank-faced as a "wax figure," she made her vows and listened to the cardinal recite in a singsong voice "a precious homily" about "a long line of female saints who had endured *unendurable* inflictions and mortifications." Then "the poor thing" was led behind the grate of a side chapel, was disrobed, and had her abundant black hair—"her only personal wealth"—cut off. In spite of the "flippancy" with which Sedgwick recalls the scene, she had to admit that when the service for the dead was chanted over the girl's prostrate body, she had found it "a touching sight to see a young creature self-immolated through the force of most unnatural circumstances." After all, in Rome "the alternative" for women "is, for the most part, between vice and vacuity," so she may as well give "a religious colour to the latter." And since female education is "in the hands of the nuns," you "may imagine how well fitted to prepare girls to be wives and mothers, and effective members of society, these poor wretches must be, who know the world only through their sighs and unavailing regrets."[15]

Margaret Fuller, author of *Woman in the Nineteenth Century*, naturally seized the opportunity to witness such an anachronistic event during her first year in Rome. Her young woman was also being given away by a princess, and the cardinal secretary of state himself officiated. The ceremony, however, was "much less effective" than "the descriptions of travellers and romance-writers" had led her to expect. The prospective nun, "an elegantly dressed woman" of about twenty-five with a "quite worldly air," was evidently being disposed of by "one of those arrangements" between the Church and noble families. Her confessor, "in that strained unnatural whine too common among preachers of all churches and all countries, praised himself" for having shown her the true path. "Poor thing! she looked as if the domestic olives and poppies were all she wanted; and lacking these, tares and wormwood must be her portion." During the exchange of clothing and the haircutting, "the black-robed sisters who worked upon her" looked "like crows or ravens at their ominous feasts," so that the "effect on my mind was revolting and painful to the last degree." To Fuller, "monastic seclusion" would be acceptable if it were voluntary and revocable; it is even attractive as a "refuge" such as Protestant communities fail to provide for the "broken-hearted." No doubt there are also some types of minds and characters that it "suits exactly." "But where it is enforced or repented of, no hell could be worse," nor is there a "more terrible responsibility" than that incurred by him who persuades a novice "that the snares of the world are less dangerous than the demons of solitude."[16]

Only one man—the last to give an account of the event—agreed with Margaret Fuller in finding it morally perverse rather than either picturesque or ludicrous, and he did not even make Fuller's allowance that it might ever be good. According to Norton in 1856, no one who wished to retain an ideal image of the scene should go to see it. He had learned this by bitter experience while witnessing a daughter of the Sforza family enter the convent of Benedictine nuns at Santa Cecilia. The large and motley audience included many foreigners who, by "looking at the scene as at a show," gave the church "the air of a theatre." After the cardinal had arrived, the girl

came in "dressed in a ball costume." A "dry old" priest delivered a sermon consisting of "the emptiest commonplaces regarding the dangers and miseries of the world" and the wisdom of those who withdrew themselves "from its duties, to avoid its perils." The girl and her friends, in the front-row reserved seats, listened "utterly unmoved," and the foreigners grew restless. When finally she was taken behind the grating that separated the church from the convent, "a general rush took place among the ladies to get standing-places upon a platform" to watch the disrobing and haircutting. The Swiss Guards strove vainly to maintain some decorum. Afterward printed sonnets celebrating the occasion, just as "unpoetical" as the whole ceremony, were distributed. Norton was left with "a profound sense of melancholy." Whatever the girl had been or felt before, she now "confine[d] herself within limits so narrow that neither the affections nor the intellect could escape being stunted and crushed by them. If the heart beat against the bare convent-wall as against prison-bars, it would but deaden itself the sooner." The entire thing represented a "perversion" of the gospel of one who had come to save the world, not abandon it. But in Rome this perversion was easily "explicable," for here "domestic life," like everything else, was "so ill-understood."[17]

Neither sorrow nor anger were provoked by the washing of the pilgrims' feet. By this ritual Americans were mostly just irritated or amused, but it gave many of them the pleasure of justified contempt for aristocrats who made fools of themselves. Seeing an aproned pope tuck up his gown and pretend to wash the perfectly clean feet of thirteen men costumed and bearded like the apostles was funny enough for Grace Greenwood, but when she went afterward to the Trinità dei Pellegrini hospital to see real pilgrims get their filthy feet washed and their hungry bellies filled through the labors of princes and princesses, she found the scene more than ridiculous. The pilgrims, of course, were not those "saintly" figures in "flowing brown robes, with rosary and staff" that she had anticipated. The women (the pilgrims, nobility, and witnesses were separated by sex) were the most "pitiably poor, wretched, and repulsive" she had ever seen: "Wild, coarse, uncouth, unwashed, uncombed, covered with the merest rags, . . . some were old and decrepit, none very young, all hideously ugly." Six ladies were "eagerly proffering their services" as foot washers and waiters to each pilgrim: "These fair devotees—principessas, duchessas, marchessas, and Roman ladies untitled, but of wealth and fashion—were dressed in black, but many very richly, and wore large aprons of some bright-red stuff, . . . and a badge of the Virgin on the left breast—altogether a very becoming and a slightly-coquettish costume." The women washed feet "with their bare hands, in tubs of warm water, with plenty of soap—scrubbing away lustily at successive deposits of weeks on weeks of pilgrimage." Then each pilgrim was escorted by her lady to an upper room to be fed.

"I noticed," Greenwood wrote, "a Roman princess—whom I had seen one night at the Colonna palace so blazing with diamonds that I almost shrank back from her . . . come up, arm in arm with the most squalid and bedraggled beggar of them all." To see the "velvet" of the one in contact with the "rags" of the other was "simply disgusting." Greenwood was equally repelled both by the "pharisaical parade of a soulless and worthless humility in a set of women of a limited mental

enlightenment" and by the pilgrims, "these tramping devotees," sanctioned in their "fanatical vagabondism" by the Church. They ought to be scrubbed up in private, given new clothes, exhorted "to the Christian virtues of industry and cleanliness," and sent home permanently to the "duties of husbands and wives, fathers and mothers." But, of course, "this would spoil the sight" and "deprive the noble Roman ladies of a favorite penance."[18]

Theodore Dwight alludes to this annual ritual with scorn when, in *The Roman Republic*, he describes the Committee of Ladies headed by Princess Christina Trivulzio Belgioioso that was in charge of the hospitals during the Siege of Rome: "Very different duties did they undertake from those, so much vaunted of, when the washing of the feet of a few poor persons is annually performed in public by some who pretend, by such ostentatious acts, to sustain their claim to be imitators of Jesus Christ."[19] Such was inevitably the view of almost all Americans who report having witnessed the scene; this was not the way in which the extremes of society came together and helped each other. In order for an American woman to take another point of view, it was necessary for her to grow up in a Roman palace and eventually to convert to Catholicism. Looking back half a century to her youth in papal Rome, Mrs. Hugh Fraser, the daughter of Thomas Crawford, recalled that she had frequently witnessed this "scene of unique interest." The one moment when a humorous perception of incongruity glimmers from her account only makes the prevailing pious tone seem to be a conscious defiance of laughter:

> The greatest ladies in the world, in Court dress of black velvet and a long black veil, and wearing their most magnificent family jewels, came to do honour to the Pope's guests. . . . [First] the poor dusty feet that had travelled so far must be washed, and the Princesses, following Christ's example, went round from one to another on their knees to perform this kindly act. . . . The first time I witnessed it I found myself beside the group under Princess Massimo's care, and I shall never forget my amazement when I saw that dear and holy lady stagger forward with a tub of steaming hot water. . . . The Princess was wearing the famous Massimo pearls, string after string of enormous shimmering globes, which hung so far below her waist that they kept getting hopelessly mixed up with the hot water and soapsuds. Talking kindly to the dazzled contadina, she made a very thorough job of her distasteful task, and when it was accomplished carried away her tub like any hospital nurse. . . . For three nights . . . she and her peers rendered this tribute of poverty and faith, while their husbands and sons did the same for the men on the other side of the building.[20]

Less singular occasions for estimating the character of the Roman aristocracy were provided by the balls Americans were sometimes invited to attend. "Who has not heard of the great banking-house of Torlonia, and of the brilliant parties given by its head, to which all the clients are invited?" asked George Hillard in 1853. People of "all climes and colours and tongues," from millionaires to the poor artist "with a knapsack on his back," have "paid tribute" at the Torlonia counters and in reward were invited to the Torlonia soirees. Indeed, the "Palazzo Polonia" of Rome appears as one of the most promiscuous halls in Thackeray's *Vanity Fair* (1847); it is there

that the vagabond Becky Sharp (passing as "Mrs de Rawdon") encounters, among the "princes, dukes, ambassadors, artists, fiddlers, monsignori, . . . French widows, dubious Italian countesses," and other "refuse," her old lover Lord Steyne. The founder of this family was no Fabius; Giovanni Torlonia, a financial genius whom the pope had made the duke of Bracciano, had died only in 1829. But his son married a daughter of a relatively impoverished family of somewhat older foundation, the Colonna, and his daughter married Prince Orsini. So Hillard tells the original Torlonia's story (not with entire accuracy) to contrast it with the "state of decay and decline" characteristic of this older nobility, who were now driven to pay court to a man of "rough and coarse nature" who cynically enjoyed their need and whose energetic and prosperous career was the opposite of their dull, idle, pointless, and impotent lives.[21] The untiring Torlonia perhaps had been too much like a money-grubbing, status-seeking American, but it was at his parties that Americans could sometimes hope to see the "real thing."

Torlonia balls of the 1840s figure vividly in the memoirs of three Americans who in old age recalled the Roman joys of their youth. Julia Ward Howe, writing her *Reminiscences* in Rome in 1899, remembered one that she attended while on her honeymoon in the winter of 1843–44. She contrasted its "animated scene" with one of "exceeding stiffness" at a more elite great house to which her cousin, the consul George Washington Greene, had gained her admission. That had been "a melancholy failure, judging by our American ideas of a pleasant evening party," but at the Palazzo Torlonia the dancing had been lively. Howe recalled especially the "beautiful princess, then in the bloom of her youth," and the old gossip that "the great fortune was said to have led to her alliance with the prince, who was equally her superior in age and her inferior in rank." Howe admired her famous "pearls of enormous size," but "thought her quite as beautiful on another occasion, when she wore a simple gown of *écru* silk, with a necklace of carved coral beads." This was at a reception at the industrial charity school of San Michele, the sort of thing in which Julia Ward's own much older husband, the Bostonian Dr. Samuel Gridley Howe, was teaching his New York heiress bride (herself a banker's daughter) to take more interest than in fashionable balls. Dr. Howe wrote to Charles Sumner that the Torlonia ball was "vulgar, stupid, tawdry," and the prince "a purse-proud Dives." Howe preferred to spend his honeymoon visiting prisons and founding a kindergarten for blind children in Rome.[22]

James E. Freeman recalled the ball he attended in 1844 when he was one of those eager-eyed young artists that Hillard mentions. There were two or three thousand guests, among whom Freeman managed to meet Countess Guiccioli, Byron's mistress "for a season," but who was now "plain and dowdy" and charmless. A good supper was served at two in the morning, but the most unforgettable scene followed. "Old Costa, the master of the dance," was unable to find enough young men who knew how to dance the mazurka; whereupon all the old men of Denmark, Poland, Hungary, and Russia came forward, chose their partners, and elegantly tripped their way through the intricacies of the dance. "I think it was one of the last occasions when those gallants of the past were beheld in force upon the dancing floors of old Rome," says Freeman.[23] In a similarly elegiac vein, the folklorist C. G. Leland remembered several "Torlonia soirees" in 1846, which he thought of as the last year

of old Rome, before the political preoccupations brought on by the new pope altered the atmosphere. Leland records that anyone who had at least twenty pounds on deposit in the Torlonia bank was invited, and although the footman who delivered the invitations returned the day after the party to collect five francs from everyone who had attended, "the entertainment was well worth the money, and more." At one of them Leland saw "a marvelously beautiful and strange thing," such as Mme. de Staël had written of in *Corinne*: a young girl with a scarf who appeared upon a little stage and "merely sat or stood or reclined in many ways," all of them "natural" and "incredibly graceful."[24]

Grace Greenwood attended a more selective, but also international charity ball held at the Palazzo Braschi in 1853. Her report may be taken as typical of the thoughts that the conjunction of aristocrats and Americans was likely to provoke in liberal democratic writers. Greenwood had already been able to form some notion of the "Romans of rank and fortune," since all of them (conveniently for her interpretive habits) had "large, magnificent eyes, . . . of full-orbed yet chaotic thought, of slumberous passion, dreamy and soft, . . . utterly unfathomable, and into which you can look down to depth on depth of mystery and darkness." (It is unclear how many Romans endured the Greenwood scrutiny.) At the Braschi there were, of course, people of many nationalities, which allowed for much interesting comparative study. But the Romans were most numerous and received the most attention. Princess Spada, Princess Piombino, and others "were pointed out to me." Everyone had titles; "the countesses were countless, . . . and a count of no account." But she met none of them. On the other hand, there were Americans aplenty, who were no trouble to fathom at all: "Highly-dressed matrons" complaining about Italian inns, young ladies given to little lapses into Italian confessing to "a leaning towards Romanism, with a growing attachment to that 'darling old Pope,'" and young American men who admitted to the discovery of "aristocratic sympathies."[25]

This effect upon Americans of contact with European aristocracy also worried Caroline Kirkland, who, however, found the English a much worse influence than the Italians. Some Italian ladies had actually relinquished their front-row seats in St. Peter's Square to Kirkland and her friends when they saw that they had difficulty seeing. This was something that no English ladies, or imitative Americans, would have done on a comparable occasion. "English people are cold and exclusive on principle," Kirkland averred, but "why Americans, whose theories are so different in essential respects, should ape them in this, passes comprehension." The day must come when "an honorable, humane, and dignified simplicity shall mark our national manners as well as our political theory." For an American to ignore someone "not certified to belong to a certain class in society" is "an essential humbug."[26]

American ambivalence toward aristocratic Rome is nowhere more concentrated than in the figure of William Wetmore Story, scion of a distinguished and wealthy New England family, boyhood friend of James Russell Lowell, Harvard graduate, and former member of the Boston law firm of George Hillard and Charles Sumner. But in 1848 it was Margaret Fuller who exerted herself to find him and his wife accommodations in Rome, and they in turn had joined her in sympathy for the

Republic during the Siege of Rome of 1849. Story echoed her opinions on the "cruel inconsistency" of the pope, but he was less enamored of Mazzini. The fact that Mazzini was essentially ("like almost all Italians") a "visionary," with only a veneer of English practicality, did not appeal to him as it did to her. The sociable Story even complained that Mazzini had "a little the affectation of a busy man" when Story called on him. (This was a few days after the first French attack had been repelled, when primary responsibility for the government and security of the new Republic lay in Mazzini's hands!) Story and his wife helped collect funds from Americans for relief of the wounded, they carried ice cream from Stillman's tearoom to the parched Princess Belgioioso, and they helped Fuller take food to the Republican troops (which included her lover) who were defending the city on slopes near the Vatican. But a few days before the first battle, Story had scornfully inspected the "earth-mounds, ramparts, stockades" that the Italians had built: "Bunker Hill ramparts were thicker. Here nothing is right earnest. The labourers were leaning pictur-esquely on their spades, doing nothing, and everything was going on as leisurely as if the enemy were in France instead of at a few hours' march of the city."[27] The Storys became exasperated with "politics" and did not wait with Fuller for the denoue-ment. Hoisting a white flag over their carriage, they left the city at the end of May.

 Upon returning to the peacefully papal and French-occupied city in 1852, they sought permanent lodgings, negotiating for the Palazzo Albano, but settling instead for "a beautiful apartment in Piazza di Spagna, 93, just opposite to Hooker's [Ameri-can] Bank." Story wrote to Lowell that these quarters were "more fitted to our republican condition, though perhaps even they are a little too florid. . . . Every day I live here I love Italy better and life in America seems less and less satisfactory."[28] In a letter to Cranch, who delayed his own return to Rome for some years more, Story reported that the pope was busy creating new cardinals, which meant that there were many honorary receptions at palaces "where the Roman Princesses gleam and flash with tiaras and necklaces of diamonds. . . . The night before last we were at the Sciarra, the Colonna, the Santa Croce, and the display of jewels was such as I never saw before." At the Colonna, however, although the "scene was splendid in those towering rooms, . . . I experienced a revulsion of rage and disgust, when on passing to the last salon, I found displayed on the table, pictures representing the battles of the Roman Revolution; after so gratuitous an insult to the sensibilities of every true lover of liberty, and especially of every Italian, I could remain no longer."[29]

 After this clear statement of loyalties, Story reported in the same letter that they had been summoned "without our desire or request" for an audience with the pope, who asked whether ships going from Liverpool to New York stopped somewhere to put on coal, and who declared that "Boston was the greatest city in America."[30] The pope was perhaps not innocent in wanting to form an opinion of Story, a returned alien; but he must have been satisfied, since ten years later he solidified Story's career as a sculptor by sponsoring the exhibition of his work in London. In the meantime Story found life in Rome increasingly to his taste. Even in 1852 he was able to get up splendid theatricals and "grand musical soirees," anticipations of the life to be led in the superb setting of the Palazzo Barberini. By 1853 Story was writing to Lowell that he had "kept out of American society, having exchanged it for Italian. We now have a large acquaintance among the best of Italians, and have been to

many balls & receptions & conversazioni this winter, and find it agreeable." The "harem (scarem)" at 28 Corso, consisting of "emancipated females" like "the Cushman, Grace Greenwood," and others, was particularly to be avoided. Hatty Hosmer had scandalized the Romans by demonstrating that "a Yankee girl can do anything she pleases, walk alone, ride her horse alone, and laugh at their rules," while "the Cushman [Charlotte, a famous actress] sings savage ballads in a hoarse, manny voice, and requests people recitatively to forget her not."[31] These were, after all, social discriminations that the Storys and the Lowells would have made in Boston as well as Rome.

In the winter of 1854–55 Don Filippo Barberini, meeting the Storys in Paris, proposed that they lease a suite of about forty rooms on the *piano nobile* in one wing of his family's famous palace. The opportunity was irresistible. They stayed first for a year in the splendid Casa Cabrale in Via Sant' Isidoro while the new apartment (on which they took a life lease) was being sumptuously furnished.[32] Then, in the fall of 1857, began that period of grand hospitality for English and American visitors who had any claim to cultural, political, or familial distinction—the Brownings, Thackeray, Coventry Patmore, the Hawthornes, Charles Sumner, the Lowells, Motley, Tennyson, Leigh Hunt, Walter Savage Landor, ex-President Grant, Matthew Arnold, Lady William Russell, Henry James, the Henry Adamses, Fanny Kemble, and very many others. The Palazzo Barberini consequently figures in letters and fond reminiscences of nearly four decades, more intimately than it had when its only major attraction had been Guido Reni's *Beatrice Cenci*. A consciously select company assembled within its walls, and their sense of privilege was enhanced by the aristocratic blessing of the palace itself. "It was the name, the race, the power, that, in other days, made the palace," wrote James; "it is the palace that, in our own, has to make, stiffly and ponderously, what it can." And the Barberini made a great deal. When Cranch returned to Rome in November 1858, he was able to write to his wife, whom he had left in Paris:

> Last evening I dined with the Storys in their huge Barberini palace. You go up, I don't know how many broad stone flights of stairs, and they live at the top. . . . Two servants appeared, and after going through several enormous rooms I found Mrs. Emelyn and Edie sitting by a fire in a huge dining-room. . . . We had a simple dinner, and an Italian physician, a friend of the Storys came in. . . . After dinner we went through five or six more enormous rooms, till we came to one where we smoked; and after that there was a little party of friends gathered in the big dining-room, where Edie and several other children took a dancing-lesson.

Two months later he reported that "last Wednesday evening the Storys gave a great ball in their palatial rooms. It was very brilliant—altogether the most brilliant party of the season. . . . There were lots of English and a good many Italians—some of them *Contessas* and *Marchessas*, and a sprinkling of Americans."[33]

In this setting of princely splendor where the entertainment rivaled that of the real princes, Story could not entirely forget those American principles toward which the Italy beyond Rome was increasingly moving, nor could he forget the growing crisis in America itself. For one thing, his old friend and former employer, the

abolitionist Charles Sumner, would not let him. Sumner was a guest in the Bar-
berini in the spring of 1859, when he was still recuperating from the near-fatal
beating a congressman from South Carolina had given him on the floor of the Senate
in 1856. He arrived now in Italy, as Henry James noted, in the year in which "that
Future in which he had so general a faith . . . was all in the air and tremendously in
the balance." The Austrians were about to be driven out, and the united Kingdom of
Italy to be born, lacking only Rome. After his stay at the Barberini, Sumner wrote
Story a series of letters in which the fates and attractions of America and of Italy are
significantly counterpointed, and in which the complete harmony of views between
Story and Sumner is implied. From Turin in May: Sumner had met "the Comte de
Cavour," and had found him "calm, as if he felt himself master of the situation. . . .
He seemed to understand the condition of things at Rome—that Lady William
Russell is *très-autrichienne;* that the people there are right; but as he spoke of the
Saint-Père I thought the *subrisus* of his face seemed to expand. It is evident that he
does not doubt of the result." In August, from France: "I sympathise with you
completely in all your aspirations for dear Italy and grieve with you in her discomfi-
tures." As the time for his return to America approached, Sumner wrote:

> Oh, I do love Italy, and wish that I were there. . . . But I shall be in another place, in
> scenes very different, amidst tobacco-spitting, swearing slave-drivers, abused by the
> press, insulted so far as possible, pained and racked by the insensibility about me to
> human rights and the claims of human nature; finding little true sympathy, but
> cheered, let me confess, by the dignity of the cause I serve.

And in January 1860, from Washington:

> What a difference between this place and Rome! I feel it keenly. And yet there is a
> delight here which you have not. It is the standing up for truth and liberty. The
> slave-masters seem to me more than ever *barbarians.* . . . All things indicate a cri-
> sis. Society is dislocated.

Finally, as things worsened in America in August 1860: "I am charmed with the
news from Italy. The sooner the old is rung out and the new rung in the better. I hope
to hear very soon that Bomba has fled and Pius after him." Against all his own
longing for Italy, he had to say, "But life is real, life is earnest—does not Longfellow
say so?—and I have hard work here which I mean to do."[34]

Sumner, himself aesthetically inclined, represents the severe old American aris-
tocratic tradition that imposed civic duties upon the privileged class. Story too felt
the necessity of justifying his life through "hard work" of his own, and his pro-
digious labors in art and letters are what chiefly distinguished him from the Italian
aristocracy that he emulated in so many other ways. He did not find his "delight" in
"standing up for truth and liberty" in Sumner's way, but he did take time to write a
long lawyerly defense of the Union position in America, which Browning got
published in London, and he elsewhere made apparent his displeasure with the
government of Rome.

Roba di Roma, written during the first exciting years of acquiring intimate

knowledge of the city in which Story now planned to pass the rest of his life, reflects a relation to it that would be less characteristic in later years. In *Roba* aristocrats make casual appearances playing cards, breeding horses, or attending the theater (the best houses had separate nights for nobility, and all of them had reserved entrances and exclusive boxes). Noblemen are shown collecting rents from their tenants (this being the extent of their labors) and taking their families on *villegiature:* "going to their villas and castles" in the nearby hills, where they can keep cool while they watch the peasants cut grain or trample out the vintage. Story also tells us how they get married and buried, and how these ceremonies differ from those for the lower orders. As for the papal government, Story illustrates in devastating detail how the censors suppressed or mangled all plays or operas that seemed to express a fondness for freedom or to imply that an archbishop might be less than virtuous. By devoting a scholarly chapter to pasquinades, which includes also a discussion of *Il Don Pirlone,* Story is able to quote a great many antipapal witticisms in which he obviously took delight. They date from Alexander VI (Borgia) to the present pope Pius IX, who "opened up a large field for Pasquin" after he returned from Gaeta with Antonelli.[35]

Story's poetry, in spite of his good relations with Cardinal Pecci (brother of the future pope Leo XIII) who lived on the floor below him, contains a series of "portrait" poems that includes several repellent Roman prelates, notable for their narrow-mindedness, worldly ambition, lechery, and hypocrisy. "The Lesson of Monsignore Galeotto" to a young man considering a career in the Church is to suppress his love of liberty and truth, or at least to stop expressing it so boldly. After all, says the monsignore, the "freest people" are "the unhappiest; / Full of desires that goad them from their rest" to "end at last / In anarchy and luxury."[36] "In the Antechamber of Monsignore del Fiocco" renders the rebellious thoughts of the servant to a loathsome creature who is about to become a cardinal as a reward for his services to "Church and State":

> We don't forget him whose anointed hands
> Were flayed by order of his Reverence,
> Ere with his bleeding palms they led him down
> Into the court-yard, and we, peeping through
> The half-closed blind, saw him throw up his hands
> And forward fall upon his face, and writhe
> When the sharp volley rang against the walls.[37]

Henry James, looking about for something to praise in Story's poetry when he wrote his biography, mentioned this last, but found even more commendable "Giannone," a poem about another victim of a government spy. James says that "the pleasant image of the idle and hapless young Roman of the Pio Nono, of the Antonelli time stands before us with intensity. . . . The subject indeed is the modern Roman temperament itself—as exhibited in youth; a little excised square of the Roman social picture." Story intensifies the police-state atmosphere by beginning the poem (which is narrated by an Englishman long resident in the city) with a five-page evocation of idyllic Rome, the quiet, peaceful Rome in which the beautiful

figures of ancient mythology come alive during rides on the Campagna and during strolls among the marbles in museums. Against this is placed the reality of a world in which an English convert to Catholicism is seen to live well with no known means of support. He seems merely "a pious good-natured fool," but the reasons for the narrator's conviction that he is a spy are then presented through the story of Giannone, a half-educated and rather light-headed young Roman of great charm who has taken English gentlemen-tourists as his models of dress and manners. (The poem becomes thus a satire on the habits of the English in Rome.) At a card party where everyone else is English, Giannone is encouraged to drink too much, and he begins to proclaim his love for liberty, his hatred of priests, and his hope someday to see "the Tricolor over the Vatican fly." The narrator watches the English convert's behavior throughout this scene. And his suspicions become certainties when not long afterward the formerly ubiquitous Giannone simply disappears. He is "reduced to the unknowable," as James says. "He becomes interesting by being missed."[38]

Story's real awareness of the underlying social horrors of his adopted city was largely repressed, however, so varied, productive, and grand was the life he found he could lead there. The repression is evident in the literary methods he employs. In *Roba di Roma* the consequences of the government's severe censorship that receive stress are the amusing literary absurdities that result, rather than the serious distortion of the truth and the shackling of the thought and expression of an entire people. Awareness of the desperation and pain that motivated the pasquinades that Story lovingly assembled is less evident than his appreciation of their linguistic ingenuity. And Giannone's story is filtered through the perceptions of a garrulous Englishman (partly a self-parody, it would seem) whose style mingles those of two of Story's friends—the syntactic roughness of Browning with the comic rhymes (often triple) of Lowell. One part of Story is anxious that his satire not be taken seriously. Fundamentally "Giannone" is simply one foreign resident's warning to another (who is evoked as the immediate auditor of the story) to be careful of the company he keeps.

That was what Story himself increasingly did. He wrote to Charles Eliot Norton in the early 1860s that John Rollin Tilton, who lived in another part of the Palazzo Barberini, was almost the only American artist "with whom I have anything to do," because the "American permanent society here is very low" (Norton was sure to know exactly what he meant). Miss Cushman was "mouthing it as usual, and has her little satellites revolving around her."[39] One of these "little satellites" was the Boston painter Hamilton Wild, whom Story himself had urged to return to Rome. But when Wild, a delicate and seemingly affected man, was there, Story entirely neglected him. In his *Digressions of V*, Elihu Vedder says that while some thought Wild "Miss Nancy-ish" and embarrassing, he was actually a lonely man of great courage whose effeminate manner was "natural" for him. Wild now felt that "my life has been one long snub," and the most painful of all his rejections came from Story. Wild had faithfully nursed Story through a serious illness in earlier days, and now for an entire winter in Rome, he told Vedder, "Story has never been near me, nor ever sent any one to me." Vedder wisely noted the pathetic humility of that "nor ever sent any one to me," for Wild "had very little, barely enough to get on with," while everyone knew of Story's splendor. Vedder, himself one of those excluded

from Story's world, and having outlived everyone, used this opportunity in his memoirs to take a mild revenge:

> W. W. Story was a generous and warm-hearted man, but his palace, his great circle of distinguished friends, his large studios and the daily caravan of admiring visitors, all made him forget poor Wild, the real friend, waiting in his studio. Oh well, there is some use for a future life after all; they are both there now; and perhaps Story has looked over his friends more carefully by this time.[40]

Ironically, it was possible for a friend who was welcome within the walls of the Palazzo Barberini to fail in a sense of gratitude. In a letter written in 1874 James Russell Lowell complained after a two-week stay that life in the palace was entirely too "grand." He much preferred the "simplicity" of Cambridge, Massachusetts.[41] But to Story that simplicity had long since ceased to be anything but mean and low. The Storys passed their summers at a villa in Siena, at a country house in England (where he moved among the titled families who had become his chief patrons), or in the mountain lodge that they eventually built for themselves in Switzerland. During winters in Rome they kept up their magnificent entertainments, while Story directed a small army of workers in his vast new studios, carving the sculptures that he liked to think could be appreciated only by the intelligent few. In his correspondence Story refers occasionally to Italian painters, actors, and musicians who were close friends, but his relation with the Roman aristocracy itself (besides those who were also artists) is difficult to judge, since, of course, he had no reason to write to or about them. But in 1876 Story's beautiful daughter Edith did marry Count Simone Peruzzi di Medici, the bearer of two great Florentine names (belonging originally to the Torlonias of their time), and Story's alliance with Italy's old nobility—if not Rome's oldest—was complete. It was at the Peruzzi villa in Vallombrosa that he died in 1895.

The Last Days of Papal Rome, 1856–70

For us Americans, all these Italian troubles reduce themselves simply to a single process, by which one more of the civilized races is forming itself on the ground that we have always stood on, and taking up as its creed the same list of ideas that we have always declared to be the heart and soul of modern civilization.

—Henry Adams (June 1860)

Among those enjoying the Storys' hospitality in 1856–57 was Charles Eliot Norton, who wrote to his mother about the day on which, not having gone to breakfast with the Storys "as usual," he arrived to find "them all sitting on the loggia" listening to Harriet Beecher Stowe tell the inspiring tale of the escaped slave woman Sojourner Truth. Mrs. Norton, the American translator of Silvio Pellico's *My Prisons*—one of the first books to awaken Americans to the Italian Risorgimento—would have been interested in her son's report that "the American Eagle is ruffled here a good deal by Mrs. Stowe's presence, and our worthy friends the ———'s with their Southern

proclivities, and many other people, find Roman skies less blue for sheltering her, and give occasion to regret that a woman who has so discredited her country should not remain at home."[1]

The incident neatly records both the image of an apparently liberal intellectual circle of Americans ensconced in a servant-filled Roman palace and the fact that the increasingly bitter division in America was represented in Rome by advocates of the southern position as well. American commentary on the political situation in Rome, however, comes exclusively from writers who presume that they stand for the traditionally "American" values—the "creed" or "list of ideas" that, according to Henry Adams, expresses the ground of advanced civilization that "we" have always stood upon. Yet the theoretical list sometimes seems to omit various ideas held to be fundamental by Margaret Fuller, Charles Sumner, and Harriet Beecher Stowe; and sometimes it includes others, relating to social differences, that some northerners shared with the southern aristocracy, even while finding slavery abhorrent. Among these northern aristocrats was Norton himself.

Norton's *Notes on Travel and Study in Italy* were published in book form in 1859, a year that he describes in his preface as so "full of hope for the future" of Italy. But in 1856 signs of hope, especially in Rome, had not been so easily read. "The condition of public affairs here is thoroughly disheartening," he wrote. "No state could be more rotten and retain its vitality." Norton somberly provided some details he had learned of at firsthand. An architect acquaintance had been arrested during the workers' customary celebration of a building's completion and only after three months in prison learned the charge against him—that his *festa* was actually a seditious meeting. Performances of some operas by Verdi were forbidden. In order to increase revenues without raising the monthly tax, the government declared that 1856 would consist of fourteen months. "Corruption rules supreme," and "both justice and injustice are for sale." But to Norton "the saddest aspect of things" in Rome arose from neither the tyranny nor the corruption, nor did he suggest that these might be the cause of what he most deplored, which is "the character and condition of the people themselves. Society is divided into two great classes,—that of those whose interest it is to keep things as they are, and that of those who would change or overthrow the existing conditions, in the belief that change must be improvement." The first class, a "small minority," holds the "power, money, and troops in their hands." The other, nine-tenths of the Roman citizenry, is unorganized, weakened by mutual distrust, and divided as to both political ends and revolutionary means. Consequently the "moderate and thoughtful men" struggle daily near despair. Norton, however, tried to conclude this note with some obligatory American optimism—or pure rhetoric. Without citing any evidence, he opined that "perhaps the first glimmer of a new dawn may even at this black moment be springing fast forward. . . . Trial, sorrow, and suffering are the forerunners of justice, liberty, and truth."[2]

The absence of "equality" or "fraternity" in this list of values was not an oversight, in spite of Norton's perception of Rome as being divided into two extreme classes. Just three years earlier his first book, *Considerations on Some Recent Social Theories*, had emphatically argued that an elite class, and not "the people," should hold power everywhere, for any social progress of the lower classes had to be

preceded by their moral improvement. Hence Norton was interested in education
for the poor and in the organization of men's clubs, not in immediate extension of
the franchise. He explicitly attacked Mazzini's theories, for he did not believe that
"political liberty is an inherent right of mankind," or that "a republic is necessarily
the best form of government." Norton's rejection of the idea of "the divine right of
the people" as "absurd," however, was complemented by an insistence upon the
moral obligation of any aristocracy—privileged by birth, enlightened by education,
and possessing material advantages—to accept responsibility for leadership and
command.[3] The Roman aristocracy, however, was benighted by its selfish tradi-
tions, its limited education, and its superstitious faith. Moreover, to participate in
the government of Rome, aristocrats first had to become conformist priests, com-
mitted to the status quo.

For Norton the intellectual, what actually seems to have been most depressing
about Rome was not its class extremes but its repression of independent thought.
"No theories of government and of religion can be more diametrically in opposition
than those prevalent at Rome and in America," he wrote. "As an American, born
into the most unlimited freedom consistent with the existence of society, . . .
regarding feeling, thought, and speech as having a natural privilege of liberty," he
found in the system of the Roman church "a skillful perversion of the eternal laws
of right." In Rome, at the "source," all fears about the political effects of the Church
were confirmed. The government successfully maintained its power only by caus-
ing its people to fear each other: "Suspicion is universal." Romans talked to Norton
in whispers, and a Roman friend would say nothing in the presence of Norton's
Roman servant. Within his own letter to America he was asked to hide another from
the nephew of "one of the exiles of 1849" to his uncle, since the Roman dared not
leave it openly at the post office.

The severe censorship that existed in Rome was one of the government acts that
most directly affected visitors, making them acutely aware of the Roman citizen's
limited access to news of the world beyond the city or to critical views of Rome
itself. Norton cites the mutilation that his copies of the *Athenaeum* from London
and the *Revue des deux mondes* underwent before they were delivered to him, and
others complain of the holes in newspapers at the reading rooms and the absence of
contemporary books even at the English bookshop. When Norton discusses elemen-
tary education for the poor in Rome, the restrictions on what may be studied
distress him most, particularly since he had observed that the boys showed a
"quickness and intelligence . . . very striking to one who has been accustomed to
the dulness of intellect that is so often found among the poor children who attend
similar schools in our country." The Roman children were also distinctive for their
"pleasant looks and good manners." But few of them in fact were able to receive
even a Roman education, since the "priest and the schoolmaster are rival powers."
The Church is aware that the "alphabet is the first step toward the free exercise of
thought. Republicans are always readers." Faced with the reality of an intellectually
repressive government, Norton in Rome had no criticism to make of republics.[4]

As we have seen, George Ticknor was another Boston intellectual visiting Rome
in 1857, making his third sojourn for purposes of research. He was moved not only
to judge the social condition of the Papal States in the light of traditional American

values but to juxtapose the Papal States with the contemporary United States. These comparisons yielded a less one-sided critical perspective than Norton's. In both places Ticknor found a deceptive stability. The Union was threatened equally by northern and southern extremists willing to see it break up, and the mediocre new president, Mr. Buchanan, would be unable to keep the peace. Ticknor prophesied that within two years the "sectional excitement" would become "fierce." In Rome, only the "vigor and ability" of Cardinal Antonelli (whom Ticknor visited at the Vatican and found "winning" but too "worldly") managed to keep a financially and morally bankrupt system going. Antonelli was "the whole government" now, for since the pope's return, Pius had concerned himself exclusively with "the spiritual condition of the church." The French troops were "a grievous burden and dishonor, but no reasonable person would ask to have them taken away, so important were they to the maintenance of order." The government was acting "in the boldest, firmest manner," as though "everything were safe, sure, and easy." But there was a real question "how long such a state of things can last." Shortly afterward, in Turin, Ticknor "dined with Count Cavour, the most distinguished of all Italian statesmen at this moment, and the man who, since 1852, has been doing so much to infuse new life into Sardinia." The aristocratic prime minister's dinner guests were all "intellectual men," indicating "a great change in the tastes and character of those who govern the affairs of the kingdom."[5]

Implicitly Ticknor defines two nations going, in some respects, in contrary directions; and the brighter political future is Italian. The United States, under a series of ineffective leaders, is moving toward disunion and democratic mediocrity, divided by fundamental disagreements about national values. Italy, in contrast, is moving toward union, and, although Count Cavour and Cardinal Antonelli are both strong and distinguished men, the forces for liberty are likely to prevail. Ticknor was right, at least for the immediate future. Thus, however Americans in Rome felt about it, the Risorgimento's erratic but sure progress in the two decades between Pius's return in 1850 and the seizure of the city by a United Italy in 1870, gave Rome the feeling of a besieged city, walled off from the world by censorship and by an intellectual bigotry that repelled the "spirit of the age." The papacy found its warmest friend in Austria, which was the greatest threat to the survival of the growing secular and liberal nation that surrounded Rome, gradually pushing the papal boundaries closer as it prepared to assert a historic right to the ancient capital.

In 1859 greater strides were made toward Italian liberty and unity than in any year since 1848, but to all proposals of means by which the pope and his states might participate in the accompanying reforms, Pius "had but one answer, 'Non possumus.'"[6] In Rome itself, whatever appreciation Americans like Ticknor might express for the order maintained by the French, for the introduction of gaslights, or for a greater cleanliness imposed by Cardinal Merode (whose marble notices forbidding the dumping of garbage are still visible on the walls of Rome), the political repression only grew worse. That the government still put on a bold face of self-confidence, as Ticknor observed, is evident from Christopher Cranch's report that for the first time since the revolution of 1848–49, full masking was allowed at the Carnival, and the number of *forestieri* attending was very large. Cranch sketched a group of fellow Americans in a letter to his wife: "Such a looseness as they are all

going it with. The Haggertys and Kneelands and Motleys and Sargents and young Mason had one balcony among them. How many hundred pounds of *confetti*, do you think they threw away the first day only? About seven hundred. . . . It is very gay this year, the Carnival."[7] But also sharing the historian John Lothrop Motley's balcony on two other days that year were the Hawthornes. Nathaniel was glumly absorbing imagery that he used shortly afterward for his rendition of the Carnival in *The Marble Faun* as a moribund festival that masked a profound social malaise. In an atmosphere both hectic and sinister his liberated heroine Hilda appears on just such a balcony as the Motleys', and Miriam (his other even more mysteriously persecuted heroine) is arrested in an efficient police action hardly noticed in the general uproar. "Very gay" indeed.

An even starker image of Rome in the fateful year of 1859 (when a remarkably large number of articulate and politically minded Americans visited Italy) comes from the *Education of Henry Adams*. Adams recalls a visit he made to the studio of Hamilton Wild (whom he did not choose to snub, like Story), during which they were joined by an excited "middle-aged Englishman" who turned out to be Robert Browning. Browning was nearly overcome by a shock he had received while riding near the Circus Maximus. He had suddenly found himself confronted with a guillotine where a criminal had just been put to death. In his old-age recollection of the episode Adams pretends that its essential point, which he had failed to grasp at the time, lay in the contrast between the gentlemanly English poet and the brutal Italian image, juxtaposed against a classical backdrop. As for young Adams himself, he had stupidly waited "to learn what new form of grim horror had for the moment wiped out the memory of two thousand years of Roman bloodshed, or the consolation, derived from history and statistics, that most citizens of Rome seemed to be the better for guillotining." This is surely one of the more obvious instances in the *Education* when the often tiresomely cynical wit of the old man is attributed to the young learner, for the next May the actual young Adams had earnestly pulled diplomatic wires so that he could interview Garibaldi himself after the heroic landing in Palermo. And it was at that time that he wrote his confident statement about Italy's adoption of American political ideals.[8]

John Lothrop Motley, whom we have glimpsed on his balcony at the Carnival, was another Boston Brahmin, author of the recently published three-volume *Rise of the Dutch Republic*; the next year the first parts of his *History of the United Netherlands* would appear. Both works celebrate the triumph of Protestant enlightenment over Catholic tyranny, and as ethical histories, they tend to embody these forces in particular heroes and villains. Inevitably Motley saw in the antipapal progress of a United Kingdom of Italy an analogous struggle. Only two months after his carefree tossing of confetti on the Corso, he was "driven out" of Rome, he cheerfully claimed, by the political disturbances provoked by the war in the north. He welcomed this event in the most enthusiastic American-aristocratic terms: "Nothing can be more chivalrous, manly, vigorous, progressive, and enlightened, than the king of Sardinia, his Prime Minister, and his whole nation."[9]

But a personality very different from such critical conservatives as Ticknor, Hawthorne, Norton, Adams, and Motley provides us with a comprehensive summary of the most radically "American" reactions to the Rome of 1859–60—return-

ing us to a political perspective closer to that of Margaret Fuller, but unmodified by her aesthetic interests or her idealization of the contemporary Romans. The theologian and reformer Theodore Parker, whose intellectual progress had taken him through Unitarianism to Transcendentalism, and then on to the unpopular forefront of the fight for liberty for slaves and equal rights for women, came to Rome in 1859 desperately ill and in search of health. Through a long and rainy winter during which his friend Story modeled his bust, he took his daily walks, visiting the ruins but avoiding the dank interiors of churches and museums, observing what he could of the life of the city, and then climbing 120 steps to his chilly rooms, where he tried to write an autobiography. Rome was in every respect alien to him. Parker was not interested in the "fine arts," he wrote, only in the "coarse arts." St. Peter's was a "great toy" that had cost too much to build and cost too much to maintain. The beauty that Rome offered was no compensation for America's utilitarian accomplishments. In Rome one had the "grand sight" of cardinals "in full costume" and "in great red coaches," whereas Boston, with its "rough look," presented to the eye only senators who had been "shoemakers, farmers, storekeepers, lawyers, . . . walking through the crowded streets." In a letter written in November, headed "St. Guy Fawkes' Day," Parker reported that he had seen Pope Pius, "a kind-looking, fatheaded old man" who was "toted around" in his sedia gestatoria, but that the significant part of the procession lay in the two thousand French soldiers and the battalion of Roman cavalry that guarded the pope in the streets, and the hundreds of soldiers—"fully armed, with bayonets fixed"—who separated the "Father of the People" from his "children" inside the church. "That is a comment on the Roman Question!" While ten thousand foreigners had visited Rome in the winter of 1858–59, the winter of Parker's sojourn saw only four thousand, for they feared "tumults and revolution." Yet Parker thought that in spite of the hate the Roman people obviously had for their papal government, "10,000 soldiers will keep the cowardly city quiet."[10]

Parker agreed with most others that the men and women one saw in the streets ("and indeed, a stranger sees no others") were handsome and graceful, but that was not enough: "I have no hope for the people of Italy, specially none for the Romans. These are a miserable people, out of whom all *virtu* seems to have perished utterly." Delighted as he was to read the antipapal pasquinades, some of which he quotes, he concluded from them that the Romans are "poor wretches [who] seem to think that they have done enough when they have touched off a squib. Better our fathers, 'Trust in God, but keep your *powder* dry.'" Parker strangely supposed that the Carnival of the previous spring had been specially gotten up by the government in order to distract the people from the revolution in the North, and that the childish diversion had been effective. "What if Governor Gage had given the people of Massachusetts a holiday in 1775, and had fireworks on Boston Common just after the battle of Lexington," he asked. Or (as though a contemporary analogy might be more convincing) what "if President Buchanan should order a parade of marines in the Navy-yard, in Charlestown, to quiet the agitation about the Harper's Ferry affair!"[11]

Rome, Parker concluded, was "a fossil city—the Pope is a fossil ruler, *premedieval.* It is as impossible that a pope should be a progressive king, and rule in the

spirit of the great idea of the nineteenth century, as that a sinner should be virtuous or a thief just." At a breakfast at the new American College, Pius had "made a foolish speech . . . got red in the face, and pounded the table with his fists. He said the ideas of the nineteenth century were deadly hostile to the divine authority of the Roman Church." He referred to Garibaldi as an "assassin" and to Louis Napoleon as an "incendiary," but claimed that he was "not afraid." He would "pray to God, and He will change the elements!" Parker was sure that this was not the evolutionary God of the nineteenth century, and that the pope would "live to see the ideas of the nineteenth century shake his Pontifical State to pieces."[12]

In these comparisons there would seem to be an absolute antithesis between the Roman and the American people, and between the American nineteenth century and the Roman Middle Ages. But in other remarks Parker makes clear that the current problem in America will be "more difficult to settle" than "the Roman Question." It is morally even more abhorrent. America is "a democracy with 4,000,000 slaves, mocking at the first principles of all human society, the four great Northern cities all on the side of despotism!" A "stormy time" is predicted for America. Is there any reason for optimism about the outcome? He notes that Popes Julius II and Paul IV "were about as unprincipled and wicked wretches as you could find in the American Congress or the chairs of New York editors." As for the American political process, it seems as inherently reactionary as the papacy in the way it controls the individual. The possibility of a liberal pope is equated with the possibility of "an Anti-Slavery President" being "elected by the Democratic party." William Lloyd Garrison himself would become a James Buchanan in the post, just as Pius IX became a Gregory XVI. Yet Parker hopes that at least Sumner is now back "in his place . . . , and about his noble work." And he knows that if illness had not sent him to Rome, he would himself have been involved in the John Brown affair: "how bravely he acts, how nobly he speaks." From such men one gathered hope for America: "These things are only the beginning of sorrows; but they are birth-sorrows of freedom, not the pains of death."[13]

"I have no intention of leaving my bones in this Roman earth, which is twice cursed, politically and ecclesiastically," Parker had written when he first arrived in late October of 1859. A friend who joined him the following April thought he looked ten years older, his state deeply affected by the "miseries of the Papal *regime,* together with the damp climate." To Parker the walls of Rome were not pictur-esque; they were "green and yellow with fuci and lichens of various kinds," signs of the dampness that was killing him. Parker's desire to leave Rome became "morbid," and he expended his last strength to get out of it: "I will not die here; I will not leave my bones in this detested soil," he repeated. So his friends carried him to Florence, obeying his request that he be awakened when they crossed the frontier into Tuscany, which had just been annexed to the new Kingdom of Italy. Thus he was "profoundly moved" when, after they passed "the last station of the Papal police," he saw a milepost "newly painted red, white, and green." "One who has done so much for liberty loves to meet it on his way," his companion observed. Not long after he arrived in Florence, Parker died at the age of fifty and was buried there in the Protestant Cemetery. He had been grateful to know that "his bones would at least repose in a land henceforth free."[14]

The developments of 1859–60 caused the political poets of America—preoc-
cupied though they were with the troubles at home—to turn their thoughts once
more toward Italy. Even Longfellow, seldom deeply concerned with the politics of
either place, wrote "Enceladus," celebrating the people of Italy as the giant buried
beneath Aetna, now arising amid the fires of war. Whittier wrote an "Italy," which
from "across the sea" hailed Freedom's victory over "priestly cannibals," while his
"Rome: 1859" (retitled "From Perugia") excoriated the pope and Antonelli for
somehow being both "Herods" and "Judases" who were responsible for a "mas-
sacre" perpetrated by papal troops, an action that had, among other things, ter-
rorized the Perkins family of Boston in their hotel. Lowell wrote "Italy—1859,"
which two years later Norton cogently suggested should be matched with an
"America—1861." In 1860 Bryant wrote an "Italy," and in the following year
Tuckerman published an ode called "Italia libera," dedicated to George P. Marsh,
first U.S. minister to Italy, a man who had long advocated (privately) the hanging of
Pius IX. Tuckerman celebrated all the men most instrumental in Italy's liberation
and unification, but gave most attention to Garibaldi, recalling in two verses his
defense of Rome from within its walls in 1849 and concluding with this hopeful
image of a liberating attack from without:

> And Roman hearts now burn,
> To hail thy blest return,
> Before whose face the cruel bigots flee.[15]

Harriet Beecher Stowe may have disturbed Americans in Rome who had "South-
ern proclivities," but she found admirers among the Roman people. After an artisan
recognized her while she was admiring the head of an Egyptian slave carved in black
onyx, he gave it to her, saying, "Madam, we know what you have been to the poor
slave. We are ourselves but poor slaves still in Italy; you feel for us; will you keep
this gem as a slight recognition of what you have done?"[16] An awareness that
Italians, and especially Romans, were in several senses "enslaved"—was widely
shared by Americans, and perhaps the one thing that almost all writers agreed upon.
A government that was tyrannical and backed by a foreign power was obnoxiously
un-American on two counts. Liberation from foreign dominance and the establish-
ment of internal civil liberties were unequivocal ideals, however unlikely the
prospects for their achievement in Italy seemed to be. But the ideal of *unity* for Italy
was one that was less certainly held, even as in America that ideal was also being
cast into doubt.

Yet in Italy the ideal of unity was not really separable from the two ideals of
freedom—that of national independence and that of civil rights. At the time of the
separate republican uprisings in 1848 in various parts of the peninsula, Tuckerman
had hailed them as the destruction of the one "great barrier to all political reform,"
which was Rome's "system of intolerance and brute force," a system employed
wherever the Church's interests dominated, not just in Rome. At the same time,
Tuckerman had not seen that "a political union of the states" was "essential." In
fact, it "might prove undesirable." There was in Italy too much diversity of "cli-
mate, manners, dialect, and character" to permit a stable union, and therefore the

barriers between states might well be maintained. Just after all of those petty revolutions had apparently failed, however, William Ware more wisely observed that only union could have preserved Italy's freedom from foreign domination and thus have protected the internal reforms. The Italians had shown themselves to be a liberty-loving people, inherently republican in spirit, but incapable of united action. This was owing to their heritage from the Middle Ages, when all fundamental loyalties were local. The various states were "full of mutual jealousies":

> They are all of them what our South Carolina is, alone fortunately, in its charac-ter—all for self—ready to throw the world into universal confusion and war, rather than not be able to have her own way—like a petted baby. A few Carolinas would reduce our country to the miserable condition of the Italian republics. The want of a spirit of union and amity has destroyed them.[17]

Margaret Fuller expressed a synthesis of these views when she reported that the leaders of the Risorgimento aimed at "breaking down those barriers between the different states of Italy, relics of a barbarous state of polity, artificially kept up by the craft of her foes." At the same time they were "anxious not to break down what is really native to the Italian character,—defences and differences that give individual genius a chance to grow and the fruits of each region to ripen in their natural way,—they aim at a harmony of spirit as to measures of education and for the affairs of business, without which Italy can never, as one nation, present a front strong enough to resist foreign robbery."[18] But the Reverend Robert Turnbull was more prescient when he observed that for most Italians a central authority—whether local or national—was more important than the theoretical rights of the individual citizen. "They sigh for independence, but it is independence rather of external than internal despotism. Proud of their country, they wish to see it united and powerful; but they do not dread the sovereignty of a Pope, of an Emperor, or of a Council." This was what made the Giobertian idea, that the union of Italy could derive only from Rome, so popular. Italians found their sole basis for unity in the centralizing tendencies of Catholicism. It was in this that Italy was most unlike America. In the United States an individual is "both subject and sovereign," but Italians, because they are first of all Catholics, can have no concept of their own sovereignty. They are born and raised in slavish submission to authority and want only that their yoke be not a foreign one. Democracy—true self-government—is thus an impossibility. If Italy achieved unity, Turnbull was sure that it would do so only under an authoritarian government, if not the pope's, then that of a king or an oligarchy. Only through a long process of social revolution would Italy ever enjoy the liberties America took for granted: "liberty of worship, liberty of speech and of the press, liberty of action and pursuit." National unity alone would guarantee none of these.[19]

As late as 1855 Jarves was equally pessimistic. To expect a "united, free" Italy within the foreseeable future was "putting faith in dreams." Although "nature evidently intended her for a unity," she had in fact never been one, even under the Roman Empire or under the popes. Italy would remain Metternich's "mere geo-graphical idea" because it was in the interest of both Austria and France to keep it

so. But an even "greater obstacle" was in "the spirit of disunion among her own sons," for whom "their country is embraced within the limits of their city walls." Venetians hate the Milanese, Florentines hate the Pisanos, everyone hates Romans, and Romans hate everyone else. And the people of every little duchy want to have their duke. "The unlettered Italian mind has no conception of political liberty. It is a condition never dreamed of." Jarves can find some spark of hope only in the fundamental "genius," "natural goodness," and "intellectual vitality" of the Italian race. Somehow and someday, the principal cause of Italy's continued degeneration—Catholic despotism—will be removed, and the nation will flower again, as in the Renaissance. Toward this end she will have the benefit of the "experience of other nations who have passed through their own agony of travail."[20]

Practically the only American picture of Rome during the years of America's own new "agony of travail," the Civil War, comes to us from William James Stillman. Having abandoned his editorship of the *Crayon* four years earlier in order to turn his attention exclusively to painting, Stillman had just spent an unhappy summer in Switzerland as John Ruskin's incompatible sketching companion, during which Stillman suffered a breakdown in health that caused him to be rejected by the Union army when he returned to America to volunteer. He was given instead the post of consul in Rome, which Howells had refused. (The Ruskinian Stillman had naturally wanted Venice, which was given instead to Howells, who had asked for Munich.) The chapter on the Rome of 1860–64 in Stillman's distinguished autobiography, published in 1901, is perhaps the most joyless of all American accounts of the city after Theodore Parker's. Stillman suffered extraordinary disappointments, losses, and pain during his lifetime, and his morose temperament no doubt affected his recollections, as it did his original experience of Rome. Also, one of the political disillusionments that he felt personally (because of his friendship with the sometime prime minister Francesco Crispi) was with the New Italy itself. The final chapter of his *The Union of Italy: 1815–1895*, published in 1898, is called "Disorganization." The chief causes for that state of affairs were the premature annexation of the South and the "unfortunate necessity for transfer of the capital to Rome," an action that had introduced "elements of discord into the kingdom" and "threatened the established political system."[21]

Certainly Stillman's Rome of the 1860s was in every way unsuitable as the capital of a progressive nation, and both the city and the nation would be badly affected by any forced union. Rome was a city of walls, both within itself, and between itself and the rest of Italy. "Political and social life there was none," Stillman recalled, "and the foreign element, whether the regular or the transitory, was divided by its nationalities, and cut off absolutely from the Roman. . . . It was the most unreal world I have ever lived in." The theocratic government, "considering its authority beyond all human attack, but besieged on all sides by an invading liberalism, which had already captured all its outposts and undermined its position at the center . . . refused to make a single concession to the spirit of the epoch, and bade defiance to diplomacy and insurrection alike":

> All its former allies . . . were in refuge within the walls of the city, the King of Naples and all his court offering the daily spectacle of a parade of their downfall as

they drove through the streets. Rome itself was a huge cloister in which the only animation was in the processions of the priests and students of the theological seminaries, or the more melancholy funerals in which the hooded and gowned friars added gloom to the mystery of our common lot. . . . Government was not by law, but by the arbitrary decisions of the most incompetent of officials, enforced by the bayonets of a foreign army, the soldiers of which despised the population, and lived in the most complete separation from it.

On diplomatic business Stillman frequently saw both Pius IX and Antonelli privately. His portraits of them trace more heavily the outlines of contrasting figures with which we have become familiar: a devout, good-natured, and well-intentioned but unintelligent man in the one, and a Satanic intelligence and will in the other. But some details also flesh out the earlier sketches. Stillman met with the pope just after Garibaldi's expedition at Aspromonte had ended. Excitement in Rome was high, and much of the "ecclesiastic population" had fled in panic to rural convents. Stillman found the pope in "profound despondency," expecting Garibaldi at the gates of Rome at any time and predicting fifty years of tribulation for the Church. On other occasions the pope was more cheerful, although during one interview while a thunderstorm crashed over the city, he crossed himself after every flash of lightning. Stillman came to like and respect him, particularly when he joked about the rumors concerning "quel Cass," Stillman's predecessor who—in the pope's words—"could not be quiet of nights." Although Pius somewhat discouraged the incessant cardplaying of cardinals that had shocked Americans of earlier generations, he was completely tolerant of sexual laxity on the part of priests and people, both native and foreign. When the French authorities wanted to require brothels to be licensed, the pope said that every house in Rome was a brothel, so "it was useless to license any." Stillman seems to have been more disturbed than the pope by the extensive prostitution in Rome; two American friends who went to "a place of the most common notoriety on the Corso" were turned away because "every place was occupied." Cardinal Antonelli thrived in this atmosphere, since "his amours were the common gossip of Rome." Once when Stillman was waiting in the cardinal's anteroom, a woman arrived who was ardently received by Antonelli with "open and passionate expressions of affection." Antonelli, however, belonged only to the order of deacons, so he had never taken a vow of chastity, unlike "the younger Italian clergy," whose conduct was "a gross scandal."

But there were aspects of Rome that bothered Stillman more than its sexual promiscuity and hypocrisy. Any attempt to obtain justice in such matters as thievery, rental frauds, or contract violations required enormous expenditures of time and sometimes money, and usually ended in frustration. This he learned both on his own account and while endeavoring to help unhappy Americans as part of his consular duties. Also, Rome was dangerous. "People were not infrequently robbed in their own doorways," since the absence of lighting within or without, and of any police at night, made them easy prey. The countryside beyond the walls of the city was equally perilous, except for artists, who were assumed to be poor. Brigandage had recently increased, since the Papal States offered refuge for criminals from Naples. On a trip to Olevano, a Sabine hill town that artists loved, Stillman saw a

band of over two hundred brigands escaping from the Italian troops across the border. But ironically he himself came closest to being shot, not by a bandit, but by a French soldier, when, in profound meditation over the news of his son's birth in America, he passed near a prison for political prisoners without responding to the sentry's challenge.

If the Romans of Rome gave Stillman no joy, neither did the resident Americans. Inevitably, he was caught up in their jealousies and squabbles. Charlotte Cushman cultivated him (he had known her when she was on the New York stage, and he a reporter), and then she proposed that he "undertake the demolition of the fictitious reputations of the leading American sculptors, especially Story, Mosier, and Rogers." With Rogers she carried on "implacable war," since he was often asked at parties to sing "The Sands of Dee" in close imitation of Cushman's manner and voice. Stillman declined to take sides (although he had not been invited into Story's circle), so Cushman dropped him. When it became necessary for her to renew her passport, she refused to pay the fee—such fees being Stillman's only income—and wrote to the State Department to complain of his rudeness. Stillman forty years later recalls such things in remarkable detail and fills several pages with them. Even more irritating than Cushman, perhaps, were the Americans from the Confederate States, who now found themselves without valid passports and unable to get them renewed without taking an oath of allegiance to the Union. This caused many disagreeable personal encounters, but more seriously it caused Stillman the loss of his income, since Antonelli eventually acceded to southern requests that all Americans be exempted from the visa requirement. Finally, "bed-warmers" that the American secretary of state sent over as ostensible heads of the legation (Stillman being only the consul) tended to run up a bill and then disappear on a European tour, leaving the debts and all the work to Stillman. Congress fell to squabbling with the State Department over questions of restitution to Stillman and finally failed to approve any appropriations at all for the legation of the United States to Rome. The important relations were now with Turin, provisionary capital of the New Italy. Stillman considered that the Roman legation had been a "scandal" to begin with, fostered by the heady atmosphere of Pius the Liberal Pope, so he was happy to have participated in its abolition. Stillman departed for Crete, supposedly a quiet and well-paying post, but one that in the event nearly destroyed him and his family. Meanwhile, Charlotte Cushman pulled some strings and had her nephew appointed as the new consul at Rome.[22]

Writers now found that the degradation of Rome could be defined through comparison not only with America but with the new Kingdom of Italy in the North as well. Howard Payson Arnold's *European Mosaic* of 1864 contains one chapter on "The Lethargy of Rome" and another on "The Progress of Italy." In the second he emphasizes that the unification of the country is not yet complete, for "from the top of the Vatican the Pope, like Satan on Mount Niphates, still looks down with envy and hate on a scene of growing happiness and thrift which he would gladly destroy!" In Rome the Campagna serves as an extra wall to keep progress out, because the vitality of a city depends upon the health of its surrounding farmlands. "In our own New England the broad and invigorating stream [of rural virtue] flows full and free

from thousands of happy hearths," whereas around Rome the "malignant breath" of the papal government "penetrates the very soil," spreading devastation and thus preventing the constant moral rejuvenation upon which urban life depends. But beyond the papal domains progress is being made in education and commerce, in spite of the "rabble" who continue to "chatter and scream" and "call upon the Madonna to come forth and do and suffer for them whatever they ought to do and bear themselves." And something entirely new has appeared on the scene, which will finish the work of both unification and liberation: the railroads. "The steam-engine is the true apostle of liberty in our day. . . . The cheerful whistle of the locomotive disperses the whole grinning rabble of superstition and bigotry."[23]

The railroads of the New Italy were what Mark Twain most admired when he arrived in 1867. The smooth rails, the comfortable cars, and the new marble stations surpassed anything of the kind in America. "These things win me more than Italy's hundred galleries of priceless art treasure," he said, "because I can understand the one and am not competent to appreciate the other." Building the railroads had bankrupted the new government, of course, but this had produced the happy necessity of confiscating the property of the Church. Thus in a manner unforeseen the railroads had helped to end the sixteen-hundred-year "midnight of priestly superstition."

Being so impressed by northern Italy's dual progress through advancing technology and repression of priests, Twain was the more struck by the backwardness of Rome. But worse was the fact that as a travel writer he arrived late on the scene. Everything was very familiar. Thus he was denied the chief pleasure of life, "Discovery!" But if the American in Rome must necessarily be bored, what if the situation were reversed? If only he were a Roman arriving in America! "If, added to my own, I could be gifted with modern Roman sloth, modern Roman superstition, and modern Roman boundlessness of ignorance, what bewildering worlds of unsuspected wonders I would discover!" And so the Innocent is off, imagining the report he would give to his gaping countrymen upon his return: of a land where people managed to survive with no Mother Church and no foreign soldiers, where everyone could read and write, where no goats were driven through the streets of the cities, and where the commonest people lived in wooden houses with glass windows! At this point intrudes the first suggestion that Twain's jingoistic irony might easily be sidetracked and reversed, if not derailed. For the traveler admits that wooden houses tend to burn—often right to the ground. This unfortunate fact is quickly covered over by praise for the marvelous fire departments and insurance companies, but when the Innocent from Rome next mentions that rich men in America cannot buy their way into heaven, like those in Italy, he goes on in the same wondering tone to say that a rich man can become a governor or a senator, "no matter how ignorant an ass he is." For a while thereafter the satire is entirely against America: a wonderful place where "women put on a different dress almost every day" and buy frizzled hair for their heads in shops; where men wear black all the time, and delicate shoes, and yet they laughed at the Roman's costume as though *it* were strange.

Then the irony reverses again: in America priests and soldiers are of "astonishing" scarcity—you can fall out of a window without landing on one; common men own their own farmland instead of renting it from the Church or a nobleman; Jews

in America "are treated just like human beings, instead of dogs"; the ordinary men can protest safely against unjust laws and even get them changed; they pay low taxes; there are no mendicant friars asking them for money all the time; and what clergymen there are sometimes take baths! American mountains are higher than the Albine hills; American prairies are more extensive than the Campagna; American rivers are bigger than the Tiber. All this is true, believe it or not, but the most amazing thing the Roman Innocent learned about America was that the grandsons know more than their grandfathers! They use a sharp iron plow, not a triangular block of wood, and they mow their fields with a "horrid machine" that "works by fire and vapor." But at this demonic point in his story he sees from the faces of his auditors that his credibility has failed: "Alas!, my character is ruined, and I am branded speaker of untruths!"[24]

This passage in the *Innocents Abroad* is the last comprehensive summary ever written setting forth the basic American observations and prejudices about papal Rome and making the standard contrasts between the two nations. In fact, the French had already withdrawn their army from Rome in December of the previous year (the foreign soldiers that Twain saw were the non-Italian papal troops). That events were moving with surprising rapidity is evident from the fact that in 1864 Story had doubted the possibility of any such development. He had written to Norton that Rome was "turbulent," bombs were being thrown, and the papal troops constantly came "to blows with the French." The pope was ill and could not perform at the Easter functions, but he "may live for years yet. Until he dies there is no hope, and even then I see no prospect, for the French will not withdraw, and until they retire what can the Romans do?"[25]

The pope's continued refusal to listen to French suggestions for certain reforms, however, meant that they tired of him long before he died. In 1864 he issued his encyclical denouncing all modern "errors," including the notions that he might do without his temporal sovereignty or that the people had any inherent political rights. And soon afterward France, which felt that the military and diplomatic demands being made upon it by Prussia and Italy were now of higher priority than continued protection of a reactionary pope, agreed to withdraw its troops within two years. The same agreement supposedly guaranteed the security of the pope in Rome, but Italy was allowed to move its capital from Turin to Florence. Some observers frankly read this as an obvious prelude to a further move on to Rome. The transfer to Florence was made in 1866, just after Italy had succeeded in annexing Venetia, which left only Rome—now lacking its French "protectors"—outside the kingdom. In the very year that Twain made his visit, the impatient Garibaldi arrived with his troops at the walls of Rome against the wishes of the Italian government, which had to insist that any occupation of the city be preceded by a popular uprising demanding Garibaldi's entry. The pope in the meantime had vastly increased his own troops through foreign recruitment, and the French army also quickly returned, so naturally the uprising did not take place. Instead, Garibaldi's army was defeated by the French, and he himself arrested and imprisoned by the Italians, while back in America Whittier wrote a poem in his honor declaring that he would triumph yet. The French withdrew to Civita Vecchia, where they remained as the pope's safe-

guard until the Franco-Prussian War began in 1870, whereupon Italian troops under General Cadorna appeared at the walls of Rome.[26]

Meanwhile, Henry James had arrived in October of 1869 for the first time and had gone "reeling and moaning thro' the streets," forming indelible impressions of a uniquely wondrous place, a marvelous anachronism. He would always remain thankful that he had seen Rome in its last year under papal rule. That same winter Norton settled in Florence, the new capital of Italy, and complained about the very existence in Tuscany of the identical railroads that Arnold and Mark Twain had heralded as signs of progress. The sound of a train whistle near Santa Maria Novella in Florence, or the Campo Santo at Pisa, transferred Norton at once to the world of Boston's Back Bay and the Fitchburg Station. Railways and "the common school are Americanizing the land to a surprising degree. Happy country! Fortunate people! Before long they may hope for their Greeleys, their Beechers, and their Fisks," he wrote sarcastically to the Harvard philosopher Chauncey Wright. Norton was certain that a constitutional government, even under a king, was unsuitable to Italian conditions and temperament; what would eventually come of it would probably be "unconstitutional Despotism." Throughout Europe the discontent of the "lower classes" had reached the stage of "formulated opposition to existing social institutions and arrangements." In Italy as elsewhere there was "complaint about division of property, talk of rights of labour, of rates of wages, and other such matters." The situation was getting dangerous. But Norton did not much care; neither European nor American society as then existing were "worth preserving."

It was in this mood, in April of 1870, that he visited Rome, where a railway had only just arrived, and where the Ecumenical Council was debating the infallibility of the pope. The Council, with its great influx of priests from around the world, gave the city an unusually excited and cosmopolitan (if even more heavily ecclesiastical) atmosphere, and illuminations, commemorating the pope's "miraculous escape" when the roof of Sant' Agnese had fallen in, were more brilliant than ever. Rome remained its own world, defying developments beyond its walls. Norton reported to Ruskin in May that "Rome retains something still of its prerogative of immobility,—and resists with steady persistency the flood of 'American' barbarism and of universal materialism which is desolating Europe."[27]

But four months later the Italian army was at Rome's gates, and the Council Fathers had fled back to their homelands. Our images of the Italian occupation come from the letters and memoirs of artists long resident in Rome, who stayed through every alarm and threat of change. The isolation of papal Rome just before the end is rendered by a description quoted by Regina Soria in her biography of Elihu Vedder, who returned to the city in 1869 to make it his permanent home: "All the walls remained standing, all the gates were in use, and all were shut and bolted at a certain hour each night. The city was cut off entirely from the Campagna and slept alone in the vast plain."[28] This Rome belonged wholly to the past after September 20, 1870. The painter Maitland Armstrong, who had become American consul in Rome the preceding year (succeeding Charlotte Cushman's nephew), vividly recalled that day in his memoirs, *Day before Yesterday*. In August he had been sketching at Bellagio on Lake Como when he received the news of the Italian move toward Rome, and he

was summoned by telegram to return, since he was the only official representing the United States to the Papal States. Twenty-five miles from Rome, at the edge of the Campagna, the train stopped since the Italians had torn up the rails. Armstrong managed to find a ragged old peasant willing to rent him a rickety wagon pulled by half-starved horses, which he shared with some condescending members of the Austrian legation. After a miserable ride over a hot and dusty road, they finally made it to Rome and found the hills surrounding it dotted by the tents of the sixty thousand Italian soldiers, while on the plain regiments of cavalry were drilling. At the Porta Pia, where Armstrong and the Austrians wished to enter, the gateway and walls on either side were almost covered with sandbags and earthworks. Armstrong's American passport got him immediate entrance, but the Austrians were "obliged to remain outside the walls all night, and when I met them in Rome the next day their patronage of me had ceased." Armstrong went directly to his apartment on the Pincio.

For the next month the city was quieter than ever, even for late summer. Rome was "hermetically sealed"; all communication—by telegram, post, or traveler—had ceased. Armstrong interviewed a few stranded Americans anxious to have the protection of the flag, among them the Catholic students at the American College and the Propaganda. He drew the line only at the plea of a woman who had given up her American citizenship to marry a high Roman official, but now was frightened. The day before the attack, Armstrong went to a favorite sketching place at the Villa Medici, the "Bosco" in which artists always expected "to see nymphs and satyrs," but sometimes brought their own models instead. This time the grove was inhabited by Papal Zouaves watching the Italian troops through field glasses. "The Zouaves were attractive, dashing young fellows, . . . Americans, English, Irish, German, and French, many of them of noble families." They seemed "gay and hopeful" as they looked out at the great army.

To Armstrong's account of the events of the next day may be joined that of the jolly little sculptor Harriet Hosmer, an adoring friend of the exiled queen of Naples (to whose new horse she had just been introduced, Hosmer being a great rider herself). She wrote immediately to a friend in America:

> I am fairly upon the war-path or in the path of war. . . . Rome belongs no more to the dear old gentleman with the Tiara!!! . . . I, skeptical to the last, as one always is who has heard of a possibility for eighteen years, would not credit the fact that the Italians were really coming, that they were outside the gates. But yesterday at five o'clock in the morning began a cannonading which made us open our winkers pretty lively, and keep them open as big as saucers until near eleven o'clock, when a hole was knocked in the wall and in marched Victor Emmanuel's troops.

The battle as reported by Hosmer became a personal comedy, since her lodgings were near Porta Pia, where the wall was breached. Hearing the great noise, and receiving the news that Napoleon's Villa was on fire, she wanted to "see a little of the fun outside my own walls." She took up her spyglass and ventured out, only to have a shell burst nearby in Via Pia. A crowd was running toward her crying *"Indietro, indietro!"* so she turned about and ran with them. As they rounded a

corner another shell landed, wounding the head of a man "so near me that he was touching my dress. Pretty lively, wasn't it?"

Hosmer then "crept around corners" to join the company at "Rossetti's house in the Porta Pinciana." From there they had "a grand view of things, with a ball whizzing around our ears every few minutes," until one landed three roofs over, and they went back inside. In the meantime Armstrong and an Italian artist-friend had been trying to watch the battle from their rooftop, but had also been driven below when a bullet struck the casing of the skylight through which they had just come up. Five and a half hours later, wrote Hosmer, "the cannonading ceased and Rome became *Italian.* We can scarcely believe it, and such rejoicings as the Romans are waking up to, are perfectly unnatural in this quiet Papal city." Of course, in the afternoon everyone went out to see what was left of the Porta Pia. The "pet portal" of the "dear old Pope," who had been restoring it for years, looked "like a piece of perforated card." The most sensational and portentous fact—in which much significance was being found—was that the statues of Saints Peter and Paul standing on either side of the gate had both been beheaded. Hosmer took all this in stride, until she climbed through the riddled garden wall of the destroyed Napoleon Villa and came suddenly upon a dead Zouave, "all covered with dust, his hands and his face like marble." Armstrong also arrived at the villa, "through the grounds of which the Italians had entered by a gaping fissure that they had made in the old Roman wall, which was not at all prepared for modern artillery." He too "saw a Papal Zouave lying dead on his back under an ilex bush near the gate." But he saw something more—the same Zouaves he had met the day before in the Villa Medici were among those being marched down a long narrow street with "high walls on either side, . . . lined on both sides as far as one could see . . . with Italian bersaglieri" who shouted "Viva Italia!" at the Zouaves and spat at them and thumped the butts of their guns on their toes as they passed. "The next day the Zouaves were all assembled in the great Square of St. Peter's and expelled from Rome and we never saw them more. The whole affair was very different from the gallant defense . . . of Rome by Garibaldi in 1849."[29]

Hosmer did not believe the papal Rome that the Zouaves had fought for had ended forever: "The Pope is strong yet. . . . Playing with the Vatican is dangerous." But she ended her letter by saying that she would postpone her visit to England until Victor Emmanuel entered Rome; "it is a sight I would not miss for worlds."[30] She was ready for whatever came.

James E. Freeman recalled the events more briefly, and with the perfect detachment of the settled Roman. The people of Rome "were anxious to be conquered in the shortest possible time, and to be set free," so when a "breach was made in the walls near Porta Pia, and the soldiers of King Victor marched through it," only "a few inefficient shots opposed them," and then "multitudes of citizens went to meet them, bearing in their hands small tricolored flags, showing their adhesion to the national cause. Rome was taken!" Italy at last was a "perfect unity." The pope "shut himself up in the Vatican, and sent forth vain protests and appeals to all the Catholic powers of Europe," and hurled excommunications at the "usurper."[31]

Pius's appeals were heard in America as elsewhere, and when the Zouaves who had been recruited from its shores returned, they were met with tremendous dem-

onstrations of loyalty to the pope by American Catholics. Once more the bishops and the poets broke forth in eloquent opposition. The archbishop of Baltimore, returning from the Council, declared that liberty did not mean in Italy what it meant in America; there it meant only the liberty to assassinate and to rob.[32] But at the Academy of Music in New York in January of 1871, and at Boston at the Music Hall in February, the unification of Italy with Rome as its capital was celebrated by great gatherings at which exultant letters from the American intelligentsia were read. The aged William Cullen Bryant orated that Rome now enjoyed what Roger Williams had established in Rhode Island two centuries earlier, and Julia Ward Howe provided a "Hymn for the Celebration of Italian Unity," to be sung to the tune of "The Battle Hymn of the Republic":

> Let them sound a victor strophe from the mountains to the sea!
> Sweep away the old defences! let the tide of life run free
> As the thought of God commissioned, that outleaps captivity.
> Let Italy be one!
> CHORUS: Glory, hallelujah!
>
> . .
>
> Sound the trumpet of resurrection! let the noble dead arise!
> Let the hour long wept and wished for make God present to their eyes!
> Let one joy illume the heavens and the earthly paradise,
> Since Italy is one![33]

Civilizations Opposed: New Rome and the Old

Rejuvenated Italy is building a new Rome on the Esquiline. A fragment only of the wall raised by Servius Tullius remains to speak of his famous enclosure of the Quirinal and Viminal hills. Over the site of the "Pretorian Camp" are rising hotels, imposing dwelling-houses of the most modern style of architecture, a splendid theatre, and an American Episcopal church of Gothic construction.

—James E. Freeman (1881)

The most beautiful thing in Italy, almost, seemed to me in May and June last, the exquisite summer luxuriance and perfect tendance of that spot—I mean of course that very particular spot—below the great grey wall, the cypresses and the time-silvered Pyramid. It is tremendously, inexhaustibly touching—its effect never fails to overwhelm.

—Henry James (1907)

One side of the Protestant Cemetery in Rome is enclosed by the "great grey" Aurelian Wall where it passes the Pyramid of Caius Cestius near the noble gate of St. Paul. At the entrance, on the wall that separates the cemetery from the street on the other side, is a marble plaque bearing some lines of verse by Constance Fenimore Woolson. She was a grandniece of James Fenimore Cooper and close friend of Henry James, who visited her grave there in 1907, thirteen years after her apparent suicide in Venice. The wall was raised to its present height in 1923 in memory of Woolson's

sister, Clara Woolson Benedict, "As a Protection to the Sacred and Historic Place which She Loved So Dearly and Where She Now Rests." The extra height was needed because beyond the wall a new city was growing that inevitably disturbed the melancholy serenity of this once remote spot. If the romantic solitude of no other part of the Old Rome within the walls could be preserved, this beloved cemetery, where the remains of so many Americans now lay near those of Keats and Shelley, could at least be protected from the brutal turbulence of modernity. It was Shelley, in three stanzas of his elegy for Keats that James greatly loved, who had taught them how "the Spirit of the spot shall lead / Thy footsteps to a slope of green access" where "shelter" could be found from "the world's bitter wind."[1]

In 1856 Charles Eliot Norton, finding the grave of Keats in a neglected state, had arranged to have the stone reset and "some violets and myrtles planted around it."[2] By the time James visited Miss Woolson's grave half a century later, American visitors came out of respect not only for favorite English poets but also for artists, writers, and other wanderers from their own land: among them William Wetmore Story and his wife, who had buried their first son there as long ago as 1853 and now lay with him beneath Story's *Angel of Grief*; Joseph Mozier, another sculptor (d. 1870); Richard Henry Dana, Jr., author of *Two Years before the Mast* (d. 1882); George Perkins Marsh, first American minister to Italy (d. 1882); James Jackson Jarves, lover of Italy and hater of the Church, who had been knighted as a Cavaliere della Corona d'Italia (d. 1888); James Clinton Hooker, the Vermonter who had settled in Rome in 1847, establishing the bank in Piazza di Spagna upon which Americans came to rely for both money and messages (d. 1894); and Louisa Ward Crawford Terry (d. 1897), wife first of the sculptor Thomas Crawford and then of the painter Luther Terry, and mother of the novelist Francis Marion Crawford and the memoirists Mary Crawford Fraser and Margaret Terry Chanler. The place was, according to Mrs. Fraser, her mother's "last, long chosen point of her earthly pilgrimage," a place "to rest under the warm Roman sunshine, where the west wind she loved blows in from the Campagna and the sea." In 1900 both her husband, Luther Terry, and his fellow artist William Stanley Haseltine also died and were buried in this historic ground. In August of that year, when Mrs. Terry's niece Maud Howe Elliott was leaving Rome after a six-year residence, on her final day she gathered up "an armful of roses, oleanders, and jessamine" from her terrace overlooking St. Peter's Square and carried the flowers to the grave of her aunt, "the dear one who made this Eternal City a second home to me—who shall say to how many others?"[3]

Memory is the new element in American writing about Rome after 1870. These are years of autobiography, of letters collected and biographies written or commissioned in acts of filial piety, years of retrospective fictions. But there are also books by some who, never having seen papal Rome, could enjoy what remained of it, and even embalm it as a lost Eden of artists, without antipathy toward the monuments of New Rome and with positive pleasure in its greater comfort. Destroyed villas could go unlamented because unknown, and new hotels could be gratefully patronized. Still other writers, like William James Stillman and William Dean Howells, who had known Old Rome but never loved it, looked upon New Rome with the least regret, concerning themselves with the present and future—good or bad. The

rhetorical thread that binds almost all descriptions of Rome coming to us from the decades just before the Great War is a new comparison: no longer that between ancient and "modern" Rome, or merely that between Rome and America, but one between the romantic pre-1870 Rome and the Rome of railroad stations, tramways, massive marble administrative buildings, new Parisian streets, and luxury hotels.

The diverse Romes in these three kinds of books are all creations of Americans who find their preferred pleasures excited or their particular truths confirmed by the same circumstances. Pessimists, optimists, and ironists alike find evidence in Rome of the collapse or the progress of "civilization" and thus implicitly debate the very meaning of the word. This is what invests the new images with an interest beyond themselves. In a period when America was expanding to continental proportions as its own "New Rome," to emerge as a world power at the end of the Great War; in a period when Italy was going through its experiments in parliamentary government and imperialistic expansion that ended in a fascist state—the meaning, preservation, revival, or advancement of civilization were issues everywhere. The viability of democracy, the stability of social structures, the importance of religion and the arts, and the effects of commerce in the New Rome were evaluated according to various and often contradictory American lights. In Rome one conception of civilization was being superimposed upon another, which it sometimes effaced and sometimes assimilated to its own uses. Depending upon one's point of view, these actions represented vandalism or progress, degradations or improvements, impoverishments or enrichments of Rome as the city that everyone agreed was—or had been—central to the idea of civilization.

The first substantial expression of the nostalgic vision of Old Rome was the creation of Henry James in his biography of William Wetmore Story (1902). This work was preceded in 1877 and 1883 by the artist James E. Freeman's two *Gatherings* from his notebooks and memories of more than four decades of Roman life, but Freeman is neither sentimental nor polemical about the changes in the city. His attitude toward both the Old Rome and the New is realistic and ambivalent. In 1837 Freeman had arrived in a picturesque city where Thomas Crawford and Luther Terry were the only other resident American artists, so forty years later he naturally expresses some nostalgia for the old days associated with his youth. But he is sentimental only about people—especially his models and fellow artists. In the excerpts from his original notebooks and in the commentary with which he embroiders them, he largely accepts the historic developments in Rome, while appreciating the rare privilege of having been present to witness them. Of course, he recalls his share of moonlight serenades, but he also remembers the "vexatious" cobblestoned streets lacking both sidewalks and lights, the absence of drains from roofs and pavements, and many of the other inconveniences and miseries of Old Rome. Thus Freeman grants that it is "unreasonable and retrograde" to "miss those 'other days' of Rome," even while he frankly does so. When he analyzes the various reasons artists, scholars, poets, Catholic pilgrims, and simple refugees from alienated homelands came to Rome, some to return annually, some to remain forever, he admits both that they all agreed to ignore its many "disagreeable features" and that the "presiding spirit" that had constituted the attraction before 1870 was now losing her "dominion." Freeman's enumeration of the changes being effected by the

New Italy expresses no outrage. On the contrary, he fully understands that "the actual present, the practical and material, with the newly emblazoned watchword *progress,* is wildly interesting the whole Italian people." Why should "veneration for the glories of the past" not "pale" for them before "the absorbing excitements of *to-day*"?[4]

The answer that James and others give is that the past was more beautiful, substantive, and serious, whereas the present is ugly, superficial, and misdirected. James's adoption of this position had two motives. One was derived from romantic memories of the Old Rome as he had first experienced it in 1869 and the early 1870s. Second, James could write nothing without a sense of the ideal, and here only an idealization of the past enabled him to complete the ungrateful task of writing Story's biography. Having yielded to the importunities of Story's children (and having spent the advance payment on his house), James was obliged to make something monumentally commemorative out of a subject that he found extremely meager. His solution, as he explained to Howells, was to write a book ostensibly about Story, but actually "a little volume on the old Roman, American-Roman, Hawthornesque and other bygone days." To Sarah Butler Wister, with whom he had shared the pleasures of the Campagna thirty years before, he said that the chance to write a book "all about" Rome had made him "succumb" to the Storys' pressure. The opening pages of *William Wetmore Story and His Friends* indicate how James harmonized this task with the contemporaneous composition of his three late masterpieces—*The Ambassadors, The Wings of the Dove,* and *The Golden Bowl.* For in them he had resumed the theme of his early Roman books, *Roderick Hudson* (1876), *Daisy Miller* (1879), and *The Portrait of a Lady* (1881), all of which had specifically evoked the atmosphere of pre-1870 Rome. In *Story* James states that the attraction of his subject lies in the "romantic drama" of the "process" by which the "American consciousness" "annexed" the European world, a drama his new fictions unfolded in contemporary Paris, London, and Venice. The loss on which James's nostalgia is based is thus twofold. The loss of the innocence that belonged even to a cultivated mind (like Story's) in "primitive" America is as important as is the loss of Old Rome itself. "All the discoveries now are made," James remarks, sounding ironically like Mark Twain's Innocent. In James's own consciousness the annexation of Europe is complete, and he looks back upon a "vanished society" of happy discoverers who had enjoyed a "better 'time' " than ours—a leisurely time fit for absorption of wonders and the cultivation of "relations."[5]

Among the greatest of those European wonders was "the old Rome of the old order, the Rome of which the rough hand of history has so grievously deprived the merely modern pilgrim." When Story goes to Rome, James becomes autobiographical in recalling a city "inexpressibly romantic": "I can remember but the last winter before the deluge," when "as if foreknowing the great assault to be suffered and the great change to be wrought, the sorceress of the seven hills gathered herself up, for her last appearance, her last performance, as it were, in her far-spreading, far-shining mantle." The "Œcumenical Council of 1869" produced "a perpetual many-coloured picture—the vast, rich canvas in which Italian unity was . . . to punch a hole that has never been repaired. The hole to-day in Rome is bigger than almost anything else we see, and the main good fortune of our predecessors in general was just

in their unconsciousness of any blank space. The canvas then was crowded, the old-world presence intact." The Church—the "most ceremonial institution in the world"—has now retired into a gray background, and the new foreground will soon consist of American, English, and German tourists with a "scarcely less alien . . . admixture of Italian militarism."[6]

From this perspective James looks back upon the first portent of the usurping and rival civilization—the Roman Republic of 1849 that Story and his wife had witnessed with Margaret Fuller. Both Storys had in those days kept vivid diaries from which James extensively quotes, but he embeds his excerpts in tendentious context that denigrates both the heroic defense of Rome and the participation of foreigners in it:

> It was at this battle that foreign visitors "assisted," as in an opera-box, from anxious Pincian windows. . . . The flight of the Pontiff, the tocsin and the cannon, the invading army, the wounded and dying, the wild rumours, the flaring nights, the battered walls, were all so much grist to the mill of an artistic, a poetic nature, curious of character, history, aspects.

James is envious; the "felicity" of the Storys in the drama of 1849 had been so much greater than he had been afforded twenty years later by the mere sight of the pope dashing by in his "black-horsed coach." But, of course, if the Republic had prevailed he would not have seen even that. James envies the Storys not as political sympathizers but as detached observers of a richer scene, for his values are exclusively "artistic" and "poetic," as he assumes Story's to have been. Thus he satirizes Margaret Fuller's and Elizabeth Barrett Browning's passionate commitments to a republican Italy as factitious and incredible. Worse, in the case of Mrs. Browning, they had damaged her art unforgivably. When James goes on to question the "sincerity" of Princess Belgioioso, however, it begins to appear that his concerns are not merely about the meddling of foreigners or the debasement of poetry by politics but about the disfiguring effects of strenuous republican principles on women in general. Such women do not harmonize with the image of "the sweeter, softer, easier, idler Rome, the Rome . . . of greater and stranger differences" cherished by the "survivor of changes, extinctions, young intensities."[7]

James is using the opportunity to define a lost ideal of civilized life to which the Storys aspired in Rome. In a letter of 1873 he had written that he did not expect to enjoy the reception at the Storys' to which he was going, "as people don't pretend to," but thirty years later he evokes the Palazzo Barberini as the very symbol of "the grand style, . . . the old social appearances, old manners, figures, features, the delightful, dreadful old conception of conduct, of life." Passing quickly over an acknowledgment that the consequence of a "grand style for the few" is a "small style for the many," James sees beggars haunting church doors as but another dimension in the varied human density of the picture. The "amusement" of Rome was always "associated with something beautiful and great" and could therefore never be merely an idle waste of time or a provocation to reform. Like art, Old Rome was "a positive gain of consciousness," an "intensification . . . of experience." Rome was "the aesthetic antidote to the ugliness of the rest of the world—that is, of Anglo-

Saxondom in especial." By the end of his book James is invoking a humanizing and harmonizing "spirit of the place." It enlivened the dull, educated the ignorant, tamed the rowdy, taught civility to the crude. Most remarkably, within the confessed limits of James's concern, the effect was egalitarian: "It was, on the Roman evening, as if, for all the world, we were *equally* great and happy, or still more, perhaps, equally nothing and nobody; we were related only to the enclosing fact of Rome."[8]

James concedes that this great good place was "a state of the imagination," "a mere Rome of words, . . . a Rome of my own which was no Rome of reality."[9] But it *was* the remembered reality of Mary Crawford Fraser, Francis Marion Crawford, and their half-sister Margaret Terry Chanler, the children of Louisa Ward, Julia Ward Howe's sister. Fraser eventually wrote three books (totaling five volumes) that contain reminiscences of an ideal childhood in papal Rome, together with hagiographical lives of the popes from Pius IX to Benedict XV, and tributes to such local models of feminine perfection as Santa Susanna and Santa Francesca Romana. Chanler's autobiography *Roman Spring* (1934), although devoid of the strident polemics of Fraser's books, shares and confirms her vision. Their brother's many fictions, which must be separately considered, are dramatically most effective when they define contemporary Rome by its "decline" from its papal past. For two strong reasons the Rome perceived by this family of writers fundamentally differs from any image of the place that we have previously encountered: they grew up in magnificent Roman palaces, and all three eventually became Roman Catholics. Their sense of Rome is consequently that of a familiar rather than an alien place, and America serves as only one among many models of civilization, and not the most vivid or attractive. For them it is usually taken for granted that conservative—even reactionary—social and political values embody all justice and truth, and they hold that the embattled Catholic aspect of Rome remains its chief glory. The Catholic piety of their maturity overlays and reinforces recollections of a privileged youth. Ironically, the first and most eloquent voice to challenge their identification with an idealized Old Rome was their aunt, Julia Ward Howe.

The consciousness of Mary and Francis Marion Crawford was formed by their childhood in the Villa Negroni, and that of Margaret Terry by hers in the Palazzo Odescalchi. Mrs. Fraser's badly titled memoir, *A Diplomatist's Wife in Many Lands*, which is predominantly about her premarital years in Rome, was published in 1911, when she was sixty. It was her desire, she wrote, "to perpetuate the memory of what I cannot help regarding as a richer and more beneficent atmosphere than any immediately succeeding years are likely to produce." It was an atmosphere where "Arts and Letters were still . . . handmaids of truth and beauty; in which public and private ideals were still dominant; a time when wit and grace and virtue" instead of money were enthroned. The fine "youth of our epoch now lies dead," she claims; but it is really her own rare youth in Old Rome that she memorializes: A "little child, running in and out of regal old gardens, fingering half-effaced Latin inscriptions to learn her letters, offering love and prayers and roses indifferently to Saint and goddess, nymph and cherub—all smiling denizens of her wonderful world—could and did believe that that world, as she knew it, had existed from the

beginning and would exist forever."[10] Fraser's *Italian Yesterdays* (1913) begins with
a recollection of how as a child she had gradually become aware that her naturally
beloved "parent," Rome, was actually a ruler "venerated and feared by millions."
This knowledge "would transfigure and ennoble the memories of childhood." Her
regard for this parent—long familiar, accessible, and indulgent—was now "tinged
with awe."[11] The children of Louisa Ward all became well-traveled adults of wide
experience, but reverent loyalty for their regal parent Rome was the constant to
which they testified throughout their lives.

The first reality was that of their palace homes. The Villa Negroni, recalled by the
Crawford children, stood amid gardens in splendid isolation between the ruins of
the Baths of Diocletian, in which their sculptor father had his studios, and the
ancient wall near the Porta Pia. Built in the late sixteenth century by Pope Sixtus V
for his sister, the Negroni had been the residence of the wicked Vittoria Accoram-
boni and the "madly profligate" Luigi Chigi. But it had been redeemed, according to
Fraser, by the fact that the Chigi family for some centuries since had been "the most
God-fearing, the most self-respecting, the most conservative in Rome." Further-
more, the present owners, from whom the Crawfords leased the piano nobile, were
none other than the Massimi, whose present princess was virtually a saint—her life
"a long chain of prayer and duty."[12] From their bedroom windows in this sprawling
palace the Crawford children could look out at night to watch little foxes from the
Campagna drinking from a fountain in the garden; or they could go to the ground
floor to play with the fabulous eighteenth-century toys inherited by the Massimo
children. In those blessed days, a birthday party might be a festive family excursion
to the Fountain of Egeria on the Campagna, and a carriage ride with their governess
to the Villa Borghese was a journey into "dreamland." In time the Crawford children
appropriated to their own ideal of nobility their stepfather's memories of an even
older papal Rome, including one of the lavish public entertainments the Borgheses
held at the villa to celebrate the vintage every October before 1848. The "up-
heavals" of that year "made an end of the old feudal ways and festivities," Fraser
comments, adding that "the philistines who rule the world to-day" find it "incom-
prehensible" that such events were "mighty strands in the ties of sympathy and
good-will which hold class and class together and keep a country sober, contented,
and law-abiding"—the very opposite of modern society with its "less wholesome"
excitements.[13]

In 1865 Louisa Ward settled with her children and her new husband, Luther Terry
(who had known Rome since 1833), in the Palazzo Odescalchi, one of Bernini's
"more sober" productions, which in the past had belonged successively to the
Colonna, the Ludovisi, and the Chigi families. Although Mrs. Terry thought its
"very walls sweated wickedness," the children were pleased to recognize their
home in an engraving of the Piazza Ss. Apostoli by Piranesi, and its ghostly atmo-
sphere only made it more thrilling. The sight of something emerging from a mir-
rored doorway that led nowhere might cause one of them to drop her candle in a
faint, but on the whole "the Odescalchi was sunny, cheerful, and admirably adapted
for the kind of entertaining that young people love, theatricals improvised or long
prepared, harum-scarum dances and solemn concerts, croquet matches of an eve-

ning in the ballroom, or, best of all, some fortuitous gathering of kindred spirits." They had twenty large rooms along the entire front of the piano nobile, "panelled, painted, the walls hung with silk, every door a study of decoration, the very window shutters bevelled and gilded till it was a pleasure to handle them." Mary Crawford's own bedroom was thirty feet square, "painted to resemble the inside of a tent," with balconied windows in the deep alcoves of which she stationed her writing table, her easel, and her paints. Her wild sister Annie had a piano in her room and a cast of her father's bust of Beethoven. On the floor above lived "our menservants with their wives and families," and in the courtyard below were stables for "our horses and carriage" along with the "tame nanny goat" kept in Roman tradition to amuse the horses. In this carriage they enjoyed *trottate* down the Corso, up the Pincio, and through the Villa Ludovisi, or, on rainy days, over to St. Peter's.[14]

The earliest memories of Margaret Terry Chanler were of this palazzo, and she devotes many pages of *Roman Spring* to descriptions of its frescoed and tapestried rooms, memories the more precious because some years later they were all destroyed by fire. But Chanler's most vivid passage concerns that "great feature of Roman life," *stare in finestra*—"to stay in the window." The Odescalchi, unlike the Negroni, had no gardens, but the children found a compensatory delight in the balconies, where they sat with their feet hanging over the carved escutcheon of the Odescalchi, watching the passing scene in the piazza below them—magnificent weddings and funerals emerging from the church opposite, the fire brigade going by, goats with herdsmen from the Campagna arriving in the morning, bawling peddlers and funny foreigners passing all day long, and finally the lamplighter, after which the children turned to the "terrors and darkness" of a home "filled with strange noises and unaccountable shadows."[15]

From such a life the Crawford and Terry children naturally developed a special view of Rome. It was a place of natural and beneficent social divisions, and it was the center of international European society. Fraser opened her *Storied Italy* with a chapter called "Under One Roof" that depicts such a palace as the Odescalchi as an ideal dwelling that gives shelter to everyone from the carpenter with his shop on the ground floor to the cardinal who lives on the piano nobile. Her discriminating discussion of the women of different classes who lived beneath this one roof indicates an acceptance of divinely ordained distinctions. Fortunately, the children of Louisa Ward, even if they could not be "noble" in the European sense, were among the world's rich and well-born, and their "intimate" friends and guests the most distinguished in the world. They included Lord Houghton (Monckton Milnes), the famous walker-in-Rome Augustus Hare (who terrified them with ghost stories), the actresses Fanny Kemble and Eleonora Duse, members of the noble Caetani (Sermoneta) and Borghese families, and Professor and Madame Helbig—he the director of the German School of Archaeology on the Capitoline and she a pianist (student of both Clara Schumann and Liszt) with whom the talented Margaret Terry for many years played duets every Thursday afternoon. Rome was a place where it was necessary to speak four modern languages, and the Crawford and Terry children naturally did so. They first heard Cooper's tales of *Lederstrumpf* in German, Jean Paul Richter tutored Margaret Terry in the art of Italy, and the German Art Club

furnished Francis with his most congenial friends. Americans who were not Ro-man-Americans they did not know at all—until their aunt Julia Ward Howe arrived on the scene in 1867.

Aunt Julia did not approve of what she inferred as she was led through room after room of her sister's Palazzo Odescalchi (admittedly of an architectural dignity "unmatchable in Fifth Avenue") to a guest room in which the whole of her own apartment in Boston could easily have fit. In *From the Oak to the Olive,* which she published the next year, Howe addressed two aspects of "the Roman problem" as judged by her own ideal of an evolving and progressive civilization. In the static and stratified Rome that her nieces and nephew would later idealize, she was disturbed both by the absolutist government and by the relation of her "American friends" to Roman society. Absolutism she declared profoundly unnatural and unjust; the rulers ruled without consent of the people. Rank, which in America is "a mere convenience and classification for the encouragement of virtue and promotion of order," in Rome "takes the place of virtue, and repression, its tool, takes the place of order." All three degrees of society are equally degraded: "Abject poverty and rudeness characterizes the lower class (*basso ceto*), bad taste and want of education the middle, utter arrogance and superficiality the upper class." Worse, the "distinc-tions between one set of human beings and another is held to be . . . intrinsic." The three classes naturally exist in "all constituted society," but absolutism, here as in the American South, gives them a "false form." The "people" are "kept like human cattle," ignorant of the "decencies and amenities of life," their intelligence deliber-ately extinguished. A "century or two of education towards modern ideas" will be required to humanize "the Italian peasant" as well as the modern Greek, Celt, and "negro," so we had better begin. That Americans in Rome should ally themselves with this absolutism is "disgraceful." Lured by the "sweets" that such a society grants to the privileged few, they are "striving to join" themselves to "a false, false superiority. . . . Dresses, jewels, and equipages of tasteless extravagance; the sickly smile of disdain for simple people; the clinging together, by turns eager and haughty, of a clique that becomes daily smaller in intention, . . . do not dream that these lift you in any true way."[16]

This is the voice of a woman who later wrote a biography of Margaret Fuller that not only sympathized with her egalitarian politics but also saw her as exemplary proof that women (who were among the oppressed) could live by their intellect. With respect to Rome, Howe's chief departure from Fuller's views is that Howe would not even grant to Americans the old excuse of art for prolonged residence there, since the universal literacy of her coming utopia would deprive art of its only serious function: to inform.

The evolution of Julia Ward Howe's view of Rome reflects the successive stages of an intellectual woman's attempt to achieve a new and independent relation to society—to live according to her own idea of civilization, and by so doing to force the actual world to approximate it. In the process she rejects the Old Rome and attempts to shape the New. On her first visit in 1843–44, as we have seen, she was torn between her inclination for the brilliant social life of the sort she had been raised to enjoy and the sober sense of social duty that Dr. Howe was trying to instill in her (which included complete submission to one's husband). On this wedding

journey her first daughter, named Julia Romana, was born, and her sister Louisa, who had joined them, met Thomas Crawford, whom she married a year later. Mrs. Howe's return to Rome without her husband in 1850–51 constituted a declaration of independence from her own miserable married life. Before long she even moved out of the Crawfords' Villa Negroni and settled with her two infant children (she had left two more at home with her husband) in a separate apartment in Via Capo le Case, on the floor below the unpretentious James E. Freemans, with whom she became close friends. She cultivated her own intellectual circle and found a rabbi in the Ghetto to give her lessons in Hebrew. Julia's other sister, Annie, and her husband—a grandson of Napoleon's older brother, a one-time king of Spain—were also in Rome, so inevitably she joined in the "dissipations of the season,—an occasional ball, a box at the opera, a drive on the Campagna." But Margaret Fuller's short-lived Roman Republic of the previous year was much on her mind. Although she found that politics could be discussed with Italians "only in the secrecy of very private interviews," in "the English and American circles which I frequented" she "felt called upon to fight for the claim of Italy to freedom and self-government." When she was "invited to entertain the company" at a dinner party, she sat down at the piano and made it "ring out" with the "Marsellaise."[17]

The literary result of this year in Rome, however, was a volume of poetry far more personal than political, called *Passion Flowers*, which some Boston readers—including her husband—thought entirely too passionate. "The City of My Love" is Rome; "Via Felice" is a love poem to the young man who was her closest intellectual companion that winter; and the longest poem in the book, called simply "Rome," is an eighteen-page attempt to arrive at a personal identity that is neither that of her reformist husband nor that of her conventional sister Louisa. It begins with a rejection of Duty in favor of a day of wandering in Rome in search of pure Delight, a day that ends when she must return to her children. That night she is invited to a "feast" in a "palace, spread for high-born dames, / Princes, and dignitaries of the church." There will be music, wine, dancing, and whist. But "Gold and gems / I cannot show"; she will have to attend in a plain white dress, "Wearing my native courage on my bosom / That will not dim for Prelate nor for Prince." Into that "tainted atmosphere" she will bring "the woodlands breath of Liberty / From my far home." At this point the poem goes off into a meditation on the enthralling Past and on Death, inspired by a walk in the Villa Negroni gardens, where she heard her first nightingale. Ensuing poetic excursions allow her to consider such matters as the superiority of the monotheistic Jewish faith to trinitarian Christianity (raised an Episcopalian, she had adopted her husband's Unitarianism), the dangers of the "vampire Beauty," and a Keatsian longing for death in Rome—an oblivion much to be preferred (she implies) to either that of the moribund society of her sister in a palace or that of total subservience to her husband at the Perkins Institute for the Blind. What she had a year earlier imagined as "menace"—her own mortality—has in Rome assumed the aspect of a beautiful "promise."[18]

At the time, and for some while after, this Roman year seemed the happiest of her life. When, however, she refers back to it almost twenty years later, in her travel book of 1867, it is with "a certain salutary tingling of shame." Her emergence—to her husband's distress—as a famous essayist and lecturer in the struggle for Aboli-

tion and for women's rights now made any visit to Rome seem "a mere page of embellishment" in the "serious and instructive" volume of life. She refuses to regard Rome as a mere "picture-book," where social injustice does not matter, where life for the privileged is a form of thoughtless materialism.[19] On this visit Howe did what she could to adjust the balance: Her family, aware by now that Julia would be only herself, permitted her to give lectures in Rome—if only to the Anglo-American crowd.[20]

But when she returned in 1898 as a venerated old lady, she developed relations with an international circle of artists, intellectuals, and diplomats, proposed to Professor Lanciani that he give lectures to the Women's Club of Rome on "Houses and Housekeeping in Ancient Rome" or on "The Sybils of Italy," and gave one herself on "Woman in the Greek Drama." More important, she presided over the first meeting of the International Council of Women in which Italian women took part and gave the keynote address (in French). The next day she went to the home of the Contessa di Taverna to meet the "newly elected officers of the Council of Italian Women that is to be." They "chattered a great deal," she noted in her journal, but she "induced" them "to subscribe a few *lire* each" for secretarial materials. "Hope to help them more further on," she added, and a week later she concluded that "some good results are already beginning to appear in the co-operation of two separate charities in some part of their work." In their biography of their mother, Mrs. Howe's daughters were able to add that a few years later "the Association which she did so much to found, held the first Woman's Congress ever given in Italy, at the Palace of Justice in Rome."[21] The "larger outlook for women" in the New Rome was something often noted by Americans thereafter.[22]

A shell fired from the Janiculum by an "apostate friar" exploded in the library of the Palazzo Odescalchi when the Italians took Rome in 1870. It did much damage and nearly killed the old housekeeper and her cat. After that, nothing Aunt Julia ever did or wrote could affect Mary Crawford's melodramatic opposition of Old and New Rome. Forty years later Mrs. Fraser recalled with particular indignation that on that fateful September day she and her mother had been trapped in Florence, staying in —of all places—"that depressing Casa Guidi of Mrs. Browning," the pope-hater. "It seemed as if the gates of hell had prevailed after all," she wrote. Swept along by a mob when they went out to get news, they were forced to witness the appearance on the balcony of the Palazzo Pitti of "a purple-faced man with enormous moustaches," King Victor Emmanuel II, who would before long occupy the pope's palace on the Quirinale. The terrible prospect for Rome that they then foresaw was soon realized when one of the earliest projects of "the Vandals who have ruled Rome since 1870" was the building of railway yards, a station, and a new residential quarter on the site of her father's studios and in the gardens of their beloved Villa Negroni. The choice of site was purely vindictive, claims Fraser, since Prince Massimo was "an adherent of the Holy Father," and therefore his property was "forcibly expropriated, the historic building destroyed, and the matchless gardens swept away to make room for mean and hideous streets now inhabited by the lowest classes in the whole wrecked city."[23]

The memories of Thomas Crawford's children are infected with this rhetoric of

social and religious absolutism, and suffused with an angry sorrow over the vanished beauty of their childhood. A vision of Pope Pio Nono on the Pincio dominates their backward glance: "Coming straight towards us out of the swimming radiance of the noonday, with all Rome lying low behind him and St. Peter's in the distance, was a tall, benign looking man in robes of snowy white." Stopping his brilliant entourage of cardinals and noble guards, he blessed the "alien lambkins" with a prayer that they "might be brought into the One True Fold." That prayer was eventually granted. From the time she was nine years old, Mary Crawford had "an intense veneration" for Pius IX that she had to keep secret from her family, and the fact that her "dear parents" were ardent republicans and good Protestants troubles her memoirs. She is "sorry to say" that they had—"as was perhaps natural for born Americans—distinctly republican tendencies, and I was brought up to think it quite an heroic act in my father to join the Civic Guard." Her mother, showing the children his uniform and relating how "Papa" had helped "to defend the city walls" in 1849, made their hearts "beat fiercely in unison with all things free and republican," until in later years they came to learn how "lawless" the Civic Guard had been. Mrs. Fraser, confusing her father's possible feelings with her own of the 1860s, imagines that "Papa" must actually have been relieved when "the pretty French officers with their amazing uniforms and gay faces were making the old city once more safe and—amusing!" As for her beloved mother's perverse support for the unification of Italy, and her "animus" against "the kindly Ruler of the city where she had, by her own choice, dwelt for so many years—years of much peace and prosperity," this can be explained only by her close friendship with members of Mrs. Browning's idiotic and sentimental "Florence ring." So Mrs. Fraser devotes twelve pages of her autobiography to the demolition of Elizabeth Barrett Browning's politics.[24]

"Rome was a delightful place to live in just as it was," she says of the pre-1870 city. Even after the French had completed their withdrawal in 1866, the Pontifical Zouaves had made the city safe and pleasant. The Zouaves consisted of "Catholic gentlemen, men belonging to some of the oldest and noblest families in Europe, who marched cheerfully in the ranks shoulder to shoulder with devout peasants and workingmen." Their "picturesque Algerian uniforms" added a "pleasing note of life and colour" to streets and salons. Their commander, the marquis de Charette, was the suitor for the hand of Antoinette Polk of Kentucky, Mary Crawford's good friend and unreconstructed defender of "the cause of Southern independence." With "blatant ignorance," writes Fraser, "self-constituted historians steeped in the darkness of Protestant superstition" have completely misrepresented the Rome of this period, its ruler, and most of all Cardinal Antonelli. Intent upon restoring the balance of truth by employing rhetoric of equal extravagance, in two chapters of *Italian Yesterdays* Fraser traces "the finger of God" at work in the life and reign of Pius IX, including his maligned system of "justice." The great cardinal receives eight pages of defense, notable for their political cynicism: if anything, according to Fraser, he was too trusting. His sister and nephews were among her "greatest friends," and she and her mother were invited in 1867 to spend an afternoon with the "brave man" at a time when he was much bothered by "the plotters of the Garibaldi and Mazzini gang." In his apartment at the Vatican he showed the women (presumed to have a

natural interest in such things) his many-layered jewel box, filled with sapphires, rubies, emeralds, and intaglioed gems, explaining that he kept them because "one might have to take an unexpected journey." Fortunately, he never did, loyally remaining with the Holy Father to face the "imported revolution."

Garibaldi, that "veteran disturber of the peace," found "shabby adherents" in the "contemptible" members of the middle classes who resented "the sternly exclusive Roman aristocracy," and in members of the working classes "inflamed to anarchic violence by the propaganda of Freemasons and Socialists." When the walls of Rome were threatened once more in 1867, the Terrys unfortunately had to put out an American flag to signify a pretended neutrality, to the distress of Princess Odescalchi, "who detested foreigners." According to Fraser, Garibaldi and his son often entered the city disguised as women. She is sure that she herself received "a glance of hateful triumph" when she occasionally met the son, his boots showing beneath his voluminous skirts. As for Garibaldi, she regrets that Cardinal Antonelli did not have the chance to arrange "a quick and silent end for the old pirate," but she is pleased by the "fact" that after his defeat by the Papalini and the (returned) French, the coward was "found hiding in a confessional!" The Holy Father, in contrast, spent the time of the battle in continual prayer; afterward he bravely presented himself to the sixteen hundred prisoners in the Castel Sant' Angelo as *"un povero vecchio"* against whom they had unaccountably taken up arms, whereupon they "started crying like children and kissing his hands and his cloak."[25]

An entire chapter is given to the year 1869, the last "brilliant" winter season of Old Rome, when, as Mary Crawford, Mrs. Fraser had waltzed with Prince Leopold of Hohenzollern-Sigmaringen, "Lord Bute, . . . and a good many other men of his class." But then came "one of the saddest periods of my early life," August-September 1870. Among the Zouaves now clearly doomed to defeat were "friends most near and dear who had come and gone at Palazzo Odescalchi like sons of the house." The Romans themselves, "though supine and cowardly, literally adored Pius IX" and were not anxious to be ruled by the "stupid and weak" Victor Emmanuel. In the "burning heat" of September 19, the aged pontiff ascended the Santa Scala on his knees and prostrated himself in prayer that the Holy City might be saved from the "marauders camped outside her gates." (A friend of Mary Crawford's was nearby and heard everything he said to the Lord whose Precious Blood had been spilled on those stairs.) Because for forty years "so-called historians have perjured themselves" by "wilfully misrepresenting . . . this spoliation of the See of Peter," Fraser must reestablish many facts. Among these, the notion that the seminarists of the North American College had sought protection from their nation's consul is replaced by an assertion that they requested arms to defend the Holy Father—a request he denied. Instead, on the day of the attack the pope ordered an end to bloodshed as soon as the walls were breached. The noble Zouaves, putting down their arms in St. Peter's Square, achieved "martyrdom" when "the reptile rabble of Garibaldians" taunted them with "obscene curses." Then came the time of rejoicing for "the socialist, revolutionist, the atheist, the men who had been shunned by all decent people." Newspapers appeared vilifying the Holy Father, priests carrying the Last Sacrament to the dying were insulted, and through the gates of the battered Porta Pia "a tide of

prostitutes flowed into the city." This was what it meant to have a "civilization" based upon "Liberty of conscience" established in Rome.[26]

In 1870 Roman Society divided into two parties, the Blacks and the Whites, adherents, respectively, of the Pope and the King, the living symbols of Old Rome and the New Italy. The opposing visions of civilization were now concentrated within Rome itself: "Rome" versus "Italy" became "the Vatican" versus "the Quirinale." As was both natural and convenient, the great houses of non-Catholic Americans, like the Storys' Barberini, the Terrys' Odescalchi, and the William S. Haseltines' Altieri, became—in the words of Maud Howe—"neutral ground: we have visitors of every faith and all parties." These homes thus represented an American pluralistic vision of society, where ideological enemies could meet with civility. The "neutrality" of long-time residents in the 1870s and 1880s, however, reflected a genuine ambivalence rather than a positive social principle. Some, like the Storys and the Freemans, naturally felt an affection for Old Rome and so feared changes. But, as we have seen, they accepted many of them as beneficial and necessary even while regretting the attendant losses. Others, like Louisa Ward Terry and her children, had developed an affection for the pope—and his Zouaves—as well. But the concerns of some artists were simply practical rather than political. When preparations for the first meeting of the Italian Parliament in Rome were under way in November of 1871, the sculptor William Rinehart complained of the "hustle, noise, and confusion." He did not so much object to the cleaning of whole blocks of houses or the opening of new streets, he wrote, but to "the influx of politicians . . . and fast people. These will make the disagreeable changes. The price[s] of rents are fabulous." The next spring Rinehart wrote that the pope would permit no Easter ceremonies or illuminations, because "the old cuss is real mad." Worse, for a sculptor, was the fact that "one can only enter the Vatican now with a permit and then only two hours at a time—what nonsense." The "neutrality" of an artist like Rinehart consisted of equal irritation with both political factions.[27]

Even the pope-loving Mary Crawford found that she could not resist the chance to see Princess Margherita at the opening of Parliament. Years later, as Mrs. Fraser, she gives an amusing account—which she intends to be "heart-breaking"—of how even the noble Roman families were sundered by the attraction of the new court. "Social butterflies," like the younger Colonna and Doria men, were suddenly "inspired with progressive Liberal principles, strong enough to make them disregard parental authority" by accepting positions with the king, where they came into "contact with people whom their traditions had taught them to despise." But anything was better than being left out! On the other side, "the poor lodgers at the Quirinal" discovered that "to fill their reception rooms at all," they were "obliged to receive all and sundry." Fraser's sarcasm is not in support of any unwitting democratization that resulted from this insincerely motivated behavior on both sides, but derives ironically from her own identification with that "proudest and most refined of women," Princess Margherita, whom she had come to know and admire. How it must have pained the princess "to shake hands with and smile upon the mob"! When Mary Crawford had first seen Victor Emmanuel showing himself

in his carriage in the Corso and on the Pincio, she "could almost have turned anarchist," but in view of the behavior of the Romans, who are after all "a superficial, indolent people, very poor upholders of any cause," she decided it was "absurd for foreigners to range themselves with the 'Blacks,' . . . and forgo all the social amusement and interest left in the place." Fraser confesses that "it was a base negation of our political beliefs and of much deeper principles for some of us," forgetting that for most Americans the arrival of a form of representative government on the banks of the Tiber was an occasion for rejoicing, and a "negation" of principles would have sent them in the opposite direction.[28]

Mary Crawford and her mother lost little time in making the acquaintance of royalty. Although she felt somewhat guilty and "frightened" when she passed under the "tiara and keys over the great doorway" of the "revered" Palazzo del Quirinale from which the pope had been driven, it was worth the sacrilege to meet "the most gracious and kindly of royal hostesses." Thereafter, in the winter of 1872, she attended several balls at the Quirinale and many of the even more pleasing evening receptions during Lent. Fraser's nostalgic descriptions of these events make the princess a Jamesian heroine whose grace and simplicity transformed into a civilized community a company that necessarily included the "Roman 'Haute Finance' appearing in society for the first time," as well as vulgar Americans who were nothing but millionaires. She thus grants to the New Rome one capacity of the Old.

In a later chapter, however, she fully adjusts the balance of any implied disloyalty to the pope by writing angrily of the "desecration of holy places" that occurred during her four years in the Far East with her husband, a British diplomatist. Her opposition between the Old and the New is reestablished in absolute melodramatic terms. The Via Nazionale had been "cut through the heart of the city from my first home, the Villa Negroni, to the very door of my second, the Palazzo Odescalchi," she complains, exaggerating the truth. Worse, a princely family of her acquaintance had fled to a northern town with only one maid, and an apartment in their old palazzo had become a Satanist chapel filled with "nameless and obscene paraphernalia." In the few convents where the nuns were allowed to keep some part of their house, the government, with "diabolical spite," turned the rest—including the courtyard—into cavalry barracks, so that the "aged holy women whom I visited" had to suffer from continual profanity, bugle calls, and stamping of horses. Raphael's Farnesina Palace by the Tiber had been leased to "a sympathiser of the Papacy, so it was found necessary to broaden the river's bed at that particular point," even though it was the wrong point for flood control. It was a great relief to go from all this "vandalism" of the "beauty-haters" into the "peaceful, changeless halls of the Vatican" to meet the new pope, Leo XIII: "the Saint, the Philosopher, the Fighter, the most brilliant intellect of his day and one of the most truly humble Christians whom the world has ever seen," whose "glorious Pontificate" made Catholicism "stronger than it had been for centuries past"—in spite of the predictions of "decrepit" heretics and "haters of truth."[29]

When both Victor Emmanuel II and Pius IX died within a month of each other in 1878, the political loyalties of most people largely ceased to be thought of as personal allegiances to Satan or saint. Neither Umberto I nor Leo XIII was to be

blamed for the confrontation between New Rome and Old. "Sorrow falls / O'er all the circuit of the Aurelian walls," wrote Bayard Taylor in a poem called "The Obsequies of Rome." It declares that the king, as "Victor" over the "triple-hooded snake" of the Church, has made the New Italy secure:

> Under the Pantheon's dome,
> The undying Victor still shall reign
> O'er one free land that dare not feel a chain,
> Whose mighty heart is Rome![30]

Julia Ward Howe, who was in Rome again at the time, wrote two poems, one of which simply emblemized the dead king and pope as Freedom and Faith, which ought not to be opposed, while the other envisioned a time when the Black and the White factions would blend into a "radiant" new society.[31]

The *Roman Spring* of her musical niece, Mrs. Winthrop Chanler, goes much farther toward suggesting the possible realization of such harmony than anything written by her polemical half-sister, Mrs. Fraser. She describes the great Orsini ball, held in the winter of 1885 in the historic palazzo built over the ruins of the Theater of Marcellus, as an occasion so superb that all Rome, both "Black and White, flocked to the summons." Margaret Terry herself now entered fully into the circle of the younger Roman society, of which Don Giovanni Borghese was the "Prince Charming." During the course of a year of receptions, balls, and picnics at the Sacred Grove of Numa Pompilius and the nymph Egeria, she met the "charming idler" who became her husband. Since she was by now a Catholic, and the Chanler family strongly anti-Catholic, there might have been difficulty had not "Wintie" himself expressed indifference to whether she was "a Buddhist or a Mahometan," and the Church itself made no objections. To be sure, three dispensations were necessary, since the season was Advent, the husband was non-Catholic, and the couple were blood cousins. But their sponsor, Monseigneur Puyol, took them to the Cardinal Vicar, who, "seduced" by the charming "Wintie," did not even require him to sign promises concerning their children. Afterward, the Apostolic Notary looked with dismay upon all three dispensations and further "winced" when told that the bride's father's name was Luther, but he was obliged to follow the vicar's orders. The monseigneur had justly reassured Margaret Terry by saying, "Remember my child, we are in Rome, *ou beaucoup de choses s'arrangent.*"[32]

In a chapter describing their return to Rome in 1888, after two years in the provincial and dull cities of New York and Washington, Mrs. Chanler remembers first her exhilaration at walking once again in the streets of her beloved city, listening to "the splash of the fountains and the dear sound of bells." The couple took "our old friend Mr. Hooker's apartment in the Palazzo Bonaparte" and were soon deep into social engagements with old friends and new—shooting expeditions to the seashore with Don Giovanni Borghese and Story's son Waldo; receptions at the great art-filled palace of Prince and Princess Doria-Pamphili, who could not be described "apart from their surroundings"; conversations with the "enigmatic" Axel Munthe, "a doctor, a hypnotist, an unrivaled story-teller, and a Nordic hero"; and embassy dinners with Lord Dufferin or Count Hans Coudenhove, Austrian

ambassador to the Quirinale. Mrs. Chanler now perceived in the split between Vatican and Quirinale an advantage to Roman society: it doubled the diplomatic corps from every country. Furthermore, the frequent changes in diplomats gave a valuable element of fluidity and renewal to the "very permanent social structure" of the Roman world itself. The "motley crowd" was in "a perpetual state of change and flux, forever forming new groups and coteries. . . . So the changeful human stream flows through the same old palaces, mounts the broad easy staircases, and passes through the long suites of halls, antechambers, and reception rooms that have seen so many generations go the same way." The "two camps" of diplomats, corresponding to the Black and White division in the Roman aristocracy, officially did not recognize each other, but in fact were no longer showing "much hostility," and there was "plenty of neutral ground where the two could meet": "In later years few if any of the *Neri* held out whole-heartedly against United Italy, and the ground was well prepared for the Mussolini compromise that made the Pope the independent sovereign of Vatican City."[33]

The aristocratic and international New Rome of the Chanlers, however harmonious and satisfying within its own palatial walls, was, of course, not fully that one envisioned by Aunt Julia, whom Mrs. Chanler nevertheless remembered fondly as a quaintly unconventional old lady, and Mrs. Fraser preferred entirely to forget. A broader and deeper vision of Rome, because socially more inclusive, is evident in Helen Haseltine Plowden's memoir of her father. "Casa Haseltine" in the Palazzo Altieri also "was recognized as neutral ground where Blacks and Whites could meet without embarrassment" in the 1870s and 1880s; but growing up there did not seem to prevent Helen Haseltine from realizing that harmony among aristocrats was not the chief goal of a just society or that her palace was surrounded by a world of labor, poverty, exclusion, and pain. She thus achieves a rare balance between the values of the New Rome in which she had grown up, and the Old Rome to which her father had come, supposedly for a brief period of study, in 1857. As a landscape painter, Haseltine had found that "the solitude and tragic grandeur" of the place "had laid tender, compelling hands on him . . . until they forced him to yield and remain in Rome for the rest of his life." To such an artist Old Rome offered "a life desirable, complete, in which his career progressed and prospered." His daughter can add, nevertheless, that even in its physical aspects it was far from ideal, even for the immediate family. It was a bone-chilling world in which central heating and running water were unknown, where the streets were noisy and the roofs leaked, and where little girls were forced to drink "tepid, frothy" goat's milk fresh from the goat. For Plowden far happier personal memories were of the New Rome, when Casa Haseltine was a place said to possess "'a foreground of gaiety and hospitality, an artistic middle distance and a background of kindness and chivalry.'" The "different elements in the Roman society" that gathered there in an international aesthetic company "contributed to a life at once wholesome, gay, backed by breeding, where people of every type of learning and profession, and of different classes, mingled freely—and in which each felt called upon to give of their best for the recreation of the many." Such "jealousies, gossip, heart-burnings" as there were resolved themselves in an atmosphere of "fun, happiness," and friendship.[34]

Plowden seems tempted to keep her vision of Rome aloft in such Jamesian

ideality. But then she recalls also that even "the most generous and honest" individuals (the Crawfords and Terrys?) became "subservient to the conventions and tenets" of the society, adopting a "childish faith that class-distinctions, the appalling condition of the submerged tenth, the circumscribed life of women, were foreordained and destined to be always a part of the existing social order and decreed by a benevolent Deity." This led to a political complacency that satisfied its conscience through charitable relief for obvious cases of "poverty and distress" (chiefly friends and relatives), but made no effort "to do away with the causes." The happiness of the privileged minority in the New Rome was thus based upon a preservation of as much as possible of the style and social conditions of the Old. The absolutism that Julia Ward Howe criticized in 1851 was after all still the rule—if not the official policy—of the New Rome. Everyone was "labelled for life": one was known as a saint, as a money-grubbing businessman, as a "grand seigneur," or as a "cad" of the middle class, Plowden recalls, as though describing the characters in a novel by Francis Marion Crawford. But then she goes further: all these types at least had their place and understood function; but if you were of "the poor," you had no place and might disappear unlamented at any time. In a class entirely apart were the peasants: "unspoilt, natural, uncontaminated by the world, thankful for small mercies, overworked, old before your time," grateful for what Mother Earth gave you to eat, lifelong child of the Madonna, ruled by one thought: *"Quando non piango, canto"* (When I do not weep, I sing).[35]

The stratified society so described may not have differed greatly from the one that developed in America between 1870 and 1920, but that was no reason to pretend that it was perfect. In 1933 (exactly a century after her father had arrived in Old Rome) Chanler might complain, with—for once—some of her sister's hauteur, that the Villa Corsini on the Janiculum had been "vulgarized into a public park with a huge open square where an equestrian statue of Garibaldi stands—for the new order," but Helen Haseltine, also revisiting the villas of Rome in the twentieth century to identify the subjects of her father's sketches, took a different view. On the Coelian hill she found with initial regret that the Villa Celimontana, in whose "silence and solitude" St. Philip Neri had talked to his disciples "of the things of God," was now a public garden where the "air was filled with the shouts of happy children and the chit-chat of many people," the antique sculptures were "scribbled over with names," and the benches were occupied by "mothers and babies from the Lateran suburb." But, she concludes, this is not degradation; it is justice:

Always, since the days when Servius Tullius built his wall at the foot of the Coelian hill, and the Roman patricians of that period established their summer residences in that quarter, gardens have been tended there. Acanthus, violets, and the tiny pink monthly rose, have always shed their fragrance; obelisk, statues and columns have stood there for nearly two thousand years; they give the assurance that all has not gone beyond recall, and chide our sentimentality and peevishness. The happiness of a whole suburb, able to enjoy sunshine and air in beautiful and peaceful surroundings, free from the danger of traffic, is well worth the loss of that artistic satisfaction to the few of us who like to contemplate Beauty, alone and undisturbed.[36]

The Reality of Roman Romance

The social reality of Rome between 1865 and 1910 is nowhere represented more fully than in the "romances" of Francis Marion Crawford, Italian-born son of the sculptor Thomas Crawford and Louisa Ward Crawford. After a prolonged youth filled with travel, adventure, and curious study (journalism in India, Sanskrit in Rome, pugilism at Cambridge University, fencing at Heidelberg), Crawford tried romance writing with such instant and profitable success that at the age of thirty-one he was able to establish himself as the virtual "Prince of Sorrento." In the two decades embracing the turn of the century, even the poorest of his novels, following serialization in the most popular and literate magazines in both England and America, was purchased by tens of thousands of readers. Henry James, conscientiously laboring toward ever finer forms of his art in these same years, sometimes expressed envy and anger as Crawford unscrupulously turned out two efficient narratives a year—the minimum necessary to maintain a vast retinue of servants at the cliff-top Villa Crawford and a felluca complete with crew for sailing to the Torre San Nicola, his private retreat on the remote Calabrian coast.

Of Crawford's forty-five volumes of fiction, about one-third have Rome as a setting. Since his death in 1909, the Roman romances have fallen almost entirely out of sight along with the others, whereas most of James's novels remain in print in several editions and enjoy the highest critical esteem. History's judgment has been more just to James than to Crawford. Although in none of his works did Crawford create and sustain the persuasive imaginative reality that is the essence of the greatest fictions, several of his Roman books are far superior to the average level of commercial romance; they remain informative and entertaining in the manner expected of serious Victorian fiction. Crawford's defensive posture in his essay "What Is the Novel?" (1893) has encouraged literary historians to classify his books as "romances" in the pejorative sense, that is, as ephemeral melodramatic amusements: irresponsibly escapist, psychologically superficial, ethically crude, formally conventional, and stylistically undistinctive. They *are* all that, but some are also more than that. They are curiously hybrid works in which popular romantic formulas are worked out in a realistically specified time and place. Consequently their detailed representation of a contemporary social milieu often makes them more comparable to the realistic novels of Howells or Zola than to the romances of Sir Walter Scott or Robert Louis Stevenson. But since their place is Rome, their reality is not only compatible with but expressive of the most romantic values. The coincidence between the demands of romance and the reality of Rome, of course, gives to their "realism" a wholly different character from that based on Howells's Boston or Zola's Paris. The truthful imitation of life was often Crawford's intention as it was that of his contemporaries. But life as observed in Rome seemed to supply all the mysteries, passions, sensations, bold actions, dramatic consequences, moral examples, and historic conflicts that constituted the "poetic" and "epic" dimensions he and his readers also expected of prose fiction. In Rome there was no need either to hypothesize a pseudoscientific equivalent of Fate or to exalt the Commonplace in order to have a worthy literary subject.

To be "realistic without being repulsive" should be the aim of the modern novel,

states the poet Heine in Crawford's dialogue, *With the Immortals* (1888). Dichotomies between history and fiction, accuracy and imagination, realism and romanticism are essentially false. "Romance," asserts "Chopin," in an attempt to synthesize the debate, "consists in the association of certain ideas with certain people, either in history or in fiction":

> "The people must belong to some race of beings of whom we know enough to understand their passions and to sympathize with them. The ideas must be connected with the higher passions of love, patriotism, devotion, noble hatred, profound melancholy, divine exaltation and the like. The lower passions in romance are invariably relegated to the traditional villain, who serves as a foil for the hero."[1]

On the basis of long familiarity, Crawford wrote with the conviction that Italians—and above all Romans—constituted such a "race," ready-made for the romancer. Their lives were bold expressions of the "higher" and the "lower" passions that gave poetry and interest to any record of contemporary reality.

That Italians were capable of anything had been the opinion of Anglo-Saxons for several hundred years. Italians apparently believed it themselves, although after Dante they gave less emphasis to the talent for villainy that English authors, beginning with the Elizabethan and Jacobean dramatists, found so convenient. The behavior of Crawford's Italians, which is often as extreme and as arbitrarily motivated as Iago's, should be interpreted in the light of the literary and historical tradition. The comparison tends to make their behavior seem relatively plausible and therefore less incongruous with the realistic social context of his novels. Nothing Crawford's Romans do surpasses in criminality, folly, or sublimity what had been written into the record of Roman history since the Middle Ages. Where everything has been done, no action seems improbable. Thus "realism" loses one of its limits and becomes romance.

The few Americans who attempted to create modern Italian characters before Hawthorne had not worried at all about realism, which was not yet the fashion. But Hawthorne himself (as was seen in vol. I, chap. 3) apparently felt that his insistent definition of his works as "romances" was insufficient to forestall bothersome questions about "the probabilities"; he had to argue also that the use of Rome as a setting (like the inherently "unreal" Brook Farm) made such questions inappropriate. No such anxiety about credibility is evident in Nathaniel P. Willis's *Violanta Cesarini* (1845), a lively tale with real density of atmosphere and a totally frivolous narrative voice. An evocative introductory description of the Corso by moonlight was obviously based upon Willis's direct observation, but that scene is inherently "romantic," and the characters and action of the tale are pure invention—or rather, free adaptations from the historically based literary tradition. Two noblemen on a balcony overlooking the Corso are heard arranging the marriage of the seventeen-year-old heroine to a despicable count, while they also gossip about a cardinal who is willing to pay a thousand scudi for a Giorgione. Because the males of the Cesarini family have regularly bribed the pope to allow them to marry the peasant girls after whom they lusted, the latest in the line has degenerated into banditry and been outlawed. Violanta is consequently an heiress of great value, but she is in love with

a mere artist, who shares his studio with a deformed sculptor who may be Violanta's half-brother. Biondo, the artist, loses his right hand in a duel on the Palatine, which he fights to defend Violanta's honor after she has been insulted by Lamba Malaspina. The climax occurs during a masquerade at the Teatro della Pergola, a theater built out over the Tiber near the Ponte Sant' Angelo. Everyone is in disguise, but Violanta and Biondo manage to recognize each other and confess their love. Everyone else thinks that a hunchback looks like Violanta in disguise, but it is really the deformed sculptor. Therefore Violanta's father realizes that the hunchback is truly his son and declares him to be his heir, Count Cesarini. Violanta, no longer of interest to the Malaspina family, is free to marry Biondo, and they soon have a child who will be the next count, since Violanta's deformed brother, who loves them both, will never get married.[2]

All the elements of such a tale—arranged marriages, beautiful heiresses, worldly cardinals, the relations between nobles and peasants, the ambiguous social status of artists, duels, banditry, uncertain and mistaken identities, revelations and recognitions, happy marriages and newborn heirs—are present in the Roman romances of Crawford. But they are rendered in a realistic context and in a manner that transforms them from elements of a fairy tale into the stuff of the seriously melodramatic situations of contemporary history, a history that is continuous with the social reality of Rome as established for centuries. When George Hillard took up the topic of the "Noble Families of Rome" in his *Six Months in Italy* (1853), the best he could do was to cite from a book published in 1833 that described the typical life of the Roman nobleman: one who was without "literary or scientific tastes" to occupy him, and who chose not to enter the Church (the only route to political importance), had to "take refuge in a life of frivolous indolence or profligate self-indulgence." Naturally, Romans of "any energy of temperament" turned to "such strong excitements as gaming and intrigue" to escape "a life of such dreary monotony" as their station in life imposed upon them. Bloodcurdling records of the consequences filled the archives of every noble family.

Hillard recalls that when the duke of Corchiano met Sir Walter Scott at a dinner given by the banker Torlonia, he offered the great romancer access to the vast Corchiano archives, which contained papers "giving true accounts of all the murders, poisonings, intrigues, and curious adventures of all the great Roman families, during many centuries." Scott, he said, could publish them all "as historical romances, only disguising the names, so as not to compromise the credit of existing descendents of the families in question." With such materials, thought Hillard, a novelist of half Scott's genius "might easily earn a brilliant and enduring reputation," since "all the elements of startling adventure, picturesque description, and thrilling incident" were there. Roman palaces and secluded Apennine castles would provide the contrasting settings, and "nobles, ecclesiastics, and soldiers would mingle in the mazy dance of events with artists and scholars." The "bravo and the female poisoner" would not be lacking, and "great historical names could be introduced with no violation of probability." Hillard's description sounds amazingly like a summary of Crawford's Roman romances, a generation before they were written.

According to Hillard the reason "the annals of the great Roman families are so prolific in romantic matters is to be ascribed partly to the subtle and passionate

character of the Italians, which inclines them to crimes of treachery and violence, and partly to the fact that the nobility of Italy in the middle ages lived in defiance alike of law and public opinion, to an extent to which English history, since the wars of the Roses, affords no parallel." The families, in their separate fiefdoms, were free to behave as they pleased, "and some fragments of their former feudal privileges yet remain." Only the Italians could have produced the Cenci, and the mysterious Lucrezia Borgia is "another and representative [!] character in Italian domestic history." Hillard concludes this characterization of contemporary Roman nobility with a story from the sixteenth century concerning the Savelli family (now fortunately extinct), which contains many of the usual elements of romance: the arranged marriage, the handsome only son, the virtuous peasant girl, the jealous husband, the gruesome revenge, the wrongfully imprisoned wife, her rescue from execution by the wife of the pope's grandson (herself the "natural daughter" of Charles V), the fruitless hiring of banditti to find the murderer, and finally the madness and death in a lunatic asylum of the last duke of Savelli. This true story, states Hillard the Bostonian lawyer, "fearfully illustrates the fatal consequences which spring from the collision of fervid passions."[3] The Roman nobility may be a lesson to us all.

Crawford's relative credibility and sobriety are owing, as he himself constantly insists, to the fact that he never takes either a tourist's or a moralist's view of Italians or of Rome. In an essay called "Roman Life and Character" Crawford comments that the foreigner, who "necessarily occupies himself far more with things than with people," simply "verifies the accuracy of the opinions he had before coming to Rome, and comfortably rejoices in the certain knowledge that his own religious and political persuasions, whatever they may be, have been strengthened and consolidated by what he has seen and learned of Church and State."[4] In the romances themselves, Crawford's own unassailable authority as an insider is frequently asserted. In *Sant' Ilario*, for instance, a generalization about "the Italian race" intended to justify a change in one of his characters is in turn buttressed by the claim that an explanation of its causes would be "incomprehensible to the foreigner at large, who never has any real understanding of Italians":

> I do not hesitate to say that, without a single exception, every foreigner, poet or prose-writer, who has treated of these people has more or less grossly misunderstood them. That is a sweeping statement, when it is considered that few men of the highest genius in our century have not at one time or another set down upon paper their several estimates of the Italian race. The requisite for accurately describing people, however, is not genius, but knowledge of the subject. . . . To understand Italians a man must have been born and bred among them.[5]

Crawford, unique among foreign writers in meeting this criterion, is confident about the accuracy of his portrayal of Romans of all classes. His perception, however, of their leading characteristics—those that make them so suitable to romance—does not in fact differ radically from the prejudicial tradition. Chief among these traits is the simplicity and intensity of their passions, a trait he claims is fostered by the insularity of their family life. Noble families in particular may go to

extremes of virtue or vice, since they have little else to do but cultivate their feelings within the grand settings of their fortresslike homes and to act upon them with the freedom that comes from hereditary wealth and power. Their social position, however, also means that their privately motivated behavior has wide public ramifications: religious, political, and economic institutions and systems are all affected, as are the lives of all classes below them. Crawford's material thus objectively provided him both with many of the components of conventional romance—high-born heroes and heroines, palaces and castles—and with those of realism—social institutions, economic conditions, class relationships. The component of romantic love, even if redefined as sexual compulsion, is, of course, one that no so-called realist chose to jettison; Tolstoy and Zola, to both of whom Crawford dares to allude in a corrective tone, as well as Flaubert and Howells, who satirized romantic love while exploiting it, naturally recognized troubled relationships between the sexes as central to any imitation of life; it was, besides, something few readers were willing to do without.

The great fact of Roman society was the existence of a rigid class system with an impenetrable hereditary aristocracy. F. Scott Fitzgerald's romantic notion that the rich are different from the rest of us was certainly true in nineteenth-century Rome before the nouveau riche arrived on the scene (after which one of Crawford's concerns was to show the difference between the old and the new). In blood the Roman aristocracy was literally a separate race, according to Crawford, since so many of the wives were daughters of other European noble families rather than Italian, and the patriarchal system thoroughly Romanized all the progeny. Concern with heredity and fortune naturally made arranged marriages the rule that provoked the generational conflicts and adulterous temptations that are the stuff of all romance. But the horror of intermarriage with the brutish poor, with men who worked for money, or with persons "without a name" raised the same democratic themes of equality and self-reliance that are central to some novels by Howells. Crawford exploits both the "romantic" and the "realistic" aspects of the aristocracy's marital convention, while his own ambivalence toward this—as toward other of its values—further defines the hybrid nature of his Roman novels.

Although Crawford's most substantial achievement, the *Saracinesca* trilogy, is narrated from an authorial point of view sympathetic to the aristocratic ideal, a major tension in his Roman works derives from his recognition both of democratic dissent and of aristocratic degeneracy. One of his earliest and most satisfyingly compact tales, *The Roman Singer*, was written for the *Atlantic Monthly* while Crawford was passing the first months of 1883 in Boston with his liberal aunt, Julia Ward Howe. This novel is narrated by an interestingly individualized old bachelor, Cornelio Grandi, who once owned an estate but is now reduced to earning his living by teaching languages and philosophy. He has assumed responsibility for Nino Cardegna, the orphaned son of one of his former tenants, a boy with great musical talent. When Nino is old enough to launch his career, he falls in love with Hedwig von Lira, daughter of a German count. Grandi asks him, "How can anybody in your position hope to marry a great lady, who is an heiress?" To which Nino replies, "Do you think it for nothing that you have taught me the language of Dante, of Petrarca, of Silvio Pellico? Do you think it is for nothing that heaven has given me my

voice? . . . Or do you think that because I am bred a singer my hand is not as strong as a fine gentleman's—contadino as I am?" Grandi is shocked, and he becomes positively worried when he discovers that De Pretis, the music teacher with whom he has placed Nino, is arranging for Hedwig and Nino to meet. "Now De Pretis is essentially a man of the people, and I am not," he explains. To Grandi "a peasant boy making love to a countess" is "a most incongruous thing," but De Pretis "believes that a man may be the son of a ciociaro—a fellow who ties his legs up in rags and thongs, and lives on goats' milk in the mountains—and that if he has brains enough, and talent enough, he may marry any woman he likes without ever thinking whether she is noble or not."[6]

Eventually Grandi comes to share this view and heroically labors on behalf of the lovers. He begins with an effort to locate the girl for Nino when her angry father removes her from Rome. Unfortunately, Grandi enlists the aid of Baron Benoni, a mysterious but extremely wealthy old Jewish banker who is also a musical virtuoso and therefore an admirer of Nino. "Help him," Grandi tells Benoni; "it is not such a very terrible thing that a great artist should love a noble's daughter, after all, though I used to think so." Benoni laughs at him: "You amuse me with your prejudices about nobility. . . . The idea of talking about nobility in this age! You might as well talk of the domestic economy of the Garden of Eden." He himself had been made a baron "the other day" by some "idiot," but that means nothing. Of course he will locate Hedwig for Nino. The result is that Count von Lira decides to marry Hedwig to Baron Benoni—a development that naturally introduces other questions of "racial" prejudice. Grandi finds the count's preference particularly puzzling, since he knows that "no people are more insanely prejudiced against the Hebrew race than the Germans," who are entirely "unreasonable about it. Benoni chanced to be a Jew, but his peculiarities would have been the same had he been a Christian or an American." Nino is not above alluding to Benoni's "Jewish faith" when defining his own superior qualifications for Hedwig's hand; the count "winced palpably," but said that Benoni had nothing to do with his objections to Nino: "you are a man of the people,—I do not desire to offend you,—a plebeian, in fact; you are also a man of uncertain fortune, like all singers; and lastly, you are an artist. I trust you will consider these points as a sufficient reason for my declining the honour you propose." In the end talent triumphs, with no surprise discovery of an unknown noble parent for Nino.[7]

The ambiguous social status of the artist in Rome was obviously a constant irritant for the son of Thomas Crawford and Louisa Ward. Men of genius were honored by aristocrats and admitted into their company, but never considered to be equals. This forced Crawford to argue for a nobility based upon talent rather than name or fortune, an argument that did not require him to criticize the notion of aristocracy itself or to support notions of inherent equality and universal human rights. Crawford invented characters in several books to carry the burden of his resentment. In one case—that of Anastase Gouache in the *Saracinesca* trilogy—he clearly found his alter ego so sympathetic and convenient that he allowed a minor character to develop into a major one. But because Gouache is originally portrayed as a radical republican ·who wants to hang clericals from street lamps and turn churches into theaters, Crawford introduces Cardinal Antonelli himself to convert

the French portraitist into an acceptably loyal son of the Church by persuading him that Christianity is the only true democracy. Thus Crawford's identification with Gouache could be complete. Gouache becomes a Zouave and performs heroically in defense of the pope.

Then his career prospers so that he also becomes rich. At that point he asks Prince Montevarchi for the hand of his daughter Faustina. "You!" shouts the prince. "You, a painter, a man with a profession and with nothing but what you earn!" The prince owns a gallery of masterpieces and claims to love pictures; his daughter is nevertheless intended for a Frangipani, whose attraction derives from "the vulgar possession of wealth rather than upon those divine gifts of genius with which you are so richly endowed." Gouache cannot say what he thinks: that it is "far nobler to earn money by good work than to inherit what others had stolen in former times," that it was better "to make the name Gouache glorious by his own efforts than to be called Orsini because one's ancestors had been fierce and lawless as bears, or Sciarra because one's progenitor had slapped the face of a pope," that it was "a finer thing to be great by one's own efforts in the pursuit of a noble art than to inherit a greatness originally founded upon a superior rapacity." But he now knows that "in spite of all fame, all glory, all genius, he could never be what the miserly, cowardly, lying old man before him was by birth—a Roman prince." And it is on that clannish basis that Montevarchi dismisses him: "Situated as I am, a Roman in the midst of Romans, I am obliged to consider the traditions of my own people in respect to all the great affairs of life."[8]

The situation in *Marzio's Crucifix* (1887), a short novel that was written between the first two volumes of the *Saracinesca* trilogy, is more complex. The radical artist is not a foreigner but a Roman, and he is not converted from his socialism until the end of the book. This allows Crawford to explore two ironies he observed in Rome: the work of atheistical and anticlerical artists in the service of the Church, and the tendency of even egalitarian Roman men to be tyrants in their own traditionally patriarchal homes. Crawford also voices, through a character about whom (unlike Nino and Gouache) he feels strongly ambivalent, some criticism of the Church's politics while in the end making Marzio capitulate completely to its spiritual authority. This story was published first in Paris (in French) and received from the French Academy its highest honor. Ironically, while producing the English version, Crawford also wrote "A National Hymn" to celebrate the centennial of the American Constitution—a commission given him for no apparent reason other than that his aunt had written "The Battle Hymn of the Republic."

The plot of *Marzio's Crucifix* is a paradigm of the secular-clerical conflict in the Rome of the 1880s, resolved as Crawford's ideology rather than history dictated. Marzio, an artisan of great talent and an anarchist, is tempted to kill his brother Paolo, a priest. Marzio hates his brother because he has tyrannized over him since childhood and now constantly intervenes between Marzio and his wife and daughter, who as typical Roman women side with religious authority. The conflict of wills comes to a climax over Marzio's wish to marry his daughter to a radical lawyer, although she actually loves Gianbattista Bordogni, Marzio's most talented assistant. Crawford's initial characterization of Marzio is positive: he is the modern

heir to the noble tradition in metalwork going back to Cellini. In Marzio "the gifts of the artist, the tenacity of the workman and the small astuteness of the plebeian were mingled with an appearance of something which was not precisely ideality, but which might easily be fanaticism." He despises himself for laboring for "a scoundrelly priest" who "dresses himself up like a pulcinella" to wash his hands in "a silver ewer and basin." He resents the aristocracy as well. Why should Prince Borghese "live in a palace and keep scores of horses? . . . Am I not a man as well as he? Are you not a man—you young donkey?" he asks Gianbattista. "I hate to think that we, who are artists, who can work when we are put to it, have to slave for such fellows as that—mumbling priests, bloated princes, a pack of fools who are incapable of an idea! . . . Who have not the common intelligence of a cabbage-seller in the street! And look at the work we give them—the creation of our minds, the labour of our hands——." Nor is Marzio satisfied with the new Parliament in Rome. Italy has not gone far enough: "You must knock down everything, raze the existing system to the ground, and upon the place where it stood shall rise the mighty temple of immortal liberty." Gianbattista wonders who would buy their chalices under "the new order of things." Marzio's reply—"the foreign market"—forces him into a strangely nationalistic position: "Italy shall be great, shall monopolise the trade, the art, the greatness of all creation," as it had in the Renaissance. In Italy the "free artisan shall sell what he can make and buy what he pleases," while the priests are "turned out in chain gangs and build roads for our convenience, and the superfluous females shall all be deported to the glorious colony of Massowah! If I could but be absolute master of this country for a week I could do much."[9]

Marzio is not joking. Crawford lets him rant freely in order to expose the nationalistic and ruthlessly dictatorial tendency of socialists. He sounds like a fool. Crawford as author interpolates his own belief that all great art depends upon religion, and whenever religion goes into decline, so does art: goldsmiths who could make marvelous chalices are followed by mere jewelry makers. Marzio's work is great only because he is not indifferent; hate is the next best thing to love for invigorating eye and hand. Marzio, however, is beginning to believe that it is "his duty, for the sake of consistency, to abandon his trade." It has made him very rich. He should go into "that larger work of political agitation." In the Chamber of Deputies he could declaim "against all that existed, rousing the passions of a multitude to acts of destruction—of justice, as he called it in his thoughts—and leading a vast army of angry men up the steps of the Capitol to proclaim himself the champion of the rights of man against the rights of kings." By describing Marzio's vision this time indirectly, Crawford simultaneously expresses his own contempt. His artisan has "the frenzy of the fanatic, the exaltation of the dreamer," but he lacks "the force to accomplish." "Marzio was destined never to rise above the howling mob which he aspired to lead."[10]

Marzio's fundamental ineffectuality reminds one of Henry James's aesthetic craftsman Hyacinth Robinson, the much more delicate would-be revolutionary in *The Princess Casamassima*, a novel published the year before *Marzio's Crucifix* as one of James's own attempts to work the vein of social realism. Like James's hero, Marzio is ultimately defeated by his realization of the supreme value he personally

finds in the things he would destroy. But where James lets irony do the work for him, Crawford's exasperation with this contemporary type finally breaks into explicit condemnation:

> We have all wondered at such men. They are the outcome of this age and of no previous time, as it is also to be hoped that their like may not arise hereafter. They are found everywhere, these agitators, with their excited faces, their nervous utterances, and their furious hatred of all that is. They find their way into the parliaments of the world, into the dining-rooms of the rich, into the wine-shops of the working men, into the press even, and some of their works are published by great houses and read by great ladies, if not by great men. Suddenly when we least expect it, a flaming advertisement announces a fiery tirade against all that the great mass of mankind hold in honour, if not in reverence. Curiosity drives thousands to read what is an insult to humanity, and even though the many are disgusted, some few are found to admire a rhetoric which exalts their own ignorance to the right of judging God.

Crawford ends with a vision of an imminent "universal war" between Christians and non-Christians.[11] Such a tirade as this must have made Aunt Julia shake her head and would surely have made James shudder for reasons more immediate than war, but it may have pleased French academicians.

After this authorial intrusion one might expect *Marzio's Crucifix* to develop as pure melodrama: the artisan has become the villain, and the priest the unimpeachable hero who triumphs at the end. But Marzio is not a villain, and the plot leads to his redemption rather than his expulsion. Even his "socialism" has "one good feature": it is "sincere of its kind, and disinterested." Marzio is not the typical socialist, "a lazy vagabond" who desires "only to be enriched by impoverishing others, one of the endless rank and file of Italian republicans, to whom the word 'republic' means nothing but bread without work, and the liberty which consists in howling blasphemies by day and night in the public streets." Marzio, as a hard worker, well rewarded, has "nothing to gain by the revolutions he dreamed of, and he might lose much." Practically speaking, however, his political actions consist of "a series of domestic quarrels," while his "horror of social distinctions," instead of leading to the assassination of monarchs, merely manifests itself in "a somewhat studious rudeness" to any aristocrats who come to his workshop. Marzio wishes to burn the Vatican and hang cardinals from the pillars of the Colonnade, but in the presence of the one priest he knows—his brother—he feels a paralyzing constraint. On a walk near the Capitol he identifies not with Cola di Rienzo but with "old Marforio," the talking statue who in "the lawless days of conspiracy and treacherous deeds" had exchanged epigrams with Pasquino: "First of all the low-born Roman hates all that is," says Crawford, "and his next thought is to express his hatred in a stinging satire without being found out." Marzio suffers "from that mental disease which afflicts Italians—the worship of the fetish—of words which mean little, and are supposed to mean much, of names in history which have been exalted by the rhetoric of demagogues from the obscurity to which they had been wisely consigned by the judgment of scholars." This typically bombastic response

to the social reality contrasts with "another phase of Italian character, and one which, if less remarkable, is much more agreeable." It is illustrated by Marzio's daughter, Lucia, who regards everything "from the point of view of daily life." She has no wish to change her social position by marrying a lawyer; she only wants to marry the man she loves and live in "a simple little apartment with a terrace and pots of pinks."[12]

Don Paolo works against his brother to fulfill Lucia's goals, both because they are right in themselves and because the man to whom Marzio wishes to marry her is "an advanced free-thinker," "the devil in person." Don Paolo comes to realize the terrible social implications of his brother's position when he goes to consult a Prince of the Church concerning the purchase of Marzio's crucifix. Paolo's deference to the cardinal is more than clerical; it is an attitude "inherent in the Roman mind." A cardinal in Rome "occupies a position wholly distinct from that of any other dignitary or hereditary noble." The reverence he inspires in "the true Roman"—unlike the scoffing Piedmontese and the jealous Florentine—is "one of those many relics of old times, which no amount of outward change has been able to obliterate." In a cardinal's household one feels "in the very air the presence of a far-reaching power, noiselessly working to produce great results." Don Paolo discovers that the cardinal is completely indifferent to Marzio's atheism as far as his art is concerned, because chalices and crucifixes are sanctified by their use, not by "the moral goodness of the artist." What does concern him is Marzio the man, whose political position is evil. The cardinal obviously speaks for Crawford: a "great fight" is coming, between all Christians and those who seek "the destruction of law," which means the denial of God "because God is order." The moral majority of mankind will always be on the side of order, but the destructive minority will "fight to the death." The "mighty struggle," a universal war in which all men are either with God or against him, "will last long, but it will be decisive." For months and years men will kill each other "before the end comes." Neither the cardinal nor Don Paolo will see it, "but those little children who are playing with chestnuts down there in the court—they will see it."[13]

The rise of anarchic atheism was not the only basis for Crawford's apocalyptic fears; they derived also from his observations of the present condition of the aristocracy. Apart from his ideal Saracinesca family, which represents the best of the old order ineffectually surviving into the present, few of his aristocrats are in any way admirable. Their self-indulgences make them useful for romantic plots, but they create an atmosphere of historical incongruity and impotence, of irrational and amoral willfulness. The highest class in Crawford's fiction is shown as living after 1870 almost entirely in a vicious world of gambling and gossip that is occasionally disturbed by an exploding bomb, a workers' strike, or some other indication that something inconvenient is happening outside the walls of their palaces. Crawford's treatment of the aristocracy becomes less and less serious after *Don Orsino* (1892), the third of the *Saracinesca* books, in which the sense of the aristocracy's obsolescence and the contrasts between the old and the new, the ideal and the actual, are most explicit. The materials for his fictions are now precisely those satirized in *Pietro Ghisleri* (1893) when he observes that Roman aristocrats manage to get through the boredom of Lent only because the short intense "season" that precedes

it creates "an enormous Corpus Scandalorum Romanorum," easily sufficient for forty days of delightful sotto voce discussions.[14] In *Pietro Ghisleri, Casa Braccio* (1895), and *Corleone* (1897)—in which the Saracinescas meet the "bad blood" of Mafia-connected nobility—malignant, repulsive, and ridiculous characters proliferate at all levels of society.

In the last decade of his life, after he had been granted access to the enormous archives of the Colonna family, Crawford wanted to write only formal medieval history. But he had to keep the fictional pot boiling to sustain his princely life— princely except in the prodigious labor it required of him. His later romances are readable as products of cynicism and despair, reflections of both his troubled private life and his perception of modern society's incoherence. To exploit nobility as the subject of romances became virtually an expression of contempt. A princess in *Cecilia: A Story of Modern Rome* (1902) is introduced without qualification as "a monster of avarice, selfishness, and vindictiveness," and we learn that her nephew's financial problems are caused by the fact that all her investments are made according to advice from the ghost of her daughter, who communicates through a table-rapping "medium."[15] This woman is actually typical of the noblewomen of the later novels, whose older aristocrats tend to be either feebleminded or demonic. They are superior to the new bourgeoisie and the peasantry only in their pretensions and possessions. The virtuous young hero and heroine are invariably seen as extraordinary, whereas the other characters, whose interferences make life so difficult and mean, are entirely representative moderns. The appeal Crawford makes at one point to Thackeray's example is entirely justified.

Crawford's decidedly unpicturesque peasants provide no sentimental relief from aristocratic corruption, and they display no natural virtues. A young contadina ironically named Regina is the most admirable character in *Whosoever Shall Offend* (1904). We are told that like all her "race," she is capable of both relentless hatred and doglike devotion, but her breeding has given her no "high standard of honour, and her own ideas about right and wrong [are] primitive, to speak charitably." Like an animal she is brave, quick, and clever when faced with danger, but she is normally nothing more than the typical "Roman hill woman, apathetic, hopeless, unconsciously fatalistic and sleepily miserable." What is fine about her is that she knows her place. Devoted to the rich upper-middle-class hero whose life she has saved, and willing to sacrifice her reputation for him, she nevertheless is too good to permit him to degrade himself by marrying her (while he professes to be too honorable *not* to marry her after they have become lovers). But Regina is "far too much the real peasant girl" to think of rising to a higher social level: she is "the descendant of thirty or more generations of serfs . . . [who] had never been disturbed by tempting dreams of liberty, equality, fraternity, and the violent destruction of ladies and gentlemen." She frankly explains her own willingness to be the hero's mistress by the fact that she comes "of a bad race . . . a race of assassins and wicked women."[16]

The author's "charitable" condescension toward Regina does not prevent him from developing her with far greater sympathy than he devotes to her insipid but acceptable and victorious rival. At the end of the novel Crawford makes one of his very rare uses of classical Rome for a backdrop, and it is Regina who benefits from

the dignity of the association. Utterly defeated and resigned to her loss, at the Colosseum she "sank down on the wet ground, and drew up her knees and pulled her cloak round her; and gradually her head bent forward and rested upon her hands, till she sat there like a figure of grief outlined in black against the moonlight on the great wall." After sleeping while a white mist enveloped her, she "raised her head and saw that the great walls were dark against the starry sky, and she rose with an effort, as if her limbs had suddenly become lead." She soon dies, sacrificially and conveniently, leaving the hero to his upper-class world of pride, fraud, slander, blackmail, wife-poisonings, mysterious disappearances, and justly cynical police investigators. This may be Italy, but "crimes committed for the sake of an inheritance" have been committed "in countries that fondly believe themselves much more civilised than Italy." And although the crimes may be committed in gloomy palaces, they are still twentieth-century crimes. The heroine rides about in a limousine, the villain's messages are transmitted by telephone, and old-fashioned brigands have been driven from the Campagna di Roma by the king.[17]

The idea that religion might function as a redeeming force in modern society, as suggested by *Marzio's Crucifix*, is denied by the other romances. One of the rare scenes to show a noblewoman turning to prayer (something that noblemen never do unless they are priests) occurs in *Pietro Ghisleri*, and there the princess Adele Savelli's prayers express only her incipient lunacy. She has killed her half-sister's husband by inviting him to a dinner of reconciliation and then giving him a napkin cunningly infected with scarlet fever. This princess ultimately finds her relief not in prayer but in morphine. The story of *A Lady of Rome* (1906), the soldierly hero of which frankly despises all priests, is practically reducible to one of a noblewoman's search for a properly deferential confessor, one who will grant her absolution without making her promise to avoid adulterous temptations. The famous Padre Bonaventura of the Capuchin church, however, proves to be "ignorant" and "common"; to the countess "it was a scandal that such a prejudiced man should be a licensed confessor," so she finds a more accommodating one elsewhere who can distinguish a lady's emotions from those of a peasant.[18] Monsignor Ippolito Saracinesca, Crawford's very model of an intelligent and humane Vatican prelate, intervenes to effect a satisfactory romantic resolution to *A Lady of Rome* and *The White Sister*, but in both cases the fulfillment of secular desires (with dubiously pacified consciences) takes precedence over spiritual values.

In *Casa Braccio*, the heroine is a nun, an unwilling "prisoner . . . within the convent walls" because the "glory" of the Braccio family required that she succeed her aunt as prioress in the convent where the Braccios have always exercised power. "A tendency to religion existed in the Braccio family," Crawford comments sarcastically, "together with various other tendencies not at all in harmony with it, nor otherwise edifying." Cloistered conventual life he describes as the "destruction, by fine degrees of petty suffering, of one woman's whole life, . . . the annihilation of all its human possibilities, of love, of motherhood, of reasonable enjoyment and legitimate happiness." The present Braccio abbess, however, "not only approved of the convent life, but she liked it." It never occurred to her that any of the several score of "suffering women" over whom she exercised complete power "could possibly be unhappy if they would only pray, sing, sleep, and eat boiled cabbage at the appointed

hours." The Scottish doctor's argument that God would have to be "a malignant and maleficent demon" to require that the passion the nun feels for him should not be fulfilled seems comparatively persuasive, so she jumps over the wall. This novel ends with a revenge murder in front of Michelangelo's *Pietà* in St. Peter's.[19] Not surprisingly, *Casa Braccio* was placed on the Index of Forbidden Books.

Nine years later Crawford had the temerity to return to the theme of a nun's passion for a man in *The White Sister.* So he could be more respectful, he placed the heroine in a convent of nursing sisters whose prayers are only ten minutes long and who spend most of their time working in a very modern hospital, after having received the most up-to-date scientific training. Significantly, the Saracinescas are the bountiful patrons of this model convent. The hyperactive Mother Superior, however, turns out to be the real mother of the heroine. Having herself been confined to a convent to cover the disgrace to the Chiaromonte family of her elopement with a Protestant, the Mother Superior can sympathize readily with her daughter's "natural" love for a man, whose presumed death as a soldier in Africa had driven her into the convent in the first place. Moreover, Crawford characterizes the heroine's putative parents, Prince and Princess Chiaromonte, as complete hypocrites although they are the most fanatical Blacks. The princess was famous for an ascetic spirituality that led to her early death, and the prince's anachronistic expressions of loyalty to the pope included refusing the civil marriage required by Italian law. Thus when this Knight of Malta is run over by an automobile at the beginning of the book (an instance of Crawford's happy use of realistic modern modes of accident to further romantic plots), his "daughter" is declared illegitimate, which leaves the malicious marchesa who is her "aunt" free to inherit everything. The good side of this, however, is that it also frees the young nun from the marriage that her pious father had contracted for her with a "limp degenerate" whose hereditary disposition to fall asleep on all occasions was considered an advantage by his prospective father-in-law. In the end it is discovered that the Chiaromontes, so famous for their religious devotion, had betrayed the relative whom they had forced into the oblivion of nunhood in exchange for her child. This reduction of the heroine and hero to the necessity of participating in the work of the world and earning their own modest living is presented as a blessing, however. Noble blood and hereditary alliances with the Church are irrelevancies in contemporary life.[20]

In the philosophical digressions that Crawford occasionally permits himself, the unpredictability of life as it is rendered in his romances is never rationalized in orthodox religious terms. The mysterious role played by chance or coincidence in the fulfillment of an individual Destiny or Fate is a source of wonder and interest in human affairs, but deprives them of meaning. Morality has no necessary connection to happiness, for the good suffer and the wicked prosper, sometimes even at the end of the tale. Moreover, events in modern Rome are no more predictable, and behavior no less irrational, than they were in the Middle Ages. "For improbable situations, commend me to the nineteenth century and the society in which we live!" says Don Orsino Saracinesca after one particularly bizarre development. At the end of *A Lady of Rome* the incongruities of life during a labor strike are described as something that would be incredible "anywhere but in Rome, where it seems that nothing can ever happen in the ordinary way": proto-fascist vigilantes (of whom Crawford

approves) help the inadequate police forces by giving "a good drubbing" to "suspicious-looking individuals," while in the Villa Borghese nurses continue to push babies in prams and civilians exercise their horses in a ring. Unless some careful historian is taking everything down, Crawford asserts, in fifty years no one will believe it, "but perhaps a novelist may be trusted to tell the truth."[21]

Since the motives that impel the actions of Crawford's romances seem purely compulsive and temperamental rather than ethical and deliberative, the characters appear to enact an absurd allegory in which they are helplessly wicked or good and are damned or saved in spite of themselves. In later romances Crawford refers cautiously to Nietzsche and Schopenhauer, and more frequently to Dante, as philosophic guides. Two or three characters directly recall Dante's verses as expressions of the purgatorial or even infernal character of their present lives. Crawford finds a congruence between the passions of romance and the melodramatic oppositions of the Catholic imagination, without suggesting that either provides a means to moral enlightenment. Near the end of *Pietro Ghisleri,* the romance that contains perhaps the most intense and ludicrous mixture of mad or diabolical actions, the hero remarks, "You will hardly believe that such things can be done in our day." To which one of the Saracinescas resignedly replies, "I have seen enough in my time, and amongst my own near connexions, to know that almost anything conceivable may happen." When Ghisleri visits the painter Gouache and his wife, who have lived for twenty years in "cloudless happiness" since the day they defied her noble family, the artist advises him to take them as "an instance" of nothing:

> There is something almost comic in being as happy as I am. We should never make a subject for a play writer, my wife and I, nor for a novelist either. No man would risk his reputation for truthfulness by describing our life as it is. [I should like to] paint—subjects like Michael Angelo's Last Judgment with the souls of Donna Tullia, Del Ferice, and Donna Adele Savelli frying prominently on the left, and the portraits of my wife and myself in the foreground on the right with perfectly new crowns of glory and beatific smiles from ear to ear.[22]

This assumption that terrible torments are more credible than boring bliss (besides being more interesting), the preference for extreme characters rather than types of the average, and a heavy reliance upon coincidence in the development of plots—all these things tend to give a romance an expressionistic character that reflects its author and his audience and helps define a period (including our own) that is congenial to such treatment. Expressionism delineates psychological and moral aspects of reality. But Crawford's Roman romances distinguish themselves from the pure genre by demonstrating simultaneously another intention: to record objectively a period of rapid physical and social change in Rome. His publisher, Macmillan, advertised these books as "Novels of Roman Social Life," and in the *Saracinesca* series Crawford explicitly presented himself as a "historian" intimately acquainted with the people whose lives he chronicled. "They themselves are facts," he wrote, "and, as such, are a part of the century in which we live"; his fictions are "an honest attempt to show them as they are."[23] The historical intention is dominant only in the *Saracinesca* series, particularly in the first and third of

the initial trilogy. But even in the romances where historical place and time are more incidental to a conventional romantic plot, the illusion of a basis in contemporary history is maintained. Crawford created a vast overlapping fictional population that connects all the Roman works, and he frequently interpolated commentary on specifically dated historical events or developments that coincide with the actions of his novels and sometimes affect their course. No one can read these novels without becoming substantially acquainted with a particular historical reality as witnessed by someone who understood what he described. What is false in the sense that it is simplified or otherwise manipulated for purposes of romantic idealism is easily recognized and discounted. The fact that the historical dimension is often understood in terms of racial and environmental determinism allies these works by Crawford with the contemporary naturalistic theories of Taine and Zola and with their cruder manifestation in Stephen Crane and Frank Norris. It was the supposedly "scientific" Norris who brought matters full circle by advocating in *The Responsibilities of the Novelist* (1903) that the naturalistic novel was necessarily a romance.

Crawford's evident sense of responsibility came from his awareness that he had lived in a period of enormously significant change in the history of Rome. A city he loved for its unique character and the class that seemed to him most capable of representing a social ideal were both disappearing. *Saracinesca* (1887) opens with a detailed retrospective vision of the papal city of 1865. Crawford lists all the things that had not yet been done to it. His point is not that broad streets, whitewashed buildings, and new residential quarters are bad in themselves, but that they might be those of any place. Rome formerly had possessed a more "attractive individuality" than any city in Europe; its charm lay in its great distinction. Similarly, the vast number of "Italians" who have taken over the city are not evil occupiers, but they *are* a "race" essentially different from the Romans. Formerly the small city had been populated exclusively by descendants (at all class levels) from many generations and by sympathetic foreigners who came for at least a season, took the city seriously, and admired it for being what it was. The transformation of Rome into a national capital "with a fictitious modern grandeur" was a historical inevitability and an enormous advantage to Italy, but for Rome and the Romans it was a disaster. An interval of only twenty years created a gulf greater than one that previously required centuries. To have taken the measure of that gulf, which is the distance between *Saracinesca* and *Don Orsino*, was Crawford's major accomplishment.[24]

In reading the *Saracinesca* series, and the Roman novels as a whole, one becomes very aware of the intimate relation between a specific physical environment and the social customs of the people who inhabit it. Since most of the romances are concerned primarily with the aristocracy, the most recurrent setting is the typical Roman palace with its incredible number and variety of rooms. Often the palaces are experienced by the reader simply as incidental to the action: people descend grand torch-lit staircases, disappear into the shadowy corners of great halls, stare in stupefied suffering at the faded frescoes in their high-ceilinged bedrooms, cross anxiously through secret passages into their private chapels, climb to a portrait artist's studio on an upper floor, consult the family archives with the aid of their librarian, eavesdrop from behind a potted plant in a conservatory, look meditatively

down upon a fountain splashing in one of the inner courtyards, or slam shut the *portone* to keep out rioters in the streets.

Occasionally Crawford sketches a particular palace as a whole to indicate how it is the architectural manifestation of a long-established social structure: the antiquity, riches, and power of a noble family are evident in the very existence of its palace, which shelters within its walls a hierarchical, interdependent feudal community. The point is made notably in the opening paragraphs of *Saracinesca*, chapter 3, which preface a scene in which Prince Leone, the aging father, is first shown in anxious conversation with the as-yet unmarried heir, Giovanni. An even more elaborate description of a palace is also thematically functional in chapter 17 of *Casa Braccio* when the inheritor of the family palace undertakes its complete renovation in 1859–61. A significantly superficial twentieth-century redecoration of the Palazzo Montalto occurs in *A Lady of Rome* in chapter 10. Crawford's most amusing indulgence in the symbolism of palace renovation occurs in *Cecilia: A Story of Modern Rome* (1902) when he has his heroine rather than the Italian government (as was really the case) come into possession of the Villa Madama on Monte Mario, a villa designed by Raphael and decorated by Giulio Romano and Giovanni da Udine. Crawford describes first the sort of vulgar modernization that would desecrate it and then what his heroine "really" accomplished through her superbly sensitive restoration of both the house and the terraced gardens overlooking Rome. The result makes the perfect setting for a great ball which restores the city's reputation for social splendor, and also for a romantic encounter between the mysterious leading characters. (In reality, the Villa Madama became the prosaic seat of government offices.)

The feudal grandeur of the Roman palaces makes them operatic stages upon which only great passions and bold actions seem appropriate. They also encourage human beings to regard life as something large, wonderful, and significant—as an ongoing narrative in which one does well to attend primarily to people who merit superlatives. The action of *Saracinesca* begins at an embassy reception where ministers and secretaries leap to obsequious attention when someone even more important enters "the great drawing-room"—namely, the heroine of our story, Corona, the duchessa d'Astrardente. She is, naturally, "the most remarkable" woman in Rome, while to one side of her is the "most conspicuous" man, Giovanni Saracinesca, and to the other is "a scoundrel of the first water," the non-Roman "Count" Del Ferice (his title is suspect), and all three are being narrowly observed by Donna Tullia Mayer, the most vain and vulgar of noblewomen.[25] Crawford knew that in the small world of Rome in 1865 individuals could actually be so distinguished; even in his time he watched his own friends Giovanni Borghese and Vittoria Colonna play their leading social roles with conspicuous success.[26] He saw no reason to prefer, as subjects of fiction, girls of the street, lustful dentists, or social mediocrities who live in rented rooms. His superlative characters were no less "real" than these.

Beyond the palace walls are other well-defined areas of human activity and experience. In *A Roman Singer* the musical network of Rome that linked the music and musicians of the churches, the theaters, and the streets is exploited with an assurance possible only for someone as familiar with the reality as Crawford, who

sang in a trio with two of the leading singer-composers of Rome.[27] Great churches where artists go to install their finest works and where women pray and sometimes confess, convents, prisons, hospitals, theaters, and the club for aristocratic men— all are described as could be done only by a writer who had observed them closely, from inside. The peculiar odor of a convent—a unique mixture of smells from incense, boiled vegetables, leather curtains, and damp stone pavements and walls— is as precisely rendered as are the visual details of an apothecary's dark, neat shop with its cabinets filled with varicolored liquids and lethal powders. The imposing but sparsely furnished quarters of a cardinal at the Vatican are as fully realized as an artist's studio strewn with precious stuffs and bric-a-brac. A silversmith's workshop with its benches, tools, chemicals, warm lumps of wax, raw metals, and products in various states of finish is re-created by someone who had touched them with his own hands as an apprentice.

Beyond the walls of the city are a variety of structures on outlying roads and in mountain villages that are extensions of feudal Rome: the office of a provincial curate in Aquila with its brass Christ and cheap colored print on the wall, an Abruzzi peasant's dirt-floored household in which pigs are fellow inmates, the fortress-castle at Saracinesca, a rustic tavern on the Frascati road that is neither quaint nor repellent but simply smoke-covered and serviceable, and a spacious hunting lodge on the shore near Castel Fusano where the company of *Whosoever Shall Offend* go (like Crawford and Waldo Story and their aristocratic friends) to shoot quail. Crawford thus distinguishes his descriptions from conventional sketches of Italian settings going back to Anne Radcliffe, whose scenery came from Salvatore Rosa's paintings. In a letter to his intimate friend Isabella Stewart Gardner, Crawford wrote excitedly about his plans for *A Roman Singer:* "In that wild and desolate country I can introduce any romance I please," he said of the Abruzzi, while boasting that his description of it would be completely authentic because "I know the scene very thoroughly, certainly better than any living English writer for I have visited many places where no foreigner has ever set foot."[28]

The famous landmarks of Rome are very rarely employed by Crawford, as they were by Hawthorne and James, as elevating or ironical backdrops, as stimuli to meditations, or as allusions to specific historical events prefiguring the present narrative. Crawford's point of view is always that of the Roman who is proudly aware of the monuments, but knows them as familiar elements of everyday life, not as objects of edifying visits. The most "romantic" use of a monument occurs in the early *A Roman Singer,* but this episode is motivated, significantly, by a German girl's desire to be inside the Pantheon on a moonlit night. Preimagining this scene in his letter to Mrs. Gardner, Crawford said that it would "make a tremendous picture . . . with the full moon streaming down through the round opening in the top."[29] But thereafter he almost entirely resisted any temptation to exploit the tourist's Rome. The only substantial exception is *Cecilia,* whose subtitle—*A Story of Modern Rome*—hardly suggests that it is about a woman who in a previous life was the last of the Vestal Virgins. The best friend of her fiancé was, unfortunately, the Roman soldier and Christian convert who had been her unrequited lover. They become aware of this inconvenient relationship through simultaneous dreams of their encounters in the Forum, precisely envisioned as it was in the days before

Constantine. In the tourist-infested Forum of the twentieth century to which they are now compulsively drawn, they independently cross a wooden bridge over an excavation to arrive at an old familiar pillar near the Temple of Vesta. Cecilia instinctively turns into one room in the House of the Vestals as though it were her own, and on her second visit she is frustrated to find that the busy archaeologists have blocked its opening with a fence. *Cecilia* is the only one of Crawford's Roman romances thus invaded by the supernaturalism that made some of his other stories so popular, but here it is placed in the fashionable "modern" context of self-hypnotism, telepathy, and other mental mysteries. The hero even consults a professional psychologist about his dreams.

The use of St. Peter's in *Don Orsino* more typically converts a famous place into one so familiar as almost to go unnoticed; it ceases to be a "sight." An actual historical event—Pope Leo XIII's Jubilee on January 1, 1888—is viewed from two angles. The hero, standing nervously with his father in the vast crowd, wonders whether the cries of "Viva il Papa Re!" will incite a Black rebellion against the Italian usurpers of Rome and is himself tempted to lead one. At the same time the heroine is meeting the villainess for the first time, both having managed to secure tickets to the tribune supposedly reserved for Roman noblewomen, where they sit directly in front of the hero's offended mother. The magnificence of the procession with "Colonna and Orsini marching side by side" as the pope's noble guards, the long elaborate ritual at the altar, and the splendor of the cathedral itself are lightly sketched in by Crawford as aspects of the scene entirely subordinate to his characters' political and social preoccupations.[30]

In Crawford's characterization of the Saracinescas, the differences among the male heirs in three generations are well defined. The old prince, a man of absolute feudal convictions, is intelligent, active, and responsible in his relationships to his servants and to the peasants on his estates. Giovanni, the hero of the first book, has been a somewhat "wild adventure-seeker throughout the world" and has a more fiery temperament than his father because his mother was Spanish (the common appeal to heredity that romancers shared with naturalists). At the age of thirty Giovanni still postpones his obligatory marriage because he is in love with a virtuous married woman. Coming to his maturity at the time when modern democratic forces are closing in on Rome, he naturally feels challenged more directly than his father ever had. During a hunt-meet on the Campagna both the non-Roman "Count" Ugo Del Ferice and Donna Tullia Mayer, who for their own hypocritical reasons are participants in a Liberal conspiracy (he for profit, she for excitement and revenge), try to enlist Giovanni in their cause. In the course of rebuffing them Giovanni defends the aristocratic position. When Del Ferice cites the condition of the Campagna itself as something that its owners—including the Saracinescas—ought to be ashamed of, since it could be fertile farmland if drained, Giovanni states that no amount "of law or energy could drain this fever-stricken plain into the sea" since the water table of the Tiber valley has changed since ancient days. In any case, neither he nor "any other Roman" would force peasants to sacrifice their lives in the attempt.[31]

Later Crawford interpolates an elaborate explanation of the economic relations between noble landlords and hereditary peasants with clearly established rights on

their estates. Defects in this system, as with any other, derive from the irresponsibility of men at all levels—including the infamous middlemen. Crawford even admits that men like the Saracinescas were "great exceptions at that time." By passing many months every year at their Abruzzi castle, they became personally acquainted with all their peasants, who consequently understood and loved their "superiors." The Saracinescas, "a manly race," spent their money not on adornment of their medieval stronghold but on things that benefited the peasants, "wisely promoting in their minds the belief that land cannot prosper unless both landlord and tenant do their share." Giovanni flatly refuses Del Ferice's conspiratorial overtures. Although his family has been antipapal for centuries, it could never be republican. Giovanni asserts that as a "man of property" he abhors revolutionary changes, that as an aristocrat he scorns the notion of being ruled by an ignorant majority, and that as a subject of the pope he will fight for him to whatever extent honor requires. But if a change does come to Rome, as a gentleman and a man of common sense he will "make the best of it."[32]

In *Saracinesca* the character in direct opposition to the opportunistic Del Ferice is none other than Cardinal Antonelli. He first appears in the novel at the great Frangipani ball, which is presented as the most superb social occasion of the 1860s and is based upon a famous Orsini ball of 1885 that was intended to reestablish the splendor of Roman aristocratic life under the new regime. The great hall, thirty additional rooms, and the gardens of the ancient palace were brilliantly illuminated and thrown open, and "all Rome" was invited. Giovanni arrives as Cardinal Antonelli is leaving, spreading a hush through the glittering crowd that bows before him as he goes. Crawford uses this as the first of several opportunities to express his own admiration for this powerful, steadfast, much-hated, and lonely man. Antonelli, bidding his torchbearers wait, draws Giovanni aside. Standing in the wind at the top of grand open stairs leading to a courtyard, the cardinal diplomatically informs Giovanni that he and the Holy Father are distressed by the rumor that Giovanni may marry Donna Tullia, a "dabbler in political dilettantism." He lets it be known that he is thoroughly aware of the conspiratorial chatter of Del Ferice and the others who meet in the studio of the painter Gouache. The association of an ancient Roman name like Saracinesca with such "weak and ill-advised people" would be intolerable to the pope and dishonorable to Giovanni, says Antonelli. Later in the book the cardinal intervenes again when the duchessa d'Astrardente has become a widow. In spite of her personal aversion, Corona patiently accepts the condolences he bears from the Holy Father, and she listens to Antonelli's gratuitous and earnest advice on how she might fruitfully turn her widowhood and enormous wealth to good use. She could set a powerful example for the entire Roman aristocracy, counteracting the disturbing influence of Donna Tullia Mayer in particular. Her salon would radiate goodness, intelligence, and refinement from Rome throughout Europe.[33]

The opposing values thus embodied in the characters are dramatically realized in the action. An incident at the Frangipani ball leads to a duel between Giovanni and Del Ferice, in which the latter is nearly killed. The genuinely religious Corona, who has been a self-sacrificing daughter and a faithful wife, marries the honorable and matured Giovanni, whom she loves. The ceremony that unites them as "the richest

couple in Italy" is conducted with the highest pomp at the insistence of Antonelli, speaking for the pope, who wishes to signify the "solidarity" of the Roman nobility with the Church while demonstrating once again that the "Roman court" is the most magnificent in Europe. The foolish Donna Tullia, defeated in her attempts to prevent the marriage and to humiliate Corona, is coerced into marrying Del Ferice. Consistent with history rather than melodramatic convention, this marriage also prospers in later books. But at the end of *Saracinesca* Del Ferice must flee from Rome (actually aided by the compassionate Corona), because Antonelli has discovered to his rage and embarrassment that Del Ferice's espionage system has been fully as effective as his own. Giovanni and Corona, to the happiness of old Leone, unite their vast neighboring estates in the Abruzzi, and immediately employ whole villages in the building of roads, housing, schools, and an aqueduct: an ideal image of benign and fecund Roman feudalism projected against the historical fact of the system's demise.[34]

Twenty-one years later, in *Don Orsino*, the next heir comes of age in a wholly changed city. Of the Roman novels, this one is most fully a product of the realistic movement in fiction. To be sure, the arrival of a widowed, tragic noblewoman of uncertain origin who is mysteriously connected with the even stranger "melancholy Count Spicca," a famous duelist, engenders one of the two plot lines. But the second plot—which occupies more than half the book—is entirely taken up with a contemporary young nobleman's attempt to find a modern occupation. Don Orsino's involvement in Rome's speculative building craze of the 1880s relates the novel to other American fictions, from Mark Twain's *The Gilded Age* (1873) to Dreiser's *The Financier* (1912), that deal with the capitalist fevers of the epoch— that is, with money. Crawford's representation of the world of financial speculation is in fact far more complexly detailed and technical than are accounts of business rendered by Howells or even Norris and Dreiser. Besides the universal matters of mortgages, leases, and the costs of building materials, localized concerns with the effects of the abolition of the law of primogeniture and of new laws forbidding the sale for export of art treasures owned by noble families are not the sort of information one usually extracts from romances.

 In its representation of the details of financial processes, *Don Orsino* has affinities with Henry Blake Fuller's *The Cliff-Dwellers*. This novel, published two years later (1893), describes the building boom in Chicago on the eve of its imperial Columbian Exposition, which, according to Fuller, struck a "dominant Roman note" that referred with "a straight and unbroken directness to the great structures of Caligula and Nero."[35] Sometimes cited both as a naturalistic advance upon Howellsian realism and an anticipation of Sinclair Lewis's satire, Fuller's book like Crawford's exposes the amorality of the business world in which men of least refined origin are most successful, while its other plot concerns the same questions about the proper marriage for a young man of good family and about the preoccupation of women with social status. It ends with patricide and suicide, events more melodramatic and sensational (not to say incredible) than anything in *Don Orsino*. Both of these novels employ what someone recognized as the "sandwich" structure of Dreiser's *Financier*, by which love episodes alternate with business episodes, the

only difference being that for neither Fuller nor Crawford could the love episodes become explicitly sexual. What most differentiates Crawford from Fuller (and Howells) is the passionate dialogue of his prolonged love scenes. Interestingly, Maud Howe defended even her cousin's dialogue as realistic: "The fact is, that in those days people talked that way. Conversation was an art. We had time to exchange our thoughts clothed in decent language, not as today in a sort of naked code of dots and dashes."[36] Whether or not this is so (it is possible that lovers in Boston and Rome, if not Chicago, did imitate romantic art in their speech), *Don Orsino* is more intensely engaging than *The Cliff-Dwellers* in its rendering of both love and business. In the 1890s Chicago may have been imitating Rome, and Rome Chicago, but they were still different realities. Differences in local atmosphere— the difference between a feudal palace and a modern office skyscraper—may account for the differences between the books more than any difference in genre.

At the opening of *Don Orsino* three generations of Saracinescas are living in their palace. The chasm between the youth of the oldest and that of the youngest is immediately established through retrospective descriptions of the funerals of Pope Pius IX, King Victor Emmanuel, and Cardinal Antonelli. The novel begins in 1887 and ends in 1890, and the Rome of this brief period is a completely different place from that of the decade 1860–70, in which the three great men had struggled to possess it. The division of loyalties that they represented, which in their time had been of universal and tragic significance since both sides were "right" and both tested devotion not only to principles but to persons, was now an absurd abstract anachronism that some members of society insisted upon perpetuating. Crawford treats the delicate matter of whether a newcomer to Rome will fall into the hands of the Whites or the Blacks as the stuff of comedy. He clearly shares the attitude of Giovanni: Rome being lost, one should "make the best of it." For two pages he laments once more the creation of New Rome, which to the returning native who wanders its streets seems a wholly alien place, but he observes that in a view from the Janiculum "the capital of modern Italy sinks like a vision into the earth. . . , and the capital of the world rises once more":

> The greater monuments of greater times are there still, majestic and unmoved, the larger signs of a larger age stand out clear and sharp; the tomb of Hadrian frowns on the yellow stream, the heavy hemisphere of the Pantheon turns its single opening to the sky, the enormous dome of the world's cathedral looks silently down upon the sepulchre of the world's masters. . . . The great house has fallen into new hands and the latest tenant is furnishing the dwelling to his taste. That is all. He will not tear down the walls, for his hands are too feeble to build them again.[37]

This proto-modernist view pervades *Don Orsino:* no matter how terrifyingly energetic the modern age is in both destruction and construction, its conceptions are ignoble and its effects petty. In such a world as this a young man with noble traditions cannot find a worthy occupation.

The source of conflict between Don Orsino and his father and grandfather is the very notion that he must *have* an occupation other than the one he has inherited. Crawford's sympathy with Don Orsino's unwillingness to accept the "tribal" life he

was born to—which consists of hunting, gambling, dancing, and drinking, punctuated by occasional rent-collecting excursions to one's estates—is a criticism of the rich and well-born who are content so to live. But Orsino's rebellion must face the reality that he has few options. What noble field of action does the modern world offer? The most conspicuous person in Rome is now Count Ugo Del Ferice, to whom the triumph of Italy reopened the city's gates. He has risen to power both in the House of Deputies and in the world of finance that is building New Rome. It is Del Ferice, not Orsino's grandfather, father, or cousin (to all of whom he first turns) who provides Orsino with something to do.

Crawford's portrait of Del Ferice as the Liberal conspirator in *Saracinesca* was so virulent that on the last page of that book he felt obliged to deny that Del Ferice was meant to represent New Italy's essential character. Del Ferice instead stood only for the large number of opportunists who were undeniably a part of the movement. In *Don Orsino* Del Ferice's character has not changed, but he is even less the conventional villain than he was in *Saracinesca*. Although pure hate and a desire for revenge plausibly remain among his secondary motives, intentional evil is no part of his character. In Crawford's view the effects of such completely amoral politicians and businessmen may be evil, but they themselves are not so, and he does not violate this principle for the sake of melodramatic simplicity. Del Ferice recognizes in Don Orsino's request for advice and help the possible seed of some future advantage to himself, and he is willing to nurture the seed without knowing what fruit—if any—it may bear. He does not malignantly conceive a plot to humiliate the House of Saracinesca, but he is too clever and too proud not to exploit whatever opportunity follows from Don Orsino's initiative. Crawford's portrait of Del Ferice as a representative modern politician-businessman is one of the most convincingly conceived of the period. And his wife, the former Donna Tullia Mayer, also receives a more rounded treatment in the later book. She welcomes the heroine into her "unpleasantly gorgeous" home in a new quarter of the city, and when she finally dies of a heart attack, the reader shares the hero's regret that her cheerfully vulgar and aggressive presence has disappeared from the social scene. (Her husband, although genuinely grieved, uses the legacy specified in her will for some "public charity" to commission a statue of himself for the town in the South that he represents in Parliament.)[38]

Don Orsino's involvement with Del Ferice in the building of the New Rome has several ironic aspects. It cannot entirely allay his sense of futility, since he realizes that the sole motive of building speculation is to make money, and as the heir to three enormous fortunes he hardly needs to accumulate another. Still, it is an occupation that will prevent him from being "sacrificed upon the altar of feudalism." Having received (like Henry Adams) an education irrelevant to the modern world, and being without genius in anything, he has only money to work with, but money is at the heart of the age into which it was his misfortune to be born. Money may be the basis for "a career" such as every modern man must have, and his unorthodox choice will break through "traditions and prejudices" that separate him from other men—at the cost, inevitably, of alienating him from his own grandfather and father. The destruction of exclusive social traditions and the prejudice against business is seen by Crawford as a good in itself. This is proven by the fact that he

makes Corona (Orsino's mother and Crawford's ideal woman) say to her son, "One of my thoughts is that our old restricted life was a mistake for us, and that to keep it up would be a sin for you." She recognizes that she and Giovanni had been "at the head" of a world that "stood still," but the world "is moving now and you must move with it or you will not only have to give up your place, but you will be left behind altogether." In the words of Count Spicca, there is "but one hope for us. The Americans may yet discover Italy, as we once discovered America."[39]

The most positive result of Orsino's brief "career" in business is that it brings him into an intimate relation with someone who earns his own living: Andrea Contini, the architect and director of construction on the building projects to which Del Ferice assigns Orsino. A "man of skill and energy," Contini (or "little count," a nobleman by merit) knows "his business to the smallest details and could show the workmen how to mix mortar in the right proportions, or how to strengthen a scaffolding at the weak point much better than the overseer or the master builder." Orsino's partnership with Contini—whom "under ordinary circumstances" he never would have met—makes him happier than he has ever been. Seeing their work through Contini's eyes, Orsino develops a "passion for stone and brick and mortar" and wishes he had been practically educated as an architect or engineer. He also begins to perceive that by judging "his own countrymen from his own class," he "had understood little or nothing of the real Italian nature when uninfluenced by foreign blood." Among the things he now understands is that name and class are not the only sources of pride. The pride of Contini—who claims descent from the revolutionary Cola di Rienzo, in whose murder a Saracinesca was involved—is based upon his individuality. When Contini becomes a friend, closer than "any man of his own class," Orsino can even tolerate praise from someone "below" him. Contini sympathetically repeats the heroine's assertions "that of all the Roman princes you were the only one who had energy and character enough to throw over the old prejudices and take an occupation. That it was all the more creditable because you had done it from moral reasons and not out of necessity or love of money."[40]

Crawford's portrait of "the young man of the Transition Period" comes to a conclusion with his financial failure in the panic of 1889–90. He had entered late into the "rage of speculation" that swept Rome for the two decades of the building boom caused by the tremendous influx of people and by the destruction of old housing stock to "beautify" Rome. Moreover, he owed his apparent continuing success (when everyone else was failing) not to his own talents but to the secret self-interested interventions of Del Ferice at the bank that he controlled. Thus Orsino is finally "completely beaten in his struggle for independence."[41]

In freeing himself from his parents' feudalism Orsino subjected himself to even more humiliating modern determinants of fate: unpredictable economic forces and the whims of opportunists like Del Ferice. In following the trajectory of Orsino's story, Crawford delineates a unique period in the history of Rome. Until the permanence of the "prosperity" that followed the "Italian occupation" proved to be illusory, "everything was successful and every one was rich." All the women rode in coaches, and all the men smoked long black cigars. Everyone got married. "Everybody was decorated." "Society danced frantically and did all those things which it

ought not to have done." One particularly modern man declared that Rome was now "one of the greatest of cities, and he smacked his lips and said that he had done it." But after a short time there were few who "did not suffer in the almost universal financial cataclysm." "Princes, bankers, contractors, and master masons went down together in the general bankruptcy." Thousands of immigrant workmen lost their jobs; they and their families "were by slow degrees got out of the city and sent back to starve out of sight in their native places." Visible everywhere were the "dismal ruins of that new city which was to have been built." Seven-story houses stood roofless and uninhabitable in the midst of weeds and rubbish on the "broad, desolate streets." Beside "heavy low walls which were to have been the ground stories of palaces, a few ragged children play in the sun, a lean donkey crops the thistles." In the disfigurement of Rome, barbarians and Barberini finally have been outdone by "these modern civilizers."[42]

The participation of the oldest families of Rome in their city's destruction was one of the most painful ironies of the period. The senior Saracinescas could afford to remain pure and ideal, unsullied by "business." Others could not. But even many who could did not. When Orsino, upon first meeting Del Ferice, speaks bitterly of what the speculator and his kind are doing to Rome, Del Ferice observes that "time" is a "beautifier which we have not at our disposal. We are half Vandals and half Americans, and we are in a terrible hurry." Rome as "the capital of an idea" had all eternity at its disposal. As "the capital of a modern kingdom, it fell a victim to modern facts—which are not beautiful." When Orsino persists in his criticism, Del Ferice points out that "as far as personal activity is concerned, the Romans of Rome are taking as active a share in building ugly houses as any of the Italian Romans." The destruction of the Villa Ludovisi, for example, was entirely the work of old Romans exploiting the new situation. Orsino coldly remarks that the Saracinescas, at least, "have had nothing to do with the matter." Del Ferice's reply to this opens the door to Orsino: it is a great pity "such men as you, Don Orsino, who could exercise as much influence as it might please you to use, leave it to men—very unlike you, I fancy—to murder the architecture of Rome and prepare the triumph of the hideous." At this, Orsino begins to realize that his father and grandfather have not evaded responsibility for what is happening to Rome by remaining detached and passive when confronted by an inevitable historical change. One has only a choice of how to be implicated. Such a dilemma arises from the complexities of realism rather than the simplicities of popular romance. When in the end Orsino is extricated from both his financial entanglement and his commitment to an unsuitable marriage through the self-sacrifice of the high-souled heroine, the reversion to romance does not invalidate the realistic texture of the novel's exposition of modern life, but it does reaffirm the hybrid character of Crawford's Roman works.[43]

Crawford, watching Old Rome disappear into the gulf of history, observing "the triumph of the hideous," fearing the growth of social anarchy, and predicting a universal war between Christians and non-Christians, imitated his hero Giovanni Saracinesca by "making the best of it." By the time he wrote *A Lady of Rome* (1906) he had fully discovered the usefulness of Italy's army as a source of new heroic types (especially if the officers had been born aristocrats). Wars against Africans and

anarchists were proving that bravery was a contemporary virtue and that patriotism fully equaled any earlier gentlemanly motive. What is more, Crawford had decided that Italian patriotism was justified:

> No one who can recall the old time before the unification can help seeing what has been built up. It is a good thing, it is a monument in the history of a race; as it grows, the petty landmarks of past politics disappear in the distance, to be forgotten, or at least forgiven, and the mountain of what Italy has accomplished stands out boldly in the political geography of modern Europe.

Now a new generation, taking pride in what their fathers achieved, have "the honest and good hope of doing something in the near future not unworthy of what was well done in the recent past." In *Cecilia* (1902), of the two central male characters, one is both an Italian officer and the reincarnation of an ancient Roman soldier. The other is the skeptical, indecisive, suicidal son of a deposed king. As such Guido d'Este knows that he is "the end of a race that had reigned and could never reign again." He must resign himself without even "a cry of impotent hatred uttered against Something which might not exist after all." In the end the modern heroine (Cecilia reads Kant, Fichte, and Hegel) responds not to the pretensions of a noble name but to the vital substantiality of the modern—and ancient—soldier.[44]

Who will be the inheritors of Rome? That question is asked implicitly by Crawford's late romance, *The Heart of Rome* (1903), which may be read as an allegory. It opens with the desertion of the three-hundred-room Palazzo Conti by all of its servants except the old porter and his wife. There are also incongruous modern signs of termination. The telephone company "sent a man to take away the instrument," says the porter to the inquisitive Baroness Volterra. "Then the electric light was cut off," he adds. "When that happens, it is all over." However much the baroness, whose "position in the aristocratic scale was not very well defined," pities the Conti, she cannot resist looking upon the palace as a possible residence for herself, if only the king can be persuaded to confer upon her husband a title more consistent with its splendor. Her husband, a senator who may once have been a pawnbroker in Florence, in fact owns the mortgages on the Palazzo Conti, and upon taking possession he hires an architect-archaeologist to study its substructures. His great interest in the palace is owing to a legend that treasures are hidden in its foundations among caverns cut off by the "lost waters" of Rome.[45]

In a postscript Crawford establishes the authentic basis for the adventures of his characters in their competition to possess these treasures at the heart of Rome. He had himself recently seen "a construction like the dry well in the Palazzo Conti, which was discovered in the foundations of a Roman palace, and had been used as an oubliette"; it contained skeletons and weapons from the sixteenth and seventeenth centuries. The rise and fall of pure waters of an unknown source beneath Roman palaces is also a fact, but one largely beyond exploration since "the older part of modern Rome was built hap-hazard, and often upon the enormous substructures of ancient buildings, of which the positions can be conjectured only." As for possible lost treasures, Crawford as a boy in 1864 had witnessed the retrieval of "the colossal statue of gilt bronze which now stands in the circular hall known as the 'Rotunda'"

at the Vatican. It had been accidentally discovered in the courtyard of the Palazzo Righetti in the Campo de' Fiori, "carefully and securely concealed by a well-built vault, evidently constructed for the purpose, in the foundations of the Theatre of Pompey." In *The Heart of Rome* Crawford places this statue beneath his fictitious Palazzo Conti. His hero-archaeologist identifies it as a "Commodus as Hercules," while Crawford's heroine calls it "a gilded Roman monster," "hideous" but "magnificent." As such it embodies one aspect of Rome's imperial heritage. Lying beside it in the cave, however, is a Venus, "delicate, slender, and deadly"—a supreme expression of the Greek ideal of divine humanity which Rome also valued and transmitted to later ages.[46]

The right to ownership of these buried treasures beneath the Palazzo Conti is uncertain. All the characters want to claim them or the palace itself. Of the members of the Conti family, only Sabina, the younger daughter, is sympathetically portrayed. From the point of view of the family's steward, the others are despicable. Pompeo Sassi, whose name suggests the rocklike foundation of feudal tradition, believes that when the late Prince Conti died, the end had already come, for his "traditional Ciceronian virtues" had been replaced "by the caprices of the big, healthy, indolent, extravagant Polish woman [the Princess], by the miserable weakness of a degenerate heir, and the fanatic religious practices of Donna Clementina," the elder daughter. These three are potential claimants, but they wish only to convert the statues into gowns, automobiles, or an endowment for nuns. The values of the Volterras are equally inappropriate. While exploring the abandoned palace and noting the dust gathering upon the marble, the baroness, "who hankered after greatness, felt that the gloom was a twilight of the gods." Crawford sees the aristocratic gods being replaced by a new species—the snobs, of whom the baroness is his supreme example. Unfortunately for her, the baron, although he knows well the commercial value of old things—old palaces which might be sold to the Vatican, and antique sculptures which might be sold secretly to foreign collectors—"had a predilection for a new house, in the new part of the city, full of new furniture and modern French pictures." A third set of claimants comes from the lower class—Toto the mason and Gigi the carpenter. Toto's family has maintained the Palazzo Conti for centuries, and to him alone has been transmitted an intimate knowledge of its structure and of the conduits that control the flow of lost waters. Moreover, his grandfather's bones lie unblessed somewhere within the cellars where he drowned during the reign of Pope Gregory XVI. Toto's earnest desire is to give the skeleton a decent burial and—since he is "a genuine Roman of the people"—to give the statues to the pope. The Vatican, of course, will have an interest in acquiring the statues no matter who recovers them, and the Italian state has a preemptive right, according to newly promulgated laws.[47]

There remain the two people who understand and value the statues disinterestedly: the celebrated young archaeologist, Marino Malpieri, whom the government had once sentenced to three years' imprisonment for publishing a republican newspaper, and Sabina, the only "true" Conti, the one the old family steward still loves. The perilous adventures of this pair in the dark passages beneath the Palazzo Conti and in the chamber with the statues, while the rushing lost waters rise and fall, provide the book with its primary means of suspenseful elaboration. Their

fortitude and courage and love prove their true nobility of character and make them the rightful heirs to Hercules and Venus. In an early chapter Sabina was shown consciously rejecting her mother's "life of perpetual pleasure," her sister's cold religious mania, and the baroness's class consciousness. She wishes above all to be self-reliant, free, and loved, and that is what in the course of the book she becomes. She and Malpieri, a republican from one of the oldest of Venetian families, are explicitly characterized as "quite modern young people," totally liberated from the sentimentality and hypocrisy of the nineteenth century. Naturally, the book ends with their union. They are the ideal representatives of the new heart of Rome.[48]

A distinction of Crawford's Roman romances is that he finds an "American" point of view within that of the modern Roman. Foreigners figure in his works only to the extent necessary to reflect Rome's cosmopolitan character, particularly among its nobility. Germans, Russians, Poles, Spaniards, English, and French are especially numerous because they provided aristocrats with whom intermarriage was possible. There are also some French artists and governesses. Americans are notably rare. The "international novel" as developed by Howells and James was no part of Crawford's interest. An American named Paul Griggs whom Crawford employed as his alter ego in several books is prominent in Rome only in *Casa Braccio*, and even there the delineation of real or symbolic national differences is incidental to the action. Crawford is almost unique in his fictional representation of a Rome in which Romans are central. The only person who once rivaled him in this was his sister Mary (Mrs. Hugh Fraser), who published *Gianella*, a gracefully structured and beautifully detailed Roman romance full of nostalgia for papal Rome, in 1909, the year of Francis Marion Crawford's death at the age of fifty-four.

Tales of Rome written by other Americans, before and since Crawford, are chiefly chronicles of Americans in Rome. Even when they are ostensibly about Italians, like Henry Blake Fuller's satire, "What Youth Can Do" (1898), the primary interest derives from the foreign point of view. In this story a Venetian's rise from being the gondolier of a lustful duchess to being her gigolo, which enables him to purchase a title and be sent to the Parliament at Rome as Count Crassegno, is narrated by a frustrated, aging Englishwoman who compensates for her outsider's inability to be an active participant in Italian life by aggressive voyeurism and gossip. Her story constitutes a response to an American's invidious remark that Europe "gave no chance to youth." Having a "slight curiosity" as to whether Latins are capable of mastering the Anglo-Saxon "parliamentary forms," she and her husband, Ethelbert, visit Montecitorio, where the handsome young orator provokes her intense curiosity and her subsequent inquiries into the Italian mode of rising in the world.[49]

Even this form of imaginative intimacy between Italians and foreigners is absent from Constance Fenimore Woolson's "Street of the Hyacinth," published in *Century* magazine in 1882. The central figure of this story—Ethelinda Faith Macks of Tuscolee Falls—may be the fictional representative of who knows how many young Americans who went to Rome to develop their talent and were never heard of again. Ironies arising from ill-founded hopes are compounded here by the fact that "Ettie" has come to Rome, dragging her "uncultivated" old mother with her, not for the sake of Rome or Romans, but to impose herself upon another American, an art critic

whose writings have inspired her. He begrudgingly visits the galleries with her, and she afterward writes down everything he has said, verbatim, while agreeing with none of his judgments. Her acquaintances are entirely English and American until, after more than a year of lessons, someone finally tells her that her paintings are terrible. She then takes to tutoring noble children to survive. After two summers in service at a villa in Albano, she has the opportunity to marry the young Count L——, whose scandalized relatives (who intended him for a rich Neapolitan cousin) are grateful when she refuses ("these Italians are so worldly, you know!") The snobbish art critic himself finally marries her after some months of taking the old mother for drives on the Pincio and riding with Ettie in the Campagna. Woolson's Rome is thus the separate and peripheral foreigners' city, but it is more various and subject to change than James's. The narrow, dark, and dirty Street of the Hyacinth, where Ettie and her mother find cheap rooms in the top floor of a house directly behind the Pantheon, is not the sort we usually read about as a foreigner's address (Hilda's home in *The Marble Faun* comes closest), and yet there must always have been many who necessarily took such lodgings. And Woolson's story is placed with historical precision in the 1880s, for its crisis is precipitated when Ettie learns that she will be "driven out" of the Street of the Hyacinth, which is to be demolished to free "the magnificent old Pagan temple" from the "modern accretions" that "disfigure it."[50]

Neither Rome nor Italy is strange to Woolson, but rather people like Miss Macks who go there wholly blind to its special character (the art critic cannot make Ettie see the beauty of the vegetable markets; all she thinks of are the prices). The problem is the reverse for the cosmopolitan characters in Henry Blake Fuller's *The Chevalier of Pensieri-Vani* (1886), *The Last Refuge* (1899), and *Gardens of This World* (1929), and in Thornton Wilder's *The Cabala* (1926). For them—and for their authors—the reality of Italy is a living romance for the rich, the eccentric, the talented, and the imaginative from all over the world. They manifest their freedom by following out their whims. The only time that current affairs impinge upon Fuller's Pensieri-Vani, a brilliant non-Italian organist, is when he must decide whether to be made a *cavaliere* by the Blacks or the Whites, by "Sanctity or Majesty." The companions on his peregrinations of the peninsula come from a motley group of deracinated aesthetes more likely to take an interest in affairs Etruscan than contemporary. As a young man of twenty-two Fuller had arrived in Rome on December 6, 1879, and devoted three months to intensive study of the city; he returned to Italy for a sixth and last time in 1924. But his greatest love was not for Rome but for the smaller places of Tuscany. So Rome serves as the basis for only one episode in *Chevalier*—one characteristically concerned with a battle for possession of a newly discovered Etruscan Pot, "an extremely exceptional affair" which "shook the whole peninsula, and at one time threatened the most serious international complications."[51]

Fuller's narrator airily assumes not only an intense interest in such antiquarian matters, but a knowledge of "the outlying hills of Rome" (the Coelio, the Esquiline, the Aventine). These "slighted and deserted tracts" are unknown to ordinary tourists, but to initiates they offer "unlawful trespassings on quiet gardens and cloisters . . . ; entrance into some ancient, unchurched church . . . where frescoed saints

and angels crumble slowly from the damp walls," and other esoteric delights. The battle over the Iron Pot involves the Curator of the Museo Capitolino, the Archaeologist-in-Chief of the German embassy, the German and French ambassadors, and the Italian Minister of Fine Arts, with everything ending up in the hands of Count Imbroglio, the Minister of Foreign Complications. The "whole Town, native and foreign,—especially foreign, for the affair came as a perfect godsend to the leisured Anglo-Saxon colony,—divided into two hostile camps." Then the rumor spread that "the Vatican itself was about to take advantage of the situation to claim the Iron Pot, on very plausible grounds, as the property of the Holy Church," thus making the contest three-cornered and adding "the horrors of civil strife . . . to the agony of foreign war."[52]

Of whatever nationality, Fuller's characters are cartoonlike abstractions in a plotless fantasy held together by the elegance and wit of his style and by an effete tone that is best defined simply as anti-Chicagoan. The unity of Thornton Wilder's episodic *The Cabala* similarly depends primarily upon its elegant style and a tone both rapturous and bemused. That this fiction too is a romantic fantasy becomes apparent at the end of the first chapter when the narrator, on his first day in Rome, visits a young English poet who is dying in a house at the foot of the Spanish Steps. This encounter with the unnamed John Keats exactly a century after his death is more than a whimsical conceit. The poet's "hunger for hearing things praised," his desire most of all to hear "the praise of poetry" and the names of great poets, and his belief that he "was meant to be among those names" are assertions of values— values of language, of the imagination, of divine genius—that inform the book as a whole and culminate in its final pages with a vision of Vergil, the prophetic poet of Rome.[53]

The Cabala is dedicated to Wilder's "friends at the American Academy in Rome, 1920–21." As a twenty-three-year-old resident guest (not a Fellow) at the academy, Wilder studied archaeology and explored the city. But his academic friends did not suggest the characters of his book. The superb eccentrics who make up the Cabala are creatures of Wilder's imagination. To live in Rome is to learn that such people exist, but according to Wilder himself he never entered their circle. His book, originally called *Memoirs of a Roman Student,* is a compensatory romance in which the narrator's intimacy with Italian aristocrats and wealthy cosmopolites affords Wilder (and the reader) the vicarious experience of a rarified world. For the writing of *The Cabala* and of his later plays, Wilder's presence at the premiere of Pirandello's *Sei personaggi in cerca d'autore* was probably more valuable than an acquaintance with the reality of the most exclusive social circles of Rome would have been.[54] The romance of Roman reality for this American lay not in the accidental characteristics of actual individuals but in the very idea of a place where people who knew themselves to be superior cultivated their special gifts and exercised their privileges with complete indifference to modern ideas of utility and social responsibility.

The comedy and pathos of the Cabala's anachronistic pretensions and pursuits could be rendered most effectively by a naively adoring outsider because their passions are the means of his own imaginative liberation. Shortly after his arrival in Rome the young American finds himself taking tea in the Palazzo Barberini with an elderly insomniacal American heiress who sometimes hires the Lateran choir to

sing Palestrina to her from midnight until dawn. At her dinner that night he receives two invitations. One is from a "high Merovingian maiden" whose obsession is to restore the French monarchy by means of an Oecumenical Council that will establish the divine right of kings as dogma. When she says, "I shall see France return to Rome before I die," the sycophantic American obligingly replies that "both the French and Italian temperaments seemed to me singularly unrepublican, whereupon she laid her long pale hand upon my sleeve and invited me to come that weekend to her villa." She owns the Villa Horace at Tivoli, on the site of the ancient poet's farm.[55]

The second invitation is to pass a week at the Villa Colonna-Stiavelli, "the most beautiful" and "most famous of Renaissance villas," one that was "obstinately closed to the public." The duchess d'Aquilanera wants the presumptively puritanical and "naturally good" young American to "save" her lecherous sixteen-year-old son from his debauchery so she can marry him off properly: "'He is important because he is somebody. How you say?—he is a personage. We are of a very old house. Our family has been in the front of Italy, everyone in her triumph and in her trouble. You are not sympathetic to that kind of greatness in America, not? . . . You must realize how important the great families are.'" The narrator—whom the Cabalists soon name "Samuele" because his wide-eyed attention and unqualified affection remind one of them of a dog by that name—immediately assures the duchess that he has "great respect for the aristocratic principle." Although terrified at the idea of attempting to reform the priapic young nobleman, he of course accepts the invitation. Throughout his year in Rome he remains at the beck and call of the Cabalists, serving them by listening to their woes and carrying their messages. His reward is a life lived at a high pitch in superlative settings and the gratitude of the Cabalists. "My youth and foreignness never ceased to amuse them. . . . From time to time they would point their fingers to where I sat staring at them in sheer wonder." According to Alix, the princess d'Espoli, Samuele simply loved them "in a disinterested new world way."[56]

Samuele's involvement with them, however disinterested, is not without consequence. The "new world way" has puritanical and democratic biases not easily corrected. The intervention with Marcantonio, the duchess's son, is particularly disastrous. Samuele consults first with the orientalized Cardinal Vaini, a Cabalist who long ago had written "a thesis of unparalleled brilliance and futility on the forty-two cases in which suicide is permissible," but long since had become "the greatest of all the Church's missionaries since the Middle Ages." The cardinal wonders "why this young fellow couldn't have had his five or six little affairs and gotten over it?" Samuele unsuccessfully struggles to hide his amazement and shock at the idea of even five or six. When he suggests that the cardinal does not "really believe in temperance," the prelate replies, "Of course I do. Am I not a priest? . . . But after all, *we are in the world.*" Samuele laughs hysterically, thinking: "How clear it makes all Italy, all Europe. *Never try to do anything against the bent of human nature.* I came from a colony guided by exactly the opposite principle." When Marcantonio subjects Samuele to a complete catalog of his sexual conquests, Samuele is impressed; "no New Englander could help it." But Marcantonio's detailed recollections and fantasies end with a confession of helplessness, and he too

asks Samuele to save him. At that the New Englander "became possessed with the wine of the Puritans and alternating the vocabulary of the Pentateuch with that of psychiatry I showed him where his mind was already slipping." The "vindictive" tirade that Samuele gleefully delivers "had the energy and sincerity which the Puritan can always draw upon to censure those activities he cannot permit himself,—not a Latin demonstration of gesture and tears, but a cold hate that staggers the Mediterranean soul." Marcantonio, prostrate and weeping, finally begs him to stop. The following day passes quietly, but in the evening Samuele thinks he witnesses some incestuous byplay between Marcantonio and his sister. In the night Marcantonio awakens him to say, "You were right," and runs from the room. The next morning a Mr. Perkins from Detroit, who had written to Samuele to request an introduction to some "real Italians" so he could see "what they were like in their homes," climbs uninvited over the wall of the Villa Colonna. What luck! "Surely a rich old Italian villa is at its most characteristic when a dead prince lies among the rosebushes."[57]

The "luck' is Samuele/Wilder's. The sensational, decadent, and dying aristocratic Rome of legend is open to his imagination, which can leap over any number of excluding walls. He had first heard of the existence of such people, "so wonderful that they're lonely," on an overcrowded train from Naples. The train had been filled with a vulgar, polyglot company such as "Rome receives ten times a day, and remains Rome." Listening to the banalities of his democratic fellow travelers, he thought the Cabalists must be in comparison "semi-divine personages": "Perhaps it was in revulsion against such small change that the impulse first rose in me to pursue these Olympians." The fact that he finds them ridiculous, extravagant, even insane does not stop the process of deification. Such a "rare" personality as the promiscuous princess d'Espoli cannot "derive nourishment from ordinary food"; the question of "worldly propriety" does not exist for her as she passionately pursues a cold American scholar, for only an "inner, spiritual propriety" determines the behavior of a Cabalist. A woman of lower standing in Rome has "a sort of hysterical fear of them, and thinks they're supernatural," since they occasionally "descend from Tivoli" to get a bill through Parliament, arrange "some appointment in the Church, or drive some poor lady out of Rome." She longs to be one of them, "as some long for the next world." Wilder describes this woman's conception of their company in terms that recall those that Henry James used in describing the company gathered at the Storys, also at the Palazzo Barberini: "She assumed all was wit and love and peace. There one would find no silly people, none envious, none quarrelsome."[58]

Samuele's intimate knowledge of the Cabalists does not confirm this vision, but he worships them nonetheless. In the present age they dare to "hate what's recent." "They're medieval," but passionately alive. Samuele's archaeologist friend Blair spends all of his time studying "the women of the Caesars and yet could scarcely be dragged to dinner at the Palazzo Barberini," because he finds "all moderns trivial"; "only those faces not present are beautiful" to him. But to Samuele the antique beauty survives in these "powerful and exclusive" women, even when he discovers that their words and deeds are in fact comparatively trivial. Expecting their table

talk to be full of "wit and eloquence" and fearing to be found "doltish," Samuele is surprised that "it was not unlike that of a house party on the Hudson." Perhaps, he thinks, his presence prevents them "from being at their best." He recalls the tradition "that the gods of antiquity had not died but still drifted about the earth shorn of the greater part of their glory—Jupiter and Venus and Mercury straying through the streets of Vienna as itinerant musicians, or roaming the South of France as harvesters." Their "supernaturalism" would not be apparent to "casual acquaintances," for they "would take good care to dim their genius" in the presence of an "outsider." Yet he comes to perceive that the modern world as a whole must render them more generally impotent; far from restoring the Holy Roman Empire, the most they can do is save some trees in the Villa Borghese, block "the canonization of several tiresome nonentities" from Sicily and Mexico, and delay the establishment of a museum of modern art in Rome. When measured against their godlike pretensions, their meager power is ludicrous and pathetic.[59]

Early in the book the daughter of a "popular Senator" warns Samuele that the members of the Cabala had nothing in common "except that they despise most people, you and me and my father and so on." But Samuele's willingness to share their attitude exempts him from their contempt and admits him to their circle. Yet a democratic bias keeps breaking into his retrospective narrative, rendering his point of view ambivalent. When Alix, the princess d'Espoli, tries to cure herself of her infatuation for the American archaeologist by breaking out of the Cabala, she discovers a world of unimagined variety and interest. Other members of the Cabala call this episode "Alix aux Enfers," but Samuele is her guide through these lower regions of Rome and his account of her discoveries is both admiring and satiric. At a party held in one of the ugliest of modern houses, the princess meets the wife of a great engineer, "an inventor of many tremendous trifles in airplane construction." This woman of "humble extraction" had "directed incalculable labors" during the Great War (of which the Cabalists have remained unconscious), and although the engineer's wife "dressed badly" and "walked badly," the princess immediately recognizes her "excellence" and "is astonished to find such quiet mastery in a woman without a *de*." Alix proceeds to make friends with all the women there. "She kept asking me what their husbands 'did.' It delighted her to think that their husbands did anything." "To think that all this has been going on in Rome without my knowing it," she says. Thereafter she forsakes the Cabala, goes everywhere, meets everyone, and soon leaves even Samuele behind. "The acquaintances she was now pursuing for distraction, I had long since pursued for study or from simple liking," says Samuele (although he had said nothing of them before); "but she soon outstripped me by the hundreds." They see each other at Commendatore Boni's house on the Palatine, they hear Benedetto Croce lecture on George Sand, and Samuele sees Alix lose "a comb in defence of Reality at the stormy opening of Pirandello's Sei Personaggi in Cerca d'Autore." But the princess's desperate "social researches" all come to an abrupt end when she unexpectedly encounters the archaeologist in the sordid top-floor rooms of a palace where Samuele had taken him to witness a seance, and where Alix had come to consult the medium. Democratic distractions had not worked as a cure for a grand passion, but had led to vulgar

superstition. All the contacts the princess had established with the "real" world proved inauthentic and are dropped. She is welcomed back to the Cabala on the Olympian heights of Tivoli.[60]

The final section of *The Cabala* is called "The Dusk of the Gods." Before leaving Rome, Samuele goes again to the Palazzo Barberini to call on Miss Grier, the America heiress. In his initial biographical sketch he had defined her life in Rome critically as an attempt "to fill somehow the moneyed emptiness of her days." But on this last occasion he approaches her almost with reverence: "I shall never know such company again," he says of the Cabala and asks her to reveal the "secret" of "what made you so different from anyone else?" A cynic would expect her to anticipate Hemingway's famous reply to Fitzgerald concerning the difference of the rich: "We have more money!" But she instead informs him that "the gods of antiquity did not die with the arrival of Christianity." When they lost worshipers they "began to lose some of their divine attributes," including the inability to die; however, whenever one does die, "his godhead is passed on to someone else." To Samuele's skeptical response, Miss Grier patiently says, "I won't tell you whether this is true, or an allegory, or just nonsense." But she reads him a story (thus placing the argument at a second remove) of a Dutchman born in 1885 who, with the accession of new powers, had discovered that a dying god had been reborn in him. He went first to Paris, but then to Rome in June of 1912, for "it is at Rome that we were last worshipped under our own names, and it is thither that we are irresistibly called." In the Forum he found the ruins of his own temple, and after a year, at the Church of Santa Maria sopra Minerva, he encountered Minerva herself, and at the railroad station he recognized Vulcan in the engineer of the Paris Express. Samuele says he is more confused than ever, so in summary, Miss Grier tells him that the gods fear to be laughed at for what they have lost, for people forget that "enviable powers" remain: "a strange elation; their command over matter; their ability . . . to live beyond good and evil." Modern incarnations of the gods all decide to die sooner or later, since "all gods and heroes are by nature the enemies of Christianity—a faith trailing its aspirations and remorses and in whose presence every man is a failure." So, says Miss Grier in a tone of "desolation," the gods finally "give in. They go over. They renounce themselves."[61]

Whether *The Cabala* itself is "true, or an allegory, or just nonsense" is something Wilder is also willing to leave to the reader. Certainly, although each member of the Cabala is said to have "some prodigious gift," and Miss Grier even suggests that Samuele may be Mercury, no close correspondence between the characters and the Olympian gods is intended. They are confused and crepuscular incarnations, necessarily. And Wilder's final intimation is that although people in whom the gods may be reborn are inevitably attracted to Rome, it is not in Rome where they can flourish. Keats dies in Rome, "dead-poor," imagining that his name will never be among those of divine genius, like Homer and Vergil. When Samuele sails out of the Bay of Naples at night, reciting the *Aeneid,* he is "longing for the shelf of Manhattan." Aware that this is "Virgil's sea," and "the very stars were his," Samuele calls upon the "Prince of poets, . . . greatest of all Romans," to appear before "the last of the barbarians," to tell him whether he is wrong to leave "the city that was your

whole life." The spirit of Vergil tells him that his poetry had been inspired by the delusion that "Rome and the house of Augustus were eternal." But other Romes preceded it and will follow. "Seek out some city that is young," he advises. "The secret is to make a city, not to rest in it. When you have found one, drink in the illusion that she too is eternal." As Vergil's ghost fades, "the engines beneath me pounded eagerly towards the new world and the last and greatest of all cities."[62]

It is far from Rome to New York, and even farther to Our Town. But a few years before, with an undergraduate's temerity Wilder had written a poem in which he imagined himself as Dante to the Vergil of his great teacher of classics at Oberlin College in Ohio. Under Professor Wager's tutelage Wilder had absorbed the essential spirit of the ancients, as Willa Cather had from her classics professor at the University of Nebraska. And that spirit is reflected on the first page of *The Cabala* when the eager young student looks out upon "Virgil's country" and hears "a wind that seemed to rise from the fields and descend upon us in a long Virgilian sigh, for the land that has inspired sentiment in the poet ultimately receives its sentiment from him." *The Cabala* is a comic elegy to the old home of the gods, in which an ancient idea of power, beauty, and excellence survives pathetically in a dying aristocracy, but can be vigorously reborn only elsewhere. In time Wilder's new world would inspire, and receive back from him, a "sentiment" of its own.[63]

In the meantime, the romance of Rome died—for one generation. A sign of the Cabala's declining power was its ineffectuality in doing anything "about the strikes" and "about the Fascismo," which was being heard from for the first time while Wilder was in Rome. The Cabala spent "a great deal of money" and goaded "hundreds of people" before they "realized that the century had let loose influences they could not stem, and contented themselves with less pretentious assignments."[64] American poets and writers of fiction likewise mostly turned away, leaving Rome to the journalists and diplomats. In Crawford's romance, Fuller's fantasy, and Wilder's myth the aristocrats of Rome found their last imaginary American homes before the fascist hiatus, during which the reality of Rome proposed itself neither as romance nor as the home of the gods. But the idea would survive both fascism and another war. It would reappear in 1952 in *The Judgment of Paris* as the mythic dream world of the young Gore Vidal.

Rome of the House of Savoy

After 1878 America's royalty-loving citizens could find in Roman society a new pleasure, the presence of a king and a queen. The court was appreciated for partially filling the hole created by the curtailment of the ecclesiastical ceremonies that had contributed so much to the entertainment of papal Rome, but, more important, it provided an unassailable apex to the social pyramid, sanctioning and stabilizing the old hierarchic distinctions within the new "democratic" city. The House of Savoy and its attendant aristocracy had a reassuring legitimacy that, in America, the House of Morgan did not. The attitudes of Americans toward royalty—especially of

women toward the queen—reflected the discovery here in Rome (as in Victoria's England) of an established and coherent social organization that could only be defiantly asserted back home.

Margherita, the first queen of Italy, daughter of the duke of Genoa, seems to have become the central unifying figure of the New Rome, in effect a female and secular pope, and she was adored. The absurd extreme to which American adulation could go may be sufficiently indicated by two of the more egregious examples. One is a poem by T. W. Parsons, "On a Photograph Received from a Friend in Rome," addressed to the "Pearl of Savoy!" Its most rational lines come at the end:

> O Margherita la superba,—Queen!
> In this New World which thy great Genoese
> Gave to mankind,—thou hast one lover here
> Who bows before thy majesty of mien,
> And for thy land's sake holds thine image dear.[1]

Another tribute comes in an essay on "Eight Little Princes" by Frances Hodgson Burnett, published in 1897. The last princeling considered is the prince royal of Italy (who was over twenty at the time). His interest derives entirely from "his beautiful mother, Queen Margherita." Everywhere in Italy one sees her picture, showing "the ropes of her famous pearls wound round and round her throat. She has made herself so beloved by the people, because she is so sweet, and also, I have no doubt, because she has been such a good mother, and has loved her one boy so dearly." Mrs. Burnett's proof of the latter comes from a visit she made to the royal villa at Monza when the queen was in Rome. In the queen's bedroom she found pictures of the prince painted in every year of his life, so that when "Queen Margherita opens her beautiful eyes in the morning she sees him at all ages." That shows how every queen is a mother, and every mother a queen. So "even in the most republican country in the world—even in America which does not believe in kings," everyone—Mrs. Burnett is sure—is praying for the little princes and "the queens who are their mothers."[2]

All personal records of residence in Rome during this period show an intense consciousness of the House of Savoy. *Roma Beata,* for instance, the vivid record of the six-year sojourn in Rome of Julia Ward Howe's beautiful daughter Maud, is practically structured around appearances of Queen Margherita between 1894 and 1900. Soon after her arrival Maud found as much pleasure in seeing the king and queen ride by in their crystal and gilt coaches, attended by scarlet-coated grooms, as Henry James had found in an unexpected sighting of the pope. Not long afterward she saw them again at the annual memorial mass for Victor Emmanuel II in the Pantheon—a splendid requiem, lighted by classical torches and with the "very fine" music of Cherubini. In March of 1895, Maud and Mrs. Potter Palmer of Chicago had a private audience with the queen. The account of this is readable as a parody of pre-1870 papal audiences. Since Maud had been fully "tutored" in court etiquette by her cousin Francis Marion Crawford ("who has often been 'received'"), the "visit went off very well." Queen Margherita showed them her new American piano, a Steinway. She had read an article on Newport and thought the houses there "must

be very fine." With Mrs. Palmer she discussed the recent World's Fair in Chicago. When she rose at the end of twenty minutes, "we made our three courtesies and backed successfully from the room." The queen, Maud concluded, was charming, good, and clever. That royalty in the New Rome possessed certain social advantages that had been denied to the decorous rulers of Old Rome in its last century is evident later, when Maud describes the queen attending a ball held in the Palazzo Ludovisi in honor of the retiring American minister, Mr. MacVeagh. The queen was "so winning, so fascinating, that the Americans were enthusiastic about her," she wrote, adding that "nothing could be better arranged for entertaining in the grand manner than the present American Embassy."[3]

The climax of Maud Howe Elliott's record comes when she tells of the queen's visit to John Elliott's studio in June 1900 to see the huge ceiling painting for the Boston Public Library that was his primary project in Rome. The royal family normally avoided the Borgo, out of respect for the neighboring pope's feelings, so the notice brought by a messenger only one day in advance was as unexpected as it was exciting. Maud and her husband and their servants desperately prepared for "the dear and lovely lady" by cleaning the studio, the dark stairs leading to it, and the "squalid" street in front. Then they hauled over a huge armchair—the one in which Julia Ward Howe had recently been painted by Villegas. Secret service men patrolled the area all day long, and five more guards arrived one hour in advance. Elliott himself was temporarily stopped while taking a shortcut around the Palazzo Torlonia-Giraud, because he was wearing a red cravat, "the badge of the anarchists." He had gone to borrow the elegant young porter belonging to the Haywards, a "Black" American couple devoted to the pope, so that the queen could be properly received at his door. (The Haywards, being away, would never know about their servant's disloyal act.) Everything went well after the queen arrived in her carriage. Her lady-in-waiting, Duchess Massimo, and the attendant gentlemen of the court looked "aghast" at the winding narrow stairs, but the queen stepped gaily upward, as though upon a red carpet. In the lofty studio she indicated that art was to her "one of the matters which it is her duty as a sovereign, as the mother of her people, to foster by every means in her power." She was full of gracious inquiries about Elliott's painting, "said many pleasant things" about the Boston Public Library, and showed much "curiosity" about the studio and Elliott's other work. When she left after half an hour, Duchess Massimo assured Maud that "the Queen has been much interested and much pleased." Not long afterward a letter from Countess Villamarina, the queen's maid of honor, expressed the appreciation of the " 'august sovereign,' " and begged Maud's acceptance of a medallion displaying the queen's initials in diamonds. The populace of the Borgo had also been excited by the visit, and the hunchback cabman now addressed Elliott as "Signor Marchese" and expected bigger tips. Elliott made a portrait of King Umberto for Queen Margherita, which thereafter she always carried with her on her travels.[4]

A few weeks after the queen's studio visit, King Umberto was assassinated at Monza by an Italian anarchist who had lived in Paterson, New Jersey. In one of the newspapers Maud Howe read that the American government was to blame, for it allowed Italian exiles to publish journals advocating such actions. The freedom of the press that Rome now enjoyed did not, of course, extend so far. In 1878 Maud

Howe and her mother had strewn roses before the "sumptuous funeral car" of Victor
Emmanuel, and now she watched the even grander procession for his son, a proces-
sion in which the American chargé d'affaires was pleasingly conspicuous for his
"plain black coat," surrounded by the "glittering liveries of kings." When Maud
went to the Quirinale to inscribe her name in the queen's book, what struck her
most was that among those waiting to sign were "poorly dressed lads, . . . newsboys,
messengers, and the like." They were "the best witness of the progress made in the
last twenty years; when King Umberto came to the throne, the street boys of Rome
did not write their names." This is one of her few observations indicating an
awareness that the New Rome had meant more than simply a division of society at
the top. But even that level was changing, for at the time of the peaceful succession
of King Victor Emmanuel III, which secured the dynasty, some princely sons of
Black nobility donned Italian uniforms. It appeared that "Blacks and Whites, *Dio
grazie,* are fast fading into Grays."[5]

The great irony of the year 1900 in Rome was that the somberly magnificent
funeral for Umberto I in the Pantheon, and the undisturbed royal succession,
occurred during the first Holy Year that the papacy had felt confident enough to
declare since 1825. From her terrace Maud Howe watched hordes of pilgrims arrive
between Christmas and Easter to pay homage to the "Prisoner of the Vatican," who
became very popular with the "shop keepers, hotel keepers, and cabmen" of New
Rome. She devoted most of a chapter to descriptions of the colorful crowds and to
the return of magnificent rituals to the Vatican. But the resurgence of Catholicism
in Rome also caused her eviction from the Palazzo Rusticucci, in which she had
lived happily with three servants for six years, and on whose roof the Elliotts had
created a bower of such floral magnificence that it became one of the sights of Rome
for people approaching St. Peter's. The palazzo had been purchased by one of the
religious orders establishing their headquarters in Rome at the pope's request. Elihu
Vedder had already been evicted for the same reason from the studio he had used for
twenty years. The Church had decided that it could not, after all, allow itself to be
excluded from the New Rome; it would share the Eternal City with the secular
House of Savoy.[6]

An Italian historian has remarked that visitors returning to Rome around 1900 must
have regarded it with something like the amazement of pilgrims returning in 1600.[7]
Umbertine Rome was as greatly transformed as Sistine Rome had been. Much had
been destroyed; much was entirely new; broad straight streets had been cut through
from point to point where narrow lanes had wound before. This new topography was
inevitably symbolic, and not merely where that was the specific intention, but
generally, through its indication of priorities and its correspondence to political and
social changes. A great period of excavation had begun, in which medieval buildings
were destroyed in order to reveal more splendidly, and to know more accurately, the
ancient grandeur that New Rome wished to appropriate as part of its unifying
image.

Like others visiting Rome at this period, Maud Howe took a great interest in the
discoveries. The chapter in *Roma Beata* called "Old and New Rome" includes a
description of the work of Giacomo Boni in the Forum; elsewhere she mentions the

great archaeologist Rodolfo Lanciani as a guest at dinner on her terrace. Her first view of the city in 1878 had been close enough to the Old Rome to allow her to speak of the demolitions directed by these men as archaeological "vandalism," but she is not a sentimentalist. The priorities of the new government indicated by other projects were inarguably correct. In 1877 it had begun the enormous and costly work of building the Tiber embankment so that the great flood of December 1870, which the Blacks attributed to divine displeasure, might be the last in the long history of Rome. Of this work Maud Howe wrote: "It spoiled the picturesqueness of the river—the sloping banks covered with trees and flowers must have been wonderful—and it did away with Roman fever!" Rome now was the healthiest city in Europe after London. Maud Howe's Old Roman cousins naturally felt differently about the changes. To Francis Marion Crawford only "a fine hygienic frenzy" could explain the destruction of the Ghetto, and for Mrs. Chanler no possible use or pleasure to be found in the new "Via Vittorio Veneto, on which stand the modern palace [the present American embassy], built by the Boncompagni and bought by Queen Margherita after the death of King Humbert, and a row of 'palace' hotels," could justify the destruction of the "most beautiful" Villa Ludovisi with its "immemorial grove of ilex trees" and "shady avenues." "Let us pass with averted face!" she cries.[8]

The relatively few important American painters who came to Rome in the 1890s and 1900s naturally directed their gaze toward what remained of the old and "picturesque," yet their own vision was new. The impressionists' love of light and color, their preference for a near view of architectural form over the monumental vista with grand "associations," their delight in the pleasures of their contemporaries and their indifference to ancient ruins, had naturally attracted them to Venice as their favored place of loving labor in Italy. But on occasional excursions to Rome several of them, apart from Whistler (who hated Rome's "hard, blue sky"),[9] managed to find congenial subjects even there. John Singer Sargent saw baroque stairways and Renaissance fountains in secluded villa gardens that pleased his eye and saw a challenge in the creations of Bernini and Borromini in Piazza Navona (fig. 23). Childe Hassam discovered that views from hilltop terraces—from which a green turbulence of trees pushed up among rectangular brown-orange towers beneath a sky bursting with sunlight—offered powerful compositions for his watercolors. Such subjects were simply "Italian," however. Hassam found something specifically Roman in his view of one curving arm of the Scalinata rising up from Piazza di Spagna (fig. 24). But he emphasized the fact that this is a part of Old Rome that has survived, by confining the figures on the stairs to women in the "picturesque" costumes of the contadini.

One of several watercolors by Maurice B. Prendergast painted the following winter (1898–99) of the festive scene further up the Pincio (fig. 25) reflects the continuity of the Old and New in the fashionable late-afternoon parade of carriages and pedestrians. Everyone still came to see and be seen, just as they had when James's Daisy Miller had scandalized her compatriots there by proposing to walk alone with her Italian admirer. The only thing that has changed is the style of the dresses and hats of ladies and girls, and Prendergast delights in the irregular blobs of bulging color they make in the shallow space in front of the flat brick wall. The wall

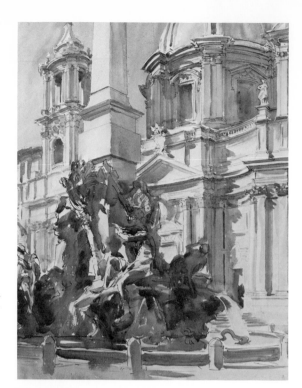

Fig. 23. John Singer Sargent.
Piazza Navona, Rome. 1907.
Watercolor and sepia ink. 20
× 16½". Courtesy Coe Kerr
Gallery, New York City.
(See plate 3.)

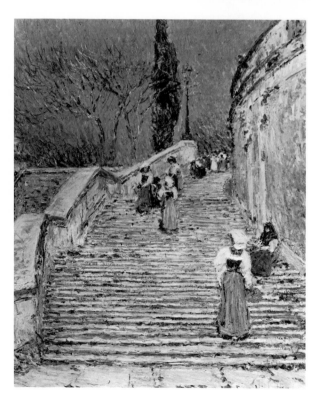

Fig. 24. Childe Hassam.
Piazza di Spagna, Rome.
1897. Oil on canvas. 29¼ ×
23". The Newark Museum.
(See plate 4.)

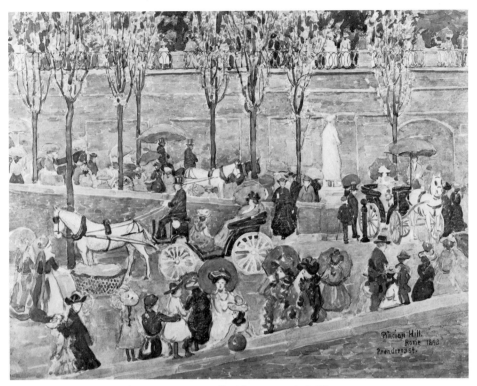

Fig. 25. Maurice B. Prendergast. *Pincian Hill, Afternoon.* 1898. Water-
color. 21 × 27″. The Phillips Collection, Washington, D.C. (See plate 6.)

itself is neatly measured off by its white marble coping, its geometrical pattern of
indentations, the loops of its iron rail, and the stiffly vertical lines of the elegantly
pruned trees. Prendergast saw here the same joyous *plenitude* of social life enhanced
by a beautifully designed environment that he celebrated in his festive watercolors
of Venice and Siena, and found in the parks and seaside resorts of America as well.
The white horses with their blinders, the toylike wheels of the carriages, and the
stolid blank statue standing at the turn of the road are all aspects of a scene to which
Prendergast's good humor responded. Another product of this visit to Rome is even
more remarkable. A small oil monotype on cream woven paper, it is called *Roman
Campagna* (fig. 26) as though to point up its antithetical relationship to the far-
horizoned, ruin-littered, melancholy, and allegorical Campagnas of the tradition
represented by Thomas Cole (see fig. I:17). The Campagna Prendergast paints is
emphatically that of the New Rome, so densely populated by bulkily fashionable
picnickers and elegant hunters that it is almost totally obscured. Its famous flatness
becomes the flatness of the paper, on which are lain the colorful shapes of horses,
riders, and feminine gowns. The umbrella pines of Rome, scattered in isolation over
the plain, wittily repeat the shapes of parasols from Paris.

To New Rome's appearance Americans now made their own contributions, first
in the form of an Episcopal church, and later in the building of their own academy—
both essentially aristocratic endeavors. The church (after 1870) and the academy
(after 1894) make incidental appearances in the biographies and letters of the time,

267

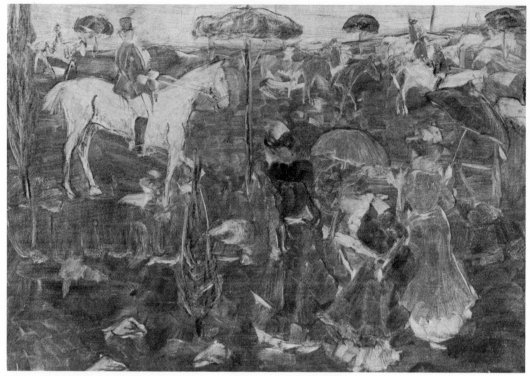

Fig. 26. Maurice B. Prendergast. *The Roman Campagna*. Oil monotype on cream woven paper. 9⅛ × 12⅜". Des Moines Art Center. Truby Kelly Kirsch Memorial Fund. (See plate 5.)

where they are understood as symbolic acts of possession and identification. The first constitutes an exploitation of the liberal atmosphere of New Rome, made on behalf of the most "Catholic" and upper class of the non-Catholic Christian sects; the second amounts to an official perpetuation and extension of Old Rome as the city indispensable to the level of knowledge and taste required for the building and decoration of the luxurious New Rome of the West. Both projects were extensively underwritten by J. P. Morgan, who found in Rome the city most congenial to his tastes.

Before 1870 Americans frequently complained about obstacles to Protestant worship in papal Rome. Catherine Maria Sedgwick, writing in 1840, is unique in saying that it "is greatly to the honour of the pope [Gregory XVI] that he permits the public worship of heretics here in the very heart of his dominion," a fact that she found "better than the burning of the convent in our land of liberty of conscience and universal toleration." Others considered that being driven to worship with the English in an improvised chapel *outside* the Porta del Popolo constituted a form of persecution. In the next decade American worship within the walls of the city was managed by the consul Mr. Cass through the subterfuge of declaring a certain "upper room" to be "an appendage of his embassy," as Benjamin Silliman reported. According to Silliman, only sixty people attended when he was there in 1851, but he

was told that the congregation sometimes numbered two hundred at the height of the season.[10]

In 1857 resident Americans of various denominations agreed to unite in the establishment of an Episcopal church under the protection of the consul, John P. Stockton; its minister would be official chaplain to the legation. William Chauncy Langdon arrived as rector in November 1859, holding opening services in the legation at the Palazzo Bernini in the Corso, and afterward conducting the new church's organizational meeting at the home of the sculptor Joseph Mozier. Writing in the *Atlantic Monthly* twenty-four years later, after a visit to the New Rome of 1883, Langdon is able to contrast the primitive and incongruous conditions of "the earliest beginnings" with the "noble church on the Via Nazionale" in which the "younger generation" of Americans must feel "a patriotic pride." Stressing a comparison with the conditions of the early Christians in Rome, Langdon recalls that the day after the meeting at Mozier's, Cardinal Antonelli let Stockton know in a "good-humored" way that he knew all about it; "the authorities were watching us." Nevertheless, during that politically troubled winter of 1859–60 as many as 140 out of the 400 Americans in Rome attended services, and "amid the wildest saturnalia of the Carnival" the American chaplain made his way through the streets from "the bedside of one dying American traveler to another," who would otherwise have been denied the comfort of a minister of his faith. The next year the legation was ordered out of the Palazzo Simonetti, to which it had moved, unless the "heretic worship" beneath its roof ceased. Cardinal Antonelli refused to permit hiring of separate rooms especially for this purpose, so the legation moved again, to the Palazzo Lozzano. Here papal gendarmes stood outside the door every Sunday to prevent the entrance of Italians, and services had to be held in the ballroom, which was lavishly decorated with gilt-framed mirrors, a frieze of "dancing nymphs and graces," and a ceiling fresco of "mythological figures and subjects, of which the central group represented some revelry of the gods." This "incongruous" setting, so greatly contrasting with the solemn "interior and chancel of the church on the Via Nazionale," was, however, "probably" like those "festive saloons" belonging to "the richer members of their brotherhood," in which "early Roman Christians worshiped" between the period of the catacombs and the building of their own churches in Rome.[11]

Memories of mild persecutions continue in accounts of the 1860s. William J. Stillman proudly recalls how as consul he outmaneuvered Cardinal Antonelli with defiant displays of Old Glory and the American Eagle over the doors of rented chambers, and Helen Haseltine Plowden tells of another eviction of the legation, this time by the Duchess Salviati, who had heard about these "non-Catholic services" in her palace and, gossips said, had it fumigated afterward. Such discouragement of Protestant worship was advanced in the American Congress as one of the arguments for terminating America's diplomatic representation to the Papal States in 1867.[12] In that year American worshipers found themselves once again trooping through the Porta del Popolo to "an old badly-ventilated granary," reached "by a long, winding, up-hill inside slope meant for pack-mules and donkeys," according to Plowden. Nevertheless, "the congregations were always exceptionally large," and so immediately upon the seizure of Rome in 1870 by the Kingdom of Italy, "Ameri-

cans resolved to build a church inside the walls." They purchased land on what would soon become the modern Via Nazionale, although at that time the site still seemed remote and "desolate," "almost in the Campagna," on a road that led only to that "monstrosity," the new railway station. Mrs. Plowden says that the new church was designated "St.-Paul's-within-the-Walls" with reference to the saint's probable familiarity with that vicinity of Rome, the nearby house of Santa Pudenziana being mentioned in his Epistle to the Romans; but no doubt other factors were the association with St. Paul's of London (Anglican rival to St. Peter's), and a note of triumph in the words "within-the-walls," needed to distinguish it from the Catholic San Paolo fuori le Mura (outside-the-walls). Artists resident in Rome—Maitland Armstrong, C. C. Coleman, George Inness, William S. Haseltine, Elihu Vedder, and others—contributed pictures for an auction to help finance the project, while an appeal for funds in America met with an "astoundingly generous" response. An English architect was hired, and decorations were commissioned from Edward Burne-Jones and William Morris, just as they were for the splendid new Episcopalian churches being built in New York and Boston. The church was begun in 1873 and consecrated in the centennial year of 1876, on March 25; that afternoon Elihu Vedder's infant son was the first child to be baptized there. The fact that Vedder did not even consider himself a Christian had not prevented him from being made a vestryman for the sake of his "advice" about "artistic things," although he was apparently not considered the obvious choice as muralist for the church (his great reputation in the art was yet to come).[13]

In 1883 the Reverend Mr. Langdon found all possible significance in the presence of the new church, connecting it with the foundations of true Christianity, with the very meaning of the New Rome, and with the defeat of the Old. In 1859 the tourist had been "obliged to leave the train *outside* the city walls, where our passports were closely scrutinized by the police." Now the tourist arriving in the Rome of the House of Savoy "enters the city under an arch opened for the purpose in the walls near the Lateran Gate," and follows "the line of the far more ancient Servian wall" to the "spacious and incongruously modern station opposite the ruins of the Baths of Diocletian." Afterward he is carried in his barouche through the beautiful new Piazza d'Esedra to the "modern avenue of the Via Nazionale," which takes him "down into the very heart of the city, passing in front of the stately American church, whose noble Lombard tower rises on the corner of the Via Napoli,—a monument, as the present King of Italy once said that it would be, of American faith in the stability of the Italian kingdom, and especially in the continuance of freedom of worship in the city of Rome." When the foundations had been laid in 1873, workmen had dug down through forty feet of medieval rubbish to find solid support in ancient stonework. "But out of those depths rose the substructure on which the spacious chancel was built up, and the solemn apse. Upon that Servian wall the tower now stands firm, and from its fair open arches the sweet bells chime out on the clear air of Rome their call to prayer."[14]

In spite of such clerical enthusiasm, few people testify to having found that the new St. Paul's adequately rivaled the Catholic churches of Rome, in either its form or its services. At any rate, it came too late for Margaret Terry Chanler, who, in explaining her feeling that she had always been a Catholic "at heart," recalls the

dreariness of the services in the "converted hay barn" outside the Porta del Popolo to which she was taken, inevitably contrasting them with the mystery and splendor of the Catholic rituals. In the new church even Christmas Day services, according to Maud Howe's memory of them in 1878, were "colorless," and the congregation "meager," in depressing contrast to the crowded and glorious St. Peter's, where she had witnessed the ceremonies the night before. Apparently even the fact that her handsome young cousin Marion Crawford (not yet a Catholic) sang "The Trumpet Shall Sound" before Dr. Nevin's sermon did not help. Dr. Robert Jenkins Nevin, a cavalry officer of the Union army who had become the Episcopal priest in Rome in 1869 and who oversaw the building of the new church, is treated with mild satire in most reminiscences of the period. Maud Howe designates him "the Nimrod rector," and Mrs. Chanler, more contemptuously, calls him "a sporting parson and muscular Christian" who collected curios, helplessly wept while he preached, and was held responsible by Louisa Ward Terry for her daughter's defection to Catholicism.[15] He figures more frequently in recollections of the fox hunting in the Campagna that became so popular in the last decades of the century than he does in connection with spiritual matters.

Maitland Armstrong, the American consul-general to the New Italy, gives one of the fuller pictures of the upper-class American Episcopalian social circle which, in apparent confidence in its own permanence in Rome, built Dr. Nevin's church. It consisted naturally of the same people who were building similar aesthetic Anglican places of worship for themselves in America.[16] These included the amateur artists and wealthy art patrons William H. Herriman and Waldorf William Astor. Astor, who first came to Rome in 1870 to study sculpture, was heir to the greatest American fortune and thus well able during his tenure as U.S. minister to Italy (1882–85) to represent his nation with more splendor than democratic simplicity in the Palazzo Rospigliosi, directly opposite the royal Palazzo del Quirinale itself. (He also wrote a historical romance about the Borgias.) Such Americans as these took pleasure in penetrating the exclusive Hunt Club of Rome, made up primarily of Roman noblemen who liked to imitate the habits of the English aristocracy, with which they had extensively intermarried, as some Americans were also inclined to do. Dr. Nevin happily moved in this circle, and Maitland Armstrong's only anecdote concerning him tells of the occasion when the confused financial books of the American Church were quickly put straight by Pierpont Morgan, chairman of its Board of Trustees. This humiliation Dr. Nevin overcame by reminding Morgan that whatever the clergyman's inferiority as a money-man, he was a much better shot than the famous financier.[17]

The Anglican and would-be aristocratic group that built an "American" church in a congenially royalist Rome was hardly inclined to make it a manifestation within the walls of the radically "American" attitudes of those Unitarians and Transcendentalists of an earlier generation who had been the chief critics of papal Rome. Its English design and decoration conceded its American identity only to the extent of including in Burne-Jones's mosaics for the apse a representation of J. P. Morgan as St. Ambrose, while among the soldiers of Christ appear General Grant shoulder to shoulder with General Garibaldi, and Abraham Lincoln in a green tunic. Later an American, George Breck, was trusted to create the mosaics for the façade

and for the interior of the west wall. Breck held the first scholarship for mural painting at the new American Academy in Rome from 1897 to 1900, and five years later had become the director of the academy. His mosaics for the west wall, paid for by J. P. Morgan and William H. Herriman, were unveiled in 1913. These essentially completed the church's decoration and achieved whatever level of beauty it might claim in this line of art to rival the famous mosaics of the nearby Santa Maria Maggiore. Now a conspicuous landmark in the most crowded part of the New Rome, where its very un-Roman architecture is less incongruous than it would have been elsewhere, the church in time was officially recognized by the Italian government as part of the nation's patrimony and became a source of pride for many members of Rome's American community. In September 1926, a half-century after its dedication, when the parishioners gathered for the funeral of Helen Marshall Haseltine, widow of William S. Haseltine, one of its original builders and a senior warden until his death in 1900, the "old verger" remarked, "There goes the last of the founders of this church." Thus the first American-built structure in Rome was assimilated into the heritage from Rome's past. The Reverend Walter Lowrie, who had arrived in 1895 as one of the first students in the new American School of Classical Studies, had been appointed Dr. Nevin's successor in 1907. A specialist in early Christian art in Rome, he now added to his several books on the primitive church one that commemorated the first fifty years of St. Paul's-within-the-Walls.[18]

If the American Church represented an exploitation of new possibilities in Rome, the American Academy reaffirmed the Old Rome that had been deemed essential to all students of art. The Rome of the Renaissance, with its roots in antiquity, was to be claimed as the inspiration for the American Renaissance in a more official manner than had been possible through the heroic individual efforts of American artists for a century past. As we have seen in the first volume, the idea for the academy was born in the mind of Charles McKim at the World's Columbian Exposition in 1893, for which architects, artists, and sculptors, in Renaissance-like collaboration, created the illusion of imperial splendor on the shores of Lake Michigan. An academy in Rome, argued McKim, would save America from the "Yahoo and Hottentot" designs likely otherwise to prevail in the expanding nation.[19] The new academy, after a first year in a few rooms of the Palazzo Torlonia, just around the corner from that century-old artists' haven, the Caffè Greco, in 1895 moved up the hill to the Villa Aurora (named for the Guercino fresco so admired by earlier generations). Here it was joined by the newly founded American School of Classical Studies, intended to foster the nation's coming-of-age in that area of scholarship. It was to the Villa Aurora that the future popular muralist Barry Faulkner came to study in 1907, when George Breck was director. His memoirs take us quickly from this site, through the next, and finally to the permanent building on the crest of the Janiculum.

The Aurora, located very near the French Academy at the Villa Medici, which symbolized the status to which the American Academy aspired, "combined splendid surroundings with primitive living conditions." From the terraced gardens the students could enjoy both the magnificent view of all Rome and the sight of "trim American girls entering and leaving the Hotels Boston and Beau-Site" in the street below. But the students' bedrooms on the top floor had no running water, and there

were no studios. Faulkner, however, found the daily walk down the Spanish Steps to his studio in the Via Margutta—long known as the street of artists—one of the best parts of his life in Rome. The hallowed associations of the Caffè Greco, where he and his fellows ate, did not adequately compensate for its bad food and coffee, but the stories of Old Rome told in the evenings by the "octogenarian" Elihu Vedder, possibly "the greatest American muralist of his time," did inspire the novice. Rome itself, "an over-rich layer-cake," at first caused "indigestion" from being "eaten greedily," but gradually Faulkner's mind became "less agitated" and he began "to feel at home with the repose of the Classic and the fire of the Baroque." The frescoes of the Raphael *Stanze* and the Borgia Apartments in the Vatican, which Faulkner had studied in 1901 with his uncle, the muralist Abbott Thayer, were, of course, fundamental to the career he planned.

After a summer tour to Perugia and to Florence, where he sought the advice of his uncle's friend George de Forest Brush, Faulkner returned to Rome to find that the academy had moved a mile beyond the Porta Pia, to the Villa Mirafiori, originally built for the morganatic wife of Victor Emmanuel II. There were toilets, to be sure, and a mess hall instead of the stale bread of the Caffè Greco, but the grounds were dreary with American spruce and hemlock instead of Roman pines and ilex, and the site was remote from the life of the city. Early in the next year Faulkner ran away to Florence to study with Brush, although the director, George Breck—whom he had first met in the Raphael Stanze when Breck himself was a student only six years earlier—informed him that he was jeopardizing his scholarship and his diploma. An ultimatum did not arrive from New York headquarters, however, until a year later, so Faulkner only then returned to Rome, when Frederic Crowninshield was now the director and Paul Manship the brightest new Fellow. A group of trustees from New York, come to look into the academy's affairs in 1910, grumblingly granted Faulkner a diploma in spite of his flagrant irregularities.

Twelve years later Faulkner was a member of the team (with Eric Gugler and Paul Manship) that won the competition to design a memorial for the courtyard of the great new academy building at the Villa Aurelia on the Janiculum. And so he returned for a year as a teacher in 1922–23, and was given "a studio with a splendid view on the second floor and my bedroom on the floor above." The academy now included, besides architects, painters, sculptors, and classicists, students of musical composition and landscape architecture. Among them were the composers Randall Thompson and Howard Hanson, and the architect Walter K. Harrison. The new building, built "in the form of a Roman palace, with fore- and interior courts and accommodations for forty men," was "still raw in texture," but had a definite air of permanence. In the central bay of the west arcade of the inner courtyard, the three former students of the original three arts at the academy created their memorial to two Fellows who had died in the Great War. Eventually the memorializing artists became trustees themselves—Faulkner in 1930. Half a century after the academy's founding—in 1945—Faulkner and Gugler thought it time that both the regulations imposed upon Fellows and the old-fashioned curriculum should be revised—especially because for years before the war only mediocre talents had been applying. Restrictions on travel and residence were lifted, women were admitted, marriage and families were permitted, commissions were allowed, and no specific work was

prescribed. In short, Fellows might do as they pleased. In the postfascist spirit of Rome, *dolce far niente* might be conceived again as an adequate and even needful curriculum for the artist.[20]

Although the academy's founders had thought of it as a rigorous school on the French model, some ambivalence about its function had become evident by the time the new building opened in 1914, not long after McKim's death and just as the war that was to mark so great a break in Western cultural traditions began. In that year the art critic Royal Cortissoz wrote, in a book published in commemoration of the academy's twentieth anniversary, that Rome served the modern artist primarily through the uniquely humanizing experience and inspirational beauty it offered. Preliminary and indispensable rudimentary training in the arts should be obtained first in Paris. Afterward, Rome was an equally essential finishing school for the soul. The artist ought to pass his time there sitting in cafés, drinking chianti, and automatically absorbing lessons in beauty. In one of the more original metaphors to characterize Rome, Cortissoz said that the modern artist who lived there would find it as Lowell had found the late lectures of Emerson—"chaotic and obscure," but with occasional stirring trumpet calls. That image of Rome differs in spirit from the assertion made in 1915 by the architect-trustee Christopher Grant LaFarge that what inspired the founding of the academy was the lesson of "the inestimable value of coherence and classical orderliness" learned at the Chicago World's Fair, and deriving from the Roman Renaissance. But in *The Painter's Craft* (1930), Cortissoz claimed that the idea of an American Academy in Rome as a place primarily for simple inspiration had occurred to him while he sat beneath Tasso's Oak on the Janiculum in the early nineties, looking down over the city. Discovering soon afterward that McKim was working toward just such an end, Cortissoz had supported the effort because McKim also believed that the point was not to encourage the American artist in "mechanical emulation" of "the old Italian masters" but to "subject him to the ennobling pressure of classical and renaissance influences, to enrich his imagination, to stimulate his sense of beauty, . . . [and] to help him toward a realization of what is fine in the arts, of how far they may be made to soar." For all this, simply being there sufficed.[21]

The move to the Janiculum was opposed by the Bostonian painter, teacher, and would-be poet Frederic Crowninshield, who in 1909 succeeded George Breck as director of the academy. Having come to Rome originally in 1869 at the age of twenty-four and having returned periodically since, Crowninshield was an Old Roman at heart, but he and his wife nevertheless found their accommodations at the modern Villa Mirafiori to their liking. In his watercolors Crowninshield demonstrated that the garden wall of the academy's villa (fig. 27) looked much like any other in Rome, and in the feeble sonnets he wrote as director, the attractions of Old and New are typically balanced between the octet and the sestet. Like Henry James, Crowninshield cries, "Thank God that I was there in those last years / Of papal Rome." But the loss of "picturesqueness" is balanced off against "A comelier view of Liberty and Right, / And nobler aims, and Government more sane." This abstract "view," however comely, was, of course, less paintable, except by the allegorizing muralists of the academy. Most of Crowninshield's watercolors show aspects of Old Rome, and his other sonnets rhapsodize over the Forum and the Campagna. In 1911,

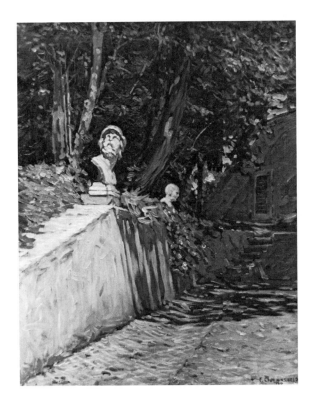

Fig. 27. Frederic Crownin-shield. *Rome—The Garden Wall, Villa Mirafiori.* Watercolor. Stockbridge Library Association, Historical Room, Stockbridge, Massachusetts.

his last year as director, he wrote two longer poems of farewell. One expresses his disappointment in the Kingdom of Italy's pageantry on the occasion of its "Cinquantenario." It "seems mock and mean" in comparison with the exciting images from the *"Reality"* of the Risorgimento's struggles that he can recall "athwart the film of fifty years." But the other poem grumbles both about the fact that a Garibaldian Republic was never achieved, and about the ongoing changes that the Risorgimento has meant for the artist's Rome. When he hears shouts for "king and 'patria,'" he yearns for his own "fatherland and unkinged men." To the Campagna he says, "Old men thy comely past will weep / When commerce shall thy classic lines deface." The closing words are a tribute to "Transcendent Rome!" for the "inspiration thou hast ever been." He was not sure, as he retired to Capri, that he would ever return to Rome. Six years later he died, and his body was brought back for burial in the Protestant Cemetery among his fellow Old Romans.[22]

To J. P. Morgan, Christopher LaFarge, and the majority of the trustees, moving the academy from the Villa Mirafiori outside the walls to the Villa Aurelia on the Janiculum was essential for the achievement both of its primary functions and of its symbolic status in Rome. Morgan, not long before he died in Rome in 1913, provided the wherewithal to expand the grounds of the villa, which Mrs. Clara Jessup Heyland had willed to the academy, so that a great new building could be constructed, with studios and a quiet garden hidden behind it, within an angle of the Aurelian Wall.[23] LaFarge joined other publicists in justifying so permanent an investment. In an eight-page rhapsody that takes the reader on an imaginative day-long circumferential tour of the city as it can be viewed in its entirety from the Villa Aurelia,

LaFarge in 1915 answered the skeptical query, "Why Rome?"—a question to which just twenty years earlier McKim had thought the answer obvious. In a briefer passage he gives the answer to the more recent question, why not the Crownin-shields' Villa Mirafiori? The answer is, that the Mirafiori "lies well outside the walls" and "has no historical association." The Villa Aurelia, in contrast, "stands upon the summit of the Janiculum, the highest point within the walls," and it was "within this house" that Garibaldi had made his last headquarters in 1849: "the siege left it a battered ruin." And besides its own history, it offers a view that is in itself a lesson:

> From its windows and its terraces one sees the dome of St. Peter's, its springing level with the eye; one sees all of Rome stretched out beneath, all of it from Monte Mario past the pyramid of Cestius to the tombs on the Appian Way; Soracte, Leonessa, the Abruzzi, the Sabine and Alban hills, the Campagna, the light-house twinkling by night at distant Ostia. The modern restored house [the Aurelia] is not in the grand manner, but it has some splendid rooms, and part of it actually is a bit of the Aurelian Wall. Those who live in it gaze daily, from a place of utmost loveli-ness, down upon "the heart of Europe and the living chronicle of man's long march to civilization."[24]

In LaFarge's vision there is no implication that Rome belongs to the past. On the contrary, what one sees is the visible history of man's achievement of "civiliza-tion," an achievement sustained by the present. Rome, as the "heart of Europe," still provides the lifeblood of the West, and through the academy it will reach to America, uplifting the raw democracy by imposing upon its public buildings the aristocratic taste and grandeur of the Roman Renaissance. The palatial mansions and aesthetic churches for which Academicians would create the designs and paint the murals would naturally also signify a stable social stratification approximating that of Rome, for a wealthy "aristocracy" too was a necessary agent of "civiliza-tion." At the same time, Italy would increasingly come to resemble the United States as a nation economically and technologically progressive and politically democratic. This process of mutual imitation would inevitably reduce the alien aspect of Italy for Americans. For better and worse, it could never again be quite what it had been.

In the years between 1895 and 1911—when Italy celebrated its first half-century—three men and two women besides Maud Howe published works in which the argument about the character of the New Italy is concluded, and the ghost of Old Rome—the city of religion and art—is laid to rest. Religious controversy disappears almost entirely as a matter of historical irrelevance or bad taste. Commentary on art is increasingly left to the newly conceived scientific "professors" of archaeology and art history or to incidental "amateur" appreciations by women. General commen-tary on the city tends in other ways as well to be divided according to sexually differentiated interests. From Cooper and Morse through Hawthorne and Hillard to James and (in parody) Mark Twain, we have seen American men assume that anyone writing about Rome was obliged to write about its beauties. Ignorance was

no excuse, since to overcome ignorance was the reason for being in Rome. Likewise, any American in Italy—man or woman—felt a perfect right, or even obligation, to say something about the Catholic religion, contemporary politics, social conditions, and the "life" of Rome, even if his or her primary interests were aesthetic and historical. Thus "art critics" like Jarves and Norton wrote lengthily on papal oppression, and upon "Italian sights" of all kinds, and women from Catherine Maria Sedgwick and Margaret Fuller through Grace Greenwood and Julia Ward Howe showed themselves ready to comment on everything: religion and politics equally with art or "Society" in Rome. Now, however—as we have already seen with Maud Howe Elliott—women primarily wrote about "Society" (although never failing to establish incidentally their appreciation for art), and men concerned themselves mostly with political and economic developments. Queens Margherita and Elena are the central sympathetic heroines of the women's picture of Rome: the men speak only of prime ministers and kings.

The change is most evident in Mary King Waddington's *Italian Letters of a Diplomat's Wife* (1905). Madame Waddington had known Old Rome as the sister of General Rufus King, the last American minister to the Vatican. Mary and Rufus were the children of Charles King, president of Columbia College, who died at Frascati in the summer of 1867 and was buried in the Protestant Cemetery in Rome. His widow and daughters afterward settled in France, where Mary King married William Waddington, a Protestant and republican gentleman of English name, birth, and education who nevertheless eventually became the prime minister of France. After the fall of his government in 1879, he and his wife went to Rome for a vacation in February of 1880. Since he was also a "scientific" scholar specializing in ancient coins and had never seen Rome before, he began a systematic exploration of the city. Consequently his wife, with her nostalgic memories of the social life of Old Rome, found herself forcibly seeing Rome for the first time "from a classical point de vue." In "the old days" she had never dreamed of looking for inscriptions on every tomb of the Via Appia, although "I certainly enjoyed the mad gallops over the Campagna." A letter to her mother in Paris recalls an Englishwoman of the 1860s who had been "so severe" with the King children—"first because we were Americans . . . and then because we knew everybody and enjoyed ourselves." The woman had informed them that " 'when she was young people came to Rome to educate themselves and enjoy the pictures, museums, historical associations, etc. *Now* one saw nothing but American girls racing over the Campagna with a troop of Roman princes at their heels.' " That purely social Rome was the one Mary King had first known and loved, and continued to value above all during her visit of 1880 and during another—as a widow—in 1904.[25]

To know everybody and enjoy herself was her constant purpose in life, and Madame Waddington does not argue with her husband's soon-expressed desire to "go over things" in the company of sober male acquaintances—including Rodolfo Lanciani—rather than his wife. Fortunately his position as ex-minister of France opens all doors to her—Black as well as White. Naturally she is no alien in the French strongholds of the Palazzo Farnese and the Villa Medici, but she also takes tea as a matter of course beneath the Raphael frescoes of the Spanish duke di Ripalda's Farnesina, goes to the Consulta for dinner with Italy's prime minister, and

has private audiences in 1880 and 1904 with both popes and both queens. At the Quirinale, as elsewhere, she joins the women in taking note of the dresses, jewels, furnishings, and music, while her husband talks politics with the men. When someone hails her in the Villa Borghese, it is likely to be "the Grand Duchess." She even cows a custodian into letting her take a solitary stroll in the pope's garden at the Vatican, simply by telling him that she could have all the *permessi* she wanted, if she bothered to ask. The stamina Madame Waddington demonstrates in exploiting her privilege is the most astonishing element of her letters. These tireless epistles to her mother, written almost daily and at extraordinary length, are a detailed chronicle of countless teas, dinners, balls, and receptions—sometimes two or three in a day, often after a drive to Tivoli or a visit to the Vatican. Their value for us, in spite of their French and rarified social atmosphere, lies in two areas. First, the paucity of Americans in her representation of the highest Roman and diplomatic circles in which she moves indicates the marginal status most citizens of her native country still held. Second, since a memory of Old Rome as seen by an "American girl" exists as her basis for defining the New Romes of 1880 and 1904, the letters reflect the city's rapid change over a period of forty years at three different points.

Madame Waddington's sister, Gertrude, was the wife of Eugene Schuyler, consul-general to Italy in 1880, and author of a biography of Peter the Great and (among other things) a nostalgic essay on "The Italy of Hawthorne." Besides these two Americans of her own family, she mentions very few. Among them, inevitably, is Dr. Nevin, who in 1880 soon appeared to invite her to his "pretty little church." She went once in 1880 and once in 1904, finding it full to overflowing, the music good, and the sermon short, but she did not return. Another inevitable American is Mr. Hooker, their banker from the old days who had helped the newly widowed Mrs. King and her children flee from Rome when an attack seemed imminent in 1867. Still living in the Palazzo Bonaparte, Hooker is full of "incredible" anecdotes about the autocratic and oppressive papal government of Old Rome, and he happily finds the "brilliant capital" of 1880 almost unrecognizable as the place to which he had come so long ago.[26] Finally, and most important for Madame Waddington, there are various American heiresses whose identities are somewhat obscured by their noble English, French, and Italian titles. As far as the Roman princes were concerned, those pursuits on the Campagna had not been in vain. Between 1880 and 1904 American wealth had its effect, overcoming aristocratic prejudice and unlocking palatial doors. The number of tiara-crowned young women in Madame Waddington's letters substantially increases, and one of her chief pleasures is to visit palazzi and castelli being renovated with American money.

In observing the changes in Rome over the years, Madame Waddington thinks of herself as an Old Roman, but she is inconsistent and ambivalent. She points out that resentment of the New Rome is not limited to foreigners; no one hates it more than the Roman aristocrats themselves, since they have been displaced from the social center of their own city by the influx of northern Italians and the doubling of the diplomatic corps. A sympathetic marchese even sends her his own nostalgic novel, *Roma che se ne va* (Rome that is disappearing). Yet other Italians are puzzled by her stated preference for "Roma com' era," since in spite of her established French identity, they think of her as an American—and therefore inevitably someone who

values change. When she laments that "the new buildings and the boulevards and the bustle and the quantities of people had spoiled the dear, dead, old Rome of our days," the prefect of Rome replies, "but you, Madame, are an American born, you surely can't be against progress." Her unquestionably irritating reply is that she does like progress in America, but that "Rome was never intended to be modern and go-ahead—it didn't go with the monuments and the ruins and the traditions of old Rome." He, however, claimed "quite seriously" that not to go ahead was to die.[27]

Occasionally Madame Waddington's letters inadvertently concede as much. Those of 1880 are naturally filled with extended and remarkably vivid recollections of the "old, happy days" when St. Peter's Square was filled with uniformed troops and picturesque pilgrims on Easter Sunday, and when drives in the Campagna included no view of a train "puffing and smoking" along beside the line of the ancient aqueducts. Another horrendous development by 1880, which she is the first to mention and which only worsens by 1904, is the organized Cook's Tour, whose ubiquitous hordes and polyglot guides are a noisy intrusion in the Forum, the Sistine Chapel, Tivoli—all the sacred old places. But a month after arriving in 1880 Madame Waddington also finds herself writing this: "It is all so curiously familiar and yet changed. I can't get accustomed to the quantities of people in the streets where there never used to be any one—occasionally a priest, or a few beggars, or a water-carrier. Now there are soldiers, people carrying parcels, small employees, workmen, carts, carriages, life in fact." This too is the New Rome: vitality. On the other hand, when she goes deliberately in search of a certain "little, dark, dirty corner" of Rome that "I was always so fond of," she comes upon this:

> The streets were dirty, the children (quantities of them playing in the streets) dirty and unkempt; clothes of all kinds were hanging out of the windows, falling over sculptured balconies and broken statues [,] . . . dreadful old men and women sitting on dirty benches and broken chairs. There was a smell (not to use a stronger word) of dirt and stale things, fruit and vegetables, also a little "frittura," which one always perceives in the people's quarter in Rome. I had forgotten how wretched it all was, and we were glad to get away.[28]

This too is "Roma com' era," and surviving.

In 1904 Madame Waddington is still seeking out such streets because they "will all disappear one day," but that has become a prospect for which she no longer expresses regret. An accommodation to the ways and comforts of New Rome becomes apparent. She dispassionately observes that "the Carnival is dead, as far as Society is concerned," and that the fashionable afternoon visit to the Pincio is dying. Golf and automobile rides in the country are far more popular. She herself enjoys nothing better than a jaunt to Albano in a Fiat, and her elegantly composed descriptions of the landscape are pleasantly fleeting impressions of shadow, light, and color, totally devoid of any old-fashioned striving after allegorical significance or historical "associations." Roman social life in general is much more easy, active, and varied than before. At first Madame Waddington will not set foot in the new Grand Hotel, but after a month, having discovered that "tea there in the Palm Garden with Tziganes playing, is one of the great features of modern Rome," she

begins going "nearly every day." So many people attend the hunt meets in the Campagna that the countryside is—as Prendergast had shown it—completely obscured by horses, hunters, dogs, carriages, and spectators in fashionable clothes— "almost as many people walking about on the Campagna as riding. It was a very pretty sight." The court ball "was very amusing, but extraordinarily simple, not to say democratic." There were no guards at the door to the palace, no footmen on the staircase, no chamberlains "walking backward with great wands of office in their hands." But it was "charming" just the same, the queen most attentive to her guests (while the king spoke only to men), and "any little couple, a young lieutenant, an American, any one, dancing under the nose of the sovereigns."[29]

In 1880 Madame Waddington had been happy to live in a hotel in the Piazza di Spagna whose windows afforded her an Old Roman view of the playful *Barca* fountain, the flower stalls, and the carriages, horses, and coachmen waiting for customers. In 1904 she is even more happy to be in a luxury hotel in the Piazza Barberini that overlooks the new Via del Tritone, whose constant human hum she hears and loves; Rome now sounds like Vienna or Paris. Incongruities have become amusing: "Yesterday I trammed over again to the Vatican (a trolley car is an abomination in Rome, but so convenient). I wanted to see the statues and my favorite Apollo Belvedere, who hasn't grown any older in 24 years—the same beautiful, spirited god." On Palm Sunday a Mr. Virgo begins to read aloud to her company "the book I am so mad about, 'The Call of the Wild'"; it is finished on Holy Thursday, after they get back from the Miserere at St. Peter's. Pure accents from Old Rome may or may not be a delight. An "animated ball" attended by "all the young dancing Rome" at the Palazzo Barberini, where Waldo Story was "keeping up the hospitable traditions of the house" fifty years after the Storys had settled there, was pleasant to see. So, at a Black dinner, was "a cardinal in all the bravery of his red robes and large jewelled cross." He made her feel "for the first time . . . as if I were back in old Rome." Yet on a drive up the Janiculum just the day before, she had seen "beggars and cripples of all ages running alongside the carriage and holding out withered arms and maimed limbs." These were as common to Old Rome as colorful cardinals, but were excluded by the filter of mythologizing memory. As interesting, pleasurable, and comfortable as the New Rome is to a woman of Society, a selective fondness for the Old necessarily remained to one who there had first learned the ways of the world. Madame Waddington's seemingly perverse effort to obtain a photograph of Cardinal Antonelli is amusingly indicative. None is to be had in the Rome of 1904. "È morto lui," the puzzled shopkeepers tell her. Dead, like Old Rome itself—except, she elsewhere implies, in two places: the Protestant Cemetery, where she visits her father's grave and notes the again-neglected grave of Keats, and the Vatican itself. In the Vatican the Swiss Guards still guard the gates, little squads of papal troops still march about the courts, chamberlains still line the stairways, ostrich-feather fans still mark the coming of the pope, and the black-veiled women still kneel in devotion: "a curious little old world," surrounded by high walls, "in the midst of the cosmopolitan town Rome has become."[30]

Such an evolution in the point of view of an Old Roman, gradually accommodating itself to the changes in the city, contrasts with that of a woman who, directly knowing only New Rome but fascinated by the legends of the Old, simply makes an

absolute division between them and finds them both good. Such was the poet and journalist Lilian Whiting, who, with the accumulated knowledge of several earlier visits, wrote *Italy: The Magic Land* after spending the winter of 1906–07 in Rome. Two one-hundred-page chapters neatly divide the city's interests between "The Period of Modern Art in Rome" (the nineteenth century) and "Social Life in the Eternal City," an enthusiastic record of contemporary pleasures. Whiting had already embalmed the Florence of the Brownings in another book, and now she draws upon written reports and oral legends to establish the morbid ideal of an "idyllic life" enjoyed in the "Rome of the Popes" by artists from Allston through Page and Story to Elihu Vedder, Moses Ezekiel, and Franklin Simmons—the last three of whom are still living and receiving visitors in their studios. The book is dedicated to Mrs. Franklin Simmons, a woman of exceptional musical talent who had made the Palazzo Tamagno a "brilliant center of social life" until her death in 1905. Now she lies buried in "the Beautiful Roman Cemetery" under a statue by her husband, *The Angel of the Resurrection*, which, according to Whiting, is "one of the great art features of Rome," and superior to Story's atheistical *Angel of Grief*, placed over *his* wife's grave.[31]

In evoking the Old Rome that was crucial to "modern art," Whiting is a religious idealist who imagines it to have been a place where even the Santa Scala was inspiring and all artists were happy. Her chief guidebook seems to be George Hillard's *Six Months in Italy*, now half a century old, but her softening vision of those early days blurs the critical edge of his commentary. The aesthetic realm that Henry James had romantically sketched just a few years earlier and that Van Wyck Brooks would gracefully resuscitate in *The Dream of Arcadia* after another half-century had passed is naively drawn by Whiting as the reality of recent history. Her prose elegy aptly recalls Dwight Benton, an American painter who had lived in Rome for twenty-five years, editing *The Roman World* and specializing in souvenir watercolors of the Protestant Cemetery. He was finally buried there himself in 1903.

Few customs or institutions that survive from Old Rome are regarded by Whiting as a natural sign of continuity in an evolving society, and thus a vital part of the present. They are looked upon as wonderful ghosts, artificial and unreal. That the continuing worship of the Madonna in Sant' Agostino is seen as a "curious feature of the past" is not surprising, but to say that the social season in Rome "prefigures itself, by the necromancy of retrospective vision, as a resplendent panorama of pictorial scenes" requires more effortful perception. At an afternoon tea in an old palazzo, where a harpist strums in the background and the company consists "largely of Roman nobility" who resemble closely the portraits on the walls, one feels like a participant in a scene from a Wagnerian opera, according to Whiting. The Church, however, shows signs of evolution rather than merely posthumous survival. It is true that the Blackest and grandest of all receptions, that in the Spanish embassy to the Vatican in the Piazza di Spagna, is a picture from the past; the arriving cardinals are still ushered up the stairs by torchbearers. But Merry del Val, the cardinal secretary of state, is a socially sophisticated and worldly young man quite different from the pope (Pius X) whom he serves. Although he receives in the Borgia Apartments of the Vatican, rides in a black carriage with black horses, always

accompanied by a gentleman-in-waiting dressed in antique Spanish costume, he represents the "most advanced and progressive thought of the day," as demonstrated by his admiration for Marconi. His status as "a remarkable twentieth-century personality" is proven by his advocating the introduction of telephones, electric lights and motors, phonographs, and typewriters into the Vatican. He also frequently plays golf at the Villa Doria-Pamphili.[32]

The progressive Savoyard Rome of electricity and golf is the one Whiting really loves. Its main interests are in "dancing and dining and driving," but these interests Americans fully share. The grand ball on Washington's Birthday, held in the embassy—now the Palazzo del Drago, leased by the current ambassador, Mr. Henry White—was brilliant, and Mrs. White was "ablaze with her famous diamonds." One of the most "delightful hostesses in Rome is the American wife of Cavaliere Cortesi," celebrated for her musicales. And in the great new sport of motoring, Americans are creating a sensation by bringing over their own touring cars. Of course, there are intellectual interests as well. Although certain "phases of modern thought" such as theosophy and Christian Science flourish more in Florence than in Rome, Americans do attend lectures on everything from Catholicism (given by an English priest) to archaeology (given by Commendatore Boni and Professor Lanciani). American ladies continue to interest themselves in the Society of Women's Work, which seeks "the larger outlook for women." In this movement, "Margherita, *la Regina Madre,* leads the way, supported by a large following of the titled nobility." Royalty continues, of course, to be at the center of patriotic interests and ceremonies. With the passing of papal splendor (the pope didn't even appear during Holy Week that year), the imposing celebration of the Birthday of Rome (April 21) and the annual masses in the Pantheon for Kings Victor Emmanuel II and Umberto I are the more valued as spectacles.[33]

As far as Whiting is concerned, the physical changes in Rome cannot proceed too rapidly. During the cold, damp winter she is grateful for the sidewalks in the Ludovisi Quarter and on the Via Nazionale. The twelve large new hotels are wonderful, but, as a resident of the up-to-date Hotel Brunswick at Copley Square in Boston, she cannot understand why similar resident hotels are not being built in Rome. "There seems to be no adequate reason why, in this age, people should be compelled to live in these gloomy, dreary, cold, old stone palaces, without elevator service and with no adequate heating, lighting, and running-water facilities." Among the other new buildings in Rome, Whiting almost alone finds the massive white marble Palazzo di Giustizia—at that time in its eighteenth year of construction and still incomplete—"splendid." She is thoroughly impressed by the grandiose national aspirations of the Kingdom of Italy and by their foundation in ancient Rome. She excitedly reports a lecture by Lanciani in which he told of the plan to lay out a carriage road around the Capitoline and across the Forum (the very road removed as an intrusion in 1983–84). His other projections for the Jubilee Year of United Italy in 1911 include the total archaeological reconstruction of the Baths of Caracalla for use as an exposition hall and palace of congresses, and the conversion of the Castel Sant' Angelo into a Medieval Museum. But most inspiring of all is the building of the "great monument to Victor Emmanuel." It is rising "near the Capitol and the Palace of the Quirinal" and "will be of the most artistic and

beautiful order. . . . All the old buildings in the vicinity will be torn down to give a
fine vista for this transcendently noble and sumptuous memorial." Italy is expend-
ing the equivalent of $7 million on this work, while America, in shameful contrast,
appropriated only $200,000 for the Grant Monument. But Rome is indeed "a city of
spiritual symbolism."[34]

To interpret the symbolic meaning—spiritual or otherwise—of the changes in
Rome was a task undertaken by all who wrote about it in the two decades before
1911, but for three American men whose knowledge of the city went back thirty to
forty years and more, the meaning was more political than it usually was for Maud
Howe Elliott, Mary King Waddington, or Lilian Whiting. William James Stillman,
William Roscoe Thayer, and William Dean Howells each wrote extensively be-
tween 1895 and 1907 on the significance of what they observed on return visits.
They say little about "Society" and nothing of the American Church, but the
viability of the young nation's government and the political and economic character
of its capital city are major concerns. Stillman's view—expressed in an essay, "The
Old Rome and the New" (1897), in a history, *The Union of Italy: 1815–1895* (1898),
and in his *Autobiography of a Journalist* (1901)—becomes increasingly pessimistic,
not because of the destruction of Old Rome, but because of his despair over the
politics of the New. Thayer, whose sense of the epochal grandeur of modern Italy's
emergence as a nation was the motive for his eloquent *Dawn of Italian Indepen-
dence* (1892) and for his great biography, *Cavour* (1911), reaffirms his faith in a pair
of essays collected in *Italica* (1908), "Thirty Years of Italian Progress" (1903) and
"Italy in 1907," which directly oppose Stillman's pessimism. Howells, returning to
Rome in 1908 after an absence of forty-three years, sent home to the *New York Sun* a
series of papers that were collected immediately as *Roman Holidays*. In these he
complacently accepts not only all the physical changes in Rome (noting that there
are plenty of exclusive villas and ugly baroque churches left) but even finds reason
for socialistic cheer in a general labor strike—the very thing that conservatives saw
as the terrifying portent of civilization's dissolution into anarchy. Some details of
these three perceptions of the New Rome are worth observing because, although
they inevitably involve a comparison with the Old Rome, they take us well beyond
that by judging the thirty-year evolution of the modern city in terms of its own ideal
of civilization rather than the one it rejected.

Following Stillman's stint as American consul in Rome in the 1860s, he had been
involved in a series of incredible diplomatic and journalistic adventures that finally
brought him back to Rome in 1890 as the chief correspondent of the London *Times*.
We have seen that in his autobiography he recalled no happy memories of papal
Rome. Nevertheless, in his essay of 1895 he begins by attesting to the fascination of
the city. It has possessed an entirely inexplicable "spiritual polarity" for all "Old
World" aspirations since "long before the first wall was built on either Aventine or
Palatine," and the New World now feels the same attraction. Stillman recalls the
papal Rome he knew as a medieval dream where no daily newspapers disturbed
one's tranquility, where the priest and the artist were the two most important
beings in the world, and where the Campagna offered itself "like a phrase of the
noblest poetry" to the young enthusiast of landscape art, such as he was himself at

that time. But that "phase of Rome is gone forever—gone as surely as the simplicity and stern morality of the republic, the splendour of the empire, or the moral oppression of the papal rule. . . . What has come is not so clear"—except in its hideousness. "Everything is changed in it that can be changed in a city; what can be done to break the antique charm has been done, as if in malice—mutilation, renovation, desecration." The "new barbarians" were "reared in the civic ideals of Genoa and Turin" and "have no sympathy with the monumental records of Rome." One can take only a "malignant satisfaction" in seeing that the vast speculative apartment houses built over the Villa Ludovisi are mostly untenanted. To conclude, "the transformation of Rome during the past twenty years is unique in the history of civilisation for barbarism, extravagance, and corruption; never since the world began was so much money spent to do so much evil."

Thus far Stillman sounds much like Mrs. Fraser, except for that reference to papal "moral oppression," which had been sufficiently obnoxious to make him hate Old Rome in spite of its charm. But this contrast between Old and New has simply been a rhetorical means of testifying to an immortal spirit of Rome that somehow persists even through its latest disfiguration. All of *this* will also disappear: "this pinchbeck Paris is only another illusion which time will dissipate." The "real citizen" of Rome is any member of Western Civilization who feels its mysterious pull and is as indifferent to Garibaldians and Savoyard kings as he was to popes. Members of the "exclusive" Roman aristocracy, who imagine that Rome is theirs, whether White or Black, are only "shadows" to the "spiritual Roman," who walks right through them. And this true citizen finds the New Rome more convenient, healthier, safer, cheaper, more tolerant, and more interesting than any other city in the world. This is where "the refugees from the nervous pressure of America, the social, political, and business burdens of England; from the immitigable boredom of German life, as well as the glittering superficiality of Parisian," may come to "meet on the neutral ground of traditions, memories, and associations that antedate all our national divisions, and even all existing nationalities."[35] Stillman's Rome seems to offer the ideal place in which to anticipate the great equalizer, Death.

Unhappily, neither in the 1860s nor in the 1890s was Stillman able personally to verify this somewhat morbid fantasy of Rome as a universal idea that transcended the physical reality, both Old and New—a sublime city in which a few "spiritual Romans" such as himself could take Shelleyan "refuge" from "the world's bitter wind." As a journalist personally acquainted with both Lord Dufferin, the British ambassador to Italy, and Francesco Crispi, the embattled head of the Monarchical Left whose biography he wrote, Stillman found the New Rome anything but a retreat. Through his privileged contacts and his reportage in the most influential newspaper in the world, he was deeply engaged in political developments. Consequently the final chapters of his history of the Italian nation, which was written for the Cambridge (England) Historical Series, are filled with a disillusionment so deep that in a posthumous edition (1909) G. M. Trevelyan had to add a corrective optimistic epilogue. Stillman accepted the dictum of Crispi—who was originally a Garibaldian republican—that "the monarchy unites us and the republic would divide us," and he believed that King Umberto actually took his responsibility for direction of Parliament too passively. The Left had won power in 1876 with an ideal

program for a modern nation: "electoral reforms and extension of the suffrage; full liberty of conscience; freedom of speech, of the press, and of association; the renunciation, in principle, of all legislation against political opponents," plus tax reforms and a plan for the development of state railways to be run by private agencies.

By the 1890s, however, the Italian Parliament has proven itself totally unlike the British, which Stillman takes as the model of a civilized democratic institution (he never refers to the American Congress). In Italian politics, loyalty to principle or even to party policy is almost unknown; individual power and popularity with the electorate are everything. The Parliament is a scene from the *Inferno* in which men gnaw each other's skulls with a "venomous and unscrupulous" personal hostility unseen in any country "since the Italian republics of the middle ages." Tax reforms have not aided the poor; railways built to purchase local favor have bankrupted the country; the army is as costly as it is inefficient; the imperialistic adventures in Africa have led to disaster. The reconstruction of Rome as the new capital "provoked the most reckless expenditure" and opened the way to "municipal extravagance and corruption" and to unregulated private speculation. In all this Italy may be a modern nation, but far from a model one.[36]

The personal distress that lay behind Stillman's analysis is recorded in the last chapters of his autobiography. He despaired of Italy:

> Though the state may endure, even as a constitutional monarchy, for years, the restoration of civic vitality to it is only to be hoped for under the condition of a moral renovation, to which the Roman Catholic Church is an unsurmountable obstacle, because the Church itself has become infected with the disease of the state—the passion of personal power, carried to the fever point of utter disregard for the general good.

Thus by the turn of the century, in Stillman's view, the worst aspects of both the New Rome and the Old have merged and prevailed. His "early enthusiasms" for Italy's "political progress" faded, and "I buried all my illusions of a great Italian future." Only a Cromwell could save it; otherwise "the task is hopeless and the decay inevitable." Forgetting what he had written only a few years before about an ideal Rome as a "refuge" from the exacerbations of politics, Stillman resigned from the *Times* and moved to England.[37]

A few years later—in 1903—William Roscoe Thayer arrived in Rome to attend the Second International Congress of Historical Sciences as the representative of Harvard and the American government, and the only American among the eighteen hundred delegates on the program. With particular pleasure he visited the new public park on the crown of the Janiculum (the very one that Mrs. Chanler had bitterly lamented). He followed the new Passeggiata Margherita to the colossal equestrian statue of Garibaldi that commemorates his defense at that site of the "old brick city-wall" for the Roman Republic of 1849. Perhaps Thayer had been told of it by his colleague William James, who in 1900 had observed how Garibaldi bends his head "with a look half-meditative, half-strategical, but wholly victorious, upon Saint Peter's and the Vatican." James added: "What luck for a man and a party to

have opposed to it an enemy that stood up for *nothing* that was ideal, for *everything* that was mean in life. Austria, Naples, and the Mother of harlots here, were enough to deify anyone who defied them."[38]

Thayer concurred in a note in his diary: "That Garibaldi should have such a monument in that place is one of the noblest of Time's revenges." Later he sought out the statue of Cavour by Galletti (1895). This monstrous work in the Piazza Cavour facing the Palace of Justice pleased Cavour's prospective biographer only in that it existed. Far more impressive was "Ettore Ferrari's noble statue of Giordano Bruno" (1889) in the Campo de' Fiori, also admired by William James. Thayer thought it the "finest recent monument I have seen. To the imagination it speaks more impressively than any other in Rome." He translated its inscription: "The century which he looked forward to raises this monument to Giordano Bruno on the spot where he was burned" (James, more accurately, wrote "here, where the faggots burned"). "What a revenge!" cried Thayer, while noting that in the Cancelleria, a "stone's throw from the statue," the "papal machine" that burned Bruno was still "running full time." But it "makes the tears come, for the poetic justice," thought James, with the professorial reservation that no doubt Bruno was "a very pesky sort of crank."[39]

To establish that Rome now belonged to a civilization and a century liberated from the mentality that burned Bruno was, of course, one of the government's purposes in sponsoring the kind of congress Thayer was attending. Two years later William James attended a similar congress for philosophers, at which he was amazed to discover his own fame and popularity and which he found to be "an agreeable nightmare—agreeable on account of the perfectly charming *gentillezza* of the bloody Dagoes." Gentillezza was appreciated by Thayer as well; he recorded that a countess had taken him in a landau to the Campidoglio, where the king and queen and Prince Prospero Colonna (mayor of Rome) opened the congress promptly at 9:30. Other speeches followed, interrupted only by a rude banging at the door by the German delegation, which had arrived late. At the Quirinale that evening all had dinner with the royal personages in a "magnificent" room "larger than [the] living room of Harvard Union." Thayer sat next to the historian Comparetti, "the man I most wished to see." They discussed education and archaeology in Italy, and recalled C. G. Leland, "lately dead in Florence, who asked Comparetti to introduce him to all the witches there." Comparetti congratulated Thayer on America's "recent advance in scholarship," thus incidentally alluding to Italy's priority in this aspect of civilization. On another day the president of the Italian Chamber of Deputies thanked Thayer for his interest in Italy, and Thayer took the opportunity to interview the aged deputy about his personal knowledge of Cavour. Cavour was also Thayer's chief interest during an interview with Victor Emmanuel III, to which the thirty-four-year-old king, who had read Thayer's *Dawn*, invited him. The king and Thayer agreed that Cavour was the greatest statesman of the nineteenth century after Napoleon. They discussed Italian emigration to the Americas, the "*maffia*" (the existence of which the king denied), and the problems of determining public opinion in both America and Italy, caused by the unreliability of newspapers. According to the king:

"Here, we have but one tradition—tolerance. All parties—the Pope too—live to-
gether peaceably at Rome. My Minister of War is a Jew—what more could you say?
The army, which elsewhere is supposed to be the most conservative part of the
country, is not so here. . . . The temporal power [of the pope]—that is trash. . . . Our
generation, which is now the ruling generation, does not remember the Pope as
King. Every year . . . that recollection fades out. Tolerance—that is our tradition."

The interview ended with the king recommending that Thayer learn to use the
typewriter, a most useful invention. Three days later Thayer saw the grand entry of
Edward VII of England into the city—"for Italy the most gratifying formality since
the Italians came to Rome."[40]
 When Thayer organized his impressions from this visit into an essay, his argu-
ment was the very reverse of Stillman's. He was struck in Rome "by a new spirit in
the air, a more hopeful tone, a feeling that an era of true prosperity lies just ahead."
Thirty years of Italian progress have demonstrated every reason to expect a great
future for Italy. The nineteenth century, according to Thayer, had "set two tasks"
for "all the nations of the West": the "establishment of political liberty through the
adoption of some form of representative government, and the creation of an eco-
nomic system based upon modern methods of production and transportation." But
until 1860 Italy had not even been a nation, and only since then has she been able to
"join in [the] competition of modern civilization." Thus measured, her progress has
been the greatest of all. Thayer summarizes the enormous advances in democratic
politics, in economics, and in education. As for the physical changes, only "sickly
aesthetes" could complain that "new broad streets bring light and pure air into what
were lately the most unhealthful wards of Rome." Those who cry that "the Roman
Ghetto was so picturesque!" are "sentimentalists" for whom "the life, health, and
morals of the living citizens of Rome . . . are nothing." Those who complain of
Italy's expenditures on its army and navy do not know how they have served to
unify, educate, inspire, and discipline the men.
 Italy's foreign affairs embarrassments and its conflict with the Vatican are misin-
terpreted, says Thayer, as signs of internal weakness, whereas they actually have
proven its strength. Its form of government has survived the disasters in Africa, and
only a strong and self-assured nation could tolerate the "sleepless, unscrupulous,
far-reaching enmity of the Vatican" at the heart of its capital. No other modern
nation has had to bear this particular burden or would have been willing to do so.
Would England permit the pope to dwell in London and intrigue with France and
Spain for the restoration of the Stuarts? "Or should we Americans hold hands off
from conspirators, lay or clerical, who avowedly plotted at Washington to destroy
the Republic?" By her forbearance, Italy has proven the "speciousness of all Papal
claims." The government has shown its capacity to distinguish strictly between the
religious and secular realms, while, deprived of its temporal power, the Church has
in fact prospered rather than withered away. Only a few silly foreigners now accept
the laments of papal journals "for the good old times when everybody was happy and
prosperous under the Pope's rule." Italians smile at this, just as New Yorkers smile
at tearful regrets for "the Golden Age of virtue and prosperity" under Tammany

Hall. If corruption has occurred in the government and business of New Italy, the young nation's utter inexperience in representative government and in modern finance must be remembered. Besides, "our Whisky Ring, Credit Mobilier Ring, Star Route Robbers, Sugar Ring Senators, and other rascals" are adequate counterparts to the scandals of modern Italy, and in neither country have the scoundrels been punished. Corruption such as this is not Italian, it "is the curse of the age: it has blackened modern France; it has smutched England."[41]

In 1907 the picture looks even brighter. The great experiment of United Italy— "an experiment involving patriotic, moral, racial, political, and religious consider-ations which have their points of contact with all the world"—is obviously suc-ceeding. Italy is even enjoying for the first time "financial optimism," her currency at par. The material prosperity upon which the "moral and intellectual improve-ment of the masses must rest" is everywhere evident. In Rome, the attitudes of both the nobility and the Vatican have substantially altered. With the success of the monarchy, and the desire of aristocrats to participate in government, which they can now do without becoming priests, the nobility is ceasing to be Roman and is becoming Italian. If there are holdouts, well, "a Colonna at the Quirinal is at least the social equivalent of a Chigi at the Vatican." Amusingly, Pius X unwittingly encouraged disenchantment among the "old Black families." One "distinguished noble" said to Thayer, "Pius X is a good man, religious, well-meaning, but what can we expect? He is only a peasant, with no social training." Pius IX had been a count, and so had Leo XIII; as for Jesus Christ——. The diplomatic blunders of the peasant pope and the Jesuits, and their reassertion of a reactionary "anti-Modernist" theol-ogy, undid much of what Leo XIII had gained in prestige for the Church, and oddly coincided with the pope's withdrawal of the ban on the participation by Catholics in Italian politics. All this helped. On the other side, even the Socialists had long supported the monarchy, and they too were now fading as threats to stability, just as the old Republicans had. In 1907, Thayer concluded, the situation for Italy was the most "propitious" since "the death of Cavour."[42]

In the next year—1908—Charles Eliot Norton read with amazement the succes-sive papers that his friend William Dean Howells was publishing about his Roman holiday, and Henry James heard of the forthcoming book with incredulity. During a visit to Rome the year before, James had written to his brother, William, that while "the great sense of the old place is still more or less with one," yet "the abatements and changes and modernisms and vulgarities, the crowd and the struggle and the frustration (of real communion with what one wanted) are quite dreadful." To Edith Wharton he wrote, "I shouldn't care if I never saw the perverted place again." Now here was Howells treating Rome as though it were still a joy to know and to write about. James requested a copy of the book from Howells, saying that he was envious of his old friend's ability to find a possible subject in so *"commonised"* a thing as the "transformed City." For James himself to have attempted as much would have constituted both a betrayal of "the unutterable old Rome I originally found and adored" and a questioning of the "coherency and sincerity . . . of my prime infatua-tion." In loyalty to himself and Old Rome, James preferred to treat his earlier essays to certain "titivations and expansions" for collected publication now as *Italian Hours*.[43] In the same vein Norton wrote to the Englishwoman Miss Meta Gaskell,

whom he had met fifty years earlier in Rome, that he could not "believe that the charm of Rome is as great as it was then, and yet my dear old friend Howells who has just returned from a long stay there . . . has fallen under the spell of its charm as completely as if it were the same delightful Rome that we knew so well." Norton enclosed one of the essays, admitting that Howells's "wide and ready sympathies and his quick perceptions" placed his travel writing "among the best."[44]

The seventy-year-old Howells's wider sympathy with the contemporary world is precisely what distinguishes his descriptions of Rome in 1908. Beneath the sometimes whimsically assumed superficiality of the professional magazinist there is a sympathy profounder even than that of Thayer for political, social, and technological revolutions. To create a character completely antithetical to the hero of *The Rise of Silas Lapham* (1884), he had imagined the Boston Brahmin Bromfield Corey as an Italian-speaking lover of Old Rome, an ineffectual aesthete who had studied painting there in his youth. So now Howells (a New Yorker in his own old age) is not going to become himself a sentimental patrician upon returning to Rome.

Unlike James, for Howells to love New Rome incurs no disloyalty to an earlier self. His first essay is a celebration of his new hotel on the new Via Veneto: it has all the American comforts—steam heating, elevators, electricity, private baths. Of course, it is also nearly as expensive as a hotel in New York, but worth it, and the food is much better than at home. Howells does not regret the loss of the Villa Ludovisi; indeed his complaint about the bell of the neighboring Capuchin convent that wakes him in the night conveys rather a regret that this particular feature of Old Rome had survived. The high wall of the convent itself, at the lower end of the Via Veneto, is "plastered and painted with huge advertisements of clothiers and hotels and druggists, and announcements of races and other events out of keeping with its character and tradition." This is precisely the sort of thing that so grieves the northern "sentimentalists who overrun Rome," but Howells declares himself to be "a Newer-Roman to the core, perhaps because I knew the Older Rome and what it was like." Visitors "who had perhaps never lived in a Ghetto" might think it "a pity if not a shame" that something so "picturesque" should have been destroyed, just as those who had never endured flood or fever might find the new Tiber Embankment "commonplace." It is as perverse to complain that a city is too clean and too healthy as it is to expect Rome rightly to be dirtier than London, Paris, or New York. The daily sweeping of Rome's streets is understandably irritating to the "envious New Yorker" who remembers his own "blackguard streets" and therefore looks "askance at the decency of the newer Rome" as "an offence against beauty and poetry." Howells remembers the streets of Old Rome as an offense against foot and nose. He deliberately visits the much-lamented new quarter of the Prati to see the "squalor" described by Zola in *Rome* (1896), a novel filled with "scenes of poverty and misery," which the great naturalist (who was actually a complete "romanticist") had written on the basis of a very brief visit. Finding nothing of the sort, Howells returns three times looking for anything "impressively lamentable." He finally notices three tenement houses in a space where in New York on the East or North Side they existed by the score.

Throughout New Rome, in spite of the great building projects of the last thirty years, Howells still sees blossoming trees hanging over the old walls of hidden

gardens, still sees palaces and churches defining familiar streets and piazzas, and he cannot believe that these elements in the essential character of Rome will ever be lost. But in any case it was not these, he argues, nor the mild winter and endurable summer that made Rome a "great capital"; it was "the Romans themselves who in the past made Rome the capital of the world, first politically and then religiously." Now that all Italians have become Romans, Howells has "profound faith" in their ability to "make it so hereafter." In this they will "have the help of the whole world, . . . or what is most liberal and enlightened" in the world, because even as it is, "Rome has a pull with Occidental civilization which forever constitutes her its head city." Through comparisons with New York, Washington, London, Paris, and Berlin, Howells finds Rome's distinction in her universality:

> In fact, her greatness, accomplished and destined, lies in just the fact that she is not and never can be exclusively Italian. Human interests too universal and imperative for the control of a single race, even so brilliant and so gifted as the Italian race, . . . centre about her through history, religion, art, and make every one at home in the city which is the capital of Christendom.

Noticing some "Jap" tourists, Howells considers that perhaps they alone can look at New Rome objectively without presuming a right to criticize the Italians. Since Westerners think of Rome as belonging to themselves, they are always ready "to find fault with the Rome which is now making, or making over." While benefiting from all the improvements and enjoying the antiquities maintained at enormous expense to the Italians, the northerner feels free to "censure and criticise and carp." All the foreigners Howells meets are patronizing at best toward the New Rome; he alone is "contented with her as she is, or as she is going to be without his help." Howells ends by proposing a stiff tax on all tourists, which will both give them the right to complain and help fill the treasury "which they believe is always in danger of being exhausted."[45]

When Howells turns from questions of physical change to consider the social and political conditions of Rome, he finds even greater grounds for satisfaction. Although there actually seem to be more priests in Rome than before (and he likes the color they add), there are fewer soldiers, and what soldiers there are, are Italian. The army is wisely kept outside the walls; within the city the proportion of soldiers is about that in Washington. The "monarchy" is "mild-mannered," able to hold its own against both the Church and the Republic that the people would instinctively prefer because it represents the unifying consensus of diverse wills. On the wall of the convent at the Church of San Clemente Howells noticed two inscriptions: "'VV. la Repubblica (Long Live the Republic)' and 'M. ai Preti' (Death to the Priests)." No attempt had been made to efface either, possibly because they expressed "equal hatred for the monarchy and the papacy." The "ferocity" of anticlerical expressions here and in a satirical newspaper that Howells found too obscene to read closely tends in any case to be counterproductive. On its side, the royal family cultivates its popularity with great success. Victor Emmanuel III (with whom Howells had a private interview) manifests an almost excessive anxiety to succeed

as "the best sort of constitutional king." Queen Mother Margherita is still greatly loved in her retirement and may sometimes be seen going for a drive with four policemen on bicycles as her bodyguards. Although the Romans are innately republican, their sense of gratitude to the House of Savoy that unified Italy, freed Rome from the pope, and restored it as the capital transcends ideology.[46]

But there were things to ponder more interestingly volatile than the apparently established monarchy. For Rome had clearly not reached a new condition of stasis. Like others, Howells was deeply moved by the statue of Giordano Bruno, but he saw it one day when by mischance a wreath placed on its head by some "zealot of free thought" had fallen down around Bruno's mouth, suggesting a new silencing of the heretic. And in fact an attempt by the society named after Bruno to suppress obligatory ecclesiastical instruction in the public schools had just been beaten back by the Church's vigorous response to this "agnostic attack on the altar." To counteract the impression of incomplete liberation, there was the astounding fact that in 1908 the mayor of Rome—still the capital of Christendom—was a Jew, and not only a Jew but a Freemason and a Socialist. This fact seemed anachronistic in the other direction, not only in its proof of tolerance in a city where a generation before there had been a Ghetto, but in its evident anticipation of a time when there would be neither pope nor king. For the combined parties—Liberal, Republican, and Socialist—that defeated the Clericals and installed Mr. Nathan mean nothing less than the future "economic solution of regality and aristocracy." That does not mean "old-fashioned revolution; it means simply the effacement of all social differences by equal industrial obligations." The plain sympathy with which Howells (author of the utopian Altrurian romances) makes this assertion marks, for us, the revival and continuance of the egalitarian voice of Margaret Fuller and Julia Ward Howe in the American observation of the Roman scene: a minority voice that yet makes itself heard in every generation.[47]

It is most eloquently heard in the few pages Howells devotes to the two-day general strike that occurred while he was in Rome. This *sciopero* he actually calls "the most impressive experience of our Roman winter," astonishingly adding: "In some sort it was the most impressive experience of my life, for I beheld in it a reduced and imperfect image of what labor could do if it universally chose to do nothing. The dream of William Morris was that a world which we know is pretty much wrong could be put right by this simple process." What prevented its achievement had always been the difficulty of getting "all sorts of labor to join in a universal strike," but in all of Italy four years earlier, and now for two days in Rome, the "miracle" occurred. A funeral procession for a killed worker had threatened to turn into a demonstration when it insisted upon passing before the Palazzo Venezia, the Austrian embassy which after all these years still symbolized the oppressions of the Old Regime. Police forces were deployed in front of the Gesù, church of the Jesuits, to prevent passage, and when they were attacked by the mourners with bricks, they fired upon the crowd, killing four and wounding others. Unions meeting that night voted to strike, and for the following two days Rome was silent. For the tourists there were no cabs, no buses, no porters, and on the second day, no rolls for breakfast. Howells, trying to keep his writing light, describes the arrival of some

fashionable tourists: "people who had never done a stroke of work in their lives were actually carrying their own hand-bags, rugs, and umbrella-cases. It was terrible." But he concludes more seriously:

> It was terrible for what it was, and terrible for what it suggested, if ever that poor dull beast of labor took the bit permanently into its teeth, or, worse yet, hung back in the breeching and inexorably balked. What would then become of the rest of us, us ladies and gentlemen who had never done a stroke of work and never wished to do one? Should we be forced to the hard necessity of beginning?[48]

Norton, James, and other friends of Howells must have been as amazed by *what* impressed him about New Rome as by the fact that he was impressed at all.

With this visit of old Howells the comparisons between Old Rome and New cease. Howells the fully committed realist lived always in the present and was the last of those who had really known the papal city, now so happily deceased. But the present Rome of the House of Savoy excited him chiefly by its portents of a future in which further dissolutions would occur—those of dynasty and aristocracy. Nevertheless, in the next decade others would apotheosize the New Rome as the capital of the New Italy, foundation of Western Civilization, and present bulwark against the impending chaos.

At the Altar of Italy

One of the American artists who participated in the International Exposition at Rome in 1911 was Joseph Pennell, who made invaluable drawings of archaeological and monumental innovations—including *L'Altare della Patria*, the "transcendently noble" monument to Victor Emmanuel heralded by Lilian Whiting five years earlier. Pennell had been in Italy previously in 1884–85, making illustrations to accompany his bride's giddy text in *Century Magazine* and for William Dean Howells's *Tuscan Cities* papers, also published by *Century*. Howells thought as little of what Pennell produced for this book and for his later *Italian Journeys* (1901) as did Henry James of those that Pennell made for his *Italian Hours* in 1909. But the traditional subjects that such books seemed to call for were uninteresting to Pennell. His most remarkable drawings, etchings, and lithographs are of modern cities such as London and New York in a state of construction or (in World War I) demolition. In 1911 he was thus fortunate in Venice to find the Campanile in an interesting phase of reconstruction after its recent collapse, and in Rome he found everything in upheaval for the Jubilee Year.

Pennell did do a fine etching of St. Peter's as seen from the Pincio—one of the most celebrated of views—but sighted from an original position, far back from the terrace edge so that the upper two-thirds of the etching could be the dense blackness of overhanging foliage, beneath which a delicate thin line defines the shape of the famous white dome against the white sky. But his images of New Rome are even more original. A pen drawing reproduced in his autobiography, *Adventures of an*

Illustrator (1925), shows the completed carriage road that Lanciani had described to
Whiting, cutting between the newly excavated ancient columns of the Forum and
loaded with pedestrians, horses pulling a tram, and a donkey with a wine cart. A
lithograph (fig. 28) and an etching, both called "Old and New Rome" but distinct
from each other, look across the Forum from the Palatine toward the Capitoline
from different angles. The Forum is seen as the now-familiar sunken area of regular
marble stumps, broken pavements, covered pits, and free-standing columns. Be-
yond it the wall of the Tabularium rises against the Capitoline, but the Renaissance
tower of the Senator's Palace, once the romantic's favorite viewing place for the
Forum, is obliterated by the new towers of the Victor Emmanuel Monument, their
tops still encased in scaffolding. In the lithograph the angle of vision allows inclu-
sion of both the dome of a baroque church and the medieval Torre delle Milizie
(legendarily the tower from which Nero watched another spectacular transforma-
tion of Rome). The visual complexity and suggestiveness of these works are ob-
viously very great. But the most dramatic and successful of them—the one chosen
by Elizabeth Pennell for reproduction in *Nights: Rome—Venice in the Aesthetic
Eighties* (1916)—is an etching called "Building the Victor Emmanuel Monument"
(fig. 29) showing the work in progress from the other side of the Capitoline. The
completed white marble loggias of one tower soar powerfully above elaborate and
ingenious scaffolding and machinery—bold, dark, and angular, just the dynamic
forms Pennell loved. These seemingly animated monsters in turn straddle and
almost crush the old buildings below them—doomed buildings with façades four
and five stories high reduced to insignificance by the mighty construction that is
lifting into the sky a supposedly permanent vision. No one could have been happier
than Pennell that the monument, begun in 1885, was still incomplete in 1911
(although consecrated that year). He afterward called it "a triumph of misdirected
work which has swallowed millions with no result," adding "only while it was
being built, the scaffolding which surrounded it was magnificent."[1]

The remark might be taken as an unintended satire upon the New Italy whose
creation the monument commemorates, as the monument itself afterward came
generally to be considered a grossly inflated architectural statement of Italy's mod-
ern pretensions. But an idolization of the New Italy as actually or potentially the
keystone of Western Civilization is what unites most of the American writing
about Rome from the beginning of the First World War to the visit of President
Wilson in 1919, and on to Mussolini's March on Rome in 1922. Except by Mary
Crawford Fraser, Old Rome is largely forgotten even as a secondhand dream, or it is
assimilated into the new image of a nation that is simultaneously the carrier of our
central heritage and potentially a model of social and economic development. After
the war began even Mrs. Fraser, in a typically overheated essay called "September,
1914," which she wrote to honor the death of Pope Pius X and to proclaim Benedict
XV as "Il Pontefice della Pace," admits that "clerical" and "constitutional" have
strangely come to mean the same thing. "Together," she is pleased to announce,
"the Executive at the Quirinal and the Spiritual Power at the Vatican form the
'party' of law and order."[2]

The other writers are not much concerned with popes as political powers, but
they almost invariably admire the king and the Italian people. Two of them were

Fig. 28. Joseph Pennell. *Old and New Rome, Victor Emmanuel Monument.* 1911. Lithograph. 21¼ × 15⅝″. Library of Congress, Washington, D.C.

Fig. 29. Joseph Pennell. *Building the Victor Emmanuel Monument, Rome.* 1911. Etching. 11⅛ × 9⅛″. Library of Congress, Washington, D.C.

American ambassadors to Italy: the aristocratic local-colorist of "Ole Virginia," Thomas Nelson Page, who served from 1913 until 1919, and Robert Underwood Johnson, a versifier best known for his influential forty years (1873–1913) as an editor for the Century Publishing Company, who was ambassador in Rome from January 1920 to July 1921. Another was a medical doctor, Joseph Collins, who went to Rome as a part of the American Red Cross contingent in 1917–18, the same that brought John Dos Passos's fictional Dick Savage there in the novel *1919*. The fourth was a professor of Latin from Vassar College, Elizabeth Hazelton Haight, who spent the year 1920 in pursuit of Ovid and Vergil, but also opened her classicizing eyes to much of contemporary Roman life. Finally, there was the would-be poet in Paris, Edgar Ansel Mowrer, who, in August 1914, suddenly became a war correspondent in Italy for the *Chicago Daily News*. Based in Rome until 1923, Mowrer published a book full of love and despair, *Immortal Italy*, whose title indicates the fundamental faith of all these writers, even those who saw fascism first show its face. Their thesis is that Italy *is* civilization, standing against Teutonic barbarism and godless communism, and this in spite of the damning criticisms that Collins and Mowrer found themselves making about Italians, whom they had primarily meant to praise. They explain that their exasperation is born of their love. For Mowrer the failure of Italy is most painful of all, since he, like Howells, saw Rome primarily as the West's essential and humanizing city of the internationalist future. Rome is the redemptive antithesis not so much to Bolshevik Russia or to militarist Prussia as to the conformist, repressive, jingoistic, provincial, and materialistic United States of America.

In 1920 Page published his *Italy and the World War*, a topic congenial to the romantic author of *The Old Dominion* and other commemorations of the American South. It is dedicated to the Italian People and their "noble leader, Victor Emmanuel III," whose "heroic courage and yet more heroic sacrifices" saved civilization, "which they had done so much to create." As "a close and interested observer" of Italy during "the entire period" of the conflict, Page promises an account as accurate as it is sympathetic. Since Page believes in the long view, he begins with a history of the Italian people under the Holy Roman Empire, goes on to the narrative of the development of their national consciousness in the nineteenth century, and then turns to the diplomatic struggles of the New Italy. Only his depiction of the last, in which he was a witness and participant, need concern us here.

The first and most dramatic of the events Page experiences is the arrival in Rome of the poet-novelist-aviator-orator Gabriele d'Annunzio, at a time when factions favoring intervention in the war and those opposed seemed evenly balanced and were "held in check by the Government representatives of order." D'Annunzio came with a call to war, delivered with "lyric frenzy, from hotel balconies or in theatres to excited crowds who followed him in a state of exaltation." The embassies of Germany and Austria had to be guarded by cavalry when he spoke in the Costanza Opera House. Then came the sinking of the *Lusitania*, which "sent a thrill of horror throughout Italy, as throughout the rest of the world." Noisy demonstrations demanded, day after day, that the government policy of neutrality end. Troops guarded all official buildings. And, writes Page, "in the end the People triumphed" after "the most imposing demonstration . . . that Rome had ever seen in modern

times." From the Piazza del Popolo to the Quirinale thousands marched to national hymns, carrying "old Garibaldians" on their shoulders. The noninterventionist ministry resigned, and the king confirmed a new one that would declare for war. The Parliament, surrounded by troops, was so packed that "it was with difficulty that the Ambassadors could get places." The government asked for "full powers" to take "measures imposed by the noblest aspirations and the most vital interests of the country." The Chamber of Deputies approved overwhelmingly, and the Senate unanimously, whereupon another great demonstration of the people went from the Campidoglio to the Quirinale, where "war-speeches were made, and the crowd, assured now of their royal leader's profound sympathy with their aspirations, enthusiastically cheered the King and Queen, who came out on the balcony to unite in the demonstration of Italy's complete accord in this fatal hour." The passage reads like something from Plutarch or Margaret Fuller, with the shouting Roman mob marching from place to place until the will of "the People" prevails.

Page quotes with approval the pronouncement by a Socialist deputy that the war was for the "protection of Civilization against Barbarism." Italy could boast that it "was the first Christian nation" to surrender voluntarily "a position of security and enter the war on the side of Freedom." This war would finally "settle the long-vexed question as to who should be master of Italy and its people—a question which in one form or another had been under discussion since ancient Rome found her progress barred and her security menaced by the Barbarians who poured down through the passes of the Alps to which Julius Caesar gave the names they boast today." Page thus conflates modern nationalism, a vague idea of freedom (of the nation? of the individual citizen?), and the prestige of the Roman Empire (whose "progress" and "security" were threatened by northerners) into one ideal that ennobles the New Italy. Immediately following the declaration of war in May 1915, "the streets of Rome were as quiet as on a spring afternoon," Page reports. Noisy demonstrations in the piazzas ceased, and the Italian people—"never so admirable as when in this mood"—went about the "silent and serious" business of demonstrating their "patriotic devotion" through support for their army along the five-hundred-mile-long Alpine border with their "age-long foe."[3]

Although Page conceives the conflict to be the "People's war," he really views it from the top down. Royalty is at the head of this unequivocally ideal action. Victor Emmanuel III "was a King according to the modern Evangel—the true Chief and Captain of his people." While he was at the front as a "father" to his soldiers, "the Queen was with equal quietness, yet with equal effectiveness, heading the work which War always, and this War especially, imposed on women." She transformed the Quirinale Palace into a hospital "up to date in every respect," so that the place where popes had lived and the present king now dwelled "was filled with Italian wounded—private soldiers under the personal superintendence of Her Majesty the Queen herself." The Queen Mother, for her part, "established and conducted" her own hospital in the Villa Margherita. The duke d'Aosta commanded the Third Italian Army, while the duke of the Abruzzi commanded the Italian fleet, and "the Duchess d'Aosta became the head of the Italian Red Cross." Page's praise then turns from royalty to the army, beginning with the aged General Cadorna, whose father "had commanded the troops at the capture of Rome in 1870."[4]

Did the liberal idealism of the First World War, in which Italy and America (both voluntary entrants) were for the first time allies in a great cause, tend to unite the civilizations of New Rome and Washington? To establish such a result is certainly one of the purposes of Ambassador Page's book. But even he has to admit that news of the entry of the United States into the war in April 1917 was heard in Rome without the "immense demonstrations" that occurred in London and Paris. "The People," says Page, "were profoundly relieved" and "testified their feelings with immense cordiality," although "the Clerical press manifested some disappointment." Page, however, made an "informal inquiry" to discover the reasons for the failure of "the People" to display American flags. There were several: first, he was told, there were no flags available; also (quite incredibly) Romans were not temperamentally inclined toward demonstrations; third (and much more believable), demonstrations would lead to counterdemonstrations and so were discouraged. Then Page gives his own reason: perhaps "a certain scepticism prevailed . . . as to America's real motives in entering the war." The statement that "it was solely in the cause of Liberty and to make the World safe for Democracy" seemed suspect. Although Page does not say so, one can infer that selflessly idealistic pronouncements of the sort that characterized Italy's own publicly declared war aims did not seem so credible when echoed by the new commercial empire in the West.[5]

In discussing the Italian army's retreat from Caporetto in the autumn in 1917, Page points out that in its aftermath the Italian people exhibited "greater patriotism" and "more heroic virtues" than ever before in their history. The true unity of the nation was born from this defeat. It was also on this occasion that the American Red Cross arrived on the scene, in response to the appalling conditions of the refugee civilian population, which "fled panic-stricken from the Huns." The services of the American Red Cross "in the cause of cementing friendship between the two Peoples cannot be overestimated," says Page.[6] But in the cynical retrospect of the fiction of Hemingway and Dos Passos, these efforts of American volunteers appear somewhat less effective. In Dos Passos's *1919* (1932) the effort to help "the wops" is cheerfully characterized by one of the men as "a goddam Cook's tour." It offered American expatriates in Paris a chance to develop a "tremendous" feeling for Rome. There they could have a "highclass meal" with "Frascati wine," followed by a vaudeville show on the Via Roma, and then take a cab for a view of the Colosseum by moonlight before receiving further senseless orders from the Red Cross bureaucrats sending them happily back to Paris.

Such was, of course, not the view of Joseph Collins, a medical doctor who served on the staff of Col. Robert Perkins, commissioner of the American Red Cross in Italy. Collins's book, *My Italian Year*, proves that at least one man found time to enjoy the city of Rome and to study the Roman people even while deeply engaged in humanitarian labors. Collins is anything but frivolous. He justly claims that his familiarity with Italy since childhood, his admiration for the Italian people, his professional training as a dispassionate observer, and the contact with Italians of all classes that his assignment brought him made him exceptionally qualified to write about Italy. Moreover, his point of view is proudly and specifically American (and sometimes medicinal); the book is adapted from letters written between December 1917 and December 1918 to someone "in the land that has radiated and reflected the

light of liberty to the whole world; the land in which humanity fought its most glorious battle of the nineteenth century, and which to-day is the source of a purifying stream of liberalism in which are being washed the sins of militarism, class, and dynastic privilege." As Collins's watery metaphors constantly suggest, liberty and equality are American ideals of civilization second only to cleanliness, and by these modern Italy is to be measured. As a doctor, Collins has much to complain of about Italians, but that is only because he is "prejudiced wholly in their favor," believing their potential to equal the achievements of their "incomparable past." Their "conduct and aspirations" of 1917–18 "merit the admiration and sympathy of every lover of liberty."[7]

The "indescribable filth" of Italian towns that so horrifies Collins is not unrelated to the problem of inequality. He finds it intolerable that "the country which had the Cloaca Maxima two thousand years ago" should now be so guilty of "gross and callow infractions of Hygeia's simplest rules," but the offense—which is much greater in the small towns near Rome than in the capital itself—is to be blamed upon those irresponsible Roman princes who ignore the conditions of the villages they virtually own and from which they profit, villages in which entire families who have never bathed sleep in the same bed with the windows shut. This observation is prefatory to a chapter that gives a complete analysis of the five classes of Italian society. At the two extremes it attacks the nobility at the top and celebrates Il Popolo, the mass of people at the bottom. Collins is disturbed that after two generations of "a constitutional monarchy, the equivalent of a true democracy," the "class differentiation in Italy is still distinctly made." Some particulars and peculiarities of Collins's elaborate but often confused and self-contradictory description of the social extremes and the middle are worth noting for the ideals they assert and, in some cases, for their novelty.[8]

The growth of the middle classes in Rome after 1870, and the particular nature of Collins's work, which facilitated familiarity, made them available as a virtually new subject for an American writing about Rome. Although still not a majority of the population, they are recognized as the effective rulers of the New Italy, as they are of all modern societies. Collins describes them in positive terms as intelligent and industrious, although hindered by the inefficiency of a labyrinthine governmental bureaucracy, to which Collins devotes a separate devastating chapter. Their chief fault is their extreme individualism, which makes them incapable of "teamwork" and manifests itself in unjustified conceit. They are, however, neither boastful like the Americans nor predatory like the French of the same class. Their chief virtue is their tolerance, which makes living among them so pleasant for anyone who has "suffered from the bigotries and narrow-mindedness" of other societies. The "spiritual freedom" they permit "is to be had nowhere else in the world." Middle-class Italians are rarely snobs, and "there is a great desire for liberty, a widespread belief in equality, and more evidence of fraternity than in any country I know."

In this dominating middle-class atmosphere of the New Italy, the aristocracy as Collins sees it appears completely anomalous. The nobility is notable primarily for its superficial charm, its hedonism, its provinciality, its ignorance, and its exclusivity. It is divided into two groups, both politically irrelevant. One consists of

surreptitiously pro-Austrian, pro-German, and anti-Italian supporters of the pope, and the other of ostentatiously pleasure-loving snobs and royalists, so old-fashioned in their presumption and conduct (they even fight duels) as to make one wonder if they are "living in the twentieth century." Among these, sexual licentiousness is prevalent. The women are as proud of their adulterous escapades as men are in Anglo-Saxon countries. More strangely yet, lesbians are not regarded with much "disparagement or contempt." Male homosexuals, however, are "looked at askance by all healthy-minded members of the community," producing "that profound reaction accompanied by contempt, disgust, and anger which it does in other communities." This "strange and inexplicable abnormality" in the nobility is apparently the growth of centuries of indolence and luxury, which "modern civilization and modern morality" have not yet been able to "eradicate." The scientific Dr. Collins takes comfort in the thought that "it is quite likely that evolution in its beneficent, mysterious way is gradually eliminating the class which has always fostered" homosexuality, so that the "strange deviation from the physiological norm" will disappear along with the superfluous aristocracy itself.[9]

While the nobility disappear with their vices, the people are advancing, and to them Collins devotes an entire chapter. They are today Italy's "chief asset," although "neglected and treated almost with contumely," while the nation's other two assets—its monumental and artistic inheritance from antiquity and from the Renaissance—are venerated and protected. Collins cannot understand the government's indifference to the people. Its failure to enforce the law requiring universal education seems deliberate, an apparent concession to the Church's disapproval of state-sponsored schools, which has left 60 percent of the population illiterate. Yet the peasants of Italy are more admirable than those of any other land: more courteous, peaceable, moral, family loving, hard working, and stoical. Their "democratic" government simply exploits these virtues and taxes the people excessively, failing to provide them with fresh water supplies, good roads for delivering their produce, and instruction in modern agricultural methods. This "medieval" condition produces Italy's greatest contrast with America: the absence of social mobility. The rise of the talented and meritorious individual from the proletariat to the middle class—and even to the top of society—that is so common among us as to seem the norm is the rare exception in Italy. A second great contrast resulting from the class division is the fact that in Italy the laboring class is not paid a just wage. Employers there are interested only in paying as little as possible, and they can get away with it because unemployment is so great and because the working class does not realize its power. Italy cannot be proud, nor its future glorious, until it recognizes the "dignity of labor." But "justice" will come not through the "altruism" of capitalists but through the "universal education" of a united proletariat. And it will happen, for the "glory" of the war redounds entirely upon the people, who have been the "bone and sinew" of the army and "have sacrificed themselves to the fulfillment of the destiny of their nation":

> This war has tapped the springs from which will flow the stream of liberty which will refresh, revive, and regenerate the people of the world. . . . It is the fulfillment of the promise that the meek and the lowly shall inherit the earth. *Il popolo* are

about to take possession of their estate. In no civilized country, save Russia, have they been so long and more studiously denied it as in Italy.[10]

The Mazzinian strain here is stronger than the Marxist. Collins is thrilled to recognize, in the speeches of politicians and in the editorials of newspapers, echoes of "the great prophet's ideal of liberty," and he lets them guide his attempt "to interpret for myself Italy's aspirations and ambitions." He would not be surprised to see Italy become the military "liberator" of those countries still oppressed by Austria, her own ancient oppressor. And what he thinks Italy most needs is not another Cavour, the "executive" genius whose absence is so commonly lamented, but another Mazzini, "a prophet, an artificer of its potentialities, a visionary who can see its future mantled in the glory to which it is entitled by its traditions and its possessions." Perhaps Italy needs someone who combines the qualities of "prophet, agitator, and politician" to place her "amongst the most favored nations," but if the awaited leader—Il Duce—can be only one of these, let him be like Mazzini.[11]

In the last months of 1918, Collins detects in the Italians a growing distrust of her allies—especially France and the United States. Italy's "aspirations" to "redeem" the northern Italian-speaking provinces and to weaken Austria forever do not coincide with France's primary fear of Germany and are not "understood" by Mr. Wilson, who is venerated along with Washington and Lincoln for his liberating idealism, but seems indifferent to Italy's particular patriotic hopes. Her great victory over Austria in early November is celebrated in a strangely temperate and dignified manner in Rome; New York on a New Year's Eve is noisier and more animated. Relief and gratitude for the end of the war are deeply felt by the Romans, but "in nothing has their conduct been so commendable as in victory." Yet their joy is perhaps moderated by some uncertainty about what the reward will be for their sacrifices. Collins himself is far more effusive about the war's results. Italy has achieved a "glorious victory and national solidarity which has never been excelled and which will be for all time a monument to her glory."[12]

Moreover, the war has, as Page also claimed, created a permanent bond between Americans and Italians. America came as "their big brother" who was willing to "walk side by side with them over the road that led to liberation." In America Italy saw a republic "which had entered the world struggle with no other end in view than to safeguard liberty for the whole world and to permit mankind to enjoy its beneficences." On their side, the thousands of Americans who had arrived to aid Italy in the last year of the war had had the opportunity to learn, as Collins had, that the much-maligned modern Italians possessed the "capacity to carry themselves again into a commanding position in the world," to resume "the marvelous role that [Italy] played in cradling and perpetuating civilization"—the soul of which is freedom. But the burden of civilization's preservation and progress is now shared. Italians realize that "the spirit and doctrines of their great political apostle and seer [Mazzini] have had a marvelous quickening in the great republic across the Atlantic, and they hope to share in the fulfilment of our hopes for the political and social betterment of the world."[13]

While making his anxious running analysis of the changing social and political conditions of Italy during a particularly crucial year in her history from the point of

view of someone caught up in America's own militant and self-idealizing emergence as the agent of world peace and democracy, Collins did not fail to enjoy simply living in the city of Rome. Even though he admits to guilt feelings about such things as attending Sunday concerts in the Augusteo—the ancient imperial mausoleum that now served as a theater—while breadlines for refugees formed nearby and soldiers were dying in the North, his two finest chapters about Rome are not those in which he attempts impossible generalizations about the Italian people or dutifully describes the workings of "the government machine." They are completely personal chapters called "Summer Sundays in Rome" and "Walks in Rome." In the year that Collins was there, the appearance and atmosphere of the city were, of course, unusual. For one thing, Rome was for the first time in memory a Rome without tourists. With them had disappeared the flowers and loiterers of the Piazza di Spagna, and the shops in that area lost their glitter. The monotonous green-gray of army uniforms filled the streets, and the gay luxury hotels of the Via Veneto, requisitioned by foreign bureaucrats, looked like unfashionable pensions. But in spite of these differences the essential Rome persisted, and it was this Rome that Collins absorbed anew.[14]

Wandering from church to church on Sunday mornings, he is, as a medical man, revolted and depressed by symptoms of unhealthy celibacy in the celebrants of the Mass and must himself be restored to good spirits by Raphael's Sybils in Santa Maria della Pace, whose healthy paganism suggests to him that he would do better to spend his Sundays reading Whitman's *Leaves of Grass*.[15] Far more satisfying than the Sunday strolls, which tend to disturb him with thoughts about a religion both familiar and despised, are his daily two-and-a-half-mile walks across the city from the top of the Janiculum to the top of the Pincio. When the American Academy arranged to rent the Villa Aurelia to its friends in the American Red Cross—partly to keep it from being requisitioned by possibly more destructive agencies—it provided Col. Robert Perkins and his staff with accommodations more grand than they were convenient to the headquarters on the Via Veneto.[16] But for someone like Collins, able to appreciate the privilege of such a site and of a daily traversal of the city, it was ideal. The all-encompassing view from the Janiculum was to become, thanks to the academy's location there, the vista most appreciated after the Second World War by American artists and writers, but Collins was the first besides LaFarge to devote several pages to its unrivaled historical interest and visual splendor.

Even more rewarding is the Whitmanian city walk that begins there and occupies an entire chapter in the recounting. Through Garibaldi's battlefield and the Porta San Pancrazio, past the gushing waters of the Fontana Paola, down the Via Garibaldi by Bramante's Tempietto to the gate of the Bosco Parrasio and out onto the Ponte Sisto, where he pauses to take in the celebrated view of St. Peter's dome floating above the Tiber in the morning light. Then on through narrow streets along the towering wall of the Palazzo Farnese and the ornate façade of the Palazzo Spada, across the Campo de' Fiori with its lively market and monitory monument to Bruno or, by a detour cutting through S. Andrea della Valle (which makes him forget to hate the baroque), passing by the curved and columned façade of the Palazzo Massimo, pausing inevitably before the Pantheon, and often finding the pull of its light-filled interior irresistible and reminiscent not of gods but of Hawthorne and his

Hilda and Kenyon. Going on around Santa Maria sopra Minerva to the Piazza Colonna with its great column of Marcus Aurelius, most exemplary of emperors, and on up the Via del Tritone to the superb Palazzo Barberini and the Church of the Capuchins, where Collins's old-fashioned taste still urges him in, to see Guido Reni's *St. Michael.* But there begins the broadly curving Via Veneto, and the "last half mile of my journey for health and edification is uninteresting. New Rome is not perhaps ugly, except in spots, but it is not by any means beautiful."

Elsewhere in the book Collins twice attacks the three architectural monsters of the New Rome so admired by Lilian Whiting—the Victor Emmanuel Monument, the Palace of Justice, and the Bank of Italy—and he singles out the just-finished House of Parliament for several pages of scorn. All four of these buildings seem to him unfortunately accurate reflections of Italian political rhetoric: inflated, ponderous, excessively ornate, aggressive, irrational, psychologically disturbed and disturbing. But in the joyous chapter on his daily walks, these horrors are carefully avoided, and Collins concludes not with sour lamentations on the loss of the Villa Ludovisi but with a celebration of the people he has encountered in the streets and piazzas along the way: a "fine people, a self-respecting people, a respectable people, [and] a fine-appearing people." Animated, curious, and courteous, they are a pleasure to walk among. Their "civility and kindliness and urbanity," he writes (still in the days of war), "helps to give one a feeling of being more at peace with his fellow men here than anywhere else."[17]

In January 1919, Woodrow Wilson was jubilantly received in Rome as the first American president to visit the city while in office, and as the great visionary hero of the people of the world, on his way to the Peace Conference in Paris that he intended to dominate. As a Type of the American, only Buffalo Bill in 1888, racing his Indian braves against the cowboys of the Campagna, and Wilbur Wright, "soaring over the towers of Rome" like Daedalus in 1908, had been heralded with comparable enthusiasm and curiosity.[18] In John Dos Passos's *1919,* Richard Ellsworth Savage, now a captain in the army, is sent to Rome to aid in the preparations for Wilson. The visit of the great idealist is observed from Savage's point of view, and postwar Rome itself is perceived through the bleary, sensual eyes of Savage and his old friend of the Red Cross Ed Schuyler, and through those of Anne Elizabeth, a naive girl from Texas. For the first time in American fiction (Wilder's hesitant *Cabala* excepted), the sensuous nature of the city becomes overtly sexual. What was hinted at between the lines of Hawthorne and James, or openly condemned by Jarves and others as an aspect of Italian immorality in which Anglo-Saxons were assumed never to participate, now emerges as one of the pleasures of the place. Schuyler has got himself into a conventional adulterous relationship with an Italian woman, but his encounter with the outraged husband is treated as the harmless stuff of standard comedy. Rome's hedonistic atmosphere is the undoing of the virginal Anne Elizabeth, a Daisy Miller of the new age who can travel on trains alone: "She wanted all the time to throw herself in his arms; there was something about the rainy landscape and the dark lasciviouseyed people and the old names of the towns and the garlic and oil in the food and the smiling voices and the smell of the tiny magenta wildflowers he said were called cyclamens that made her not care about anything anymore." The

atmosphere of la dolce vita that would characterize post–World War II fiction was thus already defined by Dos Passos. "People sure do things over here they wouldn't do at home. . . . I declare it's peculiar," says Anne Elizabeth. "I guess it's the war and Continental standards and everything loosens up people's morals." To which Dick replies with a smirk, "In Rome do as the Romans do." But who were the Romans? And what *do* the Romans do? The sexual flirtation develops against a background of bands practicing "The Star-Spangled Banner" and the hoisting of American flags.[19]

Savage witnesses President Wilson's visit to the Forum, where an Italian official points to the temple of Romulus and says, "Everything here bears relation to the events of the great war," to which Mr. Wilson replies, "That is true. . . . We must not look upon these ruins as mere stones, but as immortal symbols." The Italian then graciously suggests that "in America . . . you have something greater, and it is hidden in your hearts." The president agrees with this, too, saying, "Yes, . . . it is the greatest pride of Americans to have demonstrated the immense love of humanity which they bear in their hearts." Through "the cock's feathers of some Italian generals," Savage can see Wilson's "gray stony cold face grooved like the columns, very long under the silk hat." Afterward, on the Capitol, Wilson is made a Citizen of Rome, and Savage sees him as "one of those old Roman politicians on a tomb on the Via Appia." The similarity is meant to be damning: "Do you know what we are, Anne Elizabeth? we're the Romans of the Twentieth Century; . . . and I always wanted to be a Greek." Anne Elizabeth is Wilson's warm admirer; but Savage tells her that in the peasants' huts of Italy people are praying before the bloodless Wilson's photograph, and their prayers will not be answered. "I'm damned if I'll be a Roman," says Dick, "let's stay human as long as we can." Whereupon Anne Elizabeth loses her virginity. Later Savage wanders among the excited crowds on the Corso, where America is being honored with flags and illuminations. He is picked up by some Italian officers as their special friend: "It was all asti spumante and Evviva gli americani and Italia irridenta and Meester Veelson who had saved civiltá and evviva la pace, and they ended by taking Dick to see the belle ragazze."[20]

Dos Passos's heavy ironies reflect the disillusionment with Wilson that the Italians were the first to experience. After what they saw as his betrayal of them at Versailles in April, their strongest term of abuse for an American tourist became "son of Wilson." According to the journalist Edgar Mowrer, the "Presbyterian President" by 1921 was "remembered only as the tyrant who robbed Italy of her victory."[21] It was in this hostile atmosphere that the sixty-seven-year-old Robert Underwood Johnson, author of *Italian Rhapsody and Other Poems of Italy* (1917), arrived in Rome as Wilson's appointee in 1920, anxious to put the best face on matters. According to the autobiography of Edgar Mowrer's wife, it became immediately obvious that Johnson was a politically naive diplomatist who made matters worse by cheerfully admitting his ignorance.[22] But in his own autobiography, *Remembered Yesterdays* (1923), Johnson naturally presents himself as an astute and successful mollifier of the exacerbated Italian soul.

Johnson had first visited Rome in 1886, and he recalls how even then Rome remained a "picturesque pageant" in which one saw the "soldierly King Umberto" and the "gracious Queen" driving "fearlessly among the people" on the Pincio. In casual allusions to Roman monuments Johnson frequently seems to share Mark

Twain's convenient assumption that everything—including the Colosseum—can be attributed to Michelangelo, but he shows more precise familiarity with the building that had become known in Anglo-American circles as "Hilda's Tower," from its use in Hawthorne's *Marble Faun.* Best of all he knows the cypresses that express the "spirit of Rome" over the graves of Keats and Shelley. Johnson is one of those who tries to see Rome poetically as the Old Rome he never directly knew, but had read about and heard about from those who had known it. On all his visits Johnson went faithfully to the studios of Elihu Vedder and Moses Jacob Ezekiel, last representatives of the artists who came to Rome when it was primarily a city of art. His special contributions to the city before his arrival as ambassador had consisted of efforts to preserve the Anglo-American Rome of the old time—hardly the prime concern of the New Italy. One stanza of his largely vacuous "Italian Rhapsody" evokes the graves of Keats and Shelley and refers to the Spanish Steps beside which Keats died. In 1903 Johnson had written a poem in the Piazza di Spagna itself, on St. Agnes' Eve, which protested the plan to remove the boat-fountain to make room for a tramway: "Rome, symbol of all change, oh, change not here!" (It didn't.) In another poem, called "The Name Writ in Water" after Keats's famous epitaph, the fountain whose unceasing sound the dying poet had heard now paradoxically fulfills his wish and subverts his intention by babbling eternally of his fame. During 1906–08, Johnson had been one of the leaders in what Lilian Whiting called the movement for "consecration" of the house beside the Spanish Steps. The successful establishment of the building as the Keats-Shelley Memorial is the subject of still another poem, "To One Who Never Got to Rome" (1908). Although Johnson was proud of such proofs that he was a "friend of Italy," his backward-looking vision of the romantic foreigners' Rome made him an odd ambassador to the New Italy which, like America itself at this time, was above all anxious to be taken seriously as a modern power, ready to "take its place . . . among the nations."[23]

On June 8, 1917, Johnson had made an attempt to arrive at a more contemporary sense of Italy by addressing it as "The Crowned Republic" upon the occasion of America's entrance into the war, at which time he also became active in the American relief efforts for Italy. In the poem Johnson's laboriously rhymed tercets trace the growth of liberty and nationality from Dante down through the great figures of the Risorgimento and conclude by apologizing to Italy for America's tardiness in realizing "The incredible cunning of the monstrous plan / Whereby the spider State has set its web for Man." American ships will now sail bravely above the "iron sharks" of the Germans, bringing men and munitions to Italy. Italian and American flags will be joined on the battlefields of Freedom, for we have heard the trumpet call of Garibaldi, "Who found his foster land what thou wert born to be!"[24]

During his tenure as ambassador Johnson's concern was to reassure the Italians that American civilization still represented a worthy model and destiny. No doubt with Page's resignation after Versailles in mind, Wilson had warned Johnson "not to be so Italian as to forget I was an American," and Johnson agreed that there were inherent differences—chiefly temperamental—between the two peoples. But he holds that in their ideals of democracy and freedom they have a common cause. "These are men that fought for us two years before we entered the war," he thought as he watched a parade of Italian veterans. And to prove America's worthiness he

never ceased to remind "our Italian friends" of the "disinterested motives which led us into the War." Other "conspicuous examples" of American "altruism" were cited to "offset" the frequent charge that American civilization was purely commercial: the "open door" policy in the East, our "two retirements from Cuba," our "virtuous second thoughts" about unequal tolls on the Panama Canal, and our Monroe Doctrine "for the benefit of the Spanish-American countries." These facts, says Johnson, were "revelations to my audiences" that restored some of America's moral prestige.[25]

Johnson's year as ambassador coincided with the year spent in Rome by Elizabeth Hazelton Haight, professor of Latin. But the city of her *Italy Old and New* (1922) hardly seems to be the same one that Johnson knew. The more complex character of the New Rome, the altered position of both the American and Italian nations in the world, and a greater diversity in the interests of Americans arriving in Rome meant that for the first time entirely separate "American" Romes, one hardly impinging upon the other, could be recorded as existing at the same time in the same geographical space. The separate worlds of Haight and Johnson converged only on the occasions of the great patriotic spectacles that now became a major feature of the city's life, and even these were differently perceived.

Johnson, his wife, his son, his daughter-in-law, and his granddaughter all lived in the Grand Hotel because the stupid Congress and State Department still had not realized the necessity for a permanent embassy to prevent the humiliation of its representatives who could not afford to lease a palazzo of their own. Johnson's style as host was consequently cramped, yet his world was one of grand diplomatic receptions, and he made the most of them. Haight, in contrast, like many an academic to follow her, lived happily in a top-floor *pensione*. Hers was on the Piazza dell' Esquilino opposite the choir of Santa Maria Maggiore, and she had a view of Garibaldi on the Janiculum in one direction and of the Alban Mount—where the son of Aeneas had settled—in the other, a totally satisfying comprehension of both New Rome and Old—by which, of course, she meant ancient, not papal. Johnson delightedly described the three black coaches with black horses that carried him and his staff to the Quirinale to meet the king, where they were greeted with a fanfare of trumpets as they passed through the portal. Haight wrote an entire chapter called "The Joys of the Orario" about how in these days you can get almost anywhere—Hadrian's Villa or Horace's Farm—by trolley. Haight even went up in an airplane for twenty minutes to see Rome from a uniquely modern angle of vision, but Johnson went up twice in an Italian-built dirigible that America was buying and flew all the way to Naples in it. From the novel perspective of the city enjoyed by the passenger standing out on a deck nine hundred feet above the ground, "the walls and gates were well defined, and through the opera glass we could descry the details of the famous monuments . . . the Lateran, the pyramid of Cestius and the dark cypresses near the graves of Keats and Shelley, the royal palace of the Quirinal and its garden, the ruined baths of Caracalla, the green Forum and Palatine, the great Victor Emanuel monument, white and impressive, the Pantheon, . . . the Janiculum Hill with the beautiful American Academy, the Borghese and Pincian gardens, . . . the shining and sinuous Tiber, the Coliseum and St. Peter's." Johnson proudly recalled how he turned this occasion into a diplomatic coup by announcing on April 21,

Rome's Birthday, that the American government would retain the dirigible's original name, *Roma*.[26]

As with Ambassador Page, the people of Johnson's Rome are naturally the official and the powerful: he first received "His Majesty" at the opening of the annual exhibition at the American Academy; then he and his wife were presented to the queen and to the queen mother, after which Mrs. Johnson was "at liberty to call upon other Ambassadresses of older service." The entire international diplomatic corps existed to be cultivated, a job he found easy since "it is not difficult to represent a people whose history has been an epic of kindness to so many others," and when a fellow diplomat called upon him he was always ready to get down the atlas to find a country like Colombia if he did not know where it was. There were, too, the social entertainments of those "several American ladies" who had served "for more than one generation" as "hostesses to American visitors" in their splendid palazzi. And Italians and Americans got together not only at official dinners but at private teas, at the traditional receptions on Thanksgiving Day and Washington's Birthday, and at one grand American ball offered to the cosmopolitan world of Rome. Unfortunately the death of Her Majesty's father meant that for a year there were no court balls like those Mr. and Mrs. Johnson had enjoyed in 1903 and 1906, but royalty did give a dinner at the Quirinale for the king and queen of Denmark of a splendor sufficient to merit an entirely separate section of Johnson's autobiography. Finally, the ambassador took pleasure in presenting "famous American men of affairs" like Mr. Charles M. Schwab to Count Sforza, the foreign minister. Johnson took notice of the "striking contrast between the tall slender aristocratic Italian nobleman with a countenance like that of a Tintoretto portrait and the robust, vivacious 'captain of industry.'" It was wonderful how two peoples so different could find a common cause in business.[27]

Elizabeth Haight begins with the people in her piazza—the chestnut-roaster in the fall, who is replaced by the cherry-vendor in the spring. One chapter concerns a peasant family on the Campagna that lives with beautiful simplicity in a hut like that of Vergil's Evander; another chapter—concerning the coffee and teashops of Rome—reaches its conclusion with a heroic story of the war, like an episode from an epic, told to her in her favorite café by a sergeant from Sicily. Still another essay gives the results of Haight's investigations into the life of Italian women: has the war returned to them some of the freedom, prestige, and power enjoyed by the *matronae Romanae* of the Republic and Empire? Very little. There are a few women doctors, lawyers, and professors, but the lives of most can be extended and improved now only through work in nursery schools and greater education in child hygienics. Haight also thinks the most serious need of the Italian women is for physical education, like that offered at Vassar College. But she recalls that at Vassar there is a stained-glass window representing the conferral of a doctorate upon a seventeenth-century Venetian woman at the University of Padua. The intellectual capacities of women were first recognized in Italy, so cleaner babies and stronger bodies define only the first stage of their modern aspirations. The "American ladies" in their palazzi, however, have no significance at all for Haight. Neither does the all-male American Academy. But Vergil, Ovid, and Horace are sufficiently effective letters of introduction to the Roman people, the people who matter to her.

 The one pleasure that Johnson and Haight shared that year was in the patriotic
spectacles at the Campidoglio and in the adjacent Piazza Venezia, which had been
enormously expanded by the modern government precisely to provide for quasi-
religious rituals before the Altar of the Nation at the Victor Emmanuel Monument
abutting the hill of the ancient Capitol. The special celebration of the fiftieth
anniversary of *Roma capitale,* and the annual commemorations of the Italian
victory at Vittorio Veneto in 1918 ("the greatest single victory of the war!"),[28] gave
magnificent reassurance that beneath the divisive turbulence of these postwar years
there existed a proud and passionately unified patria. But the volatile and often
violent political situation itself was something neither the diplomat nor the pro-
fessor of Latin could overlook while they waited for ceremonial confirmations of
unity. Johnson made jokes about labor strife and the occasional Communist bomb-
ings, and was thanked by the worried Italian government for officially notifying his
State Department that Italy was perfectly safe—all those rich but timid American
tourists ought not to be afraid to come, for there would be no Red revolution.
 Haight's political education began in her own piazza, whose great flight of stairs
in front of the church provided "an excellent rostra" for orators from various parties.
The poor priests, to be sure, had to spend time scrubbing graffiti such as " 'Qui regna
il falso,' 'here reigns the false' " off the walls of Santa Maria Maggiore; and some-
times "ardent youths" who shouted "Viva la Russia" and "Viva Lenin" at an orator
from the Popular (clerical) party had to be discouraged from greater violence by a
show of mounted guards on one side of the church. Occasionally "resplendent
carabinieri" had to give extra protection from angry citizens to the nearby residence
of the "god-like" Giolitti, minister of the interior. Elsewhere in the city Haight
attended all the popular seasonal festivals to get a sense of the fundamental culture
of the people, and she frequently went to sessions of the Socialist-dominated House
of Deputies, the riotous nature of which confirmed her sense of Italians as individu-
alists committed to the right of free speech. Roman popular and political life was
extraordinarily democratic, colorful, and exciting, and Haight knew from her clas-
sics that great Rome, mother of our civilization, could survive whatever came.[29]
 What was coming made its appearance that very year—1920–21. For both Haight
and Johnson it seemed only one faction of the general political strife, but a faction
rather more comforting than disturbing. In Haight's book the Fascisti first appear in
a context that, with our hindsight, seems particularly inappropriate: right after her
description of the children's festival that accompanied the blessing of the lambs at
San Giovanni Laterano. Haight's theme is the "vivacious self-expression" natural to
the period of adolescence that follows childhood. In "this era of world-strikes and
group action," there is nothing "strange" about "students in Italy banding together
in public demonstrations which are as innocent as they are lively." It is all songs and
speeches, ending in peaceful dispersal by the Royal Guard. One day Haight saw the
hymn-singing "young Fascisti" marching up the Corso Umberto calling upon all
patriots to display the Tricolor. So "from Palazzi, office windows and shops, men
looked out tolerantly and with good-humored response unfurled their flags until the
Corso was brilliant with the waving red, white, and green." Later she comments
that the formation of the Fascisti after the war demonstrated the "innate reverence"
of Italians, especially in the presence of death. These young men had "banded

together" in honor of their half-million dead "brothers" in order to realize "some of those ideals-in-words for which they fought." And it is the admirable willingness of Italians to "experiment" that allows both workmen to try to operate factories and "forty Fascisti, elected deputies on a vague program and with no party affiliations, [to] dash into the Arena of public life chanting 'Ci siamo noi,' 'We are here,' and attempt, like the knights of the round table, 'to right all wrong.'"[30]

One of the wrongs that the Fascisti righted, as far as Ambassador Johnson was concerned, was on the occasion of a general strike that left his family without service or food in the Grand Hotel. This development he did not regard, like Howells, as an exhilarating anticipation of a future world of workers united. The Fascisti, he gratefully reports, "took the vacant places . . . , and we had the honor of being waited upon by young veterans of the war, many wearing medals of valor, and by undergraduates of the University of Rome, to none of whom, of course, could one offer a gratuity in appreciation of such public-spirited service." To Johnson this episode was simply a personal instance of the general justification for the existence of the Fascisti: throughout the nation they were a force for law, order, and civility, responding to the anarchic violence perpetrated by "Bolshevists." The "dastardly" attempts to overthrow constitutional government by means of "systematic propaganda among the Italian laboring classes," paid for by foreign agents, sometimes led to violence. But most Italians were "too just and too honest" to be convinced that they somehow had a right to the factories and farms where they worked—including some in which "American capital was largely invested." Realizing their failure, the Bolshevists turned to "tactics of personal violence" against their opponents. But "the patriotism of the people" produced a counterforce "which developed into the Fascisti." This "interesting body of vigilantes, (as they would have been called in California in 1849), had been organized by Benito Mussolini . . . to demonstrate that the people would support law and order even if they had to fight to obtain them." But when the bands became aggressive rather than defensive, "it seemed as if the cure might be worse than the disease," and worst of all, their "super-activity" reinvigorated the Socialists. Fortunately, the government was able to achieve a pact demobilizing both sides of the conflict and returning law enforcement to itself. Italy, Johnson concludes, is fundamentally conservative, and against the "Bolshevist, as against the Germans and Austrians," she "has held firmly 'the right of the line' of civilization."[31]

How glorious is the civilization she upholds is evident to both Haight and Johnson in the celebration of Vittorio Veneto in the Piazza Venezia. This five-hour-long pageant, in which regiments from all over Italy march to militant music while carrying war-torn banners up to the Altar of the Country and then mass themselves beneath the towering white wall of marble that masks the Capitoline Hill, thrills Johnson and Haight equally, although they watch it from entirely different vantage points. On the raised broad terrace at the center stand the king and queen and ministers of Italy, and the ambassadors of the world. Among these we find Ambassador Johnson, enjoying a view down the full length of the Corso to the Egyptian obelisk in the Piazza del Popolo and proudly noting that he, "the American representative," has been ushered to a spot where he stands "shoulder to shoulder with the Duke d'Aosta, and just behind His Majesty," who actually turns to shake hands

with him. No one in Europe, thinks Johnson, is "more democratic" than the kings of Great Britain, Belgium, and Italy. It also occurs to him that "I had a right to be part of this sacred ceremony, for were not these our comrades in one, great, never-to-be-forgotten cause?" To Johnson the elaborate but flawless pageant demonstrates "the forces of law and order"; "it was a good day for militant Socialists to stay at home." But most of all it reminds one of the "colossal contributions" Italy has made to "the progress of the world," the victory of Vittorio Veneto being merely the "most honorable" recent achievement. "She is indeed the best-loved daughter of History."[32]

So thinks also Elizabeth Haight, eagerly standing on tiptoe and looking between heads as one individual among the masses in the square below. Perhaps she sees nothing quite so humanly moving now as she had at the fiftieth anniversary celebration in September, when she had watched forty Garibaldini, "old, old men in scarlet shirts and caps, proudly stumping up the slope of the Capitoline, the heroes of the day for the sake of their youth when they had flung lives and fortunes into the cause." But their heirs, the young veterans of the recent Great War who are chiefly honored upon the present occasion, have their own grandeur, and with them too "Italy in silent reverence seemed to reconsecrate herself to united effort towards those ideals of liberty, democracy, and justice for which she had believed she was fighting." The transcendent meaning of both ceremonies is thus one of national resurrection and continuity. This is what we "Americans in our young nation" often fail to understand about Italy, because we cannot conceive of "the tremendous and steadying power that great traditions of thousands of years of history have upon the descendents of Romulus." Watching the marching regiments while airplanes circle overhead, Haight feels "with the great crowd in the Piazza that the strength of Italy which Vergil pictured before the Emperor Augustus on the Palatine was here born anew, consecrated by the blood of her dead, and assured by the devotion of her sons."[33] In Haight's unconscious identification of republican idealism with imperial glory we can see the ease with which, in the rituals of patriotism, the poetry of national freedom enhances the lust for power.

Edgar Mowrer's *Immortal Italy* was published in the same year as Haight's Vergilian vision of modern Italy, 1922—just before Mussolini assumed power. Like Johnson, Mowrer too believed that the king had managed to disarm both Socialist and Fascist sources of disorder. The dedication of the book refers to Italy as "an oasis of social and intellectual freedom," and the first chapter, called "Where Dreams Come True," asserts that "Italians are closer to the thing called civilization than any other white man." Their Latin tradition "stands for civilized living, with its virtues and defects," and however low they fall, "they can never become barbarians." Their combination of old traditions and modern innovations gives their country a "universal spirit—so broadly human compared with the petty nationalism of other countries." Indeed, the hope for the future rests upon this supposedly "moribund land of beggars and museums," not upon America with its ephemeral skyscrapers, constant change, "aimless activity," and "unlimited self-esteem." Italy offers instead "contemplation, skepticism and enduring monuments."[34]

The exalted nature of Mowrer's ideal of Italy, however, is what causes his book to be largely a heroic effort to forestall disillusionment. In chapter after chapter the

journalist accumulates evidence of New Italy's failures, of the maddeningly intractable nature of her problems, of innate defects in the character of her people. From his arrival in May 1915 until his departure in 1923, when Mussolini's power was absolute, no American lived more sympathetically or hopefully among the Italians, so none was more frustrated by the reality. His belief down to 1922 was that to know Italy intimately was to become fully human, which meant to transcend nationality, to free oneself from parochial prejudices of all kinds. It taught one to be "less superficially optimistic but more soundly hopeful for mankind, and at the same time more charitable and tolerant of human sins." There was in Italy none of the coerced moral and intellectual conformity that characterized Prohibition America. The Mowrers welcomed Sinclair Lewis and Ezra Pound on their visits to Rome as fellow spirits, and Edgar's book specifically reverses the nineteenth-century American attitude by praising the Italians for their uninhibited sexuality. Elsewhere he attacked America's hypocrisy and her subservience to "public opinion," that savage suppressor of all individuality and genius, with a bitterness that recalls Cooper's atypical use of Italy for the same satirical contrast so many decades before. But Mowrer's book is strangely divided against itself. He assumes that in spite of its superior plumbing, America has almost everything to learn from Italy and that "no two members of the white race are less fitted to get on together than the average American and the average Italian." And yet he seems as anxious for Italians to alter their ways as for Americans to do so, and much that he writes serves as documentary confirmation of American prejudices about Italian—especially Roman—indolence, dishonesty, superstition, and vanity.[35]

The chief virtue of the Italian, however, makes up for almost everything else, Mowrer claims. In developing this point, Mowrer writes more as the satirist of America than as the objective analyst of Italian life. He inverts received opinion about Italians and claims for Italy the democratic freedom that America boasts of but actually restricts. Contrary to everything that nineteenth-century American writers said about the Italian's childlike nature, "Italy is a land for adults. It goes to the extreme of considering each human being a responsible citizen, mentally and morally entitled to decide his own line of thought and conduct." Italy, not America, is Whitman's "great city," a "land where 'men and women think lightly of the laws.'" Americans are uncomfortable with democracy because they do not really like individualism; they prefer "social tyranny" and treat each other like "infants" who must be made to be good. Furthermore, Mowrer surprisingly asserts, modern Italy is also democratic in that "almost any one with qualifications can obtain entrance to what is called the best society. He is free—to become what his education and abilities permit." This is surely the first time an American made this particular claim for Italy, and its expression seems motivated more by a wish to contest America's assumption that such words described only it than by any justifiable confidence in the openness of Italian society. In the same manner Mowrer goes on to praise the "virtue of disorganization" that makes Italy the "land of liberty—a word that successive generations of Americans are less and less able to understand." Americans are free only to be good, never to choose for themselves, and they prefer a Prussian "forest of *verbotens*" to Italy's disorderly freedom. Thus to "many Americans, gasping for air in the grip of anti-white-slave laws, prohibi-

tion, anti-cigarette leagues, moral uplifters, Billy Sundays, Chautauqua orators, home missionaries, sociologists and efficiency experts, Italy may well seem the promised land."[36]

Just as most nineteenth-century American visitors needed to experience Italy as a Counter-Nation of Art and History, so Mowrer needed it to be a Whitmanian Counter-Nation of Liberty, Individualism, and Tolerance. In both cases Italy was valued for being what America was not. For Mowrer that meant further that Italy had to be a nation that, paradoxically, transcended nationalism. Nothing was more dangerous than the chauvinism that had caused the war in Europe and that now corrupted the American spirit. But the national soul that had been "reawakening" for a century in Italy was of a completely different character, for universality was of its essence. So Italy must "again become the teacher of mankind," for her historical mission is "to reconcile nationality and humanity!"[37]

With this view, it is not surprising that when Mowrer traces through several chapters the historical development of United Italy, his hero is the same as Margaret Fuller's, the visionary Mazzini. He is the "pure figure" whose "clear light" and "inexhaustible spiritual strength" made him the "soul" of the nation precisely because he based it upon universal human worth. Mowrer notes that naturally "an American" (Thayer) has written an "idolatrous" biography of the politician Cavour, who was actually merely the "brain" of the Risorgimento, as Garibaldi was the "right arm" and Victor Emmanuel II the "outer visage." By developing in its first stages as an anachronistic monarchy, rather than as a pure republic, United Italy to a degree betrayed its Mazzinian "soul." It also attempted, like America, to become a "Great Power" instead of a "moral force." Consequently between 1876 and 1914 its politics and commerce degenerated, and Giolitti the "dictator" built up "a political machine for graft and electoral manipulation superior to anything the United States can boast." Yet nothing in Italy is as bad as it seems, while everything in America is worse. That is because Italians are perfectly candid about their "arrangements" and hyperbolic in their attacks upon one another, while Americans are hypocrites and liars. No Italian politician has yet "turned national resources over to private pillage so shamelessly as in the United States and does not, in the British manner, confound commercial privilege and private riches with patriotism and religion." Yet it is true that public life in Italy is corrupt; its purification awaits the education of the Italian masses. Upon the "gradual awakening to public consciousness" of the common people, kept for centuries in "supine ignorance," Mowrer places his faith.[38]

The war provided the greatest impetus toward the necessary great awakening, according to Mowrer, and the second half of his book is devoted to the war and its aftermath. For "the sake of their country's soul," a "determined minority" forced Italy into joining the Allies against its ancient oppressor. "Official" Italy had its own nefarious purposes, but "the people entered the struggle in obedience to a deep instinct, a blind feeling for the better part, for the world's future." It was "a test of their moral right to democracy and independence, of their claim to respect, of their character and capacity." And it became "the triumph of the new Italian over the ignominious past." Mowrer's discussion of what the war meant to Italy comes close to supporting the doctrine of "purification through violence" enunciated by the Futurists, by D'Annunzio, and finally by Mussolini, but "purification through

national victory" is all that he really believes in. Italians, he says, are neither militaristic nor imperialistic, and this war was essentially a "moral" instrument through which the Italians were able to "purify" their "soul" by defeating Austria. In each soldier "an old Italian struggled with the new. On the one hand servility, selfishness, and skepticism; on the other will power, patriotism, and self-sacrifice." But "the strong prevailed"; "we foreigners were confronted with a new people; the *Risorgimento*, Garibaldi, the communes, ancient Rome became intelligible."[39]

Mowrer is angry that in 1922 everyone seems to recall most vividly Italy's "shameful" defeat at Caporetto in 1917 and to forget the ultimate victory at Vittorio Veneto in 1918. It was the defeat that made the victory possible, for it produced a great "change in the common soldier" when he saw the Austrians invading his country. Until then he had not known what he was fighting for. Now the *idea* of Italy became a reality to him. At the same time that Hemingway was in the war zone, absorbing imagery and theme for *A Farewell to Arms* and some of his most moving short stories, Mowrer was there, and wrote afterward: "Never have I lived in contact with another so exalted body of humble heroism." The common soldier's subsequent defense of the Piave was "the greatest military achievement of modern Italy." Economically the war was "a terrible disaster," but morally, patriotically, and politically "it was by far the most fruitful event" in Italy's "young existence." Unfortunately, its exalting effect turned ugly and mean as a result of the humiliation at Versailles in 1919. While France and England greedily enriched their commercial empires, Italy's desire for a few crumbs was somehow made to seem ignoble and was partially denied. "What the Italian nationalists have never forgiven Wilson and the Allies was less the loss of Fiume and Dalmatia than the destruction of the spirit of triumphant victory—a precious possession to a people but slowly awakening to national consciousness."[40]

But Mowrer maintains his "faith in Italy" to the end of his book, basing it upon his "acquaintance" with the "younger generation" that "held the Piave." After a chapter devoted to "The Revolution that Never Was," showing the failure of the Left, and a chapter called "The Reaction that Failed," analyzing the "momentary hysteria" that produced fascism, he feels he can conclude optimistically. His analysis of the Fascisti sees them as "similar in spirit to the more intolerant elements of the American Legion, not unlike in their methods to the ancient and revived Ku Klux Klan," although "they have outdone both." Acknowledging the complex, confused, and contradictory motives of the Fascisti as both reactionary and revolutionary nationalists, and sufficiently illustrating the manner in which they terrorized half the peninsula, throwing it back six hundred years to the strife of medieval factionalism, Mowrer nevertheless regards fascism as a somewhat comic phenomenon that can be written about in the past tense. "In Rome *fascism* meant little but Adriatic bombast," an assault on the baggage of "a bolshevik commercial mission," some searching of "a few peaceful citizens," the occasional "closing of shops by force," and "a rowdy national congress." In the national elections, their brutality was somewhat less innocuous, but itself produced a new movement in reaction, the *"Arditi of the People,"* who patrolled the streets of Rome and used the Fascists' own methods against them. "From all classes and districts appeals were lifted heavenward for peace," and the king on August 2, 1921, assembled the

warring factions and made them submit to sovereign authority. "Officially, the *fascist* reaction was over," and "Italy settled down to a condition of normal anarchy."[41]

In the unstable social peace that prevailed when Mowrer finished his book, he found reason for hope in his constant belief that during the war Italy underwent "a kind of conversion," and that this change in her "soul" had simply "not yet had time to emerge in action." Foreigners had better realize that the "typical figures are no longer (if they ever were!) the street musician and the handsome indigent count seeking to win the heart of an heiress." Through education, the majority peasant population of Italy will come into possession of its nation. The typical young veteran of the war will guide Italy to her Destiny. "For him the old question of Quirinal and Vatican has lost its bitterness." He does not fear an accommodation to the Holy See, but he does fear the pope's reemergence as "master of the entire country" through control of the Popular party if that party should win power. The king (so beloved of ambassadors) is now merely "a historic anachronism," largely irrelevant. Most troubling, however, are the "baffling and disastrous" activities of the governmental bureaucracy. That problem must somehow be solved, but "sooner or later this country, with its wholly admirable sense of civilization, its brilliant flowering of individual genius, its wide tolerance and humanity, will inevitably take a great part in the evolution of world culture and politics." Some of the younger men seem interested in "noisy nationalism and the worship of the big stick," so there is always a danger that "the spiritual revolution" will degenerate into "mere violence." Violence, however, "may well be preferable to subtle corruption and a first step toward honest readjustment." In any case, although democracy has been "partially discredited" by bad government, "there is no room for social or political reaction in Italy":

> To-day Italy remains, despite the *fascisti*, almost the only country where liberty and opinion are respected, where it is permitted to dissent from current opinion and, within limits, from current behavior. If the country remains true to its innate liberalism, it may come to take the place, once so proudly held and now so tragically abandoned by the United States, Britain and Switzerland, as a refuge for the persecuted and the dissenting, a shelter for the outcasts of to-day who blaze the trail for to-morrow.[42]

Mowrer and his British wife stayed on in Italy until 1923. Mrs. Mowrer, writing her autobiography in 1937, recalled the pleasures of a tourist-free wartime Rome, followed by unpleasant years of constant labor strife, anti-Americanism, and the rise of Fascism that began with the appearance of long-haired, black-shirted, swaggering bands of young men early in 1921. Her chapter called "The March on Rome" is an ironic and tragic addendum to the conclusion of her husband's *Immortal Italy*. The day itself—October 28, 1922—is vividly evoked: "cavalry and machine-guns at the city gates," telephone and telegraph lines cut, typewritten notices posted on walls throughout the city "announcing the arrival of the Fascists," Fascist soldiers assuming command of the principal streets without resistance from the Royal Guards, the king's refusal to follow his minister's advice that martial law be de-

clared, and from all parts of the country, "a poorly armed force of adolescents" marching along the roads toward Rome in the rain, singing "*Giovanezza, giovanezza*" (youth, youth). Within the city, the "Romans looked on, curious, chattering, gesticulating; the streets and squares were full, the cafés crowded." That night the Socialist press was destroyed. The next day the king invited Mussolini to come from Milan to form a government. He arrived in Rome by express train.

Five days later it was time once more to celebrate the victory of Vittorio Veneto before the *Altare della Patria* with the "magnificent procession" that had so excited Ambassador Johnson and Professor Haight two years before. Mussolini, in a frock coat, stood beside the king and received the salute of the marching veterans—the Blackshirts among them. Soon thereafter everything began to change in Mowrer's tolerant "land of Liberty." Mussolini's development of the personal cult of Il Duce even received the help of the new American ambassador, Richard Washburn Child, "a Harding appointee who became a chief personal admirer of Benito and a member of the Italian Fascist Party." A speech Child gave in defense of Fascism to the Italo-American Association in Rome received much attention because "never before had an American Ambassador so openly approved an un-American political philosophy in the country to which he was accredited." As for Mowrer, his wife remembered, he "lost all joy in his work in Italy":

> In Italy the story was finished. . . . Everything was being mashed into the standardized form dictatorship imposes: theatres, newspapers, conversation—every phase of life was censored; there were endless pompous parades and public speeches with militant celebrations of this victory and that victory; Blackshirt officers everywhere; a tremendous façade of importance and next to nothing beneath.[43]

In 1923 the Mowrers moved to Berlin.

Mussolini's Balcony

It was youth and the spirit of the crusaders that came swinging down the Corso toward us in the Piazza Venezia. They came with the swinging glad melody, Giovanezza, which was thrown back at them from the crowd, was echoed between buildings and filled the open piazza over the soil which once had felt the rumble of the triumphal cars of the Caesars.
—*Ambassador Richard Washburn Child, October 31, 1922*

The tall windows of the Palazzo Venezia opened. Benito Mussolini stepped to the balcony, two stories above the heads of the crowd. His short, peasant's body wore the black tunic, gray breeches, and black leather boots of the Leader of Fascist Italy. He scowled under a black cap with the golden eagle emblem of the Roman Empire. Almost simultaneously with the dictator's appearance, two other figures stepped to the balcony. One wore the navy-blue uniform of Adolf Hitler's civil service. The other was dressed in the frock coat, gray-striped trousers, and silk hat which form the diplomatic uniform of the Japanese. The crowd gave its customary triple cheer of "Duce, Duce, Duce," promptly, but without fervor.
—*Richard G. Massock, December 11, 1941*

The Palazzo Venezia, a grim fortresslike edifice of the early Renaissance, encloses the west side of the vast piazza that was laid out in 1911 between the Victor Emmanuel Monument and the end of the famous Corso. Broad modern streets lead from here to every part of Rome—up to the royal palace and the railroad station, across the Tiber to Trastevere or the Vatican, and straight along the Via dei Fori Imperiali to the Colosseum, which looms at the end of the great boulevard created in 1932 to accommodate Fascist parades. On a high brick wall that stretches along one side of the street, an inspirational series of marble maps depicts the stages of ancient Rome's expansion from a tiny village into an entity that encompassed the Western world. The Street of Imperial Forums is aligned diagonally with the center of the Palazzo Venezia's east façade, from which projects what became for a time the world's most famous balcony. There Mussolini emerged from his vast Sala del Mappamondo to harangue the Roman people—a sight witnessed and reported by many Americans down to that day in December of 1941 when those who had come to hear Il Duce's latest pronouncement afterward ran to take refuge in their country's embassy.

On January 30, 1933, one of the most influential American poets of this century, Ezra Pound, was received in the Sala del Mappamondo by his hero, Mussolini. Pound had lived in Italy since 1924, attracted partly by Fascism itself, which he believed to be a direct expression of the *genialità* of Il Duce, whom he had never met. In 1933 Pound had just finished collaborating on a film script about the birth of Fascism. For nine months he had been attempting to meet with the chief of state to give him the benefit of his ideas about the economic conditions of Italy. He presented Mussolini with a copy of his earliest *Cantos* and an eighteen-point statement of his political theory. In a later *Canto* (XLI) Pound recorded Il Duce's reaction to the poems:

> "MA QVESTO,"
> said the Boss, "è divertente."

Pound interpreted this remark as further proof of Mussolini's superior mind. "The Boss" never received Pound again, but remained the intended recipient of the poet's gift books and gratuitous advice. Within days after the interview, Pound began writing *Jefferson and/or Mussolini*, which he sent as a birthday present in 1935. Pound's letters to Mussolini, like those written even to American friends, were dated with Roman numerals according to the Fascist Era (beginning 1922). They typically started with the Fascist slogan that Pound made his own by printing it on his stationery—*Molti nemici molto honore:* "many enemies much honor"—and closed with some such phrase as *con divozione fascista.* Mussolini's secretary at the Palazzo Venezia, while summarizing one of Pound's more fantastic written proposals in 1935, noted for the record that it had originated in a "foggy mind, deprived of all sense of reality."[1]

Pound was unique among Americans only in the extremity and constancy of his devotion to Fascism and Mussolini. His relative isolation at Rapallo, in northern Italy, perhaps made maintaining his illusions easier than more extended visits to

Rome would have done, but it is obvious that neither the elaboration of his theories nor the writing of his poetry depended upon any reality beyond his eclectic reading and his own exacerbated, overcrowded mind. For all Mussolini's obsession with the grandeur of imperial Rome, neither it nor the modern city are central to Pound's fabrication of "historical" myths for the *Cantos.* The meeting with Mussolini himself obviously only confirmed Pound's preconceived image of an intellectual strongman, and by the time Pound was making regular weekly visits to Rome in the early 1940s to broadcast his Fascist propaganda, his thinking had reached a level of venomous incoherence and irrelevance that not even the most benign—or appalling—environment could have rectified. But even at this pathetic extreme Pound still represents the general truth that prejudices and personal needs reshaped the Fascist reality for all who saw it. What Margaret Fuller was, among Americans, to the Roman Republic of 1849, Pound was to Mussolini's Italy.

American representations of Rome during the Fascist Era are primarily the work of journalists and diplomats. Most painters and most writers of poetry and fiction naturally found the more liberal and less politicized Paris, London, and (during the twenties) Berlin more congenial than a totalitarian state. Consequently for twenty years Rome is refracted through the distorting lenses of political preoccupations, and the physical features most boldly projected tend to be those created precisely to make an ideological point: imperial avenues, marble maps, forums of physical culture. The vast quantity of writing about Fascist Italy produced in the new age of rapid news service and mass communication through popular magazines has been well analyzed by John P. Diggins in *Mussolini and Fascism: The View from America* (1972). His depressing story of antidemocratic rhetoric, nativist prejudice, narrowly capitalistic self-interest, and Roman Catholic rationalization need not be retold. But within this morass of opinion and argument there is a body of personal narrative that tells a multisided story of what Rome meant to Americans who knew it—not by hearsay, but directly—in these two decades.

For many of them it was a time and place of intense and dramatic contemporary political significance, the very opposite of what the anachronistic papal town of a century earlier had been. It also became a place almost entirely lacking the classic dignity, spiritual distinction, melancholy quiet, and exemplary beauty that previous generations had found in it. These absences partly define a difference in the modern perceivers and recorders, but they also reflect the element of noisy parody in Italy's own attempt to leap back over Catholic and medieval Rome to recapture its lost imperial grandeur. America's Fascist Rome—proud, self-assertive, cruel, and absurd—is both an entirely new Rome and a grotesque embodiment of those aspirations, both Italian and American, that had taken ancient Rome as their measure.

The continuing metaphor in the collectively told tale is theatrical: obviously symbolic settings, mass choruses, thrilling language, bravura performers. The effectiveness of the performance is undeniable, since for the first thirteen years the participant-spectators take it as heroic reality. As the American reviewers change, however, we find that the representation of Mussolini's Fascist Rome also changes. By 1936 it has become a sham. What had been rendered by America's own ambassador as a provincial epic with universal significance has become a farcical puppet

show that ends in tragic terror. And by that time the writers themselves have become antagonists in the drama.

"What different things Rome stands for to each generation of travelers" is one concern of Edith Wharton's most celebrated short story, "Roman Fever," published in 1936, the year before she died and the year that marks the turning point in American representations of Fascist Rome. It takes the point of view of two upper-class New York women who are left behind to meditate on this theme while their daughters—latter-day Daisy Millers—go off with their Italian aviator boyfriends, not for a visit to the Colosseum, but for a flight to Tarquinia (returning by moonlight, however). Yet, as the story develops, it appears that the changes both in Rome (airplanes instead of landaus) and in what it "stands for" have been superficial. Even for the girls of the earlier time (the present mothers), Rome had been not so much a place for historical and aesthetic education as for sexual adventure less innocent than Daisy's. The romantic idealization of the Roman setting had veiled the eternal realities of lust and deceit. What is new is a modern attitude of cynicism and brutal candor that exposes the fraudulence of former hypocrisies. As the two mothers sit on the terrace of a hotel restaurant overlooking the Forum, with the Palatine hill of the Caesars rising above it, their conversation moves gradually toward a double revelation about their own distant past. It concerns an assignation in the Colosseum between one of the women and the fiancé of the other.

Although "Roman Fever" is as much a story of New York as of Rome (its basic action could have occurred anywhere), Wharton several times alludes to the specific setting as though it had large significance, as in the works of Hawthorne and James. It does, but—as in the nonfictional renderings of Fascist Rome—its significance lies in its moral ambiguity and in the question of its relation to contemporary figures. Does its imperial magnificence serve as ironical contrast to the petty intrigues and cruelties of these contemporary women, pointing up their triviality? Or does the association lend to their futile middle age a melancholy grandeur? But the reverse may be equally true: *their* association with *it* diminishes its stature by suggesting that the imperial dames who lived in the Palace of the Caesars were no different from these rich society women of New York. Empress Livia, Augustus's wife, might have recognized a kinship with that Aunt Harriet who killed her younger sister and rival-in-love by deliberately sending her into the Forum at night to pick a rare night-blooming flower.

In other fictions Wharton certainly participates (with an insider's informed malice) in the debunking of aristocratic pretense to ethical superiority. Yet she does not fully equate intrigues that control imperial dynasties with the tawdry jealousies of upper-class New Yorkers. "Roman fever" is a metaphor for heightened passions that makes them morally equivalent, although the effects are widely disparate. When Wharton comments that to both women "there was a relief in laying down their somewhat futile activities in the presence of the vast Memento Mori which faced them," we cannot help but consider that as a memento mori, any skull will do. The Roman setting exists in the story primarily because it was so important a part of the social history of Mrs. Wharton's period—something of enormous prestige that a certain class of people appropriated as the setting suitable both to their ennui and to

the enactment of their personal dramas. Wharton is not entirely pitiless, but insofar as her use of Rome here does more than establish a historical fact, it serves as ironic comment: these women "of ripe but well-cared-for middle age" are small; their lives are small, and their jealousies self-demeaning. The Roman images that surround them, which they condescend to admire with an expression "of vague but benevolent approval," can only make them smaller.[2]

A "vague but benevolent approval" is what all of Fascist Rome received from most of those for whom it continued to exist primarily as a winter resort that offered exceptional cultural or religious benefits. The hotels could not be too warm, the food too good, the streets too clean, the people too obedient, the police too efficient, nor the trains too punctual. These modern improvements simply facilitated emulation of old-fashioned literary or aesthetic pilgrimages that some travelers undertook with the supposition that Rome did *not* mean something different to each generation. Before we turn to more characteristic images of the Fascist Era, which focus on the contemporary scene with little regard for the past, two attempts to recapture the nineteenth-century experience may be observed—one that succeeded and one that is ironically aware of the extent of its failure.

An extreme of selective perception is evident in the Rome recalled by William Lyon Phelps, celebrated genteel professor of literature at Yale. In his *Autobiography* (1939), Rome is exclusively the late seventeenth-century Rome of Robert Browning's nineteenth-century poetry. Oblivious to any analogous contemporary executions in Rome, he and other members of the Fano Club trooped dutifully through the streets with copies of *The Ring and the Book* in hand, going along "the track of the condemned men as they were led from the prison cell by Castle Angelo, across the Tiber, through the Via Panico, Via Governo Vecchio, Via Pasquin, Piazza Navona, by the Pantheon through the Piazza di Colonna, and down the full length of the Corso to the place of death." On another day they visited the Church of San Lorenzo in Lucina and were thrilled to find that "every detail of the church is still exactly as Browning describes it." That is all that Phelps chose to recall of Fascist Rome, although he too had been received by Il Duce.[3]

The familiar essays of another professor of English, this one an early interpreter of Henry James, show an ironic awareness that many things in Fascist Rome were not the same—and not better—than when the Master had written about them. In *Meek Americans* Joseph Warren Beach of the University of Minnesota takes as his points of departure the traditional petty irritants to travelers in Italy—tipping, beggars, guides, dirty streets. In finely spun humorous essays a mildly argued recurrent theme eventually emerges as a political comment: the romanticism that found one of its most expressive images in nineteenth-century Rome is both the antithesis and a source of fascism. Visiting Italy in Year II of the Fascist Era, Beach discovers that some Romans are already beginning to think that although Mussolini's dictatorship was needed in 1922, what is needed now is "a little more freedom." On the walls of Rome one reads the slogan "Fascism is liberty—but not the liberty to assassinate the fatherland!" The ways one can assassinate the fatherland are evidently many, but Il Duce's entire program reduces itself to the words "Get back to work!"—a "cheerful message" that "had a familiar ring to American ears," since it is a slogan many bankers and politicians were promoting at home. But

this injunction does not take into account "human nature"—particularly Italian human nature. Its emphasis on discipline and order, with all phases of life strictly regulated, however admirable as theory in the eyes of Anglo-Saxon tourists, does not necessarily harmonize with the Italian sense of what makes life worth living. The strict Fascist laws against tipping, for instance, which ought to have eliminated a constant bother, in fact made for greater confusion. The underpaid waiters, museum functionaries, and cabdrivers, for whom every day is an exciting economic challenge, regard the prominently displayed prohibition as an offense to the "personal liberty" of givers and receivers alike. As with Prohibition in America, it incites a desire to break it. Thus the traveler soon learns that tips are not only still accepted but even expected, no matter how boldly the bill asserts that "service is included." The net result is the paying of perhaps double or triple tips, and more nagging doubts than ever.[4]

An essay called "The Beggar in the Forum" begins with all the clichés of romantic Rome. The discovery of a wild iris blooming near the Fountain of Juturna, "the ancient goddess of waters," augurs a beautiful spring morning of "antiquarian research" and "peaceful browsing among ruins." Although "the ancient gods were all gone, together with the heroes who fostered their worship," yet "the goddess Nature" divinely persists. But at that point a shabby young man offers himself as guide. He is refused, since with a guide one can "neither study, nor meditate, nor make love—and what else should be the objects of a visit to the Forum?" But the young man mentions his need to eat. When inquiries reveal that he is an unemployed law clerk, he is given a lira and dismissed. But his need and the refusal to employ him haunt the morning in the Forum, so Beach's essay is not about ruins, but about beggary. He tries to establish a tone like that of James Russell Lowell ("Even when the Italian beggar is a cripple you suspect him of being a comedian"), and he recapitulates all the old rationalizations for refusal. But in the end he accepts the fact that the young man really only wanted "to get to work" in any way he could—something the Fascist command by itself had not enabled him to do. "He was a man looking for honest employment, eager to reconcile hunger with his self-respect." Thus Beach proved that it was still possible to write a thoroughly nineteenth-century essay about a moral dilemma that was known to earlier generations in Rome, but that officially no longer existed.[5]

The disjunction between Fascist rhetoric and reality is more explicitly but less concernedly developed in an essay on the slogans by which the nation is governed and which give force to Mussolini's speeches during the turbulent spring elections of 1924, through which Fascist power was consolidated. Il Duce's discourses are "as pointed and graceful, as impassioned and colorful, as the orations of Pericles recorded by Landor," says Beach in admiration. Fascist rhetoric "is the flower of the rhetoric of young Italy, which is the growth of poetry and mystical faith." Wall posters proclaim that the Fascisti are "the Praetorian Guards of ancient Rome, reborn through the eternal youth of this gentle adamantine Italic stock." Beach finds "something romantically pagan about every gesture of this 'rebellious youth.'" The eloquence with which Mussolini responds to the most commonplace invitation or ennobles the thorniest labor pact is "as colorful as Tintoretto, and as sweet as Bellini." Of course, the problems "solved" by florid proclamations persist in reality,

for "when were fine words ever final?" Beach's punning dismissal, however, is too easy, for if the solutions are illusory, the fact of power is real, and Beach recognizes that the heroic exercise of power through poetic language and violence is itself one expression of the romantic spirit.[6]

In his final essay, "The Dirty Street," Beach resumes the concern of William Wetmore Story and others over the contradiction between picturesque beauty and modern "progress"—but now in relation to a Fascist program far more coercive than even the United Italy of 1870 had been able to bring to Rome. Without being so old-fashioned as to appeal to the "picturesque" as an absolute value (or even to use the word), Beach nevertheless evokes a typical street of the sort that Story loved. "It may have been Rome and it may have been Naples," but it was definitely not Geneva, Switzerland, or Columbus, Ohio. Brightened by the lavender and green shawls of women buying food for Sunday dinner, the street was "enlivened" by boys throwing copper coins, by vendors with carts laden with oranges and vegetables, and by hurdy-gurdy players and blind violinists. Although the pavement was muddy and stained, and the air filled with bad smells, the place was "full of a pleasant confusion" and "the people seemed happy." Beach's wife "thinks it ought to be cleaned up," but Beach knows that Latins "like animation better than order, and smells better than cleanliness." The matrons of Baltimore may get satisfaction from scrubbing their stoops, but the citizens of Dirty Street are "humble Platos" who prefer "contemplation and peripatetic discussion." They are like a Romanian artist friend, who refused to take tea with the Beaches in a fashionable and costly place in the Piazza Venezia, but happily dined with them at a trattoria with an unswept floor "in a back street near the Pantheon." Of course, Beach admits, the American tourist may agree theoretically with this preference while insisting on steam heat in his hotel, but beneath his ambivalence, sentimentality, and nostalgia there is an obscure recognition of the vitality and security of disorderly and humble people. Not wishing to rise, they cannot be cast down: the wheel of Fortune is for the ambitious, for heroes. In their lives, "all objects and acts" refer "to the primary necessities of life, and that in our day, is an aesthetic asset for any street."

Nineteenth-century romanticism was "a reaction of human nature against too much order," and in Dirty Street this philosophy unconsciously flourishes "alongside of the political doctrine of *Fascismo* and the Big Stick, of a system of government which implies the establishment and maintenance of order by compulsion." It is true that Carlyle himself "would have been the first to hail Mussolini as the God-sent hero," but the same movement that inspired heroes and the worship of heroes also reminds us that "order itself may become a nuisance and a weariness." Perhaps after all the Roman Empire fell when people began to long for a little confusion and finally "called in the Goths."[7]

Wharton, Phelps, and Beach represent those literary Americans who still came to Rome with a strong sense of its traditional meanings for earlier generations. But the diplomats and journalists who above all provide the representations of Rome during the Fascist Era were of a new breed. The new position of America in Europe, resulting from the First World War, and the new status of Italy meant that the embassy in Rome would no longer be a sinecure for writers or artists, but would be

filled with lawyers, businessmen, and professional diplomats, most of whom had no knowledge of Rome before they arrived. At the same time daily newspapers, their syndicates, and weekly magazines began depending upon initially ignorant "correspondents" to wire detailed accounts of breaking events—falling governments or dying popes—as soon as they got off the train. Other journalists who had proven their professional capacity to write about anything were sent abroad specifically to "look into" things entirely new to them. Not surprisingly, the diplomatic and journalistic writing that resulted entirely emphasized the contemporary scene as perceived with only a superficial sense of its relation to Rome's past. To them, the only meaningful point of reference for comparison was contemporary America.

With one major exception, from 1922 until the Italian invasion of Ethiopia in 1935, when Mussolini's ambitions and methods became of unavoidable international concern, observations both of him and of Fascism in Rome were mostly admiring—and this in spite of the fact that the violent methods and authoritarian character of the regime were evident from the first. Some justified both the violence and the repression and would have countenanced similar phenomena in America; others assumed that both ends and means were appropriate and necessary for Italians and were of no concern to Americans. That enormous economic and social improvements were being made was accepted as a fact and judged by most writers to be worth the sacrifice of democratic freedoms of speech, press, and assembly. In Italy, only anarchy had resulted from such freedoms. As early as 1934, in *Denier du rêve*, Marguerite Yourcenar exposed "the hollow reality behind the bloated façade of Fascism," and she later took pride in the fact that she had done this *before* the Ethiopian conquest, the Italian participation in the Spanish Civil War, the alliance with Hitler, and the anti-Semitic laws—all the things that were necessary to persuade most Americans that fascism was bad, even for Italians.[8]

American portraits of Mussolini, the hero of the fascist drama, fall into two groups—the mostly colorful and glorifying images from the twenties, based upon personal acquaintance or interviews, and the more distant caricatures from the thirties, when his relatively few appearances were carefully managed and his son-in-law and foreign minister, Count Galeazzo Ciano, tended to take center stage in the arenas of diplomacy and journalism. The change reflects not only a shift of critical interest from Italy's internal affairs to its foreign policy but also a change in the visitors' perception of fascism, as its character was being more bluntly defined by Hitler.

Admiration for Mussolini in the 1920s came from a wide variety of Americans in Rome. These included the muckrakers Lincoln Steffens and Ida Tarbell as well as people like Clayton Sedgwick Cooper (a Baptist minister, globe-trotting advocate of Bible-study groups, and publicist for the W. R. Grace Corporation), Ambassador Richard Washburn Child (a Theodore Roosevelt Republican and an appointee of Warren Harding, whom he had served as a campaign manager), and Anne O'Hare McCormick (a cultivated Roman Catholic apologist reporting from Rome for the *New York Times*). Their motives are distinguishable, but they are united by a respect for what one strong man—a leader (Il Duce)—can accomplish when confronted with the social chaos produced by democracy. They witnessed the happy results in Italy, which they all agreed was preeminently in need of just such a man.

But they also thought that from the great Mussolini "lessons" were to be learned that had universal application. For Cooper and Child the admiration went beyond that for Mussolini as a dictator to fascism itself as an ideal expression of disciplined youth. Not coincidentally, Cooper had been an administrator in the Young Men's Christian Association, and Child in later years became active in the Boy Scout movement in America. "Virility," "purity," and "discipline" were the watchwords of both men. Even McCormick romanticized fascism as the expression of vigorous but responsible youthful idealism until Mussolini outlawed the Catholic Youth Movement as a political rival to his own organization; she then joined the pope in seriously criticizing him for the first time.

How ready American centers of power were to accept fascism in Italy is evident from the fact that the material on Italy's "economic and industrial renaissance" had been gathered for Cooper's strongly profascist *Understanding Italy* (1923) in the summer of 1922, *before* Mussolini assumed power. The fascist "revolution" simply gave Cooper a far greater measure of confidence in the "renaissance." His book, the first of its kind written on Italy by an American, was undertaken at the suggestion of the editor of the leading Italian-American journal in New York, who provided Cooper with introductions to "the leading men of affairs of Italy"—his primary sources of information, apart from America's own business-oriented diplomatic corps. In this connection, Cooper mentions that the large number of Italian immigrants to America has created an exceptionally strong new bond between the two nations. But his book is primarily motivated by the belief that as a result of the war, America's "national prosperity and destiny" are interwoven with that of Europe as a whole. America's "moral duty" and "national welfare" both require that it "understand" Europe and offer material aid, particularly in the form of investments. Nowhere can this be done more wisely than in Italy, a country that particularly manifests a "spirit of hope and progress." Cooper concludes his preface with the assurance that "Benito Mussolini and his youthful crusaders," in their recent "capture" of the country, only reinforce his thesis, for "whatever we may think of their method," they do "represent the spirit of vigorous youth in the nation, while back of them, acting as supporters, are the industrialists, bankers, foreign traders, and also the merchants and manufacturers of the country." The Fascist youth are ready to "march to modern music," crying out "Let us forget our ancestors and our glorious yesterdays!" Cooper closes by quoting a line from the "patriotic" hymn, "Giovanezza": "O Youth, O Youth, Springtime of Beauty."[9]

Cooper acquired what little knowledge of Italy's history he thought necessary from Mowrer's just-published *Immortal Italy*. But unlike Mowrer he is essentially contemptuous of the past. He asserts that Italians themselves are most anxious to escape it—except for one ideal: ancient Rome. Mussolini, says Cooper, showed "the old Roman spirit" when (like a modern Coriolanus) he contemptuously subjugated Parliament and then turned over the railways, telephone, and postal service to private enterprise. The man who came to Rome like a conquering and courageous Caesar is "the inspiration and the practical genius which brought together literally millions of Italy's virile, intelligent, and effective population under the Fascisti banner." He does everything on a truly "magnificent scale." Quoting Mussolini on Fascism's mission to awaken Italy "to a full sense of its own greatness and destiny

as a nation . . . at any cost, even at the cost of democratic conventions," Cooper sees
no reason to question this cost, for Mussolini's aim is to eliminate "socialism" and
"bolshevism." After the king had shown the "wisdom and good sense" to hand over
power to Mussolini, "socialistic newspapers in Rome were obliged to close their
doors," the Communist party was dissolved, and "the radical element . . . was
thoroughly demoralized." Cooper does not specify the means (burnings, beatings)
by which these ends were achieved. The Soviet-inspired radicals had been given
their chance. In fact, in Italy socialists had been allowed more freedom than in any
country outside Russia. They had marched "undisturbed" through the streets of the
national capital, and "Red literature of highly sensational and inflaming nature was
permitted." In contrast, in the United States we unhesitatingly jailed or deported
"scores of men for sedition of much less consequence than certain Radicals have
flaunted with immunity before the faces of Italians for the last four years."

 In just such an exasperatingly inflamed atmosphere in July 1922, Cooper had sat
down at a sidewalk café on the Corso in Rome "with a group of young Italians who
were discussing politics and drinking the usual innocuous lemonade." They were
"youth of the intelligentsia," several of them veterans, all of them sympathizers
with "the Fascisti movement" but none of them yet a participant. But Cooper is
sure that by 1923 they are all wearing black shirts, for they were sick of a weak
government of words only. They wanted action, strong government, "a ministry
that will get busy and do something." And that, says Cooper, is what they got from
Mussolini, "a real out-and-out leader." Under a photograph of the Fascisti in Rome
on the day of the "bloodless revolution," Cooper prints a quotation from the
president of Columbia University, Nicholas Murray Butler: "There is law that
makes for lawlessness and there is lawlessness that makes for law." And he de-
scribes a drawing in the *New York Tribune* that shows Garibaldi leaping from his
statue in Washington Square, "sword in hand," ready "to join his brothers of a later
generation for a second liberation of his beloved Italy." Indeed, asserts Cooper,
Mussolini is Mazzini, Garibaldi, and Cavour all in one man. Moreover, fascism is
"active in many places in Europe, and this new life contains some of the most
hopeful signs of European revival and reconstruction." But Italy is leading the way
with its unified and broadly representative action. In October 1922, "a large com-
posite army representing students, peasants, industrial workers, sons of wealth, and
sons of shopkeepers, farmers, nobility—an army even more picturesque than Gari-
baldi's famous thousand—entered the gates of the historic Roman city, borne along
on the applause of the multitude like some heroic Caesar and his legions returning
from their wars."

 Cooper admits that such an experience in some of the "dawdling democracies"
might have led to "anarchy," but not in Italy. His chapter, "Fascismo, the New
Italian Nationalism," pointedly concludes with a ten-page verbatim translation of
the sixty-one "Rules of Discipline for the Black-Shirted Princes of Italy: Fascist
Militia." These begin with the Fascist Oath, and then cover everything from defini-
tions of "impurity," "unworthiness," and "traitor" (and the procedures for dealing
with such cases) to a careful delineation of the membership and "The Hierarchy."
The fascinating list ends with five rules concerning "the Uniform," six on the
character and management of public parades, and thirteen on the awarding of

medals. All this, according to Cooper, promises that "Fascismo will be the means of advancing the country to a position of unique influence in world affairs."[10]

Ambassador Child states similar views with even greater conviction. His portrait of Mussolini, the most intimate and sympathetic, is painted with a passion not usual in diplomats. After he resigned his ambassadorship (to Mussolini's great personal regret), Child published *A Diplomat Looks at Europe* (1925), some of which had previously been published in the popular *Collier's* and *Century* magazines. The hero of the book is Mussolini, the one brilliant figure in a Europe of "flabby democracies." Child pictures himself sailing into the Bay of Naples in July 1921 as the young American ambassador to "old Italy," and again three years later, as he leaves, looking back from the Alps upon a "new Italy," the creation of Mussolini—or rather "a new Italy hidden in the hearts and spirit of the people," which had "made Mussolini." Il Duce, according to Child, was the inevitable product of a great popular movement. In the first year of his ambassadorship Child witnessed the appalling weakness of what he describes sarcastically as a "liberal," "benevolent," and "peace-loving" government, to whose failings he devotes many vividly satiric pages. The "virile" little King Victor Emmanuel III was the only real man in sight. But Child also satirizes those who were unduly alarmed by the anarchic acts of the Socialists ("titled Roman ladies next to whom I sat at official dinners would whisper fearful prospects into my ear"). Such fears of a Red revolution he thought unreasonable, considering the innate cowardice of communists and the innate individualism of Italians. It was the "feebleness" of the "badly conceived machine of democracy" that had become intolerable.

Signs of governmental impotence were everywhere. Child says that the constant demonstrations and strikes did not inconvenience him personally, although he and his wife and daughter were threatened with kidnapping or murder by agitators who did not understand that Sacco and Vanzetti had recently been convicted because they were guilty, not because they were radicals and Italians. Child refused to use the back door or to disguise himself. He responded to the anti-American demonstrations by bravely going alone to meet with a committee of five "reds," whom he instructed in the American federal system and whose friendship he won. The meeting ended in manly laughter. In the midst of other disturbances, the diplomatic license plates on his chauffeured "motor" got him smoothly through "police barriers," and (Rooseveltian that he was) he enjoyed the "cornet of cavalry trumpeting to disperse an assembly below the window of a palace, which was almost a fortress" (he had leased the Palazzo Orsini as his residence). But the unending turbulence had become too much for the Italians themselves. One tottering ministry after another offered the eternal advice of "Pazienza!" to an exasperated citizenry. Factions were pacified with "handouts," and the do-nothing bureaucracy became ever more bloated. "Everything was cynicism and drifting. There was a ravenous yearning to begin a new day." In April of 1922 Child wrote to Washington that "a dictator was inevitable." He followed up this dispatch by looking about for one. He found Mussolini. In October an Italian friend brought the Fascist deputy to Child's home, and the ambassador's infatuation began that night. A few days later Mussolini visited Child again, at the embassy. "He held out his hand and smiled. Rome had been taken. He was the Premier of Italy."[11]

Child's talents as a popular novelist are most evident in a chapter called "Open the Gates!" based on the diary he kept during the days leading up to the March on Rome. Its focus, tone, and detail significantly contrast with those we saw in the account of these days by Lilian Mowrer. For Child the Fascist movement possessed a "lyric and epic quality." One sunny October day he had gone down to the Tiber to sit upon the travertine wall and watch "the same flow of brown water which Caesar gazed at in meditation, and Garibaldi, sweating from battle, observed from the Janiculum." An Italian friend who joined him said, "Can't you sense it coming? Not like winter but like spring?" The Fascist revolution was like that, "the rise of national spirit" having "the inevitability of the approach of a new season." If you listened, you "heard the rhythm of universal desires and hungers on the march." One day when Child's two little girls came home from the Borghese Gardens they improvised Fascisti uniforms from their bloomers and began singing "Giovanezza"—"Youth! Youth! Springtime of beauty." Mussolini "had the whole country singing, and the song was not a song of battle and conflict, of class against class; it was a song of unity." Laborers and "titled idlers," shopkeepers and "men of the fields," all were "falling into line."

In late October a sirocco was blowing up from Africa, and everyone in Rome became depressed and irritable. Then steady rain began to fall. In Naples, the Fascisti were meeting. On the twenty-seventh all communications with Rome were cut. In the evening, although "the old cobblestones" were menaced with the blood of civil war, dinner parties "went gayly forward." Child dined with J. P. Morgan, Jr., at a meeting of the Harvard Club. But all that night one could hear marching feet, "distant bugles and the rumble of army trucks." On the twenty-eighth Rome awoke to martial law. Child's chauffeur drove him safely through police barricades in the wind-whipped rain of the Piazza Venezia on his way to the embassy. There he found his staff bright-eyed in the expectancy of violence ("The best of us have love of conflict"). Soon Morgan arrived, wanting to know whether he and his wife could go as planned to visit the ruins of Ostia with Senator Lanciani, the archaeologist. But martial-law posters appeared on the walls of Rome forbidding the circulation of all vehicles—senators and Morgans not excepted. However, "this country is a country of manifestoes; the walls are always covered with paper proclamations," and by evening the old ones were pasted over with new announcements mobilizing the Roman Fascisti. The king, Child wrote in his diary, had recognized that the "will of the people" was more important than his ministers' "babble about constitutionality." On the twenty-ninth Mussolini, now to be called "*Duce*—Leader," was summoned to Rome from the Fascist headquarters, where he had gone after adjourning the meeting at Naples. On the thirtieth Child "motored about" to see how the city was reacting. There was no disorder, except for some revolver shots that disturbed the ambassador's lunch on the Via Veneto, and a few stacks of burning newspapers outside the Socialist party office, which had been wrecked. Otherwise all that he saw were flag-waving girls standing out on balconies to cheer the black-shirted youths as they passed by. Americans were not disturbed, but some Italians "whose private lives are not in order" made futile appeals to Child for protection.

Later from his embassy windows the ecstatic diplomat watched "columns of the invaders passing from the railroad station or coming from the Via Nomentana. It

was a muddy, tired, healthy lot." Whereas "most armed men had taken cities for hate and loot," he considered, "this taking of a city was done for love and common weal. The voice of Italy had said 'Open the gates!' and Rome had opened them until they yawned." On the thirty-first Child and his wife joined the "jostling crowd" gathered in Piazza Venezia to watch a parade of forty thousand men come marching and singing down the Corso. As the Fascisti turned to ascend the Quirinale to express loyalty to the king, they saluted the Altar of the Country by throwing forward one straight arm, palm down, in the salute of the Roman Republic—"a gesture suggesting equally welcome or farewell, democracy or benediction."[12]

In defending Mussolini's Fascism, Child makes light of its violent means. Of reports that Fascisti forced "decadent" Italians to drink entire bottles of castor oil, he says, the "story is amusing, but it has been greatly exaggerated"; Child himself finds these "medicinal cures" a funny joke. Certainly these episodes do not outweigh the "endless examples of heroism and restraint and contributions to public welfare and order." Dismissing violence as incidental, Child turns to defending fascism by identifying it with the true American philosophy, and by showing the resemblance between Mussolini and Theodore Roosevelt—the only other great man Child has ever known, and one in whom Mussolini has taken a great interest, saying that he associates both his own ideas and his willingness to "hit and hit hard" in the "defense of principle" with Roosevelt's. Of course, Mussolini is a "brutal realist," Child admits, but he is also "an idealist who makes love of country and commonwealth a religion." Properly to be considered a "patriot" rather than a dictator, he is that rare combination of inspired leader and efficient administrator such as America also has need of (Calvin Coolidge was by then in the White House). Guided by a "moral idea" of order and "a philosophy of discipline," Mussolini realizes that "men are perhaps weary of liberties." Like Theodore Roosevelt, he emphasizes not "rights" but "duties," and knows that youth today responds to the words "service" and "organization." Thus Mussolini is effecting not merely a material but an "ethical and spiritual . . . restoration of Italy."[13]

Before Child delivered his notorious speech to the Italian-American Club of Rome, he discussed its contents with Mussolini himself, saying that he would "state principles which were Roosevelt's and which were mine, and which I believe were American long before the word 'Fascisti' was in existence." Mussolini laughed delightedly and informed Child later that his speech revealed "an exact understanding of our movement," which was very "remarkable because Fascismo is so complex that the mind of a stranger is not always the best adapted to understand it." Il Duce declared Child to be "the most brilliant exception to the rule," since his speech had given an accurate exposition of "the philosophy of Fascismo, interwoven with an exaltation of beauty, of discipline, of authority and the sense of responsibility." According to Child, his speech expressed only "sound American doctrine" when it said that "folly and weakness and decay" were worse enemies to the progress of mankind than the "menaces of war." Strength in a leader is more important than benevolence, since it sets the example of "Self-Reliance." The first requirement in making "the fasces" is "to find the individual rods, straight, strong and wiry," as Mussolini had found the Italian youth when he "so skillfully" bound them together in unity. If they had been "rotten sticks," he could have done

nothing. "I shall be the last to believe," declared Child, "that weak groups or nations or races are superior or are more worthy of my affection than those who mind their own business with industry, strength and courage, and stand upon their own strong legs." Italy had become a model among independent nations, with a message for America. True, its philosophy was "sterner" than had been "fashionable since the war," but Fascism in the end was to be judged by its performance, not its theory.[14]

In the last pages of his chapter on "The New State," Child sketches a series of contrasting pictures of Mussolini. In one he is seen as Child found him one morning sitting at his desk, "hollow-eyed and pale," with black stubble on his chin, after a long night of labor for his country. Child advised him to keep up his health with boxing lessons, but Mussolini assured him that he was only "slightly tired"; his strength was boundless. Anyway, he was taking riding lessons, not to preserve his health, but to learn how "to sit a horse in a manner to give Italian hearts pride in the appearance of their leader." Later Child shows Mussolini relaxing in Child's own home, "with my two little daughters climbing over his knees." The "Mussolini who with a metal, muscled face snaps out orders, paces up and down, runs a nation and pumps into it spirit and vitality" had disappeared into a young man who could laugh and play with children.[15]

This heroic, hardworking, and young-fatherly Mussolini was described with "deep affection" by Child in the foreword to Mussolini's English-language auto-biography, published in 1928 by Scribner. Child says that he had persuaded Mussolini to tell his story, had provided him with the outline of topics, and had edited the result after it had been dictated and roughly translated. But a different story is told by the popular novelist of American patriotism Kenneth Roberts, who had written pro-Fascist articles for the *Saturday Evening Post* and published *Black Magic* (1922) in praise of the movement. He says the autobiography originated in a visit the Mussolini-admiring old publisher S. S. McClure made to Rome in 1927. McClure discovered that for forty thousand dollars Mussolini would "collaborate" by signing his name to a book (if he found it satisfactory) to be written by a ghostwriter supplied by the *Post*, with Mussolini's biographer and former mistress Margharita Sarfatti serving as go-between. Roberts was chosen because of his knowledge of Fascism and his acquaintance with the journalists Salvatore and Arnaldo Cortesi, employees in Rome of the Associated Press and the *New York Times*. Roberts did not like the idea of being a ghostwriter, but he went to Rome, where Sarfatti ("a dumpy, hard-voiced, coarse-skinned bleached blonde") told him that the forty personal interviews with Mussolini that he requested were out of the question. The "autobiography" would be compiled from her own book on Il Duce and from various other documents she would supply. Before publication in ten installments it would undergo censorship at three levels. Although McClure offered Roberts a bribe to conform to these conditions, he refused and went back to New York. At the *Post* offices he found Richard Washburn Child, who soon afterward returned to Italy. Within months Mussolini's "inside story" was appearing in the *Post*.[16]

In the foreword to the book Child brought his worship of Mussolini to its climax. Il Duce is said to be "the greatest figure of this sphere and time," a "mystic" who, when he "reaches forth to touch reality in himself," finds that "he himself has gone

a little forward, isolated, determined, illusive, untouchable, just out of reach—
onward!" Six years after the March on Rome, the Italian people still find "spiritual
ecstasy" in his leadership. He has built a government that is a "machine which will
run and has a soul." Like Roosevelt, he is a pragmatic man in a dynamic world, an
"outdoor leader," which means "more magnetic, more lasting and more boyish and
likeable for their power than the indoor kind." Also like Roosevelt, he offers an
"unexpected joy" in his leadership. "Battle becomes a game. The game becomes a
romp. It is absurd to say that Italy groans under discipline. Italy chortles with it! It is
victory!"[17]

This was published long after some journalists and Italian deputies had suggested
a less joyous view of matters, particularly in relation to the discovery in June 1924 of
the headless body of the Socialist deputy Giacomo Matteotti in a ditch outside
Rome, subsequent to his delivery of a strong speech against Fascism. Outraged
reaction to this event provoked the crisis that, by threatening Mussolini's increas-
ing power, made him act to solidify it. The most outspoken American reporter in
Rome at this time was George Seldes, who had recently been sent as the *Chicago
Tribune*'s replacement for Vincent Sheean, after Sheean's reports on the Vatican had
angered the American Catholic hierarchy. Seldes himself eventually had trouble
with the Church when his ignorance of theological distinctions became apparent in
his writing about the Holy Year of 1925. But that was nothing in comparison with
his difficulties as a reporter of Fascist Rome. Eventually Seldes would make a
profession out of criticizing censorship of newspapers (particularly by their own
publishers), and he would also write *Sawdust Caesar* (1932), America's first sub-
stantial demolition of Fascism as a political movement. But, according to his
autobiography, *Tell the Truth and Run* (1953), he arrived in Rome without precon-
ceptions. He had already met Mussolini in 1920, when he was simply a friendly
fellow journalist and former Socialist who had just founded something called Fas-
cism. Even Seldes's "eyewitness experiences with Blackshirt street fights, stab-
bings, shootings, the torturous use of castor oil, the endless bloodshed and occa-
sional murders" did not lead him to "jump to conclusions." On the last day of
February 1924, he managed to have an interview with Mussolini, which was granted
only after Seldes said that his intentions were nonpolitical—he wanted to write
about Il Duce only "as a human being." Consequently he heard about Mussolini the
teetotaler, the violin player, the lover of Vivaldi and Charlie Chaplin, the atheist
who believes only in his "star of destiny," the disciple of Machiavelli and Nietz-
sche, the man who as a nineteen-year-old exile in Switzerland had flipped a coin to
decide whether to emigrate to America or return to Italy. Seldes thought that
Mussolini had dropped his "actor's mask" and showed himself "as a man the world
could like, perhaps even understand." Mussolini gave him an autographed picture of
himself with his pet lion cub.

But Seldes rapidly learned that an honest reporter's life under Fascism went less
smoothly than this interview. In the *Tribune* files at the Hotel Excelsior he dis-
covered that his Italian predecessor, Vincenzo De Santo (the very man who had
arranged for Mussolini to meet Ambassador Child just days before the March on
Rome), had accepted (like most foreign correspondents) "the Fascist bribe of free
cable and radio tolls" in return for slanted reports. The files demonstrated that De

Santo had simply been a conduit of Fascist propaganda to the *Tribune*, which "almost uniquely among American dailies, had been a Fascist paper for more than a year." Seldes informed his newspaper's Paris office that he would no longer accept the bribe, but was told by return wire that he should try to "get along with Fascism." Seldes, however, proceeded to send dispatches that not only reported in a "constructive" way about Fascism's achievements but also showed that the "Fascisti were hoodlums" and the "Duce was a murderer." He was notified that he would no longer receive the free cable services.

The crisis came in June 1925, when Seldes's assistant and interpreter, Camille Cianfarra, obtained from members of the "Aventine Opposition" documents said to prove Mussolini's responsibility for Matteotti's murder a year earlier. Seldes was certain that the "sensation-loving American press"—especially the *Tribune*—would be delighted by the fact that the actual killer was Amerigo Dumini, son of an American petty gangster in St. Louis, Missouri. Since the Italian press allowed no references to the Matteotti case (although Mussolini denied that press censorship existed), Seldes smuggled his copies of the documents to Paris, where the *Paris Tribune* suppressed them "for fear of losing tourist advertising." But the news did appear in Chicago. On June 8 the Fascist newspaper *Impero* referred to Seldes as a *grosso porco* (fat swine), and Seldes received a summons to the American embassy. The foreign minister of Italy, Dino Grandi, had complained to the new ambassador, Henry P. Fletcher (a former Rough Rider). Fletcher passed on the warning to Seldes. Later the embassy was officially notified that Seldes was persona non grata in Italy, since his reporting was "tendentious and alarmistic." Fletcher asked to see Seldes's files. Seldes protested, asserting that what he had reported was "documented truth," which could be confirmed by other American reporters who were, however, afraid to write it because they were "residents" with "wives and children" and "could not risk deportation." Fletcher promised to get the deportation order canceled. When the foreign press corps also protested to Grandi, he declared that Il Duce would allow Seldes to remain after all, since Fletcher had requested it.

Missing, however, from this meeting was Salvatore Cortesi, chief English-language reporter for both Reuters and the Associated Press and a man "blacker than the Blackshirts," according to Seldes. Cortesi separately assured Grandi that the Associated Press would not protest the expulsion of Seldes and that there "would probably be no unfavorable furor in the American press." Consequently a party held that night to celebrate the reprieve was interrupted by a Fascist secret service agent, who officially ordered Seldes to get out of Italy within twenty-four hours. The *Tribune* was now fearful for his physical safety and cabled the embassy for protection. Seldes, however, calmly took the train to Milan and from thence to the French border. At the last Italian station Blackshirts on the platform were shouting *"Dov'è Seldes?"* ("Where is Seldes?") and came into the compartment he was sharing with three British officers. One of these indignantly ordered the hoodlums out, identifying Seldes as one of themselves.

This first expulsion of an American correspondent from Rome caused little reaction in either governmental or journalistic circles, Seldes recalls, noting bitterly that the Associated Press actually "complimented Salvatore Cortesi for his stand" and "sent an official to Rome to apologize to Mussolini for my behavior." The *New*

York Times maintained silence on the incident. The Paris office of the *Chicago Tribune* sent representatives to Rome "to grovel before Fascism," for which they were rewarded by a page of advertising from the Fascist travel agency. Although Seldes threatened to resign, the Chicago office refused to intervene through the embassy to protect his assistant Cianfarra; to Colonel McCormick he "was just another foreigner." A few months later Cianfarra was beaten by a Fascisti gang and soon afterward died. By that time Seldes was far away in Syria, still laboring for the *Tribune* he despised.[18]

Seldes's experience and views are almost unique among Americans in the pre-1936 period, anticipated only by the discontent of Edgar Mowrer. The adulatory portraits of Mussolini produced by the muckrakers Lincoln Steffens and Ida Tarbell come after Seldes's expulsion and after Il Duce had boldly accepted responsibility for *everything* done in the name of Fascism (including the murder of Matteotti). But Steffens's interest in the social transformation of Italy preceded the Fascist Era. In 1920 he saw in its postwar turmoil the possibility of a Latin variation on the Marxist revolution he so much admired in Russia. He had "been to Moscow" and therefore was "sure of the future." He thought the Italian radicals were "the most intellectual in the world," and so, watching them first from across the border in Monte Carlo, he was tempted to go to Rome to witness their rise to power. Steffens looked forward to an amoral movement somewhat less grim than the one in Russia—"genially experimental and always growing and playing." He was in Rome for May Day, 1920, but the radicals cleverly kept quiet. That the "cavalry in the court under our window" turned out to have "nothing to do" was "amusing." The government's "pathetic" and "comical" deployment of troops simply proved that the guilty "fears of the bourgeoisie" were excessive. Steffens was amazed that his guide to the catacombs, who pointed out his own name on an antique stone, sympathized with the early Christians but despised the Socialists who were their modern equivalents. J. P. Morgan no doubt did not "foresee that some of his children will, in the future, be guides in New York to some rich Bolshevik from Russia, and the rest of them wine-sellers, boarding-house runners, and beggars." Rome, because it stimulated thought of the past and produced a "consciousness of history" in the culture of the "lower class," thus made one aware of the future. "The Italians are the future of Rome. They are the future of all other people too." Rome, Steffens found, had "broadened" him, "made me more patient and 'philosophic.'"[19]

By 1923 Steffens was living happily on the Italian Riviera (on income from Wall Street investments) in a country that offered him not the genial and playful Marxist revolution he had expected in 1920 but something equally interesting to the dispassionate student of political science—Fascism. He wrote to Mussolini requesting an interview, which was refused. But Ambassador Child arranged for him to see "several men who can talk better about that [the Fascist program] than Mussolini," which (says Steffens) pleased him just as well. When the murder of Matteotti occurred the next year, Steffens observed that "the crimes" committed by the "more violent hangers-on, high up in the councils," who were "the representatives of Business"—oilmen and bankers—might bring an early end to Fascism. American businessmen, at least, had not yet resorted to murder; if any were involved in this Italian deed, their guilt would be—like Mussolini's (he is sure)—only by associa-

tion. By January 1 of the next year Mussolini's "part in the assassinations, etc., by members of his own Fascist bloc" had been exposed, but Il Duce was "taking a bold course," making new alliances and giving notice of a "new election law." Mussolini, wrote Steffens, "is a political genius. . . . But anything may happen in Italy this next year,—anything. It is a good place to be." A year later still, after watching Mussolini gain total control of the country, Steffens wrote that Il Duce had given "the answer" to liberalism by establishing "dictatorship." He and Lenin "showed the way": you seize power first, and then use it to "change the circumstances of life, and then, maybe, you may breed men fit for self-government."[20]

In this letter of January 1925, Steffens is—as always—thinking simultaneously of America: "I don't want to see the people look to Congress rather than to the presidency," he says. "That is a democrat's wish, a liberal hope." Steffens himself had long since lost that illusion. More than once he had recommended the need for individual "strong men"—as opposed to the clergy, the patrician elite, or businessmen—to cure the corrupt "democratic" practices of American cities. Steffens the muckraker can understand how the "timidity, the stupidity, the cupidity" of the Italian Parliament had made Mussolini so "sick" that he had told it "to go to hell." Steffens believes that "the job" of social reform can be accomplished, "but not by democratic methods." The right methods—the ones that worked—he was trying to discover, expecting to find "in the news of the day a basis for a science of politics." In the "facts" that destroyed each of his successive illusions, he found "a better, or at any rate another,—illusion."[21]

It was the Mussolini-illusion that Steffens evoked in an adoring chapter that comes very near the end of his *Autobiography* (1931). Only two years later, with Hitler's sensational and surpassing imitation of Mussolini's fascism providing him with more obviously instructive "news of the day," Steffens would be writing bitterly anti-fascist letters in which only his Lenin-illusion survived.[22] But in the *Autobiography* Steffens echoes (for very different reasons) Pius XI's declaration that Mussolini was a providential figure. The chapter appears to be a fabrication intended to mark an important stage in "the education of Lincoln Steffens." As if to point up its primarily emblematic character, Steffens begins with the odd statement, "Let this, the truest chapter in this narrative, my story of Italy and Mussolini—let it be also the purest fiction, romance." Benito Mussolini was "a romantic figure" who "came like thunder on the right"—an apparent intervention of God—a "new light" intended to redeem the manmade "darkness" of "physical, mental, moral confusion." This "divine Dictator" was "lightning that illuminated" Russia, Europe, and the United States by showing that only "method" mattered. Steffens casts himself as the typical "broken liberal" open to new experiments in government. What Lenin was to the Left, Mussolini was to the Right, and fortunately Steffens was present when "Mussolini leaped into sight." Steffens moved to Italy because it now provided "the best show." There, "watching this dictator work," he might "complete the changes occurring in my mind." It follows that Steffens must represent Mussolini as an acute and effective educator.

Vaguely referring to some "later" time when he interviewed Il Duce, he makes Mussolini ask and say exactly the things most pertinent to Steffens's own need for enlightenment. When Steffens queried Mussolini about his seizure of power, Mus-

solini's reply "showed that he understood my question and me, that I was a liberal with preconceived liberal principles." His "fierce face expressed his contempt" as he demanded to know whether Steffens had seen the war, the peace, and the Russian Revolution—and if so, whether he had learned anything from them? This "searching question" was, says Steffens, "God's question to man," and it demolished all the "old ideas" that Steffens carried in "one compartment of my brain" undisturbed by "the news" that he "saw and reported." Steffens and his kind seem incapable of learning "from experience, from history, from events" because they try to "judge" them. No "mere intellectual," Mussolini sees the practical meaning of events and acts upon it. He knows that "there is no absolute knowledge, . . . only theories," and—"as bold as Einstein"—he simply changes the axioms. People want "to be governed, not to govern themselves." They do not wish to lead; they want to work. Mussolini gave them work. As Russia showed, "economic democracy is the way to political democracy." Democracy might be an end, but it is not a method. Democracies readily become dictatorships when extreme conditions require; even Wilson had been "absolute" during the war, and Americans too had willingly "abolished liberty." Mussolini told him, Steffens says, that in every country—including the United States—there was "an empty throne" waiting to be filled. According to Il Duce " 'what was done in Russia and in old Rome could be done in new Rome.' "

So Steffens watched from the Riviera, rationalized the press censorship complained of by correspondents who came up from Rome to visit him, and reminded them that it was necessary to see things from Mussolini's point of view. In the subsequent chapter, called "Experimental Europe," Steffens assumes the pose of the intellectual chastened by history, whose only remaining job is to learn from "the news" as the actors perform it. The "insolent" black-shirted youths seen throughout Italy "murdered, tortured, in some places," yet he found them "a bracing sight" as they strutted through the streets and the trains, "in command of the world." Liberty and justice, after all, "may be only our illusions." In Italy, "Mussolini was re-establishing the actual sovereignty of the state, an old, old experiment, but the Italian experiment was under new, modern conditions and with temporary success and meaning." It deserved to be studied, not condemned.[23]

That was also the assumption of Ida Minerva Tarbell in 1926. Famous as the muckraker who had exposed the Standard Oil Company nearly twenty-five years earlier, the indefatigable sixty-nine-year-old writer-lecturer, having just done a job on Florida for *McCall's*, was offered a sum—twenty-five thousand dollars—that "I could not afford to refuse" to "look into" Italy. The fact that she "knew little" about that country was no deterrent. What she did know was that after a period of postwar turbulence "a dictatorship" had been established "without bloodshed"—"not a brick thrown, not a head broken. It was the most amazing transfer of government I had known of." Very unhappy with the mindless American prosperity, which was rendering audiences inattentive to her dire lectures on the need for political and economic reforms, Tarbell nevertheless still defended democracy against the alternatives of socialism, communism, or a dictatorship. But for two years she had done so "with a spirit so low that my tongue was in my cheek." So she thought that perhaps "there were lessons" to be learned in Italy—if only lessons about how "manacles are put on free government." Everyone warned her of repression in Italy.

She herself would probably be arrested and searched, and her books and papers confiscated. She would be required to give the Fascist salute and to speak only in Italian, of which she knew not a word. But such was her character that she insisted upon going anyway, and the first of her pleasant surprises was that in Rome no one searched her, she saw no one giving the Fascist salute, French and English newspapers were sold on the streets, and she could speak French all day without reprimand. In fact, for the next five months she was allowed to go everywhere and see everything, and do just as she pleased.

Looking back at the experience from as late as 1938, when she wrote her autobiography, Tarbell had only the happiest memories of a productive and joyful country with a noble and charming leader. Before going to Italy she had despaired over the failure of Americans to realize that "toil and self-control" were essential to democracy. What she saw as she went about Italy was a country in which the leader "worked and made people work." Tarbell's most lyrical paragraphs describe the "men, women, and children bent in labor," tending sheep, running machines, spinning, weaving, molding, building—"a world of work." These "pictures of labor" are complemented by those of "these same men and women at play." Six years earlier, Italians "had been as badly out of step as they were perfectly in step at the present moment." Instead of "rhythmic labor" and Sunday gaiety such as Tarbell now everywhere beheld, there had been "a clash of disorder and revolt." Instead of "steady balance, orderly action," there had been the anger and violence of people insecure in their lives. "How could it be, one asked, that in so brief a time a people should drop its clubs and pick up its tools?" The answer was simple: Mussolini. Ambassador Fletcher told her to "just go down and have a chat with him." She did. "Nothing was more interesting" in all Italy than the antechamber of Il Duce, where people waited, entered, and then came out either "exultant" or "collapsed." Tarbell herself eventually came out exultant. "It was all so different from what I had expected," she exclaims. Mussolini charmed her at once, speaking English and apologizing with "a most extraordinary smile." Shifting to "fluent, excellent" French, Il Duce became "excited and stern" and "pounded the table" as he talked about the need for good housing for the people. A nondrinker himself, he inquired about how Prohibition was affecting the "working people" of America. At the end of an "illuminating half-hour," Mussolini accompanied Tarbell to the door and "kissed my hand in the gallant Italian fashion," and she understood one source of his power. He was "a fearful despot," no doubt, "but he had a dimple." Tarbell had forgotten to bring up the pragmatist William James, whom the dictator was said to admire, but otherwise she was pleased by the interview. She went back to America and published her series, "The Greatest Story in the World Today," in *McCall's*, whose editor boasted to his readers that America's "most noted" woman journalist had found Mussolini to be "neither violent nor forbidding," but one who owed his "exalted position" to his "actual abilities and force of personality."[24]

In August of 1923 Steffens wrote to his friend E. A. Filene, a Boston businessman and innovator in labor and social relations for whom he had worked in 1915, that the sculptor Jo Davidson "wants to do Mussolini's head, and his sittings would be a fine chance for an interview with the man who represents American ideals so literally." Davidson finally got his wish in 1926. In his memoirs he recalls that "Lincoln

Steffens had been talking to me about Il Duce and his position in history." Tom Morgan of the United Press, "who was very close to Mussolini at that time," arranged for the sittings. A young sculptor from the American Academy helped Davidson "put up the clay" at the Palazzo Chigi, the Foreign Ministry where Mussolini still had his office. There "black-shirted and black-frocked ushers, dark and slick-haired, hovered about." From the end of "the longest room I ever crossed," Mussolini gave him the Fascist salute and beckoned him forward, and then sat down and continued to work at his desk. The sculptor admired his "very mobile face, and extraordinary eyes—the whites bluish, the irises very deep and dark." The dictator informed Davidson that he was doing "seven in one," since Mussolini "held seven portfolios" in the government. During the sitting on the second day, there was "a continuous flow of visitors"—most attractively "a galaxy of Contessas and Marquesas" who "brought violets and roses for Il Duce" and discussed "the Fascist program for women." On the third day Mussolini expressed impatience, so Davidson requested some interval of real posing. This was granted, and Il Duce began to like it. " 'For the first time I am being made as I am,' he said." A few days later Davidson's remark that Mussolini's eyes had to be modeled separately because they were not alike was taken as an insult, but he continued to regard this bust as "the best," and in the end he signed it himself, "and dated it 'Anno V.' " Davidson wrote happily to Steffens that Mussolini "*did* pose for me, and when I say 'pose' I mean he posed for me as he poses for others; he has undoubtedly great histrionic power."[25]

A coup de théâtre that enormously enhanced Mussolini's international reputation was his achievement of the Lateran Treaty with the Vatican, signed in 1929. This finally resolved the dispute over the possession of Rome that had existed since 1870. Vatican City became a sovereign state, a concordat between the Vatican and the Kingdom of Italy spelled out the special status and privileges of Catholicism in the nation, and an indemnity for confiscated church property was paid. No sooner had the treaty been signed, however, than in America an angry book called *Pope or Mussolini* was patched together and published. Dedicated "To the Late Thomas Jefferson of Monticello," with a preface by the anti-Fascist exile Gaetano Salvemini, it was written by John Hearley, who had become interested in the relations between the Vatican and the Italian government when he served as an assistant to Ambassador Thomas Nelson Page during the First World War. He had visited Fascist Italy in 1927. As a defender of the ideals of the Risorgimento, Hearley asserted that the treaty represented the belated triumph of the Vatican, since it sacrificed many of the freedoms for which the creators of United Italy fought. Restrictions that until 1870 had applied only to papal Rome now extended over the entire peninsula and were enforced by the Fascist government. Even before the Lateran Treaty, the crucifix and Catholic instruction had been restored to public schools, Masonry abolished, and pornography and nightclubs banned. Dancing, theater, tea concerts, and movies were outlawed for everyone during Holy Week, thus making Rome an exclusively Catholic city. Now the concordat made Catholicism the religion of the state, and for the first time canon law—covering such matters as marriage and divorce—was imposed upon the entire population. No wonder the pope, who only twelve months earlier had referred to Mussolini as "a limb of Satan" when he banned "the Catholic Boy Scouts," now found that Il Duce had been "sent by Providence." The Lateran

Treaty was thus "a study in opportunism" for both Fascism and Catholicism, cynically enhancing the power of both at the expense of civil freedoms and democracy.[26]

Hearley was perhaps even more concerned with the way the treaty enhanced the reputation of Fascism than with its enlargement of the power of the Church. He saw, moreover, that Fascism fed off the spirit of Roman Catholicism and imitated it. The idea of Rome "militant and universal" was essential to both, and sometimes this alliance was even ceremonially expressed. Hearley recalled the day in May 1927 when the Fascists, in the presence of the queen of Italy, reerected the cross in the Colosseum where the Garibaldians had torn it down fifty-six years before. An "inscribed tablet" was affixed to the wall declaring Il Duce's protective attitude toward this sacred Catholic spot. "More than one foreign spectator wondered bewilderedly whether history was being made or unmade, as the tall stark cross was slowly lifted on high," a one-hundred-voice choir sang hymns, and five hundred doves flew up from the dungeons of the ancient arena. But Fascism was not merely allying itself with Catholicism through religious spectaculars such as this; it was developing its own rituals and holy days. Americans who went to Tivoli on April 21, 1927, found the Villa d'Este closed for "Rome's birthday," which was now not a local but a national event. Florentines and Venetians had been slow to become Italians, but Mussolini thought all would be glad to become Romans—ancient Romans. An Italian professor had told Hearley to read James Russell Lowell's *Fireside Travels* for a prophecy of this—and of the coming of Fascism. Lowell had written that one is aware of the "imperial ghost" lurking everywhere among the "solitudes of Rome," where "not the mere absence of man, but the sense of his departure" created a "profound loneliness." Thus arose the thought that "the Idea of Rome will incarnate itself again, as soon as an Italian brain is found large enough to hold it, and to give unity to those discordant members." *Ecco,* said the Italian professor: Mussolini.[27]

The American writer who most ardently reported the rapprochement between church and state from the opposite point of view was Anne O'Hare McCormick, who began expressing her frank admiration for Mussolini in the pages of the *New York Times* from the date of his first appearance in Parliament in 1921. She quotes approvingly the same speeches that Hearley quotes in horror. For instance, to the defiantly secular Assembly of Deputies he had daringly declared that Catholicism represented "the Latin and imperial tradition of Rome," Italy's indispensable and "universal" heritage. When he became head of the government in 1922, he shocked everyone again by calling for the help of God as he began his "precedent-shattering regime"—the first time God had been invoked publicly by an Italian prime minister. McCormick does not trouble herself with Mussolini's reputation as an avowed atheist. What is important to her, as she observes in 1926, is his alliance of Fascism's interests with those of the Church: "The paradox of the passion of Romanity revived by the *fasces,* the Roman salute, the constant evocation of 'Roma Augusta,' is that it extends also to the Pontifex Maximus, who kept Rome a capital from Caesar to Victor Emmanuel and who must remain in Rome if only to add to the prestige of the Italian capital." The reason the official Vatican newspaper frequently attacks "the abuses and restrictions" of "a regime so favorable to the Church,"

remarks McCormick disingenuously, is that "the Vatican must demonstrate its independence of any Italian government, friendly or unfriendly." At the same time these insincere attacks conveniently gave Mussolini a chance to demonstrate his "forbearance." When McCormick asked Mussolini himself whether "the excellence of present relations between Church and State" indicated an approaching reconciliation, "'I hope so!' said the Duce, so vigorously that it sounded like a promise." The Vatican, McCormick emphasizes, understands that Mussolini's dictatorial powers offer a rare opportunity; and the pope's "benevolence toward the intentions of the present government" is evident.[28]

Even when, two years after the Lateran Treaty was signed, McCormick had decided that the fundamental philosophies of Catholicism and Fascism were irreconcilable—the one having the individual soul as its primary concern, the other entirely subordinating the individual to the state—she persisted in her appreciation of what Mussolini had done for the Church. Even before the Lateran Treaty he "went to church at the head of his Cabinet, and made instruction in Christian doctrine an integral part of the Fascist educational system." So when Pope Pius XI on the occasion of the treaty "referred to Mussolini as 'a man sent from Providence' he meant it." He was also sincere in praising "the ideal of class collaboration underlying the corporative State of the Fascists," only suggesting that "the system might be improved." McCormick is troubled by the fact that on the issue of the education of youth Catholicism and Fascism are diametrically opposed, but on other topics she seeks to emphasize the harmony between them, and she continues to admire Mussolini. As we saw in an earlier chapter, in 1935 she skillfully rationalized the pope's refusal to condemn the invasion of Ethiopia, and she noted that Mussolini's "attitude toward the church" remained "conciliatory." For example, when the pope objected to a decree allowing "work on Sunday to make up for Fascist holidays during the week, the government immediately rescinded the order." When Pius XI reached eighty in 1937, McCormick observed that the character of his pontificate had been determined by the fact that he ascended the throne in the same year that Mussolini seized power. She then contrasted the general harmony that existed between the Church and Fascist Italy with the difficulty of the pope's relation to Hitler's Germany, with which he had signed a concordat in 1933 that he already regretted. McCormick can find nothing good to say of Hitler, but the "Pact of Steel" that Mussolini had already signed with the Fuehrer was, for many Americans, rapidly effacing whatever enhancement his reputation had enjoyed from his pact with the pope.[29]

The reshaping of Rome into an architectural stage set symbolically expressing Fascist ideals was regarded by Americans with both admiration and satirical revulsion. Actually, the patriotic motives and the monumental results were alike consistent with the Italian nationalism upon which the Risorgimento and the Kingdom of Italy had been founded—essentially the same that in the twenties and thirties also gave Washington, D.C., similar ponderous buildings and didactic shrines. Gigantic new palazzi holding government offices and the ceremonial Piazza Venezia with its Altar of the Country at the Victor Emmanuel Monument were readily adaptable to Fascist statism. Similarly, the excavation and enhancement of ancient monuments,

which had been an expression of pride and identity for United Italy, were activities entirely consistent with a new imperialism and therefore became an important part of the Fascist urban program. Consequently, insofar as the Forum and the Colosseum entered into contemporary representations of Rome, they did so purely in a Fascist context. Finally, the conversion of Rome into a modern capital that expressed progressive economic and social policies was also a goal that the Fascist regime had only to divert to its own sense of what the future should be. Rome would not merely catch up with Paris and Berlin; it would lead the way—through its scientific institutes, its sports centers, its automobile expressways, and its futuristic model suburb with a world exposition center. *Venus* of the Capitol and the *Apollo Belvedere* are heard of no more; but the colossal male nudes of the Mussolini Forum for Physical Culture are often mentioned—and laughed at.

In early 1927, little more than four years after coming to power, the Fascists were able to show a sympathetic journalist like Anne O'Hare McCormick an elaborately plotted sectional map that indicated their final intentions for the city in zones of green, gray, yellow, red, white, and black. This was the third scheme projected since 1870, but it covered an area five times greater than the first, of 1881. Entire sections were marked for demolition to make way for broad streets and "zones of respect" around antiquities. In describing this map for readers of the *New York Times*, McCormick says simply that "a new Italy demands a new Rome," while explicitly drawing an analogy between the "drastic labors of young engineers and architects engaged in revising Rome" and those of the "other stern young men [who] draw up edicts to reform and remodel the country." The Fascist "ambition" she finds "even more exuberant than the pagan pride that reared the biggest pleasure house in the world or the Christian fervor that built the biggest church." What is most exciting is that it "wants everything"—both "catacombs and New York subways," both Romulus and Marconi. The scale of its new civic centers is inspired by—and will surpass—that of the five imperial forums it has uncovered. Both "within and without the old walls," the twin "booms" in archaeology and architecture are evident. They reveal, amusingly, "the plagiarisms of progress." Much of the Old Rome being exhumed "bears striking resemblances" to twentieth-century America: temples for trade bigger than temples for worship, an obsession with bathing facilities, monotonous apartment blocks surrounded by villas for "tired business men," and vast facilities for spectator sports appealing to a "floating population" like New York's.

But if Rome strangely finds a modern New York model in its own ancient image, it must also be something more than New York. For it is "in some sense the center of the world—a part of what Mussolini calls 'the patrimony of mankind.'" Therefore, says McCormick, the "fate of Rome under Fascism is important to more people than the fate of democracy, or trades unionism, or the surplus population." Foreigners watch with a personal concern as Rome grows once more into a city with the population it had under Augustus. Although the city is deprived of self-government ("an imitation of the status of Washington") in order to ensure that its character will be determined by national concerns, its governor issues sonorous proclamations that are daily plastered on the city walls. The present possessors of Rome regard it as "the World," and it has never been "so magnificently dreamed of, or so carefully

tended." Flowers are constantly renewed in the piazzas, the public gardens, and along promenades like the Via Veneto; the streets are better paved and "cleaner at their oldest and narrowest than those of any American town I know." The "old stucco walls" of buildings are "patched and repainted," and the range of earth colors permitted is strictly dictated.

McCormick is appreciative of the Fascist regard for Rome's Catholic as well as pagan past. When "Mussolini got wind" of the "brilliant idea" of American Methodists to build a church on Monte Mario to "soar above and eclipse St. Peter's," the "wooded heights" were seized for a national park. (After World War II, a more democratic government would allow a Hilton Hotel to be built on the spot.) But "widened perspectives on the past" are "of the essence of Fascism." The "zones of respect" are "not cemeteries, but parade grounds, inciting to new glory." Yet Mc-Cormick tends to sympathize with those Romans who suggest that "the exposure of so many skeletons will make the city too sepulchral." The "contrast and confusion" that constituted much of Rome's former charm will be diminished by too much tidiness. The "buccaneering builders of the Renaissance" made Rome "a chronological crazy-quilt, of writhing façades masking barnlike old basilicas, of baroque palaces flaunting classic marbles and haphazard columns, of satiric fountains spraying Egyptian obelisks and Roman baths." Whether or not the result was "beautiful," it was "alive, and as intemperately and robustly Roman as the Forum and Colosseum must have been in their gilded and grandiloquent prime." The essence of Rome was its ability to borrow, steal, and adapt—it "Romanized whatever it wanted." McCormick sees this in the "sight of the Mussolini Cabinet at Mass in the church Michelangelo fashioned under the arches of Diocletian." This image happily "links Fascism with the two great Roman Renaissances." But the popular garden restaurant that formerly nestled within the ruins of Trajan's Forum brought Rome's past closer than does the present cleared architectural shell of the Basilica Ulpia. Rome's "living walls made of fragments of dead epochs" better demonstrate Rome's "eternal and indestructible" character than do "neatly roped-off ruins."

Nevertheless, McCormick realizes that "the chief business of Rome is government, antiquities, and sightseeing," so these archaeological clearances are probably worth more than commercial buildings would be. Rome's only products are "edicts, dogmas, and glamour." If such " 'imponderables,' to use one of Mussolini's favorite values," can support a million people, Rome is a uniquely fortunate city. It can both reveal to the visitor "a wall as Tarquin built it" and at the same time indulge in the greatest effort at new construction in the world. Rome has outgrown the Aurelian Wall itself, "until now always too big for the city it enclosed." Entire towns and trading centers "stretch south toward Frascati; westward along the electric railway to the sea and Rome's new bathing beach at Ostia; east along the Via Nomentana to the 'Garden City' whose narrow little houses and American front yards perch like a mechanical toy town on Monte Sacro." Inside the walls, "vast banks, insurance offices, hotels and warehouses replace the worst tenements of the old city or rise on the site of monastery gardens and villas." In the workers' suburbs that replace the slums, a New York architect may find his gayest and most original models. Burning with "the Roman ardors of Mussolini," the architects and engineers of Fascism look

into the future, opening up vistas, eliminating tram and horse traffic from the center, adding a hundred fountains to the three hundred they inherited, and making Rome's secular studies equal her ecclesiastical learning by creating a "university city." According to McCormick, "Rome rises," and "in three years it has gone further than in fifty."[30]

John Hearley, observing the emergence of Fascist Rome in the same year, no more sympathized with McCormick's enthusiasm about all this than he did with her view of the Lateran Treaty. It was too clearly a part of Mussolini's attempt to force a transformation in Italian character. Where "mere words" might fail, "a sermon in stone might win." Il Duce knew that the Romans, ignorant and slothful, required to have their former glory made "thrillingly visible" to be "persuaded, yes—even compelled to take inspiration, strength and daring from it." Self-respect and aggressive action must replace the paralyzing spirit of dolce far niente. The uncovering of the Forum of Augustus, the scraping of "age-old filth" from the theater of Marcellus, and the demolition of "the squalid Borgo quarter" to beautify the approach to St. Peter's—all are intended to instill the spirit that will build a "modern Rome" with "the world's largest sky-scraping building and a 20-mile subway." With such glories before them, the Italian people will gladly lose themselves in the collective will of the state.[31]

By 1935 Mussolini had judged that his people were ready to begin reconstruction of the Empire. With his conquest of Ethiopia that year he ceased to be the peripheral master of a provincial social experiment and moved onto the international stage of imperial competition with England and France. The number of American correspondents in Rome consequently increased, and thus the number of simultaneous narrators of the unfolding Fascist drama. The reports are now predominantly critical, although rarely rendered with the passionate bias of Seldes and Hearley. Since most of the narrators become longtime residents, an overtone of sad alienation often modifies the anger and mocking laughter with which they write of Mussolini's climactic declaration of war on Great Britain and France in 1940, and of the denouement to their story: his declaration of war on the United States in 1941. In these six years the admiration for Mussolini almost wholly ceases, and criticism of his foreign policy is enlarged to include criticism of fascism itself. What remains constant in most accounts is an affection (sometimes patronizing) for the Italian people—an affection that makes it necessary to see them as helpless victims of a brutal dictatorship from which they must in time be liberated, as they cannot liberate themselves.

The image and drama of the Rome of these years is represented in one famous painting, Peter Blume's *Eternal City* (1937; fig. 30), and in books by a varied group of American correspondents and diplomats. In their European exile or occasional wanderings, American poets and novelists sometimes descended as far as Rome, but apart from Wharton's "Roman Fever" and fragments of Mussolini-worship in Pound's *Cantos,* nothing of consequence appeared in their works. As far back as 1929 the Italophile Sinclair Lewis (who eventually died in Rome in 1951) conspicuously passed over the Fascist capital in *Dodsworth* to locate the spiritual regeneration of his American businessman-hero in Venice and Naples. Significantly too,

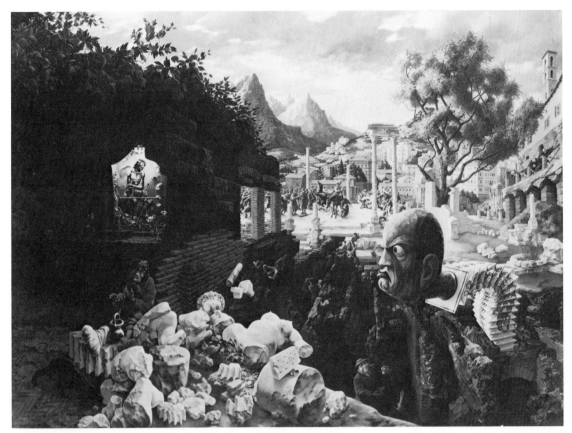

Fig. 30. Peter Blume. *The Eternal City*. 1934–37 (dated 1937). Oil on composition board. 34 × 47⅞″. Museum of Modern Art, New York City. Mrs. Simon Guggenheim Fund. (See plate 7.)

Robert Penn Warren's study of a popular American dictatorship, *All the King's Men*, was partly written in 1938 in Rome and Perugia, "where the bully boys wore black shirts and gave a funny salute."[32] But Rome was not found usable in any more direct ways, even for satire. In view of the abundance of imaginative American fiction and poetry that Rome inspired after the next war, the silence during the Fascist Era is eloquent.

Peter Blume's *Eternal City* itself constitutes a negation of Rome's beauty and of its romantic significance. The young artist had gone to Italy in 1932 (Anno X) on a Guggenheim Fellowship. A century after Thomas Cole had meditated upon the Course of Empire in the same place, Blume, observing a strange light over the Forum in January of 1933, conceived the idea of a painting that would juxtapose traditional classical and Catholic images with those of Fascism. The result was an appalling synthesis completed in America in 1937.[33] Studies of propped-up antique walls, a grotesque votary shrine, running monks, a squatting beggar, and strutting soldiers were eventually assembled on the stage of the Forum. From an excavation ditch pops a green Mussolini-head, a jack-in-the-box whose famous jutting jaws and bulging eyeballs are more comic than frightful. A backdrop of Alpine mountains is said to be

341

an image of America's own Rockies, and the lovely tree is a willow that grew in Connecticut. These beautiful natural forms heighten the artificiality of the Roman scene in which they incongruously appear. On the far right two detached tourists look over the railing of an observation platform beneath the wall of the Capitol, as though from the balcony of a theater. The hateful force of Mussolini's thrusting head seems to have shattered and prostrated the nude sculptures of lovers in the left foreground, and in the gravelike ditch below, a fat capitalist and a grinning Black-shirt look up at Il Duce's image like demented children. (Would not only children be so frightened and entertained?) The long-faced beggar with a bandaged foot and a professionally supplicant pose represents an inheritance from papal Rome: Mus-solini's banning of beggary had been successfully protested by the pope, who re-garded Roman beggars as necessary for the daily practice of charity.[34] Blume's beggar properly sits directly beneath the Catholic shrine, in which an agonized and emaci-ated Christ appears as a sideshow in his own specially illuminated alcove. In addition to his crown of thorns, he is loaded down with the tinselly and tawdry votive offerings of the superstitious, while on his shoulders he sports military epaulets. His image too is both frightful and comic, and lacks all redemptive power. Christ's grimace of extreme pain competes in life-rejecting ugliness with the pout-ing down-turned lips of Il Duce.

The only mysterious element in the painting is found in the activity progressing on the brilliantly lighted floor of the Forum in the background. Among a few reerected columns of the ancient world, citizens and soldiers mingle confusedly in various postures of aggression, rebellion, and abasement. They enact a nightmare scene in which the extreme clarity of their tiny images ironically emphasizes the ambiguity of their relations and the uncertain tendency of their conflict. All that is known is that they participate in the latest act of a tragicomic dreamplay from which the Eternal City never awakes.

In descriptions of Mussolini's Rome after 1936 the analogy of theater seems less and less metaphorical, so self-conscious of their respective roles are both performers and spectators. The language of artifice is even more recurrent and insistent than it was in descriptions of papal Rome. Even after the rise of Hitler, and the initiation of lavishly produced Nazi rituals, Rome remains the most imposing theater of fascist spectacle, featuring the original *histrion*. But American reviewers begin to find the Italian performance shallow, stale, and strident, and they watch its participant-audience becoming volatile, apathetic, and bored. Act after act is desperately im-provised from year to year, until sympathy perversely shifts to the supposed vil-lains, while the hero is ridiculed and despised. The effect of this presentation, in books mostly published after the war had begun, tends to exonerate the Italian people from responsibility for both fascism and the war. They are an attractive people who were seduced and then repressed; they are America's friends, not its enemy.

Several American correspondents, in the years after they were expelled as enemy aliens, described the Rome they had known, either in books that placed it in the historical context of Fascism's growth or in the personal context of their experience as adventurous reporters. The most distinctive of these books—a superior auto-biography in the tradition of Henry Adams—is *The Education of a Correspondent*

(1946) by Herbert L. Matthews, a reporter for the *New York Times* who first covered the Ethiopian War sympathetically from the Italian point of view, but learned a different and more advanced lesson while working in Rome between 1939 and his internment by the Fascists in 1941. Matthews's more impersonal study, *The Fruits of Fascism* (1943), belongs with a group of wartime books that include *Balcony Empire* (1942) by United Press correspondents Reynolds and Eleanor Packard, *We Cannot Escape History* (1943) by John T. Whitaker of the *Chicago Daily News*, and *Italy from Within* (1943) by Richard G. Massock of the Associated Press, all of which contain varying degrees of personal narrative. Many years later the happily whoremongering Reynolds Packard was able to flesh out his account of the Rome of 1939–42 (and to compare it with the postwar Rome of Pope John XXIII and Sophia Loren) in a candid autobiography affectionately dedicated to his wife's lovers, *Rome Was My Beat* (1975). Briefer specialized glimpses of Rome on the eve of Italy's entrance into the war in 1940 are provided by the playwright and future diplomat Clare Booth (Luce) in *Europe in the Spring*, in which she satirically follows in the wake of President Franklin D. Roosevelt's special envoy, Sumner Welles, who tells his own story of his diplomatic mission to Europe in *A Time for Decision* (1944). Finally, most of these writers appear in *Ventures in Diplomacy* (1952), the sober (not to say bland) reminiscences of the last American ambassador to Fascist Italy, William Phillips, a Republican who supported the new Roosevelt. Among writers on Fascist Rome, Phillips provides the natural transition, since he alone remains to the end an admirer of Mussolini and of what he accomplished in Italy through fascism; only the folly of his imperial ambition and his vindictive peasant personality turned him, in the last act, into America's enemy and Phillips's antagonist.

Phillips, an experienced career diplomat, knew that in the 1920s American politicians had avoided Rome, not because they disapproved of Mussolini, but because they could thereby forestall questions from their constituents about whether they had paid respects to the pope. By July 1936, however, when Phillips became ambassador to Italy, Mussolini had become as problematic as the pope. The conquest of Ethiopia had placed the United States in clear opposition to Italy for the first time in history. As a result, Phillips would become known as "ambassador for life," because his country's refusal to recognize the king of Italy by his added title of "Emperor of Ethiopia" made accreditation of a new ambassador impossible. Soon after his arrival Phillips sought audiences with "the big three," Mussolini, his son-in-law Count Galeazzo Ciano (who had been appointed foreign minister following his exploits as an aviator in Africa), and the king. The Bostonian Phillips thought Ciano a very satisfactory gentleman when he met him at his office at the Palazzo Chigi, but was disgusted that at social events Ciano turned into an inattentive and ill-mannered "young man with a roving eye." Phillips perceived that he had "no standards morally or politically." The diminutive king was on the whole more to Phillips's liking; and the ambassador thoroughly enjoyed having "four magnificent state coaches" with bewigged and scarlet-clad coachmen sent to bear him and his entourage to the Quirinale for the first meeting. But the king had no power.[35]

To prepare for his meeting with Mussolini, Phillips visited the Mussolini Forum, "the Duce's famous Fascist Academy of Physical Education," which was "one of his pet projects." This establishment, "with its great buildings and stadiums and sports

fields, was an impressive sight." So was the "powerfully built" Mussolini himself when Phillips met him at the Palazzo Venezia on October 6. His "complete baldness seemed to exaggerate the size of his head," and his "most striking feature, his eyes, suddenly seemed to expand and the whites to protrude, when he riveted his glance upon me or sought to express himself forcibly." These eyes significantly "dilated" when he was told that Roosevelt was certain to be reelected even though 80 percent of the American press was against him; after all, the Italian press was 100 percent for Il Duce. There was otherwise nothing "blatant" about his behavior during this ten-minute interview. Phillips thought him at once "a man of parts," and like everyone else judged him to be "a great actor." Even in the retrospect of postwar memoirs, Phillips's criticism of Mussolini concerns his foreign policy only. Mussolini the man was wholly admirable: he had "lifted himself unaided" from "humble surroundings" to become "the leader of the Italian people" and was "a man of wide human interests and accomplishments." Besides being a "powerful public speaker," he was a "natural athlete, a long distance swimmer, skier, horseman, pilot of his own plane and motorcycle fan." A musician, he had transformed the Rome Opera "into one of the most splendid in Europe"—better than La Scala of Milan. In spite of his "many talents," he remained a "simple man" who sincerely believed that he was governing Italy for the benefit of its people. They in turn regarded him "more as a father of the family than as a dictator." As Phillips later assured Roosevelt (who said he had nothing against dictators who did not become aggressors), "the Italian people were so accustomed to an authoritarian government that anything along the lines of our form of democracy might well be a failure." Phillips found Il Duce to be an "impressive" figure when he "was out among his people" and dressed in his Fascist uniform. He did notice, however, that when Mussolini appeared in civilian dress "he looked not only the sturdy peasant, but a very rough customer."[36]

Mussolini's foreign policy, unfortunately, was another matter, but even that Phillips regarded benignly as long as he could. Italy's need for space in Ethiopia was understandable. As for the Spanish Civil War, Phillips informed President Roosevelt in 1937 that Italy's intervention constituted a "war against communism"; Mussolini reasonably abhorred the idea of a communist state on the shores of the Mediterranean. In fact, the problem with Il Duce's increasingly "bellicose language" was that foreign governments took it "literally." Mussolini simply used it to "keep alive" the "martial spirit" that he had breathed into the Italians in order to "create" a "new and vigorous race" capable of carrying out his plans for "bettering conditions of the masses." The mistaken reaction abroad was trapping him into an aggressive alliance with Hitler. Roosevelt, who was skeptical of this interpretation, did not help Phillips's position in Rome by speeches in which the president proposed to "quarantine" aggressor nations and hopefully predicted the eventual restoration of democracy in countries that had lost it. The Italian press became violently anti-American, or more precisely anti-Roosevelt. Now German-dominated, it published a family tree proving that the president was a Jew. But since the American press was by this time ridiculing Mussolini as a "little Caesar," and caricaturing him as "a common swashbuckler, all chin and no brains, rattling a sword," Phillips was called upon repeatedly to explain to Fascist authorities that the American

government did not control the press and that Americans did not take their press seriously anyway.[37]

Germany annexed Austria in March 1938, thus establishing a border with Italy. Since this was something Italians had long feared (in 1934 Mussolini had said he would fight Germany to prevent it), it provoked open expression of anti-German feeling among people "of all classes," although not, of course, in the press. Italians, however, had been promised the "greatest spectacle" in many a day when Hitler visited Italy two months later, and "Italians love a good show above everything," according to Phillips. Yet he acknowledges that "genuine spontaneity" was now impossible, so the propaganda machine had to go to extremes to produce an effect of uniform enthusiasm in the populace. All Jewish refugees from Germany were locked up, and the German police took over headquarters in Florence, Rome, and Naples—the cities Hitler was to visit. When one Roman lady asked information of a policeman in an Italian uniform, he replied "Sprechen Sie Deutsch?" This was a foresign of what was to become within two years an effective German occupation of Italy.

Hitler entered Rome by way of a specially built and lavishly beflowered railroad station outside the city. Then he was driven in state "past the Colosseum, through the Via del Impero and the Piazza Venezia to the Quirinal, where he was to stay." Ambassador Phillips was happy to find himself uninvited to any of the ceremonies of this strictly German-Italian "love-feast." He watched the procession from the rooms of an American friend "overlooking the Piazza Venezia." The Colosseum was "illuminated from within with red lights . . . , a fantastic sight." The streets were packed with people, but when the first car, carrying the king and Hitler, passed by, "there was little response." The next day Phillips himself found "indescribable" the effect of fifty-two thousand Blackshirts putting on "an exhibition of perfect rhythmic display in physical movements, directed by the voice of one leader." But during the military parade, which Phillips watched from the crowd, he noted that the Roman people were repelled by the so-called *passo romano* (the goose step), which was being performed in public for the first time. It too obviously turned the soldiers into "puppets," and one "could feel that they hated it and resented the indignity." When the goose-steppers were succeeded by soldiers marching in "the 'passo italiano,' with its easy and natural swing," the crowd "burst into enthusiastic cheers." All Rome sighed with relief when Hitler departed.[38]

By this time the journalists John T. Whitaker and Richard G. Massock were in Rome. When Whitaker had arrived from Spain early in 1937, Mussolini had summoned him to the Palazzo Venezia to get his view of the Spanish war, in which Italian "volunteers" were fighting for Franco. Whitaker advised him to withdraw them. Later he was with Mussolini in Libya when the news of the Italian defeat at Guadalajara arrived. Mussolini admitted that Whitaker had been right, but vowed that now his troops would never withdraw. A few weeks later, Mussolini summoned Whitaker again. The American found Il Duce in a deeply melancholy state that caused him at first to resort to the "bombast and posturing" usually saved for his public appearances. He even "mounted the six-inch rostrum in the alcove window of that long and impressively bare room which served as an office near the

balcony from which on momentous occasions he addressed the Italian nation."
Looking down upon Whitaker, he popped his eyes and thrust out his jaw while
delivering a "grandiloquent" monologue. Then he suddenly went to his desk, sat
down, and started talking naturally. What he said was startling. He had decided on a
firm alliance with Hitler. Germany would be allowed to take Austria, and Italy
would become the dominant power in the Balkans. Three years earlier he could have
defeated Germany, but now it was too late. A massive German rearmament had
since taken place, while the "contemptible democracies" had done nothing. Instead
of a foreign policy, the Anglo-Saxon world had only a " 'pious, puritanical hope' "
that the evil Nazis and Fascists would fight each other, said Mussolini. " 'Bah! My
dear fellow, I won't do it for you.' "[39]

In Whitaker's estimation, Mussolini "played power politics with a cool, de-
tached, and resourceful daring not seen since the days of Bismarck in Germany and
Cavour in Italy." He was not the "blustering, humorless, megalomaniac" that the
American politicians and press by 1937 wished to think him. He had successfully
given Italy an international importance far greater than it objectively merited; "he
had unwopped the wop" and proved himself "the most audacious poker player in
modern history." His public speeches were skillfully calculated for their effect on
European public opinion, and he thoroughly enjoyed the drama of his reciprocal
relation with the Italian people when he spoke. Whitaker truly understood Mus-
solini "for the first time" on the day when the journalist watched such a perform-
ance from the wings. Whitaker stood near a tank upon which Mussolini was
mounted, with a background of ancient monuments and umbrella pines. As the
crowd roared "Duce, Duce, Duce!" in response to a particularly bellicose statement,
he heard Mussolini whisper in an aside to his son-in-law, " 'Is that hot enough for
them, or shall I make it hotter?' " He then faced the crowd again with clenched fist
and scowling face, and hailed his people as "voluptuaries of danger." These appar-
ently "mad" harangues were really calculated moves by a "cold fish," a Machiavel-
lian intellectual who despised the genuinely irrational and superstitious Hitler, "a
sort of German Father Divine." To Italians, all Germans remained barbarians, Huns
to be feared but not respected. Whitaker recalled that among those marble-and-onyx
maps on the wall along the new Imperial Way, there was one that showed the
Empire at its height under Trajan. The Mediterranean was entirely surrounded with
the white that signifies civilization—Roman Law and Roman Peace. But the regions
of Germany and Russia remained forever black.[40]

In August 1938, the Rome to which Richard Massock came was oppressed both
by the "hot humidity of a sirocco" and the growing dominance of Germany. He
noticed that even the Fascists rarely greeted each other with the prescribed Roman
salute; the Italians were weary of "conflict and sacrifices"—the unpopular war in
Spain, and the high taxes to support it. Moreover, the Ministry of Popular Culture
was now promoting an uncongenial new racist policy derived from Nazism. Jews
were expelled from Italian academies and from the army and navy, and foreign-born
Jews were ordered to leave. Worst of all, the alliance with Hitler was clearly leading
to a greater war—the last thing wanted by the Italians, or even Il Duce at this point.
The Romans went about with "gloomy" faces. Therefore, when on September 27
the news spread that Mussolini's personal appeal to Hitler had stopped Germany's

threatened invasion of the Sudetenland and had produced a peace conference to be held in Munich the next day, Massock could hear through the open windows of his office in the Via della Vite the shouts of "jubilation" arising from the streets of Rome. Mussolini had demonstrated himself to be Europe's "peacemaker"; he knew what was in the hearts of his people.[41]

The choral cries of the Roman people—in the streets, in the Piazza Venezia, and in the Chamber of Deputies—punctuate Massock's *Italy from Within* and the Packards' *Balcony Empire*, which contain the fullest and most continuous American accounts of Rome in the years 1939–42. But the cries they record are rarely spontaneous shouts of joy for Mussolini as peacemaker. They are mostly responses prompted by Fascist policy. In the Piazza Venezia rehearsed demonstrators—war veterans, schoolchildren, and university students—periodically shout anti-French slogans, while deputies in the Chamber, on cue, proclaim Italy's rights to Savoy, Nice, and Tunisia. The fact that one "spontaneous" development in the Chamber was reported in a London newspaper hours before it occurred caused further restrictions on the foreign press, and Arnaldo Cortesi the loss of his job. But the Chamber itself was abolished in December, its last act the ratification of the unpopular anti-Semitic decrees, borrowed from Nazi Germany. In January 1939, Massock was present at the reception in the Palazzo Venezia given for Neville Chamberlain and Lord Halifax, and he observed that Mussolini here "was not the colorful Duce, with flashing eyes and nervous movements, of the outdoor spectacles. He was a Napoleon in rusty black broadcloth, a Caesar in modern but out-of-date dress"—a disappointed Caesar, because the English, who had finally recognized Italy's imperial claims to Ethiopia, now refused to support his grievances against France and objected to his aid to Franco in Spain. But when Madrid fell on March 28, "another demonstration of twenty thousand persons was staged under Mussolini's balcony" so that Mussolini could triumph over the hostile democracies. The crowd responded to his declaration of Fascism's defeat of Bolshevism with cries of "Tunisia, Tunisia!" A conquest of Tunisia (which had not been possessed by Rome for fifteen hundred years) was unfeasible, but proof that something had been gained from the alliance with Hitler was necessary, so tiny, impoverished Albania was seized instead. Again a "demonstration of jubilation" was "staged." The Fascists "gathered a crowd under his balcony" to hear Mussolini proclaim that the Albanians "had offered the crown of [King] Zog to Vittorio Emanuele." Mussolini took the occasion to request that "the world leave us alone in our great and daily labor." But the crowd, "at the instigation of its Blackshirt cheer leaders," responded by shouting "Tunisia! On to Paris!"[42]

In 1939 the journalists Herbert Matthews and Eleanor and Reynolds Packard were sent to Rome, a capital to which Mussolini had now given an international importance unprecedented in modern times. The individual personalities of the growing number of resident American reporters are naturally reflected in their representations of the city during the interval between the end of the Spanish Civil War and America's entry into the Second World War, but three concerns that they have in common, all of which tend to distinguish between the Italian people and the perpetrators of these wars, dominate their picture of Rome at this time. As is already

evident from the accounts of Whitaker and Massock, one concern is to stress the hollow artificiality of the theatrical spectacles in Piazza Venezia and Mussolini's genius as an actor. Second, there is the professional preoccupation of all journalists with censorship—both as it affects their ability to report the truth to the world outside of Italy and as it affects the knowledge and therefore the responsibility of the Italians themselves. And third, there is a concern to represent Romans individually and as admired friends, whom it is impossible to conceive of as enemies. Recorders of the first part of the Fascist drama tended to find justification for Mussolini in the self-indulgent character of the Italians. The narrative point of view is now inverted. The madness of Mussolini is blamed for everything that happens to these very sympathetic people.

Herbert Matthews faces the question of responsibility most explicitly, but with some equivocation, in his *Education of a Correspondent,* in chapters called "Advanced Course in Totalitarianism" and "The Eternal City." Matthews had originally come to Italy in 1925 on a postgraduate fellowship from Columbia University to study "of all things!—Dante and medieval history and philosophy." He had "absorbed" some knowledge then of Italians, but nothing of politics.[43] Ten years later he returned as a reporter and went with the Fascist forces to Abyssinia, where he covered their conquest sympathetically as one of civilization against barbarism. At that time he understood the enthusiasm of the Romans who proudly cheered their victorious soldiers. Only in retrospect do they seem to have been "at their worst, applauding a success that had been won at the expense of morality, ignoring the signs of economic collapse, deluding themselves with the belief that they were a great, martial people, worshiping the Duce who, they thought, would lead them to new and greater triumphs." In 1939 he saw "those same soldiers return [from Spain] for their poor triumph while Romans, this time under orders, lined the streets and cheered indifferently." Matthews was sure that the Romans were now predominantly anti-Fascist. But not only the Romans had changed. Matthews himself had become a confirmed anti-Fascist (but not a Communist) through the "lesson" learned while reporting the Spanish Civil War from the Republican side. He therefore had every wish to believe that his beloved Italians now felt as he did.

Seeing Fascist Rome now with a critical eye, Matthews observed that although Fascism had become unpopular, a third war, which the people did not want, was inevitable. The bitter fruits of Fascism had to be harvested. Who was to blame? "Italian complacency, indifference, and ignorance disgusted me, but I always retained a feeling for and a faith in an Italy that was at that time a sort of separate identity to me, apart from Fascism. The divorce was a specious one, since Fascism was not an accident in Italy, but I regarded it as a loathsome disease or a temporary madness that had overcome a dear friend." Matthews bitterly quotes the telegraphed blessing that Pope Pius XII sent to Generalissimo Franco, in which he thanked the Lord for "Spain's desired Catholic victory," which would lead to reestablishment of "the ancient Christian traditions which made her great." Since Italy was another Latin and Catholic country, whose people seemed naturally passive, cynical, and smug under totalitarian Fascism, Matthews took "some personal satisfaction in seeing the extent to which the effort of helping Franco had

bankrupted the country without bringing any positive results whatever." The days "when the mock heroics of Italian Fascism had vaguely appealed to me" were long over, and they were also over for the Romans: "The laughter of the Romans was false; their skepticism was genuine, and if they shrugged their shoulders, it was ruefully and with the knowledge that it was much too late to do anything about it. Rome was at last anti-Fascist, but, since nothing could be done, Romans became 'realistic' and hoped that the Duce might save them, somehow, from the impending wreck."[44]

In representing the public appearances of Mussolini in these prewar years, Massock too never fails to indicate a separation between the vainglorious Duce and the cynically passive populace, "as distinguished from the minority of Fascist fanatics." He notes that the people had been "tired out by . . . the long overdoses of political stimulants" and were, moreover, kept in entire ignorance through censorship. They genuinely did not know, for instance, that Albania had been invaded; "they accepted the propaganda version" of voluntary annexation. Both Massock and the Packards describe in detail the means of Fascist control over the reported image of Italian reality. The government did not directly censor foreign news dispatches; instead it took reprisals against offending agencies or reporters after the fact. The tough-talking Reynolds Packard was sent to Rome precisely to attempt a reopening of the United Press office, which had been closed after Packard's predecessor had falsely reported that Mussolini had suffered a stroke—a report that had necessitated an unscheduled appearance of Il Duce on his balcony the next day, shouting slogans in an especially vigorous manner.[45] Ten correspondents were expelled during Massock's first year in Rome, and the story down to 1942 contains many railway-station scenes of farewells to colleagues, until there were no more.

Two institutions were at the center of the censorship process, one the Foreign Press Association on the Via della Mercede, the other the Ministry of Popular Culture on the Via Veneto, the official source of all Italian news. Massock refers to the Fascist-sponsored Foreign Press Association, which all correspondents were required to join, simply as a place staffed with "a group of Fascist spies," who supervised the foreigners who used it. But Eleanor and Reynolds Packard clearly liked "the Club." It is the recurrent setting for *Rome Was My Beat*, and *Balcony Empire* opens with a detailed description of the privileges it offered: excellent and cheap drinks, real coffee (unavailable even in the Fascist clubs), daily "eggs fried in butter" (in spite of severe rationing for Italians), free tickets to the opera, a 70 percent discount on railway tickets, soundproofed booths with efficient and fast long-distance telephone lines (unfortunately, tapped by the OVRA, the secret police), extensive newspaper files and a (Fascist) library, writing rooms, a Ping-Pong table, a piano, a "vine-covered garden," and frequent dances. The Packards seem merely amused by the obvious bribery thus offered by Mussolini, who as a former journalist himself "believed that newspapermen could be bought." The fact that the OVRA was obviously listening to all transmissions only added to the fun that a true journalist found in meeting the challenge of getting the news out.[46] The Packards made the most of the contacts with other foreign journalists that the club's social atmosphere provided, but they by no means limited themselves to its services. Packard lost no

time in finding Count Ciano at his "favorite spot" at the Albergo Ambasciatori on the Via Veneto; Ciano gratefully remembered that Packard had supplied him with Scotch during the Ethiopian campaign. The United Press office reopened.[47]

From colleagues the Packards learned that to keep from being expelled, they should avoid saying just three things: that the lira was not sound, that the Italian soldier was not courageous, and that Il Duce was not in good health. The last point became increasingly important as Mussolini's demise was seen as one solution to Italy's problems. It was not enough to avoid hints of ill health; eyewitness accounts of Il Duce's superb physical condition became necessary. On one occasion correspondents were transported from the Foreign Press Club to the Villa Torlonia early in the morning to watch "Musso" ride a horse given him by Hitler. Just two days before his fifty-seventh birthday, "the Duck" (as Reynolds calls him) jumped hurdles "in perfect style," while a young cavalry officer who followed him sometimes missed, "just to show how good Benito was." That afternoon reporters were returned to the villa to watch Mussolini "win" a doubles match of tennis played with professionals.[48]

The Ministry of Popular Culture is, of course, described contemptuously by everyone as being neither popular nor cultured. Foreign correspondents were invited there to be fed propaganda at daily press conferences. The ministry controlled (in Massock's words) "everything that the public saw with its eyes, or heard with its ears." This "publicity service was primarily a suppression service." Among the things suppressed in the interests of a pure Italian culture were American comics, but the Italian children protested so vociferously when Mickey Mouse, Pluto, Donald Duck, and Popeye were banned that these creatures were allowed to return.[49] The omissions in the representation of the truth to adult Italians, however, were serious, and all correspondents testify to the limited sense of reality within which Italians were living after nearly twenty years of Fascism. Most Italians had no accurate knowledge of Germany, England, France, America—or Italy. Americans were bemused to find that one of the shapers of that reality was Giorgio Nelson Page, great-nephew of Thomas Nelson Page, the former American ambassador. Giorgio Page, whose father was director of a major Roman bank and whose mother was Italian, had been raised in Rome among aristocrats—gamblers and horseback-riders. In 1933 he scandalized Americans by renouncing his inherited citizenship to become an Italian. He also became the radio censor in the propaganda ministry, which caused journalists to hate him the more. Massock, who had a submitted script gutted, attacked Page as "one of the most Fascist of the Fascists."[50] But this was not so. A Fascist he was, but also deeply ambivalent, and increasingly troubled by his unique destiny as war with America approached. Page's own Italian-language apologia, *L'Americano di Roma* (1950), is, in spite of many patent fictions, a persuasive and often eloquent defense of a wasted life.

The Rome that existed between the beginning of World War II on September 1, 1939, and America's entry into the conflict in December 1941 is a bizarre place as it appears in the accounts of American reporters and diplomats. Its collective mood alters from month to month, and throughout the period it is simultaneously a grim place of increasing deprivations for the populace at large and a splendid city of luxurious living where the privileged dance on the edge of a precipice.

Nazi Germany's invasion of Poland made September 1 a "day of doom in Rome as elsewhere," noted Ambassador Phillips. The crucial question was whether Rome's alliance with Berlin required Italy to support Germany in the conflict against the wishes of the Italians themselves. That night the streets of Rome were darkened for the first time, and Phillips saw "dimly lighted buses filled with grim young soldiers" going toward the station to be placed on north-bound trains. However, the release of a telegram received that day by Mussolini (actually written by himself, but signed by Hitler),[51] which stated that Germany did not require Italy's active support at present, caused an outburst of genuine joy in the streets of Rome—the last such spontaneous demonstration until June 5, 1944, according to Matthews.[52] In 1942 the Packards wrote, "Since that day, there has never been manifest a Roman-holiday spirit of like magnitude by the Italian people." Everyone was smiling, and "in the cafés and shops the people were joking and laughing once again."[53] They would have peace.

For the ten months that Italy maintained its "nonbelligerent" (but not neutral) status, the American journalists and their Italian friends kept up their spirits with numerous parties (in conscious defiance of Fascist pronouncements). But the number of Americans in Rome steadily diminished. One of Ambassador Phillips's main concerns was to secure a safe exodus for the two thousand American tourists and students in Italy, whom he assumed "were anxious to get home." This was managed by the resumption of sailings by the Italian Lines, a good sign in itself, even though a British passenger ship was sunk on September 4 by a German submarine.[54] Finally there was practically no one left but the diplomatic corps and the journalists, their families, a woman named Teddy Lynch (one of J. Paul Getty's former wives, who was in Rome to study opera and refused to leave), and the Reverend Hiram Gruber Woolf, rector of St. Paul's within-the-Walls. (Both Lynch and Woolf were eventually arrested as probable spies.)[55]

Ambassador and Mrs. Phillips continued to offer their annual dinner dances at the Villa Taverna, with Count and Countess Ciano as guests of honor, and they offered regular musicales with "world renowned Italian tenors" as "guest artists."[56] The Roman populace, even while it endured increased rationing of meat and gasoline, the prohibition of coffee, rapid inflation in the cost of food, and the early closing of cafés, rejoiced in this period of uncertain peace. Italy's equivocal position made Rome "more and more the active center of the diplomatic and political war," and "Italy basked under the blandishments of both sides." In fact, intrepid travelers happily found Rome a gay city of light in comparison with London, Paris, and Berlin at this time. Hastily built bomb shelters were torn down, and "new arteries of traffic were opened in Rome, [and] spaces cleared for building projects." Work toward the great Universal Exposition planned for 1942 went on. Pope Pius XII, who had received his crown in sumptuous ceremonies only in March, signified his approval of Mussolini as peacekeeper by granting "an imposing state audience to Vittorio Emanuele and Queen Elena in December," and within a week the pope returned the visit, "the first call by a pope on an Italian king since the unification of Italy in 1870, the first entry of a pontiff into the Quirinale Palace since the popes lived there when they ruled Rome." Along the streets, which were closed to all traffic, flew "streamers in the colors of Italy, red, white, and green; those of Rome, purple and gold; those

of the Fascist Party, black with the golden fasces, and the white and gold of Vatican City." As the pope crossed the frontier between his tiny domain and the city of Rome, hundreds of homing pigeons flew into the air, while at the Piazza Venezia "a battery of mechanized artillery was drawn up in the pontiff's honor." Half a million people who watched the pope ride by in an automobile received his blessing. From a throne in the Palazzo Quirinale, placed slightly higher than those of the king and queen, the pope pointedly said that peace, not war, was making Italy "greater, strong, and respected."[57]

"Rome was a grandstand from which to watch, in bitterness and despair, the 'phony war' of 1939–40," wrote Herbert Matthews in his old-age memoir, *A World in Revolution*. One of the actors to appear on the scene in the spring of 1940 was Sumner Welles, undersecretary of state sent by President Roosevelt on a tour of Europe to assess the situation and convey America's hope for peace. Met in Naples by Ambassador Phillips, Welles rode to Rome in a private car provided by the government and was received like Hitler in a station decked with flowers and red carpets. When he met Count Ciano, he expressed gratitude to Italy for its contribution to the New York World's Fair and promised equal American representation in Rome in 1942. Ciano responded with a "masterful" presentation of Italian foreign policy. In the afternoon Ambassador Phillips took Welles to meet Il Duce. Phillips, whose requests for audiences had been denied for a year, was shocked by his fatigued appearance and drooping eyes. Mussolini expressed pleasure, however, at the letter from President Roosevelt that Welles presented to him, which proposed that a meeting between them, the leaders of two great nonbelligerent nations, might help restore peace in Europe.[58]

Welles himself, writing *A Time for Decision* in the election year of 1944, saw that his European tour had been undertaken in the "forlorn hope" that the president's farsighted and statesmanlike peace efforts might have some effect, even though the isolationism then sweeping America encouraged the Axis powers to believe that America would do nothing to support France and England. Only "sure knowledge that the power of the United States would be directed against [Hitler] . . . could have dissuaded Mussolini—as distinguished from the Italian people—from his fatal adventure." From Phillips, Welles received a full account of Mussolini's present "subservience" to Hitler. Il Duce was convinced that the German army was invincible. Welles was equally impressed, however, by the fact that all Italians he met, from Count Ciano down, were strongly anti-German, although they had no sympathy for the Allies. Ciano, moreover, seemed to be a reasonable and candid fellow. He and Welles discussed the possibility of America and Italy working together as the forces for world peace, and Ciano even read excerpts to Welles from his famous red diary to prove that he had worked to prevent a too-close alliance with Germany. "Throughout the conversation Ciano revealed not only his contempt and hatred for [German Foreign Minister] Ribbentrop but also an underlying antagonism toward Hitler." Nevertheless, he made Welles see that although no country " 'would want to have Germany as a neighbor,' " Italy now suffered that fate and had to " 'do the best we can to get on with her.' " Moreover, Italy bore no love for England or France, whose absurd domination of the Mediterranean was intolerable. After the conversation, Ciano and Welles posed "for an unduly protracted period" for motion pictures.

Ciano became "the 'chest out, chin up' Ciano of whom I had been told"; before that, "he could not have been more human or more simple."[59]

Before meeting with Mussolini in the Palazzo Venezia, Welles talked with Matthews, Whitaker, the Packards, and other correspondents, and with some Italians and the French and British ambassadors at Phillips's home (since the Fascists were picketing the American embassy): "From these varied and divergent sources I obtained precisely the same point of view: that not only the vast majority of the Italian people but also the key figures within the Italian government itself—save those notoriously under the Nazi influence and, of course, Mussolini himself—were totally and even violently opposed to the entrance of Italy into the war." When the self-confident Welles entered the "Sala Mapa Mondo" to meet Mussolini, it "did not seem of that ominous length so often emphasized by those who in earlier days had been granted interviews." The Duce met him "cordially" at the door, and Welles too was astonished at his appearance, for the "active, quick-moving, exceedingly animated personality" he had expected from motion pictures and descriptions appeared instead as an old man, "ponderous and static," with a face falling "in rolls of flesh." During much of the interview Mussolini kept his eyes shut and occasionally sipped from a cup of "some hot brew." The "tremendous strain" under which he existed was evident. Welles presented his letter; and later he could write that if Mussolini had answered it, as he had promised to do, "the Italian people would have been spared the tragedy which they have since undergone."[60]

Welles went on to Berlin, Paris, and London and returned to Rome on March 16. He informed Ciano that contrary to what the count had told him, he had found Berlin far more "intransigent" than Paris or London, although the last two were "determined" to suffer whatever was necessary to secure a permanent peace. While Welles was in the north, Ribbentrop himself had come down to Rome, and Ciano now agreed that Germany was committed to a complete military victory over Europe. When Welles again met Mussolini, he found him in a far more vital mental and physical condition, as though he had "thrown off some great weight." In the light of subsequent events, Welles came to believe that Mussolini had already reached his decision at that time: Italy's fate would be bound to that of Germany. Although Mussolini assured Welles that "a lasting peace was still possible," he also said that he would be meeting Hitler on March 18 at the Brenner Pass and advised Welles to postpone his departure until after that. Welles reminded Mussolini of the pacific part he had played at Munich, and Il Duce responded by proudly asserting that although the Pact of Steel between Germany and Italy did exist, "*I* nevertheless retain complete liberty of action." But when he returned to Rome on March 19, and Ciano arranged to meet Welles secretly at the golf club outside the walls, he could report only that the relation of Italy to Germany was unchanged. Ciano stated, however, that as long as he was foreign minister, "Italy will not enter the war on the side of Germany." Welles nevertheless left Rome that evening convinced that Mussolini alone had power in Italy:

Italy would unquestionably move as Mussolini alone determined. It should never
be forgotten that Mussolini remained at heart and in instinct an Italian peasant. He
was vindictive and would never forget an injury or a blow to his personal or na-

tional prestige. He admired nothing except force and power. His own obsession was the recreation of the Roman Empire. His conscience would never trouble him as to the way or means, providing his instinct told him that the method of accomplishment would serve to further the desired end.[61]

The American correspondents in Rome all found Welles wholly unsatisfactory, since he would tell them nothing. But they were impressed by his diplomatic composure, and they describe his visit respectfully. Clare Booth Luce, however, arriving immediately after his departure and even taking over the same suite of rooms (still filled with his flowers) at the Hotel Excelsior, refers to him as inferior to herself as an information gatherer "for the benefit of the American people. Mr. Welles, of course, was travelling under much more magnificent auspices. He was really going to hear things from the biggest horses' mouths, while I was just going to talk to anybody and everybody I bumped into. But the principle was the same." Her own mission, she claims, was "the more successful, because I am telling you everything I found out," whereas Welles told nobody except the president anything. She finally admits, however, that in Rome what she "found out" was precisely nothing, a fact that the chattily candid and naively "smart" tone that Mrs. Luce consciously maintains throughout *Europe in the Spring* does not hide. Indeed, she cleverly converts her ignorance and presumption into the basis for a general skepticism. Hers is a desperately rushed, frustrated, and farcical pursuit of political truth across a continent about to burst into flames. She undertook her journey, she says, to determine whether this war was really "our war." It was something she had to do, although she admits that she has no journalistic, diplomatic, or academic credentials—only a lively curiosity and an honest concern. She had never even been to Rome before, but the woman who ten years later would return as the American ambassador felt sure she could discover "how people in Rome felt about the war" simply by "sitting around for hours at luncheons and cocktail parties and dinners, and calling up newspaper men and nosing around shops and cafés and asking questions of waiters and maids and people on benches in parks, and above all walking through crowded streets until the atmosphere itself soaked into your skin and gave you true answers." She allowed herself five days to accomplish this, while also visiting all the monuments, including St. Peter's, the Vatican Museum, the pope, fifty miles of the Appian Way, and "the exceedingly disappointing Catacombs."[62]

Not surprisingly, Mrs. Luce offers no reports from citizens in parks or shops, and with one exception her luncheons, dinners, and cocktail parties were with such people as the evasive Prince del D——, the irrelevant Marchesa P——, and American newspaper men (who, she says, had it all wrong about the prospects of war). "Now, I don't know what the Romans themselves thought about all this," she confesses, "because the Romans didn't talk in front of foreigners." So two pages are given over to the bottom-pinching habits of Roman men and the probability that this "lusty approach to sex" accounted for "the numbers of rich American women who had married into Roman society," which in turn had resulted in the "democratic raffishness" and the "very pro-American sentiment of the upper classes and

the aristocracy." But that did not make them informative. Mrs. Luce complains that the Fascists had made "the communication of individual ideas on current topics . . . either a lost or a forbidden art." The Romans compensated by dancing, drinking, and riding, and by playing tennis, bridge, and golf (whenever relations with England were good enough for the Fascists to permit this British sport).

It was in a smoky salon after dinner that Mrs. Luce had her "only real 'conversation'" with an Italian, but he was none other than Count Galeazzo Ciano. The "lovely half-American Donna Cora Caetani" invited her to meet the foreign minister in a private suite at the Excelsior. Booth, famous as author of *The Women*, finds that her sharpest first impression is of Mussolini's favorite daughter, Countess Edda Ciano "in a bold print evening gown leaning languorously against the mantelpiece. She was very pale and emaciated, and her red-gold hair and heavy-lidded green eyes slipped by my direct eager glance, like a green wave from the prow of a ship, impersonal, indifferent, curiously cruel and strong. You felt right away that Edda Ciano 'met' nobody." Mrs. Luce does not mention that her husband's *Time* magazine had been banned in Fascist Italy on account of its characterization of Edda Ciano. (*Life* had also been banned, for other sins.) Donna Cora ludicrously called Edda "a dear sweet little girl," but "my feminine instincts told me right away that it would be futile to do anything else but ignore Edda." That was easy, since Count Ciano alone was willing or able to speak English, and Mrs. Luce knew no Italian. Over cocktails, she and Ciano discussed the World's Fair Building for the "Olympiad of Civilization" in 1942 (the promotional material for which she found "familiar to the American ear" since it sounded exactly like the Hollywood "Imperator-complex boys peddling their escapist dope . . . to the brute mass-mind"). All her attempts "to be very, very clever and trip Ciano into a politically indiscreet remark" were suavely defeated. Dinner was "a great bore, because I couldn't understand or say anything." She later learned that a frequently repeated word—*carbone*—meant "coal" and must have had reference to the English blockade of shipments that week. "If only I had known what Ciano was talking about, I might really have found out something," she pathetically lamented.

The comedy continues with an after-dinner scene. Edda Ciano sits down at a table and begins riffling a pack of cards, and puts "a long slim cigarette-holder into the corner of her great sullen red mouth at a very Rooseveltian angle." Mrs Luce declines to play, so she and the count retire to a sitting room where they are "rather markedly" left alone for the rest of the evening—a fact that becomes the gossip of all Rome the next morning. Ciano manages to direct the conversation decisively away from politics to literature, referring to Mrs. Luce as "an artist." But she does learn something, for when Ciano tells her that he also had started out as a playwright and had experienced two "flops" before becoming a politician, "I understood Count Ciano very well indeed, and why he was at once so indifferent and good-natured in the face of the bitterest personal attacks on him in the foreign press." For Mrs. Luce herself knew that nothing develops "a spiritual elephant-hide" like the censures of "snarling" theatrical critics. At the end of the evening, "the Count had managed to leave me with the distinct impression that he was a highly peaceful, artistic soul, who had a great love of the theatre (particularly the American theatre), and who

adored the American way of life. . . . But about Italy and the war I thought I had learned nothing, nothing at all." Of the departing count she bitterly asked, "May I quote you on all these vital matters?" To which he replied, "Oh, by all means, do."

The next night she saw him again at the embassy, where Ambassador Phillips adroitly prevented after-dinner conversation by showing the movie *Drums along the Mohawk,* a film loved by the Italian guests because—says Mrs. Luce—its plot pleasantly suggested the heroic anti-British native-killing Italian pioneers in the wilds of Ethiopia. Ciano left immediately afterward, since he was meeting Ribbentrop again the next day. Writing later in the year, after France has swiftly fallen, Mrs. Luce says that she "was too dense at the time to see" that she had talked with "one of the few men who really knew what was going to happen":

> I see now that that night Ciano had told me the truth about himself and Italy and the war. The very fact that he never indicated by word, gesture, innuendo, a flicker of an eyelash, or a half-smile how he as a free individual felt about peace or war— the only topics then worth the attention of an adult mind, which he certainly had—should have proved to me that his mind was hopelessly imprisoned in Fascist ideology, that he and with him all Italy were the creatures of Fascism's master, Mussolini, the one-man minority *who wanted war.*[63]

Three months later Italy entered the war that no one but Mussolini wanted (as all observers agree). Richard Massock wrote the best running account of the mounting tension during the spring of 1940—"days of almost intolerable strain in Rome." When the British withdrew defeated from Norway, Fascist officials began to say that Italy was not in a "nonbelligerent" but a "prebelligerent" stage and was devoted to freeing the Mediterranean from British control (why should England hold Gibraltar, the key to the ocean?). After Germany invaded Holland and Belgium, Ciano reassured Ambassador Phillips that Italy remained noncommitted. But at the Union Club (the Anglo-American men's "literary" resort in the Piazza di Spagna, which served the best Scotch whiskey and promoted informal diplomatic exchanges), the international discussions became more worried. Also, for the first time the pope officially placed himself in opposition to German aggression, with the result that the *Osservatore Romano* was burned in the street and some purchasers of the Vatican paper were thrown into the Trevi Fountain. Throughout Rome the walls were plastered with anti-British and anti-French placards, many of which, according to Massock, were promptly torn down or defaced by other Italians. The atmosphere became unreal: troubling, absurd, serio-comic. Daily student demonstrations were got up by "good-natured boys" engaged in a charade of flag burnings. One group carrying a banner proclaiming that "Chamberlain's umbrella leaks" promptly dispersed when a restaurant proprietor ordered the boys to "quit clowning and go back to school." At the ABC nightclub ("The Hollywood" until Fascists ordered a name change), Massock saw a British nobleman struck and dragged away by Blackshirts when he refused to read an anti-British pamphlet. Then an American photographer was attacked when he tried to take a picture of men removing the nameplate of the Hotel Eden just after Anthony Eden was made the British war secretary. One could laugh or weep.[64]

John Whitaker interpreted one of these incidents, in which he was involved, as demonstrating the German infiltration of the Italian Fascist forces. The Fascists, "reading nothing but their own censored press, knowing nothing of the British, the French, and the Americans," were convinced both that the Germans would be victorious and that only a victorious Germany would assure the survival of Fascism in Italy. Although the Italian army itself was anti-German, German agents exploited these fears, supplying propaganda and gold to the "bullies of the Fascist rank and file." "The Germans organized hoodlum bands" that now reinstituted the methods of early Fascism. Whitaker himself encountered one group when he and two Englishmen were escorting the roving American correspondent Virginia Cowles back to the Hotel Savoia on the night of May 11, when Churchill had replaced Chamberlain as prime minister. Stopping to read a new anti-British poster, they laughed at the German syntax of its awkward Italian. Then they were suddenly attacked by fifty men directed by a policeman who was screaming, "Inglesi! Inglesi!" While the three men were being pummeled, the elegantly tailored Virginia Cowles protested in "icy tones" and directed a retreat through the hotel's narrow door. They were pursued inside by a man with a whip. Eventually an authority was summoned, but when he arrived, he spoke Italian so badly that "our diplomatic parley went better when we spoke German with him." Whitaker saw this episode as indicative of the situation of Italy at this time. Mussolini himself, "alone, sick, and frightened," no longer had liberty of choice; he was in the hands of the Teutonic Nazi Frankenstein that his Fascism had designed. When Hitler's swift victories in the Lowlands went just as the Fuehrer had told him they would, Il Duce concluded that in spite of the contemptible pacifism of his people, and the fact that his country was woefully unprepared for war, it would have been folly and cowardly not to join in the fight.[65]

As the German army moved toward Paris in early June, and the bombing of Marseilles destroyed the French air force that was the chief threat to Italian industry in the Po valley, the imminence of Italy's entry into the war became evident in Rome. Schools closed early, the Italian Line canceled sailings, blackout regulations were posted, and placards appeared on the walls calling on Italians to "break their chains in the Mediterranean." On June 7 Ambassador Phillips (whom Ciano had privately forewarned) radioed a ship—the SS *Washington* of the United States Line—not to proceed from Lisbon to Genoa and Naples. An Italian officer said farewell to his friend Massock, saying bitterly that he would soon be fighting "for the greater glory of Germany." At last, on the morning of June 10, the Blackshirts summoned all Romans to the Piazza Venezia that evening. Fascist party men stopped at every shop, ordering it closed for the occasion. By six o'clock the Piazza Venezia was filled with Romans waiting to hear the word of their dictator. All the writers who were still in Rome describe the scene, and the inconsistencies in their accounts perhaps reflect the impossibility of their answering their most urgent question: did the Romans support Mussolini in this war? Massock estimated that an improbable 300,000 people were in the piazza, but mentions a number of conspicuous German officers scattered through the crowd. Others say 100,000 and stress the presence of Blackshirt organizers and prompters. In all there is much doubt about the actual feelings of the Romans present at this latest performance.

At 6:01 Mussolini, "dressed in his uniform of a corporal of honor, bounced up like

a jack-in-the-box on the balcony," reported Eleanor Packard, adding that he was "greeted with probably the greatest applause he had ever received since he announced the end of the Ethiopian War"—a fact that simply demonstrated the "fickleness" of Italians. In the equivocating words of Massock, "the well-trained crowd cheered itself hoarse." Matthews, however, wrote that "Mussolini came out on his balcony and announced the declaration of war against France and England, amidst the indifference of all but a few hundred organized applauders, mostly students." But about Mussolini's own performance there was no equivocation. In Massock's words, Il Duce was "never more dominating, . . . never more sure of himself, his voice never stronger," as he called upon all Italians to "take the field against the plutocratic and reactionary democracies of the west." He described the struggle as one of a "young fecund people against sterile peoples headed towards decadence." He ended by saluting "the Fuehrer, the chief of great allied Germany," and hailing the "courage" and "valor" of the Italian people. Afterward the crowd "surged up the Quirinal Hill to cheer the king," who appeared on his balcony dressed as a field marshal. Massock wrote: "The younger Fascists marched about town in a show of jubilation. Flags flew, bands played the 'Giovinezza' and the 'Horst Wessel.' But under the surface demonstration there was no jubilation in the hearts of Italians."[66]

That night "the ancient capital, with its peaceful streets and the monuments of its glorious past, was blacked out like London, Berlin, and Paris." Massock and Whitaker drove with hooded lamps to the Quirinale Hotel for dinner in a garden strung with dim blue lights. There they saw an Italian officer whom Massock knew, a temperate man (who had an English wife) now alone and drunk. At midnight the first air-raid alarm sounded in Rome. As a plane droned overhead, Massock and his wife from their roof watched the pyrotechnic display of antiaircraft fire bursting over the city. Then they went down to the basement, "where the other inhabitants of the building were huddled, the children waiting, the servant girls invoking the protection of the Madonna." At the same hour Ambassador Phillips was tuning in the radio broadcast of President Roosevelt's speech at the University of Virginia: "On this tenth day of June, 1940, the hand that held the dagger has struck it into the back of its neighbor. On this tenth day of June, 1940, in this university founded by the first great American teacher of democracy, we send forth our prayers and our hopes to those beyond the seas who are maintaining with magnificent valor their battle for freedom."[67]

That day initiated the most deeply unhappy period in American representations of Rome. The painful ambivalence toward the city intensified. On the one hand, Americans endured an officially created, virulently anti-American atmosphere that increased the more the United States openly allied itself with embattled England. On the other, Americans found satisfaction in detecting an equally increasing anti-German feeling among the people. The American journalists and diplomats who describe Rome during this period had never known it as anything but a Fascist capital, and yet the place and its people had won their affection. For Herbert Matthews, in particular, June 10 was one of the most acutely bitter days of his life:

> Fortunately, the Italians we knew—the decent, honorable, loyal Italians—were even more deeply shocked than we, since it was their shame. They were the Ital-

ians who made it possible to retain some faith and affection in the country that I had then known for fifteen years. . . . [It was] a lesson in politics, the simple one of separating a people and its country from complete complicity in the wickedness of a small group of its leaders. One could not, and cannot before history, absolve Italy and Italians from the crimes committed by Fascism, but one can recognize mitigating circumstances, and degrees of guilt. The average Italian was a passive and unthinking actor in the disgusting drama which his country played, and for that he deserves blame and punishment, but there was a difference between his attitude and the active criminality of the Fascist leaders.[68]

The sensational and demoralizing eighteen-month period that followed is recounted by Massock and the Packards from the point of view of restless reporters in the streets, bars, restaurants, and homes of the city, while Ambassador Phillips recalls his valiant efforts to sustain a normal diplomatic life after the departures of his English and French colleagues and of his own wife and children. His mission to preserve peace between his nation and Italy is obviously failing, but his exchanges with Roosevelt and his conferences with Ciano are not abated. Followed everywhere by a secret service man and prevented from bathing at his "customary beach," Phillips bravely attends a performance of Richard Strauss's *Ariadne auf Naxos* by the Munich Opera troupe in the garden of the German Academy, and in both 1940 and 1941 refuses to cancel his annual Fourth of July receptions in the gardens of his own villa for the diplomatic corps of all Latin American countries—after determining that they will not be afraid to come.[69]

What Phillips, like the others, stresses most about the Romans during this period is their apathy. They do not greatly rejoice when France capitulates only ten days after Italy entered the war (after all, Italy's slowness to move, and the swiftness of the German victory, prevent the Italians from gaining any of their own territorial objectives). Nor do they react strongly when the Italians are at first defeated in Greece, nor when Ethiopia is lost. Descriptions of apathy and passivity, formerly meant as criticisms of Roman character, ironically reverse their effect when the apathy is perceived as itself a form of criticism, even a form of passive disobedience to the ubiquitous bellicose injunctions. No public pity is manifested for Mussolini when his son Bruno dies in an airplane crash; Phillips suspects that families felt that it "was not inappropriate that he too should suffer." As rationing becomes more severe, the war is prolonged without notable advantage to Italy, and the German dominance becomes too obvious, apathy sometimes does give way to more open hostility toward the regime. Phillips is "astonished at the freedom and violence" of the criticism that Italian people he meets are now expressing, but he is sure no "organized opposition" is likely. Mussolini, feeling the "growing discontent," knowing his "influence was at zero point" and that the Germans controlled his country, was, according to Phillips, "spending more and more of his time with his mistresses, the Petacci sisters, and was appearing less and less in public."[70]

Both Massock and the Packards included detailed descriptions of the hardships experienced by Italians in the first year and a half of the war. Many staple foods became wholly unavailable, and others were drastically rationed—primarily because so much was being sent north to support German armies. Even clothing was rationed beginning in September 1941, as a result of the buying sprees of the

thousands of German tourists who had invaded the peninsula to purchase what was no longer available at home. To the flourishing black market in food, a greater one in clothing now developed, to become one of the chief preoccupations of the OVRA. As winter approached, severe limitations on heating of homes, hot water, and cooking gas were announced. In *Rome Was My Beat,* the more candid narrative Reynolds Packard found publishable by 1975, he revealed that, out of consideration for the staff and clientele, the illegal brothels of Rome (whose specialized practices Packard describes with salacious familiarity) enjoyed the only exemption from the limited hours of heating. What the Fascists called "voluptuous" travel, however, was entirely banned, and people could get to the beach only in overcrowded buses. A growing discontent, more loudly expressed, caused the revival of the *squadristi* to "take care" of the "armchair strategists, murmurers, and defeatists."[71]

The penetration of German power into all aspects of Italian life—industry, government, armed forces, police, railways, communications, society—contributed to the deepening gloom of the city. The veil that covered the contempt the Nazis felt for their allies gradually fell. Since both Catholic and Fascist teachings had instilled a strong anticommunist spirit into most Italians, the Axis declaration of war on Russia in the summer of 1941—with another promise of a quick victory— was met at first with a popular enthusiasm that had not been expressed for the war against France and England. But when the Italian army was relegated to a strictly subordinate role by the Germans, and was regarded as primarily useful as an occupation force (as in Greece, where Italy's initial attempt at independent conquest failed), the humiliation was deeply felt. German victories in North Africa, where the Italians had also been defeated, further injured their pride. Russia's successful resistance to the German army was therefore actually welcomed by many Italians, since it proved that neither were the Nazis everywhere invincible. In the late fall, when it was obvious that the war—now existing on several fronts—would not be a short one, and the government began recruitment of a million new soldiers, the full cost of the alliance with Germany began to be apparent, and the possibility of a separate peace no longer existed. The Packards devote many pages, and Massock an entire chapter called "In German Hands," to the virtual occupation of Italy that was now accomplished by its ally.

On the peninsula, hundreds of thousands of German soldiers were "in training," "to help guard the coastline," or "in transit" through Rome to Greece and Africa, while Sicily was entirely dominated by German troops. The actions in Rome of German embassy personnel—greatly increased in number—made it obvious that Berlin controlled all aspects of the Italian government. So-called liaison officers were present in every ministry. The popular Hotel de Russie at the Piazza del Popolo was "closed for demolition" to get rid of its guests, but then became the headquarters of the German High Command; the great piazza itself became a parking lot filled with "staff cars of gunmetal gray." The chief of the Gestapo in Italy, which now controlled the already extensive spy system of the Fascists, had his office in the Nazi party headquarters, established in the Via Margutta among the ancient studios of artists.

The average Italian's hereditary dislike for Germans became open hatred, but the ways in which it could be expressed were necessarily petty. Waiters in Roman

restaurants neglected German customers, pedestrians no longer broke their lei-
surely pace to make way for quickly double-stepping Germans, hotels turned away
German guests. Finally Mussolini had to issue an order giving Germans priority in a
dozen of the largest hotels, including the Ambasciatori, long favored by Americans
of the diplomatic corps, who were now evicted. And Romeo, the bartender at the
Foreign Press Club, was perceived to favor Americans over Germans and so lost his
job, accused of having "dirty hands"—an idiom that Packard at first understood
literally. But, so dominated, there was little the Romans could do in effective
rebellion, and there were, of course, many who fawned upon the Germans who were
now the only tourists Rome had. By the winter of 1941 most Italians, according to
Massock, had "lapsed into a coma of disillusionment, defeatism, and despair." In
one year Mussolini lost all his prestige and the popular gratitude for all he had
accomplished. "In privacy Italians reviled him, or they laughed at him, which was
worse, and spread nasty stories of his private life." As in Rome a century earlier, the
chief release for popular frustration was found in pasquinades—some of which were
actually allowed to be published. "We are going to lose this war," declared one; to
which the reply was, "Yes, but when?"[72]

Corresponding to the growing hatred for Germans and for Mussolini, according
to Americans who were there, was an increasing pro-Americanism. In a Rome of
deepening gloom, the loss that the few remaining Americans felt most acutely was
the company of their Italian friends. Since the Americans were regarded as probable
spies, to associate with Italians was to endanger them. But it was their acquaintance
with individual Romans of all classes and the sympathetic insight into true Italian
character they had provided that prevented these reporters from making unqualified
characterizations about the Italian people as "the enemy" in their wartime publica-
tions. The Packards, for instance, stress the ephemeral hold of the militarist Fascist
philosophy on the young Italians to whom it had been taught since childhood. It was
eradicated within a year of army life, both by experience of reality and by the innate
Italian temperament to which it was totally unsuited. When this happened, Ameri-
can ideals were as likely as any to replace it. The hundreds of thousands of Italians
who had emigrated to America, writing to their relatives in the old country about
their success in the New World, provided "a propaganda that Mussolini could not
combat." On another social level, Mussolini's imperialist adventures and alliance
with Hitler also lost him the sympathy of much of the aristocracy, where British and
American women now had real influence. On a train Packard encountered the
"Junoesque" old Princess Torlonia (formerly Elsie Moore) who was returning to
Rome to protest to Mussolini personally about the arrest of her husband, who with
Prince Doria had been accused of anti-Fascist sentiment. The princess, herself a
member of the Fascist party, was now determined to return to America, "if only to
die there"—which she did, a few days before America and Italy were at war. But pro-
British and pro-American sentiments "permeated many strata of the middle and
proletariat classes," wrote Packard, "particularly those who had been familiar with
and profited from the visits of Anglo-Saxon tourists to Italy"—a considerable num-
ber.[73]

Popular pro-Americanism, however, was increasingly contrary to the official
Fascist position, and on April 8, 1941, the first directly anti-American poster was

plastered on the walls of Rome: "Scratch an American and you find a thief, a pirate, and a gangster!" Ambassador Phillips recalled that on the same day the American embassy was the object of its first demonstration of "so-called students"—a contingent of "a hundred children" who, when asked, did not know what they were protesting. This supposed threat to the embassy's safety on the part of an outraged populace was dramatically countered by a contingent of six hundred armed Italian soldiers sent to protect it. In the meantime, the confused "boys" tore up the shrubbery of a nearby Italian government building.[74]

America's increasingly active support for England (seizure of Italian ships in American ports, passage of the Lend-Lease Act, official naval protection of shipping to England, strong attacks on the Axis in Roosevelt's speeches) stimulated the publication of extreme anti-American propaganda in the Roman newspapers. On June 10, 1941, in a speech on the anniversary of Italy's entry into the war, Mussolini stated that a de facto war now existed between Italy and the United States. The subsequent freezing of Axis funds in America was avenged in kind, with the result that one learned how many "Italians liked and trusted Americans," since servants, shopkeepers, and waiters all unhesitatingly extended them credit. When Roosevelt expelled all German consuls in America as spies, Mussolini joined Hitler in ordering all American consulates closed. "The departure of the consular train from Rome," wrote the Packards, "was the biggest social event of the summer season among the American colony," marked by "farewell bottle parties on the station platform." The "scores" of Italians who showed up to say good-bye were, however, cordoned off. Very few Americans now remained in Rome—a minimal embassy staff, a much diminished group of journalists, and the hard core of "supersophisticated" and "incorrigible Italophiles" who had resisted the State Department's year-long effort to repatriate them, risking invalidation of their passports so they could stay until the last possible moment. On October 6 Ambassador Phillips, after a farewell call upon his friend Count Ciano, himself left Rome to fly to Washington "for consultation." He never returned.[75]

A tea party for the five remaining American correspondents in Rome was given by smiling Japanese diplomats on December 3. The staff of the embassy was invited to another the following week—but that party never took place.[76] Four days after the attack on Pearl Harbor twenty thousand Romans obediently joined their *fascii* and marched to the Piazza Venezia to see Mussolini give another performance on his balcony—the last to be witnessed by Americans. The Blackshirts carried banners and standards displaying obscene cartoons of President and Mrs. Roosevelt and slogans such as "Down with Pluto-Democracy." The crowd swelled to fifty thousand. When Il Duce "popped out," wrote the Packards, "the paid Fascist claques let out a roar of 'Duce! Duce! Duce!'" In one of the shortest speeches of his career, the dictator declared that Italy was at war with the United States of America. Microphones placed near the cheering squads amplified their intermittent responses, "but to us, who could see the motionless hands and lips on all sides, the noise seemed as unreal as offstage sound effects breaking in at the wrong time."

Richard Massock, leaning against a lamppost, watched from the edge of the crowd. Many times before he had seen Mussolini sway his people "with his dynamic, theatrical personality, his poses of the inherent actor, with chest thrown out

and his bulbous chin pointed to the sky, his blunt, sometimes flamboyant phrases delivered in a loud and hoarse voice." Occasionally the people had been stimulated to "something near to adoration" by "his vitality, his acting, his imaginative and sentimental rhetoric." But today "the dictator's chest seemed deflated.... His bearing lacked swagger and fire. He ... was not the Mussolini of old." The Romans listened "with solemn faces, devoid of emotion." Herbert Matthews, listening to the speech from directly below the balcony, found a "sad consolation" in his knowledge that it was "not Italy which declared war, not the Italians, but Il Duce and a handful of his followers.... The cheering of the few was false; the indifference of the many was typical, and beneath it was much genuine sorrow." When the crowd began to disperse before the official cheering had even stopped, the Packards estimated that four-fifths of the people had "refrained from any show of approval." It was "the first open protest of an act by the Duce that we had ever seen [,] ... a passive, voiceless protest of silence, eloquent in its way, but certainly futile." Leaving the piazza as an enemy alien, Matthews wondered whether "anything could move these world-weary people from that passive, eternal, unchanging acceptance of whatever happened.... They accepted—and in that lay their crime."[77]

By nightfall of December 12, all the American male journalists who witnessed this scene were prisoners in the Regina Coeli ("Queen of Heaven") jail. They and Eleanor Packard afterward passed five rather pleasant months of loose internment at Siena, but those first nights of confinement to "small, dark, very dirty and very dark" cells were the real and fitting conclusion to their experience of Fascist Rome.[78]

Vincent Sheean had known Italy between 1922 and 1935, when Mussolini reached the height of his popularity with the "unthinking masses" who were "seduced by his heroic language and instinct for show." In *Between the Thunder and the Sun* (1943) Sheean wrote that even up until the alliance with Hitler in 1938 the "rites of leader-worship" enacted in the "theater" of Piazza Venezia had had a "base among the people." Returning to Rome simply as a tourist in 1940, Sheean renewed his acquaintance with his many Italian friends, most of whom were "technically" Fascists. Talking freely with him (at the very time Clare Booth Luce had found everyone close-mouthed), they expressed a "unanimity of opinion which I have never met anywhere else in the world at a time of crisis": "The Italians were resolutely opposed to war for Nazi Germany against their traditional friends in Europe. This emerged clearly—as clearly as the other certainty, that war *would* come by Mussolini's will and they could not prevent it."

In company with Herbert Matthews and his wife and Anne O'Hare McCormick and her husband, Sheean enjoyed a final view of Rome:

On another day of matchless Roman sunlight we lunched on the Pincio and talked of war while the honey-colored walls and domes and spires beneath us changed, softened and grew shadowy with the changing light. That view, that justly celebrated view, was never more lovely to me than this spring when it was impregnated with suggestions of a world divided, veiled, and half-lost by our mortal struggle. True, the walls of Rome looked permanent enough in the golden light, ...

but it was impossible not to think of them as menaced. . . . Rome, too, must go the way of Vienna, Salzburg and Munich, Venice and Nurnberg, into the dark realm of the enemy, on the other side of a valley filled with blood: when were we to emerge, and how, and which among us, after time and sorrow?[79]

Rome, "the Great Prize": General Clark to the Capitoline

As the navigator peered tensely into his bomb sight, I glanced in all directions at Rome below me. There were the winding Tiber and the Mussolini Forum. St. Peter's stood out so clearly that it dominated the city. . . . The house where my family and I had lived was just down to the right, as a reminder that Rome was my city, too, and that I did not really wish it harm.

—Herbert Matthews, July 19, 1943

From one of our windows we looked down on Rome. The electric light which had been cut off was turned on abruptly, and uncurtained windows flashed out brightly like a signal of liberation to come. Then, as if on the stage, all was dark once more; except for the moonlight shining through a veil of mist. Suddenly, from the direction of Porta Pia, came a burst of wild cheering. The Allies had entered Rome.

—"Jane Scrivener," June 4, 1944

Italy and the United States were officially at war for one year and nine months. Following the defeat of Italian and German armies in North Africa, the Allies invaded Sicily on July 10 of 1943; Rome was bombed for the first time on July 19. On the twenty-fifth the Fascist Grand Council deposed Mussolini, and the king appointed Marshal Badoglio as prime minister. An armistice between Italy and the Allies was announced on September 8. The king and Badoglio quickly removed themselves to the south, leaving Rome virtually undefended from the enraged Germans. On September 9 the Fifth Army, under General Mark Clark, landed at Salerno, south of Naples, to begin its winter-long movement north against strong German resistance. On January 22, 1944, American forces came ashore at Anzio, just south of Rome. More than four months later they finally entered the capital. Rome, "the Great Prize," had been won.

During this period direct American accounts of Rome—as opposed to its representation in wartime propaganda as an enemy capital—are, of course, very rare. Among the few articulate Americans who saw the city in 1943–44 were a poet-propagandist, a poet-philosopher, a nun, and a spy. The poets were two of this century's most prominent contributors to American letters, Ezra Pound and George Santayana. Their motives for being in Rome and their relation to it totally differed, but to describe its actual life was no concern of either. After a period of uncertainty about his wisest course of action, Pound resumed his ranting broadcasts for Rome Radio on January 29, 1942. Although his incoherence made at least one Fascist authority suspect that he was a spy transmitting in code, he continued to talk until Mussolini's downfall. On the day after the Americans landed in Salerno, Pound fled Rome on foot to take refuge in the North.[1] Pound's frequent presence in the capital

in these years was motivated by an exacerbated fanatic's devotion to the possibility of transforming the world according to an imagined ideal. Santayana, in contrast, found in Rome the earthly place that best nurtured his philosophical and imaginative meditations on "essences" and satisfied his skeptical idealism just as it was.

As early as 1912 Santayana had declared Rome to be "more to my liking" than Florence, "larger, nobler, more genuinely alive, and more appealing to wide reflection." A cosmopolitan wanderer with a Spanish passport, Santayana sought only "independence and solitude, . . . in sight of the market-place and the theatre." This he found in Rome, where after 1920 he passed most winters living in hotels. The Fascist demonstrations of 1921–22 did not disturb him, and by 1925 he could write that "Rome, for comfort and for stimulus, is everything that I could desire." It was a city "congenitally beautiful, born to enjoy itself humanly, and straightforward in its villainies and its sorrows." On his walks he felt "human liberty and pleasantness breaking through the mesh of circumstances and laughing at it." The political atmosphere in fact was "good," better than the "sham" democracies of England and America. In October of 1941 Santayana, now seventy-eight years old, settled at a "Nursing Home" run by Irish nuns on the Coelian Hill—"the old rustic ruinous Rome of a hundred years ago." This was a place "morally" preferable to "the international first class hotels" he had formerly occupied; "I am interfered with more, because I am attended to more." Santayana felt "*helpless*; too old and threatened by too many difficulties to look after myself successfully."[2]

There, in 1942–43, Santayana wrote *My Host the World*, the third volume of his autobiography, *Persons and Places*. Explaining the choice of Rome for his old age, he quoted an inscription from the wall of the Lateran to acknowledge the city as his *mater et caput*:

> Mother and head of my moral world, surely, and central enough even to-day: balmy also, humanly habitable at all seasons, full of ancient and modern and even of recent beauties, and inhabited by a people that more than any other resembles the civilised ancients. I could not be more at home anywhere, while preserving my essential character of stranger and traveller, with the philosophic freedom that this implies.

In his penultimate chapter, "Old Age in Italy," Santayana conveys how successfully he was able to confine his perception to the Rome of his spiritual predilection and physical need, ignoring the rest. He was "not in search of an ideal society or even of a congenial one"; he was "looking only for suitable lodgings, where the climate, the scene, and the human ways of my neighbors might not impede but if possible inspire me in my projected work and where I might bring my life to a peaceful end." This he was able to do even in the midst of war: "I soon retreated into my aesthetic, or rather my poetic, shell, and limited my diet of visual impressions to a few chosen sights." In perfect solitude he could best write his autobiography:

> In Rome, in the eternal city, I feel nearer to my own past, and to the whole past and future of the world, than I should in any cemetery or in any museum of relics. Old places and old persons in their turn, when spirit dwells in them, have an intrinsic

vitality of which youth is incapable; precisely the balance and wisdom that comes
from long perspectives and broad foundations. . . . Mind is reconciled to its own
momentary existence and limited vision by the sense of the infinite supplements
that embosom it on every side.[3]

Such a perspective on time, place, and multiplicity allowed Santayana, as a philoso-
pher in old age, to find in Rome the prized place where he could fruitfully cultivate
his intellect, imagination, and memory, little distracted by current events; only the
actuality of a progressively severe fuel shortage necessarily penetrated his chilly
cell.

We turn then to the diaries of the middle-aged nun and the very young spy for
American representations of the mundane social reality: the anxious and agonized
Rome of the German occupation. *Inside Rome with the Germans*, which "Jane
Scrivener," the nun, published in 1945, measures time on a day-to-day basis, in
terms of food acquired and distributed, beds for refugees found, men successfully
hidden from the Germans or imprisoned by them, explosions or bombing raids
survived, and constant rumors of advancing or retreating armies believed or denied.
A Spy in Rome, the personal narrative that Peter Tompkins published in 1962,
measures time even more narrowly—in suspenseful hours and minutes as he makes
contacts and sends coded messages, assumes and discards identities, crosses and
recrosses the city between his hideouts and his points of rendezvous with the
underground resistance forces of Rome. The consciousnesses of both nun and spy
painfully anticipate one historical moment: the constantly postponed entrance of
the Allies into Rome. Otherwise they have almost nothing in common.

Jane Scrivener was evidently a mature and intelligent nun with scholarly inter-
ests; although her devotion to the Church was absolute, and her account includes
deserved tributes to heroic brothers and indefatigable sisters, as well as laudatory re-
ports of the actions of Pope Pius XII throughout the ordeal, her diary is devoid of ex-
cessive piety or ejaculatory prayers. Instead, an ironical appreciation of the comical
and absurd aspects of human behavior provoked by tragic circumstances relieves a
pervasive sorrow felt from a position of relative personal security. She also expresses
notably more sympathy with the partisans—even the communists—than the Vati-
can did. But apart from these individualizing traits, her record is almost completely
self-effacing. What she did in peacetime—beyond habitual use of the Vatican Li-
brary, now closed for the duration—and exactly what she herself did day by day
during the occupation remain vague. In contrast, the personality of the twenty-
three-year-old Peter Tompkins—irreverent, self-confident, courageous, foolhardy,
arrogant, authoritative, and persuasive—is evident on every page of a book almost
exclusively concerned with the details of his efforts first of all to escape capture and
second to achieve his mission: the organization and control of the Roman under-
ground for paramilitary activities and espionage.

Both Scrivener and Tompkins knew Rome intimately from long acquaintance.
Consequently a rare topographical precision characterizes their representations of
its neighborhoods, buildings, streets, and gates. But Scrivener's Rome follows an
ecclesiastical perimeter that circles along the hilltops from the Vatican to a mid-
point at her own Pincian convent and on to Santa Maria Maggiore and the Lateran.

Tompkins's Rome is more various. It includes temporary hideouts even in the modern districts of Parioli and Prati, whose architecture and furnishings Tompkins "despises," for he was bred with the aristocratic taste of the Renaissance Roman world that extends from the Piazza di Spagna to the Tiber. Part of his childhood had been spent in the Palazzo Antici Mattei (where the huge statues in the courtyard frightened him), and he had passed school vacations until 1940 in an old palazzo in the superb Via Giulia. Since Scrivener admits no memories to her diary, her persona has no personal past and therefore virtually no identity beyond the morally concerned present-tense voice that registers the rumors and describes the events of another day in the collective life of the city.

In contrast, images from a happy and cultivated former life in Rome constantly superimpose themselves on Tompkins's present. Just after he is slipped into Rome through "the heavy gates of Piazza del Popolo," the emergence of two German officers from the Hotel de Russie causes him to hide behind his collar; but his thoughts are of "Cy Sulzberger in 1939 sitting on an old brass bed with a bottle of Johnny Walker" when young Tompkins was a fledgling correspondent, and then of his childhood in the early twenties at the same hotel beneath the slopes of the Pincio: "A whole world of afternoon tea and hansom cabs, of military bands and parasoled ladies, was conjured up and vanished." Later the same morning, arriving desperately at his former home with the hope that his family's old servants are still alive and will hide him, he looks up at the faded frescoes on the façade and wonders whether the famous critic Mario Praz might even then be "breakfasting in his Empire mausoleum above the flat we used to occupy, or perhaps peeping down at me from behind his damask curtains!" Indeed, the possibility of being recognized by old friends or neighbors constantly haunts him. On being quickly transferred to his fourth hideout, he laughs to find that it is in a palazzo owned by a Fascist-sympathizing acquaintance—now fortunately absent; and the apartment to which he is taken he immediately recognizes as the familiar former home of an English schoolboy friend. But it was precisely such intimate knowledge of Rome and his ability to speak Italian like a native that made him the ideal man for his job. Not just any American could plausibly present himself as the younger son of a Roman aristocrat.[4]

Since Tompkins's mission began in January of 1944, Jane Scrivener alone rendered the Rome of 1943. In a letter she describes the day in July on which Mussolini falls from power. All Rome has a "carnival air"; laughing and talking, perfect strangers congratulate each other on their freedom of speech, while Fascist emblems are "hacked from public buildings" and "torn fragments of Mussolini's portraits lie like snow on the pavements." New posters plaster the walls of Rome: "Evviva la liberta!" The city, "in her long history, has never known quite such a day." But its freedom is short-lived. Scrivener's diary proper begins on September 8—the day of the armistice—and it concludes on June 5 of the following year, when the Allies enter Rome. Its narrative thus has the unity of a single morally unambiguous conflict: that of the German occupation.

The action begins when the proclamations of Marshal Badoglio and General Eisenhower placing Italy and America on the same side were read on the loudspeakers in the piazzas. After sighing with relief, the people then "looked at each

other questioningly—Armistice or Armageddon?" Germany was in Rome; martial law remained in force. So "Rome was quiet." The next day began anxiously. On the radio the Germans "let loose a flood of invective against the 'vile treason of the Italians.'" The people became optimistic, however, believing "it was all over," for the Allies had dropped leaflets promising to liberate Rome within a week. All day one heard noises—were they the booming of British guns off Ostia? Or the Germans destroying their ammunition dumps before leaving? "It is strange to be in the heart of these things and to know really nothing about them." In this atmosphere of uncertainty, all the shops closed their shutters by three o'clock; then rumors spread that German troops were marching into Rome, that Badoglio had sent his daughter to Switzerland, that he himself and the king had fled to the South. "Civilians went home and shut the great doors of their houses—those *portoni*, . . . which serve them in the office of a wall or as a moat defensive to a house, and close their porte-cochères hermetically."

The next day even the doors of St. Peter's were closed in the daytime for the first time within memory and remained so for two days. At the Vatican the famous Swiss Guards replaced their medieval pikes with rifles and bayonets. Next Rome Radio announced that an anti-Fascist general was in command of the city's defense. Guns sounding in the distance fell silent, for the Germans had agreed to remain outside the city. Then the siren sounded, and artillery shells began falling upon Rome. At first the Italian soldiers—deserted by their officers—fought back as the Germans moved into the city. Fighting spread throughout Rome. "Italian troops and civilians armed with machine guns" attacked the strongholds of Fascist loyalists and Germans, who fired back from windows. Armored cars rushed through the streets while from crowded roofs and terraces anxious spectators looked down. At the gate of San Paolo the Italian soldiers were driven back. The wounded and dying were carried into the great medieval church of Santa Sabina on the Aventine, and in Trastevere bodies were hauled away in wheelbarrows. "The whole thing was a mixture of riot, civil war, real war and anarchy." A populace long deprived of food, wine, and clothing went on a rampage of looting, in which they were joined by the Germans. But gradually the German forces concentrated their strength, marching down the Via Trionfi and the Via del Impero to Piazza di Venezia, "where machine guns had been barking all afternoon." Other troops entered through the walls at St. John Lateran, "and I think those ancient walls remembered old unhappy far-off things"; Guiscard's Normans in 1084 and "Bourbon's Lutheran hordes in 1527 were, after all, not so very unlike Hitler's Huns riding in on their tanks and lorries, driving the defeated Romans before them as they went." The "nightmare" of total German occupation of Rome had come true.[5]

On Saturday, September 11, Rome "was like a city of the dead." No one went to work; no shops opened; no buses ran; the trams stood weirdly motionless where they had been abandoned the day before. No police appeared in the streets, nor did the street cleaners arrive with their brooms and hoses; pools of blood on the pavements blackened in the sunlight. To this inactivity there was only one heroic exception: the bakers baked. By nightfall everyone had "the usual meagre ration of 150 grammes of bread" (made from strange substitutes for flour), but for those who

had not stored up there was nothing else to eat. Then the radio announced an armistice between Italy and Germany. Italian soldiers were to turn in their arms. Rome was declared an "open city," in which the Germans would occupy only three places—their embassy, their telephone exchange, and the Italian radio station. But in fact Germans were everywhere: "They were going about in armoured cars with machine guns pointed significantly at the passers-by, and on foot with revolvers and rifles—and a swaggering air." Moreover, a pro-Nazi member of the House of Savoy was placed in charge of Rome, and a new set of placards appeared on the walls the same evening, signed by "Feldmareciallo Kesselring"—a name with which the Romans would become painfully familiar. These placards announced that Rome was under German martial law. Private correspondence was not permitted; all telephone calls would be monitored; a curfew was set for 9:30. Snipers, saboteurs, and organizers of strikes would be shot on sight. Italians were invited, however, to "volunteer for German service"; they would be "treated according to German principles" and paid German wages. By the thirteenth, Germans were looting the city "in earnest," stopping people in the street to remove their jewelry and money "at the muzzle of a revolver," confiscating not only the few remaining motor cars but even bicycles, and breaking into the palaces of royalist aristocrats who had turned against Mussolini. To make the depression of Rome complete, news arrived of Mussolini's rescue by Nazi paratroopers. The Italian Fascists began showing themselves openly once more, joining the Germans in acts of vindictive vandalization.[6]

The alarms and confusions of these first days persist in nightmarish variation throughout Scrivener's account of the next eight months: writings on the walls of Rome constantly changed, terrorization of the populace (especially of patriots and Jews) intensified, and rumors of imminent (but constantly delayed) liberation were punctuated by random acts of repression and more frequent bombing raids.

The placards, which were oddly printed in both German and Italian although their proclamations and exhortations applied only to Italians, were constantly defaced or "torn down under cover of darkness," but almost every day new ones went up. Scrivener thought them "ridiculous in their solemn stupidity," and supposed they came "straight from Germany," for she recognized "the work of a man who has already provided Italy with other equally repulsive drawings" since the outbreak of the war. The American nun watched the tattered Romans, sometimes long-faced and sometimes barely suppressing laughter, as they read these outrageous calls to Nazi-Fascist glory. One day she followed a woman "who carried a bunch of keys in her hand, and all the way down Via Boncompagni, as far as the Hotel Excelsior, where Germans are lodging, she ran those keys across a new set of posters, still wet with paste." This battle of wall communications was sometimes bravely reversed. On the night of October 15, "hundreds of inscriptions in red paint appeared in praise of communism, of Russia and of Stalin": "*Abasso i Tedeschi! Abasso Mussolini! Abasso il Fascismo!* with the Hammer and Sickle accompanying them. They were everywhere, in the Trastevere, in the shopping quarters, in the expensive residential quarters, and, most conspicuous of all, in huge letters on the steep wall of the Tiber embankment." A small hammer and sickle even appeared on

Scrivener's own convent wall. All day the Fascist police "fell over themselves trying to obliterate" these signs with daubs of gray paint, which only drew attention to the subversive declarations.[7]

Soon after the German assumption of power the Jewish citizens began to panic, many of them trying to leave Rome. "No one is safe. Nothing is certain. We might as well be back in the Dark Ages," wrote Scrivener. On September 28 she had more definite news. The chief rabbi had been told to deliver one million lire and fifty kilograms of gold within one day, or Jews would be deported or shot. The ransom was paid (with the help of the pope, she says). "The Romans are shocked and depressed; now that this sort of Jew-baiting has begun it has come home to them that they are really under the heel of the enemy." Three weeks later the SS began arresting the Jews in their homes; the chief rabbi had not destroyed his registers, so they had all the addresses. The Jews were "herded into open lorries in the rain, and we know nothing of their destination. It is a nameless horror. People you know and esteem, brave, kind, upright people, just because they have Jewish blood, treated like this." In November all works of art owned by Jews were declared property of the state. In December orders from Mussolini's "Republic" of Salo (called "Pinocchio's Republic" by the Romans) that all Jews in Italy must be sent to concentration camps provoked "a strong protest" in the Vatican's *Osservatore Romano* (still openly sold at the news kiosks). But no protest could any longer help the Jews of Rome. Eventually Scrivener sums up the rumored facts: "Of the 10,000 Jews who remained in Rome after the Fascist 'Racial Laws' were passed, about 6,000 were victims of Nazi brutality." One thousand of these were known to have been killed (either executed or starved to death), and the others simply disappeared without trace. "No one will ever know," she adds, "how many Jews enjoyed the personal protection of the Pope in their darkest days."[8]

The Nazi regime as described by Scrivener is characterized simultaneously by military glamor and unimaginable brutality. It created a "little Germany" extending from the hotels at the top of the Spanish Steps along the Via Sistina through Piazza Barberini and on up the Via Veneto to the Pincian Gate. This "Brighter Berlin," as it was called, was progressively barricaded from the general Roman population. But because her convent was in the area, Scrivener could continue to observe the Germans closely, although she sometimes had to persuade sentinels to let her pass. (Eventually a sign was posted at the top of the Via Veneto: "Only Generals pass this way.") As late as November 29 Scrivener noted with wonderment that the High Command at the Hotel Excelsior remained "bright and cheerful": "Officers of incredible elegance make their way in and out, sentries snap to the salute, and a good time is had by all." One night General Maelzer, a drunken boor popularly known as the "King of Rome," brought in Italian actors and singers for a grand entertainment; a producer from Berlin directed them in an imitation of the famous "Komiker Kabarett." From Italy to Russia German soldiers were dying by the thousands, noted Scrivener; but perhaps "revelry by night is inseparable from war."[9]

The complement to this glittering Teutonic display of confidence and good spirits emerged in the Via Tasso, where the methods of the Gestapo rendered forever infamous a street named for a poet. "Today 'Via Tasso' stands for all the horrors of

systematic torture." Officially a temporary Gestapo prison, "in reality it is a place whence very few return and when they do they are often broken men. Those who do not return are either tortured to death or shot." Often families are not told the fate of men taken to Via Tasso, "for mental cruelty as well as physical is brought to a fine art by the Germans." An SS man known as "the giant" is famous for employing the methods "practised at Dachau": "the electric helmet," "pincers for pulling out teeth and fingernails, whips, rods, and means of heating knives red hot." "It seems impossible to be writing all this in cold blood, as if it were just a matter of course, but then it *is* a matter of course; it would be incredible if we were not right up against it." Grieved by her helplessness to alter such a reality, Jane Scrivener can bring herself to say hopefully that the commanding officer, named Wolff, will probably be "torn in pieces by the Roman people" when they are liberated.[10]

But the day of liberation seems to keep far off. The nuns surreptitiously listen every night to the BBC, monitoring the slow progress of the Allies in the South. Their expected arrival within a week becomes two weeks, then a month, then by Thanksgiving, by Christmas, by the new year. Waiting itself becomes a form of torture. But faith in the eventual victory of the Allies remains constant. More and more people engage in the perilous hiding of escaped British and American prisoners, and lessons in English are in great demand; one Italian even asks Scrivener to teach him to sing "Tipperary." In December hope is encouraged by the presence of many German soldiers in the streets asking for directions; they seem to be in disorder, going north. In January, however, the German High Command moves from the luxury hotels of the Via Veneto to a huge modern building on the Corso d'Italia: "If they are so thoroughly settled in Rome, what truth can there be in this new rumour that they are sending no more reinforcements south?" The military stalemate at Cassino delays liberation almost beyond endurance. What is to be inferred from the arrival of refugees from Cassino as forced evacuees, or from the much-publicized German transfer of the treasures of the abbey at Montecassino to Castel Sant' Angelo? Are the Germans preparing to retreat or digging in for a heavier attack?[11]

Scrivener records all the bombing raids on Rome with incredulity and horror. Everyone had assumed that the Eternal City would be spared, for no one would dare risk hitting the Vatican. Consequently the city overflowed with refugees who sought security in Rome, protected by the pope. But the "open city" status of Rome was an obvious sham. All reinforcements and supplies for the German army had to pass through it, and the Germans were clearly using its sacred character as protective covering for military operations. For this reason the city had been bombed for the first time on July 19.

Scrivener described that attack in a letter, but the most interesting account was written from the perspective of an American lover of Rome watching the devastation from above—Herbert Matthews, one of the journalists sent along on the raid to provide eyewitness testimony that Allied bombs were directed at military targets only. Matthews regarded his story for the *Times* as "one of the greatest" of his career, although it was also one of the few he felt compelled to write explicitly as "explanation and propaganda." In his autobiography he expresses other dimensions of the experience. As a student of Italian culture intimately familiar with Rome and

filled with a sense of the historic character of the event, Matthews contrasts his attitude with that of the crew in his plane, who to the end indifferently regarded the attack as "just another raid against a military target." Also, Matthews recalls that the attack had not been as precise as he had been led to expect. While destroying the railyards near the Basilica of San Lorenzo fuori le Mura, the bombers had virtually demolished that great and ancient church, along with the adjacent working-class tenements, killing four thousand Roman civilians. Matthews nevertheless took some personal satisfaction from "returning like that to Rome, from which I had been turned out only two years before." More than one thousand tons of bombs were dropped by a fleet of six hundred planes, of which only five were shot down by the Germans. This showed the Fascists that "their game was up."[12]

If so, they did not act as though they knew it. Bombing raids had to continue intermittently for another ten months. With evident ambivalence and exasperation, Scrivener as a loyal American tries to rationalize them all, but she can find no excuse for the repeated later attacks on the pope's villa at Castel Gandolfo, which had become a refugee camp. Most terribly, on November 5 a single low-flying plane deliberately dropped four bombs on Vatican City itself. The mosaic factory was blasted to smithereens, but the Romans assumed that the radio station (undamaged) had been the target, so *i Tedeschi* were accused of the crime. The newspapers hysterically condemned the barbaric British, but Scrivener agreed with a third opinion that the culprit was an Italian Fascist flying a German plane with stolen British bombs. The attack, of course, produced a great display of popular devotion to the pope in St. Peter's Square the next Sunday. On November 23 a fleet of planes that "looked like dragon-flies in the sun" passed over the city on a raid that destroyed the airfield at Ciampino. On January 13 "a big formation of Allied bombers escorted by fighter planes came over Rome, sailed majestically round the city," dropping bombs on airfields at Littorio, Centocelle, and Guidonia (near Tivoli), and on the connecting roads. When German planes rose to meet them, fascinated citizens watched dogfights in the air over Rome; splinters and empty petrol cans fell in the streets, killing a few spectators. Five American planes were shot down—one fell on Monte Mario—but their crews bailed out, and the parachutes resembled "great white blossoms floating earthward." After the novelty wore off, as the bombing intensified and death and destruction mounted, Scrivener's descriptions became briefer and grimmer.[13]

In January the rhythm of events quickened as the German occupation entered its last phase. News reached Rome of the new Fascist Republic's execution of those Fascists who had voted against Mussolini, including Count Galeazzo Ciano (at the particular insistence of his father-in-law). This was taken as another sign of the desperation of the Fascists, who were thus using the prolonged life that the war between Germany and the Allies afforded them to turn against each other in their last hours. On January 20 an advertisement appeared announcing the sale of "building materials on the site of the 'E. 42,'" the megalomaniacal international exposition that Mussolini had planned for the twentieth anniversary of Fascism. "All that now remains is several colossal buildings set in a barren wilderness." During the night of the following day the Allies came ashore at Anzio, thirty miles south of Rome. "It seems too good to be true," wrote Scrivener. "It is as if a cloud had lifted

from the city. People in the streets look happier than they have for a long time." It was a short-lived happiness. Day after day passed, and the "grape-vine" news was not of a rapidly advancing liberating army but of delay on the beach and then of intense fighting as the Germans quickly moved to fill the gap in their defenses. How did the Germans "have so many men available all at once for this business? . . . However, surely the Allies will take Rome soon." But on February 2 the Germans marched a large body of Allied prisoners captured on the Anzio front "through the most crowded part of Rome, up the Corso and along Via del Impero to the Colosseum." The cheerful-looking prisoners made "the V sign," which the Romans interpreted as meaning liberation in two weeks. Instead, more months passed, and conditions steadily worsened. Violent acts of sabotage, assassinations, and brutal Nazi reprisals became daily occurrences. Thousands of men were rounded up and put into forced-labor gangs. The bombs falling upon Anzio, Nettuno, and the Castelli Romani could be heard in Rome, and more refugees crowded into a city already near starvation. Bombing raids upon Rome itself increased in frequency and intensity, sometimes inevitably striking the civilian population. "Regard for human life seems to be fading out as time goes by," wrote Scrivener, "and we are going back to the Dark Ages, only with modern machinery to make our own age darker."[14]

Peter Tompkins had slipped into Rome the day before the landing at Anzio; his assignment was to provide the Allies with information on the movement of troops and supplies through the city, to specify bomb targets, and above all to coordinate the actions of the Roman resistance with the arrival of the armies from without. Of particular concern was the fact known to everyone (Scrivener refers to it as common knowledge) that all bridges in Rome and all utilities—gas, water, electricity, communications—had been mined by the Germans. How to prevent the Germans from setting off the mines as they withdrew, destroying Rome as they had Naples, was a priority item on the agenda of Tompkins's first meeting with the military branch of the Committee of National Liberation. The underground world into which Tompkins came was enormously complicated, characterized by competing factions that differed both on preferred resistance tactics and on ultimate political goals, once Rome was theirs. Assuming a posture of neutrality, Tompkins actually sympathized entirely with the CNL, a center-left coalition opposed to the conservative group that supported Badoglio and the king and enjoyed the favor of the Allies, thanks primarily to Churchill's monarchical bias.

According to his own account, Tompkins maneuvered with great acuity of perception and finesse of action in this contentious and duplicitous milieu. His contacts included possible double agents and men of dubious loyalty, and displayed the entire range of motivations, from patriotic selflessness to pure opportunism. Tompkins himself sometimes sounds like a man whose Americanism is limited to his complete self-reliance, which frees him from reverence for even American institutions. He is understandably disgusted by the constant bungling of the recently improvised and therefore totally ignorant and inept American espionage agency to which he reports (and which stops receiving his messages just when they become most valuable). Tompkins's comments on the military and political stupidity of the Allied commanders are also unstinting. But his fundamental Americanism emerges

in other ways: he is gratified when Roosevelt finally insists on withdrawing support for the monarchy, and he likes his fellow spies to be motivated by ideals, preferably the ideals of "individual freedom" and "political democracy." He automatically distrusts anyone working for less noble reasons.[15]

On his second day in Rome a frightened but amused Tompkins finds himself roaring down the middle of the Corso, seated on a motorcycle behind a young lieutenant of the Italian military police, a partisan named Maurizio Giglio (code name Cervo), son of an official in the Fascist secret police, the OVRA. Tompkins himself is disguised as an auxiliary policeman. Arriving at the Piazza Venezia, he looks up at "the famous balcony" and realizes that "for the first time in a generation the great room behind it was no longer the office of the dictator of Italy." Just three years earlier Tompkins himself, watching from the apartment of a monsignor in the Palazzo Doria, had heard "a black-gloved Mussolini declare war against Britain and France."[16]

For the next four months Tompkins lives a bizarre life of multiple identities and violently altering conditions. Periods of restful but forced inactivity while in deep hiding alternate with frenetic activity—directing operations, summarizing vast quantities of intelligence data for transmission from a secret radio hidden on a bathing-barge on the Tiber, and dancing at parties attended by Nazi officers and prostitutes who seem to regard him with suspicion. For a time he is hidden in a dressmaker's shop on the fashionable Via Condotti. Its kitchen is bulging with hoarded sausages, hams, pasta, flour, onions, coffee, oil, and wine—the wartime currency of aristocrats with country estates. One trunk in the shop is filled with the unpaid-for gowns of Mussolini's favorites, the Petacci sisters. For reading matter the place offers, besides *Vogue* and *Harper's Bazaar*, a selection of Trilussa's satires in Roman dialect, a volume of the Marquis de Sade, and Pearl Buck's *The Good Earth*. He reads them all. His last day here is passed in suspense when the entire area is cordoned off and swept by police who are rounding up men for the forced-labor gang. "Cervo" arrives an hour before curfew and carries him away in a small Fiat; they get through the cordon by pretending to belong to the raiding party. On a later occasion Tompkins pretends to be a Tuscan traveling salesman and hides in a vaudeville theater whose dreadful Balkan movies and sordid stage show continue while black-helmeted Fascist policemen carrying submachine guns walk down the dark aisles of the theater and disappear backstage. Tompkins, who thinks he recognizes Cervo's father in the theater, nearly faints in his seat.[17]

This absurd Rome of terror and incongruity is not rendered entirely innocuous by its real-life conformity to the genre of the spy thriller. Nor does the grotesque character that it assumes from the bizarre perspective of Tompkins's personal narrative obscure his incidental representation of authentic tragedy unfolding in an anguished city where each passing day renews the waste of life. The narratives of Scrivener and Tompkins report in counterpoint the intensification of partisan attacks on Fascists and Nazis, followed by German reprisals. In the background bombs rain down on the Alban Hills, while the Allies remain maddeningly entrenched at Anzio, having lost the unexpected opportunity for a quick seizure of Rome. In the city, a Fascist barracks is blown up, explosions occur in restaurants favored by Germans, and several German officers are assassinated in the streets,

often by swiftly disappearing bicyclists. So bicycles are banned, mass arrests occur, and the curfew hour is constantly changed (at one time being placed as early as 5 P.M.).

Both Scrivener and Tompkins are distressed by the actions of the partisans. Scrivener sympathizes with them politically, undisturbed by their Communist component, but otherwise she agrees with the constantly reaffirmed Vatican position that condemns violent acts of insurrection in Rome. Tompkins, operating in an arena where mutual distrust and violent solutions are commonplace, adheres to the American principle that justice must await the return of legal processes; but his main concern is that a premature insurrection will cause the partisans to be decimated before the day of liberation, when their services will be crucial to the salvation of Rome. For in their rage against partisan activities the Nazis and Fascists had already extended the methods of Via Tasso to three additional houses of torture. One in the basement of the Palazzo Braschi at Piazza Navona, where the "Fascist Republican" party had independently established its headquarters, became the scene of indescribably barbaric acts of retribution, committed moreover without the sanction of the Nazi military government. When the Braschi was finally raided by the German and Italian police, they discovered not only the bodies of victims but vast hoards of jewels, gold, and food supplies. The astounded neo-Fascists found themselves under arrest.[18]

Acts of resistance and reprisal reached their terrible climax in late March. On the twenty-third Jane Scrivener stayed at home, having been warned that an announced celebration of the twenty-fifth anniversary of Fascism's founding was likely to make the streets dangerous: "Patriots are increasing in numbers and in determination, and there might be a clash." What did happen she learned in reports from friends that evening. At 3:30, while a detachment of German soldiers was passing through the narrow Via Rasella, which runs down the hill directly opposite the gates of the Palazzo Barberini, a time bomb concealed in a dustman's cart had exploded, killing and wounding many of the Germans:

> Pandemonium followed. Until 9 P.M. German soldiers, S.S. men and Fascists with tanks and machine guns, continued shooting wildly at the windows and roofs of houses not only in Via Rasella, but in the neighbouring streets also. All the inhabitants of Via Rasella as well as those who happened to be passing at the time were arrested, hustled into lorries and taken to what is now called "the slaughter house" at Via Tasso.

Although naturally these reports were imprecise in some respects (a disguised partisan actually lighted the fuse of the bomb as the column of soldiers passed), they were largely correct. The accurate detail about the dustman's cart is remarkable, since this fact afterward remained unknown even to Fascist and Gestapo investigators.[19] And Scrivener's reading of a notice that appeared the next day in the *Osservatore Romano* is notably acute. In words of exceptional urgency, printed on the front page in italics, the Vatican newspaper appealed to the people to "refrain from acts of violence" which "would only provoke severe reprisals, giving rise to an infinite series of painful episodes." For the sake of Rome, it concluded, everyone of

influence should persuade the people to remain "patient and self-controlled." From this Scrivener inferred that the writer "must already know something of the consequences of yesterday's occurrences in Via Rasella."

On the next day word spread throughout the city what the consequences had been. The Germans had cleared the political wards of Regina Coeli and transported the prisoners to a cave on the Via Ardeatina near the Catacombs of Domitilla. There they had been machine-gunned (actually they were shot one by one), and their bodies "piled in a long mound in the cave, and a mine was exploded at the entrance." Newspapers then printed a communiqué from the German High Command: for each of the thirty-two German soldiers who had been killed, ten of "Badoglio's communists" (an absurd but clever phrase that united the opposing sides of the Resistance in responsibility) had been executed. By the twenty-sixth the rest of the story came out. Prisoners in Via Tasso and other torture chambers had also been taken to the cave and similarly executed. "The long mound of corpses was then covered with some adhesive chemical substance resembling pitch, so that the remains could never be separated or identified. Earth was thrown on top of the whole, and the remaining entrances to the cave dynamited as before." Now the rumor was that not 320 but over 500 people had been shot. (The actual number was 335.) "Rome was beginning to suffer what Prague and Warsaw had witnessed: wholesale reprisals in cold blood." In the following days a "grief-stricken and indignant" people removed the refuse heaps that the Germans, trying to disguise the stench of human decomposition, had dumped at the blasted entrances to the cave and replaced them with flowers. The Germans refused to publish a list of those they had shot; families with imprisoned men were made to suffer the additional pain of not knowing their fate.[20]

Shortly before this incident Tompkins learned that Cervo, the twenty-three-year-old policeman-partisan on whose motorcycle he had frequently been transported to safety, had been betrayed. Captured by the Fascists as he tried to save Tompkins's radio transmitter, he was taken not to Via Tasso but to another torture chamber near the railroad station. Tompkins and his closest Italian collaborator, Franco, immediately planned an operation to rescue him. Then the incident of Via Rasella occurred. This partisan action particularly angered Tompkins, since it had killed only "nondescript" soldiers, but its boldness and success would certainly provoke reprisals that would endanger the entire underground operation. Since the attack had been executed with such "beauty and precision . . . damned near perfect," why had those responsible not at least directed it against Via Tasso itself or against "Kappler and his gang of butchers"? On the twenty-fifth Tompkins heard the rumor that 320 hostages had been shot. Shortly afterward Franco arrived to tell him that one of the dead within the caves at Via Ardeatina was certainly Cervo. From Cervo's orderly, who had "miraculously" escaped, Tompkins and Franco received a detailed report of the prolonged tortures Cervo had endured before being carried away to what could only have been a welcome death. He remained silent to the end.[21]

The gradual arrival of the Roman spring is an event observed by both Scrivener and Tompkins with irony and hope. In one of his hideouts Tompkins could "smell the spring where the sun warms the damp mossy stones of the walls in this ancient

part of Rome." He enjoyed sitting in the sun "on the ocher terrace" with its "pale green new wisteria leaves," looking at the roofs and domes "clear-cut against the Roman sky."

> Somewhere someone is playing softly on a concertina. He plays it well, with that langorous Gypsy wail. . . . Looking over the high wall I can just see that it is a girl in a red negligee, her lips painted, which is odd, because she is on the terrace of a tenement, her audience a handful of ragged but spellbound brats, none of them over six. Now she is playing "Lili Marlene," which will always remind me of these months, if ever there is an always![22]

Not long after Tompkins wrote this, Jane Scrivener took a walk in the Villa Borghese "to see the spring":

> It has really come at last, and the blessed warmth is penetrating into our unheated houses. . . . In a few weeks we shall be perspiring and trying to shut out the heat and glare. It won't matter though, if the Allies are not here. . . . Close to the entrance of Villa Borghese were two sinister looking German armoured cars with guns, ready to rake the approaches to the gardens if required. Nevertheless their shadow could not dim the glory of the surroundings, nor change the delicate beauty of young leaves and grass. The colour of the budding trees was like a delicate melody: golden-green, silver-green, blue-green, olive-green, mauve-green and pinkish-green harmonized against a background of thin weeping willows and solid ilexes. The buds themselves seemed deliberately fantastic in shape and texture; they were feathery, knobby, vertical, horizontal, stiffly conventionalized or recklessly baroque. . . . The Giardino del Lago, the loveliest spot of all, was closed and guarded.[23]

Easter Monday, the traditional day for the "*scampagnata* or day in the country—*fuori porta*, outside the gates," was celebrated by the Romans as well as they could: meager picnics in the Forum, on the Palatine, and in the parks. But the Birthday of Rome, April 21, passed this year without ceremony. On April 27 Scrivener reported the rumors that the Fascists had killed a plan to put Rome under an international force responsible to the pope and that "something big" would happen before May 3. "Beyond that, all is quiet here today and going on as usual; the weather is perfect, the bees are overeating themselves among the wisteria blossoms in our garden, and bombs are falling rhythmically in the distance."[24]

Spring alone provided relief; everything else worsened. Fascist dragnets constantly sought to discover hidden partisans, spies, escaped prisoners, and Jews. Assassinations and summary executions continued. The battle of wall communications heightened: "Placards on the walls gain in quantity though steadily losing in size and intelligence," Scrivener noted. One even dared to show Mussolini in company with Cavour, Mazzini, and Crispi. Others, urging Roman men to join the labor forces supporting the German defense, evoked memories of the Battle of Cannae and of "Hannibal threatening Rome," or depicted "the Statue of Liberty in New York harbour rising from a sea of flames and gore." The men who plastered

these signs to the walls did so with a "scornful air of utter weariness and disdain." Meanwhile, the refugee population grew, beggars became more numerous and aggressive, thieves were everywhere, the black market (operated by the Fascists and Germans themselves) prospered, prices steadily rose, and food riots occurred. "Bread! Bread! Bread!—Death to the people who are starving us!" now appeared on the walls of Rome. The ubiquity of such subversive expressions caused a decree to be issued making owners or custodians responsible for whatever inscriptions appears on the walls of their buildings. Obviously the police "could no longer cope with the spate of hostile remarks scrawled nightly all over the city."[25]

But such hostility, and the very effective passive resistance that Scrivener several times notes, were themselves signs of continuing hope. On April 29 a rumor that all German women were being sent away from Rome was interpreted as a sure sign of an imminent Allied victory. On May 18 the BBC reported that the Gustav Line below Cassino had finally been broken. Now the people of Rome talked of nothing else but the arrival of the Allies—once again betting on the date. Jane Scrivener's diary for May 20 contains only one line: "Cassino is taken!" At a requiem in St. Peter's for the late Cardinal O'Connell, archbishop of Boston, "all the English-speaking people in Rome [most of them confined to Vatican City] appeared to be present," seizing the opportunity to share their joy and to talk with the escaped British prisoners who had found refuge in the Vatican. The main worry now was what the retreating Germans would do: would they destroy Rome? On May 25 more refugees arrived from the heavily bombarded Castelli Romani; thirty-six of them now lived in Jane Scrivener's convent, along with two horses (refugee livestock of all kinds inhabited the gardens and ground-floor rooms throughout the city). The emotional atmosphere of Rome reaches its most painful combination of opposites: the rumor is that the Allies have taken Albano, but the "joy at their approach is balanced by dread of German savagery." In this context the propaganda ministry on June 1 issued instructions that journalists were "to write at length on the forthcoming musical season, which is opening with the Comic Opera Company at the Quirino Theatre."[26]

Instead, the Fascist journalists were "prudently" leaving the city, along with Fascist officials. German diplomats were rumored to be packing their bags. The regime's "terrible threat" to begin a house-to-house search on May 26 for the several hundred thousand Roman men (90 percent) who had not responded to the call to join the forced-labor gangs was canceled because none of the Nazi-Fascist enforcement agencies would accept an assignment certain to produce the long-feared popular insurrection. On the night of the twenty-seventh "a steady stream of German tanks, guns and lorries" was observed "passing northward through the city." The next morning the people who joined the queues in the streets, waiting to fill their pails where rigged-up pipes had supplied water since the aqueducts had been damaged, were in a very different mood from March: "Then they were mournful, dispirited, almost without hope or energy; now a cheerful buzz emanates from them." On the twenty-ninth Rome Radio fell silent because the Germans had removed the equipment as a precautionary measure; on the same day electric current to the trams was turned off. At the beginning of June, Scrivener could hear the guns day by day coming closer while aerial combat increased over the city. Otherwise, with so few

men in the streets it was even quieter than usual for June. "Rome is not looking her best," Scrivener wrote, "with her closed shops, dirty pavements and shortage of water, but the weather is exquisite and her churches and monuments are unchanged, while Father Tiber goes on his way through the city as he did two thousand years ago." On June 3 the question was, would the Germans "make Rome a battlefield"? Scrivener did not think so. In the meantime a frustrated Peter Tompkins, completely cut off from contact with the Allies, feeling useless and depressed in his hideout where he trembled whenever a truck was heard stopping in the street below his window, drank his last bottle of gin and watched the rooftops turn "from red to purple" while he waited for the day of liberation.[27]

Among the thousands of American men who were approaching the walls of Rome from the south on Sunday, June 4, 1944, several later wrote accounts of how they entered the Eternal City that night, not to conquer, but to liberate. The victorious procession through Rome on June 5 provides a climax to *Calculated Risk* (1950), the graceless autobiography of Gen. Mark Clark, who for weeks had been obsessed with the idea that he and his Fifth Army, not any other troops of the Allied forces, should be the first to pass through the gates. *Return to Cassino* (1964), the memoir of Harold L. Bond, an infantryman who after the war wrote a doctoral thesis on Edward Gibbon's *Decline and Fall of the Roman Empire*, reaches its moving conclusion with a description of one exceptionally historical-minded soldier's spiritual possession of the city on that same day. A third view, which reports both the vanity of the victorious general and the selfless valor of the fighting soldier to whom Rome meant little, was eloquently expressed by the young journalist Eric Sevareid in *Not So Wild a Dream* (1946).

Clark's account of the approach to Rome is concerned to record his negotiations with the English and French generals about their respective territorial obligations while driving the retreating German army around, through, and beyond the city. He also established the text of the communiqué that was to be released in Rome, giving full credit to the Fifth Army. On June 2 the German defenses at both Valmontone and Velletri had been broken, and Kesselring's "Caesar Line" snapped; the way to Rome along Route 6 (Via Casilina) and Route 7 (Via Appia) lay open. On June 3 Clark "went from command post to command post urging that 'this is the day' for the kill." He was also preoccupied with preventing assorted "Greeks, Poles, Indians," and other Allies from rushing to the front. On June 4 he "jeeped" forward to a point five miles from Rome and learned with satisfaction that the "spearhead" troops were already entering the city, although meeting resistance. From "the foot of a hill leading up to the gates" Clark saw a sign saying "ROMA" and decided it "would make a good news picture." While Clark and two of his generals posed beside it, a German sniper opened fire, and a bullet passed through the sign. The generals threw themselves into a ditch and quickly crawled to safety, Clark concluding that his entrance to Rome would have to wait a day.[28]

What is almost wholly missing from Clark's account is described in detail by Sevareid and Bond: a wasteland world ravaged by retreating and advancing armies, and a scene of dirty soldiers marching wearily along highways whose margins were littered with burning vehicles and the dust-covered corpses of Germans. At noon on

June 4, a few hundred yards from the city limits, Sevareid looked toward Rome, which was "obscured in haze and smoke," and heard explosions that raised the fear that its bridges were being destroyed. Here on the outskirts, between the ramparts of the trolley lines, one felt "a combined spirit of battle and of holiday." An old man held a cup of water to the lips of a dying German and gently stroked his hair, while from their windows "girls and children tossed flowers at the two lines of slowly walking American soldiers, and bouquets were now displayed on the turrets of our tanks." Another old man "began reciting a speech of Garibaldi's," and through the middle of the line of troops there came first an incongruous wedding party and then a column of refugee families from Cassino, already returning south to their pulverized homes.[29]

At the same time Bond, as a general's aide, was riding in a jeep in the "long column of Americans [winding] its weary way down the northern slopes of the Alban Hills." Everyone was wondering whether they would have to fight their way through Rome "house-to-house, street-to-street," destroying the great city as they went. In the afternoon they were passing rapidly over the Campagna:

> Off in the distance on both sides we could see other Allied columns converging on the city, which loomed in the distance. The great Claudian aqueduct . . . intersected our line of march as we came up to the ancient Appian Way. The ruins of Roman tombs . . . lined the old road, and tall cypresses pointed like dark green flames toward the sky. We were almost to the gates of the city.

Most of the heavily loaded infantrymen now "caught some of the excitement of the great event about to take place." Few perhaps knew that they were the first army to take Rome from the south in fourteen hundred years, but as they paused "near the ancient wall of the Via Appia and halted their long march to await orders to go in," the special character of the place impressed itself upon them. Throwing down their packs, the soldiers—unshaven since the attack on Velletri had begun a week earlier—lay down to rest. "The vehicles . . . stretched back in the road as far as the eye could see, across the plain and into the hills. Unlike Alaric and Attila, unlike the Saracens and the Normans, unlike the troops of Charles V, we were coming to the city as friends, not as conquerors. Unlike the Germans, . . . we were coming as liberators."

As evening fell, small fires were lit along the highway, coffee was heated, rations were eaten. They waited and then slept, while the last of the Germans fled through the northern gates. Bond's thoughts turned to two friends in his old platoon who were somewhere along the road. To them, he knew, Rome would be "just another city, possibly richer and more luxurious than Naples," but whose luxury they would not be allowed to taste. "They were too tired to be jubilant about a victory," and they had just received precise orders on how they were to pass as quickly as possible through Rome the next day, following a prescribed route. Not Rome, but the fleeing Germans, remained their objective.[30]

Within the city Jane Scrivener was writing in her diary that all that day they had rejoiced to see the Germans "quietly on the run." Telephones, radios, trams, and buses had all suddenly ceased to function, and there were no newspapers. But all

Rome knew what was happening. That morning the police had hastily replaced their Fascist badges with "the five-pointed star of Italy," and a "shower of leaflets" had fallen on the city containing a "Special Message to the Citizens of Rome" from General Alexander: "Rome is yours!" it concluded, after listing the ways in which they could help; "your job is to save the city, ours is to destroy the enemy." The Romans passed the day "unobtrusively and ironically" strolling about the streets mainly used for German traffic," witnessing "with Olympian serenity" the frantic exodus of "the defeated Huns." The Germans and the Fascist "Republicans,'" "wild-eyed, unshaven, unkempt, on foot, in stolen cars, in horse-drawn vehicles, even in carts belonging to the street cleaning department," made their disordered escape. At about 11:00 three terrible explosions shook the buildings near the convent; the Germans were destroying the Macao barracks (Castro Pretorio) and its large supply of petrol. Rumors spread about how much else they might destroy, but in the haste of their flight they had time to do little. The huge Fiat works and adjacent houses were blown up, as were some railway yards, one telephone plant, a reservoir, and six plots of the Campo Verano cemetery where explosives were hidden, but quick-acting partisans removed the detonators of the mines in the broadcasting station and "neutralized 212 pounds of nitroglycerine" in the cellars of the main Roman telephone exchange. Indeed, only "lack of time and the skill and courage of patriots prevented the destruction of many public buildings, bridges and waterworks."[31]

For these effective actions of the partisans, Peter Tompkins was chiefly responsible, according to *A Spy in Rome.* On the evening of June 3 he had received reports of the "continuous stream" of German troops, tanks, and guns going north out of the city, and he had heard the BBC broadcast of General Alexander's announcement that the Caesar Line had been broken. The next morning he converted the sitting room of his hideout into a workroom for receiving a constant flow of reports about everything happening in the city and for issuing instructions. He sent one partisan to German headquarters to see if anyone was still in charge. General Maelzer, "the King of Rome," was "stinking drunk, speaking in lamentable French, the place in complete confusion," but none of the competing partisan powers had seized control. "Clearly the time had come for me to act." In "official military form" Tompkins wrote out orders to the Roman police forces to prevent all sabotage and to arrest all Germans and "Republican" deserters. "I had no idea whether any other authority was around to issue orders, but I figured it was the only thing to do in such a case." Thus Tompkins became ruler of Rome for one day. Several dozen "odd young men" came and went reporting to him and going about "their various jobs of liaison and countersabotage." Tompkins's orders reinforced the detailed instructions to the citizens of Rome in General Alexander's leaflets. The partisans complied with them exactly, but Tompkins tacitly understood that they were likely to be exceeded in one respect: there would be summary executions of "some of the top-ranking Fascists and pro-Germans on the main black lists," who unless killed by the partisans would most likely be given the "best jobs" by the Allies in the postwar government.[32]

At 12:30 the nuns and refugees in Jane Scrivener's convent heard someone crying, "The British are at Porta Maggiore!" This was "too good to be true." The next rumor was that the "torture houses in Via Tasso and Via Romagna and at the political wing

of Regina Coeli had been broken open and their occupants set free; while Caruso and Koch, the most cruel Blackshirt bosses . . . had been arrested and locked up for trial." By 5:00 it was said that most of the Germans were gone, and that the partisans would assume power at 9:00. Scrivener thought the tale that the pope had intervened with the Allies to let the Germans escape was "incredible," but she shared the "nearly universal" belief that he had convinced Kesselring to abandon Rome without a fight. As darkness fell, "the last Germans were fleeing from the city, and Allied patrols were entering, cautiously at first, swiftly and confidently afterward." By 10:00 the men of the underground could be heard "rallying in force" throughout the city, ready "to keep order."[33]

Tompkins was so satisfied with the orderly assumption of power by the partisans that at 7:00 he had ventured away from his "focal point for intelligence" to see for himself "what was happening" in Piazza Venezia. Sitting with a partisan friend "on a grassy island" in the square, he watched the continuing pathetic flight of the Germans—in cars with no tires, on bicycles, on foot. Then three officers of the Italian military police, which had taken over the insurance building opposite Mussolini's balcony for its headquarters, ordered Tompkins and his friend to go home. They obeyed, but "it amused me . . . to think that it was really *my* order" the officers were enforcing. As Tompkins reached the palazzo where he had been hiding, a girl came running by, shouting "They're at San Paolo!" The absolute proof that this was no mere rumor lay in the detail that one of the soldiers had given a man "a can of meat and beans!" Only an American GI "could be dishing out those goddam 'C' rations to the populace!" Tompkins was now "more excited than I've ever felt in my life." He and three of his partisans each "grabbed a gun" and set off for the river, where they saw that the bridges were still intact and no longer guarded. Approaching the Capitoline, they found it surrounded by security guards who prevented them from climbing the hill. Unsure whether the Allies would enter by Via del Impero or Via del Mare, they climbed the Palatine, which would give them a view of both streets. As they approached the top, "a burst of machine gun fire went over our heads," so they crawled back down. (They later discovered that forty German paratroopers were making a last stand on the Palatine.)

Back down in the streets, Tompkins's group was fired upon by a sniper on a rooftop. They ran to a small cave at the foot of the Capitoline, but three proprietary bums drove them out. In a larger cave nearby they joined a crowd of half-starved and vermin-covered refugees who had been living there for months, since Allied bombs had fallen on their district on the periphery of Rome. A burst of machine-gun fire aimed at the mouth of the cave set the women and children screaming and intoning religious chants. Tompkins and his companion, leaning "against the dank stinking wall with the grumbling and wailing of the people all around," decided it was time to get back to headquarters. In a quiet moment, they ran from the cave and returned to the hideout. Someone had been there looking for Tompkins to participate in the official transfer of power to the Allies. It was now night, and there were no lights, so Tompkins ran through the dark toward Piazza Venezia. There, "in the faint light reflected from the monument of the unknown soldier, neatly arranged in a wide semi-circle from underneath Mussolini's balcony," stood a row of vehicles, on

which dusty American GIs lay resting and smoking as they "gazed in a friendly way at the excited *'paesanos'* ": "The Fifth Army had entered Rome."[34]

Across the city, the people in the convent were looking down upon the mistily moonlit scene and listening to the cheering from the direction of the Porta Pia as the Americans entered Rome. They came along the Via Ardeatina to the Porta San Paolo, along Via Casilina and Via Prenestina to the Porta Maggiore, and along the two Appian Ways—Antica and Nuova—to Porta San Sebastiano and Porta San Giovanni, where "the Huns" had entered last September. Some skirmishes with "belated Germans" occurred near Santa Maria Maggiore, at the Colosseum, and on some bridges. But wherever the troops passed through the walls of Rome "they were cheered, applauded, and showered with blossoms. A rain of roses fell on men, guns, tanks and jeeps." Embarrassed American infantrymen found themselves being warmly embraced and kissed on both cheeks. At about one in the morning "the tumult and the shouting died," and the nuns left their high "observation post." Five hours later, unable to sleep, Jane Scrivener got up and looked out the window:

> I saw one little jeep with four American soldiers in it, making its way slowly and soundlessly along the street. No one else was about. The thing looked so solitary, yet so significant in the cool stillness of dawn. I had it all to myself for a few seconds. It was so small, yet so secure; a vignette on a page of history; a full stop at the end of a chapter of oppression and fear.[35]

At dawn on June 5 the official passage of the Allies through Rome began. Harold Bond rode in his general's jeep, directly behind the tank that led his division. The general held a map of Rome in his lap, and two partisans riding on the tank served as guides through the city. Ahead of them the tree-lined street was deserted and silent, its shops shuttered down. The orange-yellow buildings of Rome glowed in the clear morning light. Only after the column had moved a mile down the road, "people began to appear, Romans in their bathrobes and nightdresses, cautiously, a few at a time, and then more and more. Someone started cheering, and very soon the streets were lined with people, clapping, calling gleefully to one another, shouting. We waved back to them, smiling, but kept moving at the same speed straight on." Soon the Colosseum loomed beside them on the left. Ahead the broad Via del Impero was "entirely deserted," while behind them "the crowd of Romans grew and grew." Passing the Temple of Venus and Rome and the ruins of the Forum on their left, and "the triumphant column of Trajan" on their right, the liberators clanked and rumbled their way to the Piazza Venezia and into the shadow of the monument to Victor Emmanuel and Italian unity. There they looked up at Mussolini's balcony and saw that the square before it was empty. But as soon as the Americans had "peacefully passed," people "swarmed into the streets."

Bond, who had wanted to see Rome since he read Caesar and Cicero as a schoolboy and is now writing as a scholar of Roman history, is moved by the difference between this entry into Rome and those he studied later. The march in which he had participated in 1944 was "steady, measured," no "riotous pillaging," no "cruel

and bloody sack of the city." At the time he had been merely excited, vaguely aware "that something significant was happening." Eighteen years later (as the war in Vietnam began) he could interpret it as a truly "Roman" action, for "in freeing Rome from Mussolini and Hitler we were helping the city in her eternal fight against barbarism." In her "great mission" to "civilize the world," Rome had proven that "barbarism often has to be stamped out by war." Now the British and Americans, "both of whom had taken so much of their culture and so many of their ideals from the mother city, were slowly marching through the ancient streets . . . so that these ideals could continue to live in the spirits of men."[36]

But such thoughts were not in Bond's mind as his column crossed the Tiber and he saw the Castel Sant' Angelo on the right and ahead on the left, at the end of a broad new street cut through by Mussolini, the dome of St. Peter's. When the column clanked to a halt just within the arms of Bernini's colonnades, which dwarfed their tanks, "nobody was in sight," and the great fountains were dry. The excited Italian guides were shouting that this was not where they were supposed to be. With the Thirty-sixth Division of the Fifth Army stretching for miles behind him, the general got out and shouted angrily that they must not enter Vatican City; "We'll create an international incident!" Looking at his map, he gave orders to proceed to the right, ignoring the protests of the Italian guides. While growing crowds cheered them on, the column moved forward along the Tiber—until it found itself confronting another column of American troops coming across a different bridge. Chaos ensued. Bond's column slowly backed up, crossed the trolley tracks, attempted to return to the Vatican, and came to a full halt in a traffic jam, while flag-waving Romans jumped up on the turret of the lead tank and sang songs. The division commander arrived to express his wrath with the general who had disrupted the plans for a smooth and rapid transit across Rome. MPs finally straightened things out, and the column proceeded along the Tiber, around Vatican City, up the Janiculum "where Garibaldi had fought" for the freedom of Italy, and then out the ancient Via Aurelia that for two millennia had led from the Forum to Gaul.[37]

That morning Jane Scrivener was on the Via Veneto, which had suddenly turned into a new world where "British and American flags floated in the wind," and "two long lines of American infantry were marching up either side of the roadway, toward Porta Pinciana. . . . They had roses in the muzzles of their rifles, and miniature Italian flags. . . . One has read of these things in books, and accepted them as fiction, never dreaming of witnessing them as we did today." All the pink rambler roses of Rome had been sacrificed to this day. The population of Rome seemed to have doubled, for the thousands of men so long in hiding—patriots, Italian soldiers, young men of military age, escaped Allied prisoners, and Jews were suddenly in the streets, cheering. The people were not rowdy, they laughed and talked and congratulated one another. Jane Scrivener, filled with joy and pride, went home to hoist the Stars and Stripes and the Union Jack—kept for so long carefully hidden—over the convent. "At the same moment, 10 A.M., Colonel John Pollock hoisted the Union Jack on the Capitol," and "American soldiers hoisted a big Italian flag on the balcony of the Palazzo Venezia."[38]

Eric Sevareid, riding into the city in one of the military columns, was trying to "hold tight to my emotions." The "vast, murmurous sound of human voices

flooded everywhere and rose in joyous crescendo at every large avenue we crossed."
At the Piazza Venezia, now "jammed with a monstrous crowd," flowers "rained
upon our heads, men grabbed and kissed our hands, old women burst into tears, and
girls and boys wanted to climb up beside us." He tried to remember that these
people had been "our recent enemy," and that he as a noncombatant had "no right to
this adulation," but he nevertheless felt "wonderfully good, generous and impor-
tant. I was a representative of strength, decency, and success," and "at this mo-
ment" he could forget that Germans and Fascists had once been cheered in this
same piazza. At the police headquarters opposite the balcony there was a sudden
burst of "tommy-gun fire," and Sevareid saw some partisans dashing down a cor-
ridor, "firing blindly ahead of them. There was a frightening look in their eyes, an
expression of bloodlust and hatred. The rat hunt was on." The correspondents
proceeded to the Foreign Press building to begin transmitting their reports. Nearby
they saw "vigilantes" smashing in the shop windows of Fascists and Nazi sym-
pathizers, and a beaten man ran by, blood streaming down his face. Sevareid found
the sight of vengeance "sickening." Then he hurried to the Campidoglio, where
General Clark was about to hold a "press conference."[39]

General Clark had not arrived easily at his destination. Coming into Rome on Via
Casilina and then along avenues lined with cheering Romans, he and his "little
group of jeeps" also got lost, but "we didn't like to admit it." Like Bond's division,
they eventually found themselves at St. Peter's Square. A priest from Detroit
welcomed the Americans and asked if he could help. "My name's Clark," said the
general. "We'd like to get to Capitoline Hill." Word soon spread in the crowd that
the great commander of the Fifth Army himself had arrived, and a boy on a bicycle
volunteered to lead the way. So he pedaled away, shouting to everyone to make way
for General Clark, and "by the time we reached a point opposite the balcony where
Mussolini used to appear . . . the road was blocked by curious and cheering people."
Finally a path was cleared and Clark mounted the hill to the Town Hall. The door
was locked. The general pounded for entrance, "not feeling much like the conqueror
of Rome. Anyway I thought, we got to Rome before Ike got across the English
Channel to Normandy." Finally a caretaker let him in. Then he met with his own
generals and the British and French generals, and received a welcome from "General
Roberto Bencivento [actually Bencivenga], the Italian military commander in Rome
and a splendid patriot." To Clark this meeting, although it "resulted in no momen-
tous decisions," was "a kind of turning point in the Allied attack."[40]

Sevareid and his colleagues found that meeting nauseating (Henry Adams would
have laughed). When they arrived at the Campidoglio, Clark was leaning against the
balustrade of the square, posing as "the lean, smiling victor against the appropriate
background of the great city spread out below." The other American generals had "a
questioning look in their eyes," and the French general Juin wore an "expression of
bewilderment." Clark told the correspondents that no press conference had been
intended; he had meant merely to meet with his commanders "to discuss the
situation." If they had any questions, however, "This is a great day for the Fifth
Army." "That was the immortal remark of Rome's modern-day conqueror," wrote
Sevareid in anger. "It was not, apparently, a great day for the world, for the Allies, for
all the suffering people who had desperately looked toward the time of peace."

Spreading a map on the balustrade, Clark went through the motions of pointing out
details to his embarrassed commanders, while the mob pressed close and the cam-
eras ground on.[41]

But there were other ways of possessing the city. By late in the day Harold Bond's
general had established his command post in one of the great villas on the Janicu-
lum. Too excited to go to bed, Bond walked back to the terrace that overlooks all
Rome:

> In the gathering dusk I strolled out there, hoping to fix in my mind the image of
> Rome on the night of our victory. . . . The air was heavy with the scent of many
> June flowers. The first stars of the evening were coming out. The air was warm. Al-
> most no one but myself was on the terrace. Down in the city, lights were coming
> on in the many villas and apartments, . . . but the great monuments of the past, the
> Colosseum, the ruins of the palaces, the columns of Trajan and Marcus Aurelius
> were slowly lost in the increasing darkness. For nearly three thousand years men
> had lived on these hills and in the valleys that I now looked out upon. Nor had
> they been, in their strife and turmoil, their loves and hates, much different from
> ourselves. Eternal Rome had been and still was the center of our civilization, . . .
> one of the "quick" spots of the earth. There was life here, insuppressible life, well-
> ing up always like the marvelous fountains, which could not be stopped despite
> conquest, disaster, decline, the loss of empire, the coming of every kind of evil.
> Tyranny in all of its forms—the latest being Fascism—and even the loss of faith in
> the meaning of life could not suppress the eternal vitality in this ageless city. So
> long as men walk this tired earth, Rome will be a center for them. . . . Far below me
> the Tiber . . . reflected the many lights along its bank, soft and shimmering in the
> night. An occasional sound of music floated up from the celebrating city, and now
> and again one could hear laughter from the houses stretched out below.[42]

"Nothing will erase the greatness of the day when we liberated Rome," wrote
Herbert Matthews, most thoughtful of all the American correspondents who had
accompanied the Fifth Army through "an unending scene of desolation," along
"roads of dust and blood," into the rejoicing city. The inviolable quality of that day
of ecstatic affirmations must be so insisted upon, however, because the chapter
called "The Eternal City" in Matthews's *Education of a Correspondent* is otherwise
mostly concerned with the depressing political and social realities that preceded
and followed it. Matthews had come to know the Romans as the "most blasé of all
peoples," normally "so cynical, so world-weary" that the "wild joy" with which
they welcomed their "deliverers" made them "unrecognizable." He found his "old,
anti-Fascist friends" from prewar days "safe and sound," and "for once I was glad to
be hugged and kissed by men whose affection I returned." Rome too, largely un-
damaged, seemed "the same old Rome which gladdened my heart." "I knew that our
wave of strange people and vehicles would quickly pass, and that Rome would again
look as it had always looked." American jeeps careening around Piazza San Pietro
were a passing phenomenon; the essence of Rome was untouched. Matthews even
quotes Byron on the city whose "agonies are evils of a day," but he then injects a

four-page review of the twenty-year evil of Fascism, beginning with Matteotti's murder in 1925, when Matthews had first come to Rome: "Those were the days when Rome appeared to have lost its soul." Now the passivity of the Romans that had maddened him in the 1930s seemed to have disappeared overnight:

> That attitude of indifference, world-weariness, proved to be only a mask. . . . Here were fervor, excitement, joy, a friendliness that flowed like the Tiber itself. . . . Best of all, new spiritual and moral bases were being laid, and although many were Romans in the bad sense of the word—scheming, treacherous, and cynical—very many more had found ancient virtues in themselves. . . . Not since 1870 had there been such an awakening. To see Rome alive with hope, courage, and determination was a strange and wonderful thing.

"I suspected that it might not long remain so," Matthews added, and in the months following liberation he watched with hope, skepticism, anger, and sorrow as Rome sought to renew its social, economic, and political life, and suffered the moral degradation of occupation by the Allies. The first government had been formed within days of the liberation, without consulting Prince Umberto, whose disgraced father had been forced to abdicate. More serious than the uncertain fate of the House of Savoy was the problem of creating an effective and genuinely democratic government out of Italy's competing political factions, a process that, ironically, the conservative and vindictive British and the naively anti-Communist Americans were seriously inhibiting.

As for the relation between the Romans and the Allies, "the honeymoon was soon over." Within ten days "wits were grumbling, 'Rome was never like this,' and asking when the soldiers were going to leave, why they were eating up Roman food, and whether Italians were supposed to enjoy the way Roman girls and women were throwing themselves into the arms of the American soldiers." Some people hoped that the Allies would stay "indefinitely" to prevent a Communist revolution, but those Italians "had no faith in Italy and I never felt any sympathy with them," nor for those others who only waited for the day when they could abandon "their unhappy country for the material comforts and order of the United States." Matthews soon realized that "twenty-one years of Fascism, capped by nine months of German terrorism, had left ineradicable marks of moral weakness." A demoralized people living in degrading circumstances meant that the months following "liberation" were a period of "misery and lawlessness"; "Romans were wretched." Americans themselves—who for the first time in history were helping to determine the character of Rome—soon used the word *liberation* ironically: they had "liberated" militarily insignificant villages throughout the South—as now in Tuscany—by destroying them utterly, and they "liberated" whatever cars and houses they needed from the Romans. No wonder that on a wall in Trastevere someone painted the words" *"Arivolemo er puzzone*—'We want the [big] stinker [Mussolini] back.' "[43]

Eric Sevareid also passed the summer of 1944 in Rome, making similar observations about the consequences of the mistaken political policy of the Allies and of the alienating behavior of their armies; "Rome became a city without a character of its own":

Its crooks grew rich in the black market, its honest men debased themselves to find food and work, its statesmen were frustrated by lack of real authority, its working class grew desperate because Allied wage scales were smaller than either Fascist or German, its social aristocracy seduced unprincipled Allied officers as it had seduced German officers, its real patriots became bitter because they were not allowed to fight, and its young girls prostituted themselves to the Allied soldiery. . . . Wealthy British and American women expatriates, married to Italian aristocrats, complained bitterly about the war because they had been obliged to walk to market and dress their own children—"My dear man, you have *no* idea what we went through!"

Superficially, Rome was at peace. As always, Romans took their siestas, the church bells rang, and "the marvelous sunsets burnished the tinted walls." But beneath the lazy, sensuous routine, frustration and anger grew. At first the Americans had been the most popular of the multinational invaders, but soon their "rowdy, boisterous" behavior gave them a bad reputation. Bored by the "fabled monuments" that had awed them only at first sight, Americans largely ignorant of history soon found their "chief fascination in modern comforts and erotic pleasures." Sevareid sensibly remarked that although Rome might be eternal, a soldier who had just passed months killing young men like himself and seeing his friends die around him naturally felt that "*his* life might be short." Thus he lived for the day, and Rome was his arena. As in Naples, "the perquisites were handed out to officers and enlisted men with the same injustice." The latter lived "in YMCA wholesomeness at the Mussolini Forum" while "officers drank and fornicated in the luxurious hotels along the Via Veneto." The injustice to the common soldier did not escape Bill Mauldin, the GIs' favorite cartoonist. He portrayed two weary, sad-eyed, unshaven doughboys outside the door to a luxury hotel in Rome; one is translating the offer of a solicitous Italian: "He says we kin git a room in th' Catacombs. They useta keep Christians in 'em." Mauldin wrote that he had hoped this might inspire "some flinty requisitioning colonel to donate the Grand Hotel to private soldiers in the infantry," although "if it happened I didn't hear about it."[44]

Rome that summer was "the unholiest pleasure palace in Europe." The once supremely "smart" Hotel Excelsior became "a roaring, night-long brothel," and the Vatican protested against Rome's transformation into a fleshpot. For this state of things the soldiers on their three-day leaves from the front were not to blame, Sevareid thought; what he found "deeply disturbing" was the "behavior of the women." In the excitement of liberation Roman men might kill Fascists or demand to join in the fighting, "while the women could express themselves only by sexual activity." Yet they did not do this "with their own men, the vanquished, but gave themselves at once to the victors, whatever their nationality, no matter what they had done to the Italian men or the Italian land." The deserted Italian men were embittered; "head shavings became fairly frequent events," and girls emerging from a dance were attacked by a mob of Roman men. What might have restored masculine self-respect—being allowed to fight as cobelligerents with the Allies—had been stupidly denied; even partisans who, among other heroic acts, had saved many Allied soldiers at the risk of their own lives were treated with condescension.[45]

This Rome, humiliated, grieving, and riotous, is the protagonist of an extraordinary novel written by one of the American soldiers who came to know it first as it was then. In *All Thy Conquests* (1946), as to a lesser extent in *The Girl on the Via Flaminia* (1949) and *The Temptation of Don Volpi* (1960), Alfred Hayes eloquently expresses a great love for the city, its landscape, and its people—this in realistic fictions depicting desperate acts of a brutalized and impoverished people, violent distortions of human relationships, and characters filled with mutual distrust and fear. Only their capacities for feeling shame and anger remain as primary proofs of their preserved humanity. And only the great range of the narrator's compassionate imagination transforms sordid episodes of degradation and loss into a unified action of tragic ambiguity.

The humane character of Hayes's vision of Rome may be defined by contrasting it with the Rome of Joseph Heller's celebrated absurdist novel, *Catch-22*. Written in the decade following the war, and with the further removals of a satiric narrative sensibility and a fantastic genre, *Catch-22* reduces the complexity of Rome 1944 to that of a featureless, ahistoric place for "rest and relaxation"—that is, for an "exhausting seven-day debauch." Until the chapter called "The Eternal City," which initiates the closing cadence of the book, Rome is nothing but a series of requisitioned rooms in which soldiers—both the nerve-shattered and the imperturbably brutish—get drunk, squabble, tell tiresome jokes, lament their hopeless fates, engage in non sequitur conversations, smash furniture, and—most of all—fornicate with sex-mad Italian women. Throughout the book the whores, mostly mere screeching or yawning lumps of lascivious flesh, are passed around at orgies characterized equally by rage, lust, and stupor. In this atmosphere even the triumphant procession of Liberation Day becomes a farce, for that was when the major whose vital job it was to requisition the rooms received his only wound: a gleefully malicious old man deliberately threw an American Beauty rose in his eye, and then "kissed him mockingly on each cheek with a mouth reeking with sour fumes of wine, cheese and garlic." Later this diabolical old man turns up at a whorehouse, where he emerges as the triumphantly cackling voice of Roman opportunism. One hundred and seven years old, and happy, he is the satirical foil to Nately, an American soldier who naively moralizes about honor and is killed soon afterward.[46]

In "The Eternal City" Captain Yossarian, the "hero" of *Catch-22*, finally refuses to fly more combat missions and goes AWOL to Rome, where he passes a night "filled with horrors." Here Heller exploits the specific character of the city with a deeper and more compassionate sense of its debasement. The absurdity of its condition becomes too cruel to be funny. "Rome was in ruins," Yossarian wryly notes, not only that "dilapidated shell" the Colosseum, but also the apartment of Nately's whore, who blames him for Nately's death. Yossarian is haunted by the idea of an unbreakable chain of moral responsibility: "Every victim was a culprit, every culprit a victim." The old lady who alone remains at the smashed apartment tells him that the police have driven away all the girls, citing "Catch-22" as their reason. "Catch-22," she explains to Yossarian, "says they have a right to do anything we can't stop them from doing." Yossarian goes on a desperate search for Nately's whore's kid sister; in this wretched world, he can try to protect at least one innocent virgin. "Nothing warped seemed bizarre any more in his strange, distorted sur-

roundings. The tops of the sheer buildings slanted in weird, surrealistic perspective, and the street seemed tilted." On his nightmarish walk through the dark city, one appalling image after another appears before him: a pale, sickly, barefoot boy, a mother nursing an infant in black rags, an Allied soldier lying in convulsions on the pavement, a pleading, drunken woman backed against a Corinthian column by a drunken young soldier while other soldiers watch, a man beating a whimpering dog, and then a man beating a small boy while a sullen crowd watches—insanely, the images begin to repeat themselves and merge. Rome is an infernal place of déjà vu, a city where arbitrary and meaningless scenes of human suffering and cruelty are eternally reenacted. Thus Rome provided Heller with a historically actualized surrealist setting for his cartoon characters and their grotesquely simplified actions, a city that readily expressed the comic horror of an amoral and irrational universe.[47]

The Rome of *All Thy Conquests* is also irrational and cruel, but Hayes's vision of it is dense and broad enough to indicate what is arbitrary and shallow about Heller's selective focus. Hayes's theme is also that of responsibility, but it is attached much more credibly to the tragic paradox of apparent choice in a deterministic world. A variety of subjective realities, created by distinct human consciousnesses sharing the same historical circumstances, offers a truer image—more comprehensive, less monotonously insistent—than Heller's parade of contrived freaks seen from the perspective of one pained and rebellious human being. Hayes, in the manner of John Dos Passos, follows the separate lives of six characters during the winter of 1944— four Italians and two American soldiers. With one exception his characterization of Italians, including the many subordinate characters, is the most convincing ever achieved by an American—an achievement sustained in *The Girl on the Via Flaminia*.

In 1944 Hayes was thirty-three and already a published poet. While in Rome he became acquainted with the director Roberto Rossellini and worked on the script of the film *Paisan;* much of the populist feeling and visual force of the brilliant Italian neorealistic cinema that was then being born is evident in Hayes's fictions. Certainly Giorgio, a proudly professional waiter who lost his job for making an anti-Fascist remark and is now reduced to offering himself as a guide to soldiers at the Colosseum, seems as real, as helpless, as ordinary, and as sympathetic as similar characters in Italian films. The story of his relationship with his horrible wife, Maddelena, and of his self-debasing attempt to get his old job back now that the Fascists are gone is told from his point of view, simply and unsentimentally. The group of hopeless derelicts who wait with him in the Colosseum and the Forum is not distorted into an artificially tragic chorus; their expressions of despair are pointed, but natural. One of them madly mumbles over and over again, "Io voglio lavorare"—"I want to work," and another gives a mock oration from the Rostra in the Forum on the general theme of *"Abasso!"*: "Abasso [down with] anything"; "How can you go wrong?" he asks. The Colosseum and the Forum are allowed to make their ironic presence felt in the background without intrusive symbolic stress. This tact in exploiting Rome's inevitably emblematic character is also evident when Giorgio observes how the jeeps and lorries of the Alleati have converted Mussolini's theater, the Piazza Venezia, into a parking lot.[48] As in the new Italian

cinema, what appears before him on his desperate wandering constitutes its own statement about vanished dreams and a hopeless reality.

The other male Italian who is the subject of a separate narrative, Marchese Aldo Alzani, although necessary to show the greater apparent freedom that exists in a higher social stratum, is less successfully developed. The marchese alone expresses the cynicism commonly attributed to Romans, and by that characteristic does keep the book from being overwhelmed by the emotional vulnerability of characters from the middle and lower classes. His sarcastic educated wit also effectively contrasts with their plain, often morose, speech. But Hayes resorted to an easy cliché for aristocratic decadence by making him a bisexual (he spent the period of the German occupation in Switzerland with a Greek boy), and the marchese's betrayal of his father-in-law, a rich general who secretly collaborated with the Germans on the occasion of the armistice of September 1943, reads as pure melodrama, however much it accurately typifies the personal and familial repercussions felt by the upper classes as Rome went through successive transfers of power. Hayes was more persuasive when he represented Italian men who were sympathetic even when disagreeable, such as the bitter young Italian soldier of *The Girl of the Via Flaminia* who was wounded fighting for his country in Africa, had hidden in a cellar for the last two months of the German occupation, and emerged to find himself held in contempt and his city and its women degraded by the "liberators."

Hayes's varied and insightful characterizations of Roman women serve as a reproof to the generalizations of journalists and the caricatures of Joseph Heller. Carla, the subject of an independent narrative strand in *All Thy Conquests*, is a seventeen-year-old music student loved by a middle-aged music teacher who wishes to marry her. But she longs to be "a woman of fire and passion perhaps like Claretta Petacci or Tosca, a person of consequence and beauty." She falls in love with an intelligent American soldier, seduces him, and becomes pregnant. The banality of this situation (although he returns her affection, he is already married, has lied to her, and now urges her to get an abortion) does not prevent Carla's story from achieving an effect of genuine pathos that contributes to the larger tragic character of Rome, the true protagonist of the novel. Professional prostitutes and adaptable contessas are a part of Hayes's Rome, but his primary concern is with those young women like Carla and like Lisa in *The Girl on the Via Flaminia*, who in the period of the Allied occupation find that the soldiers, corruptors of their city, can also be a means of alleviating the unendurable circumstances they have helped to create—unexpected keys to freedom from otherwise dreary destinies. But Carla's mother can only pray, "Let the ocean take them and their food and their money! Let them ruin and disgrace their own country! Dio mio, ti prego, . . . send them away!"[49]

The American soldiers who appear in Hayes's fictions are also too varied to sustain valid generalizations. That the majority were simply homesick young men who had never expected or wanted to see Rome, and now in their drunken and brutish revels had become one of its most conspicuous features, is a fact amply portrayed. Harry, an ordinary young man from Hartford who spends his entire leave trying to find the kind and gentle girl whom he had met on Liberation Day when he

asked her for directions to "Il balcony"—the "place Mussulini used to talk"—is perhaps less representative than his friend Schulte, who one night drunkenly tries to rape a girl in the Borghese Gardens, where she is strolling with her Italian lover in the happiness of a city at peace. But there are also a few soldiers who have read Gibbon, and some who want to pick up battered old editions of Dante as well as girls. And there is Captain Pollard, who suffers nightmares of the North African battles, but now enjoys (in a city desperate for housing) the use of three different places in which to pursue his adulterous relationship with Antoinette. An English-woman whose speech and behavior are modeled on those of Lady Brett Ashley in Hemingway's *The Sun Also Rises,* she is preoccupied with "scars" and prefers to make love at the Excelsior, where there is hot water for bathing. Among other duties performed in his office in the Piazza Venezia (opposite the famous balcony), Pollard doles out demeaning jobs to Italians who can claim to have performed some special service for Americans during the fighting. When Antoinette betrays Pollard by welcoming her brutal husband back to her bed, he gets drunk and is beaten up and stripped by Giorgio's crowd near the Colosseum. That is the only time two of Hayes's narrative strands momentarily cross, except through the linking images of the Rome they share.

The individually sordid, pathetic, or merely unhappy lives of *All Thy Conquests* are lifted to the dignity of tragedy by being envisioned as part of the collective life of a fallen heroic city. The title is from Shakespeare's *Julius Caesar:* "Are all thy conquests, glories, triumphs, spoils / Shrunk to this small measure?" That question may be addressed equally to Rome, in its historical reduction to relative unimpor-tance, or to America and its Allies, who envisioned Rome as their "Great Prize" and then participated in its devaluation.

Hayes's separate tales of private and diverse destinies themselves represent the truth of the city's fragmented identity, but they are given a unifying context, and the book its dramatic structure, through the telling of another story that entered the collective consciousness of the entire population in the autumn of 1944. This is the story of the trial of Pietro Caruso, the brutal Fascist questor of Rome who had drawn up one of the lists of men to be shot by the Nazis in the Ardeatine caves. The book opens with a sequence of three vignettes: "Chorus," "The Trial," and "The Liber-ated City: I." In the first, we hear the voice of a man who is watching the people of Rome cross the Ponte Sant' Angelo to reach the Palace of Justice, where the trial will be held. Our witness himself once killed a German sentry on that bridge and threw him into the Tiber, and he recalls his joy at the sight of the first American soldiers in the city. Now the "day of judgment" has arrived; surely the Fascist beast will receive his just condemnation! But will the judges be just? Hayes next presents the thoughts of the accused as he enters the courtroom, feeling betrayed and unlucky. He knows that the spectators regard him as a "fabulous monster" responsible for the deaths of 350 innocent men. But in fact he was simply an underling who had not escaped on June 3 and 4. While his superiors were all fleeing the city, he had stupidly waited for orders that never came. The newspaper on June 3 had insanely devoted three columns to the legend of Orpheus, while "bombers burned in their black protective earthworks . . . and the columns of armored traffic moving northward

over the Ponte Milvio increased each hour." Early on June 5 he finally had had himself driven away in a large car, carrying his hoard of jewels and cash, only to be injured and captured on the road to Bracciano and returned to the Regina Coeli where he had sent so many before him.[50]

Twice more Hayes interpolates an episode of the trial and an ironical "Liberated City" vignette. "The Prosecution" is an eloquent address to the court that essentially concedes the main point of the defense: the life of the accused was "the life of a mediocrity," not of someone sufficiently self-determining to be held responsible for his actions. A typical product of the impoverished small towns of the South, the accused had been a soldier in the first war and then a pitiful failure in business speculations; he finally had put on the black shirt and found his purpose in life: burning union halls, beating peasants, singing "O youth, youth, springtime of beauty!" and learning "the vocabulary of bloodthirsty idealism" by listening to the great orator. He rose steadily in the party, for "his very defects as a human being contributed to his success as a fascist." Step by step he moved inevitably toward his "minor calvary," and it came, "finally, on the night of the twenty-third of March" when the German colonel commanded him to draw up a list of hostages to be shot: "I am depending upon you." The accused went to the Italian minister of the interior: was he to obey? "What can I do? It is necessary. Yes, yes, give them the list!" That word was all that was needed. For "the accused states that having thus received his authorization from both his masters all guilt was lifted from his spirit." This was his "absolution." Twenty years of training had prepared him for "precisely this moment." He provided the list and went home to a sleep only slightly troubled. Today, it is said, he reads the Bible in his cell and prays to the Mother of God. But the prosecutor finds himself, after all, "unmoved" by both the sociological vindication and by the signs of remorse. A nation that for twenty years has "endured these careers" and "bled from these authorizations" has found that the harvest from the springtime of Fascism is a country "irreparably ruined." In justice, the accused must die.[51]

Part III opens with a dream called "The Defense " in which the accused justifies himself to God and hears the witnesses against him. His defense is that he not only was stupid but did not know he was stupid. How then could he be responsible? As a child he had lost his father—and a father is responsible for his son. He became a Son of Italy, so Italy became responsible for him. Who, when commanded by superiors to draw up the list, would not have done so? But the witnesses—the dead from the caves—say to him, "I am not you," and "I could not have been you." The accused denies this; the envious dead would *like* to have been he, rich and powerful as he was:

> What we do we do because of our natures and because it is terrible to be poor and to be ignored. No one foresees what he will be compelled to do eventually because of these things. No one knows. No one can say this would not have been forced upon me. So I would have acted, so I would have behaved. Who knows what horror they will eventually become the innocent authors of? Or how the small unhappiness of a childhood may in time become the huge crime of the man?

The "penalty of being human," he concludes, is that "there is nothing one can say one is not capable of, or anything one can say one might not have been." To which the vanishing witness replies: "I was not you. . . . I could not have been you." In a panic, the accused realizes that he will be found guilty, although he genuinely feels no guilt. He had *not* chosen to be what he was or to do what he had done. Hayes ends this dream ironically: the accused calls out "Forgive me, Father" to the Blessed Vicar, receives absolution, and has a vision of heaven: "blessed armies of subordinates, each forgiven identically, each . . . celestially and eternally authorized."[52]

All Thy Conquests ends with "The Sentence," in which the voice of the opening "Chorus" is heard again: having witnessed what happened at the end of the trial, the man now describes it to a group of citizens who are drinking lemonade at a little *chiosco* on the Janiculum while they watch the sunset over Rome. The witness had observed the people assemble outside the Palace of Justice to hear the verdict, and he saw in them representatives of all the forms of oppression and suffering that had been inflicted upon Rome by Fascism and by the war. The people, some of them climbing up on the marble statues of the ancient lawgivers, cried out for justice and for revenge until their howling became inhuman. Finally, when the doors opened, the hate-filled mob surged forward and took the hangman beast of Rome into their own hands, and "all the city beat him: every alley, every palazzetta, every square and marketplace beat him: those he had injured and those he himself had not personally injured, beat him." Then they lay his bloody body upon the trolley tracks and commanded the motorman to run over him, but the motorman refused, and so they threw him from Ponte Umberto into the Tiber. Incredibly, he began to swim toward the Ponte Sant' Angelo, but from a boathouse two naked young men paddled out and beat him with an oar until he sank, while the people of Rome howled down from the bridges and the waterstairs of the Tiber. Hearing this story, the auditors, standing near the statue of Garibaldi, wonder if the beast is now "better off"—better off than they are. But it is "a fine day," and the sky over Rome is glowing with the colors of the setting sun; "they looked down into the city and drank their lemonade."[53]

Hayes's version of the life of Pietro Caruso—whom he never refers to by name—reads as the life of Italy itself during the twenty-five years of the Fascist party. Although rationalizing away responsibility for its monstrous maturity, the Roman people nevertheless feel guilt and remorse, and they commit an act of expiatory rage and self-mutilation. The witness of "The Sentence" himself feels "a little sick" as he tells of the brutal lynching, but then he recalls the rotting corpses in the Ardeatine caves: who can say that this revenge is excessive? The manner in which Hayes has his "Caruso" die, however, is in fact his most important and significant alteration of history. Caruso was actually executed in the legally prescribed manner. His dignified and courageous behavior while facing the death squad was the subject of a story for the *New York Times* of which Herbert Matthews was so proud that he printed it in his autobiography—as originally written rather than as edited by the *Times*, which omitted his suggestion that individual Americans could conceivably also be "stood up against walls some day and shot."[54] Hayes's "Caruso" is killed in the terrible manner actually inflicted upon a different man whom the Roman mob mistook for Caruso: Donato Carretta, the vice director of Regina Coeli. Carretta

was an anti-Fascist who had done much to alleviate the Nazi-Fascist terror in his prison and was innocent of all criminal activity. Hayes must have felt that to end his book with this terrible miscarriage of justice would have introduced an ironic complication that would have distorted an already sufficiently ambiguous vision of Rome. The brutalizing moral indignation of the avenging Roman mob was frightening enough when directed toward its intended and possibly "deserving" victim; to stress the accidental consequence of its fury would deflect the question of moral responsibility from its primary target: Fascist obedience.

The beating, mutilation, and killing of the unrecognized innocent Carretta might seem to be one of history's justifications for the coming absurdist vision of a Heller. But in 1944 it provoked no sort of laughter. It shocked the world. The morally outraged articles on this "atrocity" written by Herbert Matthews, the only Allied reporter who actually saw Carretta killed, were intended to "forever blacken the name of contemporary Romans and do the Government as much harm as possible." Not surprisingly, both in New York and Rome such reporting provoked angry responses. One of Matthews's own Roman friends wrote that apparently even a reporter who "had understood everything in Europe" since the Spanish revolution had "never understood that even Italians have blood and souls" and was willing to "cause further harm to our poor country." Only the Communist newspaper, *Unità*, openly defended the mob itself and lynching as a method of popular justice; most complainers felt that Matthews should have shown some "understanding." But to the philosophical Matthews, student of *The Divine Comedy*, there could be no particular exceptions to something damnable in general: "Roman mobs have not changed since the days of Coriolanus, and, while one should not expect them to change, I cannot see why bestiality should not be condemned and fought wherever or whenever it occurs."[55]

Matthews's colleague Eric Sevareid was one of those unwilling to condemn or to apply absolute moral criteria in these particular historical circumstances. When "a woman journalist who came over from New York" began writing about the "'terrible spirit of vengeance,' the arrests and shootings 'merely because of political differences,'" Sevareid advised her to visit the Ardeatine caves, in which the bodies had just been uncovered. These too had been innocent victims, people in no way responsible for the killings for which they were killed. In the "clammy, ghostly subterranean chambers" Sevareid had seen the bones "attached to ragged, rat-chewed fragments of cloth," which the experts were assembling on tables in an attempt at identification: "This was the result of 'political differences' in modern Europe. Vengeance is not a thing of dignity at any time, nor is it always precisely just, but I found myself quite incapable of advising the fathers and brothers of such victims to be gentle with those who had caused the horrors."[56]

The theme of moral responsibility in a world of horrors, which is what all these writings on the period of the Allied occupation have in common, finds its most universally implicating expression not in such sensational events as the murders in the Via Rasella, in the Via Ardeatina, and in the Tiber below the Palace of Justice. It is in many ways more threatening when rendered through the necessities, desires, compromises, and sorrows of *The Girl on the Via Flaminia*—rendered with a tenderness that increases the sense of pain inflicted where no one intended. A kind

of decency in Robert, the young American soldier, makes him not want to stand on the Via Veneto or "to go under the bridges" for sexual relief. His desire for a girl and "a house I could come to" is a desire to escape from the army and the war to a kind of home suggesting normal human life. "I wanted it to be simple," he tells Lisa. "I thought I would just be exchanging something somebody needed for something I needed. Something somebody wanted for something I wanted." And so it had been for Lisa, who needed food to survive, but could not bring herself to go to Via Veneto or under the bridges. A friend's arrangement for her to pass as the wife of "one of the good ones," deceiving even the people from whom they rented a permanent room, seemed to save her. But for her to make love without love is not so simple. "She thought: we do finally what we thought we were incapable of doing, and it is less than we thought the doing would be, and at the same time more. And nobody listens, nobody cares, one is alone. . . . Nina was wrong: it was not the same for everyone. For everyone it is different."[57]

The mutual accommodations and accusations between Robert and Lisa proceed in the context of parallel relations between the Romans and the Allies. Six months after the liberation, they both look back on the atmosphere of the day incredulously: "the vivas painted on the outer walls of the Vatican were fading, the names of the martyrs were fading, the proclamations and the posters with clenched fists and the squadrons of planes in the painted sky were torn and shredded in the cold wind; and the cabinet was falling, and eggs were thirty lire an egg." Yet the old grandfather who is thinking this recalls how when he had seen his first "Americano" he had shouted, "because I could think of nothing else to shout, Viva la Chicago!" That day had been a heart-bursting *festa* of welcome. Now, in the winter, there are only resentments and recriminations. Robert attempts to take Lisa on a "normal" Sunday afternoon drive to Lago Bracciano; peasant boys pelt them with rotten apples and shout insults at Lisa. Eventually, when their illicit arrangement is discovered, the police compel Lisa to register as a prostitute, to be examined for venereal disease, and to carry a whore's identity card. Her friend Adele is furious: "Madonna, they bomb each other, they destroy cities—but a girl in bed is a crime!" To Robert the card means nothing; the intrusion of the state should not be allowed to interfere with their private feelings for each other. He, at any rate, is not to blame: "I didn't make the war. . . . I didn't make the police." But the degradation and the injustice have changed Lisa forever: "There were so many girls," she says of the *Questura*. "But where were the soldiers? . . . Shouldn't they arrest the soldiers too?"[58]

Antonio, the young Italian who has come out of hiding from the Nazis, interrupts a New Year's Eve party (celebrated by the Americans with cannon fire and pistol shots) to say that the Americans will someday leave Italy, and the Italians will remain to be "punished" for the "regime" and for the war, without discrimination. All will be punished as though all were guilty. "Don't look at me," says Robert; "I'm not responsible." But Antonio in his turn refuses to discriminate. American colonels, driving in big cars with women straight from the beds of Fascist bureaucrats, American soldiers drunk in the streets, officers pushing Romans off their own streets—all are guilty. "Oh, the magnificent promises the radio made us! Oh, the paradise we'd have! Wait, wait—there will be bread, peace, freedom when the allies come! But where is this paradise?" Robert has no answer, but later and privately he

and Lisa imagine their own paradise—in Italy. Lisa had once seen and loved Portofino, a white town with a blue sea. They would go there: "He wanted to see all of Italy: the quiet and undestroyed places, where the sea was blue. There must be many places like that, undestroyed. It was impossible to destroy everything. They never could destroy everything." Robert recalls a demolished village in the South, where he had seen bricklayers "rebuilding a wall of a shelled or bombed house":

> The war had been in the town only two months before. Now the trowels of the bricklayers made sharp distinct clinks as they knocked the bricks into place and set them in the mortar. They were the old bricks of the house. They were putting up the wall with the same bricks and a fresh mortar. He heard the trowels clinking all the way down the street. Yes, he thought: now it'll work.

Even while accusations, judgments, punishments, and reprisals continue, men and women attempt to counteract the historical accidents of time and place, the large destructive forces that change the shapes of their cities and affect their most intimate relations. When Robert tells Lisa that maybe Americans deserve to be hated by Antonio, by the rock-throwing boys, even by her, he adds: "Except it might have been different. Who knows? Perhaps if I had met you where there was no war. . . . All I ever saw of Italy was war. . . . But it was different once."[59]

Edmund Wilson had first seen Rome as a boy of thirteen in 1908—the same year that William Dean Howells returned for his second visit. In 1945 Wilson himself returned, to describe its condition for the *New Yorker.* The bright modern city that Howells had admired is recalled by Wilson as "ignoble, dirty, commonplace and somewhat provincial, with enormous ancient monuments embedded among hotels and shops." Now, on Wilson's own second visit, it is his turn to be astonished by Rome's "brilliance and cleanness." It seems, "amazingly, as smart and as sparkling as any city of pre-war Europe. Mussolini *had* evidently done something for Rome in policing it and building it up." The "solarium-like modernist buildings of light-tinted plaster and glass give the city a kind of *élan,*" making Rome "much more cheerful" than Moscow. After war-frazzled London, the air of "freedom and exhilaration" is refreshing, and after Naples it is "reassuring to find Italians who seem self-respecting, well-washed and well-dressed." Many people are riding shiny new bicycles; the women are "remarkably handsome" ("these Roman women have a natural ineradicable chic that is common to all sections and classes"); bookstores, news kiosks, and "wandering book-carts"—"frizzing and frothing with the covers of new books and reviews"—are more numerous than Wilson had ever seen anywhere, even in Paris; modern American books with "lively Italian titles" are much in evidence, and there is even a surprising "vogue of Herman Melville."[60]

In spite of all that, Wilson still does not like Rome—"very much." His stylishly written report on the Rome of 1945 is that of a middle-aged man both old-fashioned and up-to-date, about a city that intermittently suggests the many contrary things it has meant to generations past and also what it will become to Americans now that the war is over. Rome, in Wilson's notably ambivalent representation, contains echoes of Hawthorne and Howells, while anticipating the sensuous pleasure and

critical detachment of later representations by Gore Vidal, Eleanor Clark, Bernard Malamud, and John Cheever.

Politics and poverty still impose themselves on the traveler. The walls of Rome in 1945 are "covered with posters, remarkably well designed, exhorting the public to buy war bonds; declarations in fine black-and-white, full of rhetoric against the Fascists; and—gashing the surface of the city, keeping open the recent wounds—the reiterated outcry of Communists; a hanged man on a gallows, with the slogan '*Vendichiamoli*'" (Let us avenge them). This is unpleasant. So also is the fact that when you sit down at an outside table at a *pasticceria* to eat a tempting "little cake," the experience proves to be "embarrassing and uncomfortable," for nearby there is "a group of pallid and ragged people" lined up for an American "handout," and you are "buzzed about by little dirty kids with an eye on the sweets." When you go to eat outside at a nice black-market restaurant, a crowd gathers, some people even reach over "to grab things" from your plate, and the management sends out a bouncer: one "knocked down an old woman with a blow on the head, and drove back the mob, mostly women and children." Beggars in Rome are as bothersome as ever they were to Grace Greenwood and James Russell Lowell, and like those writers, the skeptical Wilson attempts through stylistic wit to render them textually less obnoxious:

> The supposedly crippled paupers jump briskly out of the bus, make water against the wall, then go into their professional act, becoming paralyzed, bent and pathetic. Not all are fakes, however. . . ; and this soon becomes all too obvious. . . . There are women with tiny ugly children whom they expose all day to the sun. Near the entrance to our hotel in the Via Sistina is a woman with a limp shut-eyed baby that always seems doped or dead: we try to think it is a fake made of rubber.

But the longer one stays on into the "smothering summer," the more insistent become the "stagnation and squalor that are the abject human realities left by the ebb of power and splendor." A forlorn family of beggars insists upon performing for you: the father plays an accordion, his seven children go "tooting and piping" around him, and their mother keeps time while nursing a pale babe. "Sometimes they play *Lili Marlene,* sometimes the *International.*" The worst pests of Rome, however, are the *ragazzini,* street boys ready to buy cigarettes, food, or clothing from you for the black market, and to sell you anything else. No, Rome is not pleasant.[61]

Wilson's essay called "Roman Diary: Sketches for a New Piranesi," composed in casual inconsecutive fragments, begins in harmony with old Howells on the subject of ruins. His "involuntary reaction" to the Forum is "that all that irrelevant old rubbish—the broken stones and the chunks of brick—ought to be cleaned up and carted away and the place turned into a nice public park." The columns seem like nothing but "useless old teeth that ought to be pulled," and the Forum already "mainly serves" as a "playground for the Roman poor." Children astride columns and mothers sitting "on scattered fragments" make it difficult to "focus your mind" on Horace. The Temple of Faustina is undeniably impressive—a "façade of stupefying grandeur, a huge intact block of antique Rome"—and below it "the Allied Commission has put up, for the instruction of the troops, a large sign in dubious

English." Beyond, "the old sallow arches and fractured walls" of the Palatine "have the look of faded old men with tufts of hair growing out of their noses and ears." Their "stripped carcasses" are ugly, repellent, and incomprehensible, and within their "dark vaulted chambers" you find nothing but "human excrement." You climb to the formal terraces and find that the center of the maze has become a latrine. In fact, the Palatine is "a favorite resort of the black British Basutoland troops." Since they frighten the Romans, they tend to "herd away here by themselves," except for a party of Sikhs. The great underground gallery of the ancient imperial palace may inspire "the history-read visitor" with "a feeling of dread and awe," but "the splendors of the Caesars" cannot mean much to these Africans. At nightfall "the low class of prostitutes" arrives to lead them "to a part of the ruins that has a row of little compartments: just the thing for an informal brothel." So much for the Forum and the Palatine: the visible remains of history are rubbish. The pastness of the past that some Americans had been optimistically asserting in Rome for over a century was now reiterated by Wilson with surprising assurance: "the whole past of Rome has been pushed by the war into a history that is now finished."[62]

Elsewhere Wilson recapitulates the traditional pattern of opposition between the cultivated ideal of the timeless garden outside the walls and the grim urban reality within. The Villa Borghese—"into which you pass, at the top of the broad Via Veneto, through the old chipped reddish weedy Roman wall and the stone gates with the modern eagles"—pleases Wilson more than the Forum or the Palatine precisely because it lacks authentic ruins, emphatic historical associations, and incongruous visitors. It inspires one of his most appreciatively baroque sentences:

> Here one always finds an atmosphere of gaiety, of leafage, of light bright color—everything both larger and more casual than in a park in London or Paris, and enchanting with a freedom and felicity that are characteristic only of Rome—all a little not precisely tinselly, not precisely flimsy, but slightly both tempting and teasing the foreigner by a careless disregard of plan, a cheerful indifference to purpose, that, nevertheless, derive a certain insolence from blooming among the monuments of so much solid civic building, so much noble and luxurious beauty.

To a café in the gardens of the Borghese Wilson retreats with his mail and newspapers "almost every afternoon." The wall nearby is "loaded down with midsummer vines, which revealed sculptured griffins and the flank of an embedded sarcophagus," while within the enclosure one sits on wicker chairs under "ample umbrellas" beside "wide-branching pink rhododendrons growing out of large clay jars." A radio concealed in the portico of the templelike café warbles romantic operas and Mozart arias that are announced as emanating surprisingly often from the Metropolitan Opera in New York or the Boston Symphony Orchestra. "Unobtrusive" and "sympathetic" waiters bring him his "apricot ice and little pink *paste*" and leave him alone with his papers. Here in the Villa Borghese, where Hawthorne's Donatello and Miriam had gaily danced in a Golden Age momentarily recaptured, Wilson blessedly finds that "strange blend of informality and grandeur that is so much the quality of Rome!"[63]

But back within the "corrupt and turbid" atmosphere of the historical city, one finds neither civilized ease nor creative intellectual vitality nor social coherence. "The whole stretch from the gates of the Borghese Gardens down through the Via Veneto, the Via del Tritone and the Corso Umberto to the Piazza Venezia" is "one great brothel"; "we all seem stewing like lumps of flesh and fat in a cheap but turbid soup." The Americans have made prostitution "so unprecedentedly, incredibly profitable that many girls have been brought into the streets who might otherwise have stayed at home or worked at decent jobs." The soldiers have gone further in "dispensing with even the most sketchy preliminaries" than "has ever been done anywhere in peacetime"; after a quick check to see that the girl is not "absolutely repulsive," a GI "grabs her" and backs her against the wall. "All the way along the Via del Tritone, these walls are lined with soldiers" watching the parade of prostitutes. For a moment Wilson describes the aspect of Rome that will be almost the only Rome of *Catch-22:* tarts and pimps surround the hotels in the Via Veneto requisitioned by the Allied Command, where the big-spending aviators are "allowed to have women in their rooms," so their hotel is "the center of activity and gaiety." From one of these (as in Heller) "one night, some soldiers threw a girl out the window and broke her back so that she died." Thus "what was once one of the handsomest and most fashionable quarters of modern Rome" has been converted into "a squalid market, where the behavior of Catullus' Lesbia *'in quadriviis et angiportis'*—which I have never seen in public before—is a matter of nightly occurrence."[64]

This vision of Rome is Dantesque. In the tepid evening air, watching "slow apathetic people" drift "down gray avenues" and hearing brawlers shouting in the dark side streets, "one feels that there is nothing left of the bright and varied surface of Rome but a brackish iridescent scum." In the queer quiet of the night one hears "the yowling of starved and exacerbated cats," "the songs howled by drunken G.I.'s," and "the desultory whistling of trains that do not sound as if they were really going anywhere." "Imprisoned in this pit of the past," at dawn "you are oddly awakened by the crowing of roosters and the persistent moaning of a screech-owl." Swallows "go flickering and twittering in swarms" under "the clear pale-blue innocent dome of the sky," but the current popular song, *Ma le Rondini Non Sanno,* says that "what the swallows are fortunate not to know is 'what's going on down there.'"[65]

And yet (the ambivalent Wilson is, after all, writing a diary, in which one day's firm conclusion is left to stand, even if contradicted by those of later days) there are young Italians who "seem to make a race quite distinct from any of the older people who have had in one way or another to adapt themselves to the Fascist regime." Joining a long procession of Americans going back to Henry T. Tuckerman and Margaret Fuller, Wilson tries to believe in the revival of ancient Roman virtue in a Young Italy. A candid and hopeful young poet who fought in the resistance movement points out to Wilson that in Italy there have always been "startling contrasts of character. The people of a city like Rome are predominantly distrustful and cynical; the men lend themselves to all kinds of servilities and frauds, the women all too easily become prostitutes. It is difficult to make them believe in ideas; but their indifference is always redeemed by the emergence of heroic individuals who are willing to die for ideas." In the past, people like Bruno, Garibaldi, and Mazzini "revived the antique virtue which had never quite died in Rome. It was not impossi-

ble that today, with Italy once more in ruins, it might once more produce "some
new movement that would lead the world." After Wilson returned to New York he
discovered that at the very time he had been in Rome, Roberto Rossellini had been
filming one of the greatest of motion pictures, *Città Aperta*, about Rome during the
German occupation:

> How could we correspondents, drowsing and grumbling about Rome in our anti-
> quated tourist hotel, have imagined that a work of such power, at the same time in-
> tense and restrained, had been produced in the Via del Tritone, where the
> prostitutes thronged every evening . . . , out of a patchwork of old lengths of film
> bought in the black market and with no kind of studio light, so that everything had
> to be shot during the daytime; or that the Roman Anna Magnani, that brilliant and
> intelligent actress, whom we saw in the revue *Cantachiaro*, impersonating a D'An-
> nunzio duchess in the manner of Beatrice Lillie and satirizing the Allied occupa-
> tion, had just given her marvellous performance as the mistress of an underground
> worker. It is the antique virtue again, and you can see it come to life in this film.[66]

There were other signs of creative vitality in Rome. Wilson writes at length on
Ignazio Silone, a man slightly younger than himself, who with the fall of Fascism
had returned from long exile in Switzerland. Silone and André Malraux, says Wil-
son, "stand today almost alone in Europe as writers of first-rate talent who have
continued to take imaginative literature with the utmost seriousness and who have
never lost their hold on the social developments, larger and more fundamental, that
lie behind national conflicts. They have survived the intellectual starvation, the
spiritual panic of the war, and they are among the most valuable forces still alive on
their devastated continent."[67]

Wilson also became acquainted with the painters Leonor Fini and the Marchese
Lepri and with the young novelist Alberto Moravia, whom he met at Fini's apart-
ment "in an enormous old palace in the squalid Piazza del Gesù." Here were artists
"undistracted by war-work and unshaken in morale." To get to Signorina Fini's,
one climbed "interminable marble stairs, made for unimaginable grandeur," and
glimpsed along the way heroically scaled "Roman relics" on the landings: "the
conventionally statuesque pose of a white naked hero with a sword would be
followed by a similar figure in an unexpected half-squatting posture; a single finger
from an ancient colossus, standing upright on a pedestal, loomed as tall as an
ordinary statue; and a bearded man, seated on something and leaning forward intent
on a book, had the appearance of reading in the toilet." This experience made one
realize that "Rome itself is not only intensely Romantic but even also rather
Surrealistic," so that in Rome Surrealism lost "the power to shock that was its aim
and its pride in Paris." The work of Signorina Fini and her friends in fact showed "an
element of fairy-tale enchantment and *commedia dell'arte* humor" that kept them
from being "neo-Gothic" or "modern" in the manner of Max Ernst or Dali; one
perceived here the continuity of the dream world with the "late Renaissance pat-
terns, the decorated ceilings and strips of wall, that make a background in the
Vatican Museum: hippogriffs that hang in a filigree of scrollery, vine-leaves and
tendrils, winged sphinxes with the curling rears of seahorses." Thus, far above the
sordid streets, from the window of an *attico* filled with books and art, Wilson looked

out across the gray-blue and pale buff roofs of the city and up to a sky filled with flocks of swifts. Here, he thought gratefully, "was a center of real creative life in Rome, a live spirit that had not been extinguished."[68]

But Signorina Fini herself "hated" Rome. She wanted to go to America. There she would find the freedom to be *"sauvage."* In the "antiquated mandarin culture" of Italy she and the Marchese Lepri "are not at home, not serene—probably almost as uncomfortable as I am," says Wilson. But if Rome had become repugnant to Romans, could it still have any attraction and meaning for Americans? Wilson had almost reached an answer in his elegant description of the café in the Villa Borghese, but that offered not so much a meaning as a Jamesian sensation: nothing but the necessarily transient experience of the uniquely Roman atmosphere, an atmosphere of civilized and sensuous ease, both elevating and informal, that makes one glad for a time simply to exist. But Wilson ended his description of that experience by dismissing the Rome that Americans had sought for almost two centuries. In 1945, Wilson cannot bother with churches and museums. Perhaps he will visit them in another year when he brings his children, just as his parents had brought him. Adults, he implies, no longer worship at the desecrated Altar of Italy. Modern interest is in the "phenomena of Anglo-Saxon, Germanic, and Russian Soviet civilization that is taking over the world." The Mediterranean, Latin, and Catholic civilization, evidently, is now merely what Wilson calls a "historical pageant." Rome can no longer inspire vast expenditures of energy in devoted study and strenuous walks, as once it did. "The old routine of the tourist, reading up the earlier chapters of the story which is to culminate in his grandfather, his father and himself, seems relegated to the archives now, like the final installment of a serial bound up in the completed volume of a suspended magazine."[69]

Wilson is aware that such a dismissal of Rome severs a connection not merely with genteel educated tourists carrying on a family tradition but with many great and creative souls who had found in Rome their common resource for life and art. At first he is "rather stimulated" by the discovery from plaques on the walls of the city that many "illustrious" men—Gogol, D'Annunzio, Stendhal, Salvator Rosa, Keats, Scott, Bernini, and Goethe—had all lived in the immediate neighborhood of his hotel at the top of the Spanish Steps. In this quarter writers and artists had really worked; it was "not merely a Bohemian quarter where talent went soft or ran thin." But the longer he stayed in Rome, the more these "cultural accretions of its past have come to weigh on me and affect me as cloying." The climax of Wilson's rejection comes with his visit to the Caffè Greco, where from the days of Benjamin West to those of Elihu Vedder artists and writers had taken their ease and conversed of Rome and their art, each generation telling the next where the geniuses of the previous one had sat. Although he knows the Caffè Greco had been "frequented by no end of great people" since 1760, Wilson's only words for it are "sordid," "dingy," "inadequately lighted," "dismal," "chill," "cramped and fusty." It has "ridiculous little hallwaylike rooms," its seats are "forbiddingly and uncomfortably squeezed in behind little gray-veined marble tables," and it displays "bad portraits and landscapes" on its walls. A brochure in four languages will tell you that the Caffè Greco has served, among many others, Goldoni, Canova, Leopardi, Carducci, Berlioz, Corot, Gounod, Bizet, Baudelaire, Byron, Shelley, Thackeray, Liszt, Wagner, Thorwaldsen, and Mark Twain. But Wilson's effort "to react appropriately" to these

names and associations "had upon me the effect of an emetic and compelled me to disgorge, as it were, the whole mass of lore that I had swallowed before in connection with the genius-haunted past of Rome."[70] As a visitor to Rome, Edmund Wilson had more in common with Mark Twain than with Henry James.

Yet two geniuses did still speak to Wilson of Rome. Early in his visit he went to see George Santayana in the "Hospital" of the Blue Nuns. He found him there in his single room, wearing a monkish brown dressing gown and happy to converse with someone from the world outside. Many American soldiers had visited him since the liberation, sons and friends of former students at Harvard, and philosophical young men whose studies had been interrupted by war. For Wilson,

> it was at the same time respect-inspiring and disturbing to one's wartime preoccupations to find this little husk of a man, at once so ascetic and so cheerful, sustaining at eighty-one so steady an intellectual energy, inhabiting a convent cell, among the layers of historical debris that composed the substance of Rome, intact and unmoved by the tides of invasion and revolution that had been brawling back and forth around him; and when he talked about these outside occurrences, it was as if he attached them to history: the war was an event like another which could presently belong to the past.

Wilson seems not to have perceived how such a fundamentally Roman perspective might have measured the shallow presumption of his doubts about Rome's function and future. Among the things of which Santayana spoke to Wilson was how "our conception of the flaming sun is a sensation of the same order . . . as the older conception of Apollo with his golden rays."[71]

Before Wilson left Rome he began to read for the first time Hawthorne's *The Marble Faun*. He was "amazed to find how close his reflections . . . had run to the kind of thing" that Wilson was writing down so many generations later in his own journal. Hawthorne's description of " 'those immense seven-storied, yellow-washed hovels' " called palaces, which seem to magnify and multiply " 'all that is dreary in domestic life,' " "still more or less fitted such places as the Palazzo Altieri where Leonor Fini lived." Hawthorne, like Wilson, had been " 'disgusted with the pretense of holiness and the reality of nastiness, each equally omnipresent.' " He too had been rendered " 'half lifeless from the languid atmosphere' " corrupted by " 'myriads of slaughters.' " He too had finally felt " 'crushed down in spirit with the desolation of [Rome's] ruin and the hopelessness of her future.' " That was in 1859, but an American visitor to Rome in 1945 had reason to feel that Hawthorne wrote with "perfect accuracy" of its present effect.

Hawthorne's classic damnation of Rome ended, however, with a complete reversal. And Wilson admits that "a year or so later, when I was back in the United States," he too experienced that change of heart. And so in Wilson's voice and Hawthorne's words we hear confessed once again how, after persuading ourselves that we hate Rome, after adding " 'our individual curse' " to the anathema of the ages, and after leaving it, we are astonished to discover that " 'our heart-strings have mysteriously attached themselves to the Eternal City, and are drawing us thitherward again.' "[72]

4

Epilogue: The View from the Janiculum, 1945–85

Then suddenly the gates were open again and they came flocking back in with love and gratitude and pent-up need of this above all cities, and it was all brand new, as if it had never been heard of before, but it is not like a hundred years ago nor even like the beginning of this century. . . .

Now the tourist or student or wandering intellectual, the poor seeker after something or other, comes in like a wisp of fog in a fog bank, with his angst and his foggy modern eye, and there are not many words that can help him even a little to find his identity and his way: history, surrealism, faith. . . . Ecco Roma indeed. . . . But still, in a way, there it is. Something, after all, is being presented to the glazed eyeball and the paralyzed sense of the worrying traveler, who came most often not looking for Rome at all but for love.

—*Eleanor Clark,* Rome and a Villa *(1952)*

On the right bank of the Tiber rises the highest of the hills of Rome, the one that closes in the classic city on the west. The Janiculum, or Monte Gianicolo, is named for the two-faced god of portals—patron of arrivals and departures, beginnings and endings. The sun sets behind it during winter months, and on summer evenings Romans like to ascend to its terraced top to watch its shadow spread southeastward across the city toward Tivoli and the Alban Hills. From here the Vatican is a separate place, with the dome of St. Peter's rising behind and below on a smaller hill to the north. The view of Rome from the Janiculum includes all the rest of the city that Americans observed and described in the course of two centuries. But for nineteenth-century writers this view, when noted at all, had been incidental to a visit to Bramante's *Tempietto*, where St. Peter had been crucified, or to Tasso's Oak, the grotesque remnant of which indicated the favored retreat of the great poet who in 1595 had died in the convent above. The associations of the view in the days when Longfellow saw it were with religion and myth, poetry and history; what one saw was a vision of a layered and complex past.

In the present century the view became as familiar as the opposite one from the Pincio. American writers and artists now tended to live on the Janiculum in the

buildings of the American Academy or nearby on the slopes that descend into Trastevere, a popular quarter where no nineteenth-century foreigner would have dreamed of staying. The academy gave the Janiculum something of an American identity, which was reinforced by the erection in the 1950s of an enormous new home for the North American College at the Vatican end. At least in the eyes of many resident Americans who had come to paint, sculpt, write, or compose, or for classical or religious study, this high place was theirs. The Villa Sciarra, which had been given to the city of Rome in 1930 by an American heiress (after decades of restoration to its original baroque splendor), and the Passeggiata along the ridge (happily dominated by the statue of the republican Garibaldi) became their neighborhood retreats. But in its lofty remoteness from the heart of Rome, and in the tendency of the city's complexities to dissolve into an undifferentiated whole when viewed from this perspective, we can detect symbols of two traits that characterize many of the new American representations of Rome: intellectual and emotional detachment from the life of the city and the simplification of a densely textured past into a purely aesthetic present-tense abstraction. But, of course, the most interesting works are those that represent the effort to overcome detachment and simplification, an effort at knowledge of place, even if only to discover that such knowledge is here beyond reach. At the same time, a competing view of Rome was offered from the sidewalk cafés along the Via Veneto on the opposite horizon; here, in proximity to the American embassy (now preeminent in Rome) and the hotels of la dolce vita, the explicitly hedonistic aspects of the city, long recognized only obliquely, became its major attraction. Whichever the view, and whichever the appeal, the possession of Rome through its selective representation remained a means by which individual American identities represented themselves.

The Americans who now came to Rome not only came to a changed city; they were themselves a different people who would experience the city—and wished to experience it—in new ways. They had new strategies for comprehending it or new rationales for evading its meanings. In the commentary of three writers who arrived in Rome early in the years of its new popularity we can find three different approaches that begin to characterize the difficulties faced by the writers of fiction and poetry and the painters of the last forty years.

Alfred Kazin, after visiting Rome in 1947 (five years after he had finished the synthesizing study of American writers, *On Native Grounds*), published his notes "From an Italian Journal" in which he confessed that "Rome keeps eluding me. . . . [It is] the greatest enigma of all." What surprised him was that the classic and the baroque cities were "casually interwoven with the greater modern city," resulting in a temporal ambiguity that rendered all periods of the past "equidistant." Moreover, unlike Washington and Paris, Rome was not as a whole "imperious," topographically declaiming its leading motifs in unavoidable terms. Its weathered and softened stone, its cramped streets and intimate squares, had lost all "pretense." The most diverse elements blended into "an impossible unity of experience." This, Kazin decided, makes it "so *easy*." So one might settle with that: an "impossible unity," an "easy" enigma, in which all the past has been assimilated by the present. The move is a desperate one but attractive, and many made it.[1]

But in the brilliant opening chapter of *Rome and a Villa* (1950–52), Eleanor Clark

asserts to the contrary that Rome is anything but "easy." Her starting point is the traditional one at the Campidoglio, and she has done her research, so that her view is informed. Yet she senses that Rome "was not always so strange and difficult as it is now." The "foggy modern eye" cannot clearly see it. Clark entertainingly organizes provisional views from a succession of perspectives, including that from the Janiculum. But each of these provides at best a momentary and fragmenting frame, quite illusory as a rational representation of the entire historical "jungle." Rome is a Dada collage, and to move through it is a surreal experience. Clark's essay itself, which starts in the tone of an authoritative rational expositor who is confidently taking on a confessedly incoherent subject, eventually abandons itself to mere associative flow, and then abruptly ends. Later chapters in the book—"Roman Journal I" and "Roman Journal II"—frankly become non sequitur accumulations of notes on everything from basilicas to cats—frequently mere verbless jottings, lists of "items," attempted definitions, looked-up dates and names, unadorned "facts"— passed along for what they were worth, if anything. To "know" something more seems hopeless. Clark's recurrent words in these essays are *troubling, difficult, real, unreal.* Moreover, she constantly employs the first person plural or the second person, asserting what "we" and "you" must feel. Clark thus presents herself as representative of her time; but as a visitor she is unusually strenuous, concerned to grasp something definite from the flow. She is old-fashioned in trying so hard, but modern in confessing to the achievement of so little.

Clark's essay called "Fountains" contains evidence of two other old-fashioned qualities struggling to survive: the capacity for shock and the desire to make racial generalizations. The essay at first seems to be a tough-minded aesthetic intellectual's appreciation of the city, organized around one of its most pleasurable and prominent features. But her actual theme is how "shocking" Rome still is—in 1950—to the Anglo-Saxon sensibility. When she arrives at the fact that the "urinals are shocking," she takes you up to the Bar Gianicolo to show how complementary Italian provisions for intake and excretion relate to the fact that "of course" people so relaxed about biological functions—and so concerned to provide for them—differ from people with "nordic" souls. Next, "the priests and monks and nuns are shocking." Clark observes the "men and boys in long skirts" "paddling" along the Janiculum to their "expensive new houses" or descending the hill from the Bar Gianicolo "into the fat arms of Mother Church." Why do the Romans tolerate these "prattling" parasites, who seem to her untouched "by that other life thronging around them all along the beautiful ridge of the Passeggiata"? Because, thinks Clark, "they provide a spectacle, a note of variation in the scene, and Romans will support anything for that." The condescending generalization, which converts a virtue (here, an effortful tolerance) into a vice (superficial sensationalism), could have been written in 1850. Although even then writers were sometimes amused by the sexual ambiguity of priests, what makes the remainder of Clark's comment notably of its own day is her conversion of a purely subjective but modishly modern preoccupation into the motive of an entire population: the "main hold, as a city sight" enjoyed by the begowned male ecclesiastics, "is as a tremendous sexual image in reverse, which would be sorely missed." Clark somehow even detects "a special animal

exhilaration" in the wake of "adolescent boys with tonsures."[2] To others it might seem that, to most Romans, passing priests are a sight mostly irritating, when not merely ignored as a commonplace of the city's life. Shockability and racial generalizations prove to be dubious vehicles of knowledge.

For Leslie Fiedler, in Italy in 1952, to organize one's experience was even easier than for Kazin, but he did not simply declare it enigmatic. Rome was the place where Henry Adams had set the modern tone by despairing to find historical sequence and meaning, and Adams finally sought truth in universal mythic symbols and patterns. Fiedler more fortunately starts with the knowledge that every journey is the symbolic reenactment of a myth. Thus Americans going to Italy are inevitably undertaking either a Pilgrimage "to the shrines of the idea of man" or else a "Descent into Hell." They may choose either Mark Twain or Nathaniel Hawthorne—comedy or melodrama—as their guide. Like Clark, Fiedler curiously generalizes from himself. He says that all Americans going to Italy are taking "willy-nilly a literal journey," simply because he himself takes along a copy of *The Marble Faun.* And Italy is discovered to be a Hell—a " 'neo-realistic' hell," to be sure, but one in which the same old horrors and terrors that had delighted "the liberal Protestant imagination" for so long simply appear in new forms. More "disturbing and diverting" is the discovery that America has reciprocally become the vision of Hell to Italians (by which he means those Italian intellectuals who have been reading Sinclair Lewis and William Faulkner), without ceasing to be also their Utopia. On another level Italy is busily Americanizing itself, both in the pursuit of technological conveniences and in its popular culture of Mickey Mouse and western movies.[3] Perhaps after all there is too much here to be assimilated into the generalized truths of ahistoric myths.

In a different essay Fiedler touches upon a new element that will affect the American representation of Rome: the ethnic pluralism that now characterizes its writers and artists. Although Fiedler claims that the experience of Europe makes him even more convinced of the *oneness* rather than the diversity of America, his experience of being a Jew in Rome is obviously not generalizable to that of all Americans—certainly not Roman Catholics, whom he implicitly excludes from his thought. Fiedler's essay entitled "Roman Holiday" is both moving and amusing in its description of his family's search for and participation in a community seder during Holy Week in Rome. Rome may be anticlerical, but its rhythms remain those of the Church, "and to be outside those rhythms as an American and a Jew is to be excluded as no one can ever be in America," Fiedler claims. But through a quick summary of the long history of the Jews in Rome, Fiedler effects a kind of entrance and takes possession of the Ghetto by sharing in the community's possessive regard for it. Unfortunately, to Fiedler's children the Jews of the Ghetto look like Romans, not Jews, and even their mazos aren't right; the meal is "completely Roman, non-Paschal." Fried artichokes, indeed. Fiedler has represented a new experience of Rome, that of the Jewish-American.[4]

The most important of Fiedler's contributions, however, is the one that is the major theme of the book of which the Roman essays are only a part: the realization that the myth of America's innocence is no longer valid. Americans are now

"experienced," even to the point of being "lost," long before they reach Europe, the old symbol of the fallen world. This change in motive and perspective is what most alters the representation of Rome in the new fiction.

Fictions

"Americans never lose their experience abroad, they simply magnify it," wrote Elizabeth Spencer in *Knights and Dragons* (1965). This neatly subverts the traditional myth, in which it was their innocence that Americans had to lose. The heroine of Spencer's novel is a divorcée who finds that labyrinthine Rome, with its "elegant, bitter surfaces," perfectly suits her cynicism and chronic paranoia. An embassy employee during the tenure of Mrs. Luce, Martha lives happily "sequestered" beyond the "devious stairways, corridors, and *cortili*" that Rome provides.[5] William Styron's alcoholic and unsuccessful painter in *Set This House on Fire* (1960) is another example of an American who "magnifies" his previous experience. During a period of abstinence he settles with his family in a Roman apartment that might have been in Brooklyn. But in his new clearheadedness his senses awaken to the "world of taste and sight and sound," and his ears respond "to Rome's rowdy music like singing reeds." He rejoices in the galleries and churches, the cafés and bars. "The Romans made him feel gregarious." He temperately samples the Roman wines. Then, after seven months, his religious wife brings home some Catholic Irish-Americans, and in reaction to their revolting pieties during Holy Week he gets completely drunk, ending up in a hotel in the peripheral slums on Good Friday.[6]

 This difference in Americans—the fact of their having knowledge and experience even before arrival—is evident in the earliest novels that place their characters in postwar Rome: Tennessee Williams's *The Roman Spring of Mrs. Stone* (1950) and Gore Vidal's *The Judgment of Paris* (1952). Superficially they seem opposed: Vidal's romance is the story of the "foreign" year of a young American who has yet to choose the fundamental course of his life, whereas Williams's novel is a variation upon Thomas Mann's celebrated *Death in Venice*, a "Death in Rome" about an aging actress whose fabulous and frenetic career is decisively behind her. Mrs. Stone now deliberately surrenders herself to her infatuation with a beautiful young Roman. She has no trace of Hawthorne's Hilda or James's Isabel about her, and she is the antithesis of the bravely defiant and "most innocent" Daisy Miller. Like Daisy, however, she is fully warned about her behavior. Early in *The Roman Spring* Williams introduces the voice of scandalized puritanism by means of an old friend who frankly labels his heroine a "female *Tiberius*." She then delivers a sermon of several pages attacking the "evil" and "corruption" of the age represented *equally* by the "crumbling golden antiquity of the city" and "the aging and frightened face" of Mrs. Stone. But this attack is devalued as the long-deferred "reprisal" of a woman whose lesbian advances Mrs. Stone had rejected years ago in America. Mrs. Stone's changes—both her menopause and the end of her career—are obviously not caused by Rome; they are what draw her to it. Rome renders meaningless both the procreative life of the mother that she avoided and the theatrical career she has lost. Her

personal past, a ceaseless round of social and theatrical engagements driven by pure ambition and vanity, ceases to signify in a place where time and fame are not measured as they are in New York. Mrs. Stone chooses Rome as the "most comfortable place" to lead "an almost posthumous existence." Rome recognizes "desire" as self-justifying and promises its gratification; a young man's beauty is "a world of its own whose anarchy had a sort of godly license."[7] In such a place, Mrs. Stone can face the void of her existence and surrender herself successively to the only two absolutes: eros and death.

But Vidal's Philip Warren is no innocent either. He is a twenty-eight-year-old veteran of World War II combat and a graduate of the Harvard Law School. His coolly satirical perspective on the street-theater of the Via Veneto—called the "center" by a British expatriate, but resembling "a minor avenue in Washington, D.C." to the American—is not that of a Mark Twain bumping up against European phonies. While Twain's humor deflated pretensions through real or feigned ignorance, Vidal's is that of a worldly young man who has read Petronius and witnessed death. The tradition of the American innocent in Europe in fact ironically affects the experience of some Americans who are thoroughly sophisticated, even cynical. The thirty-one-year-old male painter who narrates Sigrid de Lima's *Praise a Fine Day* (1959) has lived in Rome for three years cleverly exploiting tourists, and yet he is approached by an Egyptian Jew and a Polish exile to be the unorthodox solution to their marital problems, since they take his American "simplicity" for granted.

Vidal's Philip Warren similarly feels "trapped in a role—naive, youthful, American," and he does not immediately destroy the operative assumptions of the sophisticated circle of homosexuals who pick him up, invite him to the Baths of Nero, and then make him the temporary agent of an absurd international conspiracy to restore the monarchy. Vidal's character falls in with a rarified social group similar to the one that entranced the youthful hero of Thornton Wilder's *The Cabala*, but his ironical concessions are as far removed from the fatuous adoration of Wilder's hero as that hero's puritanism is from Philip's (and Vidal's) comic sense of the erotic. Philip has been sexually adventurous since the age of thirteen and can handle the novel situation at the Baths with perfect tact and no moral revulsion whatever.[8]

It is true that an ignorance of history or an indifference to it, which traditionally were elements of American innocence that seemed especially incongruous in history-laden Rome, continue to characterize the protagonists of most postwar fiction and often their authors as well. But in an age when history was increasingly held to be incomprehensible, ignorance of it might no longer be a sign of innocence. Mrs. Stone is an extreme case. She is totally indifferent even to the cataclysmic events of contemporary history that she has lived through and to the social conditions that have produced both the impoverished countess and the gigolo who cater to her needs.

The other extreme is marked by Gore Vidal's young lawyer, who is (like his author) practically unique in his sense of history and in the value he finds in it. As a reader of Livy and Horace, of Byron and Keats, Philip possesses rare affinities with nineteenth-century travelers. On his first day in Rome he can hardly resist running immediately to the Forum "as though to a place of origin." When he does go there, he tries to feel his way back into the pre-Christian lives of "Cicero and Brutus,

Catullus and Julius." His efforts are not fully successful, since memories of the American "Forum" called Times Square and the reality of chattering tourists inter-fere. But everywhere—below Mussolini's balcony, before the Victor Emmanuel Monument, or in the Colosseum—Philip seeks knowledge, relationship, and mean-ing. He loves the past not for its romance but for the "continuity" it offers. He has known individual death as an end, has seen it in the corpses of his friends. His awareness of mortality causes an impatience "with detail" and a curiosity "about the whole design of which only tantalizing fragments had been revealed by schol-ars, . . . all haunted by the fact of change which they attempted, in the only way they knew, to define, by fixing the near-true moment in the careful prose of history." One's own brief life is enlarged through consciousness of its place within the long movements of time. Just here in Vidal's romance the search for truth in history merges with one of the timeless mythic recurrences, as the first of three contempo-rary goddesses arrives to offer her gifts and sponsorship to young Philip. The novel is intended to be a reminder that "the old gods did not die"—another of its affinities with Wilder's *Cabala*. Myth and history provide complementary forms of con-tinuity, wholeness, and significance: the eternal and universal situation is re-enacted in the ever-novel specifics of a continuous and mysteriously complex web of causation.[9]

More characteristic of the period than either Mrs. Stone's indifference to history or Philip's reliance upon it for meaning (which would be regarded by some as itself a sign of innocence) was the sense that history's incongruities, unpredictability, and apparent absurdity established a new philosophic ground. In Bernard Malamud's *Pictures of Fidelman* (1958–69), the hero's initial comically vacuous response to Rome constitutes the book's first suggestion that history's incomprehensibility makes history itself vacuous. *"Not to understand"* is the motto of the book (taken from Rilke). So it is not American innocence but a sophisticated sense of human absurdity that now renders history irrelevant except as a validation of that idea. Fidelman has failed as a painter before he arrives in Rome, so the experience of Rome cannot destroy him, as it did James's Roderick Hudson. He has learned the difference between intention and result, and now lives in a world of the arbitrary, the non sequitur. He has come to Italy as a Jew who wants to study the Christian painter Giotto. Emerging from the railroad station, he stops to view the Eternal City and becomes aware that he can see a part of the Baths of Diocletian that Michelan-gelo converted into a church. This makes him "conscious of a certain exaltation": " 'Imagine,' he muttered. 'Imagine all that history.' " Later he feels that it is "an inspiring business" that he, "a Bronx boy," should be "walking around in all this history": "History was mysterious, the remembrance of things unknown, in a way burdensome, in a way a sensuous experience. It uplifted and depressed, why he did not know except that it excited his thoughts more than he thought good for him."

Later still we hear Fidelman confessing that he has failed to possess anything of the reality of Rome. It has given him neither love nor knowledge: "If Rome's so sexy, where's mine?" he asks; "Fidelman's Romeless Rome. It belonged least to those who yearned most for it." Gazing down on the "spires, cupolas, towers, monuments, compounded history and past time," he finds Rome's spirit "elusive; after so long he was still straniero." Although Fidelman's initial awed sense of "all

that history" as a kind of undifferentiated lump still echoes the Innocent Abroad, his final recognition of estrangement is that of the Alienated Modern Man who cannot escape an absurdist fate: "My first hello in Rome and it has to be a schnorrer," he says, having been greeted by the Jewish "exile from Israel" who becomes his nemesis.[10]

Some writers did display new versions of the old-fashioned American innocence either in their characters or in their own point of view. Vincent Sheean's *Rage of the Soul* (1952), after soul-searching in India and cold war politicking in Washington, reaches its denouement in Rome. There, in 1950, an Italo-American soprano who has been defamed by the Communist newspapers triumphs over them by persisting in a performance of *Aida* at the Baths of Caracalla. Sheean's Romans happily subordinate ideology to good spaghetti, red wine, and opera, and his Americans are supremely brave and talented. More interesting, though stylistically inept, is Michael Novak's *The Tiber Was Silver* (1961), an autobiographical fiction intended to show "what it is like for an American to study for the priesthood in Rome, in the second half of the twentieth century." It is hell—especially for a seminarian who longs to be a painter. Novak's narrator-protagonist has vague and sometimes mistaken memories of *Daisy Miller* and *The Marble Faun* to guide him, and he is sustained by his pride in being "*Civis Americanus*," especially now that Romans themselves acknowledge the "*Imperium Americanum.*" But Rome makes a "Freudian" appeal to the painter's sensuous side, and the Romans call the seminarians parasites, fools, pumpkin heads, *stupidi*, and idiots. On Christmas Day, after hearing the children preach to the Santo Bambino at Ara Coeli, the hero comes to a (temporary) realization that God is dead. In the end, however, he happily attends a papal procession on Easter and so completes religious Rome's ancient seasonal cycle. Perhaps the Roman Catholics of the 1950s were the last of the American innocents to arrive in Rome.

Mary McCarthy's Peter Levi, in *Birds of America* (1965), is an "innocent" only by the convention of satire. The son of an Italian Jew who left Fascist Italy, Peter is a college age "innocent" who passes the final two chapters (save one) in Rome. But he is no youth that ever was; he is a busy puppet, the candor of whose tongue serves as a convenience for commentary on the follies of everyone else. His mixed heritage makes him a new reflector, certainly, with reason in his blood and name for both aversion and attraction to Rome. But his mind is crammed with the learning and opinions of Mary McCarthy—some of it derivative, inert, and banal, some of it eccentrically or satirically forceful, some of it beautifully appreciative (mostly of old New England, but also of baroque architecture and the Italian people). With such a load of thought and personality to bear, Peter cannot be an American youth moving from innocence to experience by going to the Old World and to Rome. If there is any representation of innocence here, it is of the pompously critical assurance with which the more intelligent and educated American sophomores sometimes confront the monuments of Europe, deliver interior monologues, write in their diaries, or enter into debates with their traveling companion. But that seems not to have been McCarthy's intention: Peter's sensitivity and insights are assumed to be worthy because they are hers, and she is no innocent.

Naturally the Rome of American fiction is more populated with Americans and

other foreigners than with Romans. The natives tend to be down-and-out but titled eccentrics, gigolos, hustlers, vociferous landladies or *portiere,* and an occasional policeman. But the American population is now more varied than ever. It includes the whole new tribe of cinema people—movie stars, producers, scriptwriters, and directors—who, as in Harold Brodkey's "The Abundant Dreamer" (1963), find "Hollywood on the Tiber" a congenial place. To them the ahistorical perception of Rome's monuments is a great convenience. Marcus Weill, Brodkey's director, need only ask: will a shot of the Arch of Constantine, with the road deviating around it, imply that the lovers need not "pass through"? Wouldn't one of the Colosseum (previously rejected as a cliché) be better, since the symbolism of its archways is clear: you can't get in or out *without* going through? Marcus Weill "never claimed to know, only to see."[11]

In other stories, both as supernumeraries and as the protagonists who shape the image of Rome that we are given, there are lawyers and businessmen, lonely middle-aged women, writers (especially newspapermen), wandering scholars on Fulbrights, and academics of all types (even mathematicians), students on the GI Bill, employees of the American embassy or the United Nations or some relief agency in Rome, students of art and music, and professional painters and musicians. Most of these people are very unpleasant human beings. The artist at the American Academy in Edmund Keeley's *The Imposter* (1970) is a sex-obsessed fraud who, in his studio filled with examples of "Congenitalism," seduces the lover of another American, who is a sex-obsessed double-agent. Some Americans who have fully matured in America are shown to revert to childish unadaptability abroad. The economist and his wife in Spencer's *Knights and Dragons* are an extreme example. They eat frozen shrimp from the PX rather than "the filth of the markets," and when they leave Rome they smash everything in their apartment to avenge themselves on their landlord. To them, as to many other latter-day innocents abroad, the so-called "golden land" of Italy turns out to be "a dreary, damp, cold dungeon of a world where everybody was out to cheat them and none of them could get warm." These are the people who, fortunately, usually leave after their mistaken year in Rome, which they would never have seen if they hadn't been offered a job or a grant. But there are others, characterized by Elizabeth Spencer in "The Pincian Gate" as "the indeterminate sediment of people who simply hung on in Rome, trying any and everything, living barely, living some way, year in and year out, until not even they could remember quite why they had come here in the first place."[12]

For many, whatever the proximate excuse, the real reason was a search for love, or more precisely for sex. Rome as a place for sexual experience if not fulfillment—which had been only implied by Hawthorne and James, but more fully suggested by Thornton Wilder and William Carlos Williams in the 1920s, and made explicit by Edith Wharton and John Dos Passos in the 1930s—became a central theme in the fictions of Gore Vidal and Tennessee Williams, but with the crucial difference, already noted, that it is no longer a matter of sexual *initiation*. Instead the fully initiated come there to experience in a sensual and unpuritanical atmosphere what they have already discovered at home. This is particularly true of homosexual experience in the two decades following the war, before a more permissive atmo-

sphere in America made the journey unnecessary. The sexual attraction of Rome was conspicuous enough in 1950 to be remarked upon by Eleanor Clark, who observed "the variety of little sad fifth-rate adventurers always available along the Via Veneto, especially for homosexuals, because the city has become as much a world magnet in that respect as for Catholic converts or illuminated manuscript-worms."[13] The point (with the exception of the rating) is validated by the published letters and journals of Tennessee Williams and Ned Rorem. The first observation that Tennessee Williams made in his first letter to Donald Windham in 1948, was this:

> Honey, you would love Rome! Not Paris, but Rome. The pin-cushions [his term for the young male derriere] have been justly celebrated by artists for many centuries and there is nothing I can add to the statements of Michelangelo except a corroboration in modern times. I have not been to bed with his David but with any number of his more delicate creations, in fact the abundance and accessibility is downright embarrassing.[14]

A less giddy version of this perspective is transferred to Mrs. Stone in Williams's fiction, where indeed the female point of view allows him to expatiate on the "callipygian" and other specific beauties of young Paolo. As Williams's comment suggests, homosexual pleasure in Rome derived not only from the uncensorious attitude of the Romans but also from the validation that the sensibility seemed to receive in ancient and Renaissance art and in public statuary.

A painting by Paul Cadmus renders the atmosphere and full context better than any fiction. His *Bar Italia* (1953–55; fig.31), in its basic composition, is a small parody of Veronese's colossal high Renaissance feasts in Venice; but the association also works the other way: something of the splendor of sublime architectural composition is here brought to a familiar street scene perceived with good-humored satire. The gestures of the stereotypical but varied group of homosexuals in the lower left are amusingly mirrored by those of the equally stereotypical group of Italians to the right, who pay no attention to them. Both groups are fully engaged in the uninhibited expression of their own identities and temperaments. Above, Cadmus himself peers obliquely outward in close proximity to the crotch of a handsome hustler, while framed in the center is an outrageously developed satire on the bulging and sadistic male nudes of the Italian baroque, surrounded by forcefully phallic obelisks and towers. The bare-chested muscular workman within the circle of the spandrel is the sort of eye-catcher that expresses the specific sensibility of the painting. Yet, as in Vidal's *Judgment,* the homosexual component is merely part of a much larger, openly affirmative comic vision: the three dozen inhabitants of the canvas are all intensely alive—even the ancient crone who stands beside the cherubic boy who is spitting water on the gelato-eating fat girl below, even the appallingly homely beggarwoman, even the lady who calmly scrutinizes her phrasebook in the midst of the raucous crowd. The police here are a mere overseeing presence, and even one of them seems more conscious of being observed than concerned to observe. As a stage for the human comedy, an Italian bar offers as

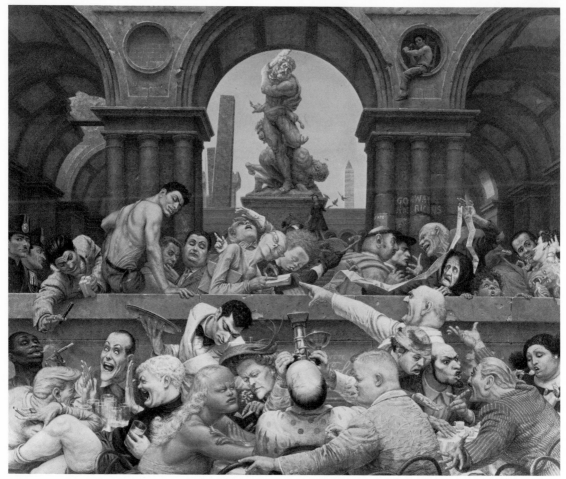

Fig. 31. Paul Cadmus. *Bar Italia*. 1953–55. Tempera on wood. 37½ × 45½". National Museum of American Art, Smithsonian Institution. Gift of S. C. Johnson and Son, Inc. (See plate 8.)

much delight to the eye as it does to the palate. Every person and every brick is painted with loving patience, even the sign "GO AWAY AMERICANS," to which no one has paid any attention except the artist.

American women, too, have sought in Rome the satisfactions of the body, and they are not typified by Tennessee Williams's Mrs. Stone only. Caroline, the twenty-three-year-old academic heroine of Lynne Sharon Schwartz's *Rough Strife* (1980) goes to Rome in the early sixties, after her father's prolonged death, precisely to seek life and passion—that is, sex. She has dispassionately "known men" during her college years and is in fact somewhat jaded. But in the atmosphere of Rome and with respect to one particular man (whom she meets at a party for Fulbright scholars) she recognizes that what she has called "desire" is, frankly, "lust"—a dominating force, frightening as well as amusing. No puritanical American voice of conscience speaks within her or arrives in the form of an old friend. Ironically, it is

now the tight-mouthed Roman portiera who, far from being an accomplice, eyes her with disapproval.[15]

The formal variety that has characterized American fiction in the last forty years has been fully reflected in the fiction that employs Rome as a setting. It served equally the absurdist looking for images of irrationality, the comic realist searching for actual rather than invented incongruities of situation and an atmosphere of tolerated eccentricity, and the straight realist who simply sought vivid images of life intensely lived.

Hawthorne had had to impose a gothic atmosphere upon Rome and James had turned to its classical sites, but postwar writers were likely to find that its predominantly baroque character answered to their needs. Nothing indicates more precisely how Rome has been re-visioned by mid-century than the way in which baroque images (which, as we saw in an earlier chapter, only in the late nineteenth century began to receive sympathetic regard) are now appreciated almost exclusively. No one so much as mentions the *Apollo Belvedere* or the *Venus Capitolinus*, nor even the *Dying Gladiator* or an *Antinous*. The attraction toward the baroque, which is taken almost for granted in the fiction, was made explicit in the early fifties in Eleanor Clark's *Rome and a Villa*, which conveys the excitement of confronting something highly troubling that needs to be justified, but toward which one can no longer be condescending or merely dismissive (that was now the "correct" unthinking attitude toward classical sculpture and Bolognese painting). In Bernini's fountains Clark appreciates "the esoteric expansion of spirit in the baroque," "the grand stride, the profound suggestion, the fantastical arrangement"; such works are a valuable "public antidote to introspection." She includes precisely descriptive paragraphs on those rediscovered churches, Bernini's Sant' Andrea al Quirinale (which only the Hawthornes had loved a century earlier) and Borromini's San Carlo alle Quattro Fontane ("solidified dance"), as well as one on the beauty of Borromini's Sant' Ivo alla Sapienza (see figs. 5, 6, 13). At the Museo Borghese Clark finds that only two artists stand out—Bernini and Caravaggio. To Bernini's youthful sculptures that she herself initially found "so loathsome," she now brings "the delight of his city-making" and discovers "the fire and poetry and diabolical stonecutter's skill in these young extravagances" (see figs. 7, 8). She defines Roman baroque anew as "death, wit, ecstasy," and sketches out a "Bernini map of Rome"—the very itinerary that Victorians would most wish to have avoided. In their pursuit of Guido Reni, Caravaggio remained totally unknown to them, although his paintings are scattered all over Rome. To this recently resuscitated artist Clark devotes two pages of prose marked by a baroque intensity and elaborateness very expressive of what she finds at the heart of Caravaggio's works: "the curiosity of revulsion." The phrase would aptly describe much twentieth-century art and is far from condemnatory.[16] It is not surprising that a decade later a young architectural student named Michael Graves, the creator in recent years of allusive postmodern buildings, should have thought it worth his time while a Fellow at the American Academy (1960–62) to draw Bernini's Fontana del Tritone, the fountains of the Piazza Navona, and the baroque façades of Santa Croce in Gerusalemme and Santa Maria di Loreto.

Much of this art and the sympathetic feeling for it enter the fiction incidentally,

through passing allusions. But two works in which it is given important thematic weight may illustrate the general point. In Mark Schorer's short story "The Lamp," a highly conventional middle-aged American couple (he is a lawyer) undertake a systematic exploration of Rome, but the only things that impress them enough to be mentioned by name are the Bernini and Borromini churches on the Quirinale, Caravaggio's *Narcissus*, baroque paintings by the obscure Zucchi brothers, and a visit to the "Truth Mouth" (the Bocca della Verità). Nothing is said of the Capitoline or Vatican sculpture galleries. What this couple discovers in Rome is that their rigidified conventional relationship is grotesquely artificial, the opposite of the organic spontaneity they witness in a loving pair of Romans. In Mary McCarthy's *Birds of America* the eager young student indicates his up-to-dateness in nothing more than in his fanatical devotion to Borromini, whose works McCarthy beautifully describes. That Borromini evidently had a "weird" sense of humor, loved wing-shapes, and committed suicide makes him sympathetic to a young man of the sixties.

The idea of Rome as spiritually a contemporary city is evident in many other ways besides appreciation of its dominating architecture. It may be expressed through simple incongruities. Howard Shaw's *The Crime of Giovanni Venturi* (1959; one of the few fictions confining itself strictly to an Italian cast of characters) is a well-told anecdote about a restaurateur of Trastevere who outwits the American-style fast-food chain that moves in next door. He tunnels from his cellar to a spot beneath their kitchen and installs a dumbwaiter, which allows him to serve their food. By emphasizing his exclusivity—requiring reservations and charging very high prices—while stressing the old-fashioned simplicity of his dining room, he manages to get into all the guidebooks and becomes popular and rich. But while digging his tunnel, he falls into the ancient tomb of Lars Porsena, which inspires him to become an expert on Etruscan civilization. The extremes of the book thus are Rome's oldest foundations and its most recent Americanization brought into comic conjunction. The Romans of the 1950s, daily celebrators of food and wine, of carpe diem, live upon a mysterious past and look forward to a joyous future (a certain Signora Pandolfi is preoccupied with the invention of a space suit for women).

Another duality of Rome—Rome as an enigmatic conglomeration of ambiguous signs and Rome as a place of very solidly particularized images—perhaps emerges in most perfect balance in detective and mystery novels. No writer achieves a better balance between the exactitude of familiar named streets and the sense of a desperate need to locate oneself within a bewildering maze than Ralph McInerny in *Romanesque* (1978), the story of an attempted theft from the Vatican Library. Topological verisimilitude rendered in an atmosphere of possibly delusory surfaces is equally effective in Oliver Banks's *The Caravaggio Obsession* (1984), an intricately plotted account of art thievery in Rome that involves also the latest activities of terrorists. The constant possibility of ambiguous signs reaching a state of total nonsignification that such novels depend upon relates them to other kinds of contemporary fiction—from Joseph Heller's *Catch-22* and Malamud's *Pictures of Fidelman* to Edmund White's elegantly incomprehensible *Nocturnes for the King of Naples* (1978).

A story that has as its theme the arrival of a moment of total absurdity is George

Garrett's "A Wreath for Garibaldi" (1959), in which the narrator is persuaded to perform an act of apparently simple symbolic meaning: the laying of a wreath at the colossal monument to the great republican on the Janiculum, on the anniversary of the defense there of the Roman Republic of 1849. But the date—April 30—just precedes the May Day celebrations of the Communists, who have recently been adopting Garibaldi as their particular hero. The narrator, after consulting officials at the American embassy, is finally notified that his intended action will be permitted by the Italian government "with the understanding that it doesn't mean anything." On April 30 the narrator takes a walk along the Passeggiata of the Janiculum, gazes at the statue of the great man, recalls that his supposedly heroic defense was actually a foolish waste of human life, and does nothing. The simple laying of the wreath would indeed have meant nothing, or the wrong thing, or too many things.[17] That is how Rome was by 1959.

John Cheever found in Italy, and particularly in Rome, an appropriate setting for his particular comic vision of sad befuddlement. "The Bella Lingua" tells of a divorced American man's attempt to overcome his "sense of being an outsider." "Learning the language," Streeter believes, is the way to "understanding a people." While expatriate life gives him "a heightened awareness of what he saw and an exhilarating sense of freedom" (no hometown folks judging him every day of his life), the sites are as "confusing" as they are "exciting." If only he could speak Italian, "the whole thing would be revealed to him." As his Italian lessons progress, he becomes "exhilarated" by the idea that soon "he would understand everything that was going on and being said." But a series of encounters and observations seems to affect his desire to understand: on a walk through the Piazza del Popolo he is approached by a beautiful whore; then he sees a man struck down by an automobile in the piazza and the excited crowd that gathers seems completely indifferent to the dying man himself; next, near the Tomb of Augustus, Streeter watches a young man put a lit firecracker into a piece of bread which he then gives to a cat, and all the Roman witnesses laugh at the cat's pain; finally in a dark street a black-plumed funeral carriage pulled by black horses passes by, followed by the mourners' carriage, which is empty. Streeter knows that he does not "want to die in Rome." The idea "could only stem from ignorance and stupidity, . . . an inability to respond to the force of life," and yet his fear of this ultimate loneliness persists.

Streeter's wish to "understand" Rome and enter into its life contrasts with the urgent desire of his American Italian-teacher's little boy to go home to America with his Uncle George. Uncle George is outraged by the nude statues in Rome and would never dream of "learning the language." The boy's arguments make Streeter realize what he sacrifices in the attempt at assimilation. Both he and his teacher have abandoned a life more comfortable, more constrained, and more hurtful—one both familiar and familial—for a life more vivid and diverting, but whose beauty is mixed with the sordid, the cruel, and the absurd. The idea that life anywhere can be "understood," however, is a boy's dream.[18]

The essential loneliness of the individual—which only the familiar context of "home" can appear to alleviate—is also the theme of Cheever's "Boy in Rome," the supposed journal of an American boy who lives in Rome because his father's bones lie in the Protestant Cemetery there, his grandfather having settled in Rome as the

place best suited to a "tycoon" like himself. The boy's widowed mother at first found plenty of friends among Rome's hundreds of American divorcées and would-be writers, but recently she has worked her way into the less exclusive circle of Italian aristocrats. The boy understands the motives of the adult Americans for living in Rome—"because of the income tax" or "because they're divorced or oversexed or poetic or have some reason for feeling that they might be persecuted at home"; but he himself feels alien. There ought to be a song, he thinks, about "the cold *trattorie* and the cold churches, the cold wine shops and the cold bars, about the burst pipes and the backfired toilets . . . [and] the archdukes and cardinals coughing." When he goes to the American church, Saint Paul's-within-the-Walls, only one other man is there to take communion with him.

In the end, his mother's favorite old princess turns out to be a trickster who manages to sell her Pinturicchio illegally without giving it up, since the buyers have no recourse in law. She uses the boy as the conveyer of the empty carton to Naples, and his unhappiness reaches its climax there. Looking at a ship in port, he is cheered by the idea that sometime he will go back "to someplace where I would be understood"—that is, to a place he can understand. In the New World "there are no police with swords and no greedy nobility and no dishonesty and no briberies and no delays and no fear of cold and hunger and war." Italy, with all these things, can neither be understood nor loved. If they are not really all lacking in America, it was anyway "a noble idea." This is the conclusion; but on the penultimate page of the story Cheever intervenes in the narrative to declare that he is "not a boy in Rome" but a "grown man" in the "prison and river town of Ossining," living far from "the dark streets around the Pantheon" and with memories of perfectly affectionate living parents. It is only "an incurable loneliness" that makes him imagine himself "a fatherless child in a cold wind" in a foreign land.[19]

In both of these stories Cheever notably puts the "innocent" view of America in the mind of a child still young enough to refuse "experience," imagining that in America cruelty and suffering do not exist. In "Clementina" Cheever presents the superiority of America over Italy through the imagination of a simple woman from the Campagna who is taken to America by her American employers. The story is an elaboration of the device Mark Twain used in *Innocents Abroad*, where he imagined an "innocent" from the Campagna going to America and returning to report on its marvels. As with Twain's satire, this account is filled with ambivalences and ironies; Clementina's superstitions and ignorance are used to show up American varieties of the same. But, *without* having to "learn the language," Clementina makes a happy marriage and enters exuberantly into a "diverting and commodious life." She ends up wearing mink at a luxury hotel, while her unhappy former employers get divorced. Clementina wonders why God "opened up so many choices and made life so strange and diverse." Her delight in the strange is what some Americans equally found in Rome; but America's diversity—the possibility of "so many choices," such as the one she made—allows the alien to find a place where they are understood and understand more easily than does Rome.[20]

The difficulty of choice and change in Rome is the point of another Cheever story, "The Duchess," in which he also dares to enter imaginatively into the life of a Roman. Cheever's point of departure is that of the provincial man from Mas-

sachusetts who has "aristocratic sympathies" such as were frequently expressed in the nineteenth century. The narrator's detailed sketch of the duchess's family palace and history parodies all the received ideas about the Roman aristocracy: it reads like an epitome of Francis Marion Crawford's Roman novels told with a sense not of the romance but of the fundamental absurdity of Rome's social structure. The current duchess, who feels the weight of a four-hundred-year-old name, refuses so many suitors that even the pope feels obliged to admonish the heroine, just as he would have done in Crawford. Donna Carla's situation, however, is given specific contemporary complications: a father confessor refers her to a psychiatrist, but she cannot be psychoanalyzed because a noble lady cannot "lie down in the presence of a gentleman"; later the Communist party becomes one of her chief antagonists. But Cheever's point is that trapped within the title and the tradition is a specific human being, a woman who in fact is a commonsensical and talented businesswoman; in the end she marries her secretary-accountant, and all the aristocratic inhibitions and pretensions simply cease to matter.[21]

Cheever enjoyed absurdities more than their correctives, however, and his more famous celebrations of old-name "aristocrats" in New England never ended with their becoming commonplace people. The energetic eccentricity and repressed eroticism in *The Wapshot Scandal* (1963) seem to reach their climax with a kind of inevitability in Italy: in the sexual slave–market on an isle in the Bay of Naples; in the "Supra-Marketto Americano" in Rome; in old Honora's using the occasion of her papal audience to tell the pope about the glories of autumn in New England; and in her more sublimely perverse gesture of withdrawing all her money from the American Express and distributing it to *everyone* in the Piazza di Spagna, staging a kind of apotheosis of all the Americans who have given lire to beggars in the same place. Cheever seizes the opportunity to write a bravura paragraph cataloging all the types of humanity that have gathered in the Piazza di Spagna for over two hundred years. Obeying her "impulse to scatter her money," Honora ascends the famous stairs "while the voices of thousands blessed her in the name of The Father, The Son and The Holy Ghost, world without end."[22]

The representation of the specific character of Rome in the decades after the war—beyond its thematically appropriate incongruities—is merely incidental to the other purposes of all this fiction. Attempts to read Rome's images allegorically, like Hawthorne, or convert them into symbols, like James, are rare. Tennessee Williams's attempts are certainly the most obvious: his Rome consists almost exclusively of stone and running water, the rosy phallus of an obelisk (inscribed with enigmatic hieroglyphic messages) that rises directly below Mrs. Stone's window, and the domes that bulge like gigantic breasts on the horizon (they are elsewhere compared to spiders hovering over their webs of streets). Edmund White's unnamed Rome becomes surreal through grossly antiromantic figures of speech: the ruins of its Forum emerge "out of the ground in that way wisdom teeth erupt through the gums"; the Colosseum "looked like those clumsy plasticine molds, uppers and lowers, that dentists ask you to bite into."[23]

More realistic fictions than those of Williams and White attempt to render the contemporary and distinctive character of Rome as a place, as evidence of an

author's or a character's ability to perceive and to take limited possession, if not to understand. The primary narrator of William Styron's *Set This House on Fire*, an employee of a relief agency, has an apartment on the Gianicolo with a "luxurious" terrace from which he watches the shadow of the hill "roll up the city in darkness" at sunset while he drinks whiskey and listens to Liszt. After living in Rome for three years, he looks out over the city during the night he is to leave it, and "for a moment—though perhaps it was just the wine—I felt that Rome, too late, was finally intelligible to me." But the moment passes; he drives down the hill realizing that "what I was leaving behind—with both affection and a very special sort of malice [his irritations with the bureaucracy have been chronicled]—was simply Rome." In order not to be "peremptory, rude" in departure, he stops in the Piazza di Santa Maria in Trastevere for a beer. The piazza offers him an epitome of Rome: "a gang of children, a beggar scratching at a violin, and young priests with programs," "a tattered billboard" of Ava Gardner, the "weathered composure" of the "fine fountain," pigeons in the blue shadows of the church portico, the aphrodisiac smell of coffee and flowers, the soft clang of a bell in the campanile, the clatter of shutters from a closing restaurant, a weary voice in a side street calling out *"Tommasino!"* and a cat passing by with a "piratical look and a suave grin."[24]

Squalling cats, tinkling bells, sputtering Lambrettas, banging shutters are heard throughout the Roman stories of Elizabeth Spencer as well. Peddlers and beggars are as ubiquitous and annoying as in nineteenth-century representations, and the traffic is much worse. In fact, the perils of Roman traffic become a common motif, with the sounds of crashing motor scooters and cars heard frequently in the background. In the Jamesian "White Azalea" a Latin-reading spinster from Alabama who has sacrificed her life to her family finds that in spite of its negative features, Rome answers positively to her long-deferred wish to live for herself. When letters arrive that summon her back to her "duty" to an ailing, ungrateful relative, she tears them up and buries them in one of the enormous pots of azaleas with which the Spanish Steps are banked in the springtime. She has had her classical sense of "measure" confirmed, which enables her to give the letters—and her past—this most splendid funeral. Rome is for her.[25]

One writer—William Murray—had the exposition of postwar life in Rome as his primary aim in a series of *New Yorker* sketches, the earliest of which were stitched together and published as an autobiographical novel, *The Americano*, in 1968. The essays themselves were republished—together with later ones from the 1970s—as *The Fatal Gift* in 1982. Murray's exceptionally engaged, nontouristic feeling for Italy derives from the facts that his mother was Italian and that his purpose in going to Rome in 1947 (on the GI Bill) was to study opera. In both versions of his life there, finely detailed, sympathetic, and yet comprehensive reports are given of the daily life of the people (the nobility, the newly rich, the workers, and the poor) and of the foreigners who were trying to study or work in Rome. The later essays describe the government bureaucracy as it is actually experienced by citizens, the insanity of Italian divorce procedures, and, finally, the emergence of the new terrorism in the 1970s (terrorism itself hardly new to Italy). Both books contain an evocative account of a day in the life of the Campo de' Fiori. The later book has a fine essay on Rome's enormous, costly, and almost hopeless effort to preserve its antiquities, and another

on the now wall-less Ghetto and the Jews of Rome. In these essays Murray is most clearly the heir to Hawthorne writing on the market of Piazza Navona, of William Wetmore Story on the Ghetto, and of Howells on the excavations of Rome.

In *The Americano* the fiction fills in those areas of experience that are too private and too improper for the *New Yorker* and are more closely related to the Rome of Williams, Vidal, Cheever, and Schwartz: the parties of mean-spirited Fulbright scholars on lovely terraces, movie people on the Via Veneto, sexual liaisons of all kinds (including those with the corrupt nobility), and fun and games at the Press Club bar and the Kit Kat Klub (operated by a Mafia man expelled from America). A climax comes at a multinational Christmas party given by the American ambassador. Such novelistic reportage makes apparent what would not have been inferred from *The Fatal Gift*, that the life of a sane-sounding and sympathetic American reporter in Rome may actually be absurd, deteriorating "into a long, slightly hysterical party full of jokes and strange encounters." But all this human nastiness does not prevent the endlessly entrancing and moving Renaissance Rome of the essays from firmly emerging in the novel, and it is even intensified through the author's friendship with a local inhabitant who—in an energetic act of both possession and sharing—makes the American see and understand every street, every palace, every doorway, every stone. "There is only man!" the friend cries. "You understand? I make myself clear?" And for once an American does understand.[26]

Poems

The representation of Rome in postwar American lyric poetry is as varied as the characters of the many poets who went there, and it changed also as Rome itself changed in the course of four decades. For some poets Rome was not a particularly congenial or relevant place to be; they could make nothing of it. "Remember when someone / asked you what you'd do in Rome, you said, walk along / the Tiber and look at weeds," Richard Hugo wrote in "Letter to Ammons from Maratea."[1] And for all we know from Ammons's poems, that is all he did. Louis Simpson, who was at the American Academy in 1957–58 and again in Italy on a Guggenheim Fellowship in 1963, refers to Rome only once in his autobiography, *North of Jamaica* (1972); he recalls an unexpected sight in the Sistine Chapel: Allen Ginsberg "coming toward me, from the middle of the Last Judgment."[2] But we find nothing of Rome in Ginsberg. In "Trasimeno" Simpson himself ponders the question why Hannibal, having defeated the Romans, failed to move on to Rome. He suggests that any stranger might soon satisfy a "hunger for stone," returning at night "to the trees / and the ways of the barbarians."[3]

Similarly Robert Francis, who was also at the academy in 1957–58, confessed in his autobiography, *The Trouble with Francis* (1971), how difficult both Rome and the academy had been for him. For a man used to living alone in a cottage in the woods near Amherst, Massachusetts, being transplanted to a "big bustling aggressive institution" in "the city of cities" took courage. Francis did venture out to major points of interest, but the place he loved most was the Villa Sciarra, nearby on

the Janiculum, where he enjoyed the wide "prospect" almost every day as he strolled among the flowers and the children. He preferred the Trattoria Pasquino, a humble and friendly place run by three brothers, to the loud dinners at the academy. Usually after a snack in his room he chose to pass the evening alone on a roof terrace that offered a view of the "lights celestial and terrestrial" of the "whole illuminated city": "I would stand facing west and think of America. For the time being that terrace itself was my protection and escape."[4] Something of Francis's discomfort is conveyed in the most interesting poem to come out of this experience, "Thoreau in Italy." Thoreau "converses" with the Latin inscriptions on "stones, imperial and papal," but recoils at the touch of the warm flesh of the present, whether in form of "satyr or saint"—the two extreme tendencies of identity that Rome seems to propose. He is revolted equally by the "dazzling nude with sex / lovingly displayed like carven fruit" and the "black / robe sweeping a holy and unholy dust":

> Always the flesh whether to lacerate or kiss—
> conspiracy of fauns and clerics smiling back
> and forth at each other acquiescently through leaves.

Francis's Thoreau returns happily to Concord, "An Italy distilled of all extreme conflict, / collusion—an Italy without the Italians."[5]

Simpson rejects a stone city for trees; Francis a sensual present world of conflict and collusion for a transcendent world of letters. Such poems are simple, emphatic negations of an aspect of Rome rather than attempts at synthesis, accommodation, incorporation, or enlargement of identity. A third example of one-sided resolution of a duality reverses Francis's preference: the past—history—is the burden, and the carnal present is the salvation. In "Rome" (a "Night-Poem" paired with one called "U.S.A."), George Garrett, who was at the academy in 1958–59, describes how "the great gray European dark" fell upon the city, causing one's heart to sink beneath "History," that oppressive "giant," until the sight of embracing Roman lovers whispering, listening, and laughing caused the "astounded giant" to fall under the slung shot of his living heart.[6]

More commonly the oppositions experienced in Rome are left in suspension, and the problematics of understanding and choosing are themselves the theme that defines the poet. The delicate four-quatrain sentence of James Merrill's "Italian Lesson" (1959) distinguishes among three modes of communication, three hard lessons: idiomatic Italian to be used in glance-exchanging "promenades in Rome," or the "resounding Latin" of history's "catacomb," "labyrinth," and "sphinx," or the "mute call" of a sparkling lip to "certain other lessons hard to learn."[7]

How difficult it was to "learn" anything is evident in a comic poem by Kenneth Koch (from a collection of 1962), "Taking a Walk with You." Koch accepts, to the point of delighting in, the absurdity that prose writers like Heller, Malamud, and Cheever more habitually expressed than did poets. His poem purports to be a list of "My misunderstandings." From false cognates of the two languages to confusions about Pinocchio's changes, from mysteries of childhood and adolescence in New York to the adult studies and travels that have led to the present walk in Rome, he has misunderstood everything: "I probably misunderstood misunderstanding it-

self—I misunderstood the Via Margutta in Rome, or Via della Vite, no matter what street, all of them." He "misunderstands the very possibilities of feeling, / Especially here in Rome, where I somehow think I am." He confesses that "San Giovanni in Laterano / Also resisted my questioning / And turned a deaf blue dome to me / Far too successfully." But he does understand the message of St. Peter's bells: "'Earthquake, inundation, and sleep to the understanding!'" they ring out. The poem ends with a Whitmanian conglomeration of images—"American Express! flower vendors! your beautiful straight nose! that delightful trattoria in Santa Maria in Trastevere!"—and an invitation to go to the last: "I am probably misinterpreting your answer, since I hear nothing, and I believe I am alone." There is no voice of Emerson to enter here, to exclaim, "Alone in Rome! You need not be alone!" The great souls of the ancients—the Scipios and Catos whom we heard Emerson call upon in the Forum—are no longer present even to be misunderstood.[8]

Particular Roman places that were so confidently evoked and made emblematic by nineteenth-century poets, beginning with Byron and after him Longfellow and Poe, rarely inspire modern poets. When they do, the typical result renders a difficult effort at understanding through observation rather than something actually understood. Few poems are as directly descriptive as May Swenson's "Pantheon" (1960), an attempt to relate the building's transcendent "solid geometry" of circle, triangle, and square to the simultaneous experience of the "dark and urinous" bases of its exterior columns and its "scrofulous and starving" cats "with demon eyes." This poem is an odd mixture of somewhat garbled architectural terminology and history, prosaically stated, and exalted moments out of Mrs. Browning: "Yet there strike upon my chest the radii of grandeur."[9] But Swenson strongly conveys the difficulty of apprehending simultaneously Rome's multiple and contradictory aspects, even as expressed in a single building. Richard Hugo, whose introduction to Italy had been on the battlefield (but included a fumbled sexual initiation in Rome), found the contemporary experience of the Castel Sant' Angelo to be even more ironic than Swenson's at the Pantheon. In a place famous for violent defenses, sadistic tortures, and gluttonous papal banquets beneath pornographic frescoes, placid tourists now sip espresso and look at the view. The Castel is now merely a place where titillated "touring girls from Iowa can peek" into dungeons. Hugo obviously thinks the structure's earlier uses more interesting, which is hard to deny, and he finds it difficult not to believe that they were also better.[10] Only a satire of the passive spectatorial character of modern life can be made from a contemporary experience of the history-laden Castel.

The Rome of nineteenth-century Americans was at least recalled in John Hollander's "The Muse in the Monkey Tower (Via dei Portoghesi)" (1975), which alludes to the residence of Hawthorne's Hilda in *The Marble Faun*. This poem was originally intended to be the proem to Hollander's elaborately structured long poem "Spectral Emanations" (1979), which found its genesis in a conceit that Hawthorne placed in the mouth of his puritan heroine. "Spectral Emanations" includes, as the base for the central episode of the poem, a prose fantasy called "Leaves from a Roman Journal" about the retrieval of the lost menorah from the Second Temple of Jerusalem, which legendarily lies at the bottom of the Tiber. A symbolic retrieval and relighting is what Hollander attempts in his long poem, and "The Muse in the

Monkey Tower" is a prayer for help in this "difficult task," as Hollander explains in a note. Harold Bloom, noting the oddity of Hollander's selection of the Protestant Hilda for his muse rather than the Semitic Miriam, who in Hawthorne's romance all but effaces Hilda, remarks that "Spectral Emanations" succeeds "in being American by being Judaistic, and vice versa"; like Hilda the copyist, whose copies surpass in authenticity the works of her contemporary artists and sometimes the originals themselves, Hollander returns "home" by way of an alien encounter and an imitative art.[11] What Bloom does not note is that in "The Muse," Hilda the "American girl," the dovelike innocent, quickly fades away to be replaced by a succession of sexier muses. The first three have classical names—Olive, Myrtle, Laura—names of the plants with which Petrarch was crowned poet laureate of Rome. But even these give way in the end to those who "dwell in the magic tower now": Judith or Joan. The prayer finally is to the familiar, the directly experienced. Its imagery is specific to the place: the tower over the dark streets, the angels with stone trumpets on the opposite church roof, and the flying doves are in Hawthorne, but there is also imagery from the distinctly contemporary world. The "comic Lauro" on the floor below "Shouting for Massimo" is a bit of inconsequential realism that Hawthorne would have omitted, and the appeal for a "shady bed and a hot fuck / Under the *tramontana*" is one to which Hilda as person or muse would have stopped her ears.[12]

Hollander's "Muse in the Monkey Tower" is dedicated to James Wright, the contemporary American poet in whose lyrics Italy has been felt most deeply. The Italian poems, from the years 1973–82, are inspired mostly by Tuscany and the Veneto, but the few from Rome reflect its particular identity, its traditional images and themes. Although Wright's book, *This Journey* (1982), is illustrated with a painting by Lenmart Anderson called *View from the Window of the American Academy, Rome* (1975), his writing is neither so detached nor so pleasant as this view. His brief Roman prose pieces of 1977 even include the Colosseum—since Byron the most hackneyed of allusions. "A Lament for the Shadows in the Ditches" associates the "intricate and intelligent" excavations in its floor with "the black ditch of horror" in which the body of a drowned boy had been found in the Ohio of Wright's childhood. Here, beyond reach of the brilliant, blinding sun, remain the shadows of "starved people who did not even want to die" and of the "maws of tortured animals" who devoured them. Even the "noon sunlight in the Colosseum is the golden shadow of a starved lion." In "Reflections," the Colosseum, appearing on the horizon like a "crumbling moon," reflects and "gives form" to an "ancient light," while above it "another moon, a day-moon, appears."[13]

This sense of delicate transitions and vast continuities—of ancient and modern time compressed into a single image and an evanescent moment, and change effected through a series of endless moments—is concentrated in Wright's poem "The Vestal in the Forum" (1982). The initial image is of winter's "impersonal hatred" which has pitted the "shoulders of a stone girl," one of the "lovely things men made." But this destructive action has been continued even by the spring roses, which, ceasing to be "garlands," become themselves conquerors: "The slow wind and the slow roses / Are ruining an eyebrow here, a mole there." Finally,

> A dissolving
> Stone, she seems to change from stone to something
> Frail, to someone I can know, someone
> I can almost name.[14]

Wright thus ends by looking at himself.

This traditional Roman theme of mutability is older by centuries than any American writing on Rome, and itself seems immortal. In 1983 alone the *New Yorker* published two more inevitably banal variations that would have been read with recognition by Henry T. Tuckerman or Grace Greenwood. Dana Gioia even returns us, after long absence, to the Campagna—not, however, to the Dream of Arcadia but to the Wasteland. The situation is "noon" in a walled "Garden on the Campagna," but the imagery is of fading "pale flowers" and immobile "scarred brown lizards":

> Only the smallest things survive
> in this exhausted land the gods
> so long ago abandoned. Time
> and rain have washed the hero's face
> from off the statue.

Time has also eliminated all social distinctions. The "ancient family" of the palace is "without heirs," and boys throw stones at the mumbling old man who may once have been either "the servant or the sire."[15] Howard Moss, in "Rome: The Night Before," begins with the by now commonplace view from "the terrace of the Villa Aurelia, / Overlooking Rome"—a "summer resort." Flicking "dead leaves and dried blooms" from a geranium, the poet considers that "museums in Rome are tautologies," for the faces one saw in the street "the night before" are the same that one sees "fixed" in the sculptures of the Vatican today. Although in this sense ideal beauty is constantly reincarnated in the present, which suggests a harmonious relation between flesh and stone (life and art), yet the marble, like the flesh, is "everchanging." No one can detect the "moment / In time" when "the erosion / Of stone by falling water" occurs. Since even the "colossus" turns into "candle wax," "Everything permanent is due for a surprise, ... / What everybody always took for granted / Astonishes a second before it disappears":

> In Rome one feels
> Duration threatened day by day,
> Not knowing which of its great works will last,
> Flesh and marble the same mix of mortar.[16]

Far back in the fifties Richard Wilbur's "For the New Railway Station in Rome" had attempted to refute those "pilgrims of defeat" who, "pondering on decline," have for centuries taken satisfaction in "hurt pillars" and the "stubbled forum." Wilbur joyfully announced that "there's something new / To see in Rome." The

daringly cantilevered reinforced concrete roof of the "booking-hall / Sails out into the air beside the ruined / Servian Wall," echoing its "broken profile" and "defeating / That defeat." A city that is truly eternal is one that can proclaim:

> "What is our praise or pride?
> But to imagine excellence, and try to make it?
> What does it say over the door of Heaven
> But *homo fecit!*"[17]

But this humanistic affirmation is what distinguishes Wilbur among the postwar poets. The general tendency, greatly strengthened by 1980, was to take the theme of mutability to the point of apocalyptic prophecy (Moss's title "The Night Before" has a double reference). In the decade that began in the early sixties the possible imminence of violent destruction radically modified the old theme of slow change. The death of Pope John and the assassination of President Kennedy (who had visited Rome shortly before) coincided with—and partially engendered—the new tonality, which in fact announced itself in ugly enough fashion in "Kennedy *Ucciso*" by whom else but Richard Hugo: "Don't scream at me you God damn' wops," he cries to the Italians who persist in asking him questions after he sees the gigantic headlines. But the poem ends with the words, "I weep in the *piazza,* a perfect wop." Hugo's ambivalence toward America's imperial might—Kennedy had put "sixty million lives / on some vague line and won"—and toward imperial aftermath—"You Romans, / quite *simpatici.* Someday we'll be you"—is expressed against the affirmatively hedonistic image of an illuminated fountain that "runs in thighs of lovely stone," its "naked ladies . . . giving in to fish."[18]

The increase in terrorism in Italy in the 1970s rather encouraged Americans to keep their distance from the shouting, weeping "wops." Indeed, in an ironic little poem called "Aesthetic Distance" Miller Williams, who was at the American Academy in 1975–76, takes us back up to the now familiar "terrace / on Gianicolo hill," from which the foreigners sipping their drinks can safely look down upon "a little war / in the streets of Rome." The arc of a Molotov cocktail causes someone to say "Star bright, . . . You can make a wish." Political engagement, agony, and even heroic death might be experienced by the Romans in the streets below, but the Americans, quite literally above it all, perceive only a trivial beauty.[19]

Daniel Mark Epstein, however, at the academy the next year, asked himself whether what was happening in the turbulent and tourist-frightening city might not rather be the birth of the epoch-dividing "terrible beauty" that Yeats had foreseen. The "Ode to Virgil," internally dated as a report to the Augustan imperial poet from "your American correspondent in Rome" on "Friday, April 14, 1976," at first sounds like any querulous tourist's complaint about what most annoys him—the frequent Italian strikes. Even the "Gypsies are striking in the Piazza Navona" and "the whores are striking on the Via Veneto, / everybody is lying down on the job." But Epstein then turns to more astonished declarations that "your children are burning, crossing the streets / under red flags against red lights." In fact, the Romans "love red the color of rage and fire and blood / as they love the crucifixion and ritual murder." Out of context, such lines as these, and the news that "Machine guns /

bristle around parliament because your children / have taken to kidnapping the ancient senators," might seem to be setting up a contrast between the present and some mythically calm Vergilian Rome of Augustus. On the contrary, the children are "following your stars, Vergilius, / because that's the way you left them." The "Virgil" of this poem is not the austere epic poet but the magician into which the poet had been converted by the folklore of the Middle Ages. The "patron saint of Ford and Edison," "Virgil" was the inventor of marvelous machinery by which the authorities in Rome could detect "intrigues and traitors" in the most distant provinces. He is missed now because "the art of sorcery is in a sorry decline," and no such happy means of foreseeing and preventing violence and disorder exist. In the meantime, "America is sleeping, her sun / lags half a day behind. Sweet dreams, America!"[20]

Three years later James Wright did not have to go back as far as Vergil to find a poet to contrast with contemporary Romans. In the sonnet "Reading a 1979 Inscription on Belli's Monument" he expresses his anger at the "latest Romans," one of whom has "sprayed a scarlet MERDA" on the statue of this nineteenth-century poet of the people.[21] The next year Robert Bagg delivered a poem at the American Academy explicitly declaring that "What we see this December looking out on Rome / is not the same eternal field of prizes to be won" that earlier Fellows at the academy (he names Wilbur, Hecht, Garrett, and Starbuck) had to play in. True, "Rome's sunny markets, great domes, painted figures, / . . . lovers, mad traffic, skittish aristocrats" all remain, "but often at gunpoint, and so worth preserving / someone will want it soon to explode." What the Fellows see from the Gianicolo in 1980 "won't comfort or exhilarate any poem": the photograph of a kidnapped judge, a bomb exploding downtown, the tragic aftermath of an earthquake. The poem concludes with an anecdote that expresses the new tension of life in Rome: at a trattoria near the Campo de' Fiori the night before, while listening to Neapolitan musicians, the diners had been terrified by the sudden breaking of a glass of wine, thinking it was a bomb. The music resumed, but "something inherent / remained undetonated." The final image is of a crack in the Sistine Chapel wall "that cuts across Christ's flaring hand / raising the saved and singling out the damned."[22] Nothing so apocalyptic about Rome had been written by an American since Longfellow imagined Michelangelo at the Colosseum envisioning the Last Day.

Bagg's poem, called "Rome 1980," is apparently the conscious continuation of a series of poems that had been unwittingly begun by John Ciardi with "Rome, 1951" and established by George Starbuck with "Rome, 1965." Although not reaching the point of personal terror expressed by Bagg, neither these poems nor those of the other poets to whom he alludes really portray a Rome quite so entertainingly unproblematic as he suggests. In fact, as far back as 1959, when Bagg had first been a Fellow at the academy along with Garrett, he himself had written "Paolo and Francesca," a poem about a traffic accident during "Rome's rush hour" that killed two young lovers. Re-created through imagery of crumpled bodies and flowing blood, this contemporary incident can hardly be said to "comfort or exhilarate," although the Ovidian Bagg—in explicit opposition to a Franciscan's prayers—metamorphoses the violent encounter into an eternal sexual climax, and the blood into

perennial flowers. So Bagg's apocalyptic poem written twenty-one years later appears to reflect his own temperamental predilection as much as a change in Rome.[23]

Certainly Ciardi's poem of the 1950s does find fear in a much more innocuous arena than either traffic or terrorism. It records an argument between the poet and another American over whether Ciardi was right to give five hundred lire to the "rag woman" with "a soiled baby" who sat whining on the Spanish Steps: " 'Don't you know they *rent* the babies? . . . / 'Everything in this crazy town's a racket!' " The wonder is how anyone can come so far "to walk that tight for fear / the beggars are getting rich."[24] But Ciardi's poem is not specific to its date of 1951, for it concerns a subject that had bothered Americans for more than a century. Starbuck's witty sonnet, in contrast, expresses in its octet an alertness to absurdity perhaps characteristic of the sixties. Rome offers the poet its bizarre juxtapositions and irrational rituals: "God Keats Trajan and Liz go down as one / irresistible fish story," while the burial of Pope John has been going on for three years "in exquisite stages." The sestet addresses Peter (the church, not the saint) as an "igneous intrusion / across the marble face of so damned much." Its illusory "coziness" and the "cold caverns" of its "open arms" require "any old profusion / of dogs cats cars nuns Iowans and such" to humble and humanize them. This last incongruous list is the counterweight to the octet's legendary capitalized stars of imperial, religious, romantic, and contemporary Rome.[25]

As for Anthony Hecht, it is not apparent from his poetry how he perceived Rome when first there as a Fellow in the fifties, but the poem "A Roman Holiday," published after his return as a writer in residence in the seventies, energetically impels the reader through tight rhymes and insistent enjambments on a whirlwind tour of Rome. The poem moves from an invocation of the Christian and classical sites that "pilgrims" visit, accompanied by perfectly conventional comments on impermanence, to a pair of concluding stanzas drenched with the blood of the Colosseum crying out for "judgment" while the bells declare that "Crime is at the base."

> "Blood is required,
> And it shall fall," below the Seven Hills
> The blood of Remus whispers out of wells.[26]

The essential history of Rome—blood crying out for blood—seems about to receive contemporary reenactment.

Given such poems of violence perceived, projected, and prophesied, it is not surprising that the most envious allusion in Bagg's "Rome 1980" is to Richard Wilbur's celebrated poem "A Baroque Wall-Fountain in the Villa Sciarra" of twenty-five years before. Possibly this poem is both "comforting" and "exhilarating," and a natural product of the fifties. It is, in any case, the finest emblematic summation of two contradictory aspects of Rome to which Americans had been responding, negatively or positively, since their first encounters with the city. The extremes of satyr and saint, from which Robert Francis's Thoreau had recoiled, are by Wilbur lovingly approached.

Wilbur was a Fellow at the academy in 1954–55, and this poem appeared in *Things of This World* in 1956. Four years earlier Wallace Stevens had written "To an Old Philosopher in Rome," a pre-elegy on the dying George Santayana. In that poem Stevens had seen Rome as Santayana's chosen "threshold," with "The extreme of the known in the presence of the extreme / Of the unknown," a place where "figures in the street" and "blown banners" of this world become, in a change of perspective, "figures of heaven." Stevens shared Santayana's philosophic preoccupation with the value of the sensuous world, with the adequacy of its beauty—beauty of form as well as of color—to furnish the soul with transcendent meaning. Wilbur similarly looked toward both the world and the "land" beyond, but the "shape of Rome" in his poem is not the one simplified to the essentials of one's own needs that Stevens imagined Santayana creating for himself; it is made of two opposing shapes that represent competing (or complementary) ideas of man's "excellence."[27]

The first idea is expressed by the baroque wall-fountain in the Villa Sciarra. It is described as a playful affair in which the water effortlessly falls from one cockleshell to another, until it spills over "a faun-menage and their familiar goose." The god Pan, happy in "all that ragged, loose / Collapse of water," holds up the lowest shell "with ease" as he watches his babes play in "goatish innocence" about "his shaggy knees." The mother faun leans forward "into a clambering mesh / Of water-lights, her sparkling flesh / In a saecular ecstasy." After six elaborately versified, exhilarated quatrains, Wilbur stops to ask whether, after all, this thoughtless "goatish innocence" and "saecular ecstasy" are not "too simple." Three linguistically far chaster stanzas are interpolated to describe the great fountains in St. Peter's Square (a half-hour's walk away). These stanzas suggest paradoxically that man may be more "intricately expressed" by these plain upward-struggling jets of water, "at rest / In the act of rising." This image is not one of self-denial, for the aspiring water terminates in "a clear, high, cavorting head" and then, "illumined," finally falls back to "patter on the stones its own applause." Its pattern of "excellence" is not puritanical, but classical and of the Renaissance (Wilbur uses the Greek word *areté*). Yet it does represent an ideal loftily distinct from that emblematized by the "showered fauns" in their "bizarre" house: *they* "rest in fulness of desire / For what is given." Theirs, in effect, is the other Rome, a Rome of a different myth and a different art: ragged, shaggy, loose. Their receptivity, their "humble insatiety" with pleasure, and their content to live in the "riddle" of their bewildering pool are beyond—or below—human knowing: disgust and boredom with pleasure, and discontent with not understanding, cause one to look for himself, herself, in other images.

Having created these opposed mirrors of man, Wilbur is compelled to write a third part in an attempt at resolution. In a different poem Wilbur elegantly celebrated the unity of the spiritual and the sensual in the figure of Santa Teresa as Bernini famously represented her in Rome. Rather desperately, in his final lines of "A Baroque Wall-Fountain," he maneuvers to find his third image in a parallel figure. He goes outside of Rome to find his satyr-saint, a humble figure who loved the things of this world: St. Francis, who lay "freezing and praising" in the snow and might have seen in the fauns' rest an image of "the dreamt land / Toward which all

hungers leap, all pleasures pass." The final image is one of aspiration, but aspiration toward fulfillment of the body's own hungers and pleasures, not toward an illumined spiritual realm where they would fall away forgotten. Yet the last words, "all pleasures pass," detached as they are from the phrase they are meant to reinforce, echo medieval and even Renaissance admonishments against the idea of "saecular" (both worldly and agelong) "ecstasy." And indeed this begins to sound like Robert Francis's Roman "conspiracy of fauns and clerics." But the flesh-piercing ecstasy of St. Francis, I think, is really irreconcilable with that of the fauns.[28]

Wilbur himself said it "may be" that this poem "arrives at some sort of reconciliation between the claims of pleasure and joy, acceptance and transcendence"; but he added that "what one hears in most of it is a single meditative voice, balancing argument and counterargument, feeling and counterfeeling."[29] And this is so. The unity of any successful image of Rome (of life) is finally that given to it by the perceiver and the experiencer, impressed upon it by a loving act of re-presentation, of imaginative possession through language. One could only with difficulty claim that Rome has been represented more intensely and possessed more actively by Americans in the last forty years of its revived popularity than it had been in the nineteenth century; but it has been known differently. So what is most apparent is how much there is to be known, how many ways of knowing, and how many ways of failing to understand. Representations are always mostly of oneself; but the complexity and abundance of Rome encourages amplitude of spirit: in any fountain one may find an image of oneself or see a new self coming to life.

For English-language poets in Rome the city is inevitably the place where one of the greatest of their predecessors died in his youth. The image of Keats, of potentiality lost, persists where that of General Clark at the Capitoline quickly vanishes. James Wright, in 1981, published a poem called "In View of the Protestant Cemetery in Rome." "In view of" this burial ground of romantic poets, Wright perceives Rome as a "violated place." Alluding to the monument to a minor political figure of ancient Rome that rises beside the cemetery, he sees the whole as "Idle as any deed that Cestius did / Vanished beneath his perfect pyramid."[30] In a poem at Keats's grave, Richard Hugo characteristically abjures the poet to "be bitter still" as he hears the Roman traffic screaming beyond the wall and looks down at the nameless stone on which "Despair is carved too clear."[31] But the imagery of Jorie Graham's poem "Scirocco" (1983), a meditation in the house where Keats died at 26 Piazza di Spagna in 1820, conveys a closer identification with the language and feeling of the author of "To Autumn" and the "Ode on a Grecian Urn." In the long Roman tradition, this is a poem about changes, about altering states of being and nonbeing. Graham sees the "stark hellenic forms" of grapes overripening on the terrace, "translating helplessly from the beautiful to the true." These are associated with the hands that made the death mask of Keats and with the hands of the old woman custodian, who sits in a light that "speckles her, changing her," while she sorts "chick-peas / from pebbles . . . dividing / discarding." Such fateful images of instability, termination, and judgment receive an apparent counterthrust in the last line: "Oh how we want to be taken / and changed, / want to be mended / by what we enter." The phrase "want to be mended" replaces and corrects "want to be

changed." And it sounds hopeful until recognized as an allusion to Keats's own entering of the house in Rome where he was taken, where he too came to be mended.[32]

Paintings

The duality of representation—of the self and of the subject (here, Rome)—has been more problematical for the hundreds of American artists who have gone to Italy since 1945 than for the poets. Any artist who attempts to paint a famous Roman monument today places himself less in the context of Claude and Piranesi, or even of Thomas Cole, than in the context of souvenir photographers and of the popular impressionists who predominate in present-day Piazza Navona and Via Margutta. An aura of banality surrounds almost every Roman subject, and the challenge to disperse it can appeal to few. As recently as the annual show at the American Academy in 1986, the mere sight of more heavily impastoed versions of the Colosseum was wearying; the apparent relation of its image (as angularly regarded from above) to vaginal images on neighboring canvases did not persuade one that an original vision here invited one's patient regard.

The larger contemporary context of postwar art also militated against representations of Rome by serious artists, as the idea of representation itself had been understood for three centuries. Some of the American artists who went to Rome did so confessedly to get away from a critical environment that was lifting abstract expressionism into dominance in New York. William Congdon, who first knew Italy as a corpsman, returned the year after the war ended, believing that America's mechanization, puritanism, and materialism together "shattered" its artists "into a negative and protesting abstractionism." Italy, in contrast, respected art and artists and maintained through its tradition a firm sense of both spiritual values and "reality."[1] Congdon, beginning a mystical search that eventually led him into a Benedictine monastery in Italy, is perhaps best known for his interpretations of Venetian subjects, but even he on at least one occasion painted the Colosseum (1950; Rhode Island Museum of Art). In its superimposed arcades Congdon seems to have perceived a powerful variation on the sinister patterns of fenestration he had found in his earliest subject, the façades of New York's dark tenements—an oppressive pattern that in Congdon's private symbolism was opposed by the vital "disc of gold" he found in the sun, the moon, and many domes.

A more typical artist is William Thon, a largely self-taught painter who in 1947, at the age of forty-one, received a fellowship to the American Academy. Thon, using the superior Fabiano paper he found in Rome, seems to have produced watercolors of almost everything in sight (including baroque churches and scenes on the Janiculum, but not excluding the Colosseum). Like many nineteenth-century artists, he used these later as the basis for larger oils painted at his home in Maine. The success of his exhibition of Italian paintings the following year encouraged his frequent returns to Italy during the 1950s, which included a year back at the

American Academy as an artist in residence.[2] Thon's paintings—his *Arches in Rome, Twilight in Rome, Rome after Dark, Roman Afterglow,* and so on—represent compromises between the representational and the abstract. It would be difficult to identify the domes, porticoes, ruined columns, and archways assembled in his paintings, for Thon's Rome is not a complexly layered city consisting of individual monuments with specific functions and historical associations. It is Kazin's "easy" enigma, a Rome "represented" as a timeless essence of domes, columns, and arches. Thon's paintings thus make an effect primarily through the simplified circular and rectilinear shapes and the diagonal slants of light and shadow that such architectural forms boldly project. They have as their primary and surface interest what had always been an underlying structural feature of Roman paintings, but which had been subordinate to the historical, narrative, or associative significance of the subject. The viewer of Thon's paintings is not troubled with such significance.

Thon's compromise is evident in the work of many professional figurative artists who wished to be both easily comprehensible in subject and modern in appearance. Another example is Bernard Perlin, an illustrator for *Life* and *Fortune* influenced by Ben Shahn, who went to Rome in 1949 and spent the year 1950–51 at the academy. His large version of the *Colosseum* (1954) is an interior view that invites comparison—and extreme contrast—with that of Thomas Cole. The contemporary Colosseum itself, stripped and bare, with open ditches and arched passageways exposed in the floor of the arena, now corresponds to the simplified style of painting that represents it. It is defined by shafts of light from the exterior that reveal it as simply a pattern of regularized arches and flat walls. Imposing in the manner of an operatic stage set, the scene lacks all historical and religious suggestion, or any inducement to philosophic melancholy: certainly there is not the slightest connotation of nature's triumphant reclamation, as in Cole. The Colosseum is simply a slightly bizarre contemporary spectacle with no significant context.[3]

But Rome was not a congenial place even to some conservative figurative painters, once they found themselves there on their fellowships. John Heliker, for one, arrived at the academy in Rome in 1948, when he was already thirty-nine years old. Heliker believed that "abstract expressionism seems often to mirror the turmoil and violence of the world today," whereas his aim was to "give expression to those aspects of nature which contain an inner sense of harmony." Not surprisingly, he soon realized that modern Rome was not for him, but the towns embedded in the landscapes of the Amalfi coast and Sicily proved ideal. Ironically, the encounter with Italy, which Heliker renewed almost annually in the early fifties, turned his art strongly toward abstraction: "I was much influenced by its architectural beauty," he wrote of Italy, "and concerned myself largely with architectural forms." On his return to Maine he had to adapt his new more abstract vision to nature alone, looking for the geological and organic forms within, for it was now with form that he was primarily concerned.[4]

Another artist whose style shifted decisively toward greater abstraction in Rome was Stephen Greene, who was at the academy in 1953–54. Never a "realist," Greene was a symbolist painter of religious themes who even did a series on Christ's Passion while in Rome. His "symbols" were fairly obvious and existed within a

clearly signifying context, although never a "realistic" one, and his art had a definite relation to the Italian tradition. But Greene later said that during this year in Rome "I became dissatisfied with everything I was doing. To turn away from anything that was a scene rather than a presence became important." Could it have been the superabundance of "scene" in Rome—both in its reality and in its art—that actually encouraged the turn away from imitation in any traditional sense? In any case, Greene became obsessed with "fragmentation," which he found the "clue to contemporary thinking."[5] But he seems not to have found fragmentation itself representational of Rome. Others did. Salvatore Meo, an Italian-American from Philadelphia who during the 1950s inserted himself more fully into the local Roman artistic circles than did most of the many American artists who were there, produced assemblages and collages that seemed fully congruent with the place. The appropriateness of technique to subject is immediately obvious in a work like *Rome—1956*, a collage in the Whitney collection. As an Italian critic remarked, Meo's works, "made up of old sticks, pieces of hair-net, rusty nails, fragments of bottles and worn paper, make one think that a river in flood has deposited its relics there by chance." The association of this method and its result with Rome, its river and its history, hardly requires much metaphorical effort.[6]

If fragmentation is indeed "a clue to contemporary thinking," then Rome oddly becomes a most contemporary city. And indeed this new sense of reality, and of Rome's ability to express it, seems to have become almost a cliché by 1986, when the annual show at the academy included assemblages of contradictory scraps of posters and litter collected from the streets of Rome, already rubbed into a state of "ruin" by a few weeks of time, but preserved by the artist, instant archaeologist of his age. In case anyone might miss the point, these fragments dated 1985 were mounted on the courtyard wall in close proximity to the incoherent chunks of ancient Latin inscriptions permanently embedded there.

Distinctive solutions to the problem of dual representation are evident in works by three of the better-known artists to work in Rome in the last twenty-five years. Because of extended residence, two of these—Gregory Gillespie and Cy Twombly—obviously reflect a Roman experience to an extent unknown in American art history since the nineteenth century. Cy Twombly took up permanent residence in Rome in 1957 at the age of twenty-eight. In 1962 Gregory Gillespie, then only twenty-five, went to Florence on a Fulbright grant to study Masaccio; two years later he began a three-year fellowship at the American Academy in Rome and in 1969 was given a one-man show of his work at the academy. The third artist, Philip Pearlstein, spent 1958–59 in Italy on a Fulbright grant.

Although his Italian experience was much briefer and far less essential to his career than was that of Gillespie or Twombly, the drawings and paintings Pearlstein made of Positano and of the Palatine ruins of Rome have been said to mark a "major change" in the style of an artist who was moving from a variety of abstract expressionism toward the realism for which he has since become famous.[7] His large oil, *Palatine* (1961; fig. 32), like his other studies of these imperial ruins, is specifically Roman: the progressive stages of ruin rising from the superimposed arches of the palatial substructure seem finally to terminate in what appears to be the shapelessness of weathered natural rock, but is in fact the most vulnerable and exposed part of

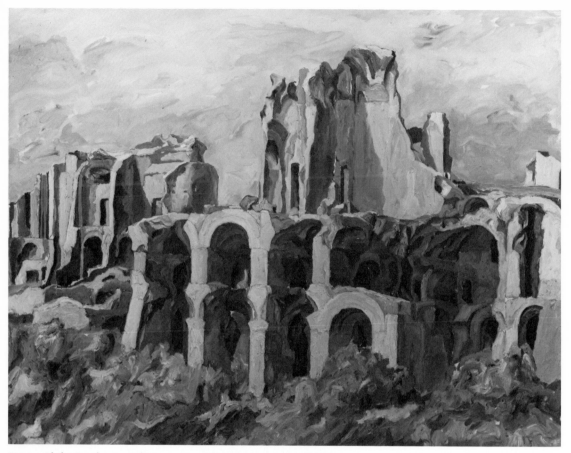

Fig. 32. Philip Pearlstein. *Palatine.* 1961. Oil on canvas. 54 × 70″. Exxon
Corporation. Photo courtesy Allan Frumkin Gallery, New York City.

the ancient imperial edifice. The lower parts (not even available to artists of earlier
centuries because they were still buried) retain a precise elegance of geometric form
that contrasts with the grotesque deformations of the higher walls. A third element,
a turbulence of trees, seems to wash up at the foundations, further destabilizing the
powerful and tragic structures that still rise into the Roman sky. The Palatine
paintings are unlike anyone else's in either subject or style; their resemblance to
Pearlstein's Positano series (in which, however, the drama shifts from the vul-
nerability and grandeur of manmade structures to the chaotic interplay of hues and
forms on the surfaces of cliffs) demonstrates how Pearlstein discovered that the
canvas-filling colors, shapes, and lines of abstract expressionism were available in
nature itself. An external "subject" neither destroyed the integrity of the painting as
such nor depersonalized the vision it expressed.

The critic Abram Lerner has observed that the importance of Italy for the works
of Gregory Gillespie is even evident in the materials and techniques employed—
gesso on wooden panels, "thin layers of paint glazed . . . to an adamantine finish,"
and the perspective grid of the Renaissance artists. The most arresting purely mod-

ern element, significantly, is the inclusion of fragments—in Gillespie's case frag-
ments of postcards or of photographs cut from newspapers and magazines, which
were then painted over or around and radically modified in the process. These in-
ternal secondary representations—mechanically reproduced realistic images serv-
ing the world of commerce and mass communications—are merely one means by
which the ambiguous nature of the "reality" a painting "represents" is manifested.
Ontological ambiguity actually constitutes the essential theme of all Gillespie's
works from his years in Italy, and it became even more pronounced after he moved
from the Tuscan countryside to the more unsettling urban environment of Rome.
As he once suggested in an interview, Gillespie found the rarified social atmosphere
of the academy itself somewhat alienating, but for a young artist who had been
raised in a Catholic home and was in a state of intense anti-Catholicism (what he
called an "impulse to sacrilege"), the close proximity of the Vatican was no doubt an
even more troubling challenge to his sense of modern reality.[8]

Gillespie's *Roman Landscape (Picnic)* (1963) shows three sunbathing nude fe-
males in three different postures (not poses): standing, sprawling, and crawling.
Apparently unconscious of each other, they share only the strange light that falls
upon them and the scruffy terrace on the edge of the Campagna. *A Street in Rome*
(1965) similarly shows three people walking in different directions within the sharp
perspective of a nondescript street. Like the nudes, they possess the naturalness of
the casually photographed figure, and they exist in an indefinite state of transition
between the photographs they "originally" were (one remove from the "actual"
people who were photographed) and the painted figures of high art toward which
Gillespie's interventions make them unwillingly aspire. More than the strange and
somewhat contrived *Picnic*, *Street in Rome* conveys the pathos of anonymity,
unrelatedness, and transience for people in an urban environment. These attributes
seem even more painful in *Three People in a Courtyard* (1966), in which the
imposed intimacy of the restricted space seems to have increased the tension of
psychic separation between the people. A disproportionate little doorway ("that's
really the way it looked," said Gillespie) seems to provide no exit: no one could pass
through it erect, and it apparently leads nowhere. "You know, in Italy everything
was strange; not everything made sense," added the artist.

When Gillespie moves us inside from terrace, street, or courtyard, the interior
space is no more reassuring. "In Rome I loved the trattorias," he said. "I used to hang
out in these places"—but not because they were "cheery"; on the contrary, he loved
them for their "melancholy quality." And that is what he conveyed in his starkly
confined interiors with stained walls, patched tablecloths, and usually no people—
only traces of human use. In one of these paintings, *Roman Interior (Still Life)*
(1966–67), a narrow cut through a deep rear wall offers a view of the Castel Sant'
Angelo ("actually" a postcard), which is partially obscured by a coffee can ("actu-
ally" an advertisement). In another painting, *Trattoria* (1966), the "traces" (as he
called them) of Gillespie's painting-over and cutting-out become part of the worn
texture of the trattoria, a texture modified by time and so expressive of the different
"realities" that succeed each other in the same place. Interiors that contain people
are not warmed by their presence; a female nude in profile strolling across a room
toward enigmatic objects, or one casually facing the viewer in total frontality while

a fully dressed woman stands slightly behind her, creates mysteries rather than narratives. The second of these paintings, in which the nude's pubic hair was fully painted in, in defiance of still-prevailing convention, was mutilated by some distressed viewer at an exhibition in Rome in 1965. Gillespie supposed the violation of a taboo was the cause, but the intensely strange atmosphere, not merely the sexual details, of these paintings might well evoke a protesting response to the anxious reality they represent, as much as to its representation.

Perhaps the most complex gathering of Gillespie's favored Roman images is *Exterior Wall with Landscape* (1967; fig. 33). Through a framed opening in the highly textured wall, on which are imprinted minute words and to which are attached flaking religious and architectural images, we can see into and through a dark interior whose dimensions strangely coincide with those of the window. The opposite end displays an "idyllic view." Objects of sexual and other less obvious significance and status are visible within the interior space, on its walls, and protruding from them. These include a tiny female nude whose breasts are attached to a sphere that displays a vulval orifice exuding a liquid that flows toward us and terminates in a pear-shaped sac/tear at the sill/threshold. On the exterior wall two more tiny nudes are imbedded in the painted stucco, along with an actual—not painted—arterial electric conduit (which disappears into a painted mouth) and various organic forms that derive, Gillespie suggested, from "our innards—gall bladder, liver, organs, organic life." Gillespie consciously opposed the "vulnerability of people" to the "cement environment" of Rome; yet when he said both that the organic forms are "buried" (and so dead?) in the wall and that they are "oozing" from it, since "the walls were alive to me," he more precisely indicated the effect of the painting. It suggests not opposition but rather ambiguous interaction and ongoing process. Far from being a joyous affirmation of harmony, this constitutes merely the realization of the symbiotic relation of a population to its built forms. These forms, when they are the long-inhabited forms of Rome, may be both oppressive and, in texture and color, beautiful. The real opposition in this painting is between the organic forms of urban reality and nature's idyllic landscape, dubious and diminished, yet also "there."

The idyllic view reminds us, of course, of the predominant interest of nineteenth-century painters. Gillespie alludes to this interest most strongly in *Roman Landscape (Periphery)* (1969), a painting that inevitably calls to mind some of those by George Inness. Just outside the ancient wall, which is visible below one of the great edifices on the edge of the city, a crowded accumulation of ancient cut stones, a small vineyard, a bit of the aqueduct, weedy vegetation, a few trees, and even two very large cows is offered as a "view" largely assembled from photographic fragments. In genre painting Gillespie less ironically recalls some of the nineteenth-century works representing the life of the people, especially of beggars and the poor (*Pawn Broker [Porto Portese]*, 1973). The great range of Gillespie's observation and sympathy in Rome made him a worthy successor, in a modern idiom of spiritual malaise, to those earlier artists of nudes, landscapes, streets—of the walls of Rome and of the people within. Gillespie made a kind of personal summation of his identification with the city in *Self-Portrait (Foro Romano)* (1969), in which the thirty-three-year-old artist's face, framed in the upper right, peers out from a

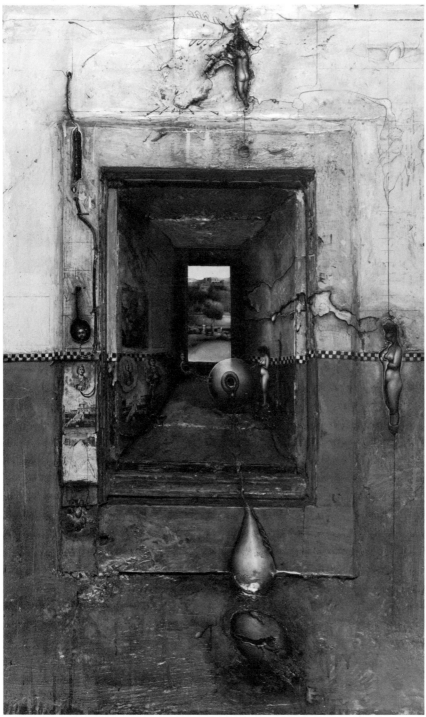

Fig. 33. Gregory Gillespie. *Exterior Wall with Landscape.* 1967. Mixed media. 38¼ × 23¾ × 4″. Hirshhorn Museum and Sculpture Garden, Smithsonian Institution. (See plate 9.)

uniquely Roman wall upon which checkered tablecloths from the trattorie seem to flow downward toward the imbedded bulging organic forms and sad nudes that give a surreal life to the fractured wall itself. At the top is the seal of the city of Rome, partly truncated but displaying its She-wolf with Romulus and Remus, its pyramid and campidoglio, its proud ancient SPQR, and its encircling Latin inscription. Down in the far right of the painting is the title's "realistic" counterpart to Gillespie's literalist representation of himself: the instantly identifiable postcard image of the Foro Romano with the Arch of Titus (where Healy, Church, and McEntee had painted *them*selves painting the Longfellows and the arch—see fig. I:15). This "eternal" image of the city requires its modern modes of survival and finds them first in the banality of the mass-produced postcard, which is here then personalized and retransmitted in the context of the symbolically rendered experience of a modern American artist, much of whose own identity emerged from his encounter with Rome, and so merged with that of the city.

But for no American painter or writer has the identification between city and artist been greater than for Cy Twombly, who has in the works of his thirty-year residence in Rome absorbed its pagan poetry and myths, its character as historical palimpsest, and its sexually charged, spiritually fragmented modern character. Except in the absence of a Roman Catholic dimension (but including a baroque exuberance of line), his work is an unintended but perhaps inevitable recapitulation of the themes that had attracted Americans throughout the nineteenth century as well as the new interests that attracted them after 1945. And for him too, as for Gillespie, an analogy between the canvas and the city necessarily exists. His scribbled graffiti signify the drama of human experience over time that inscribes itself upon a single place or space, in varying degrees of coherence and legibility, consisting of establishments and effacements, eruptions of passion and momentary harmonies, the body's instincts and the mind's analyses and measurements, idyllic dreams and brutal actualities. In many of his works the only instantly communicated message lies in the scrawled signature, the place, and the time: CY TWOMBLY ROMA————. The fortuitous echo of OM OM is sometimes exploited and the partial identity solidified through the further presence of the words ROME or ROMA within other words—FORMIAN, PROEM—that constitute the particular theme of a painting that is inescapably a "Twombly." Other names—VIRGIL or OVID—make the associations with these two so-contrasting poets of the Augustan city the "content" of the painting, even when (as is often the case) it is called *Untitled* because a title would be superfluous where a word is the subject.

So Twombly himself, Rome, and Rome's poets are the major protagonists of his works. But through them there are, necessarily, other presences. The gods are present, no longer as ideal images of the human body, but as strong forces still at work: and the chief three, as in the work of earlier Americans, are Venus and Apollo and Orpheus, the demigod poet who descended into Hades. The *Birth of Venus* (1963) is a wildly exuberant burst of genitalia from the sea, both frightening and comic; in other works the rational essence of Apollo and the anguish of Orpheus are conveyed through line or number or long flows of brilliant color. In some works the metamorphoses of Ovid, his interpenetrations of the natural, the human, and the divine, continue in the playful buoyancy of thrusting or flying phalli, unfolding

petals of flowers, or bubbles rising whimsically upward toward sketchily emergent clouds. More specific mythic narratives are condensed into essential moments which yet retain the marks of process toward climax and transformations through time; a new way is found, for instance, of evoking Leda and the Swan. Within the exclusively human arena of history Twombly investigated the ambiguity of heroic station, chiefly in the strange character of Emperor Commodus. The man to whose identification with Hercules Edwin Blashfield had devoted a single vast exercise in academic history painting (see fig. I:11) received from Twombly no fewer than nine difficult "discourses." Contemporary Romans with less lofty aspirations are "represented" in a crowded, sexually vibrant, messy, chaotic canvas (as disconcerting in detail as cheerful in large effect) called *The Italians* (1961; Museum of Modern Art, New York). Finally, the other indispensable presences in Twombly's work are, of course, his greatest predecessor artists in Rome, especially Raphael (there are now Twomblys too, that are named *The School of Athens* and *The Triumph of Galatea*) and Poussin, another *straniero* who in another age found a home and an identity in Vergil's Rome.

In the sequence of Twombly's Roman works one can find the partial summation of an experience much longer than his. The year after he arrived he finished a happy, harmonious work called *Arcadia*, but soon after he painted not only variations on "Virgilian Views" and tributes to Poussin but also a gothic *Crime of Passion*. There followed the investigations of pagan myths and human sexuality, and rangings outward from Rome to mountains and lakes. In the early eighties Twombly returned to Vergil in a series of canvases that begins with childishly, almost insanely, primitive drawings of a little carriage, above, beside, or below which drift feather-like, penlike phallic shapes; but the central subjects of these works are the *words* that dominate them: "ROMA, ANABASIS, VIR GILIAN / VIEW(S) / SYLVAE" and the dates, all of which appear in calligraphy as graceless as an obscene scrawl in a public place. These first works, "untitled" (because the work is its own title), undergo their own metamorphosis in later panels in which VIRGIL diminishes and XENOPHON begins to dominate. The series ends (if it does) in NIKE ANDROGYNE: the victory of sexual wholeness at the end of a journey upcountry. The series of works of 1982–83 that appears to have overlapped with this one and survived beyond it could hardly differ more, except that the words that supply the title (*Formian Dreams and Actuality*) are also scribbled onto the "sky" of the painting. In place of a child's wobbly carriage, the lower halves of these paintings are filled with powerful explosions of pale green, red, and dark blue over red, or sloping streaks and overlays of magenta, brown, and white. *Formian* may derive from Formia, a town of Latium, but it contains, inescapably, both the words *Form* and *Roman*. In the absence of Vergilian visionary views, Roman dreams of form find different realizations in other actualities.[9]

Alongside Cy Twombly's works of heroic scale, there exist various smaller "notes," such as the *Roman Note (no. 20)* of 1970 (fig. 34), a creation in gouache on paper. It appears, at first, like Rome itself: bewildering, a colorful but incoherent space of loops and lines, not to be "read" or "understood." But as one looks closer one sees what it is: exactly identical to itself, unique, and just what it claims to be. The letters are all there—Cy Twombly, Roman note—but they have become so

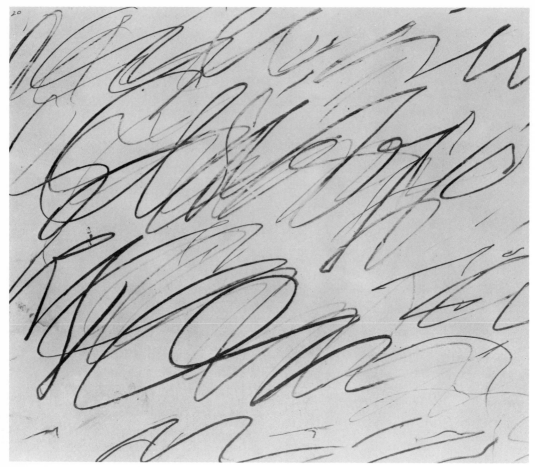

Fig. 34. Cy Twombly. *Roman Note (no. 20)*. 1970. Gouache on paper.
27½ × 34¼". By permission of the artist.

much one word, one thing, that their order, number, proportion, distribution, and size can be almost random within the larger single sign of a unified identity. This explicit and concrete note makes a claim that is justified only by Twombly's other works, but it refers to an act of possession that he has in fact achieved. His has been the latest and one of the most comprehensive and moving attempts in the two-century-old endeavor by American artists and writers to make Rome their own through the unselfish and yet self-identifying grasp of their art.

Notes

Preface

1. Norton, *Letters*, 1:349, 410.
2. H. James, *North American Review* 106 (Jan. 1868): 336; quoted in Woodress, *Howells*, p. 71.
3. H. James, *Story*, 1:125.

Chapter 1

INTRODUCTION; IL SANTISSIMO BAMBINO

1. Turnbull, *Genius of Italy*, pp. 31–32; 36, 27, 149–53.
2. J. Thayer, *Account*, pp. 6, 9, 10–11.
3. J. Thayer, *Account*, pp. 18–20, 25–27.
4. J. Thayer, *Account*, pp. 30, 32, 35.
5. W. Gillespie, *Rome*, pp. 49–53.
6. Turnbull, *Genius of Italy*, pp. 248–49.
7. Jarves, *Italian Sights*, p. 13.
8. N. Hawthorne, *Notebooks*, p. 75.
9. W. Gillespie, *Rome*, p. 53.
10. Story, *Roba di Roma* (8th ed.), 1:77–85.
11. Turnbull, *Genius of Italy*, p. 251.
12. Jarves, *Italian Sights*, p. 293.
13. Aldrich, "Ara Coeli," in Schauffler, *Through Italy*, pp. 224–25.
14. W. Gillespie, *Rome*, p. 56.
15. Turnbull, *Genius of Italy*, p. 251.

16. Story, *Roba di Roma* (8th ed.), 1:84, 83.
17. M. Howe, *Roma Beata*, pp. 159–62.
18. E. Clark, *Rome and a Villa*, pp. 249–50.
19. Stendhal, *Roman Journal*, p. 42.

SANTA MARIA MAGGIORE

1. Story, *Roba di Roma* (8th ed.), pp. 183–89.
2. N. Hawthorne, *Marble Faun*, pp. 54, 332, 296–99.
3. Ware, *Sketches*, pp. 209–11.
4. Jarves, *Art-Idea*, p. 89.
5. Jarves, *Italian Sights*, pp. 352–53.
6. Marsh, *Mediaeval and Modern Saints*, pp. 3, 124–51.
7. Norton, *Letters*, 1:144.
8. Norton, *Notes*, pp. 181–82, 13, 210, 231–41.
9. Norton, *Letters*, 2:209, 310.
10. E. Clark, *Rome*, pp. 212, 200, 212, 215, 217.
11. Norton, *Notes*, p. 203.
12. E. Clark, *Rome*, p. 217.

THE VATICAN: INTRODUCTION; ROME: CHRISTIANITY'S MISTAKE

1. J. F. Cooper, *Italy*, p. 233.
2. Ware, *Probus*, 1:61, 35–37, 199–20.
3. Ware, *Probus*, 2:13–14.

4. Ware, *Probus*, 2:59–87.
5. Stowe, *Agnes*, pp. 190–91, 80.
6. Stowe, *Agnes*, pp. 315, 153.
7. Stowe, *Agnes*, pp. 26, 315, 59, 53, 40.
8. Stowe, *Agnes*, pp. 102, 257, 223, 84–90.
9. Stowe, *Agnes*, pp. 342, 351–52, 363, 296.

PEN PORTRAITS OF POPES

1. Ticknor, *Life*, 1:173–74.
2. Theodore Dwight, *Journal*, pp. 320–21.
3. J. F. Cooper, *Italy*, pp. 235, 255.
4. Morse, *Letters and Journals*, 1:345, 339. Cf. Prime, *Morse*, pp. 198, 188.
5. Peale, *Notes on Italy*, pp. 170–73; Morse, *Letters and Journals*, 1:380–81.
6. Willis, *Pencillings*, pp. 313–15, 416–17.
7. England, *Works*, 4:150–53.
8. Auser, *Willis*, p. 46.
9. England, *Works*, 4:123–28.
10. Emerson, *Journals*, 4:155–57.
11. Cary, *Curtis*, p. 47; Curtis, *Early Letters*, p. 263. Cf. Marraro, "American Travellers," p. 477.
12. W. Gillespie, *Rome*, p. 93.
13. Ware, *Sketches*, pp. 61, 215–16.
14. Jarves, *Italian Sights*, p. 239.
15. Jarves, *Italian Sights*, pp. 225, 265.
16. Turnbull, *Genius of Italy*, pp. 235–36, 244, 251.
17. Kip, *Christmas Holydays*, pp. 60–61, 44, 53, 58–65, 66–67; Jarves, *Italian Sights*, p. 303.
18. Kip, *Christmas Holydays*, pp. 101–08.
19. Jarves, *Italian Sights*, pp. 284–302.
20. Jarves, *Italian Sights*, pp. 240–41, 251.

''PIO NONO, BELLO E BUONO''

1. See Marraro, "American Travellers in Rome 1848–50."
2. Freeman, *Gatherings . . . Rome*, p. 32.
3. N. Hawthorne, *Notebooks*, pp. 150–51.
4. Howells, *Italian Journeys*, p. 177.

5. Elliott, *Hecker*, pp. 251–77.
6. Cogley, *Catholic America*, p. 73.
7. Healy, *Reminiscences*, pp. 135–37; Freeman, *Gatherings . . . Rome*, pp. 129–30.
8. Story, *Castel Sant' Angelo*, pp. 197–99; Hawthorne, *Notebooks*, pp. 387–88.
9. D. M. Armstrong, *Day before Yesterday*, pp. 164–65, 163.
10. H. James, *Roderick Hudson*, p. 92; *Letters*, 1:164–65.
11. C. G. Leland, *Memoirs*, p. 383; *Breitmann Ballads*, pp. 214–21.
12. Hennessey, *First Council*, pp. 82, 174–75, 242.
13. Hennessey, *First Council*, pp. 31–32, 121–22, 229.
14. Hennessey, *First Council*, pp. 242, 275.
15. Norton, *Letters*, 1:379.
16. Elliott, *Hecker*, pp. 362–65.
17. Hennessey, *First Council*, pp. 318–24.
18. Freeman, *Gatherings . . . Rome*, p. 43.
19. Aldrich, *From Ponkapog*, pp. 73–115.
20. Shea, *Life of Pius*, pp. 4, 160–63.

''PRISONERS OF THE VATICAN''

1. Quoted in McAvoy, *History*, p. 317.
2. M. Howe, *Roma Beata*, pp. 78–80.
3. J. W. Howe, *Reminiscences*, pp. 125–26, 196–97, 425–26.
4. M. Howe, *Roma Beata*, pp. 90–93.
5. Pilkington, *Crawford*, pp. 142–47; Moran, *Crawford Companion*, pp. 89, 105.
6. F. M. Crawford, *Ave Roma* (1st ed.), 1:171–72, 2:53, 297.
7. M. Howe, *Roma Beata*, pp. 93–94.
8. F. M. Crawford, *Ave Roma* (rev. ed.), pp. 68–69.
9. F. M. Crawford, *Ave Roma* (1st ed.), 2:221–67.
10. Tarkington, "A Vatican Sermon," in Sweeney, *Vatican Impressions*, pp. 126–37.
11. Mencken, *Days*, pp. 143–49.

12. Dreiser, *Traveler*, pp. 371–72, 329–56, 344, 347–53.
13. A. E. Smith in Sweeney, *Vatican Impressions*, pp. 232–33.
14. Doherty, *House*, pp. 112–17.
15. Doherty, *House*, pp. 178–81, 138–41, 82.
16. Doherty, *House*, p. 92.
17. McCormick, *Vatican Journal*, pp. 3–15.
18. Collins, *My Italian Year*, pp. 194–95.
19. McCormick, *Vatican Journal*, pp. 16–24.
20. McCormick, *Vatican Journal*, pp. 67–81.
21. McCormick, *Vatican Journal*, pp. 98–104.
22. Booth, *Europe*, pp. 39–44.
23. McCormick, *Vatican Journal*, pp. 107, 122–27.
24. Sevareid, *Not So Wild a Dream*, pp. 415–16.
25. McCormick, *Vatican Journal*, pp. 119, 129–31, 134–36, 146–47.
26. E. Clark, *Rome*, pp. 211, 217–19.
27. E. Clark, *Rome*, p. 221.

CATHOLIC/ROMAN =
MODERN/MEDIEVAL =
JOHN/PAUL

1. Rynne, *Vatican Council*, p. 7.
2. Rynne, *Vatican Council*, p. 45; Kaiser, *Pope*, pp. 84–85.
3. Tracy, *American Bishop*, pp. 25–26.
4. McAfee, *Observer*, pp. 13–14; Horton, *Vatican Diary* (1963), pp. 5–6.
5. See, for example, Kaiser, *Pope*, p. 91.
6. Collinge, "Benediction," in Sweeney, *Vatican Impressions*, pp. 149–63.
7. Kaiser, *Pope*, pp. vii–x.
8. Franck, *Outsider*, pp. 19, 91.
9. Novak, *Open Church*, p. 38; Franck, *Outsider*, pp. 139–40.
10. Franck, *Outsider*, p. 147.
11. Novak, *Open Church*, pp. 304–06.
12. Rynne, *Vatican Council*, pp. 48–49; Brown, *Observor*, pp. 79–81; cf. Horton, *Vatican Diary* (1963), pp. 72–73.
13. Tracy, *American Bishop*, pp. 98, 157–58.

14. Tracy, *American Bishop*, p. 93.
15. Tracy, *American Bishop*, pp. 123, 174–76.
16. Blanshard, *Vatican II*, preface; pp. 147–49, 160.
17. Blanshard, *Vatican II*, pp. 47, 18–20, 33.
18. Blanshard, *Vatican II*, pp. 86–87, 94.
19. Blanshard, *Vatican II*, pp. 29, 51.
20. Blanshard, *Vatican II*, pp. 165, 346–47.
21. A. Greeley, *Making of the Popes*, pp. 128–31, 245.
22. A. Greeley, *Making of the Popes*, pp. 111–15, 162–65, 178.

TOWARD AN AMERICAN POPE

1. Robinson, *Cardinal*, p. 406.
2. Robinson, *Cardinal*, pp. 405, 458.
3. Robinson, *Cardinal*, pp. 19, 541, 561–62.
4. Robinson, *Cardinal*, pp. 300, 375, 381.
5. Robinson, *Cardinal*, pp. 314, 89, 309, 373, 383.
6. Robinson, *Cardinal*, pp. 309–11, 103, 542, 103, 506, 571, 576, 579.
7. Robinson, *Cardinal*, p. 567.
8. Murphy, *Vicar*, pp. 556–57.
9. Murphy, *Roman Enigma*, pp. 232–41.
10. Murphy, *Vicar*, pp. 263, 209–13.
11. Murphy, *Vicar*, pp. 212–13.
12. Murphy, *Vicar*, pp. 331, 355, 357–58.
13. Murphy, *Vicar*, pp. 515, 480, 327–28.
14. Murphy, *Vicar*, p. 364.
15. Murphy, *Vicar*, pp. 456, 560–61, 535, 568–69, 447.
16. Murphy, *Vicar*, pp. 570–72.
17. Murphy, *Vicar*, pp. 577–86.

Chapter 2

INTRODUCTION;
"THE LOWEST STAGE OF
DEGENERACY"

1. Tuckerman, *Italian Sketch Book* (1837 ed.), p. 19.
2. H. James, *Story*, 2:209.
3. Norton, *Letters*, 1:161, 144.
4. Holmes quoted in M. A. D. Howe,

Memories, p. 18; Hillard, *Six Months*, 1:160.

5. Hillard, *Six Months*, 1:281; W. Gillespie, *Rome*, p. 14; F. M. Crawford, *Ave Roma* (1898 ed.), 2:24.

6. Lowell, *Fireside Travels*, p. 288; Peale, *Notes*, p. 92.

7. Theodore Dwight, *Journal*, pp. 220–21.

8. Howells, *Italian Journeys*, pp. 152, 172; Warner, *Saunterings*, p. 189; Parkman, *Journals*, 1:178.

9. Sloan, *Rambles*, p. 302; Palgrave cited in O. E. D., s.v. "baroque"; Howells, *Italian Journeys*, p. 77.

"FREAKS IN MARBLE"

1. Sloan, *Rambles*, pp. 358–59.

2. Theodore Dwight, *Journal*, pp. 250–52; Hillard, *Six Months*, 1:307.

3. N. Hawthorne, *Notebooks*, p. 175.

4. N. Hawthorne, *Notebooks*, pp. 148–49. Cf. *Passages*, p. 143.

5. Jameson, *Legends*, p. 426.

6. Hare, *Walks*, 2:43–44; Taine, *Italy*, pp. 255–56.

7. F. M. Crawford, *Ave Roma* (1st ed.), 1:302–03; Taine, *Italy*, p. 256.

UNSEEN BEAUTY AND RARE DELIGHTS

1. Stendhal, *Roman Journal*, p. 82.

2. Hillard, *Six Months*, 2:26.

3. Peale, *Notes*, p. 90; Theodore Dwight, *Journal*, p. 245; Kirkland, *Holidays Abroad*, 1:283–84; Dewey, *Old World*, 2:74–75.

4. Taine, *Italy*, p. 202; H. P. Leland, *Americans in Rome*, p. 124.

5. Wölfflin, *Principles*, pp. 25, 53, 71.

6. N. Hawthorne, *Notebooks*, pp. 196–98, 228; Hillard, *Six Months*, 2:36.

7. N. Hawthorne, *Notebooks*, pp. 98–99; 95–96; S. Hawthorne, *Notes*, p. 223.

THE "CROSS-FIRE" OF CATHOLICISM

1. H. James, *Italian Hours*, pp. 77–78; H. Adams, *Mont-Saint-Michel*, p. 195.

2. Norton, *Letters*, 1:144; Turnbull, *Genius*, p. 255.

3. Howells, *Roman Holidays*, pp. 141–42.

4. Howells, *Roman Holidays*, p. 133; H. James, *Italian Hours*, pp. 281–82.

5. Greenwood, *Haps and Mishaps*, p. 280; J. F. Cooper, *Italy*, p. 254; Prime, *Morse*, pp. 198–99. Cf. Story, *Roba di Roma* (1887 ed.), 1:112–13; Warner, *Saunterings*, pp. 189–96; Parkman, *Journals*, 1:195–99; Dickens, *Pictures*, p. 206.

6. Willis, *Pencillings*, p. 423; Norton, *Letters*, 1:165; Jarves, *Italian Sights*, pp. 224, 240. Cf. J. W. Howe, *From the Oak*, pp. 50–60.

ST. PETER'S

1. J. F. Cooper, *Italy*, p. 190.

2. H. James, *Portrait*, 1:424–27; W. Gillespie, *Rome*, p. 19; de Staël, *Corinne*, 1:82; J. F. Cooper, *Italy*, pp. 191–92.

3. J. F. Cooper, *Italy*, p. 192; B. Taylor, *Views A-Foot*, p. 320.

4. Twain, *Innocents Abroad*, 1:280–86; Emerson, *Journals*, 4:155, 157.

5. Willis, *Pencillings*, p. 381; S. D. Greenough, *Lilian*, pp. 196–97. Cf. Fay, *Norman Leslie* (1869 ed.), pp. 338–39.

6. M. Howe, *Roma Beata*, p. 81.

7. B. Taylor, *Views A-Foot*, p. 320; Tuckerman, *Italian Sketch Book* (1837 ed.), p. 22; Hillard, *Six Months*, 1:172; M. Fuller, *Memoirs*, 2:310.

8. H. James, *Italian Hours*, pp. 207–11.

9. H. James, *Italian Hours*, p. 209. Cf. Stendhal, *Roman Journal*, p. 58; de Staël, *Corinne*, 1:91.

10. Howells, *Roman Holidays*, p. 130; Greenwood, *Haps and Mishaps*, p. 170.

11. H. James, *Italian Hours*, p. 209. Cf. Peale, *Notes*, pp. 95–96; Hillard, *Six Months*, 1:171–72.

12. F. M. Crawford, *Ave Roma* (1898 ed.), 2:304.

13. N. Hawthorne, *Notebooks*, p. 91.

"ONE SEES WHAT ONE BRINGS"

1. H. Adams, *Education*, pp. 386–87.
2. Wharton, *Italian Backgrounds*, pp. 180–89.
3. H. B. Fuller, *Gardens*, pp. 102–07.

Chapter 3

INTRODUCTION; THE POPE'S CHILDREN

1. M. Fuller, *Memoirs*, 2:264–65, 261.
2. Freeman, *Gatherings . . . Rome* (1883), pp. 130–31.
3. M. Fuller, *Memoirs*, 2:261–69; *At Home and Abroad*, pp. 380–421.
4. M. Fuller, *Memoirs*, 2:209–10, 239.
5. M. Fuller, *Memoirs*, 2:241, 227–29; *At Home and Abroad*, pp. 254–55.
6. M. Fuller, *At Home and Abroad*, pp. 248–49, 305–06.
7. M. Fuller, *At Home and Abroad*, pp. 326–27, 386–87.
8. M. Fuller, *At Home and Abroad*, pp. 262–63.
9. Lester, *My Consulship*, 2:195–206.
10. Lester, *My Consulship*, 2:214–15, 231–33, 250–56.
11. W. R. Thayer, *Dawn*, 2:17; 1:415.
12. Lester, *My Consulship*, 2:6–52.
13. Morse, *Letters*, 1:380–83; 2:37–38.
14. Dewey, *Old World*, 1:vii; 2:75, 152–53.
15. J. F. Cooper, *Italy*, pp. 244–47.
16. Sedgwick, *Letters from Abroad*, 2:170, 190, 211–15.
17. Sedgwick, *Letters from Abroad*, 2:164–65, 188–89.
18. Sedgwick, *Letters from Abroad*, 2:172–75, 179–82.
19. *United States Magazine and Democratic Review* 16 (Feb. 1845): 192.
20. W. M. Gillespie, *Rome*, pp. 192–205.
21. Kip, *Christmas Holydays*, pp. 300–02.
22. Headley, *Letters from Italy*, pp. vi, 124–28, 222–24.
23. Tuckerman, "Word for Italy," pp. 203–12.
24. Tuckerman, *Sketch Book* (1837 ed.), pp. 53–55, 270, 265–69, 272.
25. Tuckerman, *Sketch Book* (1848 ed.), pp. 9–14.
26. Tuckerman, *Sketch Book* (1848 ed.), pp. 414–15, 419, 423, 408.

TOWARD A "ROME OF THE PEOPLE"

1. Kirkland, *Holidays Abroad*, 1:vi; 2:10; 1:296.
2. Curtis, "Letter from Rome," pp. 145–46. See Cary, *Curtis*, pp. 45–47, and Marraro, "American Travellers," p. 477.
3. M. Fuller, *Memoirs*, 2:225.
4. Cranch, *Life and Letters*, p. 126. Cf. M. Fuller, *Memoirs*, 2:236; Story, *Roba di Roma*, 2:553.
5. Stillman, *Union of Italy*, pp. 121–22; Tuckerman, *Poems*, p. 158.
6. M. Fuller, *Memoirs*, 2:238, 241. See W. R. Thayer, *Dawn*, 2:256.
7. Kirkland, *Holidays Abroad*, 2:8–9. Cf. Story, *Roba di Roma*, 1:190.
8. Kirkland, *Holidays Abroad*, 2:48–53.
9. Cranch, *Life and Letters*, pp. 150, 159–60.
10. Cranch, *Bird and Bell*, pp. 13–15.
11. Tuckerman, *Book of the Artists*, p. 465.
12. M. Fuller, *Memoirs*, 2:345.
13. Norton, *Notes*, pp. 292–98.
14. Turnbull, *Genius of Italy*, pp. vii, 231–32.
15. Turnbull, *Genius of Italy*, pp. 257–74, viii–x.
16. Tuckerman, *Poems*, p. 159.
17. J. W. Howe, *Passion Flowers*, pp. 26–27.
18. Whittier, *Complete Poetical Works*, pp. 370–71, 375.
19. See Marraro, *American Opinion*, pp. 54–66.
20. G. W. Greene, *Historical Studies*, p. 463.
21. G. W. Greene, *Historical Studies*, pp. 246–51, 450–55.
22. M. Fuller, *Memoirs*, 2:209; *At Home and Abroad*, pp. 263–64.
23. M. Fuller, *At Home and Abroad*, pp. 268, 242–43, 276, 282, 297–99.

24. M. Fuller, *Memoirs*, 2:237; *At Home and Abroad*, pp. 350–53.

25. M. Fuller, *At Home and Abroad*, pp. 353–54; *Memoirs*, 2:252.

26. M. Fuller, *Memoirs*, 2:262–63, 266–67, 268.

27. M. Fuller, *At Home and Abroad*, p. 366.

28. M. Fuller, *At Home and Abroad*, pp. 225, 242, 268, 272.

29. M. Fuller, *At Home and Abroad*, pp. 280–81, 305.

30. M. Fuller, *At Home and Abroad*, pp. 307–08.

31. M. Fuller, *At Home and Abroad*, pp. 346–53.

32. M. Fuller, *At Home and Abroad*, pp. 357, 388.

33. M. Fuller, *At Home and Abroad*, pp. 306–08.

34. M. Fuller, *At Home and Abroad*, p. 418.

35. Theodore Dwight, *Roman Republic*, preface; Theodore Dwight, *Journal*, pp. 342–43.

36. Theodore Dwight, *Roman Republic*, pp. 32, vii–ix, 33–34.

37. Theodore Dwight, *Roman Republic*, pp. 32–33, 16, 34.

38. Theodore Dwight, *Roman Republic*, chs. 6 and 12.

39. Theodore Dwight, *Roman Republic*, pp. 61, 132.

40. Theodore Dwight, *Roman Republic*, pp. 136–37.

41. Theodore Dwight, *Roman Republic*, pp. 227, 239, 225–26, 239.

POLITICS OF THE
PICTURESQUE

1. Marraro, *American Opinion*, pp. 92–93.

2. Silliman, *A Visit*, 1:287, 271–72, 267.

3. H. Greeley, *Glances*, pp. 208–13, v.

4. Greenwood, *Haps and Mishaps*, pp. 191–92.

5. Greenwood, *Haps and Mishaps*, pp. 299, 201, 198, 243–47, 306.

6. See Matthiessen, *American Renaissance*, p. 603.

7. Stillman, *Autobiography*, 1:170–71; Matthiessen, *American Renaissance*, p. 613.

8. Tuckerman, *Book of the Artists*, pp. 217–21.

9. Story, *Roba di Roma* (1887 ed.), 1:5–8, iii–vii.

10. H. P. Leland, *Americans in Rome*, pp. 3–5.

11. Story, *Roba di Roma* (1887 ed.), 1:8–39.

12. H. P. Leland, *Americans in Rome*, pp. 26–34.

13. Story, *Roba di Roma* (1887 ed.), 1:30–33.

14. H. P. Leland, *Americans in Rome*, pp. 81, 88, 60–65.

15. [Murray], *Handbook to Central Italy: Rome* (1853 ed.), pp. 14, 86.

16. Perkins and Gavin, *Boston Athenaeum*, p. 20; Hendricks, *Bierstadt*, p. 57.

17. Story, *Roba di Roma* (1887 ed.), 2:420–24, 456–57.

18. Weir, *Robert W. Weir*, p. 21.

19. See Darley, "... illustrated by Darley," fig. 103, and Darley, *Sketches Abroad*, pp. 114, 124, 153.

20. Story, *Roba di Roma* (1887 ed.), 1:182.

21. Darley, "... illustrated by Darley," p. 2.

22. Taine, *Rome*, pp. 304, 104, 271–72, 283, 299–301, 267–70, 302–03.

23. Story, *Roba di Roma* (1887 ed.), 1:231, 38–39.

24. Story, *Roba di Roma* (1887 ed.), 2:548–51.

VISIBLE SIGNS OF OPPRESSION

1. Parker, *Life and Correspondence*, p. 404.

2. Sedgwick, *Letters*, 2:213–14; M. Fuller, *At Home and Abroad*, pp. 416–17.

3. Greenwood, *Haps and Mishaps*, pp. 176, 260; S. Hawthorne, *Notes*, pp. 241–42.

4. J. W. Howe, *Reminiscences*, pp. 122–

23; Bryant, *Letters of a Traveller* (2d ser.), p. 260; H. Greeley, *Glances*, p. 204; Weed, *Letters*, p. 567.

5. Arnold, *European Mosaic*, pp. 153–54, 232, 234–44, 221–29.

6. Greenwood, *Haps and Mishaps*, pp. 176–77.

7. Parkman, "A Convent in Rome," p. 450.

8. Parkman, *Letters*, 1:16; *Journals*, 1:180, 193.

9. Kirkland, *Holidays Abroad*, 2:6–7.

10. W. Gillespie, *Rome*, pp. 154–55.

11. Theodore Dwight, *Roman Republic*, p. 226; C. G. Leland, *Memoirs*, p. 385; Silliman, *Visit*, 1:337–38; Parker, *Life*, 2:377.

12. Story, *Roba di Roma* (1887 ed.), 1:58–63.

13. N. Hawthorne, *Marble Faun*, p. 267; Twain, *Innocents Abroad*, 1:269–70, 161.

14. W. R. Thayer, *Italica*, p. 209.

15. Jarves, *Italian Sights*, pp. 310–19; 332–37.

16. Story, *Roba di Roma* (1887 ed.), 1:52–56.

17. Story, *Roba di Roma* (1887 ed.), 1:57–59; H. Greenough, *Letters*, p. 375.

18. Kip, *Christmas Holydays*, p. 300.

19. Baedeker's *Handbook* (1909 ed.), p. xiv; Story, *Roba di Roma* (1887 ed.), 1:46–47, 56–57.

20. C. B. Fairbanks, *My Unknown Chum*, pp. 78–79.

21. Arnold, *European Mosaic*, p. 327.

22. Greenwood, *Haps and Mishaps*, pp. 175–76, 247–48.

23. Read, *Poetical Works*, 2:349.

24. Greenwood, *Haps and Mishaps*, p. 176.

25. Sedgwick, *Letters from Abroad*, 2:177.

26. J. R. Lowell, *Fireside Travels*, pp. 310–12.

27. N. Hawthorne, *Notebooks*, pp. 76–77; Darley, *Sketches Abroad*, p. 160; Cranch, *Life and Letters*, p. 235.

28. Story, *Roba di Roma* (1887 ed.),

1:41–46; cf. Hillard, *Six Months*, 2:28–29.

29. Greenwood, *Haps and Mishaps*, pp. 248–49.

30. Tuckerman, *Book of the Artists*, p. 416.

31. Tuckerman, *Book of the Artists*, p. 418.

32. Burnett, *Giovanni*, pp. viii, 120–21, 132–33.

33. Payne, "Anne Whitney: Art and Social Justice," pp. 245–60.

34. Quennell, *Colosseum*, pp. 90–91.

PALACE WALLS

1. H. James, *Story*, 1:360; Jarves, *Italian Sights*, p. 315; H. James, *Roderick Hudson*, p. 493.

2. H. James, *Golden Bowl*, 1:164, 42, 23, 9–10, 6, 12, 31; 2:250, 56–57.

3. H. James, *Portrait of a Lady*, 2:100–01.

4. N. Hawthorne, *Notebooks*, p. 194.

5. J. F. Cooper, *Italy*, pp. 227–32.

6. Willis, *Pencillings*, p. 386.

7. M. Fuller, *Memoirs*, 2:317.

8. H. James, *Italian Hours*, pp. 242–44.

9. Ticknor, *Life*, 2:343, 69, 75.

10. Quoted by Jacobs, "Diary of an Artist's Wife," p. 12.

11. Weir, *Robert W. Weir*, pp. 125–27.

12. Tuckerman, *Book of the Artists*, pp. 213–14; *Italian Sketch Book* (1837 ed.), p. 45.

13. Freeman, *Gatherings* (1877 ed.), pp. 70–72 and ch. 10.

14. Ticknor, *Life*, 2:71–72.

15. Sedgwick, *Letters from Abroad*, 2:186–88.

16. M. Fuller, *At Home and Abroad*, pp. 271–72.

17. Norton, *Notes*, pp. 44–48.

18. Greenwood, *Haps and Mishaps*, pp. 286–88.

19. Theodore Dwight, *Roman Republic*, p. 130.

20. Fraser, *Diplomatist's Wife*, 1:76–77.

21. Thackeray, *Vanity Fair*, ch. 64; Hillard, *Six Months*, 2:234–35.

22. J. W. Howe, *Reminiscences*, pp. 123–

24; see Tharp, *Three Saints*, pp. 116–18.

23. Freeman, *Gatherings . . . Rome* (1883), pp. 72–76.

24. C. G. Leland, *Memoirs*, pp. 126–27.

25. Greenwood, *Haps and Mishaps*, pp. 183–84, 236–38.

26. Kirkland, *Holidays Abroad*, 2:11.

27. M. Phillips, *Story*, pp. 92–93; H. James, *Story*, 1:155–57, 152.

28. H. James, *Story*, 1:251–53.

29. Cranch, *Life and Letters*, p. 187.

30. Cranch, *Life and Letters*, pp. 187–88.

31. H. James, *Story*, 1:254–55; letter of 1853 corrected from manuscript in Houghton Library as quoted by Ramirez, "A Critical Reappraisal," p. 226.

32. See Ramirez, "A Critical Reappraisal," p. 310, n. 106.

33. Cranch, *Life and Letters*, pp. 234–35, 238.

34. H. James, *Story*, 2:34–50.

35. Story, *Roba di Roma* (1887 ed.), 2:312; 1:223–24; 2:307.

36. Story, *Poems*, 1:187.

37. Story, *Poems*, 1:177–78.

38. Story, *Poems*, 1:78–104; H. James, *Story*, 2:219.

39. H. James, *Story*, 2:127.

40. Vedder, *Digressions*, pp. 371–72.

41. J. R. Lowell, *Letters*, 2:118.

THE LAST DAYS OF PAPAL ROME

1. Norton, *Letters*, 1:163–64.

2. Norton, *Notes*, pp. 70–74.

3. Vanderbilt, *Norton*, pp. 44–45.

4. Norton, *Notes*, pp. 163–65, 230, 94–95, 171.

5. Ticknor, *Life*, 2:348–49, 352–53.

6. Stillman, *Union of Italy*, p. 309.

7. Cranch, *Life and Letters*, p. 240.

8. H. Adams, *Education*, pp. 92–93.

9. Motley, *Correspondence*, 1:323.

10. Parker, *Life and Correspondence*, 2:377, 386, 378, 381.

11. Parker, *Life and Correspondence*, 2:403, 389, 386, 394.

12. Parker, *Life and Correspondence*, 2:403, 417.

13. Parker, *Life and Correspondence*, 2:385, 395, 432, 395.

14. Parker, *Life and Correspondence*, 2:373, 416, 436–37.

15. See Marraro, *Relazioni*, pp. 109–14, 280–85; Whittier, *Poetical Works*, 379–81; Norton, *Letters*, 1:237.

16. Fields, *Stowe*, pp. 255–56.

17. Tuckerman, *Italian Sketch Book* (1848 ed.), pp. 12–13; Ware, *Sketches*, pp. 204–05.

18. M. Fuller, *At Home and Abroad*, p. 243.

19. Turnbull, *Genius of Italy*, pp. 144–48.

20. Jarves, *Italian Sights*, pp. 343–46.

21. Stillman, *Union of Italy*, p. 393.

22. Stillman, *Autobiography*, 1:341–74.

23. Arnold, *European Mosaic*, pp. 250–51, 318–19, 323.

24. Twain, *Innocents Abroad*, pp. 274–80.

25. H. James, *Story*, 2:129–30.

26. Stillman, *Union of Italy*, pp. 331–32, 340–44.

27. H. James, *Letters* (Edel), 1:160; Norton, *Letters*, 1:370–72, 380–81, 384.

28. Quoted in Soria, *Vedder*, p. 66, from A. M. W. Stirling.

29. D. M. Armstrong, *Day before Yesterday*, pp. 170–77.

30. Hosmer, *Letters and Memories*, pp. 283–86.

31. Freeman, *Gatherings . . . Rome* (1883), p. 4.

32. Marraro, *Relazioni*, pp. 191–92, 194.

33. Bryant, *Prose*, 2:276–77; Howe in Marraro, *Relazioni*, pp. 112, 117, 301; see also *Unity of Italy*, p. 197.

CIVILIZATIONS OPPOSED

1. H. James, *Letters*, 4:266; Shelley, "Adonais," Stanzas 49–51.

2. Norton, *Letters*, 1:144.

3. Fraser, *Diplomatists' Wife*, 1:14; M. Howe, *Roma Beata*, p. 360.

4. Freeman, *Gatherings . . . Rome* (1883), pp. 138–41, 146–49.

5. H. James, *Letters*, 4:225, 260; *Story*, 1:6, 12, 16–18.

6. H. James, *Story*, 1:93–95.

7. H. James, *Story*, 1:108–09, 127–30; 2:53–55; 1:161–63, 245.

8. H. James, *Letters*, 1:331; *Story*, 1:341, 346, 331; 2:206–09.

9. H. James, *Story*, 2:209.

10. Fraser, *Diplomatist's Wife*, 1:vi–vii.

11. Fraser, *Italian Yesterdays*, 1:1.

12. Fraser, *Storied Italy*, p. 75; *Diplomatist's Wife*, 1:67.

13. Fraser, *Italian Yesterdays*, vol. 1, chs. 2 and 5.

14. Fraser, *Diplomatist's Wife*, 1:322–26.

15. Chanler, *Roman Spring*, pp. 12–16.

16. J. W. Howe, *From the Oak*, pp. 45–49.

17. J. W. Howe, *Reminiscences*, pp. 192–203; Tharp, *Three Saints*, pp. 166–79.

18. J. W. Howe, *Passion Flowers*, pp. 8–25.

19. J. W. Howe, *From the Oak*, pp. 49, 45.

20. Tharp, *Three Saints*, p. 299.

21. Richards and Elliott, *Howe*, pp. 344–53.

22. Whiting, *Magic Land*, p. 140.

23. Fraser, *Diplomatist's Wife*, 2:50–52; 1:63–65, 203.

24. Fraser, *Diplomatist's Wife*, 1:60–61, 29–30, 169–73.

25. Fraser, *Diplomatist's Wife*, 1:178, 330–37; 2:3–17; *Italian Yesterdays*, 2:70–107.

26. Fraser, *Diplomatist's Wife*, 2:22, 40–55.

27. M. Howe, *Roma Beata*, p. 85; Rusk, *Rinehart*, pp. 36–37.

28. Fraser, *Diplomatist's Wife*, 2:55–58, 83.

29. Fraser, *Diplomatist's Wife*, 2:83–87, 197–202.

30. B. Taylor in Marraro, *Relazioni*, pp. 302–04.

31. J. W. Howe, *From Sunset Ridge*, pp. 135–36, 140–41.

32. Chanler, *Roman Spring*, pp. 170–82.

33. Chanler, *Roman Spring*, pp. 214–24.

34. Plowden, *Haseltine*, pp. 117, 67, 97, 54–55, 118–19.

35. Plowden, *Haseltine*, pp. 117–20.

36. Chanler, *Roman Spring*, p. 20; Plowden, *Haseltine*, pp. 132–33.

THE REALITY OF ROMAN ROMANCE

1. F. M. Crawford, *With the Immortals*, pp. 85–86, quoted in Moran, *Crawford*, pp. 518–19.

2. Willis, *Dashes at Life*, pp. 123–30.

3. Hillard, *Six Months*, 1:234–39.

4. F. M. Crawford, "Roman Life and Character," pp. 57–58.

5. F. M. Crawford, *Sant' Ilario*, pp. 37–38.

6. F. M. Crawford, *Roman Singer*, pp. 26–27, 40–41.

7. F. M. Crawford, *Roman Singer*, pp. 179, 259.

8. F. M. Crawford, *Sant' Ilario*, pp. 2, 279–82.

9. F. M. Crawford, *Marzio's Crucifix*, pp. 2, 6–9, 14–15.

10. F. M. Crawford, *Marzio's Crucifix*, pp. 26–29.

11. F. M. Crawford, *Marzio's Crucifix*, p. 36.

12. F. M. Crawford, *Marzio's Crucifix*, pp. 67–69, 92–93, 116–17.

13. F. M. Crawford, *Marzio's Crucifix*, pp. 124–25, 194–95, 202, 206–07.

14. F. M. Crawford, *Pietro Ghisleri*, p. 52.

15. F. M. Crawford, *Cecilia*, p. 8.

16. F. M. Crawford, *Whosoever*, pp. 308, 324, 343, 156, 348.

17. F. M. Crawford, *Whosoever*, pp. 366–67, 309, 79.

18. F. M. Crawford, *Lady of Rome*, p. 89.

19. F. M. Crawford, *Casa Braccio*, 2:54; 1:36–39, 141; 2:147.

20. F. M. Crawford, *White Sister*, p. 11.

21. F. M. Crawford, *Don Orsino*, p. 239; *Lady of Rome*, pp. 356–58.

22. F. M. Crawford, *Pietro Ghisleri*, pp. 380, 424.

23. F. M. Crawford, *Sant' Ilario*, p. 434.

24. F. M Crawford, *Saracinesca*, pp. 1–7, 65–66.

25. F. M. Crawford, *Saracinesca*, pp. 54, 38, 152, 260.

26. See Fraser, *A Diplomatist's Wife*, 2:61, and Chanler, *Roman Spring*, p. 172.

27. Moran, *Crawford*, pp. 104, 106.

28. Quoted in Pilkington, *Crawford*, p. 60.

29. Quoted in Pilkington, *Crawford*, p. 60.

30. F. M. Crawford, *Don Orsino*, pp. 65–69.

31. F. M. Crawford, *Saracinesca*, pp. 62–63.

32. F. M. Crawford, *Saracinesca*, pp. 297–300, 64–67.

33. F. M. Crawford, *Saracinesca*, pp. 118–24, 228–34.

34. F. M. Crawford, *Saracinesca*, pp. 333, 413, 425–26, 441–43.

35. Quoted in Pilkington, *Fuller*, p. 82, from the *Chicago Record* of 1892.

36. M. Howe, *Crawford*, p. 187.

37. F. M. Crawford, *Don Orsino*, pp. 4–6.

38. F. M. Crawford, *Don Orsino*, pp. 135, 56, 413, 375.

39. F. M. Crawford, *Don Orsino*, pp. 137, 207, 47.

40. F. M. Crawford, *Don Orsino*, pp. 200, 253, 406, 296.

41. F. M. Crawford, *Don Orsino*, pp. 448, 49.

42. F. M. Crawford, *Don Orsino*, pp. 208–09, 399–400.

43. F. M. Crawford, *Don Orsino*, pp. 116–18.

44. F. M. Crawford, *Lady of Rome*, p. 11; *Cecilia*, pp. 99, 199.

45. F. M. Crawford, *Heart of Rome*, pp. 4, 2.

46. F. M. Crawford, *Heart of Rome*, pp. 392–94, 202, 206.

47. F. M. Crawford, *Heart of Rome*, pp. 29, 9, 12, 118.

48. F. M. Crawford, *Heart of Rome*, pp. 40–43, 132.

49. H. B. Fuller, *From the Other Side*, p. 95.

50. Moore, *Woolson*, p. 66; Woolson, *Front Yard*, pp. 137–93.

51. Pilkington, *Fuller*, pp. 36–41; H. B. Fuller, *Chevalier*, p. 54.

52. H. B. Fuller, *Chevalier*, pp. 56–57, 62–63.

53. Wilder, *Cabala*, pp. 47–48.

54. Goldstone, *Wilder*, pp. 47–48, 35–37.

55. Wilder, *Cabala*, pp. 34–36.

56. Wilder, *Cabala*, pp. 59–63, 109.

57. Wilder, *Cabala*, pp. 70–71, 83–104.

58. Wilder, *Cabala*, pp. 13, 9, 15, 113, 124, 11–12, 137–38.

59. Wilder, *Cabala*, pp. 11–12, 116, 78, 108.

60. Wilder, *Cabala*, pp. 39, 148, 29, 141–50.

61. Wilder, *Cabala*, pp. 29, 218–25.

62. Wilder, *Cabala*, pp. 13, 43, 225–30.

63. Harrison, *Enthusiast*, p. 44; Wilder, *Cabala*, p. 7.

64. Wilder, *Cabala*, p. 108.

ROME OF THE HOUSE OF SAVOY

1. Parsons, *Poems*, p. 182.

2. Burnett, *Giovanni*, pp. 149–51.

3. M. Howe, *Roma Beata*, pp. 50–54, 69–71.

4. M. Howe, *Roma Beata*, pp. 305–13; *American Artists*, p. 10.

5. M. Howe, *Roma Beata*, pp. 338–51, 297.

6. M. Howe, *Roma Beata*, pp. 270, 300.

7. Procacci, *History*, p. 141.

8. M. Howe, *Roma Beata*, p. 158; F. M. Crawford, *Ave Roma* (1898 ed.), 2:2; Chanler, *Roman Spring*, p. 20.

9. Whistler, *Whistler Journal*, p. 41.

10. Sedgwick, *Letters from Abroad*, 2:154; Silliman, *A Visit*, 1:347.

11. Langdon, "Recollections," pp. 503–07.

12. Stillman, *Autobiography*, 1:353–54; Plowden, *Haseltine*, pp. 101–02; Marraro, *Diplomatic Relations*, p. 65.

13. Plowden, *Haseltine*, pp. 101–03; Vedder quoted in Soria, *Vedder*, p. 105.

14. Langdon, "Recollections," pp. 503, 507.

15. Chanler, *Roman Spring*, pp. 9, 230, 146–47; M. Howe [Elliott], *Three Generations*, p. 159.

16. See Lears, *No Place of Grace*, pp. 184–215.

17. M. Armstrong, *Day before Yesterday*, pp. 217–19, 186.
18. Plowden, *Haseltine*, p. 103; Lowrie, *Fifty Years*.
19. Quoted in Valentine and Valentine, *American Academy*, p. 6.
20. Faulkner, *Sketches*, pp. 63–66, 120–21, 178.
21. *American Academy* (1920), p. 19; LaFarge, *American Academy* (1927), p. 5; Cortissoz, *Painter's Craft*, pp. 436–37.
22. Valentine and Valentine, *American Academy*, p. 52; Crowninshield, *Villa Mirafiori*, pp. 7, 56–59, 82–83, 97–99; Soria, *Dictionary*, p. 101.
23. Valentine and Valentine, *American Academy*, pp. 58–64.
24. LaFarge, *American Academy* (1927), pp. 13–21, 6.
25. Waddington, *Italian Letters*, p. 53.
26. Waddington, *Italian Letters*, p. 174.
27. Waddington, *Italian Letters*, pp. 273, 279.
28. Waddington, *Italian Letters*, pp. 96–97, 57, 170–71.
29. Waddington, *Italian Letters*, pp. 275, 244–46, 248, 266, 243–44.
30. Waddington, *Italian Letters*, pp. 247, 279, 239, 240, 238, 284, 256–57.
31. Whiting, *Italy*, pp. 3–4, 105, 221–22.
32. Whiting, *Italy*, pp. 198–99, 128, 136, 146–49.
33. Whiting, *Italy*, pp. 145, 166, 171, 204, 130, 173, 140, 179, 189–90.
34. Whiting, *Italy*, pp. 174–77, 67, 138, 118, 215, 159.
35. Stillman, *Old Rome and New*, pp. 1–24.
36. Stillman, *Union of Italy*, pp. 365–76, 382.
37. Stillman, *Autobiography*, 2:711–12, 725–26.
38. W. James, *Letters*, 2:139.
39. W. R. Thayer, *Letters*, pp. 121–22; W. James, *Letters*, 2:139.
40. W. R. Thayer, *Letters*, pp. 122–28; W. James, *Letters*, 2:228.
41. W. R. Thayer, *Italica*, pp. 199–229.
42. W. R. Thayer, *Italica*, pp. 307–46.
43. H. James, *Letters*, 4:449, 457; H. James, *Letters* (Lubbock ed.), 2:100. See Woodress, *Howells and Italy*, p. 195.
44. Norton, *Letters*, 2:410.
45. Howells, *Roman Holidays*, pp. 70–88.
46. Howells, *Roman Holidays*, pp. 125–26, 179–80, 193–94.
47. Howells, *Roman Holidays*, pp. 165–66, 190–92.
48. Howells, *Roman Holidays*, pp. 159–63.

AT THE ALTAR OF ITALY

1. E. R. Pennell, *Nights*, p. 29; E. R. Pennell, *Pennell*, 1:130–33, 2:97–98; J. Pennell, *Adventures*, pp. 157–58; J. Pennell, *Etchings*, pp. 213–14; J. Pennell, *Lithographs*, p. 75.
2. Fraser, *Storied Italy*, pp. 20–21, 26–27.
3. T. N. Page, *Italy*, pp. 211–15.
4. T. N. Page, *Italy*, pp. 232–33.
5. T. N. Page, *Italy*, p. 293.
6. T. N. Page, *Italy*, pp. 318–19.
7. Collins, *My Italian Year*, pp. vii–viii.
8. Collins, *My Italian Year*, pp. 10–11, 21.
9. Collins, *My Italian Year*, pp. 24–42.
10. Collins, *My Italian Year*, pp. 45–69.
11. Collins, *My Italian Year*, pp. 90–91, 172–73.
12. Collins, *My Italian Year*, pp. 194–200.
13. Collins, *My Italian Year*, pp. 235–36, 293–95, 305.
14. Collins, *My Italian Year*, pp. 148, 79.
15. Collins, *My Italian Year*, pp. 143–45.
16. Valentine and Valentine, *American Academy*, pp. 75–76.
17. Collins, *My Italian Year*, pp. 174, 117–21, 14, 175, 178.
18. On Buffalo Bill's visit: Chanler, *Roman Spring*, pp. 219–20, and Plowden, *Haseltine*, pp. 114–15; on Wright Brothers' visit: M. Howe, *Three Generations*, p. 335.
19. Dos Passos, *1919*, pp. 393–98.
20. Dos Passos, *1919*, pp. 402–05.

21. E. A. Mowrer, *Immortal Italy,* pp. 257–58.

22. L. T. Mowrer, *Journalist's Wife,* p. 88.

23. R. U. Johnson, *Remembered Yesterdays,* pp. 458–59, 462–63, 545, 557; R. U. Johnson, *Italian Rhapsody,* p. 23; Whiting, *Italy,* pp. 132–33.

24. R. U. Johnson, *Italian Rhapsody,* p. 37.

25. R. U. Johnson, *Remembered Yesterdays,* pp. 552, 563.

26. R. U. Johnson, *Remembered Yesterdays,* pp. 551, 577–79.

27. R. U. Johnson, *Remembered Yesterdays,* pp. 514, 554–56, 568–73.

28. R. U. Johnson, *Remembered Yesterdays,* p. 561.

29. Haight, *Italy,* chs. 1 and 6.

30. Haight, *Italy,* pp. 58, 61, 69.

31. R. U. Johnson, *Remembered Yesterdays,* pp. 546–48.

32. R. U. Johnson, *Remembered Yesterdays,* pp. 561–64.

33. Haight, *Italy,* pp. 65–67, 229.

34. E. A. Mowrer, *Immortal Italy,* pp. 1–4.

35. E. A. Mowrer, *Immortal Italy,* pp. 22–27, 38–44.

36. E. A. Mowrer, *Immortal Italy,* pp. 46–49.

37. E. A. Mowrer, *Immortal Italy,* pp. 62–63.

38. E. A. Mowrer, *Immortal Italy,* pp. 123, 140–42.

39. E. A. Mowrer, *Immortal Italy,* pp. 194–95, 230–32.

40. E. A. Mowrer, *Immortal Italy,* pp. 236, 240, 270.

41. E. A. Mowrer, *Immortal Italy,* pp. 398, 344, 359, 370–73.

42. E. A. Mowrer, *Immortal Italy,* pp. 382–83, 388–89, 396–98.

43. L. T. Mowrer, *Journalist's Wife,* pp. 76–78, 91, 165–68, 174–78.

MUSSOLINI'S BALCONY

1. Zapponi, *L'Italia di Ezra Pound,* pp. 48–55. Cf. Stock, *Pound,* pp. 306–07; Norman, *Pound,* pp. 314–15. Pound, *Cantos,* p. 202.

2. Wharton, *Collected Stories,* 2:837, 833.

3. Phelps, *Autobiography,* p. 548.

4. Beach, *Meek Americans,* pp. 183, 95–112.

5. Beach, *Meek Americans,* pp. 137–58.

6. Beach, *Meek Americans,* pp. 181–90.

7. Beach, *Meek Americans,* pp. 211–22.

8. Yourcenar, Afterword to *A Coin in Nine Hands,* pp. 172–73.

9. C. S. Cooper, *Understanding Italy,* pp. v–viii, 8.

10. C. S. Cooper, *Understanding Italy,* pp. 4, 15–18, 42–86.

11. Child, *Diplomat,* pp. 152–76.

12. Child, *Diplomat,* pp. 177–200.

13. Child, *Diplomat,* pp. 185, 226–27.

14. Child, *Diplomat,* pp. 208–11.

15. Child, *Diplomat,* pp. 215, 227.

16. Roberts, *I Wanted to Write,* pp. 176–79; on Roberts's pro-Fascist writings, see Diggins, *Mussolini,* pp. 16–19.

17. Child, Foreword to Mussolini, *My Autobiography,* pp. xi–xviii.

18. Seldes, *Tell the Truth,* pp. 179–200.

19. Steffens, *Letters,* 2:538–43.

20. Steffens, *Letters,* 2:618, 648, 679, 681.

21. Steffens, *Letters,* 2:681–82, 685.

22. Steffens, *Letters,* 2:954–55.

23. Steffens, *Autobiography,* pp. 812–25.

24. Tarbell, *All in the Day's Work,* pp. 376–83; Brady, *Tarbell,* pp. 238–41.

25. Steffens, *Letters,* 2:619; J. Davidson, *Between Sittings,* pp. 226–29.

26. Hearley, *Pope or Mussolini,* pp. 49, 80, 105–06, 17.

27. Hearley, *Pope or Mussolini,* pp. 107–10, 113–15.

28. McCormick, *Vatican Journal,* pp. 25–34.

29. McCormick, *Vatican Journal,* pp. 59–62, 78, 95–96.

30. McCormick, *Vatican Journal,* pp. 46–55.

31. Hearley, *Pope or Mussolini,* pp. 119–23.

32. Warren, preface to *All the King's Men* (1953 ed.), and Warren, "*All the*

King's Men: Matrix of Experience," pp. 161–67.

33. A. A. Davidson, *Eccentrics,* p. 171; Soby, "Peter Blume's *Eternal City,*" pp. 1–6.

34. J. Davidson, *Between Sittings,* p. 229.

35. W. Phillips, *Ventures,* pp. 120, 188, 192–93.

36. W. Phillips, *Ventures,* pp. 189–91, 207.

37. W. Phillips, *Ventures,* pp. 195, 199, 204–05, 207, 217.

38. W. Phillips, *Ventures,* pp. 213–15.

39. Whitaker, *We Cannot Escape,* pp. 54–56.

40. Whitaker, *We Cannot Escape,* pp. 56–59.

41. Massock, *Italy,* pp. 94–101.

42. Massock, *Italy,* pp. 104, 110, 120–21, 126–27, 161.

43. Matthews, *Education,* pp. 13–14.

44. Matthews, *Education,* pp. 202–03, 462–63.

45. Massock, *Italy,* p. 162; Packard, *Rome,* p. 8.

46. Massock, *Italy,* p. 113; R. and E. Packard, *Balcony,* pp. 3–5.

47. R. Packard, *Rome,* pp. 7, 11; cf. R. and E. Packard, *Balcony,* pp. 97–99.

48. R. Packard, *Rome,* pp. 10, 50–52; R. and E. Packard, *Balcony,* pp. 146–48; Massock, *Italy,* pp. 235–38.

49. Massock, *Italy,* pp. 113–14.

50. Massock, *Italy,* p. 179.

51. W. Phillips, *Ventures,* p. 236.

52. Matthews, *Education,* pp. 463–64.

53. R. and E. Packard, *Balcony,* pp. 103–04.

54. W. Phillips, *Ventures,* pp. 238–39.

55. R. Packard, *Rome,* p. 61; Massock, *Italy,* pp. 358–59.

56. W. Phillips, *Ventures,* p. 218.

57. Massock, *Italy,* pp. 185–86, 190, 197, 203–06.

58. Matthews, *World,* p. 128; W. Phillips, *Ventures,* pp. 261–64.

59. Welles, *Time,* pp. 77–82.

60. Welles, *Time,* pp. 83–89.

61. Welles, *Time,* pp. 143–47.

62. Booth, *Europe,* pp. 35–36.

63. Booth, *Europe,* pp. 48–61.

64. Massock, *Italy,* pp. 219–24.

65. Whitaker, *We Cannot Escape,* pp. 70–72. Cf. Massock, *Italy,* pp. 221–22.

66. Massock, *Italy,* pp. 225–27; R. and E. Packard, *Balcony,* pp. 123–25; Matthews, *Education,* p. 207.

67. Massock, *Italy,* pp. 227–28; W. Phillips, *Ventures,* pp. 279–81.

68. Matthews, *Education,* pp. 207–08.

69. W. Phillips, *Ventures,* pp. 295, 286, 315.

70. W. Phillips, *Ventures,* pp. 319–20, 293.

71. R. and E. Packard, *Balcony,* pp. 251–58; Massock, *Italy,* pp. 250, 294, 297–98, 326–34; R. Packard, *Rome,* p. 63.

72. W. Phillips, *Ventures,* pp. 294–96, 320; R. and E. Packard, *Balcony,* pp. 206–23, 290–91, 301–04; Massock, *Italy,* pp. 287–305.

73. R. and E. Packard, *Balcony,* pp. 279, 136–37.

74. W. Phillips, *Ventures,* pp. 301–02; Massock, *Italy,* pp. 314–15.

75. R. and E. Packard, *Balcony,* pp. 311–27; Massock, *Italy,* pp. 315–21; W. Phillips, *Ventures,* p. 324.

76. Massock, *Italy,* pp. 340, 343; R. and E. Packard, *Balcony,* pp. 327–28.

77. Massock, *Italy,* pp. 3–6; R. and E. Packard, *Balcony,* pp. 12–14; Matthews, *Education,* pp. 209, 464.

78. Matthews, *Education,* p. 209, Massock, *Italy,* pp. 345–51; R. and E. Packard, *Balcony,* pp. 334–38.

79. Sheean, *Between the Thunder and the Sun,* pp. 90–94.

ROME, "THE GREAT PRIZE"

1. Stock, *Pound,* pp. 392–98; Zapponi, *L'Italia di Ezra Pound,* pp. 62–63, 69.

2. Santayana, *Letters,* pp. 122, 191–92, 208–09, 221, 350.

3. Santayana, *My Host the World,* pp. 56, 119, 128, 131–32.

4. Tompkins, *A Spy in Rome,* pp. 40, 42, 48–49, 97.

5. Scrivener, *Inside Rome*, pp. viii, 2–6.
6. Scrivener, *Inside Rome*, pp. 7–14.
7. Scrivener, *Inside Rome*, pp. 15, 16, 28, 38.
8. Scrivener, *Inside Rome*, pp. 15, 31, 38–39, 61, 65, 176.
9. Scrivener, *Inside Rome*, pp. 187, 88–89, 154, 62–63.
10. Scrivener, *Inside Rome*, pp. 121–22, 161, 177.
11. Scrivener, *Inside Rome*, pp. 61, 64–65, 90, 68–69.
12. Matthews, *Education*, pp. 407–11.
13. Scrivener, *Inside Rome*, pp. 48–49, 60–61, 88–89.
14. Scrivener, *Inside Rome*, pp. 87–99, 103.
15. Tompkins, *A Spy in Rome*, pp. 66–67, 59–63, 152n., 50–51.
16. Tompkins, *A Spy in Rome*, pp. 54–55.
17. Tompkins, *A Spy in Rome*, pp. 85–96, 193–96.
18. Scrivener, *Inside Rome*, pp. 63–64.
19. See Katz, *Death in Rome*, for complete factual account.
20. Scrivener, *Inside Rome*, pp. 142–47.
21. Tompkins, *A Spy in Rome*, pp. 205–15.
22. Tompkins, *A Spy in Rome*, p. 158.
23. Scrivener, *Inside Rome*, pp. 157–58.
24. Scrivener, *Inside Rome*, pp. 155, 163, 166.
25. Scrivener, *Inside Rome*, pp. 121–22, 141, 151–53.
26. Scrivener, *Inside Rome*, pp. 148, 166, 167, 174–76, 180–81, 192.
27. Scrivener, *Inside Rome*, pp. 184–86, 191–94; Tompkins, *A Spy in Rome*, pp. 328–29.
28. M. Clark, *Calculated Risk*, pp. 357–64.
29. Sevareid, *Not So Wild*, pp. 408–10.
30. Bond, *Return to Cassino*, pp. 182–85.
31. Scrivener, *Inside Rome*, pp. 194–97.
32. Tompkins, *A Spy in Rome*, pp. 332–35.
33. Scrivener, *Inside Rome*, pp. 199–200.
34. Tompkins, *A Spy in Rome*, pp. 337–42.

35. Scrivener, *Inside Rome*, pp. 198–200.
36. Bond, *Return to Cassino*, pp. 188–91.
37. Bond, *Return to Cassino*, pp. 191–95.
38. Scrivener, *Inside Rome*, pp. 200–02.
39. Sevareid, *Not So Wild*, pp. 412–13.
40. M. Clark, *Calculated Risk*, pp. 365–67.
41. Sevareid, *Not So Wild*, pp. 413–14.
42. Bond, *Return to Cassino*, pp. 198–200.
43. Matthews, *Education*, pp. 451–68, 482.
44. Sevareid, *Not So Wild*, pp. 421–22; Mauldin, *Up Front*, pp. 163–64.
45. Sevareid, *Not So Wild*, pp. 422–24.
46. Heller, *Catch-22*, pp. 131–32, 240–41, 346–47.
47. Heller, *Catch-22*, pp. 396–409.
48. Hayes, *All Thy Conquests*, pp. 23–25, 231–35, 35.
49. Hayes, *All Thy Conquests*, pp. 68, 273.
50. Hayes, *All Thy Conquests*, pp. 7–19.
51. Hayes, *All Thy Conquests*, pp. 101–09.
52. Hayes, *All Thy Conquests*, pp. 193–204.
53. Hayes, *All Thy Conquests*, pp. 286–95.
54. Matthews, *Education*, pp. 476–81.
55. Matthews, *Education*, pp. 473–76.
56. Sevareid, *Not So Wild*, pp. 425–26.
57. Hayes, *Girl*, pp. 127, 123.
58. Hayes, *Girl*, pp. 40–41, 157, 195.
59. Hayes, *Girl*, pp. 108–09, 211, 207–08, 200–01.
60. Wilson, *Europe*, pp. 39–40.
61. Wilson, *Europe*, pp. 40–41, 216, 70–71.
62. Wilson, *Europe*, pp. 40–41, 56–58, 63.
63. Wilson, *Europe*, pp. 61–63.
64. Wilson, *Europe*, pp. 200–01.
65. Wilson, *Europe*, pp. 71–73.
66. Wilson, *Europe*, pp. 77–79.
67. Wilson, *Europe*, p. 95.
68. Wilson, *Europe*, pp. 202–06.
69. Wilson, *Europe*, pp. 206–07, 63.
70. Wilson, *Europe*, pp. 209–11.
71. Wilson, *Europe*, pp. 46–47, 51–52.
72. Wilson, *Europe*, pp. 211–12.

Chapter 4

INTRODUCTION; FICTIONS

1. Kazin, *Inmost Leaf*, pp. 79–80.
2. E. Clark, *Rome*, pp. 46–51.
3. Fiedler, *Collected Essays*, 1:91–108.
4. Fiedler, *Collected Essays*, 1:115–23.
5. Spencer, *Stories*, pp. 148, 187, 131.
6. Styron, *Set This House*, pp. 296–312.
7. T. Williams, *Roman Spring*, pp. 13–14, 33, 41.
8. Vidal, *Judgment*, pp. 5–6.
9. Vidal, *Judgment*, pp. 5, 19–20, 40–41, vii.
10. Malamud, *Pictures*, pp. 4–5, 12, 53.
11. Brodkey in M. Williams, *Roman Collection*, p. 197.
12. Spencer, *Stories*, pp. 152, 149, 125.
13. E. Clark, *Rome*, p. 18.
14. T. Williams, *Letters*, p. 207.
15. Schwartz, *Rough Strife*, pp. 51–52.
16. E. Clark, *Rome*, pp. 57, 59–60, 263–66, 274–75.
17. Garrett, *Wreath*, pp. 9–21.
18. Cheever, *Stories*, pp. 302–18.
19. Cheever, *Stories*, pp. 452–66.
20. Cheever, *Stories*, pp. 438–51.
21. Cheever, *Stories*, pp. 347–58.
22. Cheever, *Wapshot Scandal*, pp. 224–26.
23. E. White, *Nocturnes*, pp. 116–17.
24. Styron, *Set This House*, pp. 20–25.
25. Spencer, *Stories*, pp. 63–70.
26. W. Murray, *Americano*, pp. 124, 197.

POEMS

1. Hugo, *31 Letters*, p. 14.
2. Simpson, *North of Jamaica*, p. 277.
3. Simpson, *Adventures*, p. 67.
4. Francis, *Trouble*, pp. 110–17.
5. Francis, *Come Out*, pp. 24–25.
6. Garrett, *For a Bitter Season*, p. 21.
7. Merrill, *From the First Nine*, p. 57.
8. Koch, *Selected Poems*, pp. 60–63.
9. Swenson, *To Mix with Time*, pp. 39–40.
10. Hugo, *Good Luck*, p. 23.
11. Bloom, "The White Light," pp. 95–113.

12. Hollander, *Spectral Emanations*, pp. 90–91, 234.
13. J. Wright, *To a Blossoming Pear Tree*, pp. 11, 44–45.
14. J. Wright, *This Journey*, p. 15.
15. Gioia, *New Yorker*, 8 Aug. 1983, p. 40.
16. Moss, *New Yorker*, 13 June 1983, p. 46.
17. Wilbur, *Things*, pp. 49–50.
18. Hugo, *Good Luck*, p. 26.
19. M. Williams, *Boys*, p. 6.
20. Epstein in M. Williams, *Roman Collection*, pp. 262–65.
21. J. Wright, *This Journey*, p. 9.
22. Bagg, "Rome 1980," *New Boston Review*, March-April 1982, p. 14.
23. Bagg, *Madonna*, pp. 8–9.
24. Ciardi in M. Williams, *Roman Collection*, p. 90, from *For Instance*.
25. Starbuck in M. Williams, *Roman Collection*, p. 231, from *White Paper*.
26. Hecht, *Hard Hours*, pp. 100–101.
27. Stevens, *Collected Poems*, pp. 508–11.
28. Wilbur, *Things*, pp. 43–45.
29. Wilbur, *Responses*, p. 121.
30. J. Wright, *This Journey*, p. 16.
31. Hugo, *Good Luck*, p. 25.
32. Graham, *Erosion*, pp. 8–11.

PAINTINGS

1. Congdon, *In My Disc*, p. 2; Wittman, "Americans in Italy," pp. 292–93.
2. Facts from Gruskin, *Painter and His Techniques*.
3. Baur, *New Decade*, p. 64, where the painting is reproduced.
4. Baur, *New Decade*, p. 42; Goodrich, *Heliker*, pp. 6–16.
5. Quoted by Ashton, Introduction to *Greene*, n.p.
6. Quoted in *Salvatore Meo*, p. 12 (my translation).
7. Nochlin, in *Pearlstein*, n.p.
8. Facts and quotations, here and below, are from Lerner, *Gillespie*.
9. Sources for facts: Delehanty, *Twombly*; Twombly (Karsten Grave, 1984); Twombly (Hirschel and Adler, 1984).

Bibliography

In addition to works cited in the text and notes, a few books that have contributed in a more general way are included here. Standard reference works are not listed.

Abbott, Jacob. *Rollo's Tour in Europe: Rollo in Rome.* Boston: Brown, Taggard & Chase, 1858.

Adams, Henry. *The Education of Henry Adams.* 1908. Edited by Ernest Samuels. Boston: Houghton Mifflin, 1974.

———. *Mont-Saint-Michel and Chartres.* 1905. Boston: Houghton Mifflin, 1967.

Adelman, Robert H., and Colonel George Walton. *Rome Fell Today.* Boston: Little, Brown, 1968.

Aldrich, T. B. *From Ponkapog to Pesth.* Boston: Houghton Mifflin, 1883.

Allston, Washington. *Monaldi.* Boston: Charles C. Little and James Brown, 1841.

American Academy in Rome 1894–1914. New York: Privately printed, 1914.

American Art in the Newark Museum: Paintings, Drawings, and Sculpture. Newark: The Museum, 1981.

American Artists. East Lansing: Michigan State University Press, 1924.

American Paintings. Toledo, Ohio: Toledo Museum of Art, 1979.

Amfitheatrof, Erik. *The Enchanted Ground: Americans in Italy, 1760–1980.* Boston: Little, Brown, 1980.

Appleton, Thomas Gold. *Life and Letters of Thomas Gold Appleton.* Edited by Susan Hale. New York: D. Appleton, 1885.

Armstrong, David Maitland. *Day before Yesterday: Reminiscences of a Varied Life.* New York: Scribner's, 1920.

Arnold, Howard Payson. *European Mosaic.* Boston: Little, Brown, 1864.

Art and Archaeology 19 (February 1925). Special issue on American Academy in Rome.

Auser, Cortland P. *Nathaniel P. Willis.* New York: Twayne, 1969.

Baedeker, Karl. *Handbook for Travellers: Central Italy and Rome.* 15th rev. ed. New York: Scribner's, 1909.

Bagg, Robert. *Madonna of the Cello.* Middletown, Conn.: Wesleyan University Press, 1961.

———. "Rome 1980." *New Boston Review,* March-April 1982, p. 14.

Baker, Paul R. *The Fortunate Pilgrims: Americans in Italy 1800–1860.* Cambridge: Harvard University Press, 1964.

Banks, Oliver. *The Caravaggio Obsession*. Boston: Little, Brown, 1984.

Barrett, C. Walker. *Italian Influence on American Literature: An Address and a Catalogue of an Exhibition*. New York: Grolier Club, 1962.

Barthes, Roland. "Cy Twombly: Works on Paper." In *The Responsibility of Forms: Essays in Music, Art, and Representation*, pp. 157–76. Translated by Richard Howard. New York: Hill & Wang, 1985.

Baur, John I. H. *Modern American Art*. Cambridge, Mass.: Harvard University Press, 1951.

Baur, John I. H., ed. *New Art in America: 50 American Painters in the 20th Century*. New York: New York Graphic Society and Praeger, 1957.

Baur, John I. H., and Rosalind Irving. *The New Decade: 35 American Painters and Sculptors*. New York: Whitney Museum, 1955.

Beach, Joseph Warren. *Meek Americans*. Chicago: University of Chicago Press, 1925.

Beers, Henry Augustine. *Nathaniel Parker Willis*. Boston: Houghton Mifflin, 1885.

Bishop, John Peale. *The Collected Poems of John Peale Bishop*. Edited by Allen Tate. New York: Scribner's, 1948.

Blanshard, Paul. *Paul Blanshard on Vatican II*. Boston: Beacon Press, 1966.

Bloom, Harold. "The White Light of Trope: An Essay on John Hollander's 'Spectral Emanations.'" *Kenyon Review*, n.s. 1 (1979): 95–113.

Bond, Harold L. *Return to Cassino*. Garden City, N.Y.: Doubleday, 1964.

Booth, Clare. *Europe in the Spring*. New York: Knopf, 1940.

Brady, Kathleen. *Ida Tarbell: Portrait of a Muckraker*. New York: Seaview/Putnam, 1984.

Brooks, Van Wyck. *The Dream of Arcadia: American Writers and Artists in Italy 1760–1915*. New York: Dutton, 1958.

Brown, Robert McAfee. *Observer in Rome: A Protestant Report on the Vatican Council*. Garden City, N.Y.: Doubleday, 1964.

Bryant, William Cullen. *Letters of a Traveller*. 2d ser. New York: Appleton, 1859.

———. *Letters of William Cullen Bryant*. Edited by W. C. Bryant II and Thomas G. Voss. 3 vols. New York: Fordham University Press, 1975.

———. *Prose Writings*. Edited by Parke Godwin. 2 vols. 1884. New York: Russell & Russell, 1964.

Buckley, Charles. *Peter Blume: Paintings and Drawings in Retrospect 1925–1964*. Manchester, N.H.: Currier Gallery of Art, 1964.

Burnett, Frances Hodgson. *Giovanni and the Other: Children Who Have Made Stories*. New York: Scribner's, 1892.

Calvert, George H. *Scenes and Thoughts in Europe*. 1st ser. 2 vols. Boston: Little, Brown, 1863.

Campell, William P. *John Gadsby Chapman*. Washington, D.C.: National Gallery of Art, 1962.

Cary, Edward. *George William Curtis*. Boston: Houghton Mifflin, 1894.

Chamberlain, Georgia S. *Studies on John Gadsby Chapman: American Artist 1808–1889*. Alexandria, Va.: N.p., 1963.

Champney, Benjamin. *60 Years' Memories of Art and Artists*. Woburn, Mass.: Wallace & Andrew, 1900.

Chanler, Mrs. Winthrop [Margaret Terry]. *Roman Spring: Memoirs*. Boston: Little, Brown, 1934.

Cheever, John. *The Stories of John Cheever*. New York: Knopf, 1978.

———. *The Wapshot Scandal*. New York: Harper & Row, 1963.

Child, Richard Washburn. *A Diplomat Looks at Europe*. New York: Duffield & Co., 1925.

———. Foreword to *My Autobiography by Benito Mussolini.* New York: Scribner's, 1928.

Ciardi, John. *As If: Poems New and Selected.* New Brunswick, N.J.: Rutgers University Press, 1955.

Clark, Eleanor. *Rome and a Villa.* Garden City, N.Y.: Doubleday, 1952.

Clark, Mark. *Calculated Risk.* New York: Harper & Brothers, 1950.

Cogley, John. *Catholic America.* New York: Dial Press, 1973.

Collins, Joseph. *My Italian Year: Observations and Reflections in Italy during the Last Year of the War.* New York: Scribner's, 1919.

Congdon, William. *In My Disc of Gold.* New York: Reynal, 1962.

Cooper, Clayton Sedgwick. *Understanding Italy.* New York: Century, 1923.

Cooper, James Fenimore. *Gleanings in Europe: Italy.* 1838. Edited by John Conron and Constance Ayers Denne. Albany: State University of New York Press, 1981.

Cortissoz, Royal. *The Painter's Craft.* New York: Scribner's, 1930.

Cranch, Christopher Pearse. *The Bird and the Bell, with Other Poems.* Boston: J. R. Osgood, 1875.

———. *Life and Letters of Christopher Pearse Cranch.* By Leonora Cranch Scott. Boston: Houghton Mifflin, 1917. Reprint. New York: AMS, 1969.

Crawford, Francis Marion. *Ave Roma Immortalis: Studies from the Chronicles of Rome.* 2 vols. New York: Macmillan, 1898. Rev. ed. 1 vol. 1902.

———. *Casa Braccio.* 2 vols. New York: Macmillan, 1895.

———. *Cecilia: A Story of Modern Rome.* New York: Macmillan, 1902.

———. *Don Orsino.* New York: Macmillan, 1892.

———. *The Heart of Rome: A Tale of the "Lost Water."* London: Macmillan, 1903.

———. *A Lady of Rome.* New York: Macmillan, 1906.

———. *Marzio's Crucifix.* New York: Macmillan, 1887.

———. *The Novel: What It Is.* New York: Macmillan, 1893.

———. *Pietro Ghisleri.* New York: Macmillan, 1893.

———. "Roman Life and Character." *Fortnightly Review* 44, n.s. 38 (July 1885): 56–66.

———. *A Roman Singer.* 1884. New York: Macmillan, 1893.

———. *Sant' Ilario.* New York: Macmillan, 1889.

———. *Saracinesca.* New York: Macmillan, 1887.

———. *The White Sister.* New York: Macmillan, 1909.

———. *Whosoever Shall Offend.* New York: Macmillan, 1904.

———. *With the Immortals.* New York: Macmillan, 1888.

Crawford, Mary. See Fraser, Mrs. Hugh.

Crowninshield, Frederic. *Villa Mirafiore.* Boston: Houghton Mifflin, 1912.

Curtis, George William. *Early Letters of George William Curtis to John S. Dwight.* Edited by G. W. Cooke. New York: Harper & Brothers, 1898.

———. "Letter from Rome." *Harbinger* 4 (13 February 1847): 145–46.

Darley, Felix O. C. ". . . *illustrated by Darley.*" Wilmington: Delaware Art Museum, 1978.

———. *Sketches Abroad with Pen & Pencil.* New York: Hurd & Houghton, 1868.

Davidson, Abraham A. *The Eccentrics and Other American Visionary Painters.* New York: E. P. Dutton, 1978.

Davidson, Jo. *Between Sittings.* New York: Dial Press, 1951.

Deiss, Joseph Jay. *The Roman Years of Margaret Fuller.* New York: Thomas Y. Crowell, 1969.

Delehanty, Suzanne. *Cy Twombly: Paintings, Drawings, Constructions 1951–1974.* Philadelphia: University of Pennsylvania, Institute of Contemporary Art, 1975.

DeLima, Sigrid. *Oriane.* New York: Harcourt, Brace & World, 1968.

———. *Praise a Fine Day.* New York: Random House, 1959.

De Staël, Madame. *Corinne; or Italy.* 1807. Translator anonymous. 2 vols. London: Dent & Co., 1894.

Dewey, Orville. *The Old World and the New.* 2 vols. New York: Harper's, 1836.

Dickens, Charles. *Pictures from Italy.* 1846. Edited by David Paroissien. London: Andre Deutsch, 1973.

Diggins, John P. *Mussolini and Fascism: The View from America.* Princeton: Princeton University Press, 1972.

Doherty, Martin W. *The House on Humility Street: Memories of the North American College in Rome.* New York: Longmans, Green, 1942.

[Dorr, David F.] *A Colored Man Round the World, By a Quadroon.* Cleveland [?], Ohio: Privately printed, 1858.

Dos Passos, John. *1919.* 1932. New York: Washington Square, 1961.

Dreiser, Theodore. *A Traveler at Forty.* New York: Century, 1913.

[Dwight, Theodore.] *A Journal of a Tour in Italy in the Year 1821. By an American.* New York: Printed for the author, 1824.

———. *The Roman Republic of 1849 with Accounts of the Inquisition and the Siege of Rome.* New York: R. Van Dien, 1851.

Earnest, Ernest. *Expatriates and Patriots: American Artists, Scholars, and Writers in Europe.* Durham: University of North Carolina Press, 1968.

Eliasoph, Philip. *Paul Cadmus: Yesterday and Today.* Oxford, Ohio: Miami University Art Museum, 1981.

Elliott, Maud Howe. See Howe, Maud.

Elliott, Walter. *Life of Father Hecker (1819–1888).* New York: Columbus Press, 1891.

Emerson, Ralph Waldo. *The Complete Works of Ralph Waldo Emerson.* Edited by Edward Waldo Emerson. Vols. 5 and 9. Cambridge, Mass.: Riverside Press, [1903–04].

———. *The Journals and Miscellaneous Notebooks of Ralph Waldo Emerson.* Vol. 4. Edited by Alfred R. Ferguson. Cambridge, Mass.: Harvard University Press, 1964.

———. *The Journals and Miscellaneous Notebooks of Ralph Waldo Emerson.* Vol. 10. Edited by Merton M. Sealts. Cambridge, Mass.: Harvard University Press, 1973.

———. *The Letters of Ralph Waldo Emerson.* Edited by Ralph L. Rusk. New York: Columbia University Press, 1939.

England, John. "Letters from Rome." In *The Works of the Right Rev. John England,* edited by I. A. Reynolds, 4:122–49. Baltimore: John Murphy, 1849.

Fairbanks, Charles Bullard. *My Unknown Chum: "Aguecheek."* Edited by Henry Garrity. New York: Devin-Adair Co., 1923.

Faulkner, Barry. *Sketches from an Artist's Life.* Dublin, N.H.: William Bauhan, 1973.

Fay, Theodore S. *Norman Leslie: A New York Story.* New York: G P. Putnam, 1869.

———. *Norman Leslie: A Tale of the Present Times.* 2 vols. New York: Harper, 1835.

Fiedler, Leslie A. *Collected Essays of Leslie Fiedler.* 2 vols. New York: Stein & Day, 1971.

Fielding, Mantle. *Dictionary of American Painters, Sculptors and Engravers.* 1965. Enl. and rev. ed. Green Farms, Conn.: Modern Books and Crafts, 1974.

Fields, Annie. *Life and Letters of Harriet Beecher Stowe.* Boston: Houghton Mifflin, 1897.

Francis, Robert. *Come Out into the Sun: Poems New and Selected.* Amherst: University of Massachusetts Press, 1965.

———. *The Trouble with Francis.* Amherst: University of Massachusetts Press, 1971.

Franck, Frederick. *Outsider in the Vatican.* New York: Macmillan, 1965.

Fraser, Mrs. Hugh [Mary Crawford]. *A Diplomatist's Wife in Many Lands.* 2 vols. New York: Dodd, Mead, 1911.

———. *Gianella.* St. Louis: B. Herder, 1909.

———. *Italian Yesterdays.* New York: Dodd, Mead, 1913.

———. *Storied Italy.* New York: Dodd, Mead, 1915.

Freeman, James E. *Gatherings from an Artist's Portfolio.* New York: D. Appleton, 1877.

———. *Gatherings from an Artist's Portfolio in Rome.* Boston: Roberts Brothers, 1883.

Fuller, Henry B. *The Chevalier of Pensieri-Vani.* 2d ed. Boston: J. G. Cupples, 1891.

———. *From the Other Side: Stories of Transatlantic Travel.* Boston: Houghton Mifflin, 1898.

———. *Gardens of This World.* New York: Knopf, 1929.

———. *Waldo Trench and Others: Stories of Americans in Italy.* New York: Scribner's, 1908.

Fuller, Margaret [Ossoli]. *At Home and Abroad, or, Things and Thoughts in America and Europe.* Edited by Arthur B. Fuller. 1856. Reprint. Port Washington, N.Y.: Kennikat Press, 1971.

———. *Memoirs of Margaret Fuller Ossoli.* Edited by J. F. Clarke, R. W. Emerson, and W. H. Channing. 2 vols. Boston: Phillips, Sampson, 1852.

———. *The Writings of Margaret Fuller.* Edited by Mason Wade. New York: Viking, 1941.

Garrett, George. *For a Bitter Season.* Columbia: University of Missouri Press, 1967.

———. *A Wreath for Garibaldi and Other Stories.* London: Rupert Hart-Davis, 1969.

Gebbia, Alessandro. *Città teatrale: Lo spettacolo a Roma nelle impressioni dei viaggiatori americani 1760–1870.* Rome: Officina Edizioni, 1985.

Gettlein, Frank. *Peter Blume.* New York: Kennedy Galleries, 1968.

[Gillespie, William Mitchell]. *Rome as Seen by a New Yorker in 1843–4.* New York: Wiley & Putnam, 1845.

Gioia, Dana. "The Garden in the Campagna." *New Yorker,* 8 August 1983, p. 40.

Goldstone, Richard H. *Thornton Wilder: An Intimate Portrait.* New York: Saturday Review Press, 1975.

Goodrich, Lloyd. *John Heliker.* New York: Whitney Museum, 1968.

Goodrich, Lloyd, and John I. H. Baur. *American Art of Our Century.* New York: Praeger, 1961.

Graham, Jorie. *Erosion.* Princeton: Princeton University Press, 1983.

Greeley, Andrew M. *The Making of the Popes, 1978.* Kansas City: Andrews & McNeel, 1979.

Greeley, Horace. *Glances at Europe.* New York: Dewitt & Davenport, 1851.

Greene, George Washington. *Historical Studies.* New York: Putnam, 1850.

Greene, Stephen. *Stephen Greene: A Retrospective Exhibition of Paintings and Drawings.* Introduction by Dore Ashton. Washington, D.C.: Corcoran Gallery of Art, 1963.

Greenough, Sarah Dana [Loring]. *Lilian.* Boston: Ticknor & Fields, 1863.

Greenwood, Grace [Mrs. Sara Lippincott]. *Haps and Mishaps of a Tour in Europe.* Boston: Ticknor, Reed, & Fields, 1854.

Gruskin, Alan D. *The Painter and His Techniques: William Thon.* New York: Viking, 1964.

Haight, Elizabeth H. *Italy Old and New.* New York: Dutton, 1922.

Hamilton, James A. *Reminiscences of James A. Hamilton.* New York: Scribner's, 1869.

Harding, Jonathan P., and Harry L. Katz. *The Boston Athenaeum Collection: Pre–Twentieth Century American and European Painting and Sculpture.* Boston: Northeastern University Press, 1984.

Hare, Augustus. *Walks in Rome*. 4th ed. London: W. Isbiter, 1974.

Harrison, Gilbert A. *The Enthusiast: A Life of Thornton Wilder*. New Haven: Ticknor & Fields, 1983.

Hawthorne, Julian. *Nathaniel Hawthorne and His Wife*. 2 vols. Boston: Osgood, 1884.

Hawthorne, Nathaniel. *The French and Italian Notebooks*. Edited by Thomas Woodson. Centenary ed. Columbus: Ohio State University Press, 1980.

———. *The Marble Faun*. 1860. Centenary ed. Columbus: Ohio State University Press, 1968.

———. *Passages from the French and Italian Notebooks*. Vol. 10 of *The Works of Nathaniel Hawthorne*, edited by George Parsons Lathrop. Boston: Houghton Mifflin, 1883.

Hawthorne, Sophia Amelia Peabody. *Notes in England and Italy*. New York: Putnam, 1869.

Hayes, Alfred. *All Thy Conquests*. New York: Howell, Soskin, 1946.

———. *The Girl on the Via Flaminia*. New York: Harper & Brothers, 1949.

———. *The Temptation of Don Volpi*. New York: Atheneum, 1960.

Headley, Joel T. *Letters from Italy*. New York: Wiley & Putnam, 1845.

Healy, G. P. A. *Reminiscences of a Portrait Painter*. Chicago: N.p., 1894.

Hearley, John. *Pope or Mussolini*. New York: Macaulay, 1929.

Hecht, Anthony. *The Hard Hours*. New York: Atheneum, 1975.

———. *Millions of Strange Shadows*. New York: Atheneum, 1977.

Heller, Joseph. *Catch-22*. 2d ed. New York: Simon & Schuster, 1961.

Hendricks, Gordon. *Albert Bierstadt: Painter of the American West*. Fort Worth: Amon Carter Museum, 1972.

Hennessey, James. *The First Council of the Vatican: The American Experience*. New York: Herder & Herder, 1963.

Hersey, John. *The Conspiracy*. New York: Knopf, 1972.

Heyen, William, ed. *American Poets in 1976*. Indianapolis: Bobbs-Merrill, 1976.

Hillard, George Stillman. *Six Months in Italy*. 2 vols. Boston: Ticknor, Reed & Fields, 1853.

Hollander, John. *Spectral Emanations: New and Selected Poems*. New York: Atheneum, 1978.

Horton, Douglas. *Vatican Diary 1963: A Protestant Observes the Second Session of the Vatican Council II*. Philadelphia: United Church Press, 1964.

———. *Vatican Diary 1965: 4th Session of the Vatican Council II*. Philadelphia: United Church Press, 1966.

Hosmer, Harriet. *Harriet Hosmer: Letters and Memories*. Edited by Cornelia Carr. New York: Moffat, Yard, 1912.

Howard, Richard. *Alone with America: Essays on the Art of Poetry in the United States since 1950*. Enl. ed. New York: Atheneum, 1980.

Howe, Julia Ward. *From Sunset Ridge: Poems Old and New*. Boston: Houghton Mifflin, 1898.

———. *From the Oak to the Olive: A Plain Record of a Pleasant Journey*. Boston: Lea & Shepard, 1868.

[———]. *Passion Flowers*. Boston: Ticknor, Reed & Fields, 1854.

———. *Reminiscences 1819–1899*. Boston: Houghton Mifflin, 1900.

Howe, Mark Anthony DeWolfe. *Memories of a Hostess*. Boston: Atlantic Monthly Press, 1922.

Howe [Elliott], Maud. *My Cousin, Marion Crawford*. New York: Macmillan, 1934.

———. *Roma Beata: Letters from the Eternal City*. Boston: Little, Brown, 1904.

———. *Three Generations.* Boston: Little, Brown, 1923.

Howells, William Dean. *Italian Journeys.* 1872. Rev. ed. Boston: James R. Osgood, 1877.

———. *Roman Holidays and Others.* New York: Harper & Brothers, 1908.

Hughes, H. Stuart. *The United States and Italy.* Rev. ed. Cambridge, Mass.: Harvard University Press, 1965.

Hugo, Richard. *Good Luck in Cracked Italian.* New York: World, 1969.

———. *31 Letters and 13 Dreams.* New York: Norton, 1977.

Hull, Raymona E. *Nathaniel Hawthorne: The English Experience 1853–1864.* Pittsburgh: University of Pittsburgh Press, 1950.

Hunter, Sam. *American Art of the 20th Century.* New York: Abrams, 1972.

Jackson, W. G. F. *The Battle for Rome.* New York: Scribner's, 1969.

Jacobs, Phoebe. "Diary of an Artist's Wife: Mrs. George Loring Brown in Italy, 1840–1841." *Archives of American Art* 14, no. 1 (1974): 11–16.

James, Henry. *Daisy Miller.* 1879. New York ed. New York: Scribner's, 1909.

———. *The Golden Bowl.* 1904. 2 vols. New York ed. New York: Scribner's, 1909.

———. *Italian Hours.* 1909. Reprint. New York: Horizon Press, 1968.

———. *Letters.* 4 vols. Edited by Leon Edel. Cambridge, Mass.: Harvard University Press, 1974–84.

———. *Letters of Henry James.* Edited by Percy Lubbock. New York: Scribner's, 1920.

———. *The Portrait of a Lady.* 1881. New York ed. 2 vols. New York: Scribner's, 1908.

———. *Roderick Hudson.* 1875. New York ed. New York: Scribner's, 1908.

———. "Taine's Italy." *Nation* 6 (7 May 1868): 373–75.

———. *William Wetmore Story and His Friends.* 2 vols. Boston: Houghton Mifflin, 1903.

James, William. *Letters of William James.* Edited by Henry James. 2 vols. London: Longmans, Green, 1920.

Jameson, Anna. *Legends of the Monastic Orders.* 1850. Edited by Estelle M. Hurll. Boston: Houghton Mifflin, 1896.

Jarves, James Jackson. *The Art-Idea.* 1864. Reprint. Cambridge: Harvard University Press, 1960.

———. *Italian Sights and Papal Principles Seen through American Spectacles.* New York: Harper & Brothers, 1855.

Johnson, Robert Underwood. *Italian Rhapsody and Other Poems of Italy.* New York: Published by the author, 1917.

———. *Remembered Yesterdays.* Boston: Little, Brown, 1923.

Kaiser, Robert Blair. *Pope, Council and World: The Story of Vatican II.* New York: Macmillan, 1963.

Katz, Robert. *Death in Rome.* New York: Macmillan, 1967.

Kazin, Alfred. *The Inmost Leaf.* New York: Harcourt, Brace, 1955.

Keeley, Edmund. *The Imposter.* Garden City, N.Y.: Doubleday, 1970.

Kip, William Ingraham. *The Christmas Holydays in Rome.* New York: D. Appleton, 1845.

Kirk, Clara Marburg. *W. D. Howells and Art in His Time.* New Brunswick, N.J.: Rutgers University Press, 1965.

Kirkland, Caroline Matilda. *Holidays Abroad: or, Europe from the West.* New York: Baker & Scribner, 1849.

Kirstein, Lincoln. *Paul Cadmus.* New York: Rizzoli, 1984.

Koch, Kenneth. *Selected Poems 1950–1982.* New York: Random House, 1985.

LaFarge, Christopher Grant. *The American Academy in Rome.* New York: N.p., 1920, 1927.

Langdon, William Chauncy. "Recollections of Rome during the Italian Revolution." *Atlantic Monthly* 52 (October 1883): 503–07; 52 (November 1883): 658–64; 52 (December 1883): 746–53.

Lathrop, Rose Hawthorne. *Memories of Hawthorne.* Boston: Houghton Mifflin, 1897.

Lears, T. J. Jackson. *No Place of Grace: Antimodernism and the Transformation of American Culture 1880–1920.* New York: Pantheon, 1981.

Leland, Charles Godfrey. *Etruscan Roman Remains in Popular Tradition.* London: T. Fisher Unwin, 1892.

———. *Hans Breitmann's Ballads.* Boston: Houghton Mifflin, 1914.

———. *Memoirs.* New York: D. Appleton, 1893.

Leland, Henry P. *Americans in Rome.* New York: Charles T. Evans, 1863.

Lerner, Abram. *Gregory Gillespie.* Exhibition catalogue. Hirshhorn Museum. Washington: Smithsonian, 1977.

Lester, Charles Edwards. *My Consulship.* 2 vols. New York: Cornish, Lamport, 1853.

Lewis, Sinclair. *Dodsworth.* New York: Harcourt, Brace, 1929.

Loeb, Harold. *The Way It Was.* New York: Criterion, 1959.

Lowell, James Russell. *Fireside Travels.* 1864. 15th ed. Boston: Houghton Mifflin, 1888.

———. *Letters of James Russell Lowell.* Edited by C. E. Norton. 2 vols. New York: Harper & Brothers, 1894.

Lowell, Robert. *Life Studies.* New York: Farrar, Straus & Cudahy, 1959.

Lowenthal, David. *George Perkins Marsh.* New York: Columbia University Press, 1958.

Lowrie, Walter. *Fifty Years of St. Paul's American Church: Rome.* Rome: N.p., 1926.

Lyman, Theodore. *The Political State of Italy.* Boston: Wells & Lilly, 1820.

Lynn, Kenneth S. *William Dean Howells: An American Life.* New York: Harcourt Brace Jovanovich, 1971.

Malamud, Bernard. *Pictures of Fidelman: An Exhibition.* New York: Farrar, Straus & Giroux, 1969.

Mariani, Andrea. "William Wetmore Story's *Roba di Roma:* The Sculptor's Prose as Painting." *Studi Anglo-Americani* 3 (1984–85): 123–31.

Marraro, Howard R. *American Opinion on the Unification of Italy 1846–1861.* Italian Historical Society ed. New York: Columbia University Press, 1932.

———. "American Travelers in Rome 1848–50." *Catholic Historical Review* 29 (4 January 1944): 470–509.

———. *Diplomatic Relations between the United States and the Kingdom of the Two Sicilies.* New York: S. F. Vanni, 1951.

———. *Relazioni fra l'Italia e gli Stati Uniti.* Rome: Edizioni dell'Ateneo, 1954.

———. "Rome and the Catholic Church in Eighteenth-Century American Magazines." *Catholic Historical Review* 32 (July 1946): 157–89.

Marsh, Caroline Crane, ed. *George Perkins Marsh: Life and Letters.* New York: Scribner's, 1888.

[Marsh, George Perkins]. *Medieval and Modern Saints and Miracles.* New York: Harper's, 1876.

Massock, Richard. *Italy from Within.* New York: Macmillan, 1943.

Matthews, Herbert L. *Education of a Correspondent.* New York: Harcourt, Brace, 1946.

———. *A World in Revolution.* New York: Scribner's, 1971.

Matthiessen, F. O. *American Renaissance: Art and Expression in the Age of Emerson and Whitman.* New York: Oxford University Press, 1941.

Mauldin, Bill. *Up Front.* New York: Holt, 1945.

Maves, Carl. *Sensuous Pessimism: Italy in the Work of Henry James.* Bloomington: Indiana University Press, 1973.

McAfee, Robert Brown. *Observer in Rome: A Protestant Report on the Vatican Council.* Garden City, N.Y.: Doubleday, 1964.

McAvoy, Thomas T. *A History of the Catholic Church in the United States.* Notre Dame, Ind.: University of Notre Dame Press, 1969.

McCarthy, Mary. *Birds of America.* New York: Harcourt Brace Jovanovich, 1965.

McCormick, Anne O'Hare. *Vatican Journal 1921–1954.* Edited by Marion Turner Sheehan. New York: Farrar, Straus & Cudahy, 1957.

McInerny, Ralph. *Romanesque.* New York: Harper & Row, 1978.

McNamara, Robert F. *The American College in Rome 1855–1955.* Rochester, N.Y.: Christopher Press, 1956.

Mellow, James R. *Nathaniel Hawthorne in His Times.* Boston: Houghton Mifflin, 1980.

Mencken, H. L. *The Days of H. L. Mencken.* New York: Knopf, 1947.

Meo, Salvatore. *Salvatore Meo: Mostra Antologica: Assemblages e disegni 1945–1971.* Rome: Galleria Ciak, 1971.

Merrill, James. *From the First Nine: Poems 1946–1976.* New York: Atheneum, 1982.

Moore, Rayburn S. *Constance Fenimore Woolson.* New York: Twayne, 1963.

Moran, John C. *An F. Marion Crawford Companion.* Westport, Conn.: Greenwood Press, 1981.

Morse, Samuel F. B. *Samuel F. B. Morse: His Letters and Journals.* Edited by Edward Lind Morse. 2 vols. Boston: Houghton Mifflin, 1914.

Moss, Howard. "Rome: The Night Before." *New Yorker,* 13 June 1983, p. 46.

Motley, John Lathrop. *The Correspondence.* Edited by G. W. Curtis. 2 vols. New York: Harper's, 1889.

Mowrer, Edgar Ansel. *Immortal Italy.* New York: D. Appleton, 1922.

———. *Triumph and Turmoil: A Personal History of Our Times.* New York: Weybright & Talley, 1968.

Mowrer, Lilian T. *A Journalist's Wife.* New York: Morrow, 1937.

Mumford, Lewis. *My Works and Days: A Personal Chronicle.* New York: Harcourt Brace Jovanovitch, 1979.

Murphy, Walter F. *The Roman Enigma.* New York: Macmillan, 1981.

———. *The Vicar of Christ.* New York: Macmillan, 1979.

[Murray, John, pub.]. "Rome and Its Environs." Part 2 of *Handbook for Travellers in Central Italy.* 3d ed. London: John Murray, 1853.

Murray, William. *The Americano.* New York: New American Library, 1968.

———. *Italy: The Fatal Gift.* New York: Dodd, Mead, 1982.

Naylor, Maria. *National Academy of Design Exhibition Records 1861–1900.* 2 vols. New York: Kennedy Galleries, 1973.

Neville, Robert. *The World of the Vatican.* New York: Harper & Row, 1962.

Newlin, Frederic. *Etchings and Lithographs of Arthur B. Davies.* New York: Mitchell Kennerley, 1929.

The New Yorker *Book of War Pieces.* New York: Reynal & Hitchcock, 1947.

Nochlin, Linda. *Philip Pearlstein.* Exhibition catalogue. Athens: University of Georgia Museum of Art, 1970.

Norman, Charles. *Ezra Pound.* Rev. ed. London: Macdonald, 1969.

Norton, Charles Eliot. *Letters of Charles Eliot Norton.* Edited by Sara Norton and M. A. DeWolfe Howe. 2 vols. Boston: Houghton Mifflin, 1913.

———. *Notes of Travel and Study in Italy.* Boston: Ticknor & Fields, 1859.

Novak, Barbara. *American Painting of the Nineteenth Century.* New York: Praeger, 1969.

———. *Nature and Culture: American Landscape and Painting 1825–1875.* New York: Oxford University Press, 1980.

Novak, Michael. *The Open Church: Vatican II, Act II.* New York: Macmillan, 1964.

———. *The Tiber Was Silver.* Garden City, N.Y.: Doubleday, 1961.

Ormond, Richard. *John Singer Sargent: Paintings—Drawings—Watercolors.* New York: Harper & Row, 1970.

Packard, Reynolds. *Rome Was My Beat.* Secaucus, N.J.: Lyle Stuart, 1975.

Packard, Reynolds, and Eleanor Packard. *Balcony Empire.* New York: Oxford University Press, 1942.

Page, Giorgio Nelson, *L'Americano di Roma.* Milan: Longanesi, 1950.

Page, Thomas Nelson. *Italy and the World War.* New York: Scribner's, 1920.

Parker, Theodore. *Life and Correspondence.* 1864. Edited by John Weiss. 2 vols. Reprint. New York: Arno, 1969.

Parkman, Francis. "A Convent in Rome." *Harper's New Monthly Magazine* 81 (August 1890): 448–54.

———. *Journals of Francis Parkman.* 2 vols. Edited by Mason Wade. New York: Harper & Brothers, 1947.

———. *Letters of Francis Parkman.* Edited by Wilbur R. Jacobs. 2 vols. Norman: University of Oklahoma Press, 1960.

Parsons, Thomas William. *Poems.* Boston: Houghton Mifflin, 1893.

Patterson, Annabel, ed. *Roman Images.* Selected Papers from the English Institute, n.s. no. 8. Baltimore: Johns Hopkins University Press, 1984.

Payne, Elizabeth Rogers. "Anne Whitney, Art and Social Justice." *Massachusetts Review* 12 (1971): 245–60.

———. "Anne Whitney, Sculptor." *Art Quarterly* 25 (Autumn 1962): 244–61.

Peale, Rembrandt. *Notes on Italy Written during a Tour in the Year 1829 and 1830.* Philadelphia: Carey & Lea, 1831.

Pennell, Elizabeth Robins. *Life and Letters of Joseph Pennell.* Boston: Little, Brown, 1929.

———. *Nights.* Philadelphia: Lippincott, 1916.

Pennell, Joseph. *Adventures of an Illustrator.* Boston: Little, Brown, 1925.

———. *Catalogue of the Etchings of Joseph Pennell.* Edited by Louis A. Wuerth. Boston: Little, Brown, 1928.

———. *Catalogue of the Lithographs of Joseph Pennell.* Edited by Louis A. Wuerth. Boston: Little, Brown, 1931.

Perkins, Robert F., Jr., William J. Garvin III, and Mary M. Shaughnessy, eds. *The Boston Athenaeum Art Exhibition Index, 1827–1874.* Cambridge: MIT Press, 1980.

Peterson, Roy Merel. "Echoes of the Italian Risorgimento in Contemporary American Writers." *PMLA* 47 (March 1932): 220–40.

Phelps, William Lyon. *Autobiography.* New York: Oxford University Press, 1939.

Phillips, Mary E. *Reminiscence of William Wetmore Story.* Chicago and New York: Rand McNally, 1897.

Phillips, William. *Ventures in Diplomacy.* Boston: Privately printed, 1952.

Pilkington, John, Jr. *Francis Marion Crawford.* New York: Twayne, 1964.

———. "F. Marion Crawford: Italy in Fiction." *American Quarterly* 6 (1954): 59–65.

———. *Henry Blake Fuller.* New York: Twayne, 1970.

Pine-Coffin, R. S. *Bibliography of British and American Travel in Italy to 1860.* Florence: Leo S. Olschki, 1974.

Pinto Surdi, Alessandra. *Americans in Rome, 1764–1870: A Descriptive Catalogue of the Exhibition Held in the Palazzo Antici Mattei* Rome: Centro Studi Americani, 1984.

Plowden, Helen Haseltine. *William Stanley Haseltine: Sea and Landscape Painter.* London: F. Muller, 1947.

Pound, Ezra. *The Cantos of Ezra Pound.* London: Faber & Faber, 1981.

Preyer, Robert O. "Breaking Out: The English Assimilation of Continental Thought in Nineteenth-Century Rome." *Browning Institute Studies* 12 (1984): 53–72.

Prezzolini, Giuseppe. *Come gli Americani Scoprirono l'Italia: 1750–1850.* 1933. Exp. ed. Bologna: Boni, 1971.

Prime, S. I. *The Life of Samuel F. B. Morse.* New York: D. Appleton, 1875.

Procacci, Giuliano. *History of the Italian People.* Translated by Anthony Paul. New York: Harper & Row, 1970.

Protestant Cemetery in Rome. *Il Cimitero Acattolico di Roma.* Rome: Esse Gi Esse, 1982.

Quennell, Peter. *The Colosseum.* New York: Newsweek, 1971.

Quick, Michael. *American Expatriate Artists: Painters of the Late Nineteenth Century.* Exhibition catalogue. Dayton, Ohio: Dayton Art Institute, 1976.

Ramirez, Jan Seidler. "A Critical Reappraisal of the Career of William Wetmore Story (1819–1895), American Sculptor and Man of Letters." Ph.D. diss., Boston University, 1985.

Read, Thomas Buchanan. *The Poetical Works.* 3 vols. Philadelphia: J. B. Lippincott, 1866.

Richards, Laura E., and Maud Howe Elliott. *Julia Ward Howe: A Life and Letters.* 2 vols. Boston: Houghton Mifflin, 1916.

Richardson, Edgar P., and Otto Wittmann. *Travelers in Arcadia: American Artists in Italy, 1830–1875.* Detroit: Detroit Institute of Art, 1951.

Rivas, Michele. *Les Écrivains anglais et americains a Rome et l'image litteraire de la societé romaine contemporaine de 1800 à 1870.* Paris: Université de la Sorbonne Nouvelle, Atelier National de Reproduction des Thèses, 1979.

Roberts, Kenneth. *I Wanted to Write.* Garden City, N.Y.: Doubleday, 1949.

Robinson, Henry Morton. *The Cardinal.* New York: Simon & Schuster, 1950.

"Rome, as Seen by a New Yorker." [Review of W. M. Gillespie.] *U.S. Magazine and Democratic Review* 16 (February 1845): 192–93.

"Rome in the Carnival: A Leaf from the Journal of an American in Europe." *Knickerbocker* 17 (1841): 314–20.

Rorem, Ned. *The Final Diary.* New York: Holt, Rinehart & Winston, 1974.

———. *The New York Diary.* New York: George Braziller, 1967.

———. *The Paris Diary of Ned Rorem.* New York: George Braziller, 1966.

Rose, Barbara. *American Art since 1900.* Rev. and exp. ed. New York: Praeger, 1975.

Rusk, William S. *William Henry Rinehart, Sculptor.* Baltimore: Norman T. R. Munder, 1939.

Rustengberg, Leona. "Documents: Margaret Fuller's Roman Diary." *Journal of Modern History* 12 (1940): 209–70.

Rynne, Xavier. *Vatican Council II.* Rev. and cumulative ed. New York: Farrar, Straus & Giroux, 1968.

Salomone, A. W. "The 19th Century Discovery of Italy: An Essay in American Cultural History; Prolegomena to a Historiographical Problem." *American Historical Review* 73 (June 1968): 1359–91.

Sanford, Charles L. *The Quest for Paradise: Europe and the American Imagination.* Urbana: University of Illinois Press, 1961.

Santayana, George. *Letters of George Santayana.* Edited by Daniel Cory. New York: Scribner's, 1955.

———. *My Host the World.* New York: Scribner's, 1953.

Sapir, Richard Ben. *The Far Arena.* New York: Seaview Books, 1978.

Schauffler, Robert Haven, ed. *Through Italy with the Poets.* New York: Moffat, Yard, 1908.

Schorer, Mark. *Pieces of Life.* New York: Farrar, Straus & Giroux, 1977.

Schwartz, Lynn Sharon. *Rough Strife.* New York: Harper & Row, 1980.

Scrivener, Jane [Mother Mary St. Luke]. *Inside Rome with the Germans.* New York: Macmillan, 1945.

Sedgwick, Catherine Maria. *Letters from Abroad to Kindred at Home.* 2 vols. New York: Harper & Brothers, 1841.

Seldes, George. *Tell the Truth and Run.* New York: Greenberg, 1953.

Sevareid, Eric. *Not So Wild a Dream.* New York: Knopf, 1946.

Shaw, Howard. *The Crime of Giovanni Venturi.* New York: Henry Holt, 1959.

Shea, John Gilmary. *The Life of Pope Pius IX and the Great Events in the History of the Church during His Pontificate.* New York: Thomas Kelly, 1877.

Sheean, Vincent. *Between the Thunder and the Sun.* New York: Random House, 1943.

———. *Personal History.* 1935. 3d ed. Boston: Houghton Mifflin, 1969.

———. *Rage of the Soul.* New York: Random House, 1952.

Silliman, Benjamin. *A Visit to Europe in 1851.* 2 vols. New York: Putnam, 1853.

Simpson, Louis. *Adventures of the Letter I.* New York: Harper & Row, 1971.

———. *North of Jamaica.* New York: Harper & Row, 1972.

[Sloan, James]. *Rambles in Italy in the Years 1816–17, by an American.* Baltimore: N. G. Maxwell, 1818.

Soby, James Thrall. *Contemporary Painters.* New York: Museum of Modern Art, 1948.

———. "Peter Blume's *Eternal City.*" *Museum of Modern Art Bulletin* 10 (April 1943): 1–6.

Soria, Regina. *Dictionary of Nineteenth-Century American Artists in Italy 1760–1914.* E. Brunswick, N.J.: Associated University Presses and Fairleigh Dickinson University Press, 1982.

———. *Elihu Vedder: American Visionary Artist in Rome.* Rutherford, N.J.: Fairleigh Dickinson University Press, 1970.

Spassky, Natalie. *American Paintings in the Metropolitan Museum of Art.* Vol. 2, *Painters Born between 1816 and 1845.* New York: Metropolitan Museum of Art, 1985.

Spencer, Elizabeth. *The Stories of Elizabeth Spencer.* Garden City, N.Y.: Doubleday, 1981.

Spini, Giorgio. *Italia e America dal settecento all'età dell'imperialismo.* Rome: Marsilio, 1976.

Stebbins, Theodore E., Jr. *The Life and Works of Martin Johnson Heade.* New Haven: Yale University Press, 1975.

Stebbins, Theodore E., Jr., Carol Troyen, and Trevor J. Fairbrother. *A New World: Masterpieces of American Painting 1760–1910.* Boston: Museum of Fine Arts, 1983.

Steegmuller, Francis. *The Two Lives of James Jackson Jarves.* New Haven: Yale University Press, 1951.

Steffens, Lincoln. *Autobiography.* 2 vols. New York: Harcourt, Brace, 1931.

———. *Letters.* 2 vols. Edited by Ella Winter and Granville Hicks. New York: Harcourt, Brace, 1938.

Stendhal [Marie Henri Beyle]. *A Roman Journal.* Edited and translated by Haakon Chevalier. New York: Orion, 1957.

Stevens, Wallace. *The Collected Poems.* New York: Knopf, 1954.

Stillman, William James. *The Autobiography of a Journalist.* 2 vols. Boston: Houghton Mifflin, 1901.

———. *Old Rome and the New.* 1898. Reprint. Freeport, N.Y.: Books for Libraries Press, 1972.

———. *The Union of Italy.* Cambridge: Cambridge University Press, 1898.

Stock, Noel. *Life of Ezra Pound.* New York: Pantheon, 1970.

Story, William Wetmore. *Castel Sant' Angelo and the Evil Eye.* London: Chapman & Hall, 1877.

———. *Fiametta.* Boston: Houghton Mifflin, 1885.

———. *Graffiti d'Italia.* Edinburgh: Blackwood, 1868.

———. *Poems.* 2 vols. Boston: Houghton Mifflin, 1886.

———. *Roba di Roma.* 1855. 2 vols. 8th ed. 1877. 13th ed. Boston: Houghton Mifflin, 1887.

Stowe, Harriet Beecher. *Agnes of Sorrento.* 1862. Riverside ed. Boston: Houghton Mifflin, 1863.

———. *Life and Letters of Harriet Beecher Stowe.* Edited by Annie Fields. Boston: Houghton Mifflin, 1897.

Strout, Cushing. *American Image of the Old World.* New York: Harper & Row, 1963.

Styron, William. *Set This House on Fire.* New York: Random House, 1960.

Sumner, Charles. *Memoir and Letters of Charles Sumner.* Edited by Edward L. Pierce. 2 vols. Boston: Roberts Brothers, 1877.

Swan, Mabel Munson. *The Athenaeum Gallery 1827–1873.* Boston: Boston Athenaeum, 1940.

Sweeney, Francis, ed. *Vatican Impressions.* New York: Sheed & Ward, 1962.

Swenson, May. *To Mix with Time: New and Selected Poems.* New York: Scribner's, 1963.

Taine, Hippolyte. *Italy: Rome and Naples.* 1868. Translated by J. Durand. 4th ed. New York: Henry Holt, 1889.

Tarbell, Ida. *All in a Day's Work.* New York: Macmillan, 1939.

Taylor, Bayard. *Views A-Foot, or Europe Seen, with Knapsack and Staff.* 2d ed. New York: A. L. Burt, 1848.

Teasdale, Sara. *The Collected Poems of Sara Teasdale.* New York: Macmillan, 1966.

Thackeray, William Makepeace. *Vanity Fair.* 1847–48. Riverside ed. Boston: Houghton Mifflin, 1963.

Tharp, Louise Hall. *Three Saints and a Sinner.* Boston: Little, Brown, 1956.

Thayer, John. *An Account of the Conversion of the Rev. Mr. John Thayer . . .* 3rd ed. Manchester: G. Swindells, 1787.

Thayer, William Roscoe. *The Dawn of Italian Independence: Italy from the Congress of Vienna, 1814, to the Fall of Venice, 1849.* Boston: Houghton Mifflin, 1892.

———. *Italica; Studies in Italian Life and Letters.* Boston: Houghton Mifflin, 1908.

———. *The Letters of William Roscoe Thayer.* Edited by Charles Downer Hazen. Boston: Houghton Mifflin, 1926.

Ticknor, George. *Life, Letters, and Journals of George Ticknor.* 2 vols. Edited by George S. Hillard and Anna Ticknor. Boston: Osgood, 1876.

Tompkins, Peter. *A Spy in Rome.* New York: Simon & Schuster, 1962.

Tracy, Robert E. *American Bishop at the Vatican Council.* New York: McGraw-Hill, 1966.

Trauth, Mary P. *Italo-American Diplomatic Relations 1861–1862: The Mission of George Perkins Marsh, First American Minister to the Kingdom of Italy.* Washington: Catholic University of America Press, 1958.

Tuckerman, Henry T. *America and Her Commentators.* New York: Scribner's, 1864.

———. *Book of the Artists.* New York: Putnam, 1867. Reprint. New York: J. F. Carr, 1966.

————. *The Italian Sketch Book.* Philadelphia: Key & Biddle, 1835. 2d ed. enl. Boston: Light & Sterns, 1837. 3d ed. rev. and enl. New York: J. C. Riker, 1848.

————. *Poems.* Boston: Ticknor, Reed & Fields, 1851.

————. "A Word for Italy." *United States Magazine and Democratic Review* 17 (September 1845): 203–12.

Turnbull, Robert. *The Genius of Italy.* New York: Putnam, 1849.

Twain, Mark [Samuel Langhorne Clemens]. *The Complete Travel Books of Mark Twain: The Later Works.* Edited by Charles Neider. Garden City, N.Y.: Doubleday, 1967.

————. *The Innocents Abroad.* 1869. Reprint. 2 vols. New York: Harper & Row, 1911.

Cy Twombly. Cologne: Galerie Karsten Greve, 1984.

Twombly, Cy. *Cy Twombly: Paintings and Drawings 1952–84.* New York: Hirschl & Adler, 1984.

United States Magazine and Democratic Review 12 (May 1843): 454–55; 17 (September 1845): 203–12; 18 (February 1846): 119–20.

The Unity of Italy: The American Celebration. New York: Putnam, 1871.

Valentine, Lucia, and Alan Valentine. *The American Academy in Rome, 1894–1969.* Charlottesville: University of Virginia Press, 1973.

Vanderbilt, Kermit. *Charles Eliot Norton: Apostle of Culture in a Democracy.* Cambridge: Harvard University Press, 1959.

Vedder, Elihu. *The Digressions of V.* Boston: Houghton Mifflin, 1910.

Vidal, Gore. *The Judgment of Paris.* 1952. Rev. ed. New York: Ballantine, 1961.

Waddington, Mary King. *Italian Letters of a Diplomat's Wife.* New York: Scribner's, 1905.

Ware, William. *Probus, or, Rome in the Third Century.* 2 vols. New York: C. S. Francis, 1838.

————. *Sketches of European Capitals.* Boston: Phillips, Sampson, 1851.

Warner, Charles Dudley. *Saunterings.* Boston: James R. Osgood, 1872.

Warren, Robert Penn. *All the King's Men.* 1946. 2d ed. New York: Modern Library, 1953.

————. "*All the King's Men:* Matrix of Experience." *Yale Review* 53 (Winter 1964): 161–67.

Weed, Thurlow. *Letters from Europe and the West Indies.* Albany: Weed, Parson, 1866.

Weir, Irene. *Robert W. Weir, Artist.* New York: Field-Doubleday, 1947.

Welles, Sumner. *A Time for Decision.* New York: Harper & Brothers, 1944.

Wermuth, Paul C. *Bayard Taylor.* New York: Twayne, 1973.

Wharton, Edith. *Collected Short Stories of Edith Wharton.* Edited by R. W. B. Lewis. 2 vols. New York: Scribner's, 1968.

————. *Italian Backgrounds.* New York: Scribner's, 1905.

Whistler, James A. MacNeil. *The Whistler Journal.* Edited by Elizabeth R. Pennell and Joseph Pennell. Philadelphia: J. B. Lippincott, 1921.

Whitaker, John. *We Cannot Escape History.* New York: Macmillan, 1943.

White, Edmund. *Nocturnes for the King of Naples.* New York: St. Martin's, 1978.

Whiting, Lilian. *Italy, the Magic Land.* Boston: Little, Brown, 1907.

Whittier, John Greenleaf. *Complete Poetical Works of John Greenleaf Whittier.* Boston: Houghton Mifflin, 1894.

Wilbur, Richard. *Responses: Prose Pieces, 1953–1976.* New York: Harcourt Brace Jovanovich, 1976.

————. *Things of This World.* New York: Harcourt, 1956.

Wilder, Thornton. *The Cabala and The Woman of Andros.* New York: Harper & Row, 1968.

Williams, Miller. *The Boys on Their Bony Mules.* Baton Rouge: Louisiana State University Press, 1983.

Williams, Miller, ed. *A Roman Collection.* Columbia: University of Missouri Press, 1980.

Williams, Tennessee. *The Roman Spring of Mrs. Stone.* 1950. Reprint. New York: Ballantine, 1985.

———. *Tennessee Williams' Letters to Donald Windham 1940–65.* Edited by Donald Windham. New York: Holt, Rinehart & Winston, 1977.

Willis, Nathaniel P. *Dashes at Life with a Free Pencil.* New York: Burgess, 1845.

———. *Pencillings by the Way.* 1835. New York: Scribner's, 1852.

Wilmerding, John, ed. *The Genius of American Painting.* New York: William Morrow, 1973.

Wilson, Edmund. *Europe without Baedeker.* 1947. 2d ed. London: Rupert Hart-Davis, 1967.

Wittman, Otto, Jr. "Americans in Italy." *College Art Journal* 17 (1958): 284–93.

———. "The Attraction of Italy for American Painters." *Antiques* 85 (May 1964): 552–56.

———. "The Italian Experience (American Artists in Italy 1830–1875)." *American Quarterly* 4 (1952): 3–15.

Wölfflin, Heinrich. *Principles of Art History: The Problem of the Development of Style in Later Art.* Translated by M. D. Hottinger. 1932. Reprint. New York: Dover, 1950.

Woodress, James L. *Howells and Italy.* Durham: University of North Carolina Press, 1952.

Woolson, Constance Fenimore. *The Front Yard and Other Italian Stories.* New York: Harper & Brothers, 1895.

Wright, James. *This Journey.* New York: Random House, 1982.

———. *To a Blossoming Pear Tree.* New York: Farrar, Straus & Giroux, 1977.

———. *Two Citizens.* New York: Farrar, Straus & Giroux, 1973.

Wright, Nathalia. *American Novelists in Italy: The Discoverers: Allston to James.* Philadelphia: University of Pennsylvania Press, 1965.

Yourcenar, Marguerite. *A Coin in Nine Hands.* 1934. Rev. ed. 1959. Translated by Dori Katz. New York: Farrar, Straus & Giroux, 1982.

Zapponi, Niccolo. *L'Italia di Ezra Pound.* Rome: Bulzoni, 1976.

Index